Cognitive Science and Technology

Series editor

David M.W. Powers, Adelaide, Australia

More information about this series at http://www.springer.com/series/11554
Book's web site including new events, projects and multimedia at http://roboticart.org

Damith Herath · Christian Kroos · Stelarc
Editors

Robots and Art

Exploring an Unlikely Symbiosis

 Springer

Editors
Damith Herath
Human Centred Technology
 Research Centre
University of Canberra
Canberra, ACT
Australia

Stelarc
Alternate Anatomies Lab,
 School of Design and Art
Curtin University
Perth, WA
Australia

Christian Kroos
Alternate Anatomies Lab,
 School of Design and Art
Curtin University
Perth, WA
Australia

ISSN 2195-3988 ISSN 2195-3996 (electronic)
Cognitive Science and Technology
ISBN 978-981-10-0319-6 ISBN 978-981-10-0321-9 (eBook)
DOI 10.1007/978-981-10-0321-9

Library of Congress Control Number: 2016938046

Printed on acid-free paper

This Springer imprint is published by Springer Nature
The registered company is Springer Science+Business Media Singapore Pte Ltd.

To Amma and Thattha

Damith Herath

To my parents

Christian Kroos

For my partner, Nina Sellars

Stelarc

Preface

This is an unusual book.

It brings together perspectives of human activity and thinking that seemingly could not be further apart: science, engineering and technology on the one side, the arts and critical culture studies on the other. Yet, in contemporary robotic art they have been intertwined from the start, living off and nurturing each other. The current book follows this symbiotic relationship. It takes a path that meanders between the territories of the unlikely partners, along the fault lines of the areas, changing its style and viewpoint on the run as the narrative of robotic art makes inevitable.

For this book to come into being it took an unexpected collaboration. About seven years ago, a multidisciplinary, multi-university research project with funding from the Australian Research Council and the National Health and Medical Research Council was initiated at the MARCS Institute at Western Sydney University, Sydney, Australia. Titled the 'Thinking Head Project', it aimed to develop a sophisticated embodied conversational agent: a virtual, autonomous talking head that could generate appropriate and intelligent responses.

Unlike most other research projects, this project included an artist—an oddity indeed. In the beginning, there were no robots. As the research project progressed, the need for physical embodiment emerged from the desire to make the conversational agent more interactive and engaging. The new 'Articulated Head' was designed as a mixed-reality system, part virtual and part physical: An industrial robot arm moving the monitor that displayed the virtual agent. A robotics engineer was hired and a cognitive scientist already in the project switched from researching virtual human–computer interaction to handling the AI controlling the new robotic chimera. It may not come as a surprise then to readers that it is these three individuals who are the editors of the current book.

Such interdisciplinary collaborations are not without difficulties. Replicability and measurability required by science and engineering are at odds with the integrity of a work of art which transcends these norms: Not to be repeated, not to be measured. In implementing the Articulated Head, it became quickly apparent that the enfolding head-on collision of mindsets and methods was neither pragmatic

in nature nor project-specific. It is inscribed in the historical development of disciplines and despite encouragement of interdisciplinarity by universities, funding bodies and government programs in many countries, anyone working at the intersection of very diverse disciplines has experienced these apparent incommensurabilities. In academia especially, the organisational structures and evaluation processes often impede work attempting to bridge the gap between science and art.

It became our ambition to lower the disciplinary boundaries between robotics and art. We started with full-day workshops at international robotic conferences and discovered a rich culture of collaborations in robotic art, sometimes reaching back several decades. However, these collaborations had seldom entered mainstream robotics. The current book is an attempt to mend fences—not by ignoring established requirements and practices of the involved disciplines, but by opening the view to other perspectives.

As you will discover, the artists included in this book—either in their own account or as topic of analysis—have created some of the most iconic and seminal works in robotic art. The contributors to this book were invited for their diverse approaches and viewpoints and the quality of their work. Each contribution has undergone a thorough peer review process. The result is an informed and insightful look at the concepts, the technology, the history and the philosophy of robots in contemporary art and the notable influence it has had on the discussion of robot-related issues in society. The result is also a very readable book, accessible to a wider readership beyond disciplinary boundaries and beyond academic scholarship and education.

Acknowledgment

We are indebted to the authors for their contributions amidst busy schedules and work commitments, gracefully accepting our relentless reminders, additional questions and revise requests. We also acknowledge the fertile landscape that was the Thinking Head Project, which provided the necessary support and the framework for us to collaborate and explore this unlikely union of robotics and art and between roboticists and artists. Especially, Denis Burnham and Kate Stevens at the MARCS Institute, Western Sydney University, along with other investigators of the Thinking Head project. We also acknowledge the many other organisers of the Robots and Art workshop series at ICRA for facilitating and promoting the cross-disciplinary dialogue over the years.

Many colleagues including some of the authors themselves have lent considerable personal time to review the draft chapters. Specifically, we acknowledge the contributions from the following reviewers: Bhante Sujato, Chris Drane, David St-Onge, Eleanor Sandry, Elizabeth Ann Jochum, Elizabeth Stephens, Guy Ben-Ary, Heidi Dokulil, Janise Farrel, Jayasinghe Herath, Jean-Paul Laumond, Jeni Thornley, Leonel Moura, Lesley Christen, Matthew Connell, Nicolas Reeves and Paddy Murray.

We collectively wish to acknowledge the support received from the MARCS Institute at the Western Sydney University, Brunel University, London, Alternate Anatomies Lab at Curtin University, SMaRT Centre at the University of New South Wales, Sydney, Human-Centred Technology Research Centre at the University of Canberra, and the Powerhouse Museum (Museum of Applied Art and Science), Sydney—the proving ground for our adventures in robotic art. We want to thank our long-standing colleague and friend Zhengzhi Zhang and Robological Pty Ltd for the many contributions made to the projects.

We are grateful to Springer for commissioning this important work and to the whole editorial and production team, especially Loyola (Loy) D'Silva, our publishing editor for patiently guiding this project through.

Finally, we thank our next of kin, friends and colleagues who played a key role in shaping this book over the years.

We would like to invite you, the reader, to embark on an exploratory journey with us and the contributors, travel through conflicting fields of studies and witness how they come together to form an unlikely symbiosis in the creation of robotic art. We hope you will enjoy this unusual journey as much as we did over the last five years while designing, editing and contributing to this book.

Contents

Editors and Contributors

About the Editors

Damith Herath Human Centred Technology Research Centre, University of Canberra, Australia

Damith Herath received his Ph.D. in Robotics from the University of Technology, Sydney in 2008 while at the ARC Centre of Excellence for Autonomous Systems (CAS) and has a B.Sc. (Hons) in Production Engineering, University of Peradeniya, Sri Lanka in 2001. He held a doctoral fellowship at CAS prior to joining MARCS Institute on the Thinking Head Project as the Research Engineer. At MARCS, he led several robotic projects that explore various nuances of Human–Robot Interaction including reciprocal influences between the arts and robotics. His interests include autonomous robot navigation, localization and mapping, human–robot interaction and robotic art. Over the last 4 years, he has contributed to a number of robotic art projects as the lead roboticist. He is also the convener and program co-chair of the 2011 International Conference on Robotics and Automation—Workshop on Robots and Art.

Christian Kroos Alternate Anatomies Laboratory, School of Design & Art, Curtin University, Perth, Australia

Christian Kroos received his M.A. and Ph.D. in Phonetics and Theatre Studies from the Ludwigs-Maximilians-Universität, München, Germany. His work on speech articulator movements and face motion during spoken language led to interdisciplinary research covering computer vision, cognitive sciences and robotics conducted internationally at the Institute of Phonetics and Speech Processing at Ludwigs-Maximilians-Universität (Germany), at ATR International (Japan) and at Haskins Laboratories (USA). At MARCS Institute, University of Western Sydney, Australia, he explored non-verbal human–machine interaction in the Thinking Head project. Besides his interest in robotic agents, he is still fascinated by human speech production and the evolution of language.

Stelarc Performance Artist, Distinguished Research Fellow, Director Alternate Anatomies Lab, School of Design & Art, Curtin University Perth

Stelarc explores alternate anatomical architectures, using prosthetics, robotics, medical imaging, biotechnology and the Internet. He has performed with a Third Hand, a Virtual Body, an Extended Arm, a Stomach Sculpture, Exoskeleton and a Prosthetic Head. He is surgically constructing and stem-cell growing an ear on his arm that will be Internet enabled. Publications include Stelarc: The Monograph, Edited by Marquard Smith, Forward by William Gibson (MIT Press 2005). In 1996 he was made an Honorary Professor of Art and Robotics at Carnegie Mellon University, Pittsburgh and in 2002 was awarded an Honorary Doctorate of Laws by Monash University, Melbourne. In 2010, he received the Ars Electronica Hybrid Arts Prize. He has recently been presented with the inaugural Australia Council Award for Outstanding Achievement in Emerging and Experimental Arts. Stelarc is currently a Distinguished Research Fellow and Director of the Alternate Anatomies Lab, School of Design and Art (SODA) at Curtin University. His artwork is represented by the Scott Livesey Galleries, Melbourne.

Contributors

Gemma Ben-Ary Gemma is an independent art curator, writer and visual artist who works on public arts projects and exhibitions, and is the Curator of the contemporary art collection of the City of Joondalup, West Australia, a collection featuring the work of Western Australian contemporary artists. She is currently completing a BA (Writing Minor, Visual Art Major) at ECU and sits on the Board of the Mundaring Arts Centre. Since graduating from TAFE in 2007 with an Advanced Diploma of Visual Art, she has worked in various cultural development roles and her artistic practice combines feminist theory and contemporary craft.

Guy Ben-Ary SymbioticA: The Center for Excellence in Biological Arts, the University of Western Australia

Guy Ben-Ary is an artist and researcher at SymbioticA at the University of Western Australia. Recognised internationally as a major artist and innovator working across science and media arts, Guy specialises in biotechnological artwork, which aims to question our understanding of life. Guy's work has been shown across the globe at prestigious venues and festivals from the Beijing National Art Museum to San Paulo Biennale to the Moscow Biennale (to name a few). In 2009, his work was awarded an Honorary Mention in Ars Electronica and also won first prize at VIDA, an international competition for Art and Artificial Life.

Louis-Philippe Demers School of Art, Design and Media, Nanyang Technological University

Louis-Philippe Demers makes large-scale installations and performances building more than 375 machine performers over the past two decades. His projects

can be found in theatre, opera, subway stations, art museums, science museums, music events and trade shows. Demers' works have been primed at Ars Electronica, VIDA, Japan Media Arts Festival, Lightforms and at the Helpmann Awards. Demers was Professor at the Hochschule fuer Gestaltung Karlsruhe, affiliated to the world-renowned Zentrum fuer Kunst und Medientechnologie (ZKM, Germany). Since he joined the School of Art, Design and Media at the Nanyang Technological University (Singapore).

Stefan Doepner He studied experimental film and intermedia arts at the University of Arts Bremen. Doepner primarily works in the field of technology-based art, robotics and sound. He confounded several art groups and initiatives, e.g. f18institute in Hamburg, Obrat and Cirkulacija2 in Ljubljana. Since 1997 he collaborates with Stelarc. Doepner participated at the documenta9 project VanGogh TV (1992); exhibited at Steirischer Herbst, (2006); Synthetic Times: Media Art China, Beijing (2008); Ars Electronica, (2008); MedienKunstLabor, Graz (with Cirkulacija2, 2009), f18institut's Playground Robotics project, Switzerland and Slovenia (2004). The NanoŠmano project with Dusseiller and Leskovšek—nano-scale material, lifeforms and tools (2010–2012) at Kapelica Gallery. The "Total Art Platform" (2010–2013) and "The Noise is Us" festival (2014/15) with Cirkulacija2.

Ken Goldberg University of California Berkeley

Goldberg is an Artist and Professor of Engineering at UC Berkeley. He explores the intersection of the digital and the natural worlds. His artworks include a living garden tended by a robot via the Internet and the award-winning film "Why We Love Robots". His works have appeared at the Whitney Biennial, Venice Biennale, Pompidou Center, Walker Art Center, Ars Electronica, ZKM, ICC Biennale, Kwangju Biennale, Artists Space and the Kitchen. He is the Founding Director of Berkeley's Art, Technology, and Culture Colloquium.

Tara Heffernan Tara Heffernan is a Melbourne-based independent art writer. Contributing to numerous Australian art magazines, such as Artlink, Eyeline, and un Magazine, Heffernan's research concerns performance, technology and video in contemporary art. She received a Bachelor of Fine Art (with an honours in Art History) from Griffith University in 2012.

Hiroshi Ishiguro Graduate School of Engineering Science at Osaka University; Hiroshi Ishiguro Laboratories at the Advanced Telecommunications Research Institute

Hiroshi Ishiguro received a D.Eng. in Systems Engineering from the Osaka University, Japan in 1991. He is currently Professor of Department of Systems Innovation in the Graduate School of Engineering Science at Osaka University (2009–) and Distinguished Professor of Osaka University (2013–). He is also visiting Director (2014–) (group leader: 2002–2013) of Hiroshi Ishiguro Laboratories at the Advanced Telecommunications Research Institute and an ATR fellow. His research interests include sensor networks, interactive robotics, and android science.

Elizabeth Jochum Aalborg University

Elizabeth Jochum (BA Wellesley College; MA, Ph.D. University of Colorado) is an Assistant Professor of Robot Aesthetics at Aalborg University (Denmark) and the co-founder of Robot Culture and Aesthetics (ROCA) research group at the University of Copenhagen. Her research focuses on the intersection of robotics, art and performance.

Urška Jurman Program manager of the Igor Zabel Association for Culture and Theory.

Urška Jurman graduated 2002 in Art History and Cultural Studies from the Faculty of Arts, University of Ljubljana. She works as editor, writer, curator and producer. Her field is contemporary art and its social context. Collaborations in Slovenia: Škuc Gallery, '95–'97; SCCA-Center for Contemporary Art, '99–'02, '05–'06; hEXPO festival 2000; festival Break 2.2, '03; Gallery P74, '05–'08. Since 2012, she is Program Manager of the Igor Zabel Association. She is Co-founder of Obrat Association.

Jean-Paul Laumond LAAS-CNRS, Toulouse, France

J.P. Laumond, IEEE Fellow, is a roboticist. He is Directeur de Recherche at LAAS-CNRS. His research is devoted to robot motion. He has published more than 150 papers in international journals in Robotics, Computer Science, Control and Neurosciences. He has been the 2011–2012 recipient of the Chaire Innovation technologique Liliane Bettencourt at Collège de France in Paris. His current project Actanthrope (ERC-ADG 340050) is devoted to the computational foundations of anthropomorphic action.

Chico MacMurtrie Amorphic Robot Works

Chico MacMurtrie is internationally recognised for his large-scale, interactive public sculpture, performances and robotic installations. After graduating from UCLA in 1987, he has received various awards and grants including from the Rockefeller and Daniel Langlois Foundation. In 1991 he founded Amorphic Robot Works/ARW, a collective of artists, engineers, and scientists dedicated to the creation of anthropomorphic, organic, and abstract robotic forms. ARW has exhibited in major museums and institutions worldwide, including: Reina Sofia Museum, Madrid; NAMOC, Beijing; MUAC, Mexico City; Beall Center for Art and Technology; Shanghai Biennale, Pioneer Works, (NY); SESC, Sao Paulo; Cité des Sciences, Paris.

Leonel Moura is a European artist born in Lisbon who works with AI and robotics. In 2003, he created his first swarm of 'Painting Robots', able to produce original artworks based on emergent behaviour. Robotic Action Painter (RAP), produced for the American Museum of Natural History in New York and ISU (The Poet Robot), both from 2006, are able to generate highly creative and original art works. In 2007, the Robotarium, the first zoo dedicated to robots and artificial life, opened near Lisbon. In 2009, Moura was appointed as the European Ambassador for Creativity and Innovation.

Kohei Ogawa Graduate School of Engineering Science at Osaka University

Kohei Ogawa received a Ph.D. in Future University-Hakodate, Japan in 2010. He is currently an Assistant Professor in the Department of Systems Innovation in the Graduate School of Engineering Science at Osaka University (2012–) His research interests include interactive robotics, and human agent interaction.

Simon Penny University of California Irvine

Simon Penny is an interactive media artist, teacher and theorist with a long-standing concern for embodied and situated aspects of artistic practice. He explores—in both artistic and scholarly work—problems encountered when computational technologies are interfaced with cultural practices whose first commitment is to the engineering of persuasive perceptual immediacy and affect. Currently, a Professor of Electronic Art and Design, he teaches Mechatronic Art, Gizmology and related practices. He is also the Founding Director of Arts Computation Engineering graduate program, UCI; Labex International Professor, Paris8 and ENSAD 2014; visiting professor, Cognitive Systems and Interactive Media masters, University Pompeu Fabra Barcelona, 2006–2013, Professor of Art and Robotics Carnegie Mellon, 1993–2000. See simonpenny.net.

Nicolas Reeves NXI GESTATIO Design lab—University of Quebec in Montreal

Trained in architecture and physics, a graduate of MIT, Nicolas Reeves is an artist and researcher at the School of Design at University of Quebec in Montreal (UQAM). His work is characterised by a highly poetic use of sciences and technologies. A founder member and, later, Scientific and Research-Creation Director of the Hexagram Institute from 2001 to 2009, Vice-President of the Société des Arts Technologiques from 1998 to 2008, he directs the NXI GESTATIO design lab, which explores the formal impact of digital information in all creative fields. He has produced a number of acclaimed works, such as Harpe à Nuages (Cloud Harp) and triggered the Aerostabiles research programme, which studies the potential of flying automata able to develop autonomous behaviour. The winner of several prizes and grants, he has shown work and given talks on four continents.

Ken Rinaldo The Ohio State University

Ken Rinaldo is internationally recognised for his interactive installations blurring the boundaries between the organic and inorganic and speaking to the co-evolution between living and evolving technological cultures. His work interrogates fuzzy boundaries where hybrids arise. Biological, machine and algorithmic species and their unique intelligences are mixing in unexpected ways and we need to better understand the complex intertwined ecologies that these semi-living species create. Rinaldo is focused on trans-species communication and researching methods to understand animal, insect and bacterial cultures as models for emergent machine intelligences, as they interact, self organise and co-inhabit the earth. Rinaldo's works have shown and commissioned by museums, festivals and galleries internationally.

David Rye Australian Centre for Field Robotics, The University of Sydney, Australia; Adjunct Associate Professor, Creative Robotics Lab, UNSW Art & Design, The University of New South Wales, Australia.

Associate Professor David Rye is a co-founder of the Australian Centre tor Field Robotics, which was established in the School of Aerospace, Mechanical and Mechatronic Engineering at the University of Sydney in 1999. He holds a Ph.D. in Mechanical Engineering from the University of Sydney. He has conducted extensive research in fields related to automation and control of machines, including applied nonlinear control, container handling cranes, excavation and autonomous vehicles. Since 2003, he has worked with Mari Velonaki in the field of social robotics, designing and implementing autonomous robots that can interact with people in social spaces. Rye is recognised as a pioneer in the university teaching of mechatronics, having instituted the first Australian BE in Mechatronic Engineering in 1990.

Eleanor Sandry Curtin University

Eleanor Sandry is a Lecturer in Internet Studies at Curtin University. Her research develops an ethical and pragmatic recognition of, and respect for, otherness in communication. She writes about communication theory and practice, using examples from science and technology, science fiction and creative arts to illustrate her ideas. She has a particular interest in human–robot interactions and her first book, Robots and Communication, was published by Palgrave Macmillan in 2015.

David St-Onge Département de Robotique, Université Laval, Québec

An engineer in arts trained as a mechanical engineer, David St-Onge then graduated in project management to acquire the skills required to work in a multidisciplinary environment. His Ph.D. in space robotics is conducted at the Department of Mechanical Engineering of Laval University in Quebec. He works with some of the most important artists of the Quebec technological arts scene, providing them with the tools needed to express their talent and vision.

Elizabeth Stephens Southern Cross University

Elizabeth Stephens is an Associate Professor in Cultural Studies and Director of Research in the School of Arts and Social Sciences at Southern Cross University. Her books include Anatomy as Spectacle: Public Exhibitions of the Body from 1700 to the Present (2011) and Queer Writing: Homoeroticism in Jean Genet's Fiction (2009). She is currently completing a new book, A Critical Genealogy of Normality, with Peter Cryle.

Mari Velonaki Director, Creative Robotics Lab, UNSW Art & Design, The University of New South Wales, Australia; Adjunct Associate Professor, Australian Centre for Field Robotics, The University of Sydney, Australia.

Mari is a researcher in the fields of social robotics and interactive art. Mari's research expanded to robotics when she initiated and led a major Australian Research Council (ARC) project 'Fish–Bird' (2004–2007) at the Australian Centre for Field Robotics. She founded the Centre for Social Robotics in 2006 within ACFR. In 2014, Mari was awarded an ARC grant for the creation of a National Facility dedicated to Human–Robot Interaction Research. Mari is the Director of

the Creative Robotics Lab at UNSW. In 2014, she was voted by Robohub as one of the world's 25 women in robotics you need to know about.

Bill Vorn Concordia University

Based in Montreal, Bill Vorn is working in the field of Robotic Art for more than 20 years. His installation and performance projects involve robotics and motion control, sound, lighting, video and cybernetic processes. He holds a Ph.D. degree in Communication Studies from UQAM (Montreal) for his thesis on Artificial Life as Media. He currently teaches Electronic Arts in the Department of Studio Arts at Concordia University (Intermedia program) where he is a Full Professor.

Norman T. White Norman White started his art career as a painter, but in the late 1960s he taught himself electronics and began to create electrical machines in order to better model the often unpredictable behaviour of dynamic systems, especially that of living organisms. White has exhibited his artwork throughout North America and Europe. Many of his works can be found in public collections, including those of the Art Gallery of Ontario, the Vancouver Art Gallery, the Canadian Art Bank and the National Gallery of Canada. Since 1978, he has taught electronics, mechanics and computer programming at both OCAD and Ryerson Universities in Toronto.

Amy M. Youngs The Ohio State University

Amy M. Youngs is an artist and creative researcher in the areas of eco art, interactive installation and socially-engaged practices. She has exhibited her work at venues such as the Te Papa Museum in New Zealand, the Trondheim Electronic Arts Centre in Norway, the National Art Museum of China and the Peabody Essex Museum in Salem, Massachusetts. She has published articles in Leonardo and Antennae and her artwork has been featured in many art and science publications. She co-developed the Art and Technology program at the Ohio State University, where she has been on faculty since 2001.

Part I
Prologue

Engineering the Arts

Damith Herath and Christian Kroos

Abstract This book is a result of chance encounters, random discussions and a colluding collaboration between an engineer, a scientist and an artist. From the onset, the interdisciplinary nature has set us on a colliding course of ideas, expectations and interests. While interdisciplinary research is celebrated en masse by funding agencies, government bodies and the academia, researchers who embrace interdisciplinarity live a distinctly strenuous life with little recognition for their efforts that appear to fall into the chasm between the established norms and practices of the constituent disciplines. Here, we anecdotally backtrack our journey through the years, homage to the individuals who assume flexible identities, seeking out adventures beyond the confinements of their chosen field.

> **Innovation resides where art and science connect is not new. Leonardo da Vinci was the exemplar of the creativity that flourishes when the humanities and sciences interact. When Einstein was stymied while working out General Relativity, he would pull out his violin and play Mozart until he could reconnect to what he called the harmony of the spheres.**
>
> – Walter Isaacson, The Innovators: How a Group of Inventors, Hackers, Geniuses, and Geeks Created the Digital Revolution

Introduction

This has been written by the first author from his perspective as an engineer with input from the co-author and numerous contributors to the projects described herein.

D. Herath (✉)
Human Centred Technology Research Centre, Faculty of Education,
Science Technology and Mathematics, University of Canberra,
University Drive, Bruce 2617, ACT, Australia
e-mail: damithc@gmail.com

C. Kroos
Centre for Vision, Speech and Signal Processing,
University of Surrey, Guildford GU2 7XH, UK

© Springer Science+Business Media Singapore 2016
D. Herath et al. (eds.), *Robots and Art*, Cognitive Science and Technology,
DOI 10.1007/978-981-10-0321-9_1

Robotics without utility is anathema in most robotic research labs. Robotic art, at a cursory glance, lacks the pragmatism demanded by proprietary and prosaic research, which is the norm in engineering. Thus, it begs the question as to what made us, and perhaps many of the engineers represented in this book, delve into the 'forbidden' realm of robotic art. This book paradoxically is an answer, both for and against the utilitarian paradigm of robotic research. Through our own work with Stelarc—the artist, we have seen how robotic art informs and drives pure and applied research in robotics, engineering and many other related fields, which otherwise would have taken longer to arrive at or, even worse, would have never been explored and exploited at all. However, such cross-discipline collaborations are not without peril. As we personally experienced it, ramifications for engaging in art—robotic art in this instance, could in fact be career threatening. What follows is a series of flashbacks, recollections and afterthoughts from the engineering-science point of view of a robotic art nexus—spanning half a decade that resulted in this book. These anecdotes hint at the subtle tensions, the occasional humour in miscommunication, the triumphs and the failures that one could expect from interdisciplinary research.

Beginnings

In 2006, the Australian Research Council (ARC) and the National Health and Medical Research Council (NHMRC) of Australia announced three jointly funded special initiative projects collectively called the "the Thinking Systems" initiative. On the opening press release,[1] the title ostensibly announced "$10 million to develop 'thinking' robots". It went on to read:

> **New cross-disciplinary research that brings together neuroscience, artificial intelligence, robotics and computer science will receive $10 million over the next five years under the Australian Government's Thinking Systems initiative.**

> **This is a very exciting field of research that will lead to the development of a new generation of intelligent machines, robots and information systems, and keep Australia at the forefront of an internationally competitive area of increasing importance.**

Of the three projects announced, "From Talking Heads to Thinking Heads: A Research Platform for Human Communication Science" (Thinking Head Project) received $3.4 million Australian dollars to research human-machine communication through the development of virtual 'thinking/talking heads'. The project was headed by the MARCS Auditory Laboratory at the University of Western Sydney along with a consortium of universities and partners. The original project brief stated:

[1]https://www.nhmrc.gov.au/_files_nhmrc/file/grants/funding/funded/thinking_systems_media_release.pdf (accessed 6 Dec 2015).

In this project current Talking Head technology will be taken into the realm of a highfidelity Thinking Head, with implications and applications for basic and applied research. Outcomes will bear on human-machine communication, telecommunications, ecommerce, and mobile phone technology; personalised aids for disabled users, the hearing impaired, the elderly, and children with learning difficulties, foreign language learning; and will facilitate the development of animation in new media, film, and games. In addition to output in scholarly journals, beta-versions of the Head will be made available, and public visibility for the project will be facilitated by the incorporation of high-profile installations and exhibitions.

While the brief in general alludes to the outcomes expected of a typical government funded scientific enterprise, the last sentence hints at something unique, particularly for a medical/engineering research project. The non-standard research outcomes in the guise of marketing (viz. "...*public visibility through high-profile installations and exhibitions*") were a careful crafting of words to integrate artistic outcomes into an otherwise 'scientific' endeavour. Thus, an artist was officially commissioned to interpret medical/engineering outcomes in a public friendly way.

The Robot in the Crate

One reason for including the artist in the Thinking Head project was the convenience factor that he already had a working talking head—Stelarc's Prosthetic Head [1]. The Prosthetic Head formed the basis on which later Thinking Head research would be based on. In fact, one could argue that the artist has provided the intellectual seed for the project. Though the artist was never made a primary investigator of the project, he was offered a part time senior researcher position as a way of acknowledging his contribution to the project. Stelarc, however, was already a step ahead and was already contemplating a new embodiment for the Prosthetic Head.

At the time I was working as a postdoctoral fellow researching robotic navigation. A chance contact with an academic involved in the Thinking Head project brought my attention to the project and the subsequent meeting with Stelarc. As most other engineers would, I was ignorant of Stelarc's influence in the performance art realm. However, his amicable ways and the mentioning of a particular robot packed in a crate outside the lab had me excited of a potential collaboration with Stelarc.

The robot in the crate was a FANUC LR mate 200ic, an industrial robot arm. It has been sitting there for over a year at this stage, almost at the end of its warranty. The robot had been bought on behalf of Stelarc. But there was no local expertise in the lab, since MARCS was predominantly a psychology and linguistic lab and an industrial robot arm was of little 'research' interest to the academics at the facility. The robot was to fulfil the stated publicity outcomes of the Thinking Head project and was originally conceived as a kinetic sculptural presence for Stelarc's Prosthetic Head—essentially a robotic embodiment of the virtual talking head. The new embodiment was called the Articulated Head and Stelarc was looking for a robotics engineer to team up with.

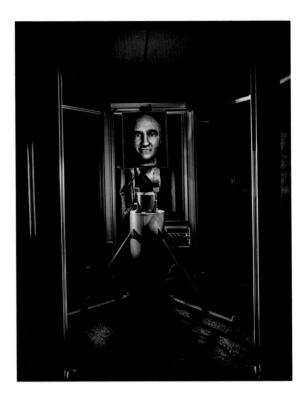

In late 2008, I was offered a research engineer position at the MARCS Lab to work on the Thinking Head Project, to work with Stelarc to bring the robot in the crate to "life". My former robotics supervisor was not impressed with the departure from robotics, from science to the, as he saw it, ephemeral field of art. I was warned that it would be a risky move for an upstart robotics researcher to veer considerably off course from his chosen field of research—nevertheless I took the plunge.

The Articulated Head

There were several reasons to move from the original Prosthetic Head to the Articulated Head (Fig. 1). The use of a six degrees of freedom robot arm as some kind of neck was an important one [2]: It gave the installation an anthropomorphic presence without the complications of a humanoid robot with its potential to fall into the uncanny valley [3]. This opened up a rich platform for us to carry out research in a number of disciplines while justifying the artistic enterprise that drove the project forward. Among them was the study of Human Robot Interaction (HRI), a burgeoning field of research that sits at the intersection of robotics, psychology, social sciences and a host of other related fields.

Fig. 2 Body in White
(2015), Sculpture in plaster of
Paris, by Stephen Antonson
and Ken Goldberg

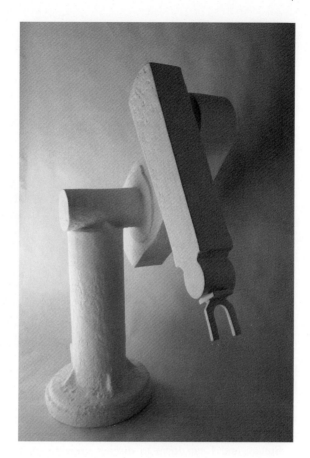

Seductive Movements

Very little has changed over the years in the way in which industrial robots have been perceived since the early industrial robots such as the now iconic PUMA [4] (Fig. 2).[2] So when Stelarc insisted that the Articulated Head "should announce its presence and be seductive in its motions", we had very little to base our work on. In engineering parlance the FANUC robot is a category 4-safety system meaning the highest safety precautions must be implemented prior to its operations. Thus the early work began with the robot fenced off inside a temporary cage with a 14-inch computer monitor mounted as its end effector (Fig. 3) and the monitor displayed the Prosthetic Head. An auditory localisation system [5] developed for the Thinking Head project was adapted to the Articulated Head. This enabled the

[2]The image is an interpretation by Stephen Antonson and Ken Goldberg of the classic "Programmable Universal Machine for Assembly (PUMA)" industrial robot arm developed in the 1970s.

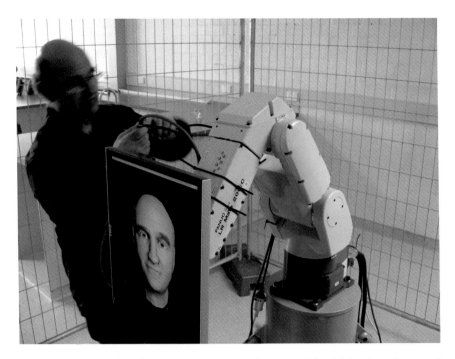

Fig. 3 Articulated Head, Artist assisting the engineering team with cabling—the safety cage is visible in the background. Image by Damith Herath

robot to turn its 'head' in the direction of sound events. The first hints of aliveness starting to show albeit with crude, abrupt and mechanistic movements.

Stelarc and I sat down to discuss creating more 'seductive' movements for the robot. We started by programming the robot with a set of random motion sequences. I would ask him "where should I move the arm next?" and he would reply "here…" pointing to, what appeared to be an arbitrary point in space. Then he would ask me to combine several of those points in a particular order to play back as a motion sequence. One time, I combined them in the wrong order by mistake. When I replayed the sequence, the robot arm moved in the most uncanny way. Realising the error I said to Stelac "I think I made a mistake". His answer was "we need to make more mistakes!" That goes against my engineering conscience—making mistakes. However, after n-number of mistakes, what initially appeared to be pointless movements of the robot's end-effecter from coordinate X to Y soon gave way to 'beautiful' movements. The robot was now not only 'alive' but also 'seductive' in its motions. An industrial robot arm that normally performs precise repeated high-speed tasks has suddenly assumed a life and a beauty of its own.

During this early testing phase, I would occasionally leave the robot running overnight to test various software and hardware components. On one such occasion, when I returned in the morning, a disgruntled security officer was

standing at the lab entrance waiting for me. Fearing for the worst, I anxiously enquired his concern. Usually at night, the security personnel would patrol the labs. In this occasion one of the junior officers had ventured unsuspectingly into the Articulated Head lab. The robot was programmed to assume a sleeping posture—the monitor lowered and tucked in, after a period of inactivity in its audioscape. When the security officer entered the lab, the robot rose from its sleeping position and, looked at the officer straight in the eye and said "Hello!" The poor officer froze in fear. He had inadvertently 'woken up' the robot with the noise from the door. It struck me as the first time the robot had literally announced its presence to the world—the robot had paid attention to its first human interlocutor.

Aesthetics of a Safety Cage

The robot hadn't been exhibited publicly yet. That moment came when the robot was invited to be installed at a local conference in June 2010 [6]. This presented us with an opportunity to test our engineered systems alongside the more abstract artistic expectations of engagement in a real-life setting. Taking the robot public also meant that we now needed an aesthetically appealing safety enclosure for the head.

The design of the enclosure turned out to be an arduous task. From an engineering perspective, the requirement was a secured enclosure that ratifies category 4 safety requirements. In ordinary language, that's a four-sided work cell protected by fences—the likes of those seen in automated car factories. There are readily available commercial structures that can be set up in a matter of hours and a safety engineer can easily validate their efficacy. However, the artist would have none of that. His intention was to create a maximally engaging sculptural presence, which could be directly experienced by the visitor without distracting physical structures obstructing that engagement. The artist's first intention was to have the robot in a fully open setting without any intervening structures or barricades. For safety, a virtual laser curtain was suggested to be installed to disarm the robot if a person would venture into the work envelop of the robot. After much deliberation, the laser curtain option was deemed unsuitable as it could be breached in a multiplicity of ways in an open public setting. It was decided to enclose the robot in a glass structure—much to the dismay of the artist, but to the relief of the safety engineer, lab manager and almost everyone else who had a duty of care for fellow co-workers and the general public.

The new enclosure was a hexagonal shaped structure made up of six large rectangular glass panes connected to each other using a steel framework that can be quickly assembled and disassembled for mobility (Fig. 4). While it was a marked improvement over the previous safety cage, it still created an obtrusive barrier between the user and the robot. It was one of those rare occasions when Stelarc agreed to a compromise, so the project could progress.

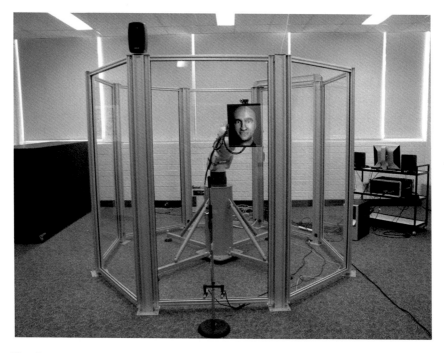

Fig. 4 Articulated Head inside its new aesthetically designed mobile enclosure. Image by Damith Herath

Engineering Excellence

In the beginning, the work was not taken as serious academic research. It was merely seen as an art installation. However, that perception changed when the Articulated Head was named the finalist in the research and development category of the Engineers Australia's (the peak professional body for engineering) 2010 Sydney Engineering Excellence Awards. A prestigious recognition usually reserved for serious industrial or academic R&D in engineering weighed against prospective economic and other utilitarian merits of a project. The team was elated to be recognised for the engineering behind the artwork. The usually sombre event was disturbed by chuckles, followed by hearty laughter as a brief video of the Articulated Head in action was shown when the project was announced as a finalist. The laughter was in recognition of the subtle sense of humour imbued within the now 'alive' industrial robot arm.

The Powerhouse Museum (Museum of Applied Arts and Science)[3] in Sydney, one of the eminent technology museums in Australia hosts an exhibition of six carefully curated projects from within the Excellence Award winners every year for a year. For

[3]https://maas.museum/powerhouse-museum/.

the year 2011, the Articulated Head was one of the six bestowed with this honour. The new challenge changed the dynamics of the project. Now the installation not only had to perform in a public setting but also had to do so fully unaided on a continuous basis for an extended period of time. On top of the public face, there were now further interests to conduct research afforded by the new situation.

A new semi-permanent enclosure was constructed at the museum to house the robot along with a small lab attached to it (Fig. 5). Over the ensuing year we carried out a number of research activities, performances and other public engagements[4] anchored around the Articulated Head. We have achieved the Thinking Head's stated goal of public visibility through 'high-profile installations', but in addition, the art had in this instance driven the research to achieve several of the other stated goals. A subtle, but an important reversal in the order of how we went about realising and fulfilling the goals of a publicly funded science focussed research program. The engineering excellence award, and the subsequent museum invite had elevated the project's profile within the broader Thinking Head project. Perhaps an external validation is an important and necessary component to the perceived success of a project of this nature.

Robots and Art Workshops

Our first academic transaction related to the project was in the form of a short video sent to the 5th ACM/IEEE International Conference on Human Robot Interaction (HRI2010) [7]—a relatively young conference for the growing research field of HRI. It was a rare occurrence for an art inspired research project to be seen in what is mostly a robotics conference. This was in the spring of 2010 in Osaka, Japan.

Auspiciously, on the sidelines of the conference was a unique workshop being organized by a roboticist, an actor and an HRI researcher [8]. The workshop was titled "What Do Collaborations with the Arts Have to Say about HRI?" To our knowledge this was the first time robotic researchers have explicitly ventured into exploring non-traditional collaborations. After the presentation of our video to a bemused crowd at the main conference, we made our way to the workshop. What ensued was a passionate exploration of ideas that strengthened our own perception of the utility in such unorthodox collaborations between the arts and the sciences.

We continued to discuss and debate what we had seen at the workshop in relationship to our own work. Also was the realisation that most engineers were ignorant to the rich potential of robotic art. This presented us with an opportunity to carry the discussion back to our engineering colleagues through the organisation

[4]Performances included, CLONE by Pyewacket Kazyanenko, et al., Orpheux Larynx by Erin Gee, et al. A doctoral student was also co-located at the minilab adjacent to the installation. Stelarc also wanted to perform with the robot, inside the safety enclosure. That request however was turned down by the museum and the university out of concern for the wellbeing of Stelarc.

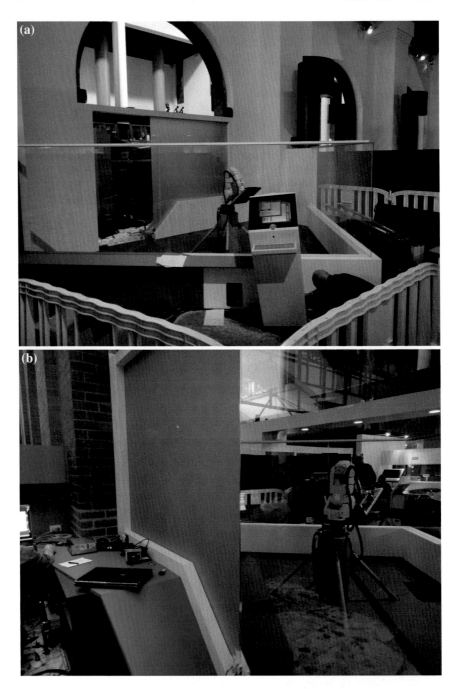

Fig. 5 Articulated Head being installed at the Powerhouse Museum, Sydney. **a** View from the front—a worker installs the computer kiosk, which was used to type in questions to the chatbot. **b** View of the robot and the minilab adjacent to the installation. Images by Damith Herath

of the first ever robotic art workshop at the IEEE International Conference on Robotics and Automation (ICRA2011), one of the venerated robotics conferences where significant developments in robotic research are presented and discussed.

The workshop was titled "Frontiers in Human-Centred Robotics as Seen by the Arts" and was motivated by the subtly provocative allusion to how art may drive robotic research.[5] To further strengthen the motivation, we included a mini workshop "Designing the Future with Science Fiction" [9] within the main workshop. Our intention was to provoke and entice roboticists and engineers to join the robotic art discussion by situating it within a venue they are already familiar with.

We had a mix group of presenters from both sides of the engineering-art divide. We also noticed researchers attending the main conference dropping by from time to time, an indication that we have piqued their interest. The workshop managed to bring together a number of artists and engineers working in relative isolation to announce their work to a broader engineering community. It informed about the mutual benefits of and the challenges faced by those engaged in robotic art. A platform and a format have been established for future engagements and the seed was planted for the book you are reading now.

Image of a Thousand Motions

One of the National Geographic magazine's photo editors noticed our work for what it was—in his own words:

> **I was doing some research for a robot story when I attended the HRI conference in Osaka. That's where I saw your video: 'The Articulated Head. It is an amazing fusion of science and art.'** [6]

An award-winning photographer was dispatched to capture one image that would convey the emotions of the robotic embodiment. Documenting a kinetic object that announces its presence through motion, seductive motion, as a singular image is an extremely difficult task, even for the most skilled. With his large format analogue camera, Max Aguilera-Hellweg, an artist and formally a medical doctor captured a handful of poses of the robot. The whole process took an entire 24 h—a testament to the enormity of the task. Yet he was not satisfied that the images would do justice to the underlying dynamics of the robotic art installation. True to his fears, the image never appeared in the original article[7] for which it was intended. This is the first time one of the compositions of the Articulated Head by Max appears in a published work (Fig. 1).

[5]Workshop website is accessible from here: http://roboticart.org/ra2011/ (accessed 12 Dec 2015).

[6]Personal correspondence with the second author.

[7]The original article which the image was intended for could be found here: http://ngm.national geographic.com/2011/08/robots/carroll-text (accessed 12 Dec 2015).

Many other media outlets published articles about the Articulated Head as well as the implications that arise from such 'intelligent' systems. One media outlet even poked fun at the robot for not being utilitarian-locked inside a cage with just the ability to look around and chat—'looking pretty without doing any work'. Our work certainly had generated enough interest to warrant a public debate about the philosophical and social questions posed by the artwork.

Endings

With the purported 'high profile' recognition to the project came considerable interest for further collaborations and with it funding. We were able to establish a new robotic lab within MARCS to further explore the interactions between humans and robots with art as the medium in which each new project would be contextualised. However, our expectations proved to be short lived.

Runaway Robot

It was decided to have a grand opening for the new robotic lab. The opening was well attended by colleagues, senior management of the university and many invitees from several of the local universities. The event included a performance by the Canadian artist and composer Erin Gee—a hybrid choir of two mobile robots and the artist. During the performance, the artist and the two robots were to interact with each other. The robots were to be puppeteered by the engineers through a Wi-Fi based remote control interface. This was the first time the engineers were actively involved in a robotic art performance. The artist had given instructions to the engineers of the expected movements of the robot, essentially human controlled 'random walks'.

At the opening night, after the customary talks and pageantry, the floor was opened for the performance. The choir was in full swing and the robots were 'performing' smoothly with the artist, manoeuvring 'artistically' under the control of the engineers. Alas! Midway during the performance, one of the robots lost its wireless connection to the controller and started to move on its own accord. This was a 150 kg Segway robot—ominously on its top were the written words by the manufacturer "this could kill"—a fact alluding to one of it's operational modes, which was disabled in this occasion so there was no real mortal danger to the participants. The robot broke away from the performance and headed towards the unsuspecting audience that surrounded the performance. There was not a minute to lose; a collision was imminent with a human with potentially catastrophic results. One of the engineers sprang to action, in the midst of the performance; he ran after the robot and pulled it back in the opposite direction. Without blinking an eye he came back, restored control and the performance continued as if nothing much happened. Bewildered, the audience thought the surprise move was part of the performance.

 Two things resulted from the runaway robot incident. The first had disastrous consequences for us. Section of the senior academics viewed the incident as deleterious to the image of the institution. A simple engineering glitch amidst a robotic art performance was seen as lack of professionalism and competence. It is prudent to reiterate that this incident occurred at a psychology lab with little insight into the field of engineering or art. For someone only exposed to polished productions at the pointy end of theatre with hours of planning, rehearsal and large engineering and technical staff, a little technical glitch in an improvised performance executed for the first time was incomprehensible and was seen as a major failure. From an engineering perspective, it was a triumph that we were able to execute the performance at short notice with little resources available at our disposal with no prior rehearsals. At the time were oblivious to the negative reaction from the management. This only became clearer later on as we deconstructed the situation and realised the misalignment between the expectations, perceived challenges and outcomes of the disciplines. For the management, it was showcasing the best of engineering as they saw it, a celebration of the engineering teams 'prior' achievements through an impeccably executed performance. For the engineering team, it was an improvisation, a hack, a time to let loose and improvise while participating in a live art performance for the first time. While the whole event, on hindsight was hilarious, it became extremely difficult for us to convincingly request further funding and support to extend explorations in robotic art.

 We were invited for a second performance of the hybrid choir at the Powerhouse Museum alongside the Articulated Head. The new performance was titled Orpheux Larynx,[8] a reference to the severed singing head of Orpheus. However, we were under strict orders from the management (not the artist) to adhere to a well-tested execution pattern rehearsed well in advance so as not to repeat our 'mistake' of the earlier performance. This was contrary to the 'improvised' nature of the performance as the artist intended and a classic example of how intervening interests play out in multidisciplinary engagements.

Misbehaving Machines

The second outcome of the runaway robot saga was a much more fruitful one. As the tensions grew between the fields, we, the robotic art team, started discussing the implications of the rogue robot. In essence, the robot had misbehaved putting the engineers in a difficult position. While the misbehaviour was seen as incompetence by the non-technically oriented management, the artist was excited by the unexpected, the surprise, a cornerstone of many approaches in contemporary art [10]. As one would recall, Stelarc was insistent in making 'mistakes' in the hope of discovering new and unexpected outcomes that heighten the experience. Thus, in 2014 we organised our second workshop on robotic art titled "Misbehaving Machines" alongside the

[8]http://www.eringee.net/works/orpheux-larynx.html.

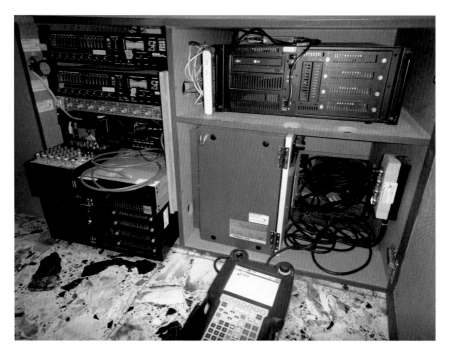

Fig. 6 Various computing and other hardware equipment used by the Articulated Head during its two year run at the Powerhouse Museum—just before being dismantled permanently at the end of the project. The bulk of the robot software was run on two high-end servers, one running a flavor of Linux and the other Microsoft Windows, respectively. It was a nostalgic moment for the team taking out parts of the robot, reminiscent of the iconic scene from Kubrick's classic movie "2001: A Space Odyssey". Image by Damith Herath

International Conference on Social Robotics 2014 in Sydney.[9] A number of contributing authors to the book presented their work at the workshop followed by extended discussions on various aspects of multidisciplinary—particularly art driven research. In parallel, the current book was maturing and the workshop provided a midway intermission for the authors to meet and discuss the book chapters in progress.

All Things Must Pass

The funding for the Thinking Head project ended in 2012. The collaboration that began over 5 years ago had produced numerous outcomes in a diverse portfolio of work, including public performances, installations, journal articles and conference presentations. As a whole, it was an impressive outcome, surpassing the goals set for the overall project. However, from each individual discipline's perspective,

[9]http://roboticart.org.

only a subset of those rich outcomes was palatable. The art installations were of little consequence to the engineering research and the engineering publications warranted little interest to the arts or the cognitive sciences, a mutually exclusive set of outcomes that had little bearing when taken apart. Also, the ensuing tensions over the prolonged interactions between the fields and the inability to delve deep into the other's way of thinking made everyone weary of partaking in the collaboration. So it was an opportune time to disperse the robotic art research team and with it the Articulated Head—no one had the strength or the will to pursue further funding or collaborations to extend the project (Fig. 6). In an ironic twist, at the same period, the MARCS Auditory Laboratory was elevated to the status of an independent institution to further the multidisciplinary research approach that proved (from an outsider's perspective) extremely successful. But to our knowledge the groups that came together under the new institution kept a fairly safe distance from each other when it came to close research interactions. Perhaps a lesson well learnt. Perhaps, multidisciplinary research is merely a means to an end and not the end in itself.

There are intervening relationships between robotics and art. Such as those related to innovation and utilitarianism in robotics engineering and social and cultural expressions in the arts. Projects at the intersection bring these relationships to the fore, providing a holistic outlook and an opportunity to explore deviant perspectives. The results are not merely artworks, but a complete understanding of an innovation process and its implications in a much broader sense. Though art may not be engineered, robotic art presents an opportunity to showcase and advance engineering in a unique way. Art therefore, is not just an inspiration for the engineer, when internalised, it is a way of life.

References

1. Stelarc, Prosthetic Head (2003) New territories. Glasgow, Interactive installation
2. Kroos C, Herath DC (2011) Stelarc, "Evoking agency: attention model and behaviour control in a robotic art installation". MIT Press, Leonardo
3. Mori M, MacDorman KF, Kageki N (2012) The uncanny valley [From the Field]. IEEE Robot Autom Mag 19:98–100
4. Marsh A (2004) Tracking the PUMA. In: Proceedings of the IEEE conference on the history of electronics
5. Kwok NM, Buchholz J, Fang G, Gal J (2005) Sound source localization: microphone array design and evolutionary estimation. In: ICIT 2005, IEEE international conference on industrial technology, 2005, pp 281–286
6. Stelarc, Herath DC, Kroos C, Zhang Z (2010) Articulated head. New Interfaces for Musical Expression++, Sydney
7. Kroos C, Herath DC, Stelarc (2010) The Articulated head pays attention. In: 5th ACM/IEEE international conference on human-robot interaction. ACM/IEEE, Osaka
8. Smart WD, Pileggi A, Takayama L (2010) HRI 2010 workshop 1: what do collaborations with the arts have to say about HRI? In: 2010 5th ACM/IEEE international conference on, human-robot interaction (HRI), pp 3–3
9. Johnson BD (2011) Science fiction prototyping: designing the future with science fiction. Synth Lect Comput Sci 3:1–190
10. Williams M-A (1996) Aesthetics and the explication of surprise. Lang Des 2:145–157

The Art in the Machine

Christian Kroos

Abstract Here the major themes that arise in the twenty-one chapters of this book are introduced and discussed within the framework of how robotic art relates to the general public and how it interconnects with science and engineering.

If you ask the person standing next to you at the train station or bus stop about their notion of robotic art, the answer will most likely conjure up some kind of robotic contraption producing works of art by drawing, painting, sculpturing, performing music and, already less often, playing a role in a theatre play. The robot replaces the human artist and fails or excels in doing so dependent on the interviewee's view of the current and near-future abilities of robots. If the robot is assumed to ultimately fail, the lack of success is construed as the consequence of a part of human thinking that cannot be approximated by machines, a quality of human thinking that is fundamentally unattainable for computational procedures. In popular culture this is frequently attributed to 'emotions' which are not 'logical' and cannot be paralleled in machines through algorithms. If on the other hand the robot is considered to match or even exceed the human artist's capabilities, the perceived perfection of machines is often invoked and contrasted with human imprecision and variability. The robot, capable of executing precise movements and repeating them exactly, creates works of art which themselves are characterised as an attempt to physically realise a perfect aesthetic ideal. In all these cases the robot becomes the artist. Rarely is the robot itself considered the artwork.

As this book documents, robotic art is almost exactly the opposite. The robot or robots constitute the work of art and do not create it, even if they sculpture, paint or draw, as for instance the '5 Robots Named Paul' by Patrick Tresset. Despite the five robots even signing their portraits, it's the entire robotic installation which

C. Kroos (✉)
Centre for Vision, Speech and Signal Processing, University of Surrey,
Guildford GU2 7XH, U.K.
e-mail: chkroos@gmail.com

© Springer Science+Business Media Singapore 2016
D. Herath et al. (eds.), *Robots and Art*, Cognitive Science and Technology,
DOI 10.1007/978-981-10-0321-9_2

is exhibited, not the drawings on their own. The pretended drawing session with a sitter and the robots' probing again and again with their camera eyes emphasise this point further. An exception might be Leonel Moura's small mobile robots, which create large floor paintings through moving and dispersing paint [5]. Even there, however, the human artist does not vanish and Moura does not confine himself to the role of an art agent or manager.

Given that robots actively change and/or witness their environment, the layperson's assumption seems to be much more reasonable than the prevalent approach in robotic art. It is as if photographic art would almost exclusively consist of photo cameras and thematise the process, in which light reflected from the environment is captured on a two-dimensional plane and leaves a permanent impression. There are, of course, artworks, which do just that, but they do not define the area. Similarly, video art does not exclusively deal with the depiction and critical appraisal of the dynamic version of this process, but is largely about the captured content and the associated issues of arranging and presenting it.

Why have the developments been so different? The long answer can be found in the following nineteen chapters of this book and is rather multifaceted. A shorter (and probably oversimplified) explanation might be that in the cultural imagination of society robots are not understood as mere tools. They occupy a special place even among the machines, no matter how complex these other machines might be and how much they would be able to automate entire production cycles. Robots appear inextricably connected with the notion of autonomy, with the assumed ability to sense, act and navigate without a human operator, even though the reality of, for instance, robot arms in industrial production looks rather differently. The robot is the 'man-made thing' that does something on its own accord and by this claims agency. At least in the Judeo-Christian tradition the stage is set for the miraculous and the uncanny alike, for an extraordinary challenge of cultural and religious believes, if not even for 'man' attempting to become god (Fig. 1).

Even within a contemporary technoscientific and non-religious context, the ability to create a robot (in the sense of an autonomous machine) is far more enthralling—not to say, enchanting—than the product of the robot's activity. This does not apply to cameras, notwithstanding how much of a sacred object an individual exemplar can be become in the eyes of its owner. The camera is not granted a life on its own, no independence from the creator or owner is assumed and that is why in the end it remains a tool despite its ability to sense. Like other tools the camera might be integrated into the human body scheme [1] and it is often compared to the photographer's extended, mechanical eye.

The British philosopher Gilbert Ryle coined the term of 'the ghost in the machine' in order to criticise Descartes' dualism of body and mind ([7], p. 11):

Now the dogma of the Ghost in the Machine [...] maintains that there exist both bodies and minds; that there occur physical processes and mental processes; [...]

In a similar way one could claim—empirically, not on principle—that the art in robotic art is not external to the robot, neither the product of the robot actions nor

Fig. 1 Ambidextrous arm
by Stelarc (developed and
engineered by Emre Akyurek
and Tatiana Kalganova,
School of Engineering and
Design, Brunel University,
London; *photo* Stelarc)

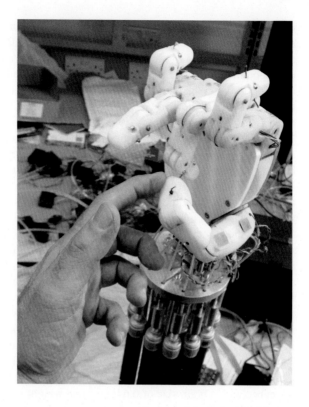

some abstract symbolic meaning to be found within the robotic artwork. The artworks stand for themselves and do not symbolise ideas of autonomous machines or mechanistic biology. They reference a multitude of concepts such as agency, presence, aliveness, transspecies communication, but they do so through their physical existence and their interaction with the audience. The art is not in the machine, the machine is the art.

This book is organised according to the major themes conceptualised in robotic art as presented in the chapter contributions and as identified by the editors. It starts with a section, which puts contemporary robotic art into the historical context ('*Then and now*'). Here diachronic conditions are investigated with respect to the 18th century beginnings and subsequent development of machine art ('*We Have Always Been Robots: The History of Robots and Art*' by E. Stephens and T. Heffernan), with respect to the history of robotic engineering starting in the 1950s ('*Robotics: Hephaestus Does It Again*' by J.-P. Laumond), and by examining its foundations and challenges in the past and current-day present ('*Robotics and Art, Computationalism and Embodiment*' by S. Penny). There is no section, however, that is explicitly dedicated to the relationship between science/engineering and the arts and their mutual influences and interdependencies. It is an implicit thread woven into the fabric of almost all the chapters and omnipresent as it is, this

inextricable relatedness appears as one of the defining characteristics of robotic art, being more prominent here than in most other media art. In this respect robotic art might be close to bio-art and as the two also share the fundamental relevance of embodiment, combinations are possible and maybe even likely, for instance, by enabling bio-engineered neural networks of living neurons to control the remaining robotic body (*'Bio-engineered Brains and Robotic Bodies: From Embodiment to Self-portraiture'* by G. Ben-Ary and G. Ben-Ary).

The overarching themes we identified in the contributions to this book are: *Otherness, Explorations, Embodiment* and *Interactions*. Arranging the contributions under these section headings should not be understood as exclusive and limiting, though. Most of the chapters with their descriptions of artworks and art practices, biographical notes and theoretical critiques touch on several of the topics and vice versa, the topics accommodate much that had to be left out in this book.

From the special place robots occupy in our cultures mentioned above results also their nature as marked others. An other, with which humans are (sometimes unwillingly) faced and which faces them, the robot perceived more as a different species than a specific category of technological artefact. The confrontation—whether real or imagined—steers up fears and hopes, centred first on the question 'What will it do?' and only then on 'What is it?', the order of the inquires arguably caused by our lack of experience with more sophisticated robots in contrast to the familiarity with our fellow animals. As emerging intentional agents robots are still newcomers in the posthuman mind setting, their poor performance in the physical world betraying their highflying portraits in fiction. Even a honeybee with a brain size of 0.64 mm^3 and weight of 1 mg [4] can at present easily outperform the most advanced robot.

As a new species, the robotic agent enters a discourse that extends far wider than the robotic kind. It encompasses all types of biological systems (including plants) and re-positions the human in a mesh of interdependencies with its environment (*'Embracing Interdependencies: Machines, Humans and Non-humans'* by Amy Youngs). Importantly, this is not seen as the outcome of recent technological or scientific development, but as a sociocultural shift in the way the human is understood, abandoning the view of an isolated mind put in an isolated body springing from the Cartesian paradigm. The new perspective offers the potential for a symbiogenesis between the many living systems and machines (*'Trans-Species Interfaces: A Manifesto for Symbiogenesis'* by Ken Rinaldo), but the autonomous robot might not always be welcomed so smoothly into the extended family of intentional agents. Humans would have to overcome feelings of uncanniness evoked by the new machines that signal awareness independent of whether they are anthropomorphoid or without resemblance to human appearance. In fact, the reservations might not be limited to humans as hinted at by numerous documented attacks on drones by birds, bees and other animals and in particular by a premeditated downing of a drone by a chimpanzee in the Royal Burgers' Zoo in Arnhem, The Netherlands [6]. Robotic transspecies artworks confront us with this uncanniness and might habituate us (*'Cultivating the Uncanny: The Telegarden and Other Oddities'* by E. Jochum and S. Goldberg) or at least make an

unmediated experience available, a glimpse of the likely shape of things to come. And robotic otherness offers more opportunities. It provides the chance to move beyond a model of communication that overemphasis commonalities between the interaction partners ('*The Potential of Otherness in Robotic Art*' by E. Sandry). The rejection of concordance as a necessary condition for communication is neither originating from considerations of human-machine interaction nor it is ending there, but it is interactive robots that bring myriads of variations of communicating others into the world and thus force a more radical test of long held believes of communication's sole grounding in congruence. Similarly, future robotic intentional agents will present us with problems of identity as sameness, with problems of individuality and subjectivity, challenging the self-concept of humanity. These questions have started to surface not just in fiction but in the physical world, owing to the advent of perfectly identical agents realisable in the control systems of robots ('*Being One, Being Many*' by C. Kroos and D.C. Herath).

The further we intrude into the uncharted territory of new concepts brought to and upon us by exploring posthumanism, postcognitivism and new robotic technologies, the more robotic art resembles a journey not unlike past geographic explorations such as the iconic forays into Antarctica. While art leaves the race and the 'glorious' conquests to science and engineering (e.g., in the last two decades the development of the first bi-pedal walking robot), it assimilates other less visible aspects of these explorations: the limitation of the human and the crucial interconnectedness with the environment as well as feelings of displacement and expendability. Robotic art rarely runs with Amundsen, so to say, it might be with Shakelton, but more often it walks with Scott, with failing machines and dying horses, with reaching the target when someone else had already been there and in the end not making it home. Robotic art had to come a long way and pioneering robotic art had been the proverbial winding road ('*Way of the Jitterbug*' by N. White), creating itself on the run. Challenging both the fundamentals of robotics and testing the limits of otherness still has the mark of encountering the limits of the experienced world ('*Still and Useless: The Ultimate Automaton*' by N. Reeves and D. St-Onge).

We have pointed out before that robots—in the way we understand the term—act in the physical world, excluding virtual agents such as chat bots. The prevalent technical separation of (analogue) hardware and (digital) software—mostly a consequence of the separate development history of computer chips and robotic mechanics—created indeed something akin to the ghost in the machine: A control system isolated from mechanical body and physical world. But as the 'winters of artificial intelligence' have shown, it could be and might have always been a dead end. Embodiment in robotic art is overwhelmingly understood as going beyond the self-evident aspect of giving the robot a physical form, it is seen as the embodiment of the control system, too, rejecting the Cartesian dualism in the same way as in biological agents and using the physical world for and instead of computations ('*The Multiple Bodies of a Machine Performer*' by L.-P. Demers). From different embodiments follow different behaviours and different ways of interaction with humans: An anthropomorphic robot is expected to act human-like and any

deviation is quickly noticed (*'Android Robots as In-between Beings'* by K. Ogawa and H. Ishiguro), while soft, inflatable structures embodying the more transient qualities of human movement enjoy a greater freedom in their abstractness (*'Into the Soft Machine'* by C. MacMurtie).

It should be noted that the difference in the human response due to the choice of robotic embodiment does not imply qualitative limitations in the resulting interactions. In particular, a structurally complex embodiment does not necessarily lead to complexity in the interaction and vice versa a morphologically simple robot does not constrain interactions to sparse, rudimentary exchanges. Interaction flows from the robot's behaviour and again it is not the complexity on its own which is decisive, but the degree to which the behaviour works within the enfolding dynamic relationship between the interaction partners [3]. Plain robotic structures can have a strong emotional impact on the audience, elicit empathy and force us to re-evaluate our relations to machines (*'I want to Believe—Empathy and Catharsis in Robotic Art'* by B. Vorn). The ensuing almost boundless diversity of designs in appearance, functionality and actualised behaviour of robots, however, opens Pandora's box in scientific human-robot interaction research. How can findings be generalised when changes in appearance or behaviour are influencing all interactions? How can the overflowing abundance of potential experiments ever be managed? Science-art collaborations do not provide an answer as they always reside in the specific that is the single artwork. But they lead the way in which the complexity of human interactions is acknowledged and considered from the onset in the design of robot appearance and behaviour (*'Designing Robots Creatively'* by M. Velonaki and D. Rye). They are less likely to fall prey to an 'one shape fits all' simplification in the interpretation of experimental findings and they highlight the intricate relationship between contemporary technology and the humans that conceive, implement or simply use it—relationships that long have deeply permeated everyday life. Robotic art can bring these relationships, which are constantly at the brink of slipping out of awareness, back into the light of conscious appraisal, both through its practice and its works (*'Robot Partner—Are Friends Electric?'* by S. Doepner and U. Jurman).

Where will robotic art go in the future? From the descriptions and considerations above it might already be evident that no definite answer can be given. Too plentiful are the potential paths of development on the engineering side alone and clearly beyond prediction when combined with scientific insights not yet known and the limitless creativity in the arts. In addition, the world's industrialised societies are in the process of a substantial change as robots are about to enter daily lives, both as part of the private homes of people and foreseeably soon at their work places, too. New avenues of mixing and interfacing the human body with robotic technology have emerged blurring further already instable boundaries. Robotic art will likely continue contesting traditional concepts of aliveness, embodiment and agency (*'Encounters, Anecdotes and Insights—Prosthetics, Robotics and Art'* by Stelarc). Chances are also that robotic art will remain at the forefront of probing human-robot interaction and that the robot itself will mostly be its topic, not the robot's creations, although the latter is already less certain.

With significant advances in technology there will surely be a few scientific and engineering surprises which in turn will reflect strongly on robotic art. We might be forced to alter our conceptualisation of agency, intentionality, subjectivity and presence. Judging by the last half century of robotic research, it is also almost guaranteed that science will encounter 'hard' problems, for which a straightforward (even if mathematically and algorithmically complex) solution will be found, and others, which had been so much underestimated that not even their fatal nature had been noticed. Again, this knowledge will eventually have an impact on culture and society at large and as history shows the arts have always processed, assimilated or contested new scientific insights and have never been intimidated by scientific complexity.

If one takes an overall look at the contributions of this book, two observations stand out: The diversity of approaches, which is reflected in all aspects of the writing—including the chosen terminology—and the depth of the questions asked (compared, for instance, to the functional focus of typical papers at scholarly robotic and automation conferences). Robotic art uses technology, very often state-of-the-art technology, and it rarely shuns a direct involvement in the technoscientific functional approach, but it then takes what it can get and creates artworks that critique, subvert, transcend, play with or expose the original function of the appropriated technology and its social consequences, its ethics and cultural meanings. With this it often reveals the blind spots in scientific and engineering research and development [2] and opens unexpected perspectives. These new viewpoints and concepts diffuse osmotically back to science and engineering, influencing its progression, and if it would only be in the form of unorthodox ideas sparked in the minds of the next generation of scientists and engineers.

References

1. Black DA (2014) Where bodies end and artefacts begin: tools, machines and interfaces. Body and Society 20(1):31–60
2. Goodall J (2011) Magnetic encounters and embodied conversations. In: Presentation given at 2011 ICRA workshop 'Robots and Art: Frontiers in Human-Centred Robotics as Seen by the Arts', Shanghai, China
3. Kroos C, Herath DC, Stelarc (2012) Evoking agency: attention model and behaviour control in a robotic art installation. Leonardo 45(5):133–161
4. Mares S, Ash L, Gronenberg W (2005) Brain allometry in bumblebee and honey bee workers. Brain Behav Evol 66(1):50–61
5. Moura L (2016) Machines that make art. In: Herath D et al. (eds) Robots and Art, Springer, Heidelberg. doi: 10.1007/978-981-10-0321-9_13
6. Press Association (2015) Ape millimetre: chimpanzees smash camera drone. *The Guardian*. http://www.theguardian.com/world/2015/sep/03/ape-millimetre-chimpanzees-smash-camera-drone-zoo. Accessed 11 Feb 2016
7. Ryle G (1984/1949) The concept of mind. London: Hutchinson

Part II
Then and Now

We Have Always Been Robots: The History of Robots and Art

Elizabeth Stephens and Tara Heffernan

Abstract Although the "robot" is a twentieth century concept, machines that conform to the same definition—are capable of carrying out complex actions automatically—are part of a much longer history. This chapter will provide an overview of this history. It will trace the contemporary emergence of the robot back to the appearance of clockwork and mechanical automata in the early modern period. In so doing, the chapter will make two key contributions to this book's study of robots and art. Firstly, it will argue that the concept of a robot predates the emergence of the word robot by several centuries, and that our understanding of the contemporary concept is enriched by recognition of this longer history. Secondly, it will show that, from its very inception, the history of robots has been closely entwined with that of art—evident not least in the fact the term itself derives from the context of theatre. This history continues to be reflexively present in contemporary performance.

The "Musical Lady," an eighteenth-century automaton on display at the Musée d'art et d'histoire at Neuchâtel in Switzerland, has often been described as one of the world's first programmable robots (See Fig. 1). The "Musical Lady" is seated before a clavier; when animated, her articulated fingers press down on the individual keys, so that the figure actually plays the music the spectator then hears.[1] Her

Tara Heffernan—Independent Scholar

[1]In this respect, the "Musical Lady" and the other eighteenth-century automata discussed below are different from those mass-produced in the nineteenth century, which were commonly simple mechanical figures positioned on top of a hidden a music box. While the figure would make the motions of playing an instrument, it was the mechanism below which produced the actual music. The famous automata of eighteenth century were unique in that the figures played instruments themselves.

E. Stephens (✉) · T. Heffernan
Southern Cross University, Lismore, Australia
e-mail: elizabeth.stephens@scu.edu.au

© Springer Science+Business Media Singapore 2016
D. Herath et al. (eds.), *Robots and Art*, Cognitive Science and Technology,
DOI 10.1007/978-981-10-0321-9_3

Fig. 1 Pierre Jaquet-Droz's
"Musical Lady" and "Writer"
(1774). Image courtesy of
the Musée d'art et d'histoire,
Neuchâtel

head and eyes follow her fingers across the board. Even for contemporary audiences, the impression of artificial life and intelligence is striking. For audiences in the eighteenth century, however, a figure that moved mechanically and with intelligent affect, able to participate in the production of a human art like music, was considered a true marvel [30]. The "Musical Lady" blurred the line between technological ingenuity and artificial life: her intricate clockwork mechanism was designed to simulate human physiology: mechanical bellows made her chest rise and fall as she played, making her appear not only alive, but emotional. That is, she was designed not only to move mechanically, but to appear moved by the music she played. Advertising for the 1776 London exhibition emphasised this: not only was the "Musical Lady" a technological wonder, but also an affecting spectacle: "the animated and surprising Motion of the Eye aided by the most eloquent gesture, are heightened to admiration in contemplating the wonderful powers of Mechanism which produce at the same time the actual appearance of Respiration" (quoted in [22, p. 94]). Extraordinarily, the figure could be programmed to play any one of six different melodies, using a mechanism so innovative it is now widely recognised as the forerunner of the modern computer.[2] In a period in which physiologists and natural philosophers were conducting a wide range of experiments in artificial life and movement—such as attempts to galvanically reanimate human corpses [27]—the "Musical Lady" was the mechanical prodigy of a post-Enlightenment age in which human reason seemed capable of mastering all the laws of nature, even life itself.

The "Musical Lady" was one of three humanoid automata made by Pierre Jaquet-Droz in the 1770s, all of which combined a lifelike appearance with mechanical movements of great precision, and could be programmed to perform a variety of tasks: the "Draftsman" produced finely detailed sketches of a diverse range of objects, including a portrait of Marie-Antoinette; the "Writer" inscribed sentences

[2]See, for instance, Gaby Wood's Edison's Eve: The Quest for Mechanical Life [30] or Simon Schaffer's "Babbage's Intelligence: Calculating Engines and the Factory System" [22].

in an elegant script, including, teasingly, "I think therefore I am." This inscription of Descartes' famous formulation of human autonomy by a programmed automaton constituted a playful reference to current debates in eighteenth-century natural philosophy about the nature of agency and the self, and the relationship of that to the body and its movements. Natural philosophers in the seventeenth and eighteenth centuries, like Descartes and La Mettrie, were centrally concerned with the question of movement, and whether it required an external origin—a "vital" (or divine) spirit—or whether the body could be understood as a autonomous mechanism able to generate its own movement. Eighteenth-century automata, with their spectacularisation of artificial life, made a vital contribution to these debates, and were objects of fascination for natural philosophers and popular audiences alike during this period [30]. Technologically, they marked the shift between clockwork mechanisms and early computer technology. Their appeal derived not only from the technological ingenuity that produced them but also their simulation of life and intelligence. Throughout the 1700s, a series of unsettlingly lifelike mechanical figures had held audiences spellbound by performing astonishing feats of skill and intelligence on the public stage. Jacques Vaucanson's "Flute Player," an elaborate humanoid musical computer that astonished audiences when it was unveiled 1738, was one of the first of these. Wolfgang von Kempelen's "Chess Player," which played against human opponents, also caused a sensation when it went on show in 1769.[3] In an age characterised by rapid technological innovation and a keen public appetite for novelties, these automata remained popular over an extraordinary long period. Jaquet-Drosz's were toured until his retirement, at the very end of the eighteenth century. They were then featured at the Paris Exposition of 1825, before being acquired by a nineteenth-century travelling show, the Museum of Illusions. Finally, they were purchased by the Swiss government in 1906 and given to the Musée d'art et d'histoire. There they remain on display today, still in perfect working order.[4]

These automata, like the other mechanical figures that so fascinated eighteenth-century publics, were not only the products of great art and technical skill: they were themselves highly skilled producers of art, participating in cultural activities widely understood to be definitively human. In turning such technical ingenuity to the production of mechanical music, or writing, or drawing, eighteenth-century automata seemed like the very embodiment of the Enlightenment. They represented the utopian promise of a human reason that was capable of both deciphering and mastering the laws of nature, a pursuit that found its ultimate expression in the attempt to create artificial or mechanical life. As such, in their own day, these figures posed important questions about the relation between agency and movement, and between the technological and the human, that continue to find

[3]This automaton is now known to have been a hoax: while the "Chess Players" movement of the pieces was genuinely mechanical, and extraordinarily complex in its range of possibilities, the moves were determined by a human chess player, hidden inside the mechanism.

[4]The Musée des arts et métiers in Paris also has a number of eighteenth-century automata in its Théâtre des automates, including another Musical Lady made for Marie-Antoinette. This is no longer functional, however.

expression in contemporary relations between robotics and art. The aim of this chapter is, in the first instance, to show how the experiments with robotics in twentieth- and twenty-first-century art examined in the other chapters of this book both developed and deviated from these early artistic robots. In so doing, we are interested to examine the function of art (that of the engineers who produced the automata, and that the automata themselves were made to produce) in enabling a cultural exploration of the relationship between agency and movement. Automata designed to make music or to draw, like the examples of contemporary robotic art discussed below and elsewhere in this book, enable forms of debate and exploration not available in other cultural domains. While there may be a cultural tendency to assume that automation (or robots) and affect (or art) are opposed, then, their history is precisely that of the "unlikely symbiosis" examined in this book. We might understand this space of intersection as the expression of a sort of machinic imaginary, in which the relationship between automated movement and agency, or art, is a mutually constitutive one.

In the eighteenth century, automata were not simply popular—and lucrative—objects of public display. As Simon Schaffer has argued, they were "arguments as well as amusements" [22, p. 16]. They were objects of great interest to natural philosophers, who were intrigued by what they revealed about human biology, and the extent to which this could be understood as a series of mechanical processes. They were also of great interest to scientists and those working in experimental and technical fields: Charles Babbage is said to have been influenced by his childhood visits to exhibitions of automata in the development of his Difference Engine, usually identified as the first computer. The cultural critic Gaby Wood argues that, for eighteenth-century audiences, automata were potent cultural symbols of the materialist and mechanistic philosophies that had begun to emerge a century earlier, most famously in the work of Descartes. The central question here was whether a self-generated movement—such as that by the mechanical figures designed by the engineers of automated—enabled a secular, rational concept of life, no longer dependent on the divine origin of a "vital spirit." This question of whether movement could be self-originating was foundational to the new concept of agency as self-determining and autonomous that was emergent in the eighteenth-century. The attempt to create mechanical and artificial life was thus also an exploration of human will and the rational mastery of the world. For this very reason, as Woods notes, there was also something troubling about these automated figures: the attempt to create mechanical life, she argues, was evidence of the danger of a rationalism and scientific ambition grown "beyond the bounds of reason" [30, p. xvii], a mad-scientist tendency to take such experiments too far, in ways that might undermine, rather than advance, the "civilised" life and culture of the post-Enlightenment period.

The historian of science Jessica Riskin argues against Wood's interpretation of eighteenth-century automata as representative of the triumph of mechanistic philosophy in the eighteenth century, however; although Riskin too notes that they are troubling objects, evidence of ontological uncertainty about the relationship between the mechanical and the human that was played out in questions about the relationship between automation and art:

The ontological question of whether natural and physiological processes were essentially mechanistic, and the accompanying epistemological question of whether philosophical mechanism was the right approach to take to understand the nature of life, preoccupied philosophers, academicians, monarchs, ministers, and consumers of the emerging popular science industry during the middle decades of the eighteenth century. Neither mechanist nor anti-mechanist conviction, then, but rather a deep-seated ambivalence about mechanism and mechanist explanation produced the context for the emergence of artificial life. (Eighteenth-century automata) commanded such attention, at such a moment, because they dramatized two contradictory claims at once: that living creatures were essentially machines and that living creatures were the antithesis of machines [19, pp. 611–612].

If automata were a focal point for such arguments in the eighteenth century, it should be recognised, it is precisely because, as charming and whimsical objects designed for public display, they were able to pose new questions and exemplify new technologies in ways that were much more difficult—even dangerous—to undertake in other contexts.

We have only to contrast the fate of Jaquet-Droz—celebrated and admired throughout his life for his technical achievement—with that of the philosopher Julien Offray de la Mettrie, to understand this. La Mettrie, notorious writer of books on materialist and mechanistic philosophy, was forced to flee the liberal Netherlands after the publication of his *Man a Machine* (1748), in which he argued that the operation of human biology was the result of mechanical processes. Jaquet-Droz, who undertook actual experiments in human physiology and demonstrated a capacity to simulate biological processes mechanically, not only escaped such censure, but was widely acclaimed for his work. Moreover, his automata continued to be popular objects of public exhibition even after the technologies he developed to produce them began to be used to automate labour practices, inciting industrial riots. It is well known, for instance, that Jacques Vaucanson used the same mechanism he devised for his automata to invent the mechanical loom, provoking the first industrial riots in France (see, for instance, Wood p. 94). Media theorists and historians such as Friedrich Kittler have drawn attention to the intersecting histories of technologies used for entertainment—like automata—and those used for industrial or war purposes—like the loom [11]. However, even during concerted anti-industrial campaigns by groups such as the Luddites, who were trenchantly opposed to automated forms of production and sabotaged industrial machinery, automata remained popular objects of entertainment. Just as the engineers of automata escaped religious censure in the eighteenth century, while philosophers like La Metrrie were persecuted, so did mechanical figures escape the culture censure directed at industrial mechanical technologies.

Throughout the nineteenth-century, as the age of industrialisation continued to transform the cultural and physical landscape, automata continued to be produced and exhibited in popular sites of entertainment, such as funfairs and amusement parks. There were a number of reasons for this. The first was that they were designed to simulate breathing, which made them seem not simply alive, but also

capable of being moved by human arts and culture.[5] The second was that, in undertaking cultural activities that seemed definitively human—playing music, drawing images—they forged an affective bond with their spectators. Finally, they seemed highly civilised and benign, and far removed from the new world of factories and mass production. They were made as exquisite and unique objects, increasingly at a remove from the mass-produced objects and industrial machines that came to define the nineteenth century.

Over the course of the nineteenth century, however, the role of automata in the cultural imaginary would transform, as the use and significance of the mechanical itself changed radically in the cultural imaginary. The invention of the word "robot" itself is one indication of this epochal shift, representative of an associated transformation in the cultural significance of mechanised humanoid figures. The neologism "robot" is commonly attributed to Czech author Karel Čapek, who coined the term in his 1920 play *Rossum's Universal Robots* (*R.U.R.*). Čapek derived the word "robot" from the Czech word *robota,* meaning "hard work", or "slavery" [1, p. 7]. Unlike Jaquet-Droz's automata, Čapek's robots were oppressed and used as mechanical servants rather than celebrated as skilled android artists.[6] Čapek's invention of the contemporary idea of the robot was a direct response to the radical cultural and economic transformations produced by increasing industrialisation. Rather than the spectacle of mechanical life made by man, as seen on the eighteenth-century stage, R.U.R. reflected the growing fears that man himself had become machine. As John Rieder writes:

> **The play's reputation and success depended heavily upon the spectacle of the expressionless, uniformed robots, numbers blazoned on their chests, marching in step onto the stage to announce, at the end of the second act, the end of the age of man and the beginning of the age of machines, as if to epitomize the traumatic transformation of modern society by the First World War and the Fordist assembly line [18, p. 49].**

The robots in Čapek's play were thus a product of a nineteenth-century machinic imaginary very different from the exceptional feats of technical innovations that marked the eighteenth-century: they are products of an age of mass industrial production, rather than intricately crafted one-off creations. Throughout the nineteenth century, argues Wood: "factory workers came to feel they had been reduced to the mechanical pieces they were in charge of producing, hour after hour, day after day" [30]. Where the eighteenth-century had intimated that modern technologies and scientific advances might allow machines and inert matter to be transformed into intelligent animate human life, the nineteenth century threatened to reduce humans to mechanical objects, robbed of agency or will—a mere "appendage" of the machine that "enslaved" them, as Marx and Engels wrote [14, p. 34]. As early as 1829, Thomas Carlyle was announcing the nineteenth century the start of the "Mechanical Age":

[5]Kathryn Hoffman notes that mechanical figures of breathing sleeping women were popular fairground exhibits throughout the nineteenth century [7, pp. 139–159].

[6]Indeed, the narrative of *R.U.R* recounts the growing resistance of the robots to their treatment by humans, until they rise to overthrow their oppressors, saving only one man whose responsibility will be the manufacture of new robots. In the process of annihilating the human race, however, the technological knowledge for the construction of robots is lost.

It is the Age of Machinery, in every outward and inward sense of that word.... Let us observe how the mechanical genius of our time has diffused itself into quite other provinces. Not the external and physical alone is now managed by machinery, but the internal and spiritual also. Here too nothing follows its spontaneous course, nothing is left to be accomplished by old natural methods.... These things, which we state lightly enough here, are yet of deep import, and indicate a mighty change in our whole manner of existence. For the same habit regulates not our modes of action alone, but our modes of thought and feeling. Men are grown mechanical in head and in heart, as well as in hand [3].

Carlyle draws attention to the ways in which the rise of automation had transformed the cultural imagination and forms of knowledge production in the early nineteenth century: the human and the technological had become completely enmeshed, so that machines themselves were no longer seen simply as objects, but as a particular mode of thinking and perceiving. The early nineteenth century thus represents a distinct historical moment in the conceptualisation of the relationship between agency, movement and the machinic, and it is one of mingled fascination and fear, embodied in the image of the human body moved involuntarily like and by a machine. The historical and cultural specificity of this moment draws attention to the important ways in which agency and movement were being reconfigured at this time.

That proliferation of experiments in robotic art that characterised the second half of the twentieth century represents both a continuation and transformation of this history, indicative of the ongoing development of the role of the machinic imaginary in understanding the relationship between the human and technological, or automation and art. It is within the sphere of contemporary art that we continue to find many of the cultural figures and narratives by which we can make sense of the developments in the sciences and technology. We see this widely in evidence in twentieth-century art, which, although not the site for technological innovation seen in Jaquet-Droz's automata, has been an important site for cultural applications and interpretations of subsequent developments in robotics. Over the course of the twentieth century, experimentation with robotics produced whole new fields of arts, defined by their inter-disciplinary engagements with technologies by which art production could be automated in various ways. At the same time, twentieth- and twenty-first century artistic experimentation with robotics marks a significant shift from the early history we have sketched above: after the Second World War, robots in art became much less humanoid, and their role in the production of the art itself much more complex.

Artist and academic Eduardo Kac notes that the significant interest in robotics arose within the visual arts in the mid-twentieth century, aligning with the simmering enthusiasm for kinetic art [10, p. 170].[7] At the time, artists began to draw on robotics as a method of exploring (or exploiting) industrial society's obsession with

[7]Kinetic art is art that utilizes perceivable motion as either a component of or central feature in, the artwork. Emerging in the 1950s and 1960s, kinetic art revolutionized sculpture, freeing it "from static form and reintroduced the machine at the heart of the artistic debate" [10, p. 170]. An early example of kinetic art is George Rickey's "Four Squares in a Square" (1972). This work involved four aluminium squares, each just over a meter squared, suspended on a steel pole nearly 7 m above the ground. Depending on the force of the wind, the would squares rotate, or flip from side to side, returning to create a flat surface when the wind was low [28, p. 277].

technology. Perhaps the most iconic of these early artistic innovations was Swiss artist Jean Tinguely's "Homage To New-York" (1960), a junk sculpture created with the assistance of engineer Billy Klüver [12, p. 936]. At the conclusion of a public performance at the Sculpture Garden of the Museum of Modern art, the 27-foot tall structure, composed of old bike parts, wheels, pullies and gears, a baby carriage, radios and other assorted paraphernalia that Tinguely had sourced from second-hand stores around the city, was intended to self-destruct [5, p. 171]. However, the elaborately crafted sculpture failed to destroy itself and after hours of anticipation a fire broke out, requiring the intervention of the New York City fire department [16, p. 425]. As artist and cultural theorist Chris Salter argues: "Tinguely's kinetic forms reflected a post-war world in which the utopian perfection of Futurism was replaced by fragmented and absurd, Duchampian-influenced, ready-made junk" [20, p. 282].

"Homage To New York" is considered a testament to anti-art in the industrial age, and is undoubtedly the most widely known of Tinguely's works.[8] The sculpture signals a point in history where artistic explorations of automation and mechanisation began to focus on the absurd, rather than the anthropomorphic. Tinguely emphasised the redundancies, the absurdities, and the ostentatious qualities of production and technology, and the public spectacle of automation, while also raising questions about the production and reception of art. As early as 1955, Tinguely created a series of art-making machines, titled "Metamatics." While non-anthropomorphic, in some ways these recalled Jaquet-Droz's "The Writer," made two centuries previously. The machines' purpose was to create works of art by drawing on pieces of paper that were inserted by the audience [21, p. 145]. At the first Paris Biennale in 1959, "Metamatic no. 17" (the largest of Tinguely's drawing machines) was featured in the courtyard of Musee d'art moderne. Powered by petrol and a motorcycle engine, with wheels for movement and a huge exhaust fan (filling gigantic balloons that would be released into the air) the machine was fed reams of paper and produced drawings in an abstract expressionist style. This automation of art practice was perceived by many painters at the time as a deliberate provocation, even affront, although Tinguely denied this to be his intention [21, p. 142]. The coin-operated machine created more than 40,000 drawings over the period of the Biennale that visitors took as souvenirs [23, p. 17]. The explorations of technology within these works were not innovations in technology, rather—as is the case with much kinetic and cybernetic art—their utilization of processes of automation manifested in chaotic assemblages that were innovative in their application.[9] These early uses of automation in twentieth century

[8]Associated with the Dada movement, anti-art describes art (or ideas) that work in opposition to established aesthetic or conceptual norms, often employing objects or images from non-traditional sources and bringing them into gallery contexts in order to critique the values held by audiences and institutions [8].

[9]Cybernetic art describes artwork by practitioners that employ the premises of the field of cybernetics; the research of operating systems and communications in both machines and living things [29], to create works that interact (in varying degrees) with their environments. Often using complex sets of sensors, cybernetic art was seldom described as interactive. Rather, artists tended toward describing their works as responsive, or reactive [24].

art considered the role of the machine and the production line in the cultural period—from art that uses automation to reinvigorate sculptural forms—"liberated from the static" as Kac explains [10, p. 170]—to art that uses automation to make art. While in the eighteenth century it was the human-like appearance of automaton that fascinated artists and engineers, in the twentieth century it was the processes and functions of technology that received most attention. Stripped of their anthropomorphic whimsy, machines like Tinguely's Metamatics paralleled the processes of industrialised mass production, and the ability and ease with which a machine could produce artefacts almost indistinguishable from hand-crafted artworks.

While very different stylistically when compared to the automatons of the eighteenth century, artistic explorations of robotics during the mid-twentieth century were driven by similar concerns. Like the "Musical Lady" playing the clavier with striking precision, or Wolfgang von Kempelen's "Chess Player," playing against human competitors, artists' in the twentieth century were similarly concerned with the machines' ability to replication the physiology of living organisms. We see this concern in the replication of physiology in the work of Edward Ihnatowicz. An artist with training in both engineering and studio art, Ihnatowicz was concerned with the relationship between technologies and their environmental awareness. Specifically, Ihnatovicz was interested in how his creations could interact with their surroundings. His most celebrated work, the "Senster" (1970) is considered to be one of the most important works of robotic art in the progressive period of the mid-to late 1960s, having an undeniable impact upon the trajectory of robotics in art contexts [9, p. 61]. At approximately sixteen feet in length, and standing eight feet tall [15] the "Senster" was a large claw-like machine composed of welded steel and resembled, as Arthur J. Miller aptly states "a cross between a giraffe and an electricity pylon or a gigantic lobster's claw" [15]. Fitted with electrohydraulics for motion, directional microphones [20, p. 294; 2, p. 236], and Doppler radar units, the "Senster" was highly sensitive to the slightest change in its surroundings. A hydraulic system supplied the power for the independent movement of the sections of the sculpture—each activated hydraulic servo-system that responded to the analogue signals from the control unit [17, p. 292]. Retracting and contorting in uncannily life-like motions, the "Senster" would respond to environmental changes triggered by the audiences movements and sounds; moving forward to explore slight sounds, and retreating at loud, or aggressive outbursts and sudden motions [2]. Audiences were fascinated by it, spending hours interacting with it, as if it were a rare animal in captivity [31]. Commissioned by the Philips electronics company for their science museum in Eindhoven, the "Senster" was the first robotic sculpture to be controlled by a mainframe computer [20, p. 295].

Explorations of human/robot relationships also manifest in more humorous, and physically engaging ways. Canadian artist Norman White provided a compelling example of this in his work "The Helpless Robot" (1985) (See Fig. 2). Exhibited in art museums and shopping malls alike [4]. "The Helpless Robot"—a simple structure made of plywood and iron—requested the participation of passers by that it

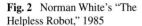

Fig. 2 Norman White's "The
Helpless Robot," 1985

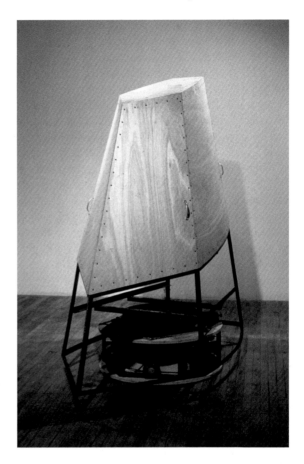

detected with motion sensors. Speaking to viewers (the robot was equipped with
a total of 512 phrases [37]) the Helpless Robot would request that the audience
rotate its simple, cage-like body [10, p. 176]. When audiences were engaging with
it, it would only become more demanding. The more attentively the individual fol-
lowed its instructions, the more frustrated the robot would become—eventually
shouting abuse until finally the individual would give up, only to be invited back
in a whining, apologetic fashion [4]. While the work was altered numerous times,
by 1997 it was controlled by two computers programmed by the artist—one of the
computers tracked the position of the rotating section while also detecting human
presence through various infrared motion detectors, while the other was responsi-
ble for analysing the information and generating appropriate verbal responses [10,
p. 179]. In another work White collaborated with fellow artist Laura Kikauka to
make a work cheekily titled "Them Fucking Robots" (1988). The project culmi-
nated in a bizarre public performance, in which the two skeletal robots met and
simulated human sexual intercourse. This was the first and last anthropomorphic
robot built by White [34].

This humorous—though rather unsettling—sight of robots simulating sexual intercourse has featured in other artworks of note. Paul McCarthy, an artist simultaneously concerned with the sleek, shiny surfaces of American popular culture and the visceral realities of the human condition, has often employed simple robotics to create his politically motivated art. Perhaps the most provocative of McCarthy's animatronic sculptures is "Train, Mechanical" (2003–2010). In this piece, two naked, potbellied sculptures of George Bush simulated anal sex with pigs. With gaping mouths, the bobble heads rotated 360° as their bodies gyrated with the sculpted farm animals. The oscillating heads were the only parts of the creation to move out of unison, seeminly glaring at onlookers who inadvertently prompted the sculptures inbuilt sensors. McCarthy utilized the same simple robotics as the iconic animatronics of American family entertainment culture, found in amusement parks and themed chain restaurants such as the popular Chuck E. Cheese. The combination of lifelike moulded skin (slightly flayed, on close inspection) and the exposed wires and whirring sounds of its mechanical interior, make this work particularly confronting. The works of Ihnatowicz, McCarthy, White and Kikauka rely on uncanny (though at times, absurd) semblance to the behaviour of living organisms. Much like Pierre Jaquet-Droz automatons played instruments, or drew pictures; these manifestations of automation in art also exhibit life-like movements. In these examples, however, simple tasks are replaced with characteristics of vulnerability, or in the case of "Them Fucking Robots", and "Train, Mechanical" carnality, confronting viewers with the juxtaposition of the skeletal robots cold, metallic sterility and their sensitive, reactive behaviours.

The revolutionary progress in robotic art made by figures such as Tinguely and Ihnatowicz has clear resonance in contemporary cybernetic art. With a similar sentiment to Tinguely's "Homage To New York," the Survival Research Laboratories—a collective comprising of artists and engineers founded in 1978 by Mark Pauline—appropriate robotic techniques and machines from other facets of culture (science, warfare, industry and production) and reconfigure them into new robotic forms that operate in opposition to their intended functions ("Survival Research Laboratories" 2013). Inspiring commercial productions such as *Robot Wars*, the machines created by Survival Research Laboratories are exhibited in elaborate public performances in which the machines interact with each other, performing unique actions, often with witty titles and undertones of political satire.[10] In the initial years of Survival Research Laboratories, their productions were comparatively rather quaint—for example, their small junk robot "Assured Destructive Capability" (1979) that defecated on photographs of the then current Soviet premier. Recent robot performances by the collective have been more spectacular, with high budgets and more advanced technology. The group have used sensors, lasers, explosives, flamethrowers and propellers in their work—even animal carcasses have been reanimated, or torn apart, in their elaborate shows. Like early

[10]Robot Wars is a popular British television program that ran from 1998–2003. The series documented battles between the radio-controlled robotic creations of professional and amateur engineers [36].

automatons, Survival Research Laboratories play on the cultural imagination, using technology in a theatre of machinic spectacle.

While the appropriation of technologies into artistic practice provides both an innovative space for artistic exploration, and (as seen in McCarthy) a context to interrogate the widespread cultural application of technology, robotic art complicates assumptions about the role of technology and production in more nuanced ways. While explorations of automation by twentieth century artists may have interrogated the interactive possibilities of robotics, making sensitive machines capable of interacting with audiences and environments, the end of the last century saw a gradual shift in focus toward the integration of nature and technology. Ken Rinaldo, a contemporary American artist, is concerned with the nuanced ways nature can be explored, or extended through the application of technology. While usually rather simple, Rinaldo's sculptures and installations are aesthetically engaging and often involve live organisms. In "Delicate Balance" (1993) a fish tank was suspended by a wire arm, extending from a tall stand in the gallery. The movement of a Siamese fighting fish inside activated a break-beam sensor that guided the tank, allowing the fish (via its motion) to move the tank around, exploring its external environment as far as the wire arm permitted. His works built on this exploration in subsequent projects in which he granted the fish more elaborate vehicles to control. In "Mediated Encounters" (1998) two fish occupied separate bowls that were each fitted with sensors, while in "Augmented Fish Reality" (2004) several small fish tanks on raised platforms were slowly guided by their hosts around a few square meters of a gallery space. The experience and potential of the fish is extended by Rinaldo's appropriation of sensor technologies. Simultaneously, images from small cameras fitted inside the tanks were projected onto the wall, allowing visitors to the gallery a chance to see the exhibition space from the perspective of the fish [35]. While in Rinaldo's work sensors enable small organisms to control the movement of their tanks (albeit in a limited capacity), academic and artist Ken Goldberg and artist Joseph Santarromana engaged Internet users the world over by providing an accessible, communal experience of networked telerobotics.[11] In the mid 1990s, Goldberg and Santarromana collaborated on a project based at the University Of Southern California that combined remotely controlled robotics, social media and agriculture. Their project, the "Telegarden" (1995), was a remotely controlled community garden accessed via the Internet (see Fig. 3). Users could tend to a garden of small plants with a robotic arm actuated online. In the first year of its launch, over 9000 members joined the online community. The project was praised for its innovation; the simple, yet pragmatic reintroduction of physical (and traditional) community fostering experience to social media environments demonstrated the scope of possibility

[11]Telerobots are remotely-controlled robots. First conceived in the 1940s to handle radioactive materials, telerobots have historically been employed to perform tasks in inhospitable environments such as under the sea, or in space. However, with the growing accessibility of the Internet and technology in the twenty-first century, telerobotics are now used in a variety of fields, from education to arts and entertainment [25, p. 260].

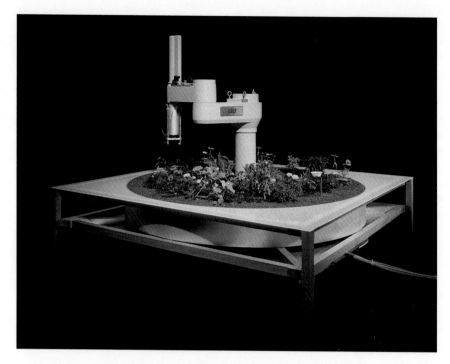

Fig. 3 Ken Goldberg and Joseph Santarromana's "The Telegarden," 1995–2004

provided by the Internet at such an early stage of its global development. Moving to Ars Electronica Center in Austria in 1996—a year after its launch at the University of Southern California—the "Telegarden" was only intended as a year long exhibit, but remained on display until 2004 attracting over 10,000 online members, and over 100,000 visitors to the physical display [38]. Rinaldo's sculptures and the "Telegarden" employ technologies that are simple by today's standards, to explore the possible extension of biological beings and nature; their innovation resides in the introduction of the interface between living organisms and technology. These experiments are significant in the period between the late twentieth century and the start of the twenty-first century, as interest in cyborg experimentation became prevalent.

The spectacle of the machinic has a continuing influence on artists concerned with the dysfunctional, or ostentatious qualities of contemporary cultural imaginings and incarnations of robots and artificial intelligence. Far removed from the elegance of "Musical Lady" American artist Bill Vorn creates eerie installation and robotic performance work that stun audiences with their replication not of human physiology, but of the mimesis of arachnids. Vorn uses his inter-medium practice to investigate the aesthetics, functions and dysfunctions of artificial intelligence in his "Hysterical Machines" (2006), a large-scale installation featuring a series of frightening, highly reactive robots. These nightmarish machines, with spherical

bodies, and eight large arms made of aluminium tubing, look like monsters conceived in a Ballardian fantasy. Each robot contains a system of sensors, a motor and control system [33]. With multiple joints, the mechanical arachnids (some suspended from the ceiling) spasm, twitch and contort in a mess of ridged appendages, with flashing lights, and whirring sounds heightening the spectacle. As featured in many of the prior mentioned automatons and robotcs, the Hysterical Machines' activity is dependant on the stimuli provided by the audience [13]. While frightening to behold, the motions and contortions of the machines resemble flailing invertebrates, and thus, inevitably suggest a life-like vulnerability. It is this impression of artificial intelligence that Vorn wishes to explore. While cold and metal, like "The Senster" or "The Helpless Robot", the movement and the responsive behaviour evoke a sense of compassion for their perceived vulnerability, despite their industrial appearance [33].

This vulnerability can be further seen in the work of the Australian artist, Stelarc. Many of Stelarc's projects and performances have involved the augmentation of the artist's body by technological devices, transforming the man himself into machine, whether through encasing his body in a giant, metallic six-legged exoskeleton, or swallowing a camera so that the interior of his stomach is externalised as a digital sculpture, or attaching automated muscle sensors to his limbs that are operated by distant agents through a computer system. Of these latter performances, Stelarc writes:

> **I've done performances where my body becomes, or is partly taken over by, an external agency. What happens when half of your body is being remotely prompted by a person in another place? It's strange…. The more and more performances I do, the less and less I think I have a mind of my own—nor any mind at all in the traditional metaphysical sense…. These alternate and involuntary experiences with technology allow you to question what a body is, what is means to be human. We fear the involuntary and we are anxious about becoming automated… but really it's a fear of what we have always been and what we have already become. I've always thought that we've been simultaneously zombies and cyborgs; we've never really had a mind of our own and we've never been purely biological entities [26, p. 39].**

Here we see a return to the questions about the relationship between autonomy and automation, and between agency and movement, that so intrigued audiences and philosophers in the eighteenth century. Much of the critical commentary on Stelarc's work has focused on the implications of this technological networking on human agency. Jane Goodall, for instance, argues that: "Stelarc confuses the traditional master/slave terminologies that are attached to human/machine relations by increasing the feedback loops to a point where the body and robot are effectively one operational system. Rather than residing in one or another, intelligence and agency are extruded into the system itself" [6, p. 15]. As a result: "agency, consciousness and deliberation will never be the same again. Specifically, they will never again belong to 'us' as individual subjects. They will be systemic and circulatory" [6, p. 17].

To argue that "agency will never be the same again" after Stelarc's work is, however, to miss Stelarc's own, more radical insight: that we have never been fully

self-determining or biological: "we've never really had a mind of our own and we've never been purely biological entities"; networked beings and techno-human hybrids are "what we have always been and what we have already become" [26, p. 39]. Indeed, this is why it is so useful to position Stelarc's work within the history that also includes the eighteenth-century automata, with which we began this paper: what this reminds us is that the emergence of the modern concept of agency is contemporaneous with that of the modern machinic imaginary. We see this, for instance, in the way Descartes' "cogito ergo sum," which so closely aligned being with individual consciousness, appeared contemporaneously with his radical insistence that the body functioned as a machine. Jaquet-Droz's "Writer," the automaton programmed to inscribe "I think therefore I am" for the amusement of eighteenth-century audiences, is the perfect exemplification of this co-emergence. The modern idea of agency as individuated is thus not undermined by the emergence of the age of machines and the vision of ourselves as techno-human hybrids, as some critics have assumed of Stelarc's work: rather these ideas are products of the same historical moment. Their relation is one of interdependence not opposition.

For Stelarc the "prosthetic body" that "experiences itself as an extruded system rather than an enclosed structure" [26, p. 39], provides an invitation to experimentation and openness. This aspect of Stelarc's practice, the generosity of his embodied encounters with the technological, remains an under-recognised aspect of his work. As Joanna Zylinska argues, Stelarc's work seems

> to have been inspired by the idea of openness, of welcoming the unpredictable and unknown Stelarc's performance of prosthetic selfhood… creates a space for an encounter with, even intrusion of, what is radically different from the self and yet what remains, paradoxically, in some sort of relationship with the self. By denying the mastery of the self (of the artist, auteur, creator, demiurge), Stelarc does not give up what he previously possessed: he rather resigns from a certain idea not only of the performance artist but also the human as only singular and autonomous. His "hospitality"—to borrow Derrida's term … —should not, however, be interpreted as an act of good will but rather as a compulsion to respond to the inevitability of the ethics and a decision not to commit violence against it [32, p. 231].

It is precisely such a problematisation of the singularity and autonomy of the human that we have seen in this survey of robotic artworks examined throughout this paper, and it is this that connects these twentieth-century works to the first robots of the eighteenth century. What we see across this history is not simply the linear development of the progressive technological advances in robotics, but rather a nuanced and multivalent response to the possibilities this affords undertaken in the field of artistic practice. If the relationship between automation and art has such a long and rich history, it is because this relationship is also a cultural site at which the complex relationship between the human and technological can be investigated and experienced. It is in this respect, as Stelarc's work so evocatively suggests, that we have always been robots: not only our physiologies but our imaginaries have long been entwined with the mechanical, an inter-relationality played out in the explorations of robotics and art through the twentieth century and beyond.

References

1. Bar-Cohen Y, Marom A, Hanson D (2009) The coming robot revolution: expectations and fears about emerging intelligent, humanlike machines. Springer, New York
2. Bentley P, Come D (2002) Creative evolutionary systems. Morgan Kauffmann, Burlington
3. Carlyle T (1829) A mechanical age. In: Edinburg review. Avaliable via History 104 Europe. http://www.indiana.edu/~hist104/sources/Carlyle.html. Accessed 16 December 2014
4. Carver G, Beardon C (2005) New visions in performance. Routledge, London
5. Ficher-Rathus L (2010) Foundations of art and design: enhanced media addition. Cengage Learning, Boston
6. Goodall J (2005) The will to evolve. In: Smith M (ed) (2007) Stelarc, the monograph. MIT Press, Cambridge, pp 1–32
7. Hoffman K (2006) Sleeping beauties in the fairground: the Sptizner, Pedley and Chemisé exhibits. Early Popular Visual Culture 4(2):139–159
8. Humble P (2002) Anti-art and the concept of art. In: Smith P, Wilde C (eds) A companion to art theory. Blackwell, Oxford, pp 244–252
9. Kac E (1997) Origin and development of robotic art. Art J 56(3):60–67
10. Kac E (2005) Telepresence and bio art: networking humans, rabbits and robots. University of Michigan Press, Michigan
11. Kittler F (1999) Gramophone, film, typewriter. Stanford University Press, Stanford
12. Kleiner F (2012) Gardeners art through the ages: a global history. Wadsworth, Boston
13. Lizchaka C, Sick A (2007) Machines as agency: artistic perspectives. Transcript Verlag, Columbia
14. Marx K, Engels F (2008) The communist manifesto. Pluto, London
15. Miller A (2014) Colliding worlds: how cutting edge science is redefining contemporary art. W.W. Norton, New York
16. Peri J (2009) New art city: manhattan at mid-century. Vintage, New York
17. Reichardt J (1972) Art at large. New scientist magazine 54(794):292
18. Riedler J (2009) Karel capek. In: Bould M, Butler A, Roberts A, Vint S (eds) Fifty key figures in science fiction. Routledge, London, pp 47–51
19. Riskin J (2003) The defecating duck: or, the ambiguous origins of artificial life. Crit Inquiry 29(4):599–633
20. Salter C (2010) Entangled: technology and the transformation of performance. University of Massachusetts Press, Amherst
21. Satz A, Woods J (2009) Articulate objects: voice, sculpture and performance. Peter Lang, New York
22. Schaffer S (1994) Babbage's Intelligence: calculating engines and the factory system. Crit Inquiry 21(1):203–227
23. Sillars L (ed) (2009) Joyous Machines: Michael Landy and Jean Tinguely. Tate Publishing, UK
24. Sommerer C, Mignonneau L (eds) (2008) The art and science of interface and interaction design, vol 1. Springer Science and Business Media, New York
25. Song D, Goldberg K, Chong Y (2008) Networked telerobots. In: Siciliano B, Khatib O (eds) Springer handbook of robotics. Springer Science and Business Media, Berlin, pp 759–769
26. Stelarc (2009) Mécaniques du corps. In: Hall G, Stelarc, Roland D, Zylinska J (eds) Enghien-les-Bains, Centre des Arts
27. Stephens E (2015) 'Dead eyes open': the role of experiments in galvanic reanimation in nineteenth-century popular culture. Leonardo 48(2) http://www.leonardo.info/leoinfo.html. Accessed 16 March 2015
28. Warkentin J (2010) Creating memory: a guide to outdoor public sculpture in toronto. Becker Associates, Toronto
29. Wiener N (1965) Cybernetics or control and communication in the animal and the machine. MIT Press, Cambridge

30. Wood G (2007) Edison's eve: a magical history of the quest for mechanical life. Anchor Books, New York
31. Zivanovic A, Davis S (2011) Elegant motion: the senster and other cybernetic sculptures by edward ihnatowicz. Kybernetes 40:47–62
32. Zylinska J (2002) The future ... is monstrous: prosthetics as ethics. In: Zylinska J (ed) The cyborg experiments: the extensions of the body in the media age. Continuum, London, pp 214–36

Online References

33. Hysterical Machines (2004) http://billvorn.concordia.ca/robography/Hysterical.html. Accessed 29 June 2004
34. Norm the artist, the Oughtist, the Ner'er-do-well (1998) http://www.normill.ca/artpage.html. Accessed 27 June 2014
35. Rinaldo K (2004) www.kenrinaldo.com. Accessed 28 June 2014
36. Robot Wars History (n.d.) http://www.robotwars.tv/history. Accessed 25 June 2014
37. The Helpless Robot (2011) http://www.year01.com/archive/helpless/. Accessed 28 June 2014
38. The Telegarden (2011) www.ieor.berkeley.edu/~goldberg/garden/Ars/. Accessed 29 June 2014

Robotics and Art, Computationalism and Embodiment

Simon Penny

Abstract Robotic Art and related practices provide a context in which real-time computational technologies and techniques are deployed for cultural purposes. This practice brings the embodied experientiality, so central to art hard up against the tacit commitment to abstract disembodiment inherent in the computational technologies. In this essay I explore the relevance of post-cognitivist thought to robotics in general, and in particular, questions of materiality and embodiment with respect to robotic art practice—addressing philosophical, aesthetic-theoretical and technical issues.

Introduction

This essay is written from the perspective of an artist/practitioner active in the field since the mid 1980s. My own engagement with the field began with desires to utilize electronics and sensors to endow installations and kinetic sculptures with awareness and responsiveness. These desires brought me into contact with the rapidly changing landscape of computing and robotics, on both a technological and theoretical level. It was during this period, in the 1990s that it became clear to me that computational technologies were undergirded by a worldview which was fundamentally in tension with the worldview of artmaking. I do not mean this in a 'two cultures' sense—concerning creativity and technics- but in respect to basic ideas of embodiment and selfhood.

S. Penny (✉)
University of California, Irvine, USA
e-mail: penny@uci.edu

© Springer Science+Business Media Singapore 2016
D. Herath et al. (eds.), *Robots and Art*, Cognitive Science and Technology,
DOI 10.1007/978-981-10-0321-9_4

For me, Robotic Art and related practices of interactive sculpture and installation provided a context in which to imagine the deployment of real-time computational technologies and techniques for cultural purposes. In the process, this practice brings the embodied experientiality, so central to art, hard up against the tacit commitment to abstract disembodiment inherent in the computational technologies. This process pushed the technologies in ways they didn't always want to go, and often necessitated designing and building systems from the ground up, in projects like Petit Mal (see below). On the other hand, it was in robotics (reactive, bottom up and action-oriented) that the traditional AI conceptions of representation and planning demonstrably failed, and were supplanted by various on-the-fly approaches 'Fast, cheap and out of control', the title if a film by Errol Morris, captures the attitude of this work, which was iconoclastic, with respect to conventional AI based robotics.[1] In this essay I will explore the relevance of post-cognitivist thought to robotics in general, and in particular, questions of materiality and embodiment with respect to robotic art practice—delving into philosophical, and aesthetic-theoretical issues as well as technical issues.

Then and Now

After a two-decade hiatus, robotics is again a hot topic. This is in large part due to the maturing of basic technologies, their miniaturization and mass production. It has to do also with the newsiness of Japanese anthropomorphic and zoomorphic robots, of quad-copters and UAVs (drones), the very visible investment in the field by Google, and its development of driverless cars. In the 1990s, media arts practices and the technologies themselves were primitive and developing rapidly. Some modalities, such as Virtual Reality, stalled in the late 90s as the Silicon Graphics computational behemoths were eclipsed by PC and internet based practices. But as the underlying technologies became cheaper, faster and smaller, the same ideas are returning as viable commodities, for instance the Oculus Rift, and the recently demised Google Glass.

The case is similar for robotics technologies, where the availability of user friendly microcontrollers (such as the Arduino) and sophisticated miniaturized sensors (such as MEMS accelerometers and IMUs—Integrated Motion Units) has obviated basic hardware engineering tasks. In 1970, the video camera on the Shakey robot at Stanford cost $50,000 (Fig. 1—Shakey). Today you can buy a far more sophisticated webcam for $2.99. Similarly, in accordance with Moore's law,

[1]Fast, cheap and out of control' Errol Morris, 1997, featured Australian roboticst Rodney Brooks, among others.

Fig. 1 Shakey. Stanford
Research Institute 1966–72.
http://www.ai.sri.com/shakey/

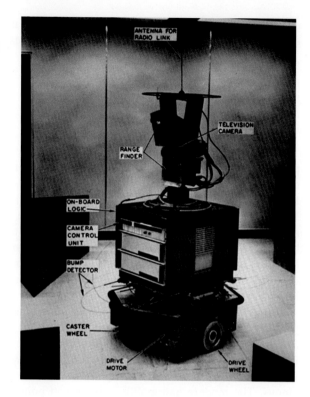

the entire range of robotics technologies has become orders of magnitude more
sophisticated and orders of magnitude cheaper: lithium ion batteries, powerful
miniature motors deploying rare-earth magnets, sensors of all sorts, and vastly
more capable processors and memory technologies.

Robots, Telerobots, Prosthetics and Machine Tools

In my view, robotics, as field, is characterised by two qualities. First: it involves
the design of behavior; and second: it bridges the gap between the immaterial
world of computing and code, and the exigencies of materiality. These two defin-
ing qualities place it in an important set of relationships with art as traditionally
understood.

Fundamental to my conception of what a robot is, is the capacity for sensing
and self guided behavior. In my opinion, as its quality of self-guidance declines, so

does its claim to the moniker 'robot'. We might frame the field of robotics in terms of a set of binaries, vectors in the state-space of robotics. These might include:

anthropomorphic/machine tool;
pop literary culture/engineering;
prosthetic end effector/autonomous sensing;
flesh/metal-plastic; and
localised/distributed.

Technically speaking, once we dispense with the frippery of anthropomorphic robotics, a robot is a self-guiding machine tool. In many cases, industrial robots perform preprogrammed tasks without sensors and real time control. In the same way that Artificial Intelligence should less sensationally be called 'automated reasoning', the use of robots for remote tasks (planetary, deep sea, robotic surgery) should more accurately be named tele-prosthetics, not telerobotics. Systems of bodily augmentation and extension—exoskeletons and the like—are cyborgian constructions as opposed to robots proper. This distinction is not to diminish consideration of the cyborgian condition, which is at least as important as robotics per se.

In the C21st, the division between an autonomous device and an effector prosthetic—for instance the teleoperated arms for moving nuclear fuel rods, or what was once referred to in military research circles as a 'force amplifier'—is now blurred. We are surrounded by quasi-intelligent machines whose control systems are partially under human control, and partially autonomous. The modern automobile is a case in point. With sensors and microcontrollers deployed ubiquitously, the notion that the driver has direct control is a fiction carefully constructed by the designers. The car senses human (driver) actions and interprets them, just as it senses and interprets oxygen levels, tire pressure and braking behavior. In this period of ubiquitous computing, digital networking (once called telematics) increasingly permeates almost all technologies—the 'internet of things'. The UAV or 'Drone' is a spectacular example, linked in real time by satellite communications to soldiers in underground bunkers on the other side of the planet. More benign and domestic examples surround us, such as the increasing presence of internet in cars. The notion of a freestanding autonomous machine or robot becomes increasingly untenable.

At the same time the blurring of control between the machine and the biological is increasingly mirrored by a blending of bodies and machines. Ezra Pound said 'artists are the antennae of the race'.[2] Stelarc has been such an antenna over

[2]He continued "but the bullet-headed many will never learn to trust their great artists." Instigations of Ezra Pound (1967).

Fig. 2 Stelarc: Split Body—Voltage-in / Voltage-Out Galerie Kapelica, Ljubljana 1996, Photographer—Igor Andjelic

decades, performatively presenting or modeling such networked and fleshy robots, rom the Third Hand to the Fractal Flesh and Split Body performances (Fig. 2— Split Body), to the Ping Body, Parasite performances and to the more recent exoskeleton machines. The collaborative project Silent Barrage uses a culture of rat neurons in Atlanta to control a robotic installation in Australia.[3] Given these levels of complexity, it is technically naïve to refer to a simple powered machine without sensor feedback loops as being a 'robot'. In the same way terminology like 'interactivity', 'digital art' and 'new media' now seem decidedly quaint, it may be anachronistic to call anything a robot anymore.

Materiality and Representation

Human construction of increasingly abstracted techniques of representation has developed and has accelerated over recent centuries. Image making, speech, then writing—possibly in that order constituted, or at least signaled, our break with our primate cousins in the Paleolithic [11]. Portable but archival documentation of writing (the book and the scroll) ushered in a second stage of representational systems which have culminated in our time in electrical communication

[3]Silent Barrage. https://vimeo.com/5620739, accessed 6 June 2014.

and representation systems. In the process, the abstract, even disembodied, nature of 'information' has become increasingly valorized. But we must add two caveats. First, these are representational systems, and second, they all remain dependent on biological sensing processes. The brain is material and biological 'all the way down.' There is no 'information' in the brain, in the sense of digital bits. Every so often some report in neurological research claims to have identified computational elements, bits, 'data' or Boolean operations. That is to be expected, given the enormous complexity of the brain, but it is a red herring. The brain may not have information but it does have procedures. It is a wondrously dynamical resonating adapting thing, more akin in its behavior to pre-digital cybernetic models [19] than the linear seriality of the von Neumann machine or the automated reasoning of the Physical Symbol System [13]. The extropian dreams of direct neural jacks and of the passing of 'pure information' into brains from computers seems motivated by a bizarre kind of body-loathing, more Christian than futuristic.

A 'robot', from these perspectives, is an ontological paradox. It is a materially instantiated thing (as opposed to an image, a representation). It operates in the world as a quasi-biological entity, and we experience it in the way we experience animate things in the world—as something that is 'moving towards me', 'scurrying around' or 'trying to achieve a goal'. It is also, in some sense, a representation. And it carries and acts upon representations—or at least some do: the reactive robots prototyped by Brooks, Steels et al. eschewed representation. As Rodney Brooks famously said "The world is its own best model" [1].

Yet representation is itself a relational concept. Like the falling tree in the forest, a poem or a street sign are not representations without a perceiver who is already trained in the deciphering of such representations. So representation requires prior cultural consensus, at least between two people (say an artist and a viewer). Without this, a representation is simply another thing in the world, open to interpretation. To a horse, Leonardo's last supper is presumably just a wall dappled with color.

Art and Robotics

Art—if one can say anything general about it—is about making things immediate and sensorial, heightening affect through artful manipulation of tangible qualities. It is not a theoretical postulation. It is not an equation or an algorithm, it is tangible, embodied, experiential and performative. Material instantiation is a central quality of art. While some radical conceptualists have contested this, it is the exception that proves the rule [14]. The way that art 'means' is in the normal way that (physical) things come to have meaning to people—through embodied experienced. Such experience occurs via the normal equipment of the human animal, specifically the senses and sensori-motor loops.

In my opinion, the central theoretical problem of the era of digital art has been the radical opposition between the culture of computing and the culture of the arts on this very matter. The former espouses the virtues of generality and abstraction, a platonic world outside matter and time. The latter espouses the opposite, the specificity of experience and material instantiation; relationality with human scale and human experience. This is why robotic art is so important. It is a fulcrum between the abstraction of computing and the situated materiality of art. It's no wonder then that thinking artists who engaged computing in the 90s were confounded by the implicit assumptions in computer software and systems. By the same token, art goals were incomprehensible to computer scientists and engineers. As Billy Kluver remarked in a 1966 *Life* magazine article, "All of the art projects that I have worked on have at least one thing in common: from an engineer's point of view they are ridiculous." And it is no wonder that so few have successfully bridged the gap.

The second way that robotic art has been so crucial in the development of digital arts practices is that robotics implies the design of modalities interaction, and the necessity for a theorization of such. But more importantly, it encompasses that field in a larger territory—the aesthetics of behavior. Robots live in the world and must survive by their 'wits'—the effectiveness of the decisions they make on the basis of the data they collect via their sensors—and success is pragmatically measurable by the normal criteria of engineering: efficiency, optimality, speed, safety, survival. The behavior of robotic artworks must also be designed, but the criteria for such design—an aesthetics of behavior—remains a nascent field. Like other computer based generative art practice to which it is related, robotic art is a meta-creative practice [24]. The design of genetic algorithms and fitness landscapes involves the creation of an armature upon which emergent behavior may take place. While commercial robots, like commercial software, are generally not expected to surprise us, works of emergent art are. That is what we mean by emergence [6].

Cybernetics, Artificial Intelligence and Robotic Art

As I have discussed elsewhere [15], Robotic Art has existed since the mid twentieth century. Pioneering work in the field was already occurring in the decade after the second world war, with such landmark projects as Nicholas Schoffer's CYSP works (Fig. 3 CYSP) Grey Walter's Turtles, and Gordon Pask's Musicolor. The emergence of machine art, and cybernetic art in the postwar period was due to a combination of factors. The second world war had generated huge advances in electromechanical technologies and technologies of control: electronics had developed rapidly to encompass radar, analog computing and the development of semi-autonomous and self-guiding machines for the war. In the late 40s and

Fig. 3 CYSP 1. Nicolas
Schöffer, 1956

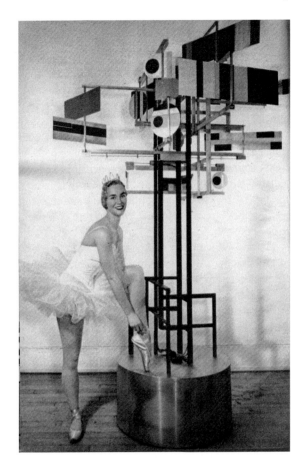

50s, the availability of war surplus electromechanical hardware influenced many
fields. As Paul Virilio has shown, the availability of 16 mm film cameras—origi-
nally developed for use on bombers—led to the French new wave filmalking [23],
American animator John Whitney made his animation machines from bombsight
hardware and cyberneticians such a Ross Ashby, Grey Walter and Gordon Pask
built their cybernetic machines from military surplus materials. Yannis Xenakis
used electromechanical control systems for his polytopes. A decade later, Edward
Ihanotwicz' utlilised war surplus radar hardware for Senster (Fig. 4 Senster). Over
that period, electronic technology developed rapidly towards the integrated circuit
'chip' through major phases of vacuum tube technology and discrete semiconduc-
tor (transistor) technology.

For the first two decades, the ethos of cybernetics as an ur-discipline of feed-
back and control was the main theoretical driver of robotics. Robotic art and the
entire 'art and technology' movement emerged within the theoretical context of

Fig. 4 Senster. Edward
Ihnatowicz. (Image courtesy
Richard Inhatowicz.)

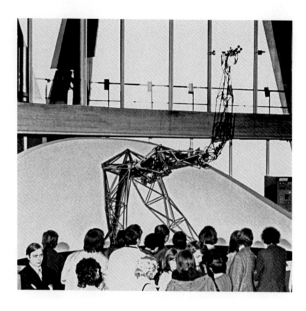

cybernetics. For cybernetics, biology and ecology were taken as models, emergent and self-organising capacities were of special interest and cognitive success was determined by (successful) adaptation. Cybernetic concepts of feedback and homeostasis were framed by a conception of the integration of an agent with the environment. The concept of 'control' has been assumed to be synonymous with cybernetics, and as a result, simplistic interpretations have cast cybernetics in an ominous light. Control Theory emerged from this community, however, 'control' was understood not so much as heavy handed and hegemonistic, but in the sense of a management of status with respect to environmental changes.

Behaviorism, which characterised postwar psychology, eschewed internalism because it was deemed to be unscientific, the territory of philosophy. The ethos of Cybernetics was sympathetic to behaviorism in the sense that it was preoccupied with the presence of, and adaptation by, an agent in an environment. As characterized by the 'black box' doctrine, delving into inner workings of the brain/mind was not encouraged. (The pioneering work of McCulloch and Pitts in neural networks shows that this was not a universal characteristic).

By the early 70s, a different theory of control and communication, in many ways the antithesis of the cybernetic vision, was on the rise. The functionalist-internalist-computationalist paradigm of Artificial Intelligence was seen as a principled way of moving beyond behaviorism. While Cybernetics had been preoccupied with relations between an entity and its environment, considered in terms of 'feedback loops', AI was concerned almost exclusively with reasoning *inside* the black box: reasoning defined in terms of Boolean logical operations

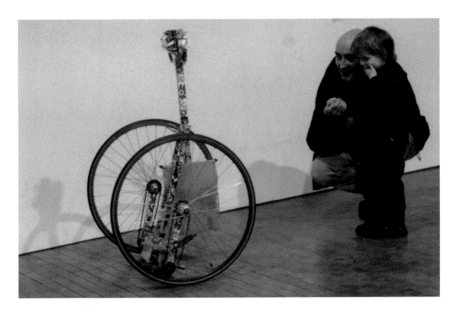

Fig. 5 Petit Mal Shown here at Smile Machines exhibition, curated by Anne Marie Duguet at Transmediale 2006, Berlin. Photograph by Simon Penny

on symbols; with the construction of internal representations and with planning with respect to them. This was characterized as the SMPA (Sense Map Plan Act) approach. The question of how the symbols got there was regarded as tangential, and the possibility of ongoing loops of action in the world without the necessity of internal representation was unimaginable within the paradigm. In a classic Hegelian synthesis, in the late 1980s, the Artificial Life movement emerged out of this tension, at the very moment of the emergence of digital arts.

An Autobiographical Interlude—Petit Mal

Petit Mal—an Autonomous Robotic Artwork (begun in 1989 and first exhibited in 1995)[4] sought to move interaction off the desktop, out of the shutter-glasses and into the physically embodied and social world (Fig. 5 Petit Mal).

[4]As with any long-term project, there is a variety of milestone dates for Petit Mal. The project was designed and the aluminium frame constructed in 1989. The major sensor and electro-mechanical parts (sensor head, motor-wheel system in the ensuing couple of years, and simple solutions to control electronics were made. In 1993, the GCB (68hc11 based) microcontroller was introduced to the system and serious software development and testing ensued.

Petit Mal arose at the confluence of embodied art practice, artificial life, and the cognitivist crisis. The focus was on the bodily experience of the 'user' in the context of behaving installations, and on the construction of a fluid relation between bodily dynamics and technological effects.

The sole function of 'Petit Mal' was to engage visitors in large-scale bodily interaction—a dance. I undertook the task of building a robust mobile autonomous machine for cultural purposes—the goals of Petit Mal, apart from the obvious one of building an autonomous mobile robot which was an artwork, were:

- to build an autonomous human scaled machine which was perceived as an active intelligence, but which did not resort to anthropomorphism or zoomorphism—at least not in its form, though its *behavior* is zoomorphic. Leafing through an Edwards Scientific catalog recently I saw any number of relatively simple mechanical toys designated 'robots' due solely to the application of self-adhesive plastic googley eyes. This was precisely what I wanted to avoid.
- to build a computational machine for which the interface was entirely gestural, bodily and kinesthetic, in which there was no textual or iconic interface, no buttons or menus, keyboards or mice, no screens or codes of flashing lights.
- to build a behaving machine that elicited play behavior among people. Petit Mal implemented a non-instrumental kind of 'play' which is quite incommensurable with conventional computer-game logic of competition, numerical scoring and 'levels' which has more to do with rationalised industrial labor than with play [17].
- to provide a working example of a situated and reactive robot, providing a physical and performative critique of conventional AI approaches to robot control and navigation. Midway through this project I became aware that my research agenda, arising substantially out of art interests, was consistent with progressive thinking in robotics, cognitive science and AI. I found that my intuitions about behavior programming was consonant with the bottom-up and reactive robotics work of Brooks, Steels and others [1–4], etc.). I came to see Petit Mal, technically, as a vindication of a 'reactive' robotics strategy and a critique of conventional AI based robotics, as well as an experiment in artificial sociality.

The motivation to interact with Petit Mal seemed driven by curiosity. People willingly and quickly adjusted their behavior and pacing to extract as much behavior from the device as possible, motivated entirely by pleasure and curiosity. (Interestingly, the only demographic who were unwilling to interact were adolescents). Petit Mal often elicited assumptions that the thing was more clever than it really was. My emphasis on engagement of the user in a situated and embodied way was consistent with contemporary critiques of AI [7, 8, 20]. These critiques put more traditional notions of intelligence as the logical manipulation of symbols in some abstract reasoning space under some pressure. New ideas about embodied and situated cognition were coming to light in work such

as Lucy Suchman's *Plans and Situated Actions*; Varela, Thomson and Rosch's *Embodied Mind*; and Edwin Hutchins' *Cognition in the Wild* [10, 21, 22]. These works variously contested 'internalist' views of cognition, showing cognition as being dynamical and contextualised, facilitated by tools, procedures and human interactions.

The context in which Petit Mal was developed is significant. I had already begun the project when I took up a cross-disciplinary position at Carnegie Mellon University as Professor of Art and Robotics in 1993. I brought to that context my experience in installation, performance, and machine sculpture, along with substantial experience in designing performative technologies and persuasive sensorial experience, and more subtly, with predictions regarding the cloud of cultural associations which might be elicited by a particular set of cues, materials, gestures and references.

The period of development of *Petit Mal* was crucial to the development of my understanding of the engineering realities of robotics and the development of my critique of cognitivism. I was fortunate to have had the opportunity to move in circles with leading roboticists and to come to terms first-hand with the technical realities and motivations of robotics. I began to recognize that my experience in creating materially instantiated sensorially affective (art) work provided me with a different approach to robotics, compared to many in the Robotics Institute whose backgrounds were in computer science and engineering. When the term 'socially intelligent agents' was abroad in AI circles in the late 90s, I coined the term 'culturally intelligent agents', and when *affective computing* became a buzz word in that world, my response was a forehead-slapping "well duh!" [18].

Given the available technology of the time, and the unusual nature of the project, I had to design mechanics, electro-mechanics, computational hardware and software at a comparatively low level. Petit Mal used a combination of ultrasonic and pyro-electric sensors to locate people. I designed and built my own sonar drive circuitry, and pyro-electric sensor array, motor drive circuitry, brake system and rotary encoders, each of which took weeks or months to design, source components, prototype and test. I managed mechanical reliability, power budget and charging issues so that the device could function robustly with the public in a large environment for 10–12 h a day. This was a significant achievement for any robot at the time. Most research robots—funded by large development budgets—ran for a small fraction of that between 'downtime'.

Petit Mal, Affect and Embodiment

One of the conversations about Petit Mal, as persistent 20 years later as when it was first shown, centers on questions of empathy and the evocation of affect. It is constantly observed that people interacting with Petit Mal quickly develop an

Fig. 6 Sniff. Karolina Sobecka and James George 2009. Photograph courtesy of the artists

almost affectionate relationship with the device. While many interactive applications, even embodied systems (such as the Kinect) induce involvement or engagement, they seldom induce a sense of care or concern for characters, agents etc., even in the case of digital pets. My project Fugitive in this context offers a control for the experiment, because the behaviors of Petit Mal and of the agent in Fugitive, are essentially very similar.[5] Yet as engaged as users become with Fugitive, often exhausting themselves running about, they never, in my experience, develop affection of the order induced by Petit Mal.

One might also compare Petit Mal to the much more recent, dynamically and behaviorally sophisticated 3D agent 'Sniff'(Karolina Sobecka and James George 2009).[6] Sniff, a virtual pup, deploys persuasive dogginess in its modeling, animation and behaviors. In a sophisticated aesthetic choice, Sniff is presented in wire frame (Fig. 6 Sniff). This was probably a wise decision, as lifelike texture mapping would drag it into the 'uncanny valley' [12]. While naturalistic and beguiling, Sniff remains a screenal representation of a cute dog. One wonders what kinds of responses Sniff would induce if encountered in an embodied immersive

[5]simonpenny.net.

[6]http://jamesgeorge.org/Sniff.

environment like the CAVE.[7] More germane to the comparison with Petit Mal, one might also ask how an audience might respond to Sniff's behavioral repertoire grafted onto a stick figure, or a ball.

What could it be about Petit Mal that induces empathy? The first and most obvious observation is that it is materially instantiated. As simple and self-evident as this fact is, in our obsessively screen- and image-oriented digital culture it seems necessary to remind ourselves of basic neuro-developmental realities—that as material creatures in the world, the significance of material realities is fundamental, and both historically and perceptually precedes image and text, these representational cultural modalities. Things can hurt us, and we can exploit things to protect ourselves. Things can eat us and we can eat things. We distinguish between the living and the non-living, between the autonomously flying as opposed to the simply falling, instantaneously.

Petit Mal is not zoomorphic in its physical form. As noted, this was an explicit intention of the project. But its behaviors, its dynamics, are zoomorphic. Petit Mal performs liveliness. Were Petit Mal twice or half the size, different emotions would come into play. Physical size plays an important role. Petit Mal is child or pet-sized—probably not big enough to be dangerous, a quality reinforced by its spindliness. Its movements are hesitant and not intimidating. So although physical instantiation is fundamental to the inducing of empathy, the specific qualities of that embodiment, as expressed in physical form and dynamics, ensure it.

Computationalism and Embodiment

A generation after Dreyfus's phenomenological exegesis in 'What computers can't do' [7] and the demise of Good Old Fashioned AI (GOFAI) [9], one still hears excited conversation regarding the purported 'singularity' when computational 'intelligence' exceeds human intelligence.[8] The conception of intelligence which makes the notion of singularity even possible is thoroughly dependent on the idea that the requirements for thinking, or intelligent action in the world, are satisfied by the Physical Symbol System Hypothesis. The circularity of reasoning which permits such a concept we might call the 'Deep Blue fallacy'. In line with the commitment to symbolic reasoning in AI, Chess playing had been taken as a test

[7]The CAVE, a recursive acronym for Cave Automatic Virtual Environment, was an arrangement of (usually four) stereographic projection screens arranged as sides of a cube surrounding the user, who wore shutter glasses and whose position and gaze orientation was tracked, usually with Polhemus magnetic sensors.

[8]The first use of the term "singularity" in this context was by mathematician John von Neumann. In 1958. Ray Kurzweil cited von Neumann's use of the term in a foreword to von Neumann's classic *The Computer and the Brain*.

case of human intellectual achievement, so when deep blue beat chess grand master Kasaparov, AI was deemed to have succeeded. But inasmuch as chess is a game which can be entirely described in a set of mutually consistent logical rules, with no necessity for disambiguating the world, it is isomorphic with AI itself.

Thus, the fact that a computer can play chess is unsurprising. Real world tasks, such as perfecting a recipe for chocolate cake, are in fact much more demanding, possibly outside the capability of AI. The failure of GOFAI was rooted in the insurmountable difficulties in coordination of information systems with the real, lived physical world 'out there'. In hindsight, it should not have been a surprise that an automation of Victorian mathematical logic was neither necessary nor sufficient to equip a synthetic organism to cope in the world, but such was the hubris of the field. In this history we see AI cast not so much as a futuristic but as anachronistic.

According to the Sense Map Plan Act (SMPA) paradigm of conventional AI, robots operate in the world via a serial von-Neumann process of input, processing and output. This construction owes more to mechanistic models such as the industrial production line than biological, ecological or enactive models. Internally, according to this model, perception is separate from action, separated by information processing, in a linear one-way process. The sensor and effector ends of the process are referred to, significantly, as 'peripherals' and serve the function of transduction into and out of digital representations. This conception reproduces an enlightenment individual autonomy, and eschews consideration of community, intersubjectivity, agency, feedback, adaptation, autopoiesis, or enactive conceptions of cognition.

It is important to recognize that however powerful localized or distributed digital computer systems are, they can only make meaningful interventions in the world by virtue of functional interfaces with the world. The negotiation of atoms into bits is by no means as facile as the notion of analog to digital conversion would imply. We must note that in the context of, say music technology, this conversion is from voltages or waveforms to bits. As such, although it is continuous as opposed to discrete, the data already exists in a quasi-numerical form. The problem is of an entirely different order when the task is the discernment of salient features of a complex, heterogenous and noisy electrophysical world. Not only might salience exist in differing electrophysical phenomena, varying by amplitude, frequency or any number of other more complex variables, but the task of building symbolic representations upon which computation can take place is potentially far more complex than the computation itself. And if 'sensing' requires intelligence, and is not a trivial matter of analog to digital conversion. If this is the case, then the von Neumann architecture is fallacious. As such, intelligence in a machine cannot be limited to its processor. To expand the vision further, the behavior of a machine—that is, its successful negotiation of tasks in an environment—demands

Fig. 7 Scribe. Built by
Pierre Jaquet-Droz,
Henri-Louis Jaquet-Droz,
and Jean-Frédéric Leschot
between 1768 and 1774.
Musée d'Art et d'Histoire of
Neuchâtel, Switzerland

a synchronisation of structural, electromechancial, sensing and computational
elements. Thus its 'intelligence is manifested in the interaction of digital reason-
ing, sensor functions, and material aspects The ethos of 'platform independence'
does not apply. There is always a sensitive interdependence between these aspects
of the system. Code must be informed by and constrained by physical form and
dynamics. Hence the 'intelligence' of any robot is in part in its non-computational
embodiment.

What Does It Mean to Do Robotic Art Now?

As robotic technologies become increasingly cheap, available and user-friendly, it
is no surprise that we more commonly see artworks incorporating 'robotic' ele-
ments. Yet often, that roboric capability is deployed in fairly familiar and formu-
laic ways. It is something of an embarrassment to recognize that in robotic art and
interactive art generally, interaction schemes have not advanced much since the
pioneering work of Grey Walter, especially given the explosion in computational
capability over the last half century.[9] At this juncture, we can see robotic art bifur-
cating in the way that interactive art has bifurcated. On the one hand, we see
modalities and genres of interaction stabilized to the point that they recede into the
cognitive background and simply support the promulgation of 'content'.

[9]British neuroscientist and cybernetician Grey Walter famously built two simple autonomous
robots, Elmer and Elsie, in the late 1940s.

Modalities of web interaction, of games, and of avatar spaces such a second life fall into this category. Other work continues to pursue a formal aesthetic inquiry into modalities of interaction, foregrounding the interaction itself. The same is true in robotic art. As robotic technologies increasingly become consumer commodities, the choice to deploy a robotic approach will be a design decision. On the other hand, there is plenty of room for work which reflexively interrogates the phenomenon of the quasi-biological machine.

The realms of social robotics and culturally intelligent agents offer expansive opportunities for such research. Utopian and distopian visions of a robotic future remain a rich territory for exploration, as indicated by the uncanny eroticism of Jordan Wolfson's sexy robot dancer "(female figure)" shown at David Zwirner gallery, New York, 2014.[10] While this work is uncanny and thought provoking, it is an animatronic puppet, not a robot in the sense we have been discussing. It straddles two cultural forms, the C17th automata and the various robotically enhanced sex dolls which are easy to find on the internet. As such it not only reminds us of how uncanny the automata of Jaquet Drosz must have been in their day (Fig. 7—Scribe).

It is worth observing that those extraordinary machines were never accorded status as art—then or now—but remained novelties. Jack Burnham called kinetic sculpture 'the unrequited art' [5]. We can see a consistent conservatism in the art world which hews to the static work and the contemplative mode or consumption. Until recently, the art world has shied away from consideration of all kinds of dynamical new media practices, screen based as well as robotic. This I think has to do with the radical ontological shift inherent in these forms, which are performative as opposed to representational [16].

But Wolfson's work is transgressive on the plane of polite acceptability as well, standing as it does uncomfortably between art and the pornographic. Sex is endlessly interesting to humans of course, and thus it is a constant subject for art, including robotic art. A much older project which deals with much the same issues in a more handcrafted style, is Them Fuckin' Robots by Laura Kikauka and Norman White, of 1989. More recently Sexed Robots by Paul Granjon, of 2005, adds genitalia and sexual behavior to devices very reminiscent of Grey Walter's Turtles.[11]

Conclusion

Robotic art challenges art traditions in one way and new media art in another. The challenge to art is around questions of an aesthetics of behavior and the shift to a performative ontology. The challenge to digital art is to give up the

[10]http://www.youtube.com/watch?v=3ivaQf1jns0,
http://www.davidzwirner.com/exhibition/jordan-wolfson-3/.

[11]http://www.youtube.com/watch?v=akgXp7hVZwA.

implicit Cartesianism in the fictions of disembodied information, and to grapple with materiality and embodiment again. In order to make way where previous agendas ran afoul, well informed robotic art research must be cognizant of the collapse of computationalist constructs of AI which are predicated upon a fictitious division between mind and body, information and matter, software and hardware. By the same token, such research agendas must pay attention to the new theorisation rooted in artificial life and post-cognitivist cognitive science. That is, it must take questions of materiality and embodiment seriously.

References

1. Brooks R (1990) Elephants don't play chess. Robot Auton Syst 6(1990):3–15
2. Brooks R (1985) A robust layered control system for a mobile robot. Massachusetts Institute of Technology, Artificial Intelligence Laboratory, A.I. Memo No. 864
3. Brooks R (1991a) Intelligence without reason. Massachusetts Institute of Technology, Artificial Intelligence Laboratory, A.I. Memo No. 1293
4. Brooks R (1991b) Intelligence without representation. Artif Intell J (47):139–159
5. Burnham J (1968) Beyond modern sculpture; the effects of science and technology on the sculpture of this century. G. Braziller, New York
6. Cariani P (1991). Emergence and artificial life. In: Langton CG, Taylor C, Farmer JD, Rasmussen S (eds) Artificial life II. Sante Fe Institute Studies in the Sciences of Complexity, vol X. Addison-Wesley, Reading, pp 775–798
7. Dreyfus HL (1972) What computers can't do: a critique of artificial reason. Harper & Row, New York
8. Harnad S (1990) The symbol grounding problem. Phys D 42(1990):335–346
9. Haugeland J (1985) Artificial intelligence: the very idea. Bradford/MIT Press, Cambridge
10. Hutchins E (1996) Cognition in the wild. MIT Press, Cambridge
11. Malafouris L (2007) Before and beyond representation: towards an enactive conception of the palaeolithic image. In: Renfrew C, Morley I (eds) Image and imagination: a global history prehistory of figurative representation. The McDonald Institute for Archaeological Research, Cambridge, pp 287–300
12. Mori M (1970) The Uncanny Valley (trans: MacDorman KF, Minato T). Energy, 7(4), pp 33–35
13. Newell A, Simon HA (1976) Computer science as empirical inquiry: symbols and search. Commun ACM 19.3:113–126
14. Penny S (1987) Simulation, digitization, interaction: the impact of computing on the arts, Artlink V7 #3,4. Art+Tech issue
15. Penny S (1989a) Art practice in the age of the thinking machine. Performance 56/7.UK
16. Penny S (1989b) Charlie Chaplin, Stelarc and the future of humanity. Artlink V9#1 1989
17. Penny S (1995) Paradigms in collision, a tentative taxonomy of interactive art in Schöne Neue Welten. In: Rötzer F (ed) pub Boer, Germany
18. Penny S (1999) Agents as artworks and agent design as artistic practice. In Dautenhahn K (ed) Human cognition and social agent technology, John Benjamins Publishing Company
19. Pickering A (2010) The cybernetic brain. University of Chicago Press, Chichester
20. Searle J (1980) Minds, brains, and programs. Behav Brain Sci 3(3):417–457

21. Suchman L (1987) Plans and situated actions: the problem of human-machine communication. Cambridge University Press, Cambridge [Cambridgeshire]; New York
22. Varela FJ, Thompson E, Rosch E (1991) The embodied mind: cognitive science and human experience. MIT Press, Cambridge, Mass
23. Virilio P (1986) War and cinema: the logistics of perception. Verso
24. Whitelaw M (2006) Metacreation: art and artificial life, The MIT Press

Robotics: Hephaestus Does It Again

Jean-Paul Laumond

Abstract After browsing through half a century of robotics research, the chapter emphasizes on motion autonomy as the key attribute of robots. The presentation follows a guiding thread inspired by an ancient myth accounting for the universally debated relationship between science and technology. In Greek mythology, Hephaestus was a talented craftsman. Enamoured with Athena, he attempted to seduce her, in vain. The goddess of "knowing" withstood the advances of the god of "doing". Robotics stems from this tension. Although the myth contradicts a current tendency to confuse science and technology, it nevertheless reflects the experience of the author as a roboticist.

Robotics explores the relationship that a machine which moves, and whose motions are controlled by a computer, can have with the real world. In this sense the robot differs from automats, whose motions are mechanically determined, and computers, which manipulate information but do not move.

What degree of autonomy can such machines be expected to have? This question does not cover robotics entirely, but it does account for a large part thereof, and it has a certain ambition. In particular, it resonates with the sciences that take

The text is adapted from the inaugural lecture delivered on the January 19, 2012, in the framework of Liliane Bettencourt Chair of Technological Innovation at Collège de France in Paris. It benefits from the translation by Liz Libbrecht of the original version entitled *La robotique: une récidive d'Héphaïstos*, and published in Collège de France/Fayard Collection « Leçons inaugurales du Collège de France », no 224, May 2012. This work has been partly supported by the project ERC Advanced Grant 340050 Actanthrope.

J.-P. Laumond (✉)
LAAS-CNRS, 7 Avenue du Colonel Roche, BP 54200, 31031
Toulouse Cedex 4, France
e-mail: jpl@laas.fr

© Springer Science+Business Media Singapore 2016
D. Herath et al. (eds.), *Robots and Art*, Cognitive Science and Technology,
DOI 10.1007/978-981-10-0321-9_5

living beings, including humans, as their research objects. We can however immediately underline an essential difference: the roboticist has to *make* robots; the neurophysiologist, the bio-mechanical researcher or the psycho-physicist seeks to *understand* humans and animals. Words have their significance. The missions differ: while the former have to *do*, and are condemned to innovating, the latter have to *understand*, and are condemned to producing knowledge.

The distinction between *doing* and *understanding* is not new in the history of science; Pasteur's quadrant aims to show that. It was introduced recently from a perspective of management and evaluation of research [1]. It structures sciences, technologies and their relations along two axes: one concerns the more or less fundamental nature of research; the other its usefulness. In this quadrant, robotics would fit in with Edison, under "applied research with a strong societal impact"—an expression that allows for a presentation of the discipline. But robotics is an activity that is not summed up so easily. I prefer not to "resolve" the tension between *doing* and *understanding*, and to that end I refer to a Greek myth that will serve as my main theme (Fig. 1).

It was when I was preparing my lecture at Collège de France in 2011 that I discovered that roboticists have a god: Hephaestus. In Greek mythology, Hephaestus was an ingenious, talented craftsman, known for the remarkable weapons he made. But he also made wheelchairs that moved about on their own (basically, mobile robots) and golden servants that helped him to move about (basically, servicing robots), and he even made Pandora, a clay statue to whom Athena gave life. He had a tumultuous love life, as attested by the following passage by Apollodorus [2], a chronicler from the second century BCE:

> Athena visited Hephaistus, wanting to fashion some arms. But Hephaistus, who had been deserted by Aphrodite, yielded to his desire for Athena and began to chase after her, while the goddess for her part tried to escape. When he caught up with her at the expense of much effort (for he was lame), he tried to make love to her. But she, being chaste and a virgin, would not permit it, and he ejaculated over the goddess's leg. In disgust, she wiped the semen away with a piece of wool and threw it to the ground. As she was fleeing...

While Hephaestus is the god of *doing*, Athena, who appears here as the one who calls the tune, is the goddess of *knowing* or—to protect me from reprimands from the exegetes—let me consider her as such for the purpose this lecture. Hephaestus was thus seeking to possess Athena. He was unable to do so. Could the *doing* not aspire to the *knowing*? A hard blow for the roboticist.

Robotics stems from this tension. Although the myth contradicts a current tendency to confuse science and technology, it does nevertheless reflects my own experience regarding innovation—experience that I might sum up as follows: even though *doing* is not *understanding*, *understanding* enables one to *do*, but unfortunately, not always. And even though one may very well *do* without *understanding*, *doing* also enables one to have tools—sometimes surprising ones—for *understanding*.

I am going to illustrate my argument in three parts: two concern algorithms used to plan motion, while the third concerns humanoid robots and recent models of anthropomorphic action. But first, let us look at a few historical milestones that enable us to situate the discipline and its fields of application better.

Robotics is 50 years old or, more precisely, 54. Although the word *robot* appeared early in the 20th century and has since fuelled a collective imaginary, the birth of robotics is generally pinpointed to the introduction, in 1961, of the first industrial robot on the General Motors assembly lines. This was the Unimate robot, patented by George Devol and industrialized by Joseph Engelberger, recognized as the founding father of robotics. From the outset, numerical control machines were the most salient feature of robotics research, along with the establishment of the first connections between machines and computers, mechanics and informatics. These beginnings were soon to be accompanied by technological progress in calculation (miniaturization and enhanced power of processors).

Robotics is now well established in the manufacturing sector, where it has had a significant part to play in altering the organization of the means of production. Its success is related to the repetitive nature of the tasks that industrial robots perform (welding, painting, sorting, transporting, etc.) in well-structured environments where problems are usually limited to engine failure or can be treated by an emergency stop. There is no need for a high level of adaptability in these environments.

The question of the autonomy of a computer-controlled machine as such arose in the late sixties only. At Stanford Research Institute (SRI), work with the mobile robot Shakey laid the foundations of research on autonomous robots. The main aim was to equip machines with the ability to reason on their actions. A robot had to perceive its state and the state of the world surrounding it (for which it was equipped with sensors), and to act (for which it was equipped with actuators enabling it to move about). The computer then "simply had to" decide automatically on the actions to perform to fulfil a specific mission and check that everything was running smoothly.

In fact the SRI researchers had no particular application in mind. At the time, robotics was seen as a possible field of application for the theories developed in artificial intelligence. It was more a dream than a project to solve specific problems concerning robots in industry.

It was in the eighties that the first scientific societies and professional federations devoted to robotics were founded: the Robotics and Automation Society (IEEE) in 1984, the International Foundation on Robotics Research (IFRR) in 1986, and the International Foundation of Robotics (IFR) in 1987. During the same period, at the 1982 Versailles Summit, the industrialized countries adopted the International Advanced Robotics Programme (IARP) devoted to scientific cooperation in the field of robotics.

Everything started to speed up in the nineties.

In 1993 the company Honda disclosed the results of 7 years of research carried out in complete secrecy: P1, an anthropomorphic robot, took its first steps. In the same year, under the Rotex project headed by Gerd Hirzinger at the DLR[1] in Germany, an on-board manipulator robot on a space shuttle grasped an object floating in space and assembled mechanical parts. On 4 July 1997, the NASA robot Sojourner started its walk on Mars. It was to be followed by the robots Sprit and Opportunity in 2004 for missions that are still on-going today. On 11 May 1999, the company Sony put the first toy robot on the market: a small dog capable of moving about, perceiving its environment and recognizing human orders. On 7 September 2001, Professor Jacques Marescaux conducted the first tele-surgery on a patient hospitalized in Strasbourg, with the help of a surgical team situated in New York. In 2002 the company iRobot, set up in Boston by Rodney Brooks from MIT, commercialized Roomba, the first vacuum-cleaner robot, of which millions have now been sold. In 2005 a team from Stanford University, headed by Sebastian Thrun, won the DARPA Grand Challenge: his vehicle was the first to cover 200 km in less than 7 h in the Mojave desert, with total autonomy. In the same year at the Aichi exhibition in Japan, Toyota presented a jazz orchestra composed of humanoid robots playing various wind instruments. The quadruped robot Bigdog, by the company Boston Dynamics founded by Marc Raibert from MIT, was tested in Afghanistan on 25 March 2009. In the spring of 2011, in the team of François Pierrot at LIRMM lab in Montpellier, the parallel robot R4 reached an

[1]Deutschen Zentrum für Luft—und Raumfahrt (German space agency).

acceleration of 100 G. Finally, to date, more than 7,000 Naos, small humanoid robots, have been produced by the company Aldebaran.

What knowledge is built around this profusion of innovation?

Robotics grew out of mechanics. It participated in the emergence of disciplinary fields such as control theory and signal processing, borrowing from computer science and feeding into algorithmics. After the appearance of Unimate, nearly two decades passed before the first attempts were made to theorize this field that was still seeking its bearings.

Two major schools of thought were to revive old debates rooted in the humanities, to apply them to the study of autonomous machines and to structure research in robotics.

The supporters of what, with hindsight, could be called a "robotics phenomenology", argued for the primacy of the model and introduced the "perception-decision-action" loop: the robot uses its sensors to assess its own state and the state of the world surrounding it; it then devises models of those states, reasons on the basis of the models, and decides on the actions to perform to fulfil the mission assigned to it. This school has never really been theorized.[2] It is structured around topics such as:

1. mechanical system design and control;
2. artificial vision and, more generally, artificial perception;
3. object manipulation;
4. algorithmic action planning and control;
5. system architecture.

It is this school that has headed large programmes in manufacturing robotics, medical robotics and planetary exploration robotics.

The other major current is the school led by Rodney Brooks, the charismatic researcher from MIT. In the eighties Brooks argued for a conception of autonomy based on the absence of models of the world: the machine's intelligence should emerge from a hierarchy of sensory-motor behaviours managed by exciter and inhibitor mechanisms [3]. This school of thought spawned a type of robotics said to be "bio-inspired". It had far less contact with industry than did the preceding one. The robot was considered above all as an experimental medium for theories from the life sciences. This was the school from which strange artificial creatures were born, such as the amphibian salamanders [4] of Auke Ijspeert at the EPFL in Lausanne. Dialogue between the two communities went via the elaboration of mathematical models. Observation of life also gave birth to very clever formal approaches, such as the one developed by Nicolas Franceschini [5], which enabled a drone to land softly, based on the principles highlighted by the study of flying insects.

[2]With the exception of an attempt by John Hopcroft, more a theoretician of computing than a roboticist, who saw in robotics the emergence of a "stereo—phenomenology". This he described in an article that, strangely, remained confidential: Hopcroft JE (1986) The impact of robotics on computer science. Communications of the ACM, vol. 29, no 6:486–498, DOI: 10.1145/5948.5949.

In fact, this separation into two schools is not as distinct today. The tendency of the two schools to move closer together is a fundamental one. It is evidenced in the 1,600 pages of the first encyclopaedia of robotics, published only 6 years ago [6].

In the introduction we saw that a robot acts through motion. Its autonomy therefore depends primarily on its ability to "decide" on its actions. So let us start with the question of the automatic motion computation.

Industrial robots have to perform tasks in welding, painting and assembling mechanical parts. A mobile robot—be it the robot exploring Mars, the future car, or the next factotum robot that will share our offices—has to be able to move about, to avoid obstacles in its way, and to inspect a place. If it is equipped with manipulator arms, it will also have to manipulate objects.

What methods should be developed so that the machine-computer twosome can reach an objective without an operator having to specify every detail of the motions required?

Suppose the robot is perfectly familiar with its environment and is able to situate itself therein: for example, it has access to a layout plan of the place in which it operates (this plan was either given to it, or it acquired it through its sensors) and the environment in which it works has already been modelled numerically (in the case of the industrial robot). In short, the geometry of the place is known to the machine. In these conditions, how can a computer compute a motion to make, based on an initial position, to attain a set goal? How can it avoid obstacles? How can it be sure whether the goal can be attained or not? The problem posed in this way has been popularized in robotics by the evocative expression "the piano mover's problem". It is one of the most emblematic problems in robotics.

Can a computer answer this question? To give meaning to this type of query, our computer scientist colleagues use the notion of decidability. When a problem is decidable, either the computer provides a solution, if one exists, or it supplies exact information on the non-existence of a solution. The question is then precise: is the piano mover's problem decidable?

The answer is yes. This was demonstrated in two steps in the early eighties.

In the first step, Tomás Lozano-Pérez (MIT) suggested transforming the problem of moving a body in space, into a problem of moving a point [7]. Thus, if one can "reduce" the piano into a ping-pong ball, the problem is far simpler. But how does one go about doing that?

To situate a rigid body in space, three position parameters and three rotation parameters are necessary. These six parameters correspond to the coordinates of a point in space, called the *configuration space*. The configuration space will be reduced to three parameters for a rigid body moving in the plane (a car, for example). More generally, it will consist of several articular parameters for a manipulator robot, and of about thirty parameters for a humanoid robot.

The problem which, for a robot, consists in finding a motion without collision in an environment filled with obstacles (our three-dimensional real world) is thus transformed into a problem of seeking a path for a point moving through an abstract space (the configuration space whose dimensions depend on the complexity of the robot considered) and avoiding obstacles, that is, images in this space

of obstacles in the real world. In mathematical terms, this consists in exploring the connected components of the configuration space without collision. This is the second step.

Since Deep Blue beat Garry Kasparov at chess, we have known that a computer has the ability to explore highly complex spaces. But the situation in a chess game, although complex, is intrinsically finite: the number of states of the game is finite (albeit huge), and transitions between two states are instantaneous. They correspond to only a few rules concerning the motion of the various pieces on the chessboard. In the case of planned motion, the problem is very different. A motion is a continuous function of time in space. How can a computer solve this problem of continuity when it is condemned to computing everything? In other words, how can this problem, which is continuous by nature, be rendered combinatorial?

Lozano-Pérez provided a solution in the case of a polygon moving in translation on a plane. But is this possible in other cases? The question appealed to mathematicians and experts in combinatorics, especially Jacob T. Schwartz and Micha Sharir of the Courant Institute of Mathematical Science in New York. In 1983 they published a general solution to the problem, valid for any type of mechanical system [8]. The idea of the demonstration was based on a method for reducing the piano mover's problem to an elementary algebraic problem of decidability (established in the 1950s by mathematician Alfred Tarski), and on an algorithm proposed by mathematician George E. Collins in the seventies. The algorithm was complete: the computer would give a solution if there was one and would otherwise affirm with exactitude the absence of a solution.

With reference to the myth, let's say that Athena had won: she *knows* what to *do*.

Was the problem solved? Not really. Or rather, it was indeed solved, but not "usefully". In fact, the complexity of the algorithm (that is, the computation time needed to execute it) is a major impediment to its application. The algorithm is doubly exponential in the dimension of the configuration space. It takes too much time: Hephaestus does not care about a powerful solution in theory if it is ineffective in practice. The mathematicians of real algebraic geometry continued to explore this route. They were reducing the complexity of algorithms but progress was slow and the research difficult. There seemed little hope of them ever being useful in motion planning.[3]

That was in the 1980s. A whole section of this research was to break away from robotics applications to contribute to fledgling computational geometry. Particular problems in low dimension spaces were to be solved elegantly: there is finesse in Delaunay's triangulation, in its dual, Voronoï's diagram, and in Minkowski's convolutions of polygons. At INRIA in France, these structures of geometric data were to serve to minimize the wastage of leather in the tawing industry (imagine having to fit as many right hands and left hands as possible onto a piece of leather, to produce as many gloves as possible!). Thus, Athena scored a small point, even

[3]Real algebraic geometry does nevertheless have real applications in robotics. In the case of parallel robots known for their speed and precision, it serves to avoid design errors.

though considerable efforts were still required to obtain the "exact" calculation that these methods required. It was to take large research projects, like the CGAL project in Europe, to accomplish that.

This knowledge nevertheless had little influence on programmes set up to develop robotics.

In 1990 I spent a few months at Stanford University. Jérôme Barraquand and Jean-Claude Latombe had just devised a new approach [9] consisting in extending a local research method developed by Oussama Khatib a few years previously: the potential method [10]. The method is applied in the configuration space. The starting point is attracted by the goal to reach, while being repulsed by the obstacles situated on its path as it progresses. The attractive and repulsive potentials generated respectively by the goal and the obstacles combine to produce a field of potential. An algorithm to monitor the steepest slope (the gradient) makes it possible to progress towards the goal. Although effective in practice, the method nevertheless has the drawback of stopping in areas of no slope, that is, potential wells that do not necessarily correspond to the goal.

Barraquand and Latombe had the idea, or I could say the audacity, to introduce random steps into these cases. The algorithm thus consists of a sequence of alternating gradient descents and random steps. How can one prove that the goal can be reached in this way? One cannot. Or rather, one can prove that if a solution exists to the problem, then there is a sequence of indefinite length that will find it. And if there is no solution, the algorithm will "loop" to infinity. In practice, it will be stopped after a certain calculation time, and there one will find oneself without a solution or any guarantee that there is not one. One cannot say that the piano mover's formal problem is solved. Yet the results are spectacular. A student did a demonstration for me on a system consisting of eight articulated bars (dimension eight configuration space—a dimension until then out of reach of any other method): the "robot" wove its way through a highly cluttered space after only a few seconds of calculation. I was flabbergasted by the ease with which it did so. Familiar with the problem, I suggested that the student run his program based on a very particular starting configuration, drawn by a very deep well of potential. After calculating for more than a night, the program had found no solution, whereas we knew that there was one. Morality was safe: there was no miracle. Hephaestus' know-how had not been promoted to the ranks of knowledge.

The problem remained whole. The problem remained whole? Of course! Except I had devised a very particular case deliberately to "trap" the algorithm. Usually it actually worked very well.

Intrigued, on my return to Stanford I launched research on a subject that can be summed up in the question: Why does the method work "so well"? After working for a year with a PhD student,[4] I was able to identify the type of mathematics that could account for performance: it concerned theories of "catastrophe" and "percolation". I went to Toulouse to give a seminar in a static physics laboratory, and there

[4]Florent Lamiraux, now a senior researcher at LAAS–CNRS.

I met specialists who very quickly understood the nature of the problem that we were focusing on. Jokingly, they suggested I join their laboratory so that we could work on it together. For me that would have meant giving up robotics. Understanding the behaviour of these methods is indeed a very difficult problem that is still unsolved today. When we returned from this seminar my Ph.D. student and I agreed to change the subject of his thesis. Hephaestus was enraged at having to give up. But so what: he had opened the door to the development of probabilistic methods.

Unlike the methods spawned by algebraic geometry or computational geometry, probabilistic methods require no explicit construction of obstacles in the configuration space. A simple checker of collision between bodies in real three-dimensional space is enough to implement them. In its basic version [11], the probabilistic algorithm draws configurations randomly: if a configuration is in a space free of obstacles (test obtained by the application of the collision checker), it is added to the data structure. We then verify if it is possible to connect it via a collision-free path with other configurations already computed. If it is, we memorize the information. The data structure is enriched as the computations are performed, and takes the form of a map, called a graph, which tends to cover the space of obstacle-free paths. Solving a problem of motion planning amounts to verifying whether the departure and the goal are attainable from the points on the graph, and whether these points can be linked up via a sequence of pre-calculated paths. The on-going problem of seeking a path in the configuration space is then reduced to the combinatorial problem of the search for paths on the graph. The shift from continuous to combinatorial is done; that was the aim. The method is simple and general. It is at the origin of numerous variants, each with its own characteristics. They are currently still being developed by several teams around the world and are constantly being improved.[5] They owe their success to the fact that they match up to the state of calculation technology so well. Had they been developed 20 years earlier and presented on the sole basis of their formal contribution, without reference to case studies that processors at the time would have been unable to solve, these methods would not have been published.

Not only are probabilistic methods effective in practice, they are also easy to program. Today they make it possible to plan the complex motions of a humanoid robot transporting cumbersome objects. And they have unexpected applications.

Probabilistic methods are at the origin of a software platform developed at LAAS-CNRS [12] in the framework of a European project in which industrial firms were participating. Scale one problems were successfully solved by simulating maintenance operations in industrial facilities. In 1999 the French law on innovation was passed. It encouraged researchers to set up their own businesses. The company Kineo was founded in December 2000 [13]. The idea was to target the virtual prototyping market. In this sector, mechanical assemblage and robot

[5]Research in this field consists in giving "meaning" to random draws, that is, introducing various laws of distribution of probability, depending on the context. A real engineering of probabilistic algorithms has thus been developed.

programming solutions have to be validated, based on digital mock-ups. The process takes place in a three-dimensional virtual world, in a design phase preceding production. Technicians explore the digital mock-up on a computer screen, shift around the mechanical parts, and check that they match the specifications. They have to prove, for example, that it is possible to fit a car seat that has just been designed, into the car. If not, the seat has to be redesigned. This is the piano mover's problem viewed from the angle of mechanical assemblage. Whereas the verification could take a technician several hours, probabilistic algorithms solve the problem within seconds. This gain is the value of the computed motion. At the time, a few years were needed to transform a software prototype developed in a laboratory into a product and, among other things, to integrate it into the software packages commercialized by Dassault Systèmes and Siemens. By 2011 the company was managing a portfolio of over 1,700 licences (150 clients in 25 countries) equipping almost all the car manufacturers in the world. The company was acquired by Siemens in 2012. Hephaestus had worked well.

But he was still furious about not understanding the reasons for this success. Let this be clear: the piano mover's problem is well set out; it can be solved on a computer, that has been demonstrated. However, its complexity put its resolution beyond the reach of calculation technology at the time. Remember that by "resolution" we mean that it is possible for a computer to decide on the absence of a solution. In this sense, probabilistic methods are not concerned with solving the problem. Generally they give a solution if one does exist, and that is enough. "Understanding" is another story, that should not slow down the innovation process. There is genius in these methods, that is for sure: it lay in their perfect match with the state of computation technology. Computers in the sixties would not have rewarded the same boldness.

Let us remain in the domain of motion.

In 1985, my mentor Georges Giralt asked me the following question: the piano mover's problem is a well understood problem; to solve it, one simply has to explore the connected components of the configuration space without collision; the underlying hypothesis is that all motion of the mechanical system appears as a path in the configuration space; but what about the converse? Is there a motion that corresponds to every path? In particular, a mobile robot with wheels has to roll without sliding; it cannot move sideways; this is not a piano that the movers can move about any way. The entire preceding construction collapses: it is not because we are going to find a path without collision in the configuration space that this path corresponds to admissible motion for the mobile robot. Parallel parking is a more difficult task than it seems. It requires one to refer back to theory.

From the 1990s and until the end of the 2000s, entire sessions in robotics conferences were devoted to the problem. They no longer exist, and the explanation is simple: the problem has been solved, or rather, today's engineers have everything they need to enable a mobile robot to decide on its trajectories, with total autonomy. Let's look at this in more detail.

In 1986 I proposed a laborious demonstration consisting in cutting and pasting arcs of circles and line segments, and showing that all the paths of a piano could be

approximated by the paths of a car of the same size, provided that the car could be manoeuvred. The link was immediately made with non-linear system mechanics: a car is a nonholonomic system, a concept encompassing the fact that a driver can act on two parameters only, the speed and the direction of the car, whereas as for him or her it is a matter of mastering the two parameters of the car's position and its orientation. In other words: the configuration space of a car is three-dimensional, while the number of its degrees of freedom is two. More colourfully, we could say that there would need to be another engine if the car were to move like a crab.

Mathematics was to contribute decisively to solving this problem [14]. It was to show the roboticist how steering this crab-like motion could be approached through a sequence of admissible motions. Underlying this were notions of vector fields, of Lie brackets and of sub-Riemanian geometry. A link had to be established between these notions, and that was a matter of pure (not applied) mathematics, and of combinatorial notions of decidability. Proof was established that to park one's car the number of manoeuvres to make varies like the inverse of the square of the free space. And if the vehicle is pulling a sequence of trailers (like trolleys in an airport), the number of manoeuvres can go so far as to follow an exponential function of $Fib(n + 3)$, a formula in which Fib represents Fibonacci's famous sequence of numbers 1, 1, 2, 3, 5, 8, 13, ... and n corresponds to the number of trailers [15]. This number increases like an exponential function, that is, extremely rapidly. The result indicates that, while it can be conceivable to parallel park a car pulling a caravan, or a tractor pulling a cart, it is not reasonable to expect the same feat from a baggage handler at an airport. It is not that the task is impossible, but it is too complex: the number of manoeuvres would be far too great. And this is not just a question of technology; it is a physical reality. Hephaestus can try as much as he likes, Athena will still mock him. This fine result of combinatorics is based on the knowledge of a somewhat exotic geometry. Knowledge has applications where one least expects them. Engineers do not only need applied mathematics to carry out their innovations, they also need pure mathematics.

The above result is actually a result of existence: it is possible to park a vehicle, under certain conditions. But how does one *do* this in practice? The roboticist demands "constructive" proof of the result of existence. The mathematician is driven into a corner: in the case of parking a trailer he gave a near complete solution to the problem. The roboticist completed it, and in 1993 the LAAS-CNRS' mobile robot Hilare was able to park its trailer entirely autonomously. This was a first. The result could be generalized to several trailers, if their hitches are centred on the axle of the trailer preceding them (the devil really is in the detail!). On the other hand, the mathematician fails to provide a construction for a general system. The problem is a very difficult, open one: we know how to calculate the trajectories of a mobile robot with two trailers with a centred hitch; we do not know how to *do* so for a robot with two trailers with an offset hitch.

What lessons can be drawn from these results?

The first lesson: the problem of parallel parking has been solved. In the early 2000s, I tried to promote the technology in automotive industry. I learnt in a

meeting with a programme manager that car manufacturers were not interested in our solutions. The reason was not the feasibility of a possible transfer. It stemmed from the fact that car manufacturers did not want to design automatic driving systems because of legal responsibility in the event of an accident. The driver had to remain the only one responsible for the car's behaviour. Complete automation of driving (that is, a form of autonomy of the vehicle) is not the order of the day. Pity. We'll stop at the computer-aided driving systems that we now see emerging.

The second lesson: if it is really *necessary*, the engineer will know how to compute trajectories for the system with two trailers with their hitches offset. How is this possible? The story goes as follows. In 2000, Airbus and the French Ministry of Infrastructure launched the "Grand Itinéraire" project to transport the six components of the future Airbus A380 by exceptional convoy from the little town of Langon to Toulouse. The dimensions of the convoy were exceptional. In places the road had to be redesigned, and for that purpose it was necessary to simulate the convoy's trajectory with precision. The Direction Départementale de l'Equipement (DDE) contacted Kineo: a fine opportunity for the start-up to establish its position as a specialist in motion planning and control. However, whereas four out of the six trucks had a trailer with a centred hitch, the other two corresponded to the model of the robot towing two trailers with an offset hitch. Bad luck! Kineo's engineers and researchers from LAAS-CNRS nevertheless developed a numerical optimization method (derived from known methods in applied mathematics) which successfully enabled the simulations of crossing through the villages of Condom and Lévignac. For Kineo the opportunity was too good to miss. The contract would enable it to pay the young company's first salaries. Was the mathematical problem solved? No. The numerical method simply corresponded to the DDE's terms of reference.

Knowledge that is of little interest and new know-how that is sterile from the point of view of advances in knowledge are typical of research and innovation processes.

Let us now turn to the last part of this presentation, devoted to humanoid robots.

Humanoid robots appeared in the 1970s. Technological advances in mechatronics—miniaturization of electronic components and increasing power of electric engines—have enabled their application in research laboratories over the past 10 years. There are currently around twenty different prototypes.

Hephaestus is starting all over again with new Pandoras. They are no longer of clay, but mecatronics. And they are animated. The roboticist keeps on asking the question of autonomy: what adaptability can we hope to give these new machines? The analogy between humans and machines has to be made [16]; it cannot be avoided. In the end, does Hephaestus have the keys to knowledge? With his machines that adapt, that "decide" on their actions, what can he tell us about our own "functioning"? The question is both dangerous and beautiful.

The danger is epistemic. Robotics cannot serve as an alibi for biology. A biological model cannot be validated on a robotic platform. Even though models of life forms can be simulated on computer, and robots can be controlled on the basis of these principles—sometimes very effectively—, it is in no way possible to conclude on their validity simply because they are operational in robotics. It is not

because a roboticist successfully uses a bio-inspired model that this success says anything about the validity of that model. And conversely, it is not because the roboticist is capable of making a robot navigate in an environment cluttered with obstacles that we know how humans or animals solve the same problem.

Yet the confusion is tempting. It is often recognized. It is maintained by the dangerous use of words. We carelessly go from the "autonomous" machine to the "intelligent" machine, then to the "thinking" or "conscious" or "sensitive" machine and why not even the "romantic" machine (although to my knowledge no one, as yet, has dared to use the latter adjective). We may be astounded at the feat of Toyota's robot playing jazz on a trumpet, but we do need to remember that it "feels" nothing, that it has no "humanity" in its playing. We need to take note of our own transference: some of us have a strange affection for our car, but I don't think that the affection is mutual!

Let us bear in mind the image of the myth—and it is only an image, for even if the roboticist can identify with Hephaestus and can shape Pandora out of clay, he is neither Athena nor Geppetto. He will never give any humanity to clay or wood. A robot is a machine controlled by a computer; nothing else. Although animated, it remains and will remain an inanimate object without a *soul that becomes attached to our soul [and without] the power of love.*[6] Let us allow the demi-gods to talk, let us enjoy works by Fritz Lang and Mary Shelley, and let us not be afraid. But are we actually anxious? That is not so sure. In any case, our Japanese friends aren't, they who are so different from us; they for whom union is possible.

The question of the analogy between humans and humanoid robots is hazardous; it had to be answered. It is also fine and fascinating, provided we give it some rigorous substance.

An anthropomorphic system—the human or the humanoid robot—is a system that is both *redundant* and *under-actuated*. Let us clarify these two terms that have the advantage of being specialized and therefore not contaminated by common usage.

Take a human skeleton like the ones that used to be displayed in the biology classes of our schools. It is a set of tens of bones articulated to one another. Giving an angle value for the various joints amounts to defining the skeleton's posture: standing, sitting, running, grasping something in its hand, etc. With all these angles, we again find the notion of a configuration space. To animate its skeleton, the human body has several hundred muscles. They constitute the motor space. The tensions on the muscles cause the values of the joints to vary. The situation of current humanoid robots is simpler: a motor is linked to each articulation. The configuration space and the motor space combine. To grasp a ball on a table, the human and the humanoid robot have to move their hand towards the ball. From a geometric point of view, this task is three-dimensional: three parameters are necessary to situate the ball in space. The robot has about thirty motors; humans have several hundred muscles. That is too many. There is a wide gap between the dimension of the task and the dimension of the motor space. This gap allows for

[6]Allusion to Alphonse de Lamartine's poem "Milly ou la terre natale": "… objets inanimés, avez vous donc une âme// qui s'attache à notre âme et la force d'aimer?".

countless ways of attaining the goal: one can use the right hand or the left hand; one can scratch one's head with one hand and grasp the ball with the other; if the ball is on the ground, one can grasp it by bending one's knees or not, depending on what one feels like and how supple one is. A system is redundant when the dimensions of its motor space are greater than those of the task to perform. The notion of redundancy is linked to that of action.

An anthropomorphic system is also under-actuated. This characteristic relates to the system's motion in its environment. The angular parameters of the skeleton mentioned above correspond to the skeleton's posture, not its position in the environment (is it close to the blackboard or at the back of the lecture room?). The system therefore has to be placed in its environment: six parameters are enough, as we have seen. The space of the configurations of an anthropomorphic system is thus composed of the articular variables of the skeleton and the six position parameters.[7] No muscle, no motor is in charge of directly varying the position parameters. It is in this sense that the system is said to be *under-actuated*.

If there is one technological feat that humans have accomplished, it has been the invention of the wheel. A disc turning in a vertical plane, placed on a horizontal plane, starts to roll. The centre of the disc moves forwards. The wheel is "specialized" in moving. While moving about is the privilege of life forms (at least at first view), surprisingly nature did not invent the wheel. The sentence "an anthropomorphic system is under-actuated" means that it does not have motors specialized in motion: humans move about by putting one foot in front of the other and then starting again, that is, by varying the articulations in their skeleton, and therefore by activating a large number of muscles, when two wheels would have been enough. Anthropomorphic locomotion is a far more "complex" task than driving a car: it involves far more motor variables than does driving.

How do all the muscles of the human body coordinate to perform the task of grasping something? How can all the motors of a humanoid robot be coordinated to perform the same task? What trajectory does an individual take to leave a room? How can the trajectory of a humanoid robot be calculated in the same situation? The questions are precise. While some seek to *understand* and others to *do*, the formulation that we have introduced shows that they are of the same nature. They question the relationship between the motor space and the physical space. This relationship is a key to understanding our relations to the world. Henri Poincaré set the terms [17]. That is where the power of mathematics lies, in proposing a formulation common to science and techniques, and it is this foundation that is contributing today to the emergence of new fields such as neuro-robotics.

If all the angular variables of a skeleton are known, it is easy to infer the position of the left hand in space: there is only one. The converse is not true. If you know the position of the left hand in space, there is an infinity of angular variables of the skeleton that give the same position of the hand (the skeleton is redundant).

[7]It may seem strange to consider six parameters, but all six are indeed needed to situate an astronaut floating in a space shuttle. In everyday life, however, the human being is not a body "floating" in space. He or she moves about on a surface, and three parameters are enough to pinpoint him or her.

They will correspond to an infinity of postures, some of which may be unrealistic. Other criteria are therefore needed to make the selection. Among all the possible positions, you can ask for the most comfortable one, that is, the one that corresponds to the least effort—effort being expressed in the motor space, as the sum of all the forces exerted on the muscles. In this case, an algorithm of numeric optimization will lead to the selection of the best posture. The method applies to redundant systems but does not account for under-actuation. It allows for the grasping of a ball, provided there is no walking. We recently lifted the restriction using a trick in modelling [18]: the under-actuated locomotory system is represented in the form of a virtual manipulator arm consisting of the imprints of steps which can fold like an accordion. We thereby artificially add redundancy to the system, and the general method can apply. An optimization algorithm is thus able to select a motion and coordinate the 30 motors of the HRP2 robot so that it can pick up a ball lying at its feet. In order to do so, the robot has to reverse. No specific locomotion program has specified this. The few backward steps that the robot takes to free the ball are an integral part of the data inputting task. Its entire body contributes to that.

I mentioned earlier that *doing* can provide instruments for *understanding*. Here is a fine example. On the basis of the principles that we have just seen and that he contributed to developing [19], Yoshi Nakamura of Tokyo University recently developed a method enabling one to "see" the state of tension of all the muscles of a human being, based only on the observation of their movements. A set of cameras identify the position of the segments of the body in the surrounding space. They are coupled to a platform which constantly situates the pressure points of the subject on the ground. That is all. Could Etienne-Jules Marey, who invented chronophotography with the same aim of observing and understanding human motion, have conceived of that? Note that this is a technique which enables us to see the muscular system inside the body on the sole basis of the visual observation of its outside. There is no need for X-rays or scanners; the mathematical model is enough: simple, effective and cheap. The technique is based solely on the control of the function that links up the space of the task and the motor space. Henri Poincaré would have saluted the invention.

The principle of optimality underlying the study of relations between the motor space and the action space could not fail to resonate with the same principles studied in neurophysiology. If the brain—and the nervous system as a whole—has several hundred muscles to control the hand that is about to grasp an object, how does it go about dealing with this extraordinary complexity? The answer is "simple": evolution has established principles of muscular synergy, a form of automation that coordinates a set of muscles through a small number of parameters [20]. Even if in the end the motion takes place in very large spaces (motor space and configuration space), studies show that the choice[8] is made in smaller sub-spaces which are consequences of coupling (when one walks, the right arm moves with the left leg) and principles of optimality. They reduce the dimension of the spaces to

[8]Mechanics talk of "degrees of freedom", a fine expression in this context.

explore. The identification of this coupling and these principles is currently a key theme in computational neurosciences. A pioneer in the domain, Alain Berthoz, has found an apt name for the theory underpinning all this: "simplexity" [21], a combination of these principles that life forms have invented to face world complexity. Together, and in collaboration with our colleague specialized in numerical optimization, Katja Mombaur, we have brought to light the principles that led up to the formation of locomotory trajectories. Take the following example: you enter a very big empty space (a shopping mall) that you have to cross through to get out (by a door). The space is vast. You are going to follow a trajectory and you think that it is yours. We have shown that everyone will actually follow very much the same trajectory. Our behaviour is stereotyped. It follows a principle that expresses a subtle combination between the comfort of movement, which leads one to anticipate the final goal to attain (being in front of the exit), and anchorage of the gaze on the door. The difficulty is to find this principle,[9] but once it has been found, it is very easy to implement it in a robot. That is how the humanoid robot HRP2 takes the same trajectories as those that we will use in its place.

The roboticist benefits from the principles governing the autonomy of life forms, while contributing to their study.

Was it *necessary* to do all that to get the HRP2 robot to work? The answer is no. Other robots use other approaches which are equally admissible from the point of view of the result.

But let us examine more closely the approach of today's humanoid robots. Most of them have flat feet and walk with bent legs.[10] This lack of suppleness is a consequence of the long process that led to their design. The main challenge of biped locomotion is balance. On a flat surface, flat feet form a support polygon. Provided that its centre of mass is above this polygon, the robot can remain perfectly immobile; it won't fall even if it is bumped slightly. Designing a method of locomotion based on this principle ensures that at every moment the centre of mass is projected evenly on the polygon, the support of the two feet. Walking is then slow and laborious. It is necessary to *do* better. A clever model of stability was introduced in 2003 by Shuuji Kajita at the Japanese institute AIST [22], based on an idea introduced 30 years earlier by Miomir Vukobratović [23]: all forces of reaction exerted by a flat floor on the surface of a body in contact with it can be reduced to the force

[9]To that end we devised a resolution paradigm: the inverse optimum control. Usually, the engineer is faced with the following problem: given a system that has to be led to a desired state, and given a cost to optimize, what is the best strategy to apply? This is a problem of optimum control. In our case the problem is the opposite in so far as we observe a natural phenomenon and wonder which principle of optimality it obeys. The postulate of the existence of a principle of optimality may be questionable (it could be discussed in a future seminar), but at least it offers the roboticist an operational approach, and the neurophysiologist an angle of approach that establishes his/her own methods of validation. These studies resemble the methods of automatic identification and automatic learning in artificial intelligence.

[10]This is not the case of surprising biped machines (or even single—legged ones!) developed by Marc Raibert at MIT from the 1980s. His work produced the quadruped robots mentioned in the introduction. It was only very recently that he launched Petman, a new project for a humanoid robot.

exerted on a point called the *centre of pressure*. To ensure that the robot does not fall, it is enough for the point to remain above the support polygon. Force sensors to measure the effort placed under the robot's feet show the position of the centre of pressure at any point in time. Controlling the robot then consists in playing on the modification of the centre of mass, to ensure that the centre of pressure remains in the support polygon. The centre of mass no longer needs to verify the same constraint. The robot's walk is more fluid. Conceptually, the innovation is based on an approach to anthropomorphic walking that starts from the feet. It nevertheless requires the robot to have flat feet and to plan the position of its feet in advance.

Intuition suggests that we don't walk like that…

Neurophysiologists have a radically different approach: nature shows that bipeds walk with their head, not their feet! What does this provocative statement mean? In brief: the method of control referred to above is based on observation of the centre of pressure exerted by a person's feet on the ground (the information is given by sensors measuring effort, placed under the robot's feet). But neurophysiology teaches us that (living) bipeds stabilize their head in rotation in the sagittal plane [24]. The reference framework at the origin of the control of locomotion is in the head (the information is given by the vestibular system). Locomotion has to be envisaged as a process starting from the eyes and going towards the feet, and not the opposite. A robot will walk like a human only if it has an articulated head containing sensors capturing data on the position of its body (inertial units and other accelerometers). The design of the biped robot therefore has to integrate a complete body: it should not be designed step by step, first the legs, then the trunk, the arms and the head, as is often the case. The head is not only there to carry two cameras and to give a human appearance to the robot; it is an essential condition for the stabilization of the living biped's locomotion. It is a possible condition for the stabilization of the locomotion of humanoid robots.

The message is clear. The principle has been discovered; the roboticist just has to invent it. It is not enough to say; one also has to do. Moreover, the child him-/herself has to "invent" it over a long learning period. What are the mechanisms driving this learning? That is a question concerning neurophysiologists, psychophysicists and roboticists alike, and which fuels the fertile tension. Dialogue is possible: the probabilistic models, for example, are there to describe the processes. Markov chains and Bayesian inference enable us to structure and to explore very large databases in huge spaces. They also benefit from technological progress in computational power. The fact remains however that, even if the correlation between two variables enables roboticists to stabilize their robots, it says nothing about the causal relations. In any case, they pay little attention to that, condemned as they are to *doing*. And if they can invent a method that can do without this learning phase, so much the better.[11] I am deliberately over-stressing the point: we never protect ourselves enough from "dangerous analogies".

[11]We have seen that roboticists are capable of finding a method for driving a car. Whereas humans have to learn to drive, the models developed in robotics free the mobile robot of any learning phase. The equations of the motion of a car are known and mastered. Yet there is no point in humans knowing these equations; they still have to learn to drive.

The past millennium ended with spectacular breakthroughs in information technology. The present one started with the robotics revolution. It is no longer simply a matter of manipulating data; now "things" are starting to move.

Manufacturing robotics discreetly imposed itself during the years of growth, without it really being held up as a factor of progress. Today, other adjectives qualify it, in a proliferation that I mentioned in the introduction: robotics is medical, personal, agrarian, sub-marine, aeronautic, spatial and military; it provides assistance and is used in exploration; it opens many routes for art development as evidenced in this book. Highly versatile, robotics is a flagship of technology today. We are expecting a great deal from it.

Since 2006 the Japanese Information and Robot Technology Programme has seen robotics as a means to address the question of the inversion of the age pyramid. Robot assistants are going to share our daily lives. They facilitate the mobility of elderly persons and provide the security for them to remain in their own home. Three years ago the US government launched the National Robotics Initiative, to which it allocated an annual grant of 70 million dollars. The aim is to develop robots capable of working in close collaboration with humans, in the manufacturing as well as medical, spatial and personal help fields. These programmes, bringing together public authorities, industrial firms, universities and research institutes, mark a turning point and a new awareness that robots can leave the confines of their factories to work with humans and serve them. Humans thus become an integral part of the robot's environment.

As in surgical robotics, where models of deformation of the heart muscle are needed to automatically control the position of a clamp on a beating heart, reasoning in a world in which humans are stakeholders requires models of humans. The human-robot relationship is now a central theme in robotics research. Alone it justifies—as if it were necessary—the multi-disciplinary researches mentioned above.

These researches are indispensable, but insufficient. Questions of security in robots' physical interaction with humans are crucial. They transcend issues of security and reliability of algorithms and programmes as they are usually addressed in computing. They concern the design of new, more compliant motors, new, more flexible materials, and new, smaller and more precise sensors. The spectrum is wide: from micro- (even nano-) technologies to questions on the computational foundations of anthropomorphic action. The ambition is huge.

The world is surprised that no robot effectively intervened in the Fukushima nuclear plant. Actually, the intervention robots that make the headlines of our newspapers are still far from being operational. In response to a message of solidarity that I had sent him, Yoshi Nakamura wrote to me on 20 March 2011, saying: "Many robotics researchers including me were shocked by the fact that we have no weapon against the difficulty. Even engineering may have shown its immaturity." (sic). This statement is dreadful, coming from one of the world's leading roboticists.

We need to be wary of hype. Research needs time. Innovation must of course be stimulated (that is the role of large programmes) but it is difficult to control.

Fig. 2 The finding of Erichthonius, Pierre Paul Rubens (circa 1616) © LIECHTENSTEIN. The Princely Collections, Vaduz-Vienna

It often appears where it is least expected; we have seen many examples of this, especially in information technology. What can be said about Nao, the small robots that educational teams use today to help autistic children? No "order" was put through, yet what a fine bit of innovation if a little machine communicating by voice and movement can help these children out of their isolation, at least partially. Recent years have shown that it is difficult to predict the impact of technological progress. Steve Jobs did not meet needs; he created needs that have become essential today, yet which we did without yesterday. That is where his genius lies.

As regards robotics, its impact is going to affect many sectors; we have listed the most probable. How are we going to adapt? Easily. Humans are highly adaptable to new technologies. The wheel led us to tar our landscapes and we find it difficult to switch off our mobile phones. Technological innovation is always a death sentence for a certain know-how *(savoir faire)* and for certain social conventions *(savoir vivre)*. In this sense, robotics should also prompt us to ask ourselves certain questions. The roboticist can tell us what it is about—and that is what I have endeavoured to do—but unfortunately nothing more. Faced with Athena, he is the eternal one who limps. He has nothing to say on what he *knows* about civilization; he only knows how to *do*[12]!

Let us conclude Apollodorus' text. The episode ends as follows:

As [Athena] was fleeing, Erichtonius came to birth from the seed that had fallen on the earth.[13]

Erichthonius was one of the first kings of Athens (Fig. 2). That is no minor detail. So, the attempt to possess was not sterile! That is clearly what we have seen: it is already transforming our lifestyles.

[12]Does what applies to the roboticist also apply to the citizen robotics researcher? I think it does, but I must admit that this is where I reach uncertain shores of my reference to mythology.

[13]Hard, op. cit.

References

1. Stokes DE (1997) Pasteur's quadrant—basic science and technological innovation. Brookings Institution Press
2. Hard R (1997) The library of greek mythology/apollodorus. Oxford University Press, Oxford, p 132
3. Brooks RA (1991) Intelligence without representation. Artif Intell 47:139–159. doi:10.1016/0004-3702(91)90053-M
4. Ijspeert AJ, Crespi A, Ryczko R, Cabelguen JM (2007) From swimming to walking with a salamander robot driven by a spinal cord model. Science 315(5817):1416–1420. doi:10.1126/science.1138353
5. Ruffier F, Franceschini N (2005) Optic flow regulation: the key to aircraft automatic guidance. Robot Auton Syst 50(4):177–194. doi:10.1016/j.robot.2004.09.016
6. Khatib O, Siciliano B (eds) (2008) Springer Handbook of Robotics. Springer
7. Lozano-Pérez T (1983) Spatial planning: a configuration space approach. IEEE Trans Comput C-32(2):108–120. doi: 10.1109/TC.1983.1676196
8. Schwartz JT, Sharir M, On the 'piano movers' problem II: general techniques for computing topological properties of real algebraic manifolds. Adv Appl Math 4(1):298–351. doi: 10.1016/0196-8858(83)90014-3
9. Barraquand J, Latombe JC (1991) Robot motion planning: a distributed representation approach. Int J Robot Res 10(6):628–649. doi:10.1177/027836499101000604
10. Khatib O (1986) Real-time obstacle avoidance for manipulators and mobile robots. Int J Robot Res 5(1):90–98. doi:10.1177/027836498600500106
11. Kavraki LE, Svestka P, Latombe JC, Overmars MH (1996) Probabilistic roadmaps for path planning in high-dimensional configuration spaces. IEEE Trans Robot Autom 12(4):566–580. doi:10.1109/70.508439
12. Siméon T, Laumond JP, Lamiraux F (2001) Move3D: a generic platform for path planning. In: Proceedings of 4th international symposium on assembly and task planning
13. Laumond JP (2006) A success story of motion planning algorithms. IEEE Robot Autom Mag 13(2)
14. Li Z, Canny JF (eds) (1993) Nonholonomic motion planning. Kluwer Academic Publishers
15. Risler JJ, Luca F (1994) The maximum of the degree of nonholonomy for the car with n trailers. In: Proceedings of the IFAC symposium on robot control. doi:10.1.1.48.2332
16. Brooks R (2008) I, rodney brooks, am a robot. IEEE Spectr 45(6):62–67
17. Poincaré H (1895) L'espace et la géométrie. Revue de métaphysique et de morale 3:631–646
18. Kanoun O, Laumond JP, Yoshida E (2011) Planning foot placements for a humanoid robot: a problem of inverse kinematics. Int J Robot Res 30(4):476–485. doi:10.1177/0278364910371238
19. Nakamura Y (1991) Advanced robotics: redundancy and optimization. Addison-Wesley Longman Publishing Co, Boston
20. Bernstein N (1967) The coordination and regulation of movements. Pergamon Press, Oxford
21. Berthoz A (2012) Simplexity. Yale University Press
22. Kajita S et al (2003) Biped walking pattern generation by using preview control of zero-moment point. In: Proceedings of IEEE international conference on robotics and automation, vol 2, pp 1620–1626. doi: 10.1109/ROBOT.2003.1241826
23. Vukobratović M, Stepanenko J (1972) On the stability of anthropomorphic systems. Math Biosci 15:1–37. doi:10.1016/0025-5564(72)90061-2
24. Berthoz A (2000) The Brain's Sense of Movement. Harvard University Press

Part III
Otherness

Embracing Interdependencies: Machines, Humans and Non-humans

Amy M. Youngs

Abstract As a creator of interactive, constructed ecosystems, I discuss my artistic practice as a way to experience self as interdependent and to re-engineer relationships between humans and other species. Technologically enhanced mirroring, participation, re-programmed elements and designing for non-humans are examined as techniques that entangle the audience within the fabricated systems. Re-configuring the human participant as one element enmeshed within a system that equally includes technology, industry, waste streams and other living things, I work towards new models of collaboration and shared world building.

Troubling the Anthropocene

Scientists and environmentalists have recently announced that we now live in the time of the Anthropocene. [1] Following the Holocene, this new epoch is human-dominated and characterized by our species' industrious progress on the earth eclipsing everything else. Blanketed by anthropogenic carbon dioxide and methane gas, we live in cities programmed by swathes of pavement, park grass, and Miracle Gro, and we experience almost nothing that is not human-made or controlled. We feel our power as humans, creating the landscape, eating animals hidden inside of fluffy buns, and spinning the world into our gold. Why work when we can harness, and then hygienically disguise, the labor of bacteria, plants, insects and animals? Speaking of cheese, why milk cows when we can program robots to do it for us? Why even bother with thoughts of messy cows, when our delicious cheese can be purchased from every grocery store wrapped in plastic with a cartoon farm on the label?

A.M. Youngs (✉)
Department of Art, The Ohio State University, 258 Hopkins Hall,
128 N. Oval Mall, Columbus, OH 43210, USA
e-mail: youngs.6@osu.edu

© Springer Science+Business Media Singapore 2016 89
D. Herath et al. (eds.), *Robots and Art*, Cognitive Science and Technology,
DOI 10.1007/978-981-10-0321-9_6

My ancestors have programmed the world to meet the desires of my species. I no longer need to think about myself as part of the ecosystem, because it is presented as a machine designed to serve me. When the non-human parts of the environment "out there" change, or cease to keep up with the pace of human consumption and waste, my smart species engineers new methods to optimize the nature machine. I can all too easily assume that my species is superior, with our big brains and ideal hands that enable us to make technological systems that harvest, mine, extract, reassemble and deliver the environment to us.

In this fantasy of human self-reliance, humans are allowed to exist as separate from a nature that is "out there", even as we eclipse it. While we do appreciate our imagined, separate nature—evidenced in vacation visits, sublime paintings and photographs, and reverent utterances about how nature knows best—this kind of romanticizing has allowed us to mentally disassociate from it. That our human bodies are intimately connected with, and reliant upon, an infrastructure that includes dirt, plankton, metal, stars, electricity, server farms and algorithms is almost unfathomable.

As an artist, my process has led me to explore and experiment with, that part of my body that extends beyond my skin. I share the optimistic view described by author Jane Bennett that, when one refigures humans and all of the non-human world into a shared status, "…it can inspire a greater sense of the extent to which all bodies are kin in the sense of inextricably enmeshed in a dense network of relations. And in a knotted world of vibrant matter, to harm one section of the web may very well be to harm oneself" [2]. Believing in a world that pretends to be cleanly divided between "natural" and "not-natural" it is difficult to see where we fit. And it is even more challenging to experience ourselves as interdependent, intermeshed, and fully entangled with all parts of it. The trouble with the Anthropocene concept is that it perpetuates the myth that humans are separate, outside of, and a dominating force over everything non-human. Some humans may experience feelings of guilt over the subjugation of this perceived "nature" and for others it may create a sense of paternalism. I believe that neither is a productive stance from which to create a collaborative working relationship with the non-human environment.

How can I, individual human, see and feel myself as a part of the world? In pursuit of this question, my creative practice over the last 16 years has been to construct situations that make the interwoven connections between human and non-human visible and *sensible*. To challenge traditional notions of what we think of as natural and our human place in it, I embrace technology as a part of the ecosystem and work with it in ways that render human interdependencies into palpable experiences. Through the process of re-assembly, re-wiring and re-presentation of partially mechanized ecosystems, I place myself, and other humans, into relationships that require participation. Immersed within interactive artworks, or in domestic-scale ecosystems that include machines, plants or animals, the human experiences self as a mutually dependent being, intermeshing and intermingling with the non-human parts.

Seeing Self in the Machine

My interest in interactive and embodied art forms comes from my early influences in the San Francisco Bay area art scene of the 1990s, which included the fire-breathing, uncontrolled robotic spectacles of Survival Research Laboratories, the delicate, fish-driven robots of Ken Rinaldo, the anthropomorphic video robots of Alan Rath and some of the earliest interactive video works by Lynn Hershman Leeson and Jim Campbell. As a young artist, I was immersed in the early examples of a new form of art recently made accessible with the surplus of microchips and sensors coming out of Silicon Valley. Interactive art was, at that time a radical new form that addressed its audience so entirely differently, it called for a new name. The audience was no longer a "viewer" or a "spectator" but was instead, a "participant" or "viewer-participant". In this new role, we were included in an unfolding dialogue taking place in the interaction between the artist, materials, culture and machines. At last, the vision of a "systems aesthetic" written about by Jack Burnham in 1968, was emerging [3].

The desire to see oneself reflected in the world extends into technology. When I worked at the San Francisco Exploratorium in the 1990s, I observed that visitors were especially interested in seeing their own images and voices reflected back to them in the technologically enhanced exhibits. This museum of science, art and human perception was for me, an excellent hands-on education in interactivity and audiences. Spending time with visitors and exhibits as an "explainer" put me in conversation with people who were learning about the connections between the world and their bodies, *with* their bodies. Technology, along with well-crafted situations, provides a way for us to step outside of our bodies and look back. While similar to the experience of seeing oneself in a mirror, techno-mediated situations allow us to go beyond the common reflection. Many of the exhibits at the Exploratorium, especially those that were invented by artists, push our bodies into new mirror-like situations where we become remapped, reprocessed, hybridized, and abstracted. Like many mirrors, these often flatter us, while at the same time they turn us into interesting aliens. Given an intuitive interface, the technology does not alienate, it integrates and becomes a part of one's vision of self. The perennial favorite of the many visitors who volunteered this information to me, was *Recollections,* an exhibit made in 1981 by artist-in-residence Ed Tannenbaum (Fig. 1). This interactive video wall captures and re-images the participant's body in a rainbow series of real time and past time silhouettes, each stacking up to create a new sense of the body that reveals the self as an expanded form that includes past and present as one. On a recent visit to the Exploratorium, I was not surprised to see that this piece remains on permanent display, even after the entire museum has moved to a new location. Though the technology in this piece is rudimentary by today's standards of interactive video, the power of this sensation of self, reflected in technology in real time, is undeniable.

Fig. 1 *Recollections* 1981, by Ed Tannenbaum. Permanent collection of the Exploratorium, San Francisco, CA. Photo by Amy M. Youngs 2013

Vulnerability, Re-engineered

Humanoid robots are a powerful reflection of self in technology, but they also carry a sense of their own identity as a frightening, or corny, popular culture being. Donna Haraway's text, "A Cyborg Manifesto", influenced my thinking around the potential of the cyborg to create destabilized, yet powerful, identities. As semi-autonomous, semi-human, semi-gendered, semi-living bodies, they open the possibilities, "of reconstructing the boundaries of daily life, in partial connection with others, in communication with all of our parts" [4]. I embraced the new feminism of strange kinships suggested by this seminal text and found that her boundary transgressing cyborgs were directly applicable to my work as an artist. When designing my first robotic artwork in 1999, I chose to work in the human scale and upright structure, but in the location where the head would normally be, I placed a plant (Fig. 2). The elevation of a plant brings it into our body scale to give it a sense of presence in the human world. I designed and built a responsive, robotic body apparatus around it, to provide a sense of movement that related to human time scales rather than what we expect of plants. The movements of the robot mirrored the movements of the human participant, offering that satisfying sensation; the recognition of self reflected in technology. The plant at the head of the robot however, puts it into the role as active, controlling agent. It might at first appear to be the "natural" player in the situation, but this is not an organism that is untouched by humankind. In fact this is an organism that has been altered—*engineered*—by humans so that it lacks its protective spines and is therefore, easier to eat, feed to livestock, and integrate into our domestic landscape as a prickle-free element. Because the *Spineless Opuntia* is an economically valuable plant, we

Fig. 2 *Rearming the
Spineless Opuntia* 1999, by
Amy M. Youngs. Photo,
Amy M. Youngs

clone, cultivate and protect it, creating a variety that is dependent on us. In my sculpture, *Rearming the Spineless Opuntia*, the vulnerable cactus appears to have gained a technological apparatus designed to protect it when humans approach (Fig. 3). Moving in specific, dynamic relationship to the distance of the human the techno-armored cactus-borg is clearly responding to the human. In this interactive situation the human participant is cast as an aggressor—and possibly as a defendant needing to avoid the very sharp metal spikes—while the cactus is cast as a motivated, sensing being working in partnership with its technological skin.

The relationship is further complicated as the robotic armature openly displays its nest of wiring, microcontroller board, clunky-clicking relay, worm-drive motor and brass mechanics. Revealing the human hand, this cyborg was built on my hybrid knowledge of jewelry-making techniques, do-it-yourself circuitry, hacking, and my novice's grasp of welding and computer programming. The spew of wires ends up at a plug in the wall, reminding us of the possibility of unplugging our human-made technologies from the human-made infrastructure of electric wires that deliver the power that we, in collaboration with our machines, have extracted from the land. The waterfalls and coal that have been harnessed as energy are being conscripted as actors in this situation of programmed computer chips and mined metals. As the creators of technology, humankind is reinserted back into

Fig. 3 *Rearming the
Spineless Opuntia*, detail
1999, by Amy M. Youngs.
Photo, Amy M. Youngs

the relationship and we see ourselves again acknowledged by the technological
infrastructure, this time programmed by us to protect a human-altered plant. The
roles are meant to slip and the categories are meant to perforate within the space
of interaction. The re-programmability of robotic elements assert the possibility
for technological remediation, or a re-engineering of the relationships between
humans and other species.

Constructed Ecosystems

In the opening chapter of **The Politics of the Impure**, Joke Brouwer, Arjen
Mulder, and Lars Spuybrock, write: "Technology has become our new nature. We
are fully surrounded by and enmeshed in it. It is beginning to form a new envi-
ronment, and it is a constant supplier of accident and event" [5]. In this fertile

ground, technology is no longer thought of as a rational, controllable element. We are subjected to the environment that technology has created, perhaps similar to the way we once felt subjected to what we used to call "wilderness" or "acts of God". We are in it, not necessarily in control of it. We program it, harvest it, enjoy certain parts, battle other parts with machines, manpower, and brainpower still, we are not in control. In our entanglements, none of us remain pure, but all of us remain reliant on each other. Despite the clever marketing campaigns designed to sell products and services, we are not going "back to nature". We have never left it. We also cannot use technology to simply devour the non-human, or to simply protect it, or ourselves from it. We are interdependent. Yet, my everyday experience does not allow me to feel this as a reality. My food and waste streams have visible ports (stores and trashcans) that imperceptibly connect to complex industrial-techno-natural streams. Reading about the radically intimate mesh of interconnections between everything, described by Timothy Morton in **The Ecological Thought**, has me yearning to *feel* it. Yet, with no center, no edges and no scale, it is too infinite for me to sense.

> All life forms are the mesh, and so are all dead ones, as are their habitats, which are also made up of living and nonliving beings. We know even more now about how life forms have shaped Earth (think of oil, of oxygen–the first climate change cataclysm). We drive around using crushed dinosaur parts. Iron is mostly a by-product of bacterial metabolism. So is oxygen. Mountains can be made of shells and fossilized bacteria [6].

The construction of human-scaled models is how I feel myself in the mesh. A miniaturized, semi-automated ecosystem was developed in collaboration with my partner and fellow artist, Ken Rinaldo. Together, we made multiple versions of our *Farm Fountain* project (2007–2013), each one based on the technique of aquaponics, where the waste from living fish circulates through a medium rich with nitrifying bacteria that feeds the roots of edible plants, which cleanse the water before recycling it back to the fish (Fig. 4). This was not a back-to-the-land project, rather, we embraced technology to build and run it and we worked in the indoor space of our urban home. We also did not imagine we were going off-grid or preparing for a catastrophe, though we certainly encountered those interest groups when doing research into aquaponics. What motivated us was a desire to develop a method for growing, knowing and living with our food in an aesthetic and practical system that could become an open source model for others to copy and build upon. At the time we created it, there were only a few commercial aquaponics systems available and only one helpful DIY project posted online. The *Barrel-ponics* project [7] created by aquaponics farmer Travis W. Hughey was influential in that it clearly described system techniques and creatively utilized repurposed plastic containers, but it did not share our interest in the placement of such a system inside the home. Our *Farm Fountain* was unique in its design to fit, both aesthetically and physically, into a vertical space in front of a window. We also developed a microcontroller-based timer system that would allow us to program and fine-tune the circulation of water and lighting cycles. That our system functioned as useful, food producer meant that the categories of art and design were used interchangeably to describe it. While the functional, designed elements

Fig. 4 *Farm Fountain* 2007–2013, by Ken Rinaldo and Amy M. Youngs. Photo, Amy M. Youngs

of the system were important to us—and to the other living things—I found that living within the system and thinking about it as an artistic pursuit allowed me to develop a more nuanced sense of the meaning of "function".

Living with this project was a sometimes thrilling, and other times frustrating experiment in interdependence. It ran continuously for 6 years and in this time we experienced an intimate connection to the many delicious meals of tilapia fish and salads grown in our system. We also experienced the annoyance of flooding, gnat infestations, the tragedy of accidental plant and fish deaths, and the painfully difficult process of catching and killing fish to eat. One of the most surprising lessons was that the system required so much maintenance. We could control the automated cycles with our electronics, we could telepresently view it from anywhere with an internet connection and the bacterial-plant-fish circulating parts of the system worked in beautiful balance together most of the time; but we had not anticipated the ongoing human labor of cleaning pumps and tubing, managing pests, clearing plant debris, sowing new seedlings and keeping up with harvesting.

Fig. 5 The author, tending to *Farm Fountain* 2007–2013, by Ken Rinaldo and Amy M. Youngs.
Photo, Ken Rinaldo

Though it took more time than expected, the process was mostly enjoyable for me, since I derived so much pleasure from spending time with the system, watching the fish, immersed in the sounds of trickling water, noticing the plants develop, grazing on a cherry tomato and, most of all, bathing in the glistening blue and red LED grow lighting bouncing off of the surfaces of aluminum, plastic, plants, water, fish, and my own skin (Fig. 5). It was a mood improvement device for me, a pleasurable sensation of the mesh, and I found that I was especially drawn to spending time with it during the dark days of winter.

The food produced in *Farm Fountain* was delicious and it was certainly part of the pleasure of the system, but as a food producer it could not compete with a visit to the local farmers market. Over time, I realized that the management of the system towards crop productivity was uninteresting to me. The questions around the meaning of productivity were intriguing though—for whom or, for what? Many aquaponics farmers skew their systems towards favorable conditions for the productivity of one crop. Some focus on fish production, stocking them densely, adjusting the pH and temperatures for them and using the plants as expendable nutrient absorbers. Others focus on a plant-based crop and use the fish as nutrient producers for the health of the plants. We tuned our system for an overall, easy-going balance because we were not so concerned with high harvesting yields. We saw ourselves in the loop of the system, as the laborers, harvesters, eaters and aesthetic appreciators needed to keep the system going. There were times I felt I was the main beneficiary of the system, and other times I felt enslaved to it, but I always felt integrated with it. Even after dismantling the *Farm Fountain* struc-ture, some of the organisms in the system live on as part of our own bodies and

others have gone on to populate the new ecosystem experiments that Ken and I have each continued to pursue.

The roles that each organism plays in the miniature ecosystem are not necessarily fixed and can be engaged differently through new arrangements, timing, location and species. As I became more interested in the horizontal leveling of the role of the human in the system, I realized that I needed to eliminate the killing and eating of fish. Even though this was always done in private, the specter of such an event became a focus that tended to place the human in the role as a killer and eater, which downplayed our roles as interdependent tenders of the system. In the subsequent ecosystem artworks I created, I sought to blur the boundaries of who should be doing what in an ecosystem. I constructed a less formal system in order to explore the potentials in shifting the players and to increase the visibility of the streams of waste and energy in and amongst the food. Like the *Farm Fountain*, the system was cybernetic in the sense that it set up dynamic interactions between the human, animal, environmental and mechanical systems that each relied on feedback and adjustment loops. Human interaction was one among many dynamic elements that communicated and controlled the overall system.

In my next project, *River Construct* (Fig. 6), I worked with the overall model of a river—which is alternately fed and cleansed by a variety of organisms along

Fig. 6 *River Construct* 2010 by Amy M. Youngs. Photo, Amy M. Youngs

its path—but the aesthetic was nothing of the sort. The artificial river I constructed flowed vertically, up and down a utility ladder, feeding and watering lettuces and herbs in a succession of plastic buckets resting on the rungs. Like a river, the inputs to this watery system were sunlight and organic waste. In the case of this mini model, a single rabbit lived by the "river" in his playpen, and two buckets of worms lived in line with the flow of the water. Left-over human food scraps, old newspapers and rabbit manure were fed into buckets containing worms, who, along with bacteria, converted the waste into nutrients that flowed through the water to the roots of the growing plants. Small guppies lived in the water basin, eating mosquito larvae and algae growing in the system. The sunlight from a window fed the growth of the plants and also charged a solar-powered battery that provided power for the system. This constructed river turned on and off intermittently, based on a timing cycle that was determined by the amount of sun available to charge the circuitry that powered the timer and pump system. The system's location at the Red Line gallery in Denver, Colorado during the summer provided enough sun to the battery to allow a timing cycle that turned the flow on for 1 min, every 45 min. The solar powered, electromechanical control elements were integrated into the system like the others—visible, yet not in full control, yet important to the overall workings of the system.

The aesthetic of this work came from utility, garage DIY, and hardware stores. The experimental, provisional nature of the system called for an openness in materials and structure. It was important that it be reconfigurable and reprogrammable. The power of the river metaphor, along with the physical presence of living plants and a rabbit, needed to be balanced with materials that are not generally thought of as part of nature: ladder, plastic tubing, buckets, fencing, toys, Ikea rugs, thrift store cook pots, wires, solar panels and control boxes. Embracing impurity and non-traditional aesthetics, the elements of a mass-industrial ecosystem joined forces to integrate with the biological ecosystem as literal support structure (Fig. 7).

Roles, Programmed and Transgressed

Each player in the system had a programmed, yet flexible role for interaction with the others inside of the ecosystem. The live rabbit was conceptually employed in this artwork as a way to point to the array of relationships humans share with other living things. Rabbits play a particularly broad range of roles, as they are wild, domestic and materially intermingled with us in a variety of ways: pets, food, food for pets, fur coats, lucky foot charms, magic trick partners, hunted game, entertainment and show specimens. In the case of the rabbit named Eddy, he began his life as a purebred, pedigreed Himalayan who was unsuccessful in his role as a show rabbit. I purchased him from a breeder for the "pet only" price of $15. His next role was as a manure producer for the *River Construct* artwork. He lived in a fenced in area next to the "river", where his manure was swept up by maintenance humans (gallery managers) and placed into the worm buckets for further

Fig. 7 *River Construct* 2010
by Amy M. Youngs. Photo,
Amy M. Youngs

processing (Fig. 8). When the exhibition ended, Eddy became a house pet. Even
in his role as a manure producer during the exhibition he did not act as expected.
He improvised, as living things do. His interest and affection for human visitors
did not surprise me (that he nipped one child was a bit unexpected), but I could
not have anticipated that he would leap out of the fenced area designed to keep
him out of the rest of the gallery. He freely visited with humans in the gallery
and he ate the low-lying food plants in the *River Construct* system, originally
programmed for the human visitors to eat. I was even more surprised to discover
that he would jump back into the enclosure to rest. The rabbit and the fence did
not work exactly as programmed, but they worked far better than expected for the
humans, who enjoyed the presence of the rabbit in the gallery. The plants he ate
might have a different perspective.

The worms also played an altered role. Their expected, terrestrial lifestyle was
reconfigured into a water-based system, where they were suspended in buckets.
This experimental arrangement keeps them healthy, provided the water has enough
oxygen, which was a function of the timing of the electro-mechanical circulation
system. Along with the bacteria, they successfully processed waste (rabbit manure,
human food waste and newspapers) into nutrients that flowed through the water

Fig. 8 *River Construct* 2010, by Amy M. Youngs. Detail of human role in waste processing. Photo, Amy M. Youngs

to the plant roots [8]. The worm colony multiplied, the plants thrived and so did the fruit flies. These uninvited guests to the ecosystem likely arrived when humans added old fruit scraps to the worm buckets. They did not affect the workings of the worms, rabbit, electronic control system or plants, but they were the undoing of the system because of how they affected the humans.

The humans who worked in the gallery were programmed with instructions to care for the rabbit, feed the worms, add water to the system and harvest the plants. The gallery visitors were programmed to pet the rabbit and to snack on the leaves of the plants. They went beyond their roles in many ways, picking up the rabbit, putting their children inside the pen with the rabbit (Fig. 9), trying to catch the guppies, etc., but the only real threat to the health of the system turned out to be the addition of the fruit flies at the same time a new gallery director began working there. One week before the show was to close, he ordered the worm buckets to be cut out of the system and put outside because he could not tolerate the fruit flies. Though this was disappointing to me personally (and it certainly affected the plants who lacked their nutrients and the worms who were subjected to an unfavorably hot outdoor climate), his action became a part of the overall system aesthetic that was a part of the work. Even in a miniature ecosystem, all parts cannot be controlled or anticipated and external forces come into play.

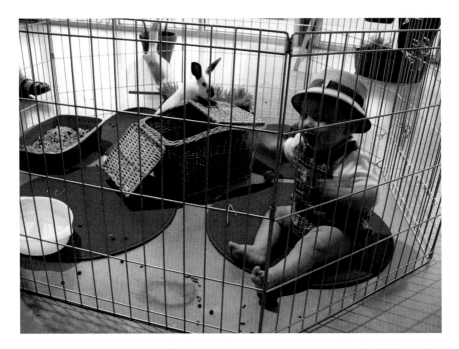

Fig. 9 *River Construct* 2010, by Amy M. Youngs. Detail of installation at the exhibition opening. Photo, Amy M. Youngs

Interfaces for New Relationships: Seeing Others Through Technology

"Play makes an opening. Play proposes" [9]. In **When Species Meet** Donna Haraway writes about her experiences at play with dogs, and she seriously engages play as an activity with the potential to connect us with non-human "others". Play can transcend language boundaries, produce shared meaning, and deepen relationships. It allows us to let our guard down and open up to something new. Taking non-humans others seriously as partners in a shared world is what is proposed.

I created the *Museum for Insects* project as an interface that allows humans to interact and play with non-human beings in the context of an art museum. It is a technologized, miniature museum space, outfitted with artwork designed to engage live crickets and humans and to provide a safe, open space to speculate about questions of aesthetics and communication. Telepresent technologies are used to re-scale the situation for each interacting agent and to provide methods for interaction that do not harm the crickets (Fig. 10). Can we know insects through electronic and artistic interfaces? Do they know us? Can they see our tiny images on their television screen? Can they experience art? Can we know something about self when we see ourselves seeing others through technology?

Fig. 10 Diagram of interaction, a sketch for the *Museum for Insects* 2013, by Amy M. Youngs

One way to get to know the House crickets, *Acheta domesticus*, is through the *Museum for Insects* website, where they greet human visitors with a written introduction, excerpted here:

Yes, you might think you know us as live bait or as food to be feed to pet lizards, frogs or snakes, but there is more to us than that. Did you know that we are domestic, like you? We like many of the foods you like (apples, cereals, carrots and leafy greens) and we like the comfort of warm, human homes. We prefer the indoor temperatures that you do – about 70 to 80 degrees is pretty nice, don't you agree? We also enjoy the safety of the indoors, since most of us are eaten by wild animals and lawnmowers when we escape to

the outdoors. If the cold does not kill us out there, and we escape the cats and birds, those wild crickets often eat us before we can get established. Like you, we choose the safety of the indoors most of the time. Yes, we are most often raised in boxes and fed processed foods and eventually die in unspeakable ways, but we enjoy a healthy population because we have found ways to be useful to your kind. Consider that there may be other ways you can interact with us - perhaps you might find it fascinating to watch our cute babies grow up, grow wings and learn to chirp? [10].

Writing in the voice of the crickets does run the risk of anthropomorphizing them in a way that might seem demeaning to their species. Yet, I would argue that humanizing them helps us begin to see them as worth knowing further. We are invited to see self in other. It is a start, not an end in itself. It is also a way to discuss our shared history and current shared world with these insects. House crickets are adapted to living in human domestic spaces. They are considered pests when they live in our homes uninvited, but they are also cultivated as an industry serving the pet market. They are offered for sale as live food for exotic lizards, snakes and tarantulas at most pet stores in the United States. We have each found uses for each other.

In the *Museum for Insects*, there are multiple methods and viewpoints from which one can try to "know" and become intimate with the "other" (Fig. 11). Technological interfaces are heavily integrated as organs of a system that attempts to change human viewpoints, disrupt a sense of self-certainty and approach a sense of empathy. Haraway uses the word *organs* to describe technological interfaces as a way to remind us of the inter-relationships we share with technology—we find uses for each other [11]. Borrowing from the contexts of surveillance and pornography, an interactive webcam is installed in the miniature museum as an eye that can give remote viewers an intimate way to get to know the crickets who live inside. They are not always visible, as the space offers hiding places, but much of the time their chirping sounds are audible, as the webcam transmits live sound with the image. From the view of the webcam the setting is quite convincing as a human scaled museum with a grand staircase, wood flooring, a museum bench and artworks installed. The crickets do not use any of it like we would though; they leave droppings on the floor, climb on the walls and sit under the bench. They do not conform to our anthropocentric space. Yet their appearance on the webcam, in scale with a human setting, does trick the human eye into momentarily seeing them as being suddenly large inside a world we relate to. As remote viewers, they cannot see us, but they can experience actions we trigger. We can enter their space through internet-enabled devices that allow us turn lights on and off, move a robotic cricket puppet left, right or center, and activate a cricket chirping sound or a human-composed audio art piece. These button choices are located below the live webcam image on an internet viewer's computer, so they can see the results of their choices enacted inside the museum in relation to the crickets. Seeing these actions in relation to the actions of the insects provides the viewer-participant a sense of play and possibility at a scale not usually experienced.

Though the remote viewer-participant appears to be in a powerful position, there is very little they can actually do. The crickets rarely appear to be "playing back" with the exception of occasionally moving toward the speaker when the cricket

Fig. 11 Webcam view of the *Museum for Insects* 2013–2014, by Amy M. Youngs. Exhibition installed in the museum is *Trans-Specie*s 2013, by Ken Rinaldo

chirp sound is activated, or riding on top of the moving cricket puppet. Because it is a technical hurdle, the crickets are not able to control symmetrical actions, such as turning off the lights or a moving a robotic human around in the remote viewer's space, but their chirp sounds and images do enter in. Sometimes, the remote viewer is subjected to the sounds and actions of the human viewers who are present in the same location as the physical museum. Their giant heads appear in a window in view of the webcam and their enormous fingers tap on the glass, causing an explosive sound inside the miniature space that is also transmitted through the webcam and broadcast to the remote viewers' computers. In this shared experience with the crickets perhaps the remote viewer knows what it is like to be an animal in an aquarium when humans are trying to communicate in a rudimentary fashion. The humans who lick the glass window and talk to the crickets in the *Museum for Insects* do demonstrate that there are many interesting ways to interact.

People visiting the *Beyond Human* exhibition located at Peabody Essex Museum in Salem, Massachusetts from October 2013 to September 2014 were able to see the live crickets inside the physical *Museum for Insects* when they peered through a window on the side of a wooden shipping crate on display (Fig. 12). Their view is opposite the webcam view, but it is not more privileged, as they are unaware of the webcam viewer watching them and they are not presented with control buttons to activate the lights, puppet or sounds. Different again, is the view from a computer screen kiosk located across the room in the exhibition. The kiosk viewer can see the webcam view and is allowed operate a computer mouse, which controls the pan, tilt and zoom functions of the webcam to change the view (Fig. 13). This action also changes the view of the remote webcam visitor, who does not have access to these controls and is forced to go along on the dizzying ride. If the kiosk viewer directs the camera view towards the wall of the museum where a tiny, bright video screen is mounted, they will realize that they are live on camera. They are seeing themselves as tiny images on a screen inside the museum, which means the crickets also see their image, as do the giant human heads that peer in the window of the museum. Or perhaps the situation unfolds differently, where the human first views the physical museum inside the wooden crate, where they see regular sized crickets inside a miniature museum that includes a television

Fig. 12 View of the *Museum for Insects* for visitors in the Peabody Essex Museum 2013–2014, by Amy M. Youngs. Exhibition installed in the museum is *Interspecies Housing* 2014, by students of Landscape Architecture at the Ohio State University. Photo by Amy M. Youngs

Fig. 13 Kiosk view of the *Museum for Insects* for visitors at the Peabody Essex Museum 2013–2014, by Amy M. Youngs. Photo by Amy M. Youngs

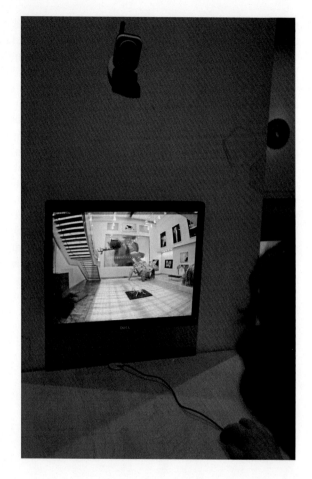

screen with tiny humans; then they later find the computer kiosk that turns them into the tiny humans who can look back at the large humans. In any case, what unfolds is a perspective shift that does not allow any of the positions—remote, semi-remote, fully present human or insect—to have a sense of full control. The limitations set into motion a playful game of connecting and interacting, but never really knowing or mastering "other", be it insect, human or machine.

Do the crickets have any control or choice? I have worked to create a comfortable home for the crickets in the museum, but I know that they have not chosen the situation. Regarding artworks that have live animals on display, theorist Irina Aristarkhova has pointed out that "...hosting the animal has the potential danger of the animal becoming a hostage to our desire to host" [12]. Although she addresses vertebrate animals, I take her concerns seriously and seek ways to ensure that the lives of the crickets are better in my hostage situation than in their previous one, living at the pet store. We can assume that being eaten by a lizard is a less desirable outcome, but if they were to remain unsold at the pet store for the

rest of their lives, they would reside in a similar sized box, in a landscape of egg crates with possibly hundreds others of their kind and fed a nutrient cube that provides both water and food. I contend that their lives in the *Museum for Insects* are better, offering less crowding, additional food and water options, and a richer environment. The museum staff has been very careful to monitor the food and water and have been mostly gentle with the crickets. I know because I can watch their activities on the webcam too. These crickets are on public display though, and are often subjected to the loud noises of visitors. My sense, coming from purchasing many crickets from many pet stores, is that the environmental disruption is similar. There, the box home is jostled about, or lids opened and closed, and human hands regularly reach into capture and then throw crickets into bags for customers.

Beyond food, water, mates, and a healthy habitat, I find it difficult to know what makes for a hospitable environment for crickets, but I approach the challenge seriously and I ask other humans to do so as well. Working alone, I might risk seeming eccentric, but involving other partners makes this pursuit more culturally meaningful. Can crickets have aesthetic experiences? How do they experience space? What imagery, structures and textures attract them and, do they look at themselves in the mirror? These were the kinds of questions asked by the artists and university students who were invited to show their work inside the

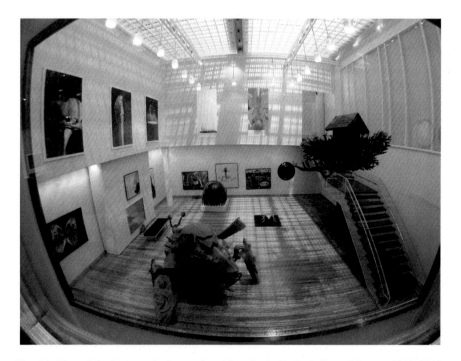

Fig. 14 View of the *Museum for Insects* for visitors in the Peabody Essex Museum 2013–2014, by Amy M. Youngs. Exhibition installed in the museum is *The Telepresent Animal Hall of Fame* 2014, curated by Doo-Sung Yoo. Photo by Amy M. Youngs

Museum for Insects. I invited Ken Rinaldo to create the inaugural exhibition for the museum. He sought to engage the sensorium of crickets in a series of images and sculptures designed specifically for them. High-resolution photographs of the faces of crickets were manipulated and represented as tiny artworks, intricate sculptures to climb in and on were created using 3D rapid prototyping techniques and images of imaginary cornucopias of seed-like foods were invented for their enjoyment [13]. For the next exhibition I invited artist Doo-Sung Yoo to serve as curator and I invited students in my art courses at the Ohio State University to submit their art works for his consideration. He developed an exhibition that included eleven student projects along with twelve prominent artists known for their inter-species artworks [14]. The exhibition, *The Telepresent Animal Hall of Fame*, gathered a formidable group of humans together to demonstrate that communications between animals, humans and technologies matter (Fig. 14).

The final exhibition at the *Museum for Insects* was created by sophomore students in a course on Interspecies Housing offered in the Knowlton School of Architecture at the Ohio State University [15] (Fig. 15). The students took their assignment to create indoor landscapes for crickets very seriously. Working in teams, they constructed models, researched materials and conducted numerous user studies with live crickets. Two projects were selected for the exhibition based

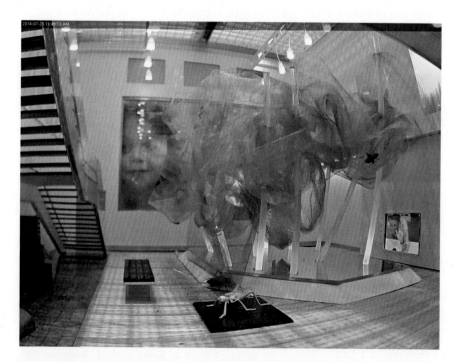

Fig. 15 Webcam screenshot of the *Museum for Insects* 2013–2014, by Amy M. Youngs. Exhibition installed in the museum is *Interspecies Housing* 2014, by students of Landscape Architecture at the Ohio State University

on the unusual ways they engaged the movements of crickets in the space. The students who created *Cricket Cloud* [16] and *Grassland Wonderland* [17] taught me that crickets experience space through touch. Indeed, the crickets were often visible on camera, tunneling through the flexible, tulle fabric that created a cloud in the middle of the museum. At other times, they appeared to be touching antennas with their own image as they stood on the brightly lit, mirrored base of the cloud. The altering of roles—human, insect, art viewers, art producers, curators, students, researchers—within the space of a miniature museum, was a productive way to explore questions of value, empathy, understanding and aesthetics in regards to non-human others. As in the other systems-based artworks I have been involved with, this project expanded beyond me and generated questions that I would not have asked or tested myself. The creation of unusual situations for interaction between humans, machines, and non-humans resulted in a microcosm where each party became an important actor in the play of communication.

Building and participating in systems-based artworks can result in interactive, shared world building, which allows us see and experience ourselves in new situations. It can also make visible—*and sensible*—the comingled mesh of interdependent relationships that include self with worms, wires, screens, insects, microchips, plants, cameras, and mirrors. These projects are artworks, not complete worlds, but they do operate as working prototypes for a future in which technology and non-human others are engaged as equally important partners, or kin, in the world that we all share.

References

1. Crutzen PJ (2002) Geology of mankind. Nature. doi:10.1038/415023a
2. Bennett J (2010) Vibrant matter: a political ecology of things. Duke University Press, Durham and London, p 13
3. Burnham J (1968) Beyond modern sculpture: the effects of science and technology on the sculpture of this century. George Braziller, New York
4. Haraway D (1991) Simians, cyborgs and women: the reinvention of nature. Routledge, New York
5. Brouwer J, Mulder A, Spuybrock L (2010) The politics of the impure. V2_Publishing, Rotterdam, pp 9–10
6. Morton T (2010) The ecological thought. Harvard University Press, Cambridge, p 29
7. Hughey TW (2005) Barrel-ponics. http://www.aces.edu/dept/fisheries/education/documents/barrel-ponics.pdf. Accessed 28 May 2014
8. Youngs AM (2014) Living with worms in the flooding machine. Antennae: J Nat Vis Cult 28:30–43
9. Haraway D (2008) When species meet. University of Minnesota Press, Minnesota, p 240
10. Youngs AM (2013) House crickets. http://hypernatural.com/museum/crickets.html. Accessed 12 June 2014
11. Haraway, When species meet, p 249
12. Aristarkhova I (2010) Hosting the animal: the art of Kathy High. J Aesthetics Cult. doi:10.3402/jac.v2i0.5888
13. Rinaldo K (2014) Trans-species. http://hypernatural.com/museum/past.html. Accessed 12 June 2014

14. Yoo D-S (2014) Telepresent animal hall of fame. http://hypernatural.com/museum/telepresentanimal. html Accessed 12 June 2014
15. Course designed by Katherine Bennett, Assistant Professor of Landscape Architecture at the Knowlton School of Architecture. Taught by Masters of Architecture students David P. Shimmel and Ian Mackay
16. Hodge A, Lesnoski N (2014) The cricket cloud. https://u.osu.edu/larchsophomorestudio/ 2014/02/24/the-cricket-cloud/ Accessed 12 June 2014
17. Beaton K, Gerich K (2014) Pathways. https://u.osu.edu/larchsophomorestudio/2014/02/19/ pathways/. Accessed 12 June 2014

Trans-Species Interfaces: A Manifesto for Symbiogenisis

Ken Rinaldo

Abstract Artist/inventor Ken Rinaldo looks to natural living systems, mimesis and communication to reveal the underlying coevolved wisdom of the biological world as it intertwines and coevolves with our technological world. He postulates the symbiotic junctures where machine, animal, plant, bacteria and humans meet are where our future as a species exist. He reveals this philosophy by showing numerous interactive robotic installations showing how we are becoming symbiont and his works pioneer interspecies communication, where the biological and technological naturally intertwine. Using coevolution as model, Rinaldo proposes we can, as a species design technologies that are more sensitive to other living things focused on directing technology for the good of all living species, we share the planet with.

As a child we had a bright orange and grey-stripped cat named Catabu. With large green eyes staring longingly into my eyes he would jump to my lap. I would scratch and rub the crown of his head working my hand to the side of his mouth as he purred approvingly. He would force the crown of his head hard against my hand and his pupils would roll upward to the back of his skull showing the whites of his eyes as his eyes would drift closed. He would slink over and relax exposing his belly with his paws outstretched he would go completely limp.

After minutes of stroking, Catabu would suddenly pop up on his back paws and place his front paws on my shoulder. He would then begin to probe my inner ear with his scratchy tongue. His whiskers tickled as he dug further, licking my ear slowly and deliberately. This was somehow a pleasurable experience, though his tongue was sticky. Cat behaviorists, would speculate he was claiming me as littermate. I think we were exchanging love and affection.

This was my first trans-species experience. Here was a cat, finding pleasure in the taste of my earwax while we provided mutual affection. This cat/human relationship

K. Rinaldo (✉)
Art & Technology at the Ohio State University,
2531 N 4th street, 43202 Columbus, Ohio, USA
e-mail: rinaldo.2@osu.edu

© Springer Science+Business Media Singapore 2016
D. Herath et al. (eds.), *Robots and Art*, Cognitive Science and Technology,
DOI 10.1007/978-981-10-0321-9_7

left a lasting legacy and deep-probing questions for me about animal-human communication, symbiosis and the contemporary notion of the computer interface.

These childhood experiences further served as a model for developing and thinking about new forms of interactive robotic art and the possibilities for unique biologically inspired interfaces. Questions arise; given the tactile nature of the human animal should interfaces have a physical component? Can interfaces play into the social norms of both human and animal? Can interfaces be used to break down interanimal and human/machine barriers?

The house cat, now a domestic breed for over 12,000 years [1] has found comfortable habitation in human homes. Within it's own evolutionary space is the propensity for social interaction and hierarchy. Dogs another domestic breed found human symbiosis much earlier, when we were hunter-gatherers. Research now places the cat, as emerging into symbiotic interaction with humans, when agriculture in the Fertile Crescent (Mesopotamia and land surrounding the Tigris and Euphrates river) required effective rodent control.

These developments lead to questions about how do animals, plants, insects and bacteria develop co-evolutionary paths? How do they develop relationships with the others in the span of natural time? How is this related to our emerging co-evolutionary and now symbiotic relationships with technological systems?

How can we by design model these animal-to-animal, animal to plant, animal to bacterial co-evolutionary systems while thinking about mimesis as a deliberate design strategy? How can these strategies be used to imagine interactive and robotic works that may advance the traditional notions of what constitutes a robot and the interface? What can we learn from these natural relationships and how are they different given the speed of intertwining technology versus the speed of natural coevolution?

As with natural, symbiotic relationships I believe there is inevitability to the arising of artificial machine intelligences. I further believe it will, by necessity, develop self-sustaining relationships with humans. Author Kevin Kelly notes in his book, What Technology Wants, "large systems of technology often behave like a very primitive organism". In particular, "networks, especially electronic networks exhibit near-biological behavior", but even taking this assertion into account it is clear that all this technology requires an interface.

The "interface" while by design is an ineffable space between humans, animal or machine interacting with one another, where each tries to understand, direct and anticipate the future behavior of the "other".

For humans, isn't culture and art, the ultimate interface? As they frame and condition how we view the natural and technological world surrounding us. Aren't artists asking the really difficult questions and advancing the field in the most profound ways given our critical stances and separation from market driven forces? Branden Hookway made me feel as if I was reading my own philosophy about the interface when he says:

> The interface is a form of relation that obtains between two or more distinct entities, conditions, or states such that it only comes into being as these distinct entities enter into an active relation with one another; such that it actively maintains, polices, and draws on the separation that renders these entities as distinct at the same time as it selectively allows a transmission

or communication of force or information from one entity to the other; and such at its overall activity brings about the production of a unified condition or system that is mutually defined through the regulated and specified interrelations of these distinct entities [2].

The central focus of my artwork has been to work at these junctures where machine, animal, plant, bacteria and humans meet. Living systems have provided the ultimate models for me as artist. Communication is at heart of my work with a desire to break down behavior, processes, patterns and the underlying beauty inherent in the intercommunication of all species (organic and machinic) at all scales.

Within the context of co-evolution and natural time (measured in billions of years) deep co-evolution has evolved, as it has been exhibited by mitochondria, foreign organelles that inhabit our cells with their unique DNA. Biologist, Dr Lynn Margulis one originator of the theory endosymbiogenisis, has written extensively on how symbiotic relationships between organisms often of different kingdoms, are the driving force of evolution. So now it is becoming true with technology and the human species [3].

With the emergence of machines and computers, we now have something we call machine-time. The computer clock-cycle and chip, GHz speeds of code execution are changing our notion of evolutionary time. While DNA and biological time, genes, have given rise to idea based MEMES and cultural evolution as Richard Dawkins has theorized in the Selfish Gene [4] genes still move more slowly. My research into living systems theory, as framed by researchers such as Miller [5] set me on a path over 35 years ago to work on artificial evolution governed by machine time.

The path is to emulate and create interactive systems, objects and art installations that blur the boundaries between living and non-living entities. Studying biology and computer science and earning an MFA in art, I was fascinated to conflate and discover process and structural relationships between natural and technological cultures. As with computer scientist/artist Myron Krueger and his work Videoplace 1978, I was also interested in embodied interaction that was not purely symbolic. I also moved away from keyboard centered interaction, though unlike Krueger, I was more interested in physically based works versus projected screen based interaction. I made a distinct decision to really directly emulate living systems and artificial life developing fully sensorial and corporeal ways of experiencing and engaging the works.

The evolution of my artwork involves the development of unique robotic interfaces for humans and other species. I have been evolving approaches to artificial-life programming techniques and unique interactions with biological systems. My process always starts as idea based inspiration with rough sketches. It moves forward with reading and research 3D modeling, fabrication, electronics in the creation of large-scale installations. Coding and interface design are always very much a part of this process.

In my work I have become one of the founder proponents of the notion of trans-species artworks, bio-based systems art and interactive robotics. It is exciting to see further developments surrounding these specialties. In defining new interfaces and functional installation works, artists are often at the vanguard in realizing unique ways of creating innovation and disruptive work, as artists are not constrained by market forces or manufacturing practicality.

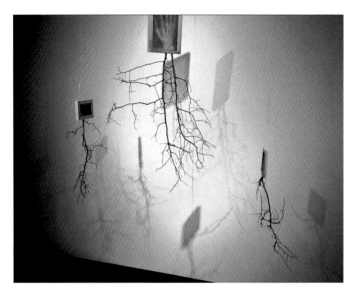

Fig. 1 Two sides of one branch—, by Ken Rinaldo

Formally, I am compelled by open structures that define form, but do not close the interiors of form off to the viewer. I often use exposed electronics and mechanics as part of the aesthetic, in proposing structural and process relationships between natural and technological systems. Wires and circuits are juxtaposed with natural branching structures as they share structural and process characteristics. For me, tree structures, are the primordial intelligent forms of our universe. They are found in neural and vascular systems as well as VLSI chips, maps of Internet connections, rivers, telephony networks and really all are constantly moving and processing matter, energy and information (Fig. 1).

Philosophically, I believe it is imperative that technological systems acknowledge and model the evolved wisdom of natural living systems. My idealistic and somewhat romantic wish is natural and technological systems will inherently fuse, to permit an emergent and interdependent earth. I see our species now better understanding the structural, behavioral and process based aspects of natural living systems as we are beginning to emulate natural worlds, in making technological systems that sense, respond, behave, evolve and sometimes misbehave. Still, technology has yet to learn the recycling/reuse strategies of natural living systems in all their intertwined integrations with bacterial cultures and their ability to break down living matter into reusable material.

While my works are conceptually inspired, I have also taken a strong stance as sculptor and person of craft. I make deliberate and provocative material choices with a hope the works better resonate with viewers. Materiality is a critical consideration for me as I believe we must first compel the eye/hand/body with corporeal ways of knowing, in order that a viewer/interactant will wish to further observe and intellectually engage the ideas inherent in a work. Recent work has also more fully engaged and modeled natural systems in recycling strategies I have brought forward in my work.

Fig. 2 I Yam what I Yam living systems painting 1988–1989, by Ken Rinaldo

In this text, I will discuss the conceptual, theoretical and ethical aspects of emulating and using living systems. This will be done with illustrations, sketches, schematics and where appropriate I will describe the central drives in my art/science practice. I will briefly navigate a few early works to demonstrate a progression in my thinking about the relationships between interactive art, interface and the ultimate symbiosis of natural and the technological.

As a younger artist, I was often frustrated with formal, static and material/craft based motivations to art making. Upon studying Marcel Duchamp and Jack Burnham systems aesthetics [6]. I was completely set free, in realizing that artists' could create culture and could construct and appropriate culture, as a way of systematically impacting ideas about contemporary media art and technological culture broadly.

With this new Duchampian freedom to "construct and grow" culture, I created a living systems painting, called **I Yam what I Yam in 1988**. This systems painting was constructed of potatoes, yams, dirt and eggs filled with tempera paint. This was a systems sculpture involving interaction and meant to subvert the notion of the precious art object. During the opening people were given stones, to throw at the painting, thus exposing the bed of yams and potatoes to the paint injected into each egg. During the opening, I was completely overwhelmed with how exuberant people were. Individuals ran up and took bites out of the potatoes and yams, while others smeared tempera paint on the frame. Seeing, "passive viewers" transformed into active and emotionally invested participants, was eye-opening and set me down the path of questioning human/art/life interfaces and wanting more interaction.

This living painting **I Yam what I Yam** continued to transform as it was moved outside receiving rain and sun and the leaves and buds bloomed while hungry slugs occupied all. They loved it till it was eaten and evolved (Fig. 2).

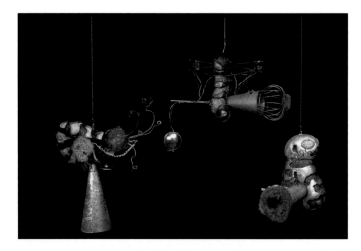

Fig. 3 Cybersqueeks Image du Futur, 1988, by Ken Rinaldo

While it was an epiphany to create an interactive living-systems painting, critical reflection also suggested a form of interaction that was more rapid, evocative and evolutive. Clearly electronics were going to be necessary for my next works.

The **Cybersqueaks 1989** were to be my first electronic digital pets. When touched they emitted emphatic and pleading sounds, triggered by motion. They hung from the ceiling with springs. Fifteen works in all, they create a cacophonous sound environment of burping and squeaking. In the creation of this work, I was able to develop a method to sew fiber optics into silicon rubber molds and I used dry-transfer circuit patterns, to create functional and formally suggestive electronic copper traces that also were the sound producing elements (Fig. 3).

Changing light allowed changing sound as photo resistors were placed near soft fur to draw the hand in. When participants touched the Cybersqueaks rocking and touch induced small mercury switches to allow them to squeak their first words. The sounds emitted were like pleading babies crying. The physical size of these works was about the scale of a fetus and this had important lessons for me. Further, art objects that emit their own voices are seen as more "alive" and touch also created important empathy for participants involving corporeal knowledge. The types of sounds induced a socially engaged emotional state of empathy.

As I was modeling living systems and symbiogenic ways of creating interactive works for humans, it seemed logical to look at interactive art for other species. Could a fish for example learn to use an electronics interface? *Delicate Balance*, 1993 is the first fish driven robot and is an interactive work designed to allow the fish to make a "choice" using the power of design, sensors and robotics (Fig. 4).

The "choice" it had was to determine the direction that it moves along a tightwire (stainless steel cable) so it could explore its environment, beyond the limits of the tank. Though, this is not a real choice, given the two directions the fish could

Fig. 4 Delicate Balance
at Ukrainian Museum of
Contemporary Art, Chicago
by Ken Rinaldo

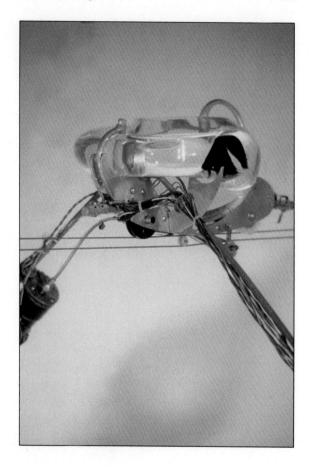

travel along the wire the work became a metaphor for the precarious balancing act of straddling natural and technological systems. With only two directions of travel the work also references environmental systems overwhelmed by technological systems.

This inceptionary work allowed to me think about how to better design interfaces for living creatures, that were more sensitive to their needs. Using custom-built circuit boards, electronics and hand blown glass, it stimulated dialogue surrounding the ethical use of animals in artwork.

When I first encountered the Siamese fighting fish, I was astounded to see they were being sold in small glasses of water. This caused me to psychoproject myself, into the space of the fish. I thought if I was that fish, I would at least want to drive my tank around. This work chose animal centered questions and concerns versus human centered concerns (Fig. 5).

The circuit design used comparators, to allow the shadow of the fish to activate sensors, which then activated motors to slowly move along the wire. Microprocessor and motor power was brought into the robot by the steel wires carrying voltage and ground. A small mirror sat on a tower and the fish would

Fig. 5 Delicate Balance
at Ukrainian Museum of
Contemporary Art, Chicago
by Ken Rinaldo

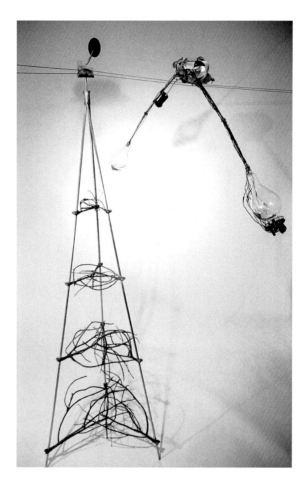

often just sit looking at self and competing with his mirror image. I was thrilled to observe that the fish was comfortable in this artificial environment and not at all afraid of the slow moving speed of the tank along the wire. This became a critical design feature for later works and I felt this was in fact a really ethical and kind way to allow the Siamese fighting fish to explore.

As my electronics experience grew, I had the good fortune to meet a group of extraordinary Silicon Valley engineers excited to collaborate. *The Flock* **1994**, by Ken Rinaldo and Mark Grossman (Co-founder of Silicon Graphics) was a work partially inspired by research with the flocking software agents, such as the Boids by Reynolds [8] (Fig. 6).

The conceptual and aesthetic questions The Flock asked were, could a group of physical and actual robotic sound sculptures be programmed to exhibit behaviors analogous to the flocking found in natural groups such as birds, schooling fish, or flying bats? In this process my collaborator, and I innovated on the science of soft robotics currently an emerging area of research. We constructed robots of natural

Fig. 6 The Flock by Ken Rinaldo and Mark Grossman. *Photo* Liz Civic

materials (cabernet sauvignon grapevines) glued together with cyano acrylate and baking soda to allow these robots to exhibit unnatural flocking behavior toward sound.

They employed new pull string mechanisms I invented and steel springs, which functioned as universal joints to allow the robots to have a full 360 degrees of motion. Most importantly, the morphology and programming allowed the robots to interact in unstructured environments with humans in safe and engaging ways. They were early examples of creating flexible and compliant structures that many researchers are now pursuing such as Festo Corporations 2010 bionic Tripod [7]. These robots were conceived in thinking about the way tendons and muscles can move through the hand, arm and legs, allowing complex and flexible motion in all degrees of freedom (Fig. 7).

Mark Grossman developed flocking algorithms programmed in c+ and the robots were able to interact autonomously in real-time very rapidly, flocking toward human voices. Custom circuit boards harvested from obsolete Silicon Graphics workstations were interfaced to four microphones, inset in conical tubes, either collected or dissipated sound and relative volumes determined response of the robots. When one of four microphones heard sound directionally, they would send their signals to custom motor drive units and move toward that sound and then communicate with the other arms to also move in that direction. The robots spoke to each other through audible telephone tones (a musical language) that would not miss trigger their responses. Telephone tones with a primary tone and secondary tone, cannot be confused with human voices, which made them an ideal choice for massive wired telephone networks and for this artwork.

Using grapevines a soft natural material was an innovation that would continue in many other works. This installation allowed me to theorize and develop ideas about

Fig. 7 The Flock at the
Machine Culture show by
Ken Rinaldo and Mark
Grossman, Siggraph, 1993.
Photo Ken Rinaldo

transparent interfaces in which the viewer/participant only need enter the space and the robots themselves "know" the most appropriate ways to behave and interact.

The *Mediated Encounters* **1996** installation was a continuation of the research involving socially engaged Siamese fighting fish augmented by robotics. The idea here was to empower four fish to interact socially and engage further into fish/human social spaces.

Integrated as aesthetic and functional elements custom built circuit boards, imbedded microcontrollers, dried grapevines and hand blown glass supported the fish environment. Infrared break-beam systems allowed microcontrollers to sense the position of the fish in the tank and allowed the fish to spin the sculpture, in one of two directions and at multiple speeds. Two male and two female Siamese fighting fish were able to use the interface to move the sculptural robotic trusses to meet and compete across the gap of the glass bowls.

A custom brush-system at the top of the robots, delivered power to the on-board microprocessors that allowed the microprocessor systems to locate and sense the position of the fish (Fig. 8).

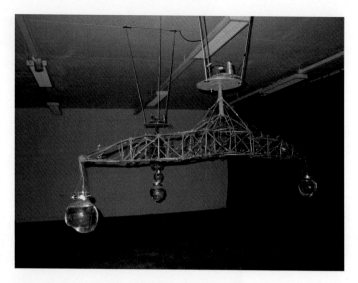

Fig. 8 Mediated encounters at robots 2004, Lille France by Ken Rinaldo

Hand blown glass fish tanks, which hung off the grapevine trusses, were designed to spin within inches of each other allowing visual intercommunication between male and female. The works hooked into the social space of sexual interest and male-to-male competition as well as male to female sexual interest and both sexes interested in human interaction presumably because of association with feeding.

This installation further stimulated dialogue surrounding living animals in public installation works of art and again, given the fish bubble nests that the males built, I felt they were comfortable habitable spaces for these fish. The glass tanks were large for Siamese fighting fish and varieties of plants suspended inside each bowl also added to this complex constructed semi natural world. This robotic work empowered the fish to interact, though also allowed a distance, where they could not fight outright. As fish often associate humans with feeding the fish tend to drive the robotic tanks toward humans, when they enter the installation (Fig. 9).

In continuing research with soft robotics, transparent interfaces and affective computing *Autopoiesis*, **2000**, is a series of fifteen artificial life sculptures that constructs an immersive and dramatic interactive environment. Artificial life programming techniques allow this installation to evolve in real-time and are most "fit" for the particular user/s environment. Autopoiesis is a word coined in1972 by Chilean biologists Humberto Maturana and Francisco Varela to define the concept of self-maintaining cells or self-making systems as this work in essence is always evolving it's own behavior [9].

The software coded in c+ was a variant of the subsumption software architecture developed by Rodney Brooks who headed the AI Laboratory at MIT [10] (Fig. 10).

These musical and robotic sculptures allowed this series to interact as both individuals and as a group consciousness of robots, as they display complex emergent behaviors.

Fig. 9 Mediated encounters
at robots 2004, Lille France
by Ken Rinaldo

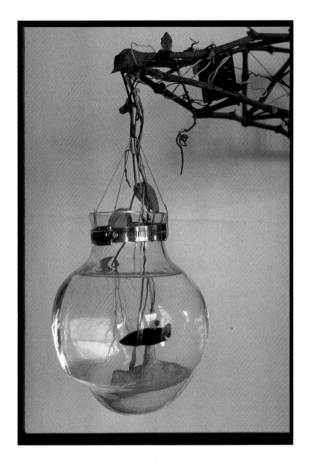

The use of grapevines integrated with blue and red cast plastic parts, created a calming and approachable sculpture. They communicate to each other through an RS485 network for noise immunity and audible telephone tones, which were used as a musical language. This gives humans sonic emotional feedback about the robots internal states and creates a systems evolution as well as an overall group sculptural/sonic aesthetic.

Autopoiesis utilizes smart sensor organization, which allowed minimal sensors, while maximizing the abilities of the software to cope with the incoming data. These lessons were learned from neuromorphic engineering. Neuromorphic engineering is a word coined by Carver Mead in which perception, motor control and multisensory integrations are based on neuro-biological principles [11] (Fig. 11).

For example, at the top of each sculpture, four (1 bit) passive infrared sensors face north, south, east and west. When two sensors are triggered, the software knows that someone is located in that vicinity and the sculptures move in that direction, giving viewers a sense of being observed. Four sensors allow eight

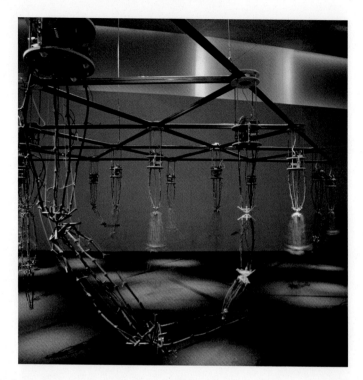

Fig. 10 Autopoiesis by Ken Rinaldo at the Kiasma Museum in Helsinki Finland, curated by Erkki Huhtamo. *Photo* Yehia Ewies

quadrants of sensing. Active infrared sensors located at the tip of each robot, stops the arm as it arrives within inches of the viewer. This allows the sculpture to display attraction and repulsion behaviors, an analog to animals sensing their world and displaying similar exploration strategies in approaching food, though cautiously approaching predators and mates.

Additionally, the robotic sensors compare their sensor data through a central—microcontroller that connects all robots as a group, so the viewer/participant is able to walk through the installation and have the arms interact uniquely each time. As each arm has it's own on-board computer control the speed of reaction is rapid and therefore life-like (Fig. 12).

Curator/Professor Erkki Huhtamo at the Kiasma Museum, Finland, interacting with Autopoiesis.

Local robotic interaction always supersedes group interaction when a local sensor is aware of a human nearby an analog to biological systems.

At the tip of two robotic arms, lipstick video cameras grab live footage and that is transmitted to projector via a transceiver. This is projected onto the walls of the space giving interactants a sense of being observed and seen by this artificial life installation. Seeing the robot vision also suggests robotic agency.

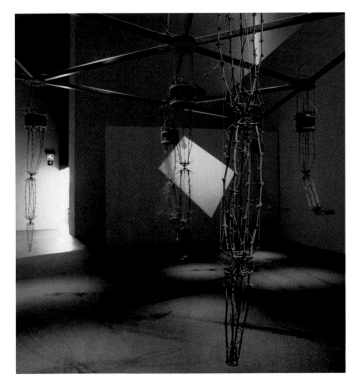

Fig. 11 Autopoiesis at the Kiasma Museum in Helsinki Finland, curated by Erkki Huhtamo. *Photo* Yehia Ewies

From a software perspective individual sculptures count and report sensor activations, which effects the overall group behavior. When there are large crowds within the installation group behaviors are less vigorous. When there are fewer interactants within the installation, less data allows the overall group behaviors to be more vigorous.

As the telephone tones are a musical language, higher rapid tones are associated with fear and lower deliberate tonal sequences, with relaxation and play. Other telephone tones give the impression of the installation whistling to itself. The touch-tones serve as a language of intercommunication and create a sense of overall robotic group consciousness where, what-is-said by one, effects what is said-by-others.

Autopoiesis continually evolves its own behaviors in response to the unique environment and viewer/participant presence. This group consciousness of sculptural robots manifests a cybernetic ballet of experience, with the computer/ machine and viewer/participant involved in a grand dance of one sensing and responding to the other.

Augmented Fish Reality, **2004**, was a further evolution of works that looked at fish cognition, social interactions and the creation of gentle environments that are friendly

Fig. 12 Autopoiesis by
Ken Rinaldo at the Kiasma
Museum in Helsinki Finland,
curated by Erkki Huhtamo.
Photo Yehia Ewies

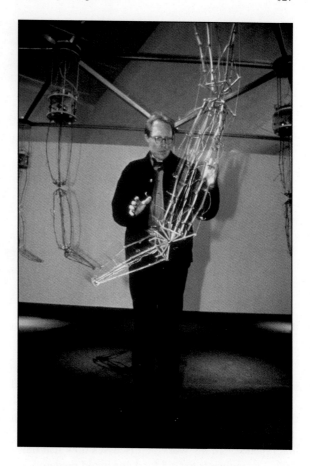

and considerate of fish. They are the first free roaming robotic fish tanks on the planet
concerned with fish desire and empowerment through sensitive interface design.

They explored interspecies and trans-species communication using closed loop
video to magnify the scale of the fish. These "bio cybernetic" sculptures empowered
Siamese fighting fish to use intelligent hardware and software to move their robotic
bowls at their will. Peace Lilies within each glass bowl created miniature cleansing
ecosystems and a comfortable while complex environment for the fish. Peace lily
plant roots served as resting place for the fish to build bubble nests and attract mates.

This work hooks into the inherent social interactions of the Siamese fighting
fish, as they are prone to want to fight given human interbreeding. As the fish swim
to locations in the tank toward other fish in other tanks, the sensor placements
allow the robots to transparently respond, by moving in that direction (Fig. 13).

As with many of my works, extensive research into the fish and robotic systems
proceeded with sketches, 3D-models and then building prototypes. Laser cutting
and machine fabrications have become increasingly important parts of my process.
Custom code, integrated with imbedded microcontrollers allowed the fish to travel

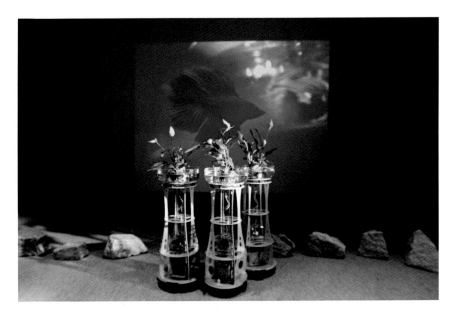

Fig. 13 Augmented Fish Reality Ars Electronica by Ken Rinaldo

anywhere in the installation they wished. Barriers of stones are often used to keep the robotic fish tanks within the bounds of the installation.

Some ask does the fish have the intelligence to learn the interface? Fish Scientist Dr. Cullum Brown discusses revisions in thinking about fish intelligence, which seems much greater than formerly imagined. Fish are "steeped in social intelligence." In his work he discusses how fish have the ability to mentally map their environments to find food and avoid predators.

> The article reports that fish pursue "Machiavellian strategies of manipulation, punishment and reconciliation" while also displaying "cultural" traditions and cooperation to elude predators and obtain food. It is said that fish track the relationships of other fish in their environment and even monitor the social prestige of other fish. It is now widely supported that fish build nests as well as exhibit "impressive long-term memories" [12].

The robotic fish bowls feature four accurate infrared sensors attached to custom coded imbedded microcontrollers. As they swim about sensing their world, each fish activates the motorized wheels in their personal vehicles and side sensors empower the fish to move the robot forward and backward and to turn the robots left or right, so they may interact. Soft foam wheels and rubber bumpers under each fish tank isolate the sound and vibration of the motors, as sound travels through water quickly.

When I saw the fish building bubble nests to attract females I was really happy, as this is a sign the males have accepted this as their home (Fig. 14).

Humans interact with the work simply by entering the environment. But these robots are under fish control, and the fish will choose to approach and/or move

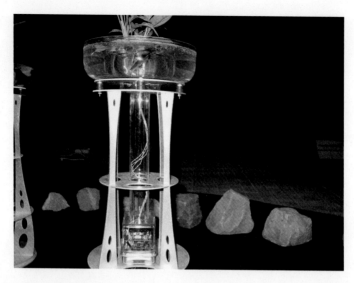

Fig. 14 Worldwide premiere of the Augmented Fish Reality in Lille France Lille 2004 commissioned by Richard Castelli

away from the human participants whenever they wish. Siamese fighting fish are top breathers and very comfortable in an oxygen deficient environment.

Both male and female Siamese fighting fish are within this installation and this tends to heighten their competitive nature. The robots are designed to exploit this fact as they allow the fish to get within 1/4 in. of each other for visual communication and interaction.

Small lipstick video cameras mounted on 45° angles, inside two of the bowls transmit images from within the tank to show the perspective of the fish. This also allows the viewer/interactant to psycho-project self, through the eyes of the fish into the tank. Here again, a transparent interface allows the fish to move toward the other fish without distinct knowledge of the interface. Here the vision system of the robot "knows" how to respond and allows humans within this interspecies artwork to empathize and see the fish on an enlarged scale to better understand their delicate and complex beauty.

In looking at engaging natural systems such as interacting fish and human cultures it is also evident that we can construct artificial nature. The *Autotelematic Spider Bots* by ken Rinaldo and Matt Howard 2005 is a work inspired by looking at the "rule-driven" nature of ant colonies. The idea was to construct a series of robots that could act like ants to find their own food source in a swarm like manner. As with real ants, energy autonomy in robotics is a complex issue. For these robots, finding food and communicating that to others, was key to their survival and staying charged up.

I designed these robots, to demonstrate a distributed intelligence and my hope was that the robots could "emerge" into energy autonomy through random foraging by first finding and then communicating their energy source "food source" back to the other robotic spiders (Fig. 15).

Fig. 15 Worldwide premiere of the Autotelematic Spider Bots at the Sunderland Museum and Winter Gardens by Ken Rinaldo and Matt Howard

These works utilize artificial life programming and neuromorphic engineering principles in creating an installation of 10 spider-like sculptures that interact with the public in real-time and self-modify their behaviors. The overall behaviors are based on interaction with the viewer, themselves (the robots) and their food source. The spider bots were designed virtually first, rapid prototyped and then built by both machine and human hands.

In this process they advanced new robotic morphologies of a unique tension-compression leg structure. Integration of custom designed circuit boards, embedded microcontrollers and software running in parallel; on a right/left hemisphere approach to code processing was unique. It allowed them to exhibit complex interaction and emergent behaviors, as they moved around their artificial environment.

The spider bots communicate to each other through Bluetooth communications and body languages to coordinate their activity. They find their food source through random foraging, looking for a 40 kHz infrared beacon that sits under a recharge rail. They are programmed so when the voltage charge is low they would go into a "seeking behavior" and sensors on each robot allow them to hone in on the food source.

In demonstration at the exhibition, one robot was able to find and attach itself to the recharge station and communicate that to others. Still, in it's current state the robots remain charged for 45 min and because the 9.6 V NiCad batteries take 2 h to charge the "emergence" of a self-charging, ecosystem of robots will be fully

Fig. 16 One robot recharging on the recharge rail AV Festival England commissioned by Honor Harger. *Photo* John Marshall

realized, when battery technology sufficiently evolves. Bluetooth is also a really power intensive technology so lower power communication protocols will be used for future innovations (Fig. 16).

For human feedback the robots talk to the interacting public with high pitched chirping sounds giving participants a sense of the "emotional" response of the spider bots. To see the vision of the robots, one of the robots has a mini video camera and video transceiver to transmit to a video projector which projects this vision to a voronoi (web like) screen, giving viewer/participants a sense of being captured in the installation's web. This screen also shows the spiders in larger scale then the viewers, subtly manipulating the power structure of the human/robot relationship (Fig. 17).

As art and robotic research these works defined a new robotic leg morphology based on a tension-compression structure and pull string mechanics. Each set of two legs acts like a flexible arch held into compression by springy plastics and monofilament. When servomotors pull the monofilaments, the arch bends allowing the leg to move organically. Six legs (biological spiders have eight) allow the robots to walk forward in a tripodic gait and turn, in either direction. This tripodic gait simulates six legged insects.

Inspiration for the robots came from a lecture by Dr. Guy Theraulaz at the Centre National de la Recherché Scientifique who reports that ants operate on rule driven systems [13]. With this in mind, it became apparent that computers and software as rule-driven-systems could be structurally coupled with their environment, allowing them to emerge and feed/recharge themselves.

The software is organized in what I term a bio-sumption architecture, which allows individual behavior to be subsumed for the fitness of the group as well as

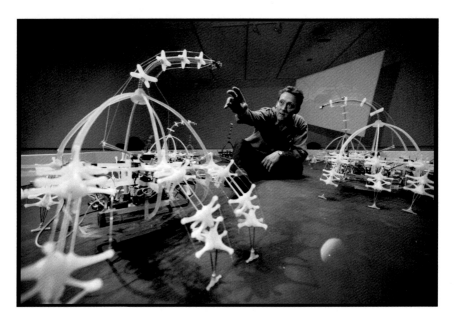

Fig. 17 World wide premiere of the Autotelematic Spider Bots at Sunderland Museum and Winter Gardens in England. *Photo* John Marshall

interaction with human participants. Behaviorally when the robots are "hungry" they have food finding, as their primary behavioral concern and ignore human interaction. This is a variation on the subsumption architectures of Rodney Brooks.

The robots were designed in the 3D software, which allowed a customization of motors and parts fitting to absolute accuracies and allowed for a rapid evolution of this complex integrated morphology (Fig. 18).

The final robots were printed with rapid prototyping plastics. The colored portions were cast in semi-clear polyurethane plastic, impregnated with Pantone™ colors, which gave each robot an individual look.

As the robots were output from rapid prototyping robotic systems, means the robots were given birth, by other robots and of course suggest interesting futures or robotic birthing machines in a kind of post human evolution.

The electronic system design allowed the hardware to distribute as much of the intelligence of the robot to integrated smart sensors and motor controllers, so the servo motor controller functions like an autonomic nervous system. This allows the motors to receive walking commands without tying up individual microprocessors. It also allows quick processing and rapid sensor/motor responsivity. The brains, microcontrollers also used a left/right hemisphere approach to parallel processing with a four-wire corpus collosum between the two hemispheres. This permitted coordination between the two-hemispheres some handling sensing like ultrasonic sensors and others servo motor control for walking and further mirrors how natural systems have evolved with left and right hemispheres in their brains.

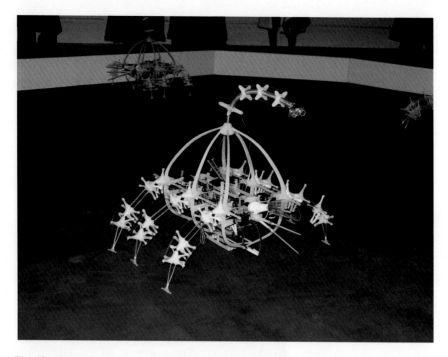

Fig. 18 Yellow Autotelematic Spider Bots Sunderland Museum and Winter Gardens in England *Photo* John Marshall

The Autotelematic Spider Bots installation is an artificial life chimera; a robotic spider, eating and finding its food like an ant, seeing like a bat with the voice of an electronic twittering bird.

In thinking on a larger and grander scale about food systems and human culture *The Farm Fountain* **2008** by Ken Rinaldo and Amy Youngs my partner and wife, was a work designed to explore and find solutions surrounding urban agriculture that also engaged the bacterial scale. The Farm Fountain is a robotic aquaponic garden designed for an ethical and environmentally friendly way of farming food both plants and fish. This food producing robot, is designed to allow fish waste to feed edible vegetables. Humans can consume the vegetables and fish and all are regulated by microprocessor systems.

This creates a symbiotic relationship between edible plants, bacteria, fish, humans and machines. With the use of pumps, gravity and systems engineering, the fish waste flows through tubes and serves as nutrients for the plants. The plants and bacteria in the system symbiotically cleanse and purify the water for the fish.

This living work creates an indoor healthy environment by providing oxygen to the humans working and moving in the space. The sound of water trickling through plant containers also creates a peaceful relaxing waterfall environment (Fig. 19).

The fish that are part of this food robot also provide a focus for relaxed viewing. The plants in this fountain are edible leafy greens, lettuces, radicchio, cilantro,

Fig. 19 Worldwide premiere
of the Farm Fountain by Ken
Rinaldo and Amy Youngs at
the Te Papa Museum New
Zealand. Commissioned by
Randy Rosenberg. *Photo*
Amy Youngs

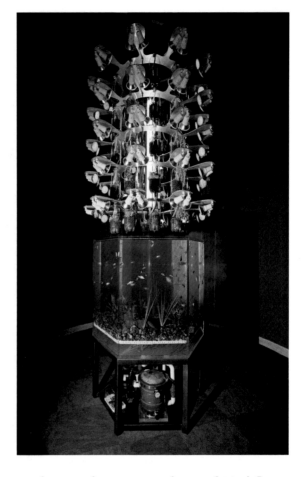

mint, basil, tomatoes, chives, parsley, arugula, mazuna, mabuna and tatsoi. In our
home version multiple tilapia were raised from fry to full-grown. Tilapia has been
farmed for thousands of years in the Nile delta. Programmed microcontrollers
integrated with pumps and controlled lighting systems allow participants to wit-
ness the future of farming.

As continuation of this research we built a solar powered version in Portugal
during a residency at Cultivamos Cultura commissioned and curated by Marta de
Menezes and Luís Graça (Fig. 20).

It is the hope of Amy Youngs and myself that these works will provide a real
model and local solution to the 1500-mi salad. 1500 miles is the average distance
salad travels from farm to fork. As part of this project we have set up a how-to website
to engage the power of social networking, to allow others to build and eat their own.

In further exploring social interaction mediated by machine culture and cam-
eras in particular the ***Paparazzi Bots* 2009** is a series of five interactive robots that
critically engage the power of cameras to reformulate private versus public space.
With a focus on self in the age of Facebook and the selfie, these robots follow

Fig. 20 Worldwide premiere of the Farm Fountain 4 by Ken Rinaldo and Amy Youngs at Cultivamos Cultura Residency Portugal. *Photo* Amy Youngs

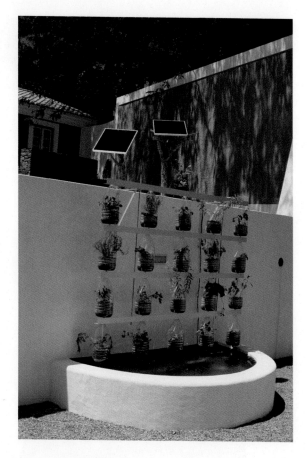

the viewer and shoot their photos, manipulating viewer to feelings of "celebrity". By being captured by the robots they "anoint" and capture participants through the machine "choice" of them.

Here machines are allowed to make decisions about beauty and prefigure future technological interfaces, where biometrics and machine vision will further become gates, through, which humans will, or will not pass.

Laser cut aluminum, cameras, custom built circuit boards and imbedded micro-controllers running in parallel allow these robots to be the first autonomous, paparazzi photographers (Fig. 21).

Comprised of microprocessors on a custom-built rolling platform, they move at the speed of a walking human while avoiding walls and obstacles. They seek one thing which is to capture photos of people and to make these images available to the press and the World Wide Web as a statement of culture's obsession with the "celebrity image" and especially our own self-images (Fig. 22).

Each autonomous robot can make the decision to take the photos of particular people, while ignoring other humans in the exhibition, based on whether or not the participants are smiling or the shape of their smile. When the robots identify

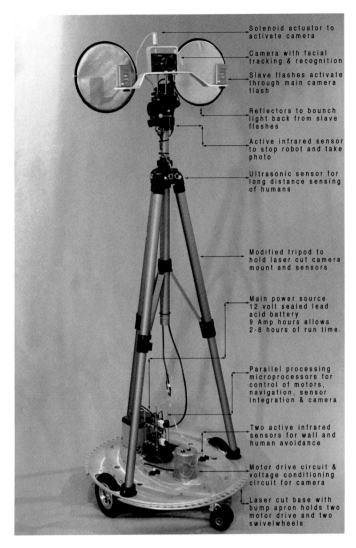

Solenoid actuator to activate camera

Camera with facial tracking & recognition

Slave flashes activate through main camera flash

Reflectors to bounce light back from slave flashes

Active infrared sensor to stop robot and take photo

Ultrasonic sensor for long distance sensing of humans

Modified tripod to hold laser cut camera mount and sensors

Main power source 12 volt sealed lead acid battery 9 Amp hours allows 2-8 hours of run time.

Parallel processing microprocessors for control of motors, navigation, sensor integration & camera

Two active infrared sensors for wall and human avoidance

Motor drive circuit & voltage conditioning circuit for camera

Laser cut base with bump apron holds two motor drive and two swivelwheels

Fig. 21 Diagram of the functional elements of the Paparazzi Bots commissioned by curator Dmitry Bulatov and the Vancouver Olympics. *Photo* Ken Rinaldo

a person they automatically adjust their focus and use a series of bright flashes to record that moment (Fig. 23).

Surveillance technologies straddle a delicate balance in contemporary culture, where we are all photographed without our knowledge by cell phones, hidden cameras and sometimes we are "celebritized". This work explores ideas surrounding the shifting territories of self and machine and how machines can manipulate the other (us) in a grand co-evolutionary dance of emerging robot-human relations (Fig. 24).

Fig. 22 The Paparazzi Bots at Nuit Blanche Toronto invited by curator Shirley Madill

Fig. 23 The Paparazzi Bots at Transmediale, Germany invited by Honor Harger

Fig. 24 The Paparazzi Bots by Ken Rinaldo capture Stelarc at the Arte e Ciência exhibition, Lisbon Portugal, curated by Leonel Moura

The recent emergence of social networks and their ability to connect people through software prompts via the World Wide Web is a prime example of the co-evolution of humans and their intelligent machines. (Fig. 25).

The fact that the software prompts use our social needs for connectivity and social space is so easily exploited in this new critical juncture, in our emerging machine-human relations.

With an interest in further looking at bacteria as the ultimate models for robotics and the mediating force of all biological life, *The Enteric Consciousness* **2010** is a glass stomach filled with living bacterial cultures. The work creates an interface allowing control of a robotic tongue that gives you a deluxe massage, if the bacteria are happy and healthy. This work senses the health of the bacterial cultures in the artificial stomach and mediates a touch-based interaction, through massage. It realizes new ways of considering and thinking about interactive art that may now be more fully focused on corporeal experience and touch.

Theoretically, it is focused on the coevolution of human and bacteria in the creation of our enteric nervous systems, which co-inhabit our stomachs and bodies. When you sit on the bacterially mediated robotic chair, if the bacteria are healthy, the robotic tongue reclines and gives you a deluxe, 15-min massage. For me this is in symbiotic sympathy with the bacterial cultures within all of us. (Fig. 26).

The glass artificial stomach that houses the bacterial cultures has a tube moving through it, with cooling liquids. The glass stomach is filled with the same bacteria that occupy our natural stomachs. Our stomach is part of our enteric nervous system, which is lined with symbiotic bacterial cultures. Our ENS consists of one hundred million neurons, about one thousandth the number in the human brain (Fig. 27).

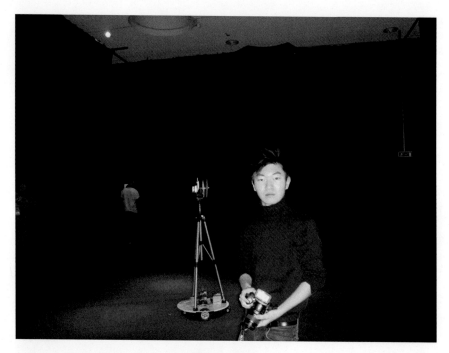

Fig. 25 The Paparazzi Bots at Transmediale, Germany

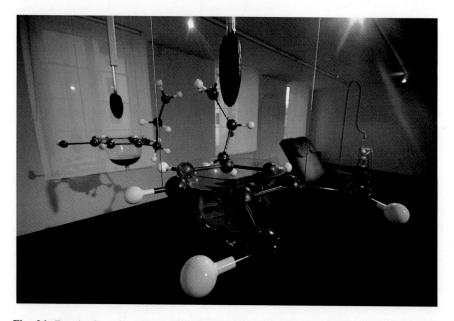

Fig. 26 Enteric Consciousness by Ken Rinaldo at the Maison d'Ailler Museum of Science Fiction and Future Journeys. Commissioned by Patrick Gyger. *Photo* Joana Avril

Fig. 27 Enteric
Consciousness installation;
glass and bacterial stomach
by Ken Rinaldo. *Photo*
Nicholas Nova

The enteric nervous system in the stomach shares the same neuro-transmitters as the brain, such as dopamine, serotonin and epinephrine. If the finger can be seen as an extension of our human brain, then the tongue can be seen as an extension of the enteric nervous system, seeking out what it prefers to ingest.

I have chosen in this work to focus on our sense of taste and touch and corporeal experience as a way to explore interactivity, as our largest sense organ is in fact our skin. When thinking about interactive art, I realized there are few examples where touch is central to the work. Here the touch of the robotic tongue is much more visceral, emotional and well, sexy (Fig. 28).

As peristaltic muscle movements propel food and bacteria through our natural stomachs, so a peristaltic pump, artificially replicates and moves cooling water through the artificial glass stomach. A PH meter measures acidity and basicity of the bacteria, monitoring its health in the artificial stomach and these signals are interfaced and activate a series of relays and micro controllers that allow the tongue robot to activate, relax and massage the viewer/interactant. The robotic tongue is covered with red emu leather giving it the appearance of swollen taste buds.

Fig. 28 Enteric Consciousness; robotic tongue and glass stomach. *Photo* Joana Avril

While our natural stomachs are sterile at birth they are soon colonized by 1,000s of kinds of bacteria, which mediate and influence what we eat and enjoy. The enteric nervous system and our brains carry on bi-directional communication and share many common neurotransmitters.

Acid-loving milk-bacterium, Lactobacillus acidophilus is a species in the genus lactobacillus, are the activators of this robotic tongue in concert with human interaction. Lactobacillus acidophilus occurs naturally in human gastrointestinal tracts in addition to vaginas and mouths. Strains of L. acidophilus have probiotic characteristics and many are used commercially in the production of yogurt.

Another element of this installation are smaller robotic tongues that dip in and out of chocolate pools, located in large glass containers. Large dopamine molecules constructed in steel hold up the glass containers. The dopamine molecule is believed to mediate the subjective experience of pleasure in humans and other animals. Chocolate and cheese (sugar and fat) are two substances that the tongue and the stomach desire. Research has proven that chocolate can boost serotonin; an antidepressant molecule and it can also stimulate secretions of endorphins that create pleasurable sensations.

This work is mostly inspired by the notion of the conscious stomach, although it is also inspired by the ideas that humans are not individuals so much as clouds of intertwined human, bacterial, and now machine cells.

We have co-evolved into hybrid symbiotic ecosystems that consist of trillions of living bacteria. Humans have ten times as many bacteria cells in and on us as we have human cells in our entire human bodies. Our armpits, crotches, and guts are like rainforests teeming with microbial life and our backs are like deserts.

The bacteria within and on us are eating and surviving and our bodies provide for their sustenance. There are one thousand trillion bacterial cells versus one hundred trillion human cells in each of our bodies, yet the human body does not end there. Bacterial cells are an important part of our health, helping us to digest indigestible foods as well as making essential vitamins and, ultimately, impacting and forming our immune systems.

Liping Zhao wrote in the *Journal of Biotechnology* that, "Humans are super organisms with two genomes, the genetically inherited human genome (25,000 genes) and the environmentally acquired human micro biome (over 1 million genes)." ..."In contrast to the human genome, the gene composition of the human microbiome is rather flexible and can be modulated by foods and drugs" [14].

This cloud of cells finds analogs in "machine cells" which are also distributed above and below the earth as they regulate and feed human society. These machine cells are engineered, though also now self-regulating systems that serve to support human existence as they are networked smartwatch microprocessors, stoplights, hundreds of trillions of transistors in intelligent devices regulating our every need.

By thinking about our engineered human existence, we reveal a comfortable proto embryonic sac of chips and wires feeding into larger dendritic networks of 100,000-V power towers and pulse-coded and frequency-modulated telephony and uplink satellites, all in regulation of human needs.

We cannot imagine the human animal surviving without our now symbiotic relationship with these engineered systems and our coevolved bacterial symbionts that regulate our lives. Just as bacterial cells are autonomous living networks, our robots are now rapidly emerging into proto living systems as they self regulate, motor around our environments, and begin adopting caretaking roles for humans.

The Enteric Consciousness installation realizes a corporeal space, celebrating the symbiotic relationship between the bacterial cultures that live in and on us and an emerging ecosystem of human-engineered robotic entities that will inhabit our homes, workplaces, galleries and now our bodies. The Internet of things portends a future network that further blurs human, robots and bacteria in regulating human and soon to be; machine "desire".

In continuation of research into robots and desire entering our bodies and our bodies entering them, the *Fusiform Polyphony* **2012** is a series of six interactive robotic sculptures that compose their own music with input from participant facial Figs. Micro video cameras mounted on the ends of these robots, move toward people's body heat and faces while capturing human snapshots. These images are digitally processed, pixelated and produce a constantly evolving generative soundscape, where facial features and interaction are turned into sound melody, tone and rhythm.

These elements manifest the viewer as participant/actor and conductor in defining new ways of interfacing and interacting with a group consciousness of robots while allowing the robots to safely interact with humans. A key element of this installation is to see self, through the robots eyes, as each bot captures images showing the nature of algorithmic vision. The title of the work refers to the part of the brain the fusiform gyrus that is optimized for seeing human faces. The work also alludes to microprocessors and expert systems developing with optimized abilities in this case to compose music (Fig. 29).

Fig. 29 Fusiform Polyphony by Ken Rinaldo worldwide premiere during Nuit Blanche Toronto invited by Shirley Madill & commissioned by Nuit Blanche

Blurring human and robots, these works are covered in natural human hair that serves to point to a human/robotic hybrid moment, where the intelligence of robots is more fully fusing with our own. Robots are absorbing bodies and our perceptual spaces as is most evident in teleoperated robotics.

The live camera-based-video of the robots is processed through MAX MSP and Jitter and projected to five massive screens for viewing. When the robot is at head height a sensor at the tip of the robot is triggered and a facial snapshot is taken.

This snapshot is held in the small area of the projected screen to the upper right. That snapshot is broken down into a 300-pixel grid and the variations of red, green and blue data of each pixel is extracted and interfaced to Max MSP to Ableton Live a sound composition tool. Max MSP and Abelton accept the facial data and mediate the rhythm, tempo and dynamics of each musical work produced by each robot (Fig. 30).

The robots are individually controlled with six Mac Minis, wired to midi-based controllers to a Miditron Midi controller, sensor and motor drive units. These are networked to a Mac Pro Tower that processes the video of the faces and interfaces these to the Abelton sound program.

Changing pixel data, directs the Ableton instrument sets with random seeds coming from the snapshots. The robotic structures were created with 3D modeled cast urethane plastics, monofilament and carbon fiber rods, laser cut aluminum elements supporting the computers microprocessor and motor drive systems.

These robots structure, inform, enhance and magnify, people's social behavior and interactions as they auto generate a unique and a constantly evolving generative soundscape. They take the unique multicultural makeup of each person and

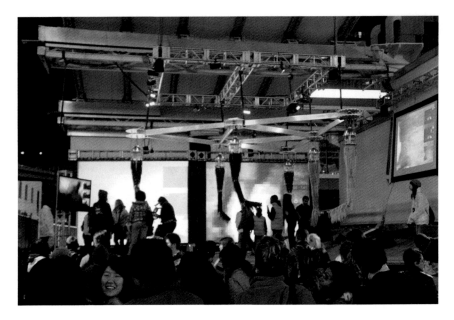

Fig. 30 Fusiform Polyphony during premiere of Nuit Blanche Toronto 2011

create "facial songs" where those songs joining with 6 robotic/human sound-scapes, creates an overall human polyphonic and video experience. They are peaceful and playful robots and sadly so many current human robotic pursuits are driven by violence, power and fear.

The ***Drone Eats Drone: American Scream* 2013** is a robotic vacuum cleaner that is hacked and rewired, that carries a mini Reaper drone crashing into another reaper drone. It is designed as an interactive warning of the coming age of drones in domestic space. It responds to human body heat (as any drone would) by moving from a recharge station, moving about—turning its drone propellers on and returning to the charge station. The robot base is covered with a miniature bucolic prairie scene, with cows and humans to elicit peaceful notions of home, while menacing drones buzz above.

As many who study technology and the issues of borders know, drones in particular have become the weapon of choice, for crossing borders and carrying out undeclared war. These drones and the technology they employ, are playing an increasing role in world politics and in particular the military industrial complexes worldwide (Fig. 31).

As lobbyist work to fund domestic drones we are on the cusp of algorithmically deciding if a person is an "enemy combatant" or not. This work critiques businesses such as IRobot (producer of military robots and the domestic Roomba vacuum cleaners) drone manufacturers such as General Atomics. (Fig. 32).

The work questions and challenges the act of continuous war and the effect on populations especially in war torn regions where the Bureau of Investigative Journalism has reported that over a 9 years period, out of 372 flights 400 civilians were confirmed dead, 94 of them children [15] (Fig. 33).

Fig. 31 Drone Eats Drone: American Scream by Ken Rinaldo premiere at La Compagnie, France curated by Isabelle Arvers. *Photo* by Myriam Boyer

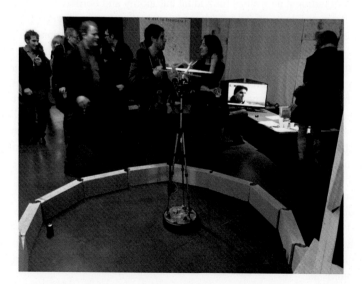

Fig. 32 Drone Eats Drone base showing bucolic scene with cows and human. *Photo* by Myriam Boyer

Fig. 33 Close-up of Drone Eats Drone base showing bucolic scene with cows and human. *Photo* by Myriam Boyer

This work challenges the idea that governments with military power and money can purchase new technologies and allow drone robots to fundamentally challenge the notion of national as well as individual autonomy and borders.

It conflates the land of other countries with the terrain of your living room and home. It seeks to join and help others understand the relationship between domestic consumer goods and our military industrial complexes who increasingly manipulate and create foreign policy with military robotic killing machines. With Google's purchase of Boston Dynamics maker of military robots as their buying satellite maker Skybox (uncannily close to Skynet) one only hopes that we are not on the cusp of being rendered obsolete, by artificially intelligent robots that "know" what is best for us. When we create robots whose sole vision is to see the world as threat and not as an exquisitely intertwined ecosystem we have lost touch with the nature of life and our future.

Each of these interactive artificial life artworks and symbio technoetic biologically based systems, work to demonstrate a philosophy of ecology and symbiosis. As robots become increasingly sentient and symbiotically intertwine with their creators I continue to hope for a time when robots emerge and do things they are not implicitly designed to do. Interfaces must become more sensitive to natural biological systems and allow a fuller spectral understanding of the natural world that surrounds us.

While many of these works engage natural systems as model we are currently in a stage on the planet where machines are more parasitic then symbiont and most are destructive to natural living systems, as evidenced by mountains of e-waste. These works show a gentle and possible future in order to express sensitivity to natural living systems and the models they provide.

In order to fully realize the dream of a symbiotic natural/technological world intertwining, we need to question understand, and emulate the lessons offered by natural living systems. We can begin by having computer/machine systems degrade in such a way they do not damage the environment and natural living systems to which they depend. Time for emerging bacterial computers. Then and only then will we begin the necessary long-term sustainable future of a process toward real trans-species animal/bacterial/machine culture, co-evolved coupling.

References

1. Zax D (2007) The Smithsonian a brief history of house cats. Smithsonian.com. 30 June 2007
2. Hookway Branden, Interface. The MIT Press, Cambridge Mass, p 4
3. Margulis L, Dorian S (1987) Microcosmos: four billion years of evolution from our microbial ancestors. HarperCollins, ISBN 0-04-570015-X
4. Dawkins R (1976) The selfish gene. Oxford University Press, New York. ISBN 0-19-286092-5
5. Miller JG (1978) Living systems. McGraw-Hill, New York. ISBN 0-87081-363-3
6. Shanken E (1998) The House that jack built: Jack Burnham's concept of "Software" as Metaphor for Art, Leonardo Electronic Almanac 6:10 (November, 1998)
7. http://www.festo.com/cms/en_corp/11371.htm
8. Reynolds CW (1987) Flocks, herds, and schools: a distributed behavioral model, computer graphics. In: Proceedings of ACM Siggraph' 87 conference, vol 21(4), pp 25–34. Anaheim California, July 1987
9. Maturana H, Varela F ([1st edition 1973] 1980) Autopoiesis and cognition: the realization of the living. In: Robert SC, Marx WW (eds) Boston studies in the philosophy of science, vol 42. Dordecht: D. Reidel Publishing Co. ISBN 90-277-1015-5 (hardback), ISBN 9-027-71016-3 (paper)–the main published reference on autopoiesis
10. https://en.wikipedia.org/wiki/Subsumption_architecture
11. Neuromorhic Engineering, https://en.wikipedia.org/wiki/Neuromorphic_engineering
12. Brown C (2003) In an article entitled learning in fishes. In: Laland KN (ed) Fish and fisheries, vol 4
13. Bonabeau E, Dorigo M, Theraulaz G (1999) Swarm intelligence, from natural to artificial systems. Oxford University Press
14. Biotechnol J (2010) Sep 1;149(3):183–190. doi:10.1016/j.jbiotec.2010.02.008. Epub 2010 Feb 20. Whole-body systems approaches for gut microbiota-targeted, preventive healthcare. Zhao L1, Shen J
15. Bureau of Investigative Journalism, http://www.thebureauinvestigates.com/

Cultivating the Uncanny: *The Telegarden* and Other Oddities

Elizabeth Jochum and Ken Goldberg

Abstract The concept of the Uncanny has attracted the attention of art critics and scholars for over a century. Freud's 1919 essay *The Uncanny* considers objects and other phenomena that evoke a powerful psychological response of fear and fascination. Freud links the human experience of the Uncanny—essentially an awareness of awareness—to repressed fears and desires. The Uncanny Valley—a related but distinct concept—was proposed by Masahiro Mori in 1970 concerning the design of robots and prosthetics. This chapter explores the Freudian and Morian concepts of the Uncanny and their influence on artists working with robots. We identify two categories: the representational uncanny is triggered by objects that look lifelike, and the experiential uncanny is triggered by non-anthropomorphic phenomena that behave in ways that signal awareness. We focus on the latter in our examination of three artworks—*The Telegarden* (1995), *Six Robots Named Paul* (2012), and *The Blind Robot* (2013)—which create a heightened atmosphere of awareness and challenge assumptions about authenticity and agency.

> *Some of the grandest and most overwhelming creations of art are still unsolved riddles to understanding.*
> Sigmund Freud

E. Jochum (✉)
Department of Communication and Psychology, Aalborg University,
Rendsburggade 14, 9000 Aalborg, Denmark
e-mail: jochum@hum.aau.dk

K. Goldberg
CITRIS "People and Robots" Initiative, IEOR and EECS,
College of Engineering, Art Practice, and School of Information,
UC Berkeley, 425 Sutardja Dai Hall, 94720 Berkeley, CA, USA
e-mail: goldberg@berkeley.edu

© Springer Science+Business Media Singapore 2016
D. Herath et al. (eds.), *Robots and Art*, Cognitive Science and Technology,
DOI 10.1007/978-981-10-0321-9_8

149

I.

How does the uncanny function in robotic art? Does the English word "uncanny" accurately convey the unique mixture of arousal and fear, familiarity and strangeness implied in the German *unheimlich*? And what is the relationship between Freud's 1919 essay *"Das Unheimliche"* and Masahiro Mori's 1970 article *"Bukimi no tani gensho"*?

On May 10th, 2013, a group of thirty scholars, artists and roboticists came together to explore these questions at the *Art and Robots* workshop held at the International Conference on Robots and Animation (ICRA) in Karlsruhe, Germany.[1] Questions surrounding translations (German, Japanese, English) and of Freud's influence on Masahiro Mori (who does not speak English) arose repeatedly that day. Professor Hirochika Inoue, a renowned expert in robotics and former student of Masahiro Mori offered to telephone Mori (now in his eighties) in Tokyo to inquire. Professor Inoue soon returned with a surprising and perplexing report: Masahiro Mori said that he was completely unfamiliar with Freud's essay and had never heard of the link with Freud until Inoue's call.

Professor Inoue and the workshop organizers soon began planning an event to be held in Tokyo that November. *Revisiting the Uncanny Valley: A Tribute to Masahiro Mori* was attended by over 200 researchers at the International Conference on Intelligent Robots and Systems (IROS) in Tokyo, Japan.[2] Professor Mori discussed his research on prosthetic hands that led him to develop the theory of the Uncanny Valley. During his presentation, Mori expressed delight at learning that his essay (which was well known to robotics researchers and artists for over 40 years) had been "re-discovered" by researchers in 2012. Mori's unfamiliarity with Freud and the significant impact of his own essay over the past four decades prompted us to investigate further. If there was no direct link between Freud and Mori, were the two authors describing the same effect? How have these theories

[1]The workshop was organized by Ken Goldberg (UC Berkeley), Heather Knight (Carnegie Mellon University), and Pericle Salvini (Scuola Superiore Sant'Anna), and included presentations by Minoru Asada (Osaka University), Niklaus Correll (University of Colorado), Raffaello D'Andrea (ETH Zurich), Louis-Philippe Demers (Nanyang Technological University), Kyle Gilpin (Massachusetts Institute of Technology), Ken Goldberg, Guy Hoffman (IDC Media Innovation Lab), Ian Ingram (independent scholar), Hiroshi Ishiguro (Osaka University), Elizabeth Jochum (Aalborg University), Heather Knight, Todd Murphey (Northwestern University), Chang Geun Oh (Seoul National University), Pericle Salvini, Reid Simmons (Carnegie Mellon University), Stelarc (Brunel University), and Patrick Tresset (Goldsmiths University London). A summary of the workshop can be found at [14]: http://uncannyvalley_icra2013.sssup.it.

[2]*Revisiting the Uncanny Valley: A Tribute to Masahiro Mori* was held November 6, 2013 in Tokyo, Japan. The event was organized by Ken Goldberg, Minoru Asada (Osaka University), Hirochika Inoue, Sigeki Sugano and Erico Guizzo. Masahiro Mori's presentation was translated by Norri Kageki. Presentations were given by Ken Goldberg (UC Berkeley), Masaki Fujihata (Tokyo University of the Arts), Hiroshi Ishiguro (Osaka University), Elizabeth Jochum (Aalborg University), Oussama Khatib (Stanford University), Peter Lunenfeld (University of California, Los Angeles), Marek Michalowski (Carnegie Mellon University) and Todd Murphey (Northwestern University). Details of the event can be found at: http://goldberg.berkeley.edu/art/uncanny-summit/.

shaped design approaches in robotics, and what role does the Uncanny play in contemporary robotic art? Here we try to answer these questions by uncovering the links between the Freudian Uncanny and the Uncanny Valley, paying specific attention to anthropomorphic and non-anthropomorphic tendencies in robotic art.

We begin our investigation by tracing the experience of the Uncanny to modern anxieties concerning machines and automation. The Age of the Automaton coincided with the Enlightenment and a shift away from religious and spiritual understanding towards scientific and rational explanations of biology and nature. During the seventeenth century, the bodies of animals and human beings were increasingly regarded as complex machines, a philosophical stance that prompted fierce debate over what, precisely, separated humans from machines. The man-machine debate in philosophy coincided with new automation practices in agriculture and manufacturing that raised fears about machines replacing human labor and potentially subjugating human beings [26]. Not unlike the automata that featured prominently in literature and art works of this period, contemporary robotic art works continue to fuel popular imagination and raise critical questions about human experience and the urge to create mechanical life. The Uncanny is central to understanding the complex human reaction to robots and other technologies that signal agency or awareness.

Both the Freudian and Morian definitions of the Uncanny pivot on figures of artificial dolls, wax mannequins and anthropomorphic objects. Whereas Freud focuses on uncanny effects in literature (he cites E.T.A. Hoffman's *The Sandman* as the literary uncanny *par excellence*), Mori emphasizes the physical design of robots and prosthetics. In contemporary art, the notion of the Uncanny seems to shift away from anthropomorphism towards issues concerning authenticity and awareness. In an increasingly computational world, we are less concerned by robots that look human-like than we are about our inability to distinguish between the real and the virtual. The contemporary Uncanny can be said to hinge on heightened experiences that provoke ambiguity about the authenticity of experience or the "aliveness" of an artefact.

Automata and anthropomorphic robots provoke the Uncanny through their remarkable lifelike appearance, but there is another category of robotic art that triggers the Uncanny through behaviors that signal awareness. We define humanoid robots as evocative of the *representational uncanny*, because they deliberately evoke the human form and shape. Examples of the representational uncanny include human-shaped automata built by Jacques de Vaucanson and Pierre and Henri-Louis Jaquet-Droz in the eighteenth century, waxwork figures found in Madame Tussaud museums, and contemporary androids such as Hiroshi Ishiguro's Geminoid HI-4(Fig. 1). A second class of artworks provoke what we call the *experiential uncanny*, where spectators perceive the robot as having agency, where the Uncanny occurs when the robot is perceived as alive or aware in ways that we typically associate with animate objects. Defining two classes of uncanny reveals their common trait: both create an *awareness of awareness*.

The aesthetic interest in behavior of interactive artworks is consistent with trends in robotic art that began during the 1960s with the advent of kinetic art and behavioral sculptures. In the twenty-first century we have become operators of online puppets, digital avatars and tele-operated robots, and it becomes increasingly difficult to distinguish real experiences from virtual ones. In this new

Fig. 1 Humanoid robots like the Geminoid (by Hiroshi Ishiguro at the Advanced Telecommunications Institute in Japan) provoke the Uncanny through their lifelike appearance and realistic movements. They are examples of the representational uncanny. (Photo by Julie Rafn Abildgaard)

landscape, the means through which objects and other phenomena provoke the Uncanny develop in new directions.

This chapter is organized in four sections. We first outline the emergence of the Uncanny during the Enlightenment in relation to the wider interest in monsters, scientific instruments and other "oddities" during the period. The second section focuses on Freud's discussion of the Uncanny in relation to psychological experiences (such as *déjà vu*), internal drives (such as the death instinct) and aesthetics. The third section considers Mori's essay in light of trends in robotics, sculpture and visual art. The final section considers three contemporary non-anthropomorphic robotic artworks that trigger the experiential uncanny. These interactive artworks raise troubling questions of authenticity and robot agency.

II. The Roots of the Uncanny

When our first encounter with some object surprises us and we find it novel, or very different from what we formerly knew or from what we supposed it ought to be, this causes us to wonder and be astonished at it. Since this may happen before we know whether the object is beneficial to us, I regard wonder as the first of all the passions.

Descartes, *The Passions of the Soul*, 1649[3]

[3]In Onians, J [22] A Short History of Amazement, p. 18.

> The eighteenth century in a sense "invented the uncanny"...the very psychic and cultural transformations that led to the subsequent glorification of the period as an age of reason or enlightenment—the aggressively rationalist imperatives of the epoch—also produced, like a kind of toxic side effect, a new human experience of strangeness, anxiety, bafflement, and intellectual impasse.

<div align="right">Terry Castle, <i>The Female Thermometer</i>, 1983[4]</div>

The Uncanny emerges from the Age of Wonder. The scientific revolution of the Enlightenment signaled both scientific and philosophical breaks with earlier notions of animism and spiritual beliefs, paving the way for both belief and skepticism in machines. This tension between belief and skepticism is at the heart of the late eighteenth century notion of the Uncanny. The Enlightenment interest in automata and their literary representations in Gothic fiction trace back to earlier creation myths concerning artificial life, from Homer's *Iliad* to the Golem myth (recounted in the tenth century *Sefer Yetsirah*, or *The Book of Formation*). The promise and threat of mechanical life gained new urgency as clockwork mechanisms assumed the shapes of humans and animals. In the previous centuries, philosophers such as René Descartes (*The Description of the Human Body*, 1647) and Julien Offray de La Mettrie (*Man a Machine*, 1748) described living bodies in mechanical terms, and late eighteenth century automata were exhibited as scientific "proof" that biological functions (such as breathing, digestion, blood circulation) could be reproduced mechanically. These proto-robotic technologies drew large crowds at public scientific lectures and captured the imagination of fiction authors. If, as Terry Castle has suggested, the eighteenth century "invented" the Uncanny, we might speculate that the Uncanny's pre-history can be found in seventeenth century philosophy. As evidence, we look to the enthusiasm for biological oddities and scientific instruments—the telescope, the microscope, and the barometer—that expanded our capacity to perceive and make sense of the world.

The mix of fear and wonder that characterizes the Uncanny relates to the concepts of the sublime, the fantastic and wonderment. Art historian John Onians connects the scientific and philosophical study of amazement with the proliferation of *Wunderkammer* (chamber of curiosities) during the seventeenth century.[5] *Wunderkammer* were collections of exotic art works, strange artefacts and other oddities held in private collections throughout England and Europe that gradually became material representations of self-understanding.[6] In the same period, the development of the microscope and the telescope made possible new sights and new modes of seeing: these tools were regarded as wonders fit for inclusion in the *Wunderkammer*. Optical instruments had the ability to turn anything into an object of wonder "whether by enlarging the familiar to make it strange or by bringing the

[4]Castle, T [4] The Female Thermometer, p. 8.

[5]Onians, J [22].

[6]Hagner, M [12] Enlightened Monsters, p. 187.

remote and invisible closer to give it novelty."[7] We will elaborate further on defamiliarization as a strategy in modern art, but what interests us is how optical tools and scientific instruments came to be regarded as aesthetic objects in their own right. Ocularism—the study of the eyes and ocular prostheses or enhancement—is a recurrent theme for Freud and central to his understanding of the Uncanny (eyeglasses, eyes and telescopes feature prominently his discussion). We do not suggest that every object that provokes wonder can be regarded as uncanny, or that the seventeenth century concept of wonder is synonymous with the eighteenth century notion of the Uncanny; however we regard the enthusiasm for *Wunderkammer* as evidence of aesthetic interest in scientific tools and material artefacts that create an awareness of awareness.

Popular interest in the Uncanny coincides with the movement away from religious belief towards scientific and rational explanations of the natural world. During the "Golden Age of Automata"[8] (or, alternately, what Gaby Wood calls the "Golden Age of the philosophical toy"),[9] mechanical statues became concrete symbols of materialist philosophical treatises (by Diderot, Rousseau, Voltaire, and La Mettrie) that sought to describe nature and biology in mechanistic terms. The Enlightenment interest in oddities and monsters from the natural word that eluded classification became the subject of scientific inquiry into the "invisible and dynamic processes of life," and the automaton became a symbol for the pursuit to replicate these processes through engineering. Androids (human-shaped automata) built by Jacques de Vaucanson, Henri and Pierre Jaquet-Droz and Wolfgang von Kempelen dealt head-on with the Uncanny. Coupled with new manufacturing processes of the Industrial Revolution, the preoccupation with machines and our relation to technology became a central concern in aesthetics and philosophy. As Gaby Wood proposes in *Edison's Eve*, "Men understood as machines and machines built to resemble men went hand in hand—it hardly mattered which had come first. Androids were more than curiosities: they were the embodiment of a daring idea about the self."[10] Androids formalized notions of mechanized human labor and society by combining the clock and the statue, fomenting the notion that living beings could be viewed as machines. But automatons were not in and of themselves uncanny: to evoke the Uncanny, something more was needed.

A machine that signals agency stimulates the uncanny by creating a heightened atmosphere of awareness. In this moment, the machine moves from being an object of wonder or fascination into the realm of the Uncanny. Vaucanson's flute player, first exhibited in 1738 at the Royal Academy of Sciences in Paris, was deeply troubling to audiences because it signaled awareness through a mechanism that simulated breath:

[7]Onians, J [22] p. 20.

[8]Kang [18] Sublime Dreams of Living Machines.

[9]Wood, Gaby [30] Edison's Eve, p. 17.

[10]Wood, G [30] p. 17.

This automaton **breathed**. Even though the art of mechanics was sophisticated enough by then to make a machine perform many other movements, and even though Vaucanson unveiled the fact that this breath was created by bellows, the very act of breathing, seen in an inanimate figure, continued to cause a stir well into the following century.[11]

The uncanny effect of the breathing android stems not only from its lifelike appearance but from what the breath signified: the possibility of the android's animacy and awareness. The possibility of a self-aware machine triggers the Uncanny because we can no longer be certain who is observing whom (or what intelligence lies behind the mechanism). The inability to resolve this question provokes a heightened state of awareness in the viewer.

Similar androids and automata followed. Pierre and Henri-Louise Jaquet Droz's android organ player also simulates breathing, and the captivating "spell" of the android's lifelike appearance is heightened through a series of small animations that embellish the organ playing but are not central to it: mechanized movements of the head simulate reading the sheet music, artificial eyes shift focus between the android's hands, the sheet music and the audience, and the performance ends with the android bowing to the audience.[12] Such programmed behaviors signal a preoccupation beyond scientific demonstration: they deliberately heighten the illusion that the android is self-aware and create an uncanny effect. The android behaves "as if" it had the faculties of sight and hearing and were conscious of its presence in front of an audience. Through these animations, the line between "real" automata becomes entangled with "sham" automata like Von Kempelen's chess player, which offered the illusion of mechanical life but was controlled by a hidden human operator. The boundary between the real and imaginary, and the line between animate and inanimate objects, becomes increasingly difficult to discern. This interplay of fascination (of the robot's remarkable human-likeness) and fear (that it may actually be alive) causes the experience of intellectual uncertainty that Jentsch and Freud will later identify as central to the Uncanny.

Following their appearance in scientific demonstrations, automata began to feature prominently in nineteenth century Gothic fiction, a genre that combines Romanticism with horror to elicit a pleasurable experience of terror. Gothic narratives frequently intertwine themes of the supernatural and the occult with figures of the double and automata: E.T.A. Hoffman's *The Sandman* (1816), Mary Shelley's *Frankenstein* (1818) and Edgar Allen Poe's short stories (*Oval Portrait*, 1842) are notable instances of automata and robots in fiction,[13] and indicate a popular fascination with the Uncanny that predates Freud's essay. The link between the Uncanny and androids is exemplified in Hoffman's *The Sandman*, which centers on the figure of a female automaton and the obsession of the young man who mistakes it for a real woman. Hoffman was familiar with Vaucanson's automata

[11]Wood, G [30] p. 25.

[12]Cohen, John [6] Human Robots in Myth and Science, p. 88.

[13]Cohen, J [6].

and drew on illustrations and diagrams from Johann Christian Wiegleb's *Instruction in Natural Magic, or All Kinds of Amusing Tricks.*[14]

Interest in the Uncanny (and in Hoffman's *The Sandman* in particular) inspired psychoanalyst Ernst Jentsch to write *On The Psychology of the Uncanny*[15] in 1906. Jentsch proposed that the Uncanny arises from objects or situations that trigger intellectual uncertainty, such as when we have difficulty categorizing or explaining objects that defy or disrupt our expectations. Jentsch is not so interested in defining the essence of the Uncanny as he is with understanding the affective response in psychological terms, or "how the psychical conditions must be constituted so that the 'uncanny' sensation emerges."[16] Making the familiar strange, rendering the invisible visible, and linking strange objects of uncertain origin with automata and Gothic literature are the foundations upon which Freud launches his investigation of the Uncanny.

III. The Age of the Uncanny

> An uncanny effect is often and easily produced when the distinction between imagination and reality is effaced, as when something that we have hitherto regarded as imaginary appears before us in reality, or when a symbol takes over the full functions of the thing it symbolizes, and so on.
>
> Freud, *The Uncanny*[17]

Freud's essay *Das Unheimliche* is an important reference for twentieth century critical theory and discourse. Harold Bloom calls it "the only major contribution that the twentieth century has made to the aesthetics of the sublime,"[18] and Hugh Haughton observes, "It is not only a theoretical commentary on the power of strangeness, but one of the weirdest theoretical texts in the Freudian canon."[19] In her post-structuralist reading, Hélène Cixous argues that the act of reading Freud's essay itself provokes an uncanny awareness, calling the essay "less a discourse than a strange theoretical novel."[20] Originally published in 1919 in the psychoanalytic

[14]Wood, G [30] p. 33.

[15]*Zur Psychologie des Unheimlichen* was published in two installments in the *Psychiatrisch-Neurologische Wochenschrift* in two parts (25 Aug. 1906) and (1 September 1906). The essay is translated by Roy Sellars and was published in Collins R, Jervis J (2008) Uncanny Modernities.

[16]Jentsch, E [16] On the psychology of the Uncanny. In: Collins J, Jervis J (eds) Uncanny Modernities, p. 217.

[17]Freud, S [9] The Uncanny, p. 244.

[18]Bloom, H [1]. "Freud and The Sublime: A Catastrophe Theory of Creativity." *Psychoanalytic Literary Criticism*. Ed. Maud Ellman. New York: Longman Publishing. 182.

[19]Haughton, H [13] The Uncanny. p. xliii.

[20]Cixous, H [5] Fiction and its Phantoms. p. 525.

journal *Imago*, Freud's essay investigates the "common core" of what makes certain objects, experiences or phenomenon appear uncanny rather than merely frightening. The essay was first translated into English by James Strachey (in collaboration with Anna Freud) and published in 1925 as *The Uncanny*.[21]

In his efforts to identify "that class of the frightening" unique to the Uncanny, Freud considers a range of objects and experiences drawn from literature to construct an aesthetics of the Uncanny. His inability to structure a unified theory says much about the elusive nature of the Uncanny and its entanglement with aesthetic philosophy, psychology and literary theory. The essay begins with a lexical index of the German word *unheimlich*, through which Freud concludes that *heimlich* belongs to two distinct—but not contradictory—sets of ideas: that which is familiar and agreeable and that which is concealed or hidden.[22] Through usage, Freud argues, *unheimlich* gradually became synonymous with the second meaning of *heimlich*, leading him to assert that "everything is *unheimlich* that ought to have remained secret and hidden but has come to light."[23] Armed with this definition, Freud offers a reading of *The Sandman* that connects the Uncanny with the subconscious and repressed desires.

Freud's interest is what the Uncanny reveals about key psychoanalytic concepts such as repression, castration anxiety, narcissism, the death instinct, involuntary repetition and wish fufilment. In his reading of *The Sandman*, Freud skips over the figure of the automaton and instead focuses on the Sandman of the title—the mysterious figure who never appears in the story and is believed to tear out children's eyes. For Freud, *The Sandman* is not about intellectual uncertainty but about fear of ocular castration, itself a symbol of repressed castration anxiety. According to literary theorist Samuel Weber, Freud's theme of ocular castration is not rooted in fact or experience ("the actual moment of non-perception"), but rather signifies a "restructuring of experience, including the relation of perception, desire and consciousness in which the narcissistic categories of identity and presence are riven by a difference they can no longer subdue or command."[24] This reading would suggest that the Uncanny is not necessarily about "not-seeing" but rather about heightened perception triggered by an object or phenomena. In other words, the Uncanny is triggered by objects or experiences that provoke the awareness of awareness.

Freud insists that a general theory "should differentiate between the Uncanny that we actually experience and the Uncanny that we merely picture or read about."[25] For Freud, this distinction uniquely positions creative writers and artists

[21]Freud, S [9] The Standard Edition of the Complete Psychological Works of Sigmund Freud.' XVII (1917–1919): *An Infantile Neurosis and Other Works.*

[22]Freud, S [9] p. 224.

[23]Freud, S [9] p. 225.

[24]Weber, Samuel [29] p. 217.

[25]Freud, S [9] p. 247.

to evoke or avoid the Uncanny in their works. For Freud, fiction is "more fertile province than the Uncanny in real life, for it contains the whole of the latter and something more besides, something that cannot be found in real life."[26] In art, the artist may "select his world of representation so that it either coincides with the realities we are familiar with or departs from them in what particulars he pleases."[27] Freud links the Uncanny to the perceptual stance we adopt towards works of fiction: "we adapt our judgment to the imaginary reality imposed on us by the writer, and regard souls, spirits, and ghosts as though their existence had the same validity as our own has in material reality." Artists, in Freud's view, provoke the Uncanny by exaggerating or distorting reality, or by staging events or experiences that could never occur in real life. The artist thereby re-exposes the viewer

> [...] to the superstition which we have ostensibly surmounted; he deceives us by promising to give us the sober truth, and then after all overstepping it. We react to his inventions as we would have reacted to real experiences; by the time we have seen through his trick it is already too late and the author has achieved his object.[28]

The deliberate exaggeration or distortion of reality for artistic purposes relates to the strategy of defamiliarization caused by optical instruments that rendered the invisible visible.[29] For Freud, the Uncanny occurs when strange or fantastic objects - or the experience of objects - depicted in fiction are experienced as real, so that we come to regard these aberrations with the same validity as our own material reality.

Freud's interest in the Uncanny coincides with the advent of machine culture in the early twentieth century. The proliferation of electrical machines in manufacturing, war and medicine elicited contradictory responses from the artistic avant-garde. Artistic responses ranged from glorification of the machine and its potential to liberate humans (the Futurists), celebration of the machine as the harbinger of social progress (the Constructivists), to profound fear and anxiety about the oppressive and destructive potential of machines (the Expressionists and Dadaists).[30] Among the visual arts, sculpture proved fertile ground for exploring the Uncanny effects of mechanization. This is partly due to sculpture's position as the "most literally and rawly material of art forms"[31] and the contradictory responses provoked by sculptural representations of the human form. In *Compulsive Beauty*, Hal Foster identifies the Uncanny as the defining concept for Surrealism, linking art works by

[26]Freud, S [9] p. 249.

[27]Freud, S [9] p. 249.

[28]ibid. p. 251.

[29]Defamiliarization is also a key concept in twentieth century art criticism, and informed visual art: Viktor Skhlovsky [27] uses the Russian word *ostranenie* while Brecht refers to the *Verfremdungseffekt* or Alienation effect.

[30]Jochum, E [16] Deus Ex Machina, p. 84.

[31]Potts, A [24] Dolls and things, p. 355.

Breton, Bataille, de Chirico, Max Ernst and Hans Bellmer in the 1920s and 1930s to Freud's essay. According to Foster, the Surrealist interest in the Uncanny reflects

> a concern with events in which repressed material returns in ways that disrupt unitary identity, aesthetic norms, and social order...[S]urrealists not only are drawn to the return of the repressed but also seek to redirect this return to critical ends.[32]

The Surrealist preoccupation with the human form, wax figures and other artificial figures created a vogue for "mannequin art" in the 1930s, a legacy which continues in contemporary figurative sculpture. The 1920s and 1930s also witnessed the advent of motor-driven sculptures and mechanical art such as Alexander Calder's kinetic mobiles and László Maholoy-Nagy's *Light Space Monitor* (1922–1930), artworks that explore the intersection of sculpture and mechanical motion through non-figurative, non-representational forms. These early non-anthropomorphic art works laid the ground for later experiments by Jean Tinguely and Julio Le Parc, among others.

It is worth remembering that Karl Capek's science fiction melodrama *R.U.R.* (Rossum's Universal Robots)—the play that first introduced the term "robot"—was published 1920, one year after the publication of *The Uncanny*. The dystopian play dramatizes the destruction of human civilization by humanoid robots designed for industrial manufacturing. The play taps into fears about the inability to understand or control the internal mechanisms that govern machines, and dramatizes human fears concerning mechanized labor. During the same period, abstract paintings by George Grosz (*Heartfield, the Mechanic*, 1920; *Daum marries her pedantic automaton*, 1920) imagined artful assemblages of the man-machine, while kinetic sculptures and machine art (Tinguely's *Radio Drawing*, 1962, Edward Paolozzi's *St Sebastian No. 2*, 1957, and Ernest Trova's *Study Falling Man*, 1966) flourished. These art works set the stage for the development of robotic art in the 1960s and 1970s.

IV. The Uncanny Valley

Man is a robot with defects.

Emile Cioran

In 1970 Mori published *Bukimi no tani gensho* in a special issue of the trade journal *Energy* titled "Robots and Thought." The premise of Mori's essay is well known: human beings have an innate affinity for inanimate objects that look human-like, but if the object becomes too lifelike without actually being alive, this affinity quickly turns to fear or repulsion. Mori maps the relationship between affinity and human likeness on a graph, where the horizontal axis is the degree

[32]Foster H [8] Compulsive Beauty, p. xvii.

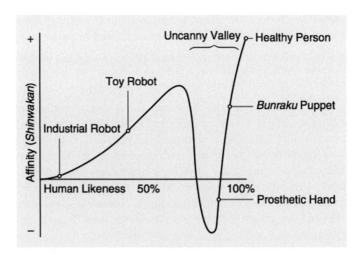

Fig. 2 The Uncanny Valley graph first appeared in Mori's essay in 1970. The graph illustrates Mori's ideas about how humans perceive robots: human beings have an innate affinity for objects shaped like humans, but if the object becomes too lifelike without actually being alive, this affinity quickly turns to fear or repulsion. (Graph translated and reprinted with the permission of Karl F. MacDorman)

of an object's similarity to a living human and the vertical axis is the degree of affinity humans have for a given object (Fig. 2). Mori posits a non-linear function with a sharp negative extreme (loss of affinity) as likeness increases beyond a critical point (where phenomena start to appear "too close for comfort"). Drawing on examples from popular culture (puppet theatre, toy robots) as well as medical and industrial robots, Mori echoes Freud's catalogue of objects and experiences drawn from fiction and real-life. Citing his prior work with realistic, moving prosthetic hands, Mori states that the Uncanny effect is amplified with movement, which steepens the curves of the Uncanny Valley (Fig. 3).

Mori considers functional and aesthetic approaches to design:industrial robots typically have designs based on functionality while toy robots and prosthetics focus primarily on appearance. Mori's concept of affinity is rooted in the popularity of human-shaped toys and puppets and the pleasure we derive from objects that look humanlike. Mori cites the human tendency to become absorbed in toys and puppets and our willingness to suspend disbelief and engage in imaginative play. Puppets, Mori states, are not inherently uncanny because we view them at a distance [33]: this critical distance acknowledges the perceptual stance reserved for works of art or fiction. Like Freud, Mori acknowledges that objects in fiction may be experienced as real or true and endowed with an artificial life, so long as that reality does not threaten our own material reality.

[33]Mori, M (1970) The Uncanny Valley, p. 99.

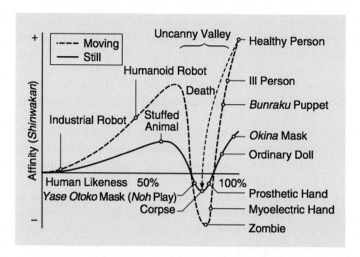

Fig. 3 Mori's second graph illustrates the effect of movement on the Uncanny Valley. The presence of movement amplifies the curves of the graph, suggesting that human perception is highly influenced by movement. (Graph translated and reprinted with the permission of Karl F. MacDorman)

Mori's essay coincides with the 1970 International World Exposition (*Expo'70*) held in Osaka, Japan. The theme of *Expo'70*, "Harmony and Progress for Mankind," highlighted the country's social and economic recovery in the wake of the World War II and sought to strengthen Japan's international reputation as a world leader in innovative manufacturing and electronic technologies. Mori—then a professor at the Tokyo Institute of Technology—advises robot designers to avoid making robots that appear too humanlike. Mori's observations are tied to his own childhood experiences with wax figures and mannequins and his later research on electronic prosthetic hands.[34] Mori briefly touches on whether the Uncanny is somehow related to human survival instincts, but he does not elaborate on this point. Although he makes no direct mention of then-contemporary trends in cybernetic and robotic art, the timing of the article with *Expo'70* (which featured numerous robotic art works) suggests that Mori was likely aware of trends in robotic art and popular interest in robots. Reading Mori's essay within the broader cultural framework of visual art and engineering research suggests how the notion of the Uncanny evolves in relation to new technologies and cultural trends.

There were few active research projects to build realistic humanoid robots in the 1970s, but the wish to develop an artificial human has long been a goal of robotics research.[35] Even though there were no realistic humans robots at the time, advancements in visual art and sculpture demonstrated the possibility of

[34]Kageki, N [18] An Uncanny Mind, p. 112.

[35]Mori, M [21] p. 98.

constructing realistic, lifelike replicas that could pass—even momentarily—as authentic humans. Sculptures by George Segal (*The Dinner Table*, 1962), Frank Gallo (*Walking Nude*, 1967) and John D'Andrea (*Couple* 1971) raised the threshold for the representational uncanny in visual art. Human-scale statues reproduce human anatomy in precise detail and provoke aesthetic defamiliarization that renders the human body simultaneously both familiar and unfamiliar. Techniques in photorealism (or *hyper-realism*), reignited the debate about realism and representation in art. Here, the Uncanny emerges from the evocative and unflinching look at the everyday in three dimensions—or what art historian John Welchman calls a "surplus of counterfeit and *trompe l'oeil* illusionism." The voyeuristic sculptures signal a preoccupation with sex and death, the haunting double, and erotic desire—all hallmarks of the Freudian Uncanny. Like death masks, preserved corpses and other *memento mori*, these art works recall deathly images and deliberately provoke anxiety about what separates the living and the dead. It is not a huge leap to imagine how these artistic techniques could be combined with mechanisms and computational control to create realistic, moving androids.

The field of animatronics developed in the 1960s and 1970s, combining new techniques in figural sculpture with robotic actuation entertainment and medical training robots. Six years prior to the publication of Mori's essay, Disney engineers unveiled a life-sized, walking and talking animatronic Abraham Lincoln at the Illinois State Exhibition at the New York World's Fair,[36] and in 1967 researchers at the University of Southern California School of Medicine developed a realistic, life-size plastic dummy for training medical students. Like their eighteenth century counterparts, medical androids simulated biological behaviors that corresponded with real patient symptoms, and researchers speculated on future humanoid robots capable of sweating, bleeding, and displaying evermore realistic behaviors.[37] In art historian Jack Burnham's view, animatronics display a "carnal anthropomorphism of plastic and electronics" that indicate the "return the humanoid robot to a place of competition with other visual mass media."[38] We do not suggest that Mori was aware of these trends in visual art (animatronics do not feature on his graph), but we do find relevance in the contemporaneity of Mori's theory with the trend of photorealism in sculpture and entertainment robots. Like androids in previous centuries, robots in fiction and their real-life counterparts inspire cultural fascination and fear surrounding the dream and threat of new (or imagined) technologies.

Mori's essay coincides with other high-profile events that merged art and robotics, such as the *9 Evenings: Theatre and Engineering* convened by Billy Klüver,

[36]Burnham, Jack [3] Beyond Modern Sculpture, p. 323.

[37]Burnham, J [3], p. 324.

[38]Burnham, J [3], p. 323.

Fred Waldhauer, Robert Rauschenberg, Robert Whitman in New York (1966) and *Cybernetic Serendipity* in London (1968), which featured many robotic art works. These events were venues for non-anthropomorphic art works like Edward Ihnatowicz's *Senster*, Jean Tinguely's painting machines, Nam June Paik's *Robot K-456* and Nicholas Schöffer's *CYSP I* are deliberately non-anthropomorphic and shift the focus from representational issues to questions of agency and behavior.[39] Interactivity and interest in the relation between objects demonstrates the "performative turn" in visual art that deliberately blurred the lines between visual art and performance[40]

Robots and popular culture intertwine in Japan at the very moment Mori writes the *Uncanny Valley*. The *manga* series *Astro Boy*—based on the adventures of a humanoid robot—was published between 1952 and 1968 and inspired a television series in 1963. The author of the series, Tezuka Osamu, designed the Fujipan Robot Pavilion for *Expo'70* which featured imaginative robots that dramatized a future of humanoid robots in a wide range of settings. Another *Expo'70* exhibit brought together international artists and engineers: *EAT* members Robert Breer and Billy Klüver collaborated with David Thomas of Pepsi Cola to design the Pepsi pavilion dome in Osaka, which was covered by a fog sculpture by Fujiko Nakaya.[41] The dome was surrounded by Robert Breer's self-propelled styrofoam *Floats*, six-foot white sculptures that moved around the perimeter of the dome and displayed "evidences of social behavior."[42] While Mori may have been unfamiliar with trends in animatronics and photorealistic sculpture, he was likely familiar with these robotic art works shown in his native Japan.

The first English translation of Mori's essay appeared eight years after the original essay was re-published in Jasia Reichardt's book *Robots: Fact, Fiction, and Prediction* (1978). Reichardt (who curated *Cybernetic Serendipity* and was familiar with the artists and art works shown at *Expo'70*) credits her friend and collaborator Kohei Sugiura with introducing her to Mori's essay and providing her with "otherwise quite inaccessible Japanese material,"[43] including a summary of Mori's article and illustrations. We contacted Reichardt about the translation of *Bukimi no tani gensho* into the English "Uncanny Valley"—a translation that invites obvious parallels with Freud's essay. Reichardt was unable to recall who was responsible for the first translation of Mori's essay.[44] Her summary was the only translation available until Karl MacDorman, professor of Human-Computer Interaction at Indiana University, translated Mori's complete essay in the early 2000s. *The Uncanny Valley* was retranslated by MacDorman and Norri Kageki for the IEEE

[39]Bown, J [2] The Machine as Autonomous Performer, p. 77.

[40]See Goldberg, R [11] and Fischer-Lichte [7] for further discussion.

[41]Packer [23] Future Cinema, p. 145.

[42]Burnham, J [3], p. 354.

[43]Reichardt, J [25] Robots: Fact, Fiction and Prediction, p. 4.

[44]Jasia Reichardt (2014) personal email message to authors.

Robotics and Automation Magazine in 2012. Mori's essay continues to be an important reference for artists, engineers and animators working across many disciplines and has become increasingly relevant in light for contemporary research in humanoid robotics.

For her own part, Reichardt advocates for a tighter integration between robotics research and art practice, and she speculates that "Innovation in the field of robotics could well come from art as well as from industrial robotics because the goals of art are not clearly defined."[45] Whereas industrial robots developed by engineers may provide solutions through the use of functional or multipurpose robots,

> it will not deal with effects, illusions or emotive principles which belong to art. Art, which results in physical objects, is the only activity that represents the half-way house between the regimentation of technology and the pure fantasy of films and literature; and only in the name of art is a robot likely to be made which is neither just a costume worn by an actor, nor an experimental artificial intelligence machine, nor one of the many identical working units in an unmanned factory.[46]

Robotic art helps us to understand the shifting ground of the Uncanny: we witness how artists of every period explore the boundaries and slippages between humans and machines. Increasingly this exploration happens in the register of the experiential rather than the representational uncanny.

V. *The Telegarden* and Other Oddities

In this section we consider three non-anthropomorphic robotic art works: *The Telegarden* (1995), *Six Robots Named Paul* (2011) and the *Blind Robot* (2013). These interactive works direct attention away from appearance towards the physical actions they enable. The robots function as catalysts for exploring our physical and psychological relationships with the material world. In these works, material artefacts play a crucial role in provoking the Uncanny by offering evidence of the robot's agency. Similar to the optical instruments and automata found in the *Wunderkammer*, these material artefacts become aesthetic objects in their own right, and can be understood as material representations of self-understanding and knowledge. The artworks invite us to look beneath the "skin" or outward appearance and observe the interaction between humans and the physical world. The experiential uncanny is triggered by the spectre of uncertainty that arises when we are no longer sure what is animate or inanimate, authentic or a work of fiction.

The three art works discussed in this section are non-anthropomorphic: they do not approximate the human form but make familiar human activities—gardening, drawing, observation through touch—unfamiliar using robotics. Each one shares

[45]Reichardt, J [25] p. 56.
[46]Reichardt, J [25] p. 56.

a concern with ocularism and provokes uncertainty by staging remote and intimate encounters between humans, machines and their environments. The artworks eschew the representational uncanny and provoke the experiential uncanny by deliberately exploiting the ambiguity of agency and authenticity The material artefacts become signs of the robot's agency and assume a level of critical importance in our attempts to discern reality from fiction.

The Telegarden (1994)

The Telegarden is a telerobotic art installation created by Ken Goldberg with Joe Santarramana and a team of collaborators including Steven Gentner, Jeff Wiegley, Carl Sutter and George Bekey at the University of Southern California (Fig. 4). Combining web cameras with a telerobotic arm operated via the Internet, *The Telegarden* was the sequel to an earlier installation called the *Mercury Project* (1994), which was recognized as the first robot controlled over the browser-based

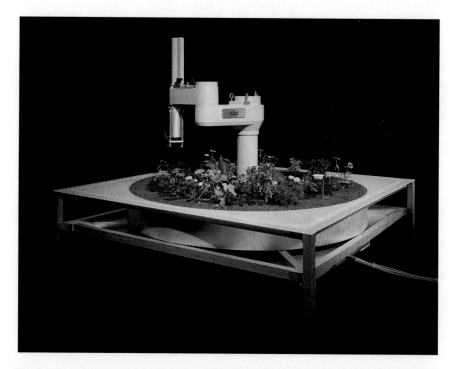

Fig. 4 *The Telegarden* (1995–2004, networked art installation at Ars Electronica Museum, Austria.) Co-directors: Ken Goldberg and Joseph Santarromana Project team: George Bekey, Steven Gentner, Rosemary Morris Carl Sutter, Jeff Wiegley, Erich Berger (Photo by Robert Wedemeyer)

Internet.[47] Both projects were designed as engineering prototypes and art installations that questioned the widespread exuberance for technology in general and the Internet in particular. *The Telegarden* juxtaposes the historical and natural pace of planting and cultivation with the desire for "instant gratification" and immediacy promised by the Internet.

In *The Telegarden*, an industrial robot was installed in a 3 m × 3 m circular aluminum container filled with eighteen inches of soil. Custom software allowed anyone on the Internet to visit the garden, and by clicking in a web browser to move the robot and digital camera on the robot's end effector. Visitors could register for a password and then participate first by watering the garden and later by planting their own seeds. Visitors were reminded that unless they returned regularly to water their plants, the plants would not germinate.[48] *The Telegarden* went online in June 1995 and attracted over 10,000 participants and more than 100,000 viewers. In September 1996, *The Telegarden* was moved to the lobby of the Ars Electronica center in Austria, where it remained online 24 hours a day until it was decommissioned in 2004. User activity was recorded in logs so that members could be self-governing: users could plant, water, and monitor the progress of seedlings via the delicate movements of the industrial robot arm. The garden was a metaphor for the promise of new communities made possible by the Internet; it also raised philosophical questions concerning the nature of tele-robotics and introduced the concept of *telepistemology*—the study of knowledge acquired at a distance.[49]

Just as seventeenth century optical instruments brought forth new ways of seeing, the combination of the Internet, the World Wide Web interface, webcameras, and robots created new modes of viewing and the ability for remote observation and interaction. Just as the telescope and the microscope made familiar object unfamiliar, telepresence (or mediated agency) heightens the potential for doubt concerning the authenticity of objects or experiences, especially when actions are mediated through the Internet. *The Telegarden* triggered the Uncanny because it called attention to experiences in remote locations and introduced uncertainty about the "here and now."[50] Although *The Telegarden* was not anthropomorphic, it provoked an awareness of awareness.

Doubt or uncertainty concerning the authenticity of an object—its aliveness or presence as indicated by appearance, motion, or representation—is central to the definition of the Uncanny. While Jentsch describes the effect as the experience of "intellectual uncertainty," Freud and Mori define the Uncanny in terms of emotional uncertainty: while we might know intellectually that an android is only a machine and not alive, we can be momentarily convinced (or deceived) into

[47]Goldberg K, Mascha M, Gentner S, Rothenberg N, Sutter C, Wiegley J [20] Desktop Teleoperation via the World Wide Web. *International Conference on Robotics and Automation.*

[48]http://www.ieor.berkeley.edu/~goldberg/garden/Ars/.

[49]Goldberg, K [10] The Robot in The Garden.

[50]Kusahara, M [19] "Presence, Absence, and Knowledge in Telerobotic Art", p. 206.

granting the object fictive life. Alternately, through defamiliarization or distancing, objects or figures that we know to be real may appear unreal or fictitious, creating uncertainty about the object's true nature and threatening our subjectivity. *The Telegarden* evokes the Uncanny on the second count: the spectre of uncertainty arises when we become uncertain that our online actions have consequences in the real world. Questions of agency and authenticity signal larger questions concerning telepresence and the technological uncanny:

> The Telegarden is real, but (unlike a traditional Commons) we never actually see, feel, or hear the garden itself—It is too far away for that. Our knowledge of the Telegarden is technologically mediated, and that introduced a disturbing doubt: How do I know that the Telegarden really exists? Perhaps the *Telegarden* website is simply sending me prestored images of a garden that no longer exists. How do I know that the Telegarden community exists? I *think* the Telegarden provides a high-tech common where I can interact with other users. But how do I know that these users really exist—that they are not fabrications of the artist, or even mere "virtual" personas cleverly programmed to mimic on-line chat?[51]

Like Kempelen's chess-playing automaton, *The Telegarden* is uncanny because it creates uncertainty about the relation between the real and the virtual: Do our actions in the virtual world have actual consequences in the real word? If so, how can we be sure? The *Telegarden* breaks new ground in our understanding of the Uncanny by insisting on veracity while problematizing our ability to verify the garden as authentic.

Six Robots Named Paul (2012)

In 2012 Patrick Tresset presented this interactive robotic art installation at the Merge Festival in London[52]. Gallery visitors were invited to have their portrait drawn simultaneously from different points of view by robots positioned throughout the gallery.[53] The artwork is based on the observational drawing robot called *Paul* designed by Tresset in collaboration with Frederic Fol Leymarie and the AIKon II project at Goldsmiths University in London. *Paul* was first exhibited in June 2011 at the Tenderpixel Gallery in the UK and has produced more than 1000 unique drawings, 200 of which have been purchased and one of which is part of the collection at the Victoria and Albert Museum in London. In 2014, Tresset

[51]Kusahara, M [19] p. 206.

[52]https://www.youtube.com/watch?v=kvfKhEjTBEI

[53]While the title suggests six robots, in actuality there were only five robots present at the exhibit. This created an unintentionally uncanny effect caused by the incongruity between the title and the set up. In his presentation in Karlsruhe, Tresset stated the actual reason was coincidental: he had intended six robots but only five were available and the project had already been advertised by the festival.

Fig. 5 The robot *Paul* (Patrick Tresset) uses computation and robotic technologies to emulate the drawing activity with an emphasis on portrait sketching. The pictured exhibition at Ars Electronica, *5 Robots Named Paul* was installed in the Gothic cathedral in a scene deliberately reminiscent of an authentic artist's studio. (Photo by Steph Horak)

exhibited the work under the title *Five Robots Named Paul* at the Ars Electronica festival in Linz (Fig. 5).

Paul uses computation and robotic technologies to emulate the process of portrait drawing. *Paul* is not a telerobotic system but an autonomous machine that uses computational programming and visual feedback to make drawings. Like gardening, drawing is considered a uniquely human activity and a powerful symbol of human civilization and culture. A machine that emulates an intimate, creative activity like drawing—not according to a pre-determined program but drawing "from life" as a human artist does—raises issues of agency and authenticity that echo those of the *Telegarden*. Unlike Jaquet-Droz's draughtsman automaton that could draw several pre-determined sketches, the object of aesthetic orientation here is neither the robot nor the software program that controls the robot. Rather, the object of aesthetic interest is the drawing activity itself—the relation between artist and subject—that is reproduced through a staged encounter in a scene reminiscent of an artist's studio.

As with *The Telegarden*, agency and authenticity are central to the experiential uncanny. The robot cannot prove its drawing capabilities without the material portrait, but even this tangible proof raises uncertainty: if the robot's actions are determined by a computational program, and all the robots run the identical program simultaneously, how do we account for the differences in the portraits (Fig. 6), the different length of times each robot requires to complete the portrait, and the artistic likeness that emulates the aesthetics of human drawing? Can we believe our

Fig. 6 The individual drawing robots, each named *Paul*, use identical software to produce unique portraits. The distinct style is influenced by differences in the camera lens, camera angle and distance of the robot from the sitter. (Images printed with the permission of Patrick Tresset)

own eyes? The material artefact (portrait on paper) demands that we grant the portrait the same validity one drawn by a human artist. Over the course of the week-long installation in Austria, the exhibition space gradually transformed from an artist's studio into a gallery.

Like *The Telegarden*, *Six Robots Named Paul* evokes the Uncanny in a manner wholly distinct from anthropomorphic art works. Tresset refers to *Paul* as an "obsessive drawing entity" that "does not attempt to emulate human appearance."[54] The characterization of the robot's behavior as "obsessive" evokes the repetition compulsion drive Freud associates with the Uncanny,[55] and the multiplicity of robots used in this particular installation—faceless drawing machines masquerading as artists under a single name—recalls the double theme. *Six Robots Named Paul* further heightens the feeling of the Uncanny through specific devices

[54]Tresset P, Leymarie F [28] Portrait drawing by Paul the robot, p. 350.

[55]The robot will draw whatever object is positioned in front of the camera. On one occasion, part of the robot arm entered the field of vision which became part of the final sketch. Tresset quipped this might have been "the first instance of a robot self-portrait."

that create cognitive uncertainty. Like Jaquet-Droz's organ player, the robots are equipped with non-functional animations (Tresset calls them "pretenses") that do not impact the drawing process but are used solely to persuade the spectators that Paul is "more alive and autonomous than it actually is." Paul's lifelike behaviors reinforce the psychological relationship between the robot and the sitter: Paul exhibits artistic mannerisms or gestures we associate with optical behaviors of humans—adjusting the camera "eye" to regard the face of the sitter with multiple saccades and fixations The Uncanny response is not elicited by the machinic or unthinking properties of the machine but rather by the possibility of sentience[56]. When a sitter becomes aware that they are being watched by the robot (or several robots), they experience a sense of insecurity and uncertainty of how they should relate to the robot/s. Just as breathing androids provoked fear and fascination, the possibility of a robot that apprehends us the way a human artist might provokes the experiential uncanny.

As with *The Telegarden*, web cameras and computer vision technologies lend themselves to ambiguity and uncertainty because they problematize the relation between subject and object (Who/what is being observed? Who/what is observing?). *Six Robots Named Paul* engages themes of ocularism and perception by further troubling this distinction. Traditional relationships between artist/model/ beholder break down as the museum visitor becomes both object (the model for the robot drawing) and subject (perceiving and interpreting the robot's actions and beholding the portraits on the wall), while the human artist assumes the role of a technical assistant in service to the robot artist. The mutual engagement between machine and human suggests a type of interactive, two-way communication between the human subject/object and the machine. Interactive art works like this one scrutinize how we relate to technological tools with increasing degrees of agency.

The Blind Robot (2013)

The *Blind Robot* is a robotic art installation that stages human-robot interaction as an aesthetic experience. The *Blind Robot* was commissioned for the Robots and Avatars project by *body > data > space* and the National Theatre in the UK and developed by Louis Philippe Demers at Nanyang Technological University in Singapore (Fig. 7). The artwork consists of a set of two-mechanical arms mounted onto a base and bolted to a table. The arms and hands are articulated plastic joints fashioned after human limbs. Metal poles are equipped with servo motors and wiring for controlling the motions and vaguely suggest the human skeleton and nervous system, but the overall aesthetic is more machinic than human. Visitors are invited to interact with the artwork by sitting in a chair opposite the robot and

[56]Tresset P, Leymarie F [28] p. 351.

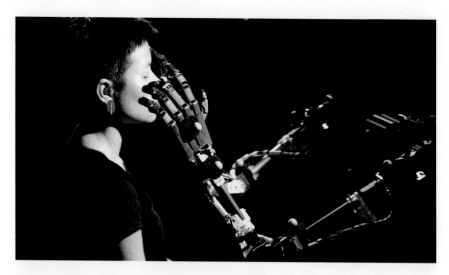

Fig. 7 The *Blind Robot* (Louis Philippe Demers) consists of a set of two-mechanical arms mounted onto a base and bolted to a table. Visitors are invited to interact with the robot by sitting in a chair as the robot delicately explores the sitter's face and upper body in a manner that recalls how blind humans supposedly use touch to recognize persons or objects. (Photo by Louis Philippe Demers)

engaging in "non-verbal dialogue" or physical touch. The robot delicately explores the sitter's body, mostly the face, in a manner that recalls how blind humans supposedly use touch to recognize persons or objects. Positioned directly behind the robot is a portrait-sized mirror that allows visitors to observe themselves during the interaction. Some exhibitions feature a video display monitor facing the visitor that provides a visual rendering of what the robot "sees"—ostensibly providing "a window to the soul of the robot."[57] Theatrical lighting and dark curtains create a heightened feeling of the Uncanny by obscuring the view of the robot and heightening the awareness of the physical sensations (Fig. 8).

Motivated partly by research in social robotics and human-robot interaction, the *Blind Robot* proposes a platform for studying the degrees of engagement—be they intellectual, emotional or physical—that arise when social robots and humans interact through touch.[58] Direct physical contact with a robot is still an exceptional and unique experience for many. The artwork raises issues surrounding proxemics, trust, and predictability which are important factors in social robotics research. The artwork dramatizes an intimate, physical interaction between a human and a robot in order to defamiliarize the physical experience of the human body in the world.

[57]http://www.robotsandavatars.net.

[58]http://www.processing-plant.com/web_csi/index.html#project=blind.

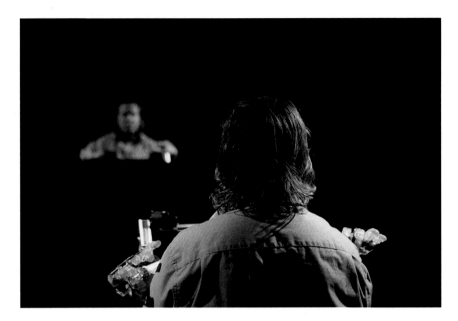

Fig. 8 *The Blind Robot*. Positioned directly behind the robot is a portrait-sized mirror that allows visitors to observe themselves while being touched by the robot. Theatrical lighting and dark curtains create a heightened feeling of the Uncanny by obscuring the physicality of the robot and allowing the viewer to focus their awareness on the experience of being touched. (Photo by Louis Philippe Demers)

The *Blind Robot* is machinic and non-realistic: the headless, torso-less, leg-less robot is decidedly non-anthropomorphic. But the deliberate motions and gestures of the machinic arms and articulated fingers create the illusion of an intentional agent. The aesthetic conceit of the artwork attributes a human malady (blindness) to a non-human object, recalling Norman White's *Helpless Robot* (1987) through the reversal of traditional associations of humans as frail or inferior to mechanically superior robots. The artwork directs attention away from the robot design to the physical actions it performs. Like *Paul*, the *Blind Robot* hinges on a physical encounter that destabilizes the traditional subject-object relationship by placing the visitor at the center of the interaction. Once again, the theme of ocularism is central: without eyes to see, the *Blind Robot* recalls Freud's theme of ocular castration and provokes fears about the unknowable processes that control the robot. Theatrical lighting directs attention away from the robot towards the interaction, which is reflected back to the viewer in the mirror opposite them. The spectator experiences a heightened sense of awareness - an awareness of awareness - that underscores the connection between narcissism, the double and the Uncanny. In his presentation at the *Art and Robots* workshop in Karlsruhe, Demers said that the goal of the artist is "to create a situation that goes beyond the context of the object." In other words, the artist's job is to help the object transcend its objectness. The *Blind Robot* succeeds by creating a context for an intimate encounter between a human and robot.

VI. Beyond the Valley

Our investigation into the secret history of the Uncanny lead us into aspects of art and robotics that are both familiar and unfamiliar. We conclude that the Uncanny in visual and interactive art can occur in two registers: the representational and the experiential. The representational uncanny is characterized by figurative, anthropomorphic representations that deliberately provoke a strange mix of fear and wonder. Static works by Ron Mueck (*Dead Dad* 1996), Toni Matelli (*Sleepwalker* 1997), Sam Jinks (*Pieta* 2007) and the subversive oeuvre of Paul McCarthy recuperate the Surrealist interest in mannequins and the avant-garde abstractions of the human form through the use of defamiliarization, the double and the grotesque. Anthropomorphic robots, such as the lifelike humanoid robots on display at the National Museum of Emerging Science in Miraikan, Japan and Jordan Wolfsen's *Female Figure* (featured at Art Basel in 2014) tap into the representational uncanny through photorealism and verisimilitude.

The experiential uncanny shifts attention from the representational figure of the robot to the physical actions it performs. In these artworks, robots interact with spectators and the material world in novel ways that deliberately provoke anxiety and uncertainty. In addition to the works discussed in this chapter, artworks by Stelarc, Zaven Paré, Shun Ito, Maywa Denki, Tim Lewis, Shiro Takatani, Masaki Fujihata, Ken Rinaldo, Chico MacMurtrie, Seiko Mikami and others create interactive experiences between robots and humans. In these artworks the robot is a catalyst for action, and the Uncanny arises from our desire and inability to discern the authenticity of the experience or determine the level of the robot's agency. While robot artworks might produce material artefacts, even these material proofs cannot always be trusted.

What unites *The Telegarden*, the *Blind Robot*, and *Six Robots Named Paul* is their ability to evoke the Uncanny despite their non-anthropomorphic design. The works do not mimic life, but rather mimic behaviors that we associate with living creatures. We yearn for proof and authentic markers before granting the robot agency. It is not enough to know that complex algorithms and machinery are capable of planting and cultivating a real garden, but our vision must be verified by tangible outputs—real plants fed by real water that sprout from real dirt. When we encounter the *Blind Robot* in a gallery, it matters little that the sightless robot lacks a head or computer vision; what matters is the physical interaction between real human skin and robotic hands. For *Paul*, the tangible portraits drawn on actual paper before our eyes verify both the encounter and the robot's agency. The portraits that accumulate on the walls gradually become part of the experience, assuring spectators that the robot is a real artist with a growing collection of works. Like the oddities and scientific instruments found in the *Wunderkammer*, material artefacts are testaments to authentic experiences and sights of knowing. Tangible objects speak to a communal encounter between robot and human— they are byproducts that authenticate and inscribe Uncanny encounters in the real world and help bridge the gap between the real and the virtual.

References

1. Bloom H (1982) Freud and the sublime: a catastrophe theory of creativity. In: Ellman M (ed) Psychoanalytic literary criticism. Longman Publishing, New York, pp 173–195
2. Bown O (2013) The machine as autonomous performer. In: Candy L, Ferguson S (eds) Interactive experience in the digital age. Springer, New York, pp 75–90
3. Burnham J (1968) Beyond modern sculpture. Penguin Press, London
4. Castle T (1995) The female thermometer: eighteenth-century culture and the invention of the uncanny. Oxford University Press, Cary
5. Cixous H (1976) Fiction and its phantoms: a reading of Freud's Das Unheimliche. New Literary History 7(3): 525–645
6. Cohen J (1966) Human robots in myth and science. George Allen & Unwin, London
7. Fischer-Lichte E (2008) The transformative power of performance: a new aesthetics. Routledge, New York
8. Foster H (1993) Compulsive beauty. MIT Press, Cambridge
9. Freud, S (1925) The uncanny. (trans Strachey J) In: The standard edition of the complete psychological works of Sigmund Freud. Hogarth, London, pp 217–252
10. Goldberg K (2001) The unique phenomenon of a distance. In: Goldberg K (ed) Robot in the garden. MIT Press, Cambridge, pp 2–20
11. Goldberg R (2011) Performance art: from futurism to the present. Thames and Hudson, London
12. Hagner M (1995) Enlightened Monsters. In: Clark W, Golinski J, Schaffer S (eds) The sciences in enlightened Europe. University of Chicago Press, Chicago, pp 175–217
13. Haughton H (2003) Introduction. In: Haughton H (ed) The uncanny, pp vii–lx. Penguin Books, London
14. ICRA (2013) Art and robotics: Freud's *Unheimlich* and the uncanny valley. http://uncannyvalley_icra2013.sssup.it. Accessed 28 June 2014
15. Jentsch E (2008) On the psychology of the uncanny (trans: Sellars R). In: Collins J, Jervis J (eds) Uncanny modernities. Palgrave Macmillan, New York, pp 216–228
16. Jochum E (2013) Deus Ex Machina: towards an aesthetic of autonomous and semi-autonomous machines. Dissertation, University of Colorado
17. Kageki N (2012) An uncanny mind. IEEE Robot Autom Mag 19(1):106–112
18. Kang M (2011) Sublime dreams of living machines. Harvard University Press, Cambridge
19. Kusahara M (2001) Presence, absence, and knowledge in telerobotic art. In: Goldberg K (ed) Robot in the garden. MIT Press, Cambridge, pp 198–212
20. Mascha M, Gentner S, Rothenberg N, Sutter C, Wiegley J (1995) Desktop teleoperation via the world wide web. In: IEEE international conference on robotics and automation, May 1995
21. Mori M (1970/2012) The uncanny valley (trans: MacDorman K, Kageki N). IEEE Robot Autom Mag 19(1):98–100
22. Onians J (1994) A short history of amazement. In: Onians J (ed) Sight and insight. Phaidon, London, pp 11–33
23. Packer R (2003) The Pepsi pavilion: laboratory for social experimentation. In: Shaw J, Weibel P (eds) Future cinema. MIT Press, Cambridge
24. Potts A (1994) Dolls and things: the reification and disintegration of sculpture in Rodin and Rilke. In: Sight and insight. Phaidon, London, pp 355–378
25. Reichardt J (1978) Robots: fact, fiction, and prediction. Penguin Books, New York
26. Schaffer S (1999) Enlightened Automata. In: Clark W, Golinski J, Schaffer S (eds) The sciences in enlightened Europe. University of Chicago Press, Chicago, pp 126–165
27. Shklovsky V (1965) Art as technique. In: Lemon L, Reis M (eds) Russian formalist criticism. University of Nebraska Press, Lincoln

28. Tresset P, Leymarie F (2013) Portrait drawing by Paul the robot. Comput Graphics 37(5):348–363
29. Weber S (2000) The sideshow: or, remarks on a canny moment. The legend of Freud. Stanford University Press, Stanford, pp 207–235
30. Wood G (2002) Edison's eve. Random house, New York

The Potential of Otherness in Robotic Art

Eleanor Sandry

Abstract This chapter compares and contrasts the creation of humanoid robots with that of non-humanoid robots, identifying assumptions about communication that underlie the designs and employing a range of communication theories to analyse people's interactions with the robots. While robots created in science and technology laboratories to communicate with humans are most often at least somewhat humanlike in form, those created as part of interactive art installations take a variety of forms. The creation of humanoid robots can be linked with ideas about communication that valorise commonality above all else, whereas robotic artworks illustrate the potential of otherness in interactions between humans and non-humanoid robots.

Introduction

Although not all robots are created with the aim of communicating with humans in mind, an increasing number are now being designed to care for, work with, and entertain people in a range of different places, including homes, working environments and public spaces such as art galleries. By analysing people's interactions with robots from the perspective of various branches of communication theory, alongside a consideration of the aims articulated by creators for their robots, it is possible to identify the presence of what might loosely be termed scientific and artistic conceptions of what it means to communicate, what being social constitutes and, therefore, how best to build a robot with which people want to interact. These scientific and artistic conceptions are not clear cut, or completely separable from each other, and should not be regarded as totally polarised. In spite of the

E. Sandry (✉)
Department of Internet Studies, School of Media, Culture and Creative Arts,
Curtin University, GPO Box U1987, Perth, WA 6845, Australia
e-mail: e.sandry@curtin.edu.au

© Springer Science+Business Media Singapore 2016
D. Herath et al. (eds.), *Robots and Art*, Cognitive Science and Technology,
DOI 10.1007/978-981-10-0321-9_9

imprecise nature of these categories, they are still helpful in explaining the wide range of interactive robot designs that have arisen across scientific, technological and artistic contexts.

Discussed below are a number of robots, ranging in form from the very human-like to the overtly other. The decisions made in creating these robots, as well as the interactions that people have with them, are analysed in relation to ideas about communication categorised using the framework developed by Robert T. Craig is his appraisal of "Communication Theory as Field" [8]. In exploring the presence of broadly scientific and artistic conceptions of communication, my focus is to iden-tify the potential of otherness in communication, a potential that is most clearly demonstrated by the non-humanoid robots that appear within art installations.

Creating Humanoid Robots

While a few designers follow a minimalist path when creating communicative robots [22], the majority of roboticists building robots designed to interact with peo-ple, either in research laboratories or as commercial products, argue that their robots need to be at least somewhat humanlike in form in order to communicate effectively [9]. Indeed, the humanoid robot has been described as "the Grail" of robotics and the pursuit of this goal leads some people to create robots that appear almost indis-tinguishable from humans [23]. This is particularly well illustrated by the work of David Hanson in the United States and Hiroshi Ishiguro in Japan. Both Hanson and Ishiguro have chosen to model a number of their robots on existing people, most famously the heads of Albert Einstein and Phillip K. Dick in the case of Hanson, whereas Ishiguro has created a Geminoid which is his own double, as well as one resembling his daughter. Moving away from the idea of 'recreating' a person, Hanson designed Jules for the Bristol Robotics Laboratory, a robotic head that was not based on a particular human individual. When creating this type of robot, the need to attain as close to humanlike appearance and behaviour, in particular through use of facial expressions and speech, is thought to be key in supporting people's interactions with the robot. As might be expected from their appearance and behav-iour, these humanoid robots are designed with the aim of making human interactions with them as close to human-human interactions as possible, and therefore easy to understand based on one's existing experience of communicating with others.

At the core of these designs is the assumption that making the robot look very humanlike improves its ability to fit into existing social structures and situations with which humans are already familiar. These robots are therefore framed quite clearly in terms of sociocultural theories for which communication is about the produc-tion, and the reproduction, of shared social understandings of the world and people's positioning within that world [5]. In addition, their ability to persuade or influence those with whom they are communicating, ideas emphasised within the sociopsy-chological tradition of communication theory, is judged to be vital [8]. These robots need to encourage people to think of them either as generically human, or, in the

case of Hanson's Einstein robot or Ishiguro's double, as representing a particular person in a believable way. The aim of the roboticist when creating a humanoid robot is to encourage people to treat the robot as they would another person and to draw them into communication that operates exactly like an exchange with a human.

The communication of these robots often involves the well-modulated use of a synthesised or recorded human voice, as well as the ability to show emotion through facial expressions. Although Ishiguro's robot double is sometimes teleoperated, allowing him to talk to people remotely 'in person', and Jules' speech often seems to be heavily scripted, the aim of this type of design is to create "robots that act and react virtually indistinguishably from their human counterparts" [17]. Hanson has stated that his long-term goal is to design robots that can evolve "into socially intelligent beings, capable of love and earning a place in the extended human family" [17]. Effective use of human spoken language is clearly a part of this process and, from the perspective of the cybernetic tradition of communication theory, success of this is most often judged in relation to accuracy in information transmission or exchange [8]. Given the importance of precision within a cybernetic process, this idea is closely linked with the semiotic tradition since, for human communication at least, the correct use of language is important in enabling the encoding and decoding of information as messages are relayed [8]. Designing robots that can speak clearly, and whose speech is supported by the use of appropriate humanlike facial expressions, is driven in part by the desire to reduce any potential for misunderstanding, which might be introduced by an unfamiliar communication style on the part of the robot. To use the cybernetic tradition's term, the aim is to reduce any 'noise' that might distract from a process of accurate information transmission.

The creation of humanoid robots as interactive partners clearly involves a great deal of artistic skill in perfecting their appearance and behaviour. However, the particular understandings of communication theory that shape the creation of humanoid robots are based on the assumption that communication success is founded on what communicators already have in common, and seeks to develop that commonality further. Whether communication success is measured in terms of the accurate transmission of information, the ability to maintain a persuasive influence, or the development and maintenance of shared social understandings in support of a cohesive culture, communication is framed as a process that can be perfected. This type of process has a correct outcome, against which the potential for ambiguity (supporting various interpretations) and misunderstanding is an undesirable risk that should be eliminated. When thought of in this rather idealised way communication can be said to be broadly 'scientific' in its aims.

Issues with the Pursuit of Commonality

The traditions of communication theory employed in the analysis above—sociocultural, sociopsychological, cybernetic and semiotic—complement one another in reinforcing the idea of the humanoid robot as like another human in a particular

context. The robot's machine otherness is understood to be something that has the potential to disrupt successful interactions with humans, and is therefore disguised as far as is possible. However, questions relating to how well striving to create a robot that closely resembles a human actually works do arise: the idea that encounters with very humanlike robots make some people uncomfortable being formalised in Masahiro Mori's concept of the "uncanny valley" [24]. Mori predicts that the familiarity people sense, and therefore their comfort with a robot, increases as its appearance becomes more humanlike. However, there is a point at which, quite suddenly, the robot is perceived as zombielike as opposed to humanlike. As attraction turns to horror, the sense of the robot as familiar and friendly drops away into a valley that Mori names "uncanny" thus highlighting its relation to Freud's use of this term to describe "that class of the terrifying which leads back to something long known to us, once very familiar" [14].

Some roboticists do not regard the uncanny valley effect as a long-term problem for humanoid robotics. Hanson, for example, argues that it is the aesthetic impact of the robot that is most important in shaping people's reactions. He therefore suggests that "any level of realism can be socially engaging if one designs the aesthetic well", using the term "path of engagement (POE)" to describe this "bridge of good aesthetic" [16]. This idea would seem to emphasise the art in creating realistic humanlike robots. However, as this chapter turns to consider human-robot interactions in art installations it becomes clear that some artists question whether people are discouraged to interact with things they perceive as uncanny, or simply as unfamiliar. In particular, artists may choose to challenge the boundaries of what is understood to be possible in communication by designing robots in a range of forms, often not pursuing anything resembling human form and therefore exploring the potential for very different paths of engagement between humans and overtly non-humanoid others.

In addition, a number of communications scholars have raised the question of whether assuming that success in communication is based on commonality, with the aim of increasing this commonality further, has an ethically desirable result [28, 29]. While Amit Pinchevski frames his argument as a critique against the "elimination of difference" [29], seeing this as a violence against the alterity of the other, John Durham Peters condemns perspectives on communication that valorise the "reduplication of the self" [28]. In human communication, ideas of reduplication and violence against the other through processes designed to eliminate difference are clearly undesirable, being linked with a general disrespect for others and their personal, cultural and social differences from the self. While worrying about violence against robotic others may seem a less important concern, the production of humanoid robots (as clear reduplications of the self at various levels) does reduce the possibility for people to come into contact with a variety of forms of robot, which might possess valuable new perceptual skills and motor abilities. It is therefore helpful that many of the robots designed and built by artists demonstrate the possibilities of non-humanoid form. These art installations push the boundaries of what is assumed possible in human communication by allowing people to encounter others whose alterity is overtly represented in their form and behaviour.

Other Faces in Robotic Art

Although the goals of a robotic art installation are often somewhat different from those for a robot created in a scientific or technological context, all robots designed to interact with humans must first attract peoples' attention, and likely aim to keep this attention for some period of time. In the section above, the idea that human- oid form is important in this process has been highlighted. In scientific studies of social robotics the ability to attract attention, and show where one's attention lies, is often used to justify the need for a robot to have eyes, whose gaze direction and movement can be recognised by humans in ways thought to encourage more mean- ingful interactions with the robot [2–4]. In art, Louis-Philippe Demers' work, Area V5, named after the section of the visual cortex thought to be important in per- ceiving movement, takes the idea of meaningful gaze to a new level, by inviting visitors "to experiment and establish a non-verbal dialog" with a wall fitted with artificial skulls containing a hundred "disembodied gazing eyes" [10].

In contrast with the attempts to create a familiar humanlike gaze embedded within a realistically humanoid robotic body, as seen in Ishiguro's Geminoid robots, Demers' artwork is explicitly meant to invoke an uncanny sensation as the disem- bodied eyes move in pairs to track visitors to the installation. Area V5's imple- mentation is designed to convey the idea that the visitor has been seen by the eyes, and through this communication attract a level of reciprocal attention. Indeed, the installation appears to fall very effectively into the uncanny valley, while nonethe- less encouraging visitors to develop a level of fascination with the artwork such that they play with the installation intent on provoking it to follow their movements [33]. Demers describes this work as "an artistic comment about scientific methodologies of approaching social robotics and the uncanny valley" [33]. Social roboticists and writers on the subject of social robotics often say that "a robot has to look friendly to be accepted" [33]. However, in the case of Area V5 there is a set of "dead skulls looking at you, but at the same time people play with this, they totally forget about the look" [33]. This installation shows that "to engage with the robot it doesn't have to be necessarily of a human appearance or even a beautiful human" [33].

As I have already explained, some communication theories can be associated with reducing, and eventually eliminating, the differences between communica- tors [29]. In contrast, Emmanuel Levinas' conception of communication places its emphasis on encounters between selves and others within which the recognition of, and retention of respect for, the alterity of the other is key. Levinas describes the encounter between self and other as "the face to face", during which, while they are brought into close proximity, an irreducible distance remains between them [19]. Within this explanation, Levinas' use of the terms proximity and dis- tance are less about physical positioning and more about paying close attention to the other, while also acknowledging the continued presence of their specific differences. Communication in such a relation is therefore not about identifying elements of commonality and sameness; instead, the interaction between self and other is founded in recognition of the difference, or distance, between them.

Levinas himself suggested that only humans could reveal this type of face, denying animals or objects the ability to take part in this level of revelation and engagement. However, it seems worth revisiting the question of whether robots, in particular those with humanlike faces can reveal themselves in this way. Humanoid robots, such as those created by Hanson and Ishiguro, clearly present some level of humanlike face, although since this face has been designed with the very aim of promoting a sense of commonality and ease in communication, there is little chance for it to reveal otherness except perhaps in terms of the uncanny. Given people's responses to Demers' Area V5, designed to emphasise the uncanny nature of robotic eyes, it seems that these robots offer a greater sense of otherness, and also indicate that potentially only the eyes are needed to elicit this type of engagement in an encounter with a robotic other.

However, a closer examination of Levinas' philosophy clarifies that the Levinasian face is not actually a physical human face at all. Instead, Levinas' conception of a face encapsulates "the way in which the other presents" or reveals themselves [19]. Levinas suggests that "by concentrating on physical facial features", one turns "towards the Other as toward an object"; instead, "[t]he best way of encountering the other is not even to notice the colour of his eyes" [20]. Elsewhere, he explains that "the whole body—a hand or curve of the shoulder—can express as the face" [19]. It therefore seems possible that overtly non-human others, even those without recognisable eyes, might also reveal Levinasian faces, in spite of the fact that Levinas himself didn't extend his thinking to the non-human.

Scholars have made considerable inroads in arguing the case for the revelation of Levinasian faces by animals, drawing not only on their own experiences, but also on Levinas' description of the behaviour of Bobby, the dog discussed in his essay "The name of the dog" [7, 11, 21, 34]. In addition, David Gunkel, considers whether machines can be, or might in the future be, regarded as Levinasian others in his book, *The Machine Question* [15]. From the perspective of this chapter, the broad description of what constitutes a face within Levinas' philosophy supports a consideration of a wide range of robots as able to reveal faces in encounters with people, whether they express themselves through language, sounds, gestures or whole body movements. As the examples below illustrate, robots with no recognisable face in anything resembling human terms are nonetheless able to reveal aspects of a personality to their human visitors through their physical embodiment and behaviours.

Turning One's Body to Express a 'Face'

A number of robotic art installations promote a different idea of gaze by illustrating alternative understandings of what constitutes a face, and exploring the impact of whole body movement in the form of turning to face someone. One example of this is Petit Mal, an autonomous wheeled robot created by Simon

Penny, appearing in public for the first time in 1995. Penny explains that his goal in designing Petit Mal was to create a robot that was "truly autonomous; which was nimble and had 'charm'; that sensed and explored architectural space and that pursued and reacted to people" [25]. He wanted the robot to give "the impression of intelligence" through the production of "behaviour which was neither anthropomorphic nor zoomorphic, but which was unique to its physical and electronic nature" [25]. Penny clarifies that his aim was not to produce an artificial intelligence, but rather a robot that "gave the impression of being sentient" while also being of minimal complexity in terms of its mechanical parts, sensors and computer code [25].

While Penny was focused on the idea of "the robot as an actor in social space", he was clearly not constrained by the assumption that this robot needed to be like a human in order to operate in existing human environments by producing familiar humanlike communication [25]. Instead, Petit Mal is able to 'speak' only through its movements, without using "textual, verbal or iconic signs" [26]. This understanding of the value of nonverbal signals, such as whole body movements, in communication is explored in Fernando Poyatos' research into simultaneous translation. Poyatos argues that communication is best thought of as a "triple audiovisual reality", which consists not only of "what we say", but also "how we say it" and "how we move what we say" [30]. Petit Mal may not be able to 'say' anything to people directly in human language, but its whole body movements allow it to communicate using what Poyatos encapsulates with the term "kinesics" [30]. This robot is therefore designed to be overtly machinelike, but nonetheless able to behave such that it is read by people as a sentient and expressive individual. Interactions with Petit Mal give visitors to the installation the opportunity to experience an encounter with a strange robot, within which a new understanding of what it might mean to be social is presented.

The movement of Petit Mal and its bodily form, which includes what visitors are likely to recognise quite easily as a non-humanoid neck and head, helps people to know where to direct their communication in interactions with the robot. Importantly, the positioning of sensors on Petit Mal's head, as well as the robot's tendency to move in a particular direction, help to clarify that this robot has a front and a back, such that visitors can judge which way the robot is facing. When a person enters the installation space and approaches Petit Mal their presence is noted, causing the robot to move its whole body to face them. As Derrida argues is possible for animals, visitors feel that Petit Mal can "look at them and address them ... from a wholly other origin", and in testing the robot's abilities people move from side to side to see it turn and follow their motion [11]. Any sense that this robot is threatening, which might arise because of the clarity and attentiveness of its gaze, is reduced by the calmness with which it moves around the space it occupies, together with the bobbing head and neck motion that these movements cause. Petit Mal reveals a gentle personality, and as a human approaches the robot it immediately backs away. This robot is situated as cautious and polite, because it seems respectful of people's personal space (and also potentially as wishing to protect its own).

Although Penny describes the desire to attain "an ongoing conversation between system and user" as opposed to following a "stimulus and response model", it is possible to identify a level of both of these processes in communication with Petit Mal [25]. Moments of turn taking are identifiable, in particular when visitors experiment with repeated movements (for example, stepping from side to side to see how well the robot maintains its orientation towards them) as they play with the robot and attempt to understand how it 'sees' them [27]. This would seem to involve experimentation with a given stimulus in the expectation of a particular response. However, the flowing movements of Petit Mal, along with its gentle bobbing and turning motion, give it a great deal of character and personality, and support a reading of human-robot interaction in this installation space as a dynamic system of communication that consists of overlapping messages, as opposed to following strict turn-taking rules at all times.

There are some similarities between Penny's work, Petit Mal, and a more recent development consisting of two wheelchair-like robots, which interact together and also with people that enter their installation space. The Fish-Bird Project was conceived by Mari Velonaki, and was built in collaboration with roboticists at the Centre for Social Robotics in Sydney University. In contrast with Petit Mal, Fish and Bird are robots whose form is overtly based on that of a familiar item, a standard hospital wheelchair. A key difference between these robots and Petit Mal is therefore their lack of a defined head and neck. However, because they are chairs, their form nonetheless indicates which way they are facing, with the seat at the front of a well-defined back complete with handles to grasp and push the wheelchair along (although these robots will not allow people to push them with any ease). This form was chosen in part because it inherently "suggests the presence or absence of a character" [36]. Thus, although these robots were, as Petit Mal was, designed to be non-anthropomorphic and non-zoomorphic, the wheelchair form is understood to draw attention to the space a person might occupy.

While recognition of this space for a person may indeed have an impact on visitors to the installation, in general people have reported "that they were attracted to the robots not because of the way that they looked, but because of the way that they behaved" [35]. People's first impressions of Fish and Bird are related to the ongoing communication that can be seen between the two robots as they move around each other in the installation, even before a human enters. From a distance, it is the kinesic channel of communication that is most obviously in use between Fish and Bird. Communication between these robots is difficult to read as a form of turn taking, appearing to be more clearly identifiable as a dynamic flow of movement, which includes moments of attention and response. As Donna Haraway suggests when discussing the communication of animals, this type of "embodied communication", which involves the shared negotiation of space as communicators move towards, away and around each other over the course of the interaction, "is more like a dance than a word" [18]. The 'dance-like' interaction of Fish and Bird is accompanied by the production of fragments of text from miniature thermal printers. Each robot uses its own distinctive handwriting "assembled from digitized bitmaps of the glyphs" to write notes to the other robot and sometimes

also to human visitors [36]. These messages are dropped on the floor as they are printed, and thus accumulate to create a fragmented and disordered history of their communication over the course of the day [36]. The way in which these messages are produced and then collect on the floor adds a sense of history to the dynamic communication between these robots without producing a definitive narrative.

In terms of their interactions with humans, one of the first, and strongest, signals of the perceptual and responsive abilities of Fish and Bird is the way that they both turn to face people entering the installation space. In contrast with Petit Mal, with its recognisable head and sensors resembling a bank of 'eyes', as already mentioned Fish and Bird certainly do not have discernible eyes. The impact of their gaze is therefore only presented through their turning movement; however, it is possible that the feeling of being 'watched' by these robots is emphasised by the way that people end up positioned at the intersection of their 'gazes'. In addition, because the robots have been engaged in communication with each other, the interruption caused by the entry of a person is also marked. Fish and Bird stop their 'dance' and turn their attention to the visitor in a way that clearly signals that the robots have noticed them, and may be willing to interact and communicate with them. It also becomes clear that Fish and Bird have individual personalities, communicated through the specificities of their movements in response to humans. Bird is the more outgoing of the two and is likely to be the first of the robots to approach human visitors, whereas Fish will often hang back to observe people from a safe distance before gradually moving closer [6].

Velonaki describes communication with Fish and Bird in terms of dialogues, which develop as the robots move around the installation space based on their understanding of the "body language of the [human] participants" who are also in the process of reacting to "the body language of the robots" [36]. However, as was suggested for Petit Mal above, it is important to recognise that the dialogue between humans and these robots is not precisely governed by turn-taking rules, but rather is more flowing and overlapping (as is the case with communication between these robots when humans are not present). This type of dynamic interaction is described by Alan Fogel as allowing "co-regulation" to arise "as part of a continuous process of communication" as opposed to being the "result of an exchange of messages borne by discrete communication signals" [12]. While this statement resonates with Penny's idea of an "ongoing conversation", it is more open to the contributions that all channels, in particular kinesic but also, as seen in the case of Fish and Bird, language in the form of texts, might make to the communication system as a whole.

The names of these robots, Fish and Bird, may encourage a level of zoomorphism in shaping people's understanding of their communication through movement, based on past interactions with animals and supported by the tentative and rather nervous personalities the robots project. Indeed, even in the case of Petit Mal, Penny notes that in spite of its purposely non-anthropomorphic and non-zoomorphic design, people can only interpret the robot based on their past experience. They therefore project all sorts of motivations onto the robot to explain its behaviour, and there is evidence that people may think of non-humanoid robots as somewhat like animals or humans, but also may call upon fictional descriptions

that they have read, in particular science fiction [32]. It is therefore vital that even as these robots are thought of as communicative, and interpreted in terms framed by one's existing experience, the unusual and unexpected nature of these wheeled robots, and the clarity of their individual characters, ensures that people are continually reminded of the robots' absolute otherness.

The communication of these robots is difficult to place in terms of sociocultural theory or sociopsychological theory. While they evoke sensations of familiarity in human visitors, their form and behaviour also causes people to question the assumptions that they make about the characters of these robots constantly, in particular in relation to them being like someone or something encountered in the past. Instead, the communication of Petit Mal, as well as Fish and Bird, is more easily analysed in terms of phenomenological theory and the Levinasian conception of "the face to face" [19]. This understanding highlights the importance of recognising the specific differences of each of the robots involved in interactions, and suggests that by meeting strange robots people may gain some insight into the possibilities of overtly different others in communication. In fact, meetings with the alterity of robots such as Petit Mal, Fish and Bird, would seem to illustrate Maurice Blanchot's contention, as he reworks Levinas' thought in *The Infinite Conversation*, that describing the difference between self and other in terms of "separation" or "distance" is not sufficient [1]. Rather, the revelation of otherness constitutes "[a]n interruption escaping all measure", which Blanchot suggests should be termed "an *interruption of being*" [1].

The phenomenological understanding of encounters with these robots exists alongside a dynamic systems perspective, which highlights the presence of overlapping attempts to communicate. Language plays only a small part in these interactions in the form of the 'hand written' notes produced by Fish and Bird, whose meanings, since they are only fragments, often remain somewhat cryptic. Cybernetic theory that values accuracy in transmission of information can therefore also be set aside. In order to understand communication in the type of dynamic system described above, which forms during human interactions with Petit Mal and the Fish-Bird project, information must be reconceptualised as something that is not fixed, cannot be precisely coded and is not transmitted in any simple way. These art installations illustrate the importance of acknowledging the presence of information that is "created in the process of communication", such that "meaning making" emerges as an outcome of the "process of engagement" between humans and robots [13]. As Penny concludes in his own consideration of Petit Mal, artworks do not "didactically supply information"; instead, there are many ways to interpret the work, and a focus on embodiment as part of communication (quite possibly in addition to verbal or written language) as well as recognising the potential for meaning to emerge during interaction, are key aspects of understanding communication in art installations [25]. This acceptance of uncertainty in communication, arising from the idea that information is not fixed and cannot be perfectly transmitted, alongside acknowledgement of many possible interpretations, can broadly be characterised as an artistic perspective on communication, which is more open to otherness than the scientific perspective discussed in relation to humanoid robots above.

Conclusion

While the creation of robotic art installations draws together the need to make artistic and aesthetic decisions alongside technical and scientific decisions, the goals of artistic endeavour do seem to be different from that of science and technology, resulting in different outcomes in terms of the robots that are designed and built. On his website, the artist Norman White, for example, expresses his interest in using creative art to ask broad questions, something that is also possible, but for him too constrained, from the perspective of 'good science' [37]. White's thinking bears some similarity to that of Penny, who argues that "the holistic and open ended experimental process of artistic practice allows for expansive thinking", such that artistic methodologies may be able to "compensate for the 'tunnel vision' characteristic of certain types of scientific and technical practice" [25]. While, as Penny clarifies, this is not meant to be a derogatory appraisal of the influence of science and technology on art as well as other fields of human endeavour, it is nonetheless evident in the influence that art's expansive thinking and science's tunnel vision can be seen to have on their respective robot designs. This chapter has considered these differences with reference to various traditions of communication theory and conceptions of the place of commonality versus otherness and difference in communication. Penny notes that his creation of Petit Mal "emerged from artistic practice and was thus concerned with subtle and evocative modes of communication rather than pragmatic goal based functions" [25]. This statement supports the sense in which this chapter has located a difference between scientific approaches to robotics, and modes of communication that are cybernetic, semiotic, sociocultural or sociopsychological, and artistic conceptions that are more open to the other's otherness, such as those related to Levinas' perspective on "the face to face", as well as dynamic systems understandings that encompass uncertainty, a multitude of interpretations and the unexpected emergence of meaning during an interaction.

The differences between artistic and scientific conceptions of communication may stem from the way in which artists learn to promote "the adequate communication of (often subtle) ideas through visual cues" [25]. In fact, I would argue that the creation of art installations that support "adequate communication" involves a careful consideration of not only visual elements, but also the potential of sound and maybe even the tactile quality of a work that people might touch. Penny suggests that the ability of artists to achieve this goal is enabled by their understanding of "the complexity of images and the complexity of cultural context" [25], aspects which scientists often acknowledge, but may then try to simplify in their production of a general solution to creating a communicative robot. In contrast, as Penny notes, the goal of the artist is more often not to generalise, but rather to provide a specific solution that works within a particular context [25]. Importantly, the sense in which an art installation 'works' is not tied to the same understanding of success as was seen in the creation of humanoid robots, since artists acknowledge that the specific nature of the solution they proffer is open to a multitude of interpretations produced by visitors to the artwork. The acceptance of a variety of interpretations

is in many ways inherent in the production of interactive art. Indeed, by making his work interactive, Ken Rinaldo explains that he hopes to encourage people to develop "active, self-determined relationships" with his art [31]. This explanation of the possibilities of interactive art is not only open to ideas of otherness and difference, but also resonates with theory that considers communication as an emergent property of systems, such that it develops between communicators, as opposed to being produced and received directly by communicators themselves.

Although the artistic practice approach to designing robots is not focused on creating machines that are completely predictable and reliable, and thus the utility and function of such robots for practical applications may be in question, the experimental breadth of art provides valuable examples of non-humanoid communicators [25]. As this chapter has demonstrated, analysing robots created in artistic contexts allows one to rethink the possibilities of interactions between communicators that are very different from one another. This is because the goals of artists more often result in situations where humans are encouraged to interact with technology in new ways, as opposed to being presented with technology designed to mimic a familiar communicative situation, such as that occurring between a human and another human. This is not to say that anthropomorphic and zoomorphic responses are not important as part of communication with an unfamiliar looking technology, but the overarching sense of meeting a strange and unfamiliar other is a constant presence, which offers people the opportunity to gain new insights into the value of otherness, and the possibilities of communication more broadly.

References

1. Blanchot M (1993) The infinite conversation. University of Minnesota Press, Minneapolis
2. Breazeal CL (2002) Regulation and entrainment in human-robot interaction. Int J Exp Robot 21:883–902
3. Breazeal CL, Edsinger A, Fitzpatrick P, Scassellati B (2001) Active vision systems for sociable robots. IEEE Trans Syst Man Cybern Part A 31:443–453
4. Breazeal CL, Hoffman G, Lockerd A (2004) Teaching and working with robots as a collaboration. In: Proceedings of the third international joint conference on autonomous agents and multiagent systems. pp 1030–1037
5. Carey J (1992) Communication as culture: essays on media and society. Routledge, New York
6. Centre for Social Robotics (n.d.) The fish-bird project. http://www.csr.acfr.usyd.edu.au/projects/Fish-Bird/index.htm. Accessed 1 Aug 2014
7. Clark D (1997) On being "the last Kantian in Nazi Germany": dwelling with animals after Levinas. In: Ham J, Senior M (eds) Animal acts: configuring the humans in western history. Routledge, New York, pp 165–198
8. Craig RT (1999) Communication theory as a field. Commun Theory 9:119–161
9. Dautenhahn K (2013) Human-Robot Interaction. In: Soegaard M, Dam RF (eds) The encyclopedia of human-computer interaction, 2nd edn. The Interaction Design Foundation, Aarhus
10. Demers L-P (2009) Area V5. In: Process. Plant. http://www.processing-plant.com/web_csi/index.html#project=areav5. Accessed 1 Aug 2014
11. Derrida J (2002) The animal that therefore I am (more to follow). Crit Inquiry 28:369–418
12. Fogel A (1993) Developing through relationships: origins of communication, self, and culture. Harvester Wheatsheaf, New York

13. Fogel A (2006) Dynamic systems research on interindividual communication: the transformation of meaning-making. J Dev Process 1:7–30
14. Freud S (2004) The Uncanny (1919). In: Sandner D (ed) Fantastic literature: a critical reader. Praeger, Westport Conn., pp 74–101
15. Gunkel DJ (2012) The machine question: critical perspectives on AI, robots, and ethics. MIT Press, Cambridge, Mass
16. Hanson D (2006) Exploring the aesthetic range for humanoid robots. Towards Social mechanisms of android science, Vancouver, pp 39–42
17. Hanson Robotics Website (n.d.) http://hanson.robotics.com/. Accessed 18 Oct 2008 (no longer available)
18. Haraway D (2006) Encounters with companion species: entangling dogs, baboons, philosophers, and biologists. Configurations 14:97–114. doi:10.1353/con.0.0002
19. Levinas E (1969) Totality and infinity. Duquesne University Press, Pittsburgh
20. Levinas E (1985) Ethics and infinity, 1st edn. Duquesne University Press, Pittsburgh
21. Levinas E (1990) Difficult freedom. The Athlone Press, London
22. Matsumoto N, Fujii H, Okada M (2006) Minimal design for human–agent communication. Artif Life Robot 10:49–54. doi:10.1007/s10015-005-0377-1
23. Menzel P, D'Aluiso F (2000) Robo sapiens: evolution of a new species. MIT Press, Cambridge, Mass
24. Mori M (1970) The uncanny valley. Energy 7:33–35
25. Penny S (2000) Agents as artworks and agent design as artistic practice. In: Dautenhahn K (ed) Human cognition and social agent technology. John Benjamins, Amsterdam; [Great Britain], pp 395–413
26. Penny S (1997) Embodied cultural agents: at the intersection of robotics, cognitive science, and interactive art. AAAI Technical Report FS-97-02. AAAI
27. Penny S (2011) Petit Mal video. https://www.youtube.com/watch?v=v_kMOMYq0MU. Accessed 1 August 2014
28. Peters JD (1999) Speaking into the air: a history of the idea of communication. University of Chicago Press, Chicago, London
29. Pinchevski A (2005) By way of interruption: Levinas and the ethics of communication. Dusquene University Press, Pittsburgh, Pennsylvania
30. Poyatos F (1997) The reality of multichannel verbal-nonverbal communication in simultaneous and consecutive interpretation. In: Poyatos F (ed) Nonverbal communication and translation: new perspectives and challenges in literature, interpretation and the media. J. Benjamins, Philadelphia, pp 249–282
31. Rinaldo K (n.d.) Artist statement. http://kenrinaldo.com/frame_about.html. Accessed 1 Aug 2014
32. Sandry E (2015) Robots and communication. Palgrave Macmillan, New York
33. Science Gallery (2011) Human + area V Louis-Philippe Demers video. Dublin. https://www.youtube.com/watch?v=hKqhgsromfc. Accessed 1 Aug 2014
34. Steeves HP (2005) Lost dog, or, Levinas faces the animal. Figuring animals: essays on animal images in art, literature, philosophy, and popular culture. Palgrave Macmillan, New York pp 21–35
35. Velonaki M, Rye D (2010) Human-robot interaction in a media art environment. Workshop: What do collaborations with the arts have to say about HRI? Osaka. http://hri.willowgarage.com/workshops/HRI2010/downloads/Velonaki.pdf. Accessed 25 June 2010
36. Velonaki M, Scheding S, Rye D, Durrant-Whyte H (2008) Shared spaces: media art, computing, and robotics. Comput Entertain 6:1. doi:10.1145/1461999.1462003
37. White N (n.d.) Norman T. White: a short autobiography and credo. http://www.normill.ca/ntwbio97.html. Accessed 1 Aug 2014

Being One, Being Many

Christian Kroos and Damith Herath

Abstract If the current development of robotics indicates its future, we will be soon able to create robots that are exactly identical, intentional agents—at least as far as their software is concerned. This raises questions about identity as sameness and identity in the sense of individuality/subjectivity. How will we treat a robotic agent that is precisely the same as multiple others once it left its inanimate appearance behind and by its intentionality claims to be individual and subjective? In this chapter we show how these issues emerged in the implementation of the artwork 'The Swarming Heads' by Stelarc.

I

Identity in intentional agents (humans, animals, robots) is traditionally understood in the Cartesian sense as being subject to spatial and structural coherence. The agent cannot be at two or more places at the same time or be several separate physical entities. Emotional and cognitive processing happens on the inside, within some kind of border that separates the agent from its environment. For biological agents Andy Clark has called this border the 'metabolic boundary' [1].

In the internalist view, the environment arrives in the form of sensory 'input' and the agent performs disassociated information processing to produce adaptive motor behaviour considered 'output'. Various externalist approaches, among them Clark, have put forward strong arguments against the input/output reduction,

C. Kroos (✉)
Centre for Vision, Speech and Signal Processing,
University of Surrey, Guildford GU2 7XH, UK
e-mail: chkroos@gmail.com

D. Herath
Faculty of Education, Science, Technology and Mathematics,
University of Canberra, Canberra, Australia
e-mail: damithc@gmail.com

© Springer Science+Business Media Singapore 2016 191
D. Herath et al. (eds.), *Robots and Art*, Cognitive Science and Technology,
DOI 10.1007/978-981-10-0321-9_10

emphasising the fact that individual beings are embedded into their surrounding environment through a *gewebe* (web) of interactive relationships. However, even if the information processing view is not upheld in an externalist approach, the agent conventionally resides in a single location and at best extends into the environment.

According to the Cartesian tenet, identical reduplication of the agent leads to the creation of several different agents with identical properties. Our phylogenetic and (currently also still) ontogenetic experience with exclusively biological agents might have crucially shaped our intuition. The metabolic boundary convincingly and verifiably defines the perceivable boundary of any biological agent (the story might be more complex in plants though).

Technically, nearly exact reduplication of a robotic agent is straightforward, owing to the industrial production of the components in the networked way described by Gilbert Simondon as drawing out the 'technical mentality' [2]. There are remaining differences between agents; hardware components are only identical to the degree specified through set production tolerances, and more importantly, the physical extension of the robot agents always allows marking them for identification in one way or another, that is, presenting them separately, referring explicitly to individuals or even destroying a specific individual while keeping the others. In contrast, the software of the agent can be *exactly* identically reproduced and would stay this way unless unsupervised learning algorithms are used or hardware problems lead to processing failures. Thus, if one would grant current autonomous robots agency—and noted, that would be controversial—we are already capable of creating agents which are different and yet the same (Fig. 1).

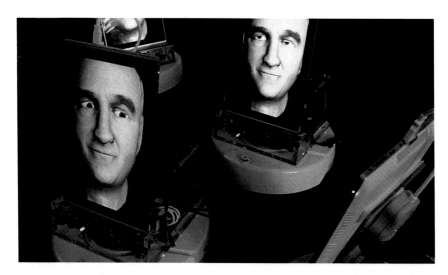

Fig. 1 Swarming Heads installation (© Christian Kroos, Damith Herath and Stelarc; *photo* Christian Kroos)

Identical robotic agents are likely to be readily accepted in the (post-)industrial culture, owing to their perception as mere machines (lacking 'feelings', 'consciousness', a 'soul', etc.). Combined with a still prevalent mind-body dualism, the mechanistic perspective prevents the dilemma of split identities our human thinking would otherwise face. If there is no mind in the machine, having several identical agents is not more problematic than a collection of e.g. identical mobile phones in a store. It becomes more complicated if the mind cannot be thought any longer as an entity independent of its physical implementation or—alternatively and currently only in fiction—if the absence of an artificial mind in a machine cannot be any longer assumed beyond doubt. In popular culture, the latter is often construed as a scenario in which the information-based mind/consciousness of an agent can be transferred to different physical implementations. The information-based mind is considered unique while the physical implementation can be identically replicated—rather the opposite of the technical reality of software and hardware today. From the tension between the fictional account and the current reality of computational programs often the fundamental conflict in these narratives arises.

Moreover, the scenario of the unique mind and the replaceable body of the machine frequently leads to the reverse inference that it will become possible at one point in the foreseeable future to transfer ('upload') the human mind using technology not yet developed but conceivable. Typically and without further explanation, the transfer can be only accomplished in the moment of dying, presumably to avoid the problematic topic of identical agents—the prospect of creating identical agent copies might be too challenging.

In the Western industrialised nations, a tradition of fearing the 'Doppelgänger' appears to be deeply engrained into society, from the German silent movie 'Der Student von Prag' (1913, directed by Stellan Rye and Paul Wegener, written by Hanns Heinz Ewers) to José Saramago's novel 'O Homem Duplicado' (2002) to the Hollywood movies 'Matrix Reloaded' and 'Matrix Revolutions' (both 2003, written and directed by the Wachowski brothers), to mention only a few. Note, however, that most of these depiction only refer to appearance while the 'mind' is always unique, including in the case when robotic technology is used as in Fritz Lang's classic silent movie 'Metropolis' (1927), in which an indistinguishable robotic copy of working class activist Maria is created.

It appears to be excruciatingly difficult or outright paradoxical to consider identical conscious agents, that are not—in some way or another—a single entity. This difficulty is also reflected in the widely unchallenged acceptance of the idea that storing all the information of the brain (whatever that exactly would mean) in an external device would constitute a continuation of this one person and not a new individual. If it would be indeed continuation, however, that is, if the person, whose brain information is transferred, is the same as the newly created recipient of this information, any additional copying of those constitutive data would create a serious predicament: Either the copies would create new individuals leading to the paradox that the process could not have been continuation in the first place (even in the case when only one new agent is created) or a single mind would split in several entities. For the latter we appear to have few concepts to apprehend its

meaning, both intellectually and emotionally. Typically it would be framed retro-spectively, in which case its defining characteristics can be reduced to identical memories of a shared past. But this ignores the transition process, in which a person changes from being one to being many, regardless of how quickly the new instantiations diverge afterwards. Admittedly, one could question whether there is continuation in the first place or whether the perceived continuation is always constructed retrospectively since any period of unconsciousness disrupts experienced continuation nevertheless.

These issues sometimes surface in the discussion of human cloning, too. Despite lacking any basis here, since only DNA is replicated and since even monozygotic twins are not genetically exactly identical [3] and the differences can be assumed to be even more pronounced in clones. Most importantly, clones would go through their own biological, in particular neural, and mental develop-ment, shaped by individual experiences. Accordingly, there are few if any justifica-tions to question the individuality of the clone. The life experiences of the clone would always be different from the ones of the source individual and if it was only because of the different 'parent' situation. Still, even a contemporary artist with a Ph.D. in Genetics appeared compelled to have to point out explicitly in a public presentation that human clones should have human rights and should be consid-ered individuals: As if a certain degree of congruence would inevitably have to be thought as complete unity and thus the seemingly identical make-up, but multiple physical instances would require re-asserting the foundations of what makes a person a person. Interestingly, it seems to be never the source human that was (hypothetically) cloned, whose individuality and personhood is in doubt as a con-sequence of the cloning process.

The aforesaid evokes an alternative solution, one which is again conjured fre-quently in popular culture—especially, if intelligent robots are involved—and which emerges as a trend in current robot development: All identical individuals are connected into one comprising 'organism'. If taken seriously, this amounts to more than a hidden communication channel among the agents. In its simpler shape, there would be a remote central controlling entity, a master mind, so to speak, and identical replication of individual semi-autonomous agents would resemble add-ing an additional eye or leg within the animal analogy. After all, humans are not alarmed by having two very similar and functionally nearly identical eyes, ears, legs or arms and adding another one would create practical but not philosophical problems—see e.g., Stelarc's Third Hand [4]. In its more complex shape, there would be no such central control and although things start to get messy in terms of imagining the inner working of such an organism, no paradoxical or unimaginable situation would present itself. Some schools of thought in contemporary neuropsy-chology are already trying to get us used to the idea that there might be no single location in the brain, where consciousness or awareness resides [5]. Any set-up of a cohesive, but dispersed technological organism without central control is at pre-sent still beyond current robotic technology and artificial cognition, with the excep-tion of the most basic levels, e.g., ad hoc networks. Artificial swarm behaviour in robot collectives [6] seems to come close, but differs in an essential aspect: The

individual robot is seen as an individual agent and is recruited to solve a common task. The biological models used are often ant or bee colonies, in which agency resides within the individual animal and is not taken over by the colony. Thus, it looks as if with future technological progress we will be first faced with the more confusing and challenging situation of identical, individual agents within in the domain of autonomous machines. It appears to be about time to explore this future.

II

In 2012 the Thinking Head project came to an end. The multi-university, inter-disciplinary research undertaking funded by the Australian Research Council and the National Health and Medical Research Council had the aim to develop a sophisticated embodied conversational agent, a 'talking head' that would venture beyond uttering only pre-defined phrases and would pass for being intelligent. The project's starting point was the *Prosthetic Head* by Australian performance artist Stelarc, a convincing virtual 3D representation of the artist, created using a laser scan of the artist's head and animated using computer graphics. People were able to interact with the *Prosthetic Head* by submitting questions or comments through a computer keyboard. A modified version of the A.L.I.C.E. chatbot [7], a widely used conversational artificial intelligence computer program, generated the responses.

The research-and-art track of the *Thinking Head* project had produced a robotic embodiment of the *Prosthetic Head*, an art installation initiated and conceived by Stelarc and built by a small team of two robotics engineers (one of them the second author of this chapter) and a cognitive scientist (the first author). The robot (Fig. 2), named *Articulated Head*, exceeded the original aims of the Thinking Head project, in which the agent was never meant to become a part of the physical world. The artist's vision of an LCD monitor displaying the *Prosthetic Head* as the end-effector of a six-degree-of-freedom industrial robot arm stimulated extensive further research. After all, here was a powerful machine with a vast range of movement possibilities: A potential waiting to be utilised and—not surprisingly—at the same time a potentiality posing deep challenges. Each of the six sequential joints allowed the rotation of the connected limb with rotational speeds ranging from 0 to 360 degree/s, enabling a rich continuum of motor behaviour that could be harnessed in order to realise the artistic and scientific aim of creating the impression of the *Articulated Head* as an intentional agent. The research resulted in a complex control system that used the advanced sensing capabilities empowering the *Articulated Head* and included a software-based attention model to let seemingly meaningful behaviour arise from the interaction with the visitor.

As the *Thinking Head* project drew to an end, Stelarc suggested another rather different robotic embodiment of the *Prosthetic Head*: A swarm of small mobile (wheeled) robots, which again would show the *Prosthetic Head* on their individual LCD monitors, but move around on their own accord.

Fig. 2 The Articulated
Head in the Powerhouse
Museum, Sydney, Australia
(© Christian Kroos, Damith
Herath and Stelarc; *photo*
Christian Kroos)

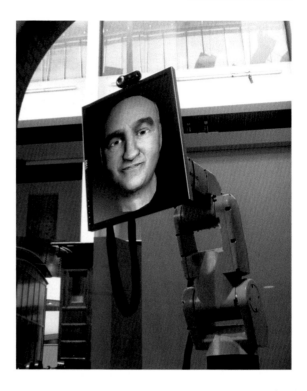

The transition between these very different embodiments and an analysis of the technical, scientific and conceptual implications will be the subject of the next sections. Our focus will be on emerging behaviour as a consequence of design and implementation choices and the resulting differences in the structuring of the interaction with humans. We will finally revisit the fundamental questions that arise from identical replication of a robotic agent and touch on issues of sameness and individuality on a more concrete basis.

III

The *Articulated Head* consisted of a robotic platform that was not able to change its location. Although fully flexible where to orient its 'face' and focus its attention, resting on a static tripod, the *Articulated Head* could not leave its safety enclosure or move its entire 'body' toward or away from an interaction partner (it could turn, though, and face the other direction). There was also only one mobile sensor, a camera, used for visitors' face detection, attached to the top of the LCD monitor. The remaining sensors were fixed: An acoustic localisation system employed two microphones clipped to the top of the back wall of the enclosure. A short-range sonar proximity sensor was integrated in an information kiosk,

which housed the similarly unmoveable keyboard. Most importantly, the main stereo camera for software-based people tracking was mounted at a museum wall opposite the enclosure, amounting to a third-person perspective. Visitors were not aware of the locations of the sensors and appeared to assume all sensing devices were attached to the computer monitor displaying the virtual face: Attempts to attract the attention of the *Articulated Head* through e.g. gestures, jumping up and down, and vocalisations were always directed toward its 'head'. Furthermore, the conceptual framework, the technical implementation and the control system incorporated the assumption of a static base location and a third-person perspective from the beginning. In some ways the *Articulated Head* resembled more a coral polyp than a mammal.

The control system of the *Articulated Head*, the Thinking Head Attention Model and Behavioural System (THAMBS), is described elsewhere [8, 9], therefore we will give only a brief overview here, going as far into the details as is needed for later sections.

THAMBS (Fig. 3) employs a primary processing cycle, which sequentially runs through all the necessary tasks to maintain its situational knowledge and generate its response behaviour. In a single processing cycle, sensory information arriving from low-level processing routines such as acoustic localisation or people tracking is turned into standardised *perceptual events* by a perception subsystem. The properties of the events are subjected to threshold tests, introduced

Fig. 3 Thinking Head Attention Model and Behavioural System (THAMBS)

to remove e.g. unreliable tracking values from further consideration. Surviving events are passed on to the attention subsystem, which subjects the events to its own thresholding based on the perceptual event type and dependent on the state of the overall system and its current task. For instance, THAMBS might be in a vision-based interaction with a visitor and thus change its setting to make it more difficult to divert its 'attention' through an unrelated acoustic event. This thresholding, however, constitutes only a basic, brute-force mechanism to manage the system's attentional behaviour. The primary mechanism employs attention weights and attention decay profiles assigned to the attention foci created from the perceptual events after passing the initial threshold test.

Since unconstrained object recognition in real-world environments is an unsolved problem [10] and even robust tracking poses serious challenges [11], attention foci are spatially defined: THAMBS pays attention to a specific confined three-dimensional region in the space surrounding the *Articulated Head*. The attention weights are determined in relation to current system preferences, task requirements and the event type. The weight values are decisive in the final selection of an attention focus as the single attended event (winner-takes-all strategy). An active focus persists for a certain duration, but its weight decays exponentially over time, though with a relatively flat curve. Persistence and decay enable short-lived, but prominent events, say, a loud noise burst, to attract THAMBS attention beyond the lifetime of the event, but also guarantees that the attention to static or repetitive attractors wanes over time (habituation). Outdated attention foci are able to bind the system's attention only if nothing else of interest happens in the robot's environment and even then only for limited time.

The attended event is forwarded to the behavioural control system, the transfer realising selection-for-action, the second primary function identified for biological attention systems besides binding different events to a single focus: Attention is guided by the actions available to the individual relative to the affordances of its environment and prioritises stimuli that have particular relevance for those potential actions. In THAMBS, its behavioural system invokes then a behavioural response, which includes the option to ignore the event. If the response involves a motor action (movements of the robot, facial expressions of the virtual avatar, speaking), a dedicated motor system generates the action command, filling in context-specific parameters where needed.

In the onsite implementation it was attempted to uphold an operating speed of 10 Hz, but the system often slowed down to speeds as low as 5 Hz due to processing bottlenecks. Nevertheless the control system served its purpose well, once it was protected against information overflow. Before that, in the opening night of the first short-term exhibition at the University of Technology, Sydney, Australia, as part of the 2010 NIME conference (New Interfaces for Musical Expression++, 15–18th June 2010) the *Articulated Head* was faced with a crowd of several dozen people instead of the usual handful during development and testing. THAMBS was utterly overwhelmed by the influx of potential attention foci, all the people standing around the robot's enclosure within its field of interaction, and the system, after briefly switching helplessly from one visitor to the next, froze and all

movements came to a halt. Though not intended and slightly embarrassing, we could not help finding the behaviour of the *Articulated Head* appropriate, simulating successfully an intentional agent that experienced a sudden unexpected large crowd of relevant other agents. The reaction of many animals would not have been so different.

From the description above it might have already become clear that the unmodified control system of the *Articulated Head* would be in a permanent crisis when 'inserted' in a small mobile robot. Instead of a fixed world entering from the outside through selected events of interest, it would now encounter a world which would change with every rotational and translational movement: THAMBS would be subjected to an inescapable first-person perspective.

IV

The *Swarming Heads* [12] were designed as small mobile robots that similarly to the *Articulated Head* would display a virtual representation of the artist's face on an LCD monitor. They were meant to be fully autonomous, although not acting to fulfil any utilitarian function, but to explore their world in a playful manner. They were built around the commercially available robot platform *Create* developed by *iRobot,* which resembles closely the original vacuum cleaning robot *Roomba* of the same company (but unfortunately lacking the useful vacuuming function). The base robot is a differential drive platform supported by front and rear castor wheels. A custom designed Perspex frame was added to hold a tablet computer that drove and displayed the *Prosthetic Head* on a 12.1 inch screen. A separate Linux computer was housed behind the tablet in a transparent casing, providing the computational power to run the sensing algorithms and THAMBS. The front Perspex frame also accommodated a skinned version of a *Microsoft Kinect* sensor. The robot used two sets of power sources, one to drive the motor mechanisms and other internal hardware of the robot base, a second one tucked underneath the Linux PC to power the computer and sensors.

The Kinect sensor returns rich 3D depth information of the environment in its field of view. It replaced the stereo camera system used with the *Articulated Head*; the acoustic localisation, however, was not transferred to the *Swarming Heads*. The robot base has an in-built four-way split cliff sensor that can detect sudden discontinuities on the ground, identifying the location of the drop ahead (whether it is to the left or right of the robot or directly in front, but again divided into left and right hand side). The wheels of the base contain odometry sensors, providing local translational information. The wheels are also connected to a lift sensor that gets activated when the robot is lifted up from the floor. A frontal bumper sensor, integrated into the robot base as well, generates left/right bumper activation signals when coming into contact with obstacles. All low-level sensory data were accessed through the Robot Operating System (ROS)—an open sources robotics-specific operating system—to be further processed and manipulated.

A new version of THAMBS was instantiated, called mTHAMBS. It included the four new sensors (cliff detection, lift sensor, bumper sensor, odometry). Due to the flexible core architecture of THAMBS the integration required only minor changes. A fundamental alteration, however, followed from the loss of the static world coordinate system. The term 'world coordinate system' is used in computer vision, robotics and related disciplines to describe a reference system anchored in the physical environment, which typically is not influenced by the robot's location and orientation or sensing parameters, e.g. perspective distortion caused by camera lenses. In the *Swarming Heads*, however, the entire visual field covered by the Kinect sensor was likely to change with any significant movement, for instance, as the consequence of the reaction to a peripheral stimulus that caught mTHAMBS's attention such as turning toward a person. In addition, any movement of the robot, but in particular rotational movements, would cause apparent motion in the visual field, and this apparent motion would mix with the real motion of external entities. New potential attention foci would be brought constantly into play, since mTHAMBS did not comprise any kind of episodic memory of its environment. As mentioned above, mTHAMBS was not able to 'lock' on objects, only people could be tracked and only for so long as they stayed within the field of view of the Kinect. As a consequence, the initial *Swarming Head* became very fixated on people, but also constantly distracted by its own exploration of the world that in a Heraclitian sense (Plato's view of it, to be precise) appeared to be in a permanent flux. Fine tuning of the attention weights, in particular re-evaluating the impact of apparent velocity, alleviated these behavioural problems to a degree that made uninterrupted interaction between a human and the robot possible and mTHAMBS was no longer producing behaviour akin to an attention disorder syndrome.

A more essential technical problem remained though. The tablet PC, which was running mTHAMBS but also the software generating and rendering the virtual head, was not able to maintain the central mTHAMBS loop at even the reduced rate of 5 Hz. It dropped regularly to 1 Hz, occasionally to half of that and sometimes even further. A perception-action cycle of 0.5 Hz meant that it took mTHAMBS 2 s to update its perception and attention system and modify any active motor command. This did not only severely impact on its capability of a timely response in human-robot interactions, but caused the *Swarming Head* to shoot straight over any cliff in its path. To avoid catastrophic damage to the robot, both the cliff and the bumper sensor were integrated into a reflex loop that bypassed mTHAMBS and secured an immediate stop of the motor. The information about the emergency motor stop was then forwarded together with the original cliff or collision detection information to mTHAMBS to 'deliberate' on the action to be taken, now that a response was no longer time-critical.

The general problem of delayed processing, however, could not be remedied. THAMBS had been already optimised for execution speed as much as was possible without compromising its flexibility. It became clear that the usual path planning strategy for a robot with two wheels driven by independent motors and a castor wheel could not be used. This conventional way separates rotational movements (turns) from translational forward movements. The strategy consists of a

two-step sequence: First turning towards the target location on the spot and then moving forward in a straight line until the target location is reached [13]. This can be followed by a potential adjustment of the orientation of the robot through a second turn. Given the slow processing, pursuit movements using this strategy would have in most cases resulted in the robot only turning on the spot, trapped in a constant adjustment of the orientation. If the robot would indeed have progressed to the stage of forward movement, it would likely have stopped shortly afterwards to re-adjust its orientation. Therefore, we implemented an alternative path planning strategy that uses curved trajectories when the target was not strictly straight ahead. To keep orientation changes and forward movements incremental and smooth, a circular trajectory between the current location of the robot and the target is computed. The current orientation of the robot relative to the target determines the curvature of the arc: It is more strongly curved if the target is located in the periphery of the robot's visual field and less curved if the target is closer to the centre of the visual field, diminishing to zero curvature (a straight line) if the target is straight ahead. If a new arc has to be computed while the robot is in motion triggered by a changed target location, it is guaranteed that only minor adjustments to the robots orientation are required, since the overall adjustment is spread out over the entire trajectory. In this way orientation angle and radial distance were gradually and simultaneously adjusted by continuously minimising the difference between actual and target orientation and location.

The procedure enabled a kind of sluggish pursuit behaviour. The price to pay were slightly awkward looking initial trajectories if the target was located in the horizontal periphery of the visual field of the robot. The robot seemed at first to move in the direction in which it was already oriented, ignoring the target, before gradually zeroing in on the target as if the robot wanted to avoid a direct 'confrontational' course.

Of course, none of the measures taken amounted to much more than control 'band aid' of the processing speed shortfalls, they could not solve, but would merely mask the fundamental problem that the robot's higher level processing was occasionally operating on a time frame not suitable for interactions with humans. Surprisingly, reasonable robot behaviour was achieved resulting in the impression of an engaging and accommodating machine. It is difficult to say whether this was due to the robot just delivering the right cues to evoke the impression of agency [9] combined with a forgiving patience of the human interaction partner or whether it was due to (approximately) smooth interaction occurring despite the robot's shortcomings.

Evidence for the former came from the experience with a gesture-based control that was implemented as part of a more traditional scientific longitudinal human-robot interaction study into bonding behaviour with a robot [14]. The gesture control used so-called skeleton tracking routines implemented in the open source Natural Interface algorithms (OpenNI) for the Kinect sensor (http://structure. io/openni). In the Swarming Heads, it allowed any person within the visual field of the Kinect sensor to directly steer the robot with a set of fixed gesture commands. There was a kick-off gesture that corresponded to a 'pay attention' command. It caused a change in the attention-related parameters of mTHAMBS to strongly

prioritise gesture recognition and associated behaviours, e.g., motor commands linked to specific gestures. Distracting the robot from following the gesture commands was made difficult, but was still possible. The remaining gesture commands can be paraphrased as 'come to me', 'turn right' ($-90°$), 'turn left' ($90°$), 'turn around' ($180°$) and 'stop'. Note that all the turn commands changed the robot's orientation sufficiently to move the gesturing human out of sight of the robot and consequently required new positioning of the human in the robot's visual field, thus, weakening the dominating role of the human in the interaction by requiring human adjustments to the robot's behaviour. If accommodations to the robot's new location and orientation were neglected, the robot would lose its prioritisation of the gesture recognition input after a short while and would happily continue with its normal exploratory behaviour.

Obviously, the gesture control was not spared by the processing delays and could render the robot unresponsive for new commands for the duration of two seconds and more while being occupied with the outdated execution of a previous gesture command or still following its internal behaviour preferences. These black-out durations were far too extended to be accepted in typical human interactions (see teleconferencing latencies, e.g., [15]) and were potentially beyond the limits of interpersonal or human-machine synchrony requirements, too [16]. However, as observed in several trials in the lab with university staff not part of the project and in a public event at the Powerhouse Museum (Sydney, Australia) people adjusted to the robot's occasional unresponsiveness. Instead of blaming failing technology, they interpreted the behaviour of the robot as inattentive, stubborn or outright mischievous. But this made them try even harder to establish a successful relationship with the *Swarming Head*.

Additional subjective anecdotal support came from the experience of the first author during early lab tests with the *Swarming Heads*. To examine mTHAMBS' working and the resulting behaviour of the *Swarming Heads* in the wild, individual robots were often set free in the HRI lab at the MARCS Institute (Western Sydney University), a spacious windowless room with a single door to a corridor leading to a public foyer and the building's exits. The door was usually left open and one day one of the *Swarming Heads* was heading straight for the exit. It happened at a stage in the development when the hardware built was finished and mTHAMBS working, but no sensing activated except for the reflex-like bumper sensors and the cliff detection. In this situation, that is, when mTHAMBS receives almost no environmental input, it switches to an exploratory 'idle' mode. It generates single movement targets or short sequences of movement targets using a constraint pseudo-random procedure applied to robot location, orientation and timing of the movement.

The robot could not see the location of the door or anything else, yet it went for the door, stopped, turned around as if to check with the experimenter, turned back and moved about a meter straightforward. It then stopped again, turned a second time, not quite far as the first time, as if pretending to have changed its intention and path, after which it rotated back to its original orientation and left the room. At this point the experimenter had to go and get it, since the busy foyer was not

a suitable environment for a small blind robot. Despite knowing better than everyone else that there was nothing going on in the robot other than a simple, but appropriately fine-tuned random procedure, the first author could not help himself from perceiving the episode in terms of an intentional robotic agent attempting to sneak out of its designated area. The series of serendipitously structured events evoked a strong sense of agency that was—at least for a brief moment—powerful enough to overcome the certainty of the developer's knowledge.

When the sensing was activated and the *Swarming Head* could detect people in its surroundings, the behaviour of the robot evoked the impression of agency convincingly without relying on serendipitous movement sequences. The responsive and exploratory conduct of the robot changed the behaviour of the human interaction partners as they started to adapt their behaviour to the robot and its perceived intentions. As a consequence, processing delays were reliably interpreted as lack of social ability or lack of willingness of the robot to cooperate or as outright defiance, but not as failures of technology. Therefore, for most people the motivation to make the robot-human relationship work increased and they put in an extra effort to compensate for the cognitive shortcomings or moods of the robot.

V

The *Swarming Heads* did not really deserve their names; they did not exhibit swarming behaviour as there were no routines implemented that triggered mimicking the behaviour of compatriots or allowed them to set their behaviour in relationship to that of another robot. They were also not entirely independent individuals, since with respect to their behavioural program they were identical copies. The use of probabilistic behaviour generation hid their lack of uniqueness on the surface, but did not alter their conceptual sameness.

The *Swarming Head* installation (Fig. 4) raised some of the questions discussed in Sect. I in a playful manner and used the anthropomorphic appearance of the *Prosthetic Head* as a reinforcement of their potentially challenging underpinnings. The installation conceived by Stelarc gathered five *Swarming Heads* robots on a circular pedestal with a diameter of 200 cm. The top side of the pedestal was flat and painted black. A six centimetres high translucent plexiglass raised rim running around the perimeter of the pedestal served as a fall-off barrier: The *Swarming Heads* could detect a cliff and avoid it, but nothing prevented a robot from pushing its colleague over the edge. The *Swarming Heads* moved freely in this area and were attracted by the presence of visitors. If visitors approached the installation with high walking speed, the *Swarming Heads* tended to avoid an interaction and turned away; if the approach speed was slow or the visitors maintained constant distance (moving in an orbit around the pedestal or standing still), the *Swarming Heads* exhibited curiosity and approached as far as possible. They then often locked on individual visitors, tracked their movements continuously and waited for gesture commands as a way to establish a robot-human relationship.

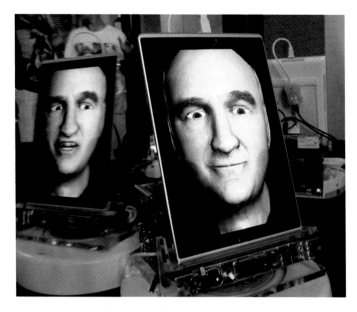

Fig. 4 Swarming Heads installation (© Christian Kroos, Damith Herath and Stelarc; *photo* Christian Kroos)

Since their area was rather limited, they frequently bumped into each other or ran into the confining outside rim. Any collision triggered an avoidance reaction in the robot—moving a few centimetres backwards and then turning (the turn angle was determined by a constrained pseudo-random procedure)—and most of the time also a verbal response. For the latter a phrase was selected out of 50 pre-scripted response phrases and uttered by the *Prosthetic Head*, both acoustically and visually (synchronised face motion). The phrases were mostly trivial such as 'Oops', 'Sorry', 'Not again' and 'Back up!', with a tendency to complain about the situation or the other ('Idiot', 'Silly', 'Are you always like this', 'Today is not my day') and occasionally putting the collision event into a larger context ('Lately I seem to run into all kind of things', 'We don't do this where I come from') or denying the problem ('I did not want to go in this direction anyway'). The intention was to pretend in a shallow way underlying intelligent behaviour that after a while would expose its repetitive character. The robots resembled each other very closely, the virtual *Prosthetic Heads* shown on the tablet screen looked exactly the same and their behaviour was revealed over time to be identical, too.

The installation was exhibited during the two days of the *Thinking Systems Initiative* Symposium on 8/9. December 2011 in the *Powerhouse Museum* (Sydney, Australia).

It was open to all museum visitors and with this to the general public. It attracted an interested crowd throughout this time and not all visitors could resist interacting with the robots in a more physical manner than just observation or gesture commands. Among the *Swarming Heads*, however, there was the notable

absence of a scenario one might have expected as the most likely based on the depiction of identical agents in popular fiction, that of all agents performing the same action at the same time. Technically, only minor algorithmic arrangements counteracted total behavioural uniformity. All decisions by the agent's central control system with regard to behaviour selection were probabilistic, albeit in a very simple manner: Stationary probabilities were assigned to the final behaviour options available after rule-based pre-selection (only within the attention system probabilities changed dynamically). But in combination with the environmental situatedness of the robot, this small intrusion of non-deterministic freedom caused constant asynchronic behaviour variation, even though over time the limited and identical behaviour repertoire of the agents became obvious through the re-appearance of similar behaviour patterns.

This is not to say, that no simultaneous collective behaviour ever emerged, but it needed a larger timeframe and specific conditions. We observed for instance the following anecdote:

During a quiet period in the museum with the conference attendees having returned to their session after a coffee break near the installation, two people (one of them the first author) remained in close proximity of the installation, absorbed in an ongoing conversation. On the pedestal the *Swarming Heads* were still bustling with movements and interjections, still 'excited' by the crowd of conference attendees present just a few seconds ago. The two people in their vicinity paid no attention to the robots, that is, they did not accommodate their behaviour in any way to that of the robots. However, the robots paid attention to the humans through mTHAMBS and continued to track their movements. Since mTHAMBS made them to attempt to approach the stationary people, the robots still constantly collided with each other—the ones in the second or third row with the robots in front of them—or the perimeter rim. However, when ending the conversation, the humans noticed with some surprise that all robots were staring at them, arranged in a cluster at the point on the pedestal closest to the chatting people, as if they were eavesdropping on the conversation. Occasionally the *Swarming Heads* still bumped into each other, but without breaking up the emerged formation: The overall pattern of activity had converged. Over a larger time period the instilled desire to approach people won over the disruptive avoidance behaviour following collisions. In the case of a single stationary people target, which was unresponsive to the robot's actions, the approach behaviour led to overall cohesion and created enough behavioural stability to overcome the disintegrative impact on synchronous behaviour patterning caused by collisions.

There seems to be little research on the relation between identical agents and emerging synchronous collective behaviour in robotics. As a striking contrast, in the field of agent-based simulations, the software-based virtual agents are almost always identical or at least resemble each other extremely closely. But they are in general at best superficially situated in their (virtual) environment. The environment is kept simple and mostly uniform since the aim is typically to uncover general mechanisms and boundary conditions of processes for which no analytical mathematical models exist or have not yet been discovered. Local variation of

the environment and a strong interaction of the agent with local specificities are not desirable since they would slow down the emergence of more general mechanisms. The simplification is acceptable if considered in the research design, but there are good reasons to assume that agents in the physical world are always engaged with the local variations of their environment. To overlook this would lead to flawed assumptions and deficient experimental research designs. If most of the employees of a firm arrive within a short time interval before 9 o'clock at the premises, it is not an indicator that the firm hires very similar people. It is the consequence of the firm's rule that regular work time starts at nine. It is the local constraint that produces the uniformity.

VI

In line with the observed behavioural diversity of our very simple identical robotic agents, we may consider two propositions by extrapolating to future more complex robotic agents:

(1) To make any judgement on the uniqueness of an intentional agent one would have to create an extended series of tightly controlled and exactly reproducible lab experiments and observe individual agents over a very long time period 'in the wild'.
(2) An intentional agent should not be assumed as an isolated entity, but as extending into the environment and into other agents. Boundaries are always only partial, differ in space and change over time. They are also conditional on the aspect under consideration.

Note that (1) is only a methodological issue in research with intentional agents (humans, animals, robots), while (2) constitutes a fundamental assumption about the interconnectedness and interdependency of agency. It goes much further than many other externalist views including Clark's external cognitive scaffolding.

But what would this interconnectedness mean concretely? Accounts in psychology that propose for instance human 'cognition beyond the brain' [17] are often clear and persuasive in their arguments against the internalist view, but slightly vague when describing what would replace the input/output information processing model. The same applies arguably to philosophical approaches. Interconnectedness is claimed and described as an all-encompassing mutual relationship between the agent and the environment. But the concrete examples given can be usually explained within an internalist view as well, requiring maybe a few more assumptions and in the worst case leading to the need of a representation of the entire world in the 'mind'. In fact, any situatedness, no matter how dominating and decisive, can always be accounted for in an internalist view by referencing mental representation and simulation. The externalist account alluded to above would be forced to go beyond the proposition of relations in which the agent is involved—no matter how deep this involvement is assumed to reach. Relations are

between entities, they have endpoints by definition and, thus, if the agent is one of the endpoints, it re-emerges as the potentially isolated, separable entity. In order to avoid this return of the encapsulated agent, one has to locate agency in the relations themselves, the relations between the body and the environment (including other bodies). It would run into the danger of creating yet another dualism, that of body/ environment (the physical) and agency (the relational), but this would only be the case if the metabolic or hardware boundary is prioritised over all other boundaries and considered as defining.

At least with robots it is easy to see how the hardware boundary is simply one boundary among many: The hardware boundary dissolves already in a robot that is connected via wireless transmission to a cloud server on the Internet and via this server to other robots. In humans, robotic art that included cyborgs (defined as mixture of machine and human) and Internet connectivity such as the works of Neil Harbisson [18] and Stelarc (Chap. 20, this volume) venture out in the same direction. But as Stephens and Heffernan (Chap. 2, this volume) pointed out, this line of work of arts shows, what we already are, not something that we will become. Deteriorating mental health caused by solitary confinement [19] and drug-induced or mystic experiences of oneness [20] point in this direction, too, as do the importance of social behaviour in human evolution [21], the idea of distributed cognition enabling joint action of groups [22] and the discovery of mirror neurons in monkeys [23] and their assumed existence in humans [24].

Animals including humans are intentional agents from the onset; it is the machines which currently are lacking agency together with subjectivity. According to Roberto Marchesini referring primarily to animals but, of course, including humans '… subjectivity is arbitrariness, possibility, imagination, creativity, and partiality' [25]. These characteristics might or might not be achievable in machines, but if they are, it will happen in a still distant future. As Marchesini points out it would be a matter of machines very different from current ones and these new machines would be no longer under the control of the humans that created them.

The characteristics of subjectivity, however, might preclude identical reduplication even in machines; it might be a choice of either replicating identical agents or attaining subjectivity. These considerations are currently mere speculation since technology has not yet advanced enough to make even an educated guess. As mentioned above, the assumption of confined identifiable informational content in the brain might constitute an ill-guided perspective from the start, but even if not, we are more likely to approach tentative answers to questions of the relation between subjectivity, individuality and identity (as sameness) through research with robotic agents than in humans or other animals due to the latter's complexity.

There is a more fundamental assumption at stake here to which we already alluded above. If we cannot think of robotic agents as being one and being many at the same time, then there is even less of a chance to imagine this for humans. There appears to be no thinkable way of continuing one's life though transferring the information 'contained' in the brain because of the arising existential ambiguity (for other arguments in the same vein see [26]). Death would still take hold of

the individual despite the recreation of one or several perfectly similar but distinct new instantiations of the said individual. This is, of course, unless we are prepared to abandon the notion of seamless continuation of a person in general (or the concept of a self). Accordingly, at any moment in time the experienced presence might not have been uniquely connected to the experienced past and might not be uniquely connected to the subjective future. In doing so we would have to ignore ongoing processing in the biological body (including the brain) of humans and other animals during unconscious states. In case of the uploaded information content of the brain, we would have to assume that initial conditions do not matter or can be preserved and reproduced as well. Difficult if not impossible to imagine for biological agents, this might be acceptable for machines. These considerations are currently more in the realm of metaphysics, but—ironically—technology could make them a physical reality: If not a human or other animal, so at least a robotic agent might awake one day from sleep to find itself being more than one.

References

1. Clark A (2009) Dispersed selves. Leonardo Electronic Almanac 16(4–5)
2. Simondon G (2012) Technical mentality. In: De Boever A, Murray A, Roffe J, Woodward A (eds) Gilbert Simondon: being and technology. Edinburgh University Press, Edinburgh
3. Zwijnenburg PJ, Meijers-Heijboer H, Boomsma DI (2010) Identical but not the same: the value of discordant monozygotic twins in genetic research. Am J Med Genet Part B: Neuropsychiatric Genet 153(6):1134–1149
4. Smith M (ed) (2005) Stelarc: the monograph. The MIT Press, Cambridge, MA and London
5. Metzinger T (ed) (2000) Neural correlates of consciousness: empirical and conceptual questions. MIT press
6. Brambilla M, Ferrante E, Birattari M, Dorigo M (2013) Swarm robotics: a review from the swarm engineering perspective. Swarm Intell 7(1):1–41
7. Wallace RS (2009) The anatomy of A.L.I.C.E. In: Epstein R, Roberts G, Beber G (eds) Parsing the turing test. Springer, Netherlands, pp 181–210
8. Kroos C, Herath DC, Stelarc (2011) From robot arm to intentional agent: the articulated head. In: Goto S (ed) Robot arms. Advances in robotics, automation and control, InTech, pp 215–240
9. Kroos C, Herath D, Stelarc S (2012) Evoking agency: attention model and behaviour control in a robotic art installation. Leonardo 45(5):133–161
10. Andreopoulos A, Tsotsos JK (2013) 50 Years of object recognition: directions forward. Comput Vis Image Underst 117(8):827–891
11. Yang H, Shao L, Zheng F, Wang L, Song Z (2011) Recent advances and trends in visual tracking: a review. Neurocomputing 74(18):3823–3831
12. Herath DC, Kroos C, Stelarc (2012) Encounters: from talking heads to swarming heads. In: Proceedings of the seventh annual ACM/IEEE international conference on human-robot interaction. HRI '12, pp 415–416
13. Thrun S, Burgard W, Fox D (2005) Probabilistic robotics. MIT press
14. Herath DC, Kroos C, Stevens C, Burnham D (2013) Adopt-a-robot: a story of attachment (or the lack thereof). In: Proceedings of the Eights Annual ACM/IEEE international conference on human-robot interaction. HRI '13, Tokyo, Japan
15. Moon Y (1999) The effects of physical distance and response latency on persuasion in computer-mediated communication and human–computer communication. J Exp Psychol Appl 5(4):379–392

16. Delaherche E, Chetouani M, Mahdhaoui A, Saint-Georges C, Viaux S, Cohen D (2012) Interpersonal synchrony: a survey of evaluation methods across disciplines. IEEE Trans Affect Comput 3(3):349–365
17. Cowley SJ, Vallée-Tourangeau F (2013) Cognition beyond the brain. Computation, interactivity and human artifice. Springer, London
18. Jeffries S (2014) Neil Harbisson: the world's first cyborg artist. The Guardian. http://www.theguardian.com/artanddesign/2014/may/06/neil-harbisson-worlds-first-cyborg-artist. Accessed 03 Oct 2015
19. Grassian S (2006) Psychiatric effects of solitary confinement. Wash. UJL & Pol'y, 22, 325
20. Goodman N (2002) The serotonergic system and mysticism: could LSD and the nondrug-induced mystical experience share common neural mechanisms? J Psychoactive Drugs 34(3):263–272
21. Tomasello M, Carpenter M, Call J, Behne T, Moll H (2005) Understanding and sharing intentions: the origins of cultural cognition. Behav Brain Sci 28:675–691
22. Hutchins E (1995) Cognition in the wild. MIT press
23. Kohler E, Keysers C, Umilta MA, Fogassi L, Gallese V, Rizzolatti G (2002) Hearing sounds, understanding actions: action representation in mirror neurons. Science 297(5582):846–848
24. Fabbri-Destro M, Rizzolatti G (2008) Mirror neurons and mirror systems in monkeys and humans. Physiology 23(3):171–179
25. Marchesini R (2015) Dialogo ergo sum: subjectivity, posthuman and nonhuman alterities. In: Curtin university CCAT symposium 'what is philosophical ethology?', Perth, Australia
26. Hauskeller M (2012) My brain, my mind, and I: some philosophical assumptions of mind-uploading. Int J Mach Conscious 4(01):187–200

Part IV
Explorations

Way of the Jitterbug

Norman T. White

Abstract Norman White retraces a long, convoluted mental journey which started with a childhood love for fishing. College courses in Biology, exposure to the work of jazz pianist Lenny Tristano, a by-chance job wiring up a telephone switchboard, travel in the Middle East, and attendance at early club gigs by Pink Floyd all conspired to set him on the path of artistic experimentation using electronics. After an initial period of building "light machines", he turned to creating interactive physical devices that have "lives of their own", wherein programmed instructions and cycles process and respond to sensory data gathered from chaotic environments, thus giving them surprising and unpredictable behaviors.

Jitterbug

My fascination with robotics may well have originated with a childhood love for fishing. Mostly I liked to fish for bass, as it gave me the opportunity to fish with "plugs", crude imitations of creatures that fish eat. These are usually made of painted wood, metal, rubber, and plastic, and bristle with treble (three-pronged) hooks. Of course, fish are unlikely to be impressed by garish paint jobs; what really fools them is how the lure *behaves*. Pulled through the water with jerks and twitches, plugs take on a life-like action, like injured minnows or swimming frogs. It's up to a fisherman to turn, by skillful manipulation of rod and line, an unseemly conglomeration of chrome and plastic into something subtly alive. Years later, this same disjuncture of appearance and function infused my robots, obviously artificial and awkward contraptions attempting to mimic the subtle behavior of living organisms.

N.T. White (✉)
Ryerson University, 268 George St. East, Durham, ON, Canada
e-mail: normill@normill.ca

© Springer Science+Business Media Singapore 2016
D. Herath et al. (eds.), *Robots and Art*, Cognitive Science and Technology,
DOI 10.1007/978-981-10-0321-9_11

Euglena

My love for fishing led me to pursue Biology. Although I got straight A's in high school, college was a different matter; I was mediocre at most of my subjects. Nevertheless, there were certain studies that I loved, specifically the labs. In my Organic Chemistry labs, I learned how minor modifications to carbon-based molecules could cause what once smelled like fresh cut grass to smell like dirty socks! And I became so attached to my fruit fly mutants that I nurtured them for weeks after the Genetics course had finished. Most of all I loved the biology labs, and I feel extremely privileged as an artist to have been exposed to the lives of invertebrates, algae, fungi, mosses, slime molds, and single-celled animals.

One genus stands out above all the others: *Euglena*. Now I'm a big fan of achieving a lot with a little, and I'll bet there are not many organisms on this earth that can compete with this microscopic, single-celled animal when it comes to Economy of Means. Here's a run-down of its principal features: (1) For locomotion it has a "flagellum", a whip-like structure that propels its torpedo-shaped body through the water. (2) It makes its own food by using green structures called "chloroplasts" to convert carbon dioxide, water, and sunlight to sugar using photosynthesis. (3) It is able to home in on sunlight thanks to a little red "stigma", or eye-spot. (4) As osmosis is perpetually causing water to penetrate its cell wall, it employs a "contractile vacuole" or bailing structure to pump the water back out. (5) And of course it has its genetic blueprints stored in a "nucleus", so that it can reproduce itself asexually by dividing from time to time. In other words, it has all the equipment it needs to prosper, given modest access to carbon dioxide, sunlight, and water… even moderately polluted water! Can there be a better muse for robot-building than this? I don't think so.

Lenny

By the time I graduated from college, I realized I'd make a poor biologist. Fortunately, as part of my liberal arts education, I had taken courses in Studio Art from T. Lux Feininger.[1] Unlike most of my other subjects, art came easy. As graduation approached, I asked Feininger whether I had a reasonable chance to succeed as an artist. With his positive encouragement, I moved to New York City in the Fall of 1959, and rented a dingy little apartment on the Lower West Side. I worked first as a Claims Examiner for an insurance company, and in 1961, as a Lab Technician at the Rockefeller Institute for Medical Research. By night I'd hang out with artists, writers, and poets in the Cedar Street Bar, just North of Greenwich Park, or sling paint at canvases in the reckless style that was all the rage those days. It was a good time to be living in New York; the East Coast

[1]Son of painter Lyonel Feininger and brother of photographer Andreas Feininger.

Abstract Expressionist movement may have been winding down, but there was a vibrant jazz scene in progress. On many evenings I'd take in live performances by Charlie Mingus, Ornette Coleman, Thelonius Monk, or Horace Silver. However, the music that had the greatest impact was that of the blind pianist, Lenny Tristano. In particular, one of his recorded pieces, "Turkish Mambo", paved the way for my understanding of the interplay of order and chaos. In this work, Tristano overlaid multiple out-of-phase tracks of his piano riffs. The result was extremely complex syncopation, rich with musical surprise.

Hunter's Point

The Fall of 1961 found me arriving in San Francisco with $5 in my pocket. I wasn't too worried about surviving; I was sure I'd soon get a job washing dishes or mopping floors in some restaurant. I was wrong on that account... those jobs required union membership! Luckily it was the time of dented-can supermarkets and day-old bread shops, so one could live very cheaply. I rented a hotel room in North Beach for fifty cents a night, and got temp jobs through a municipal employment center. A chance conversation with the hotel desk clerk informed me that a local shipyard was looking for electricians. I applied, took a test, waited a few months for security clearance, and eventually signed on as a Helper Electrician at the Hunter's Point Naval Shipyard.

It was an amazing place to work, surrounded by World War II vintage moth-balled battleships and destroyers. Here, civilian "yard-birds" like myself converted ships bristling with heavy gunnery to those carrying only a few missile-launchers each. Steel superstructures were stripped away and replaced with aluminum ones, making the ships faster and harder to hit by enemy fire. And of course all this new missile technology required masses of electronic support, including hundreds of cables connecting all the various radar, launchers, target tracking systems, and the bridge.

For the first few months I worked on a "cable gang", pulling metal mesh-sheathed cable that reduced my work gloves to shreds within a week. Eventually I was given the task of wiring up a telephone switchboard, interconnecting the hundred or so dial-up ship's telephones. It was a job that changed my life.

At the time I still considered myself to be the kind of artist that paints images on rectangular objects, and indeed I continued to struggle along in this *modus operandi* on evenings and weekends. Trouble was, although I still loved the materials of painting, the smell of ageing linseed oil and turpentine, the ritual of stretching and priming coarse linen canvas, I was lacking original subject matter, or more centrally the reason why I should paint at all. A comment by Theodoros Stamos, from whom I had taken an evening Art Students League class while living in New York City, kept haunting me: "Nice painting, but why BOTHER?" It felt as though urgency was disappearing from my artwork, that it was becoming gratuitous.

Fig. 1 Heddon Jitterbug,
drawn by the artist

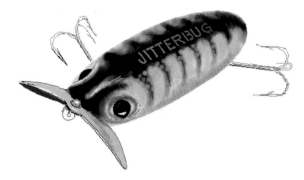

Fig. 2 Eucalyptus Trees in
Golden Gate Park (Chinese
ink on paper)

There was one exception: a small Chinese ink-on-paper painting I did from life while hanging out in Golden Gate Park. It was a painting of eucalyptus trees, though not so much of the trees as the shadows that obscured the outlines of their trunks and branches. As much science as art, it was a spontaneous enquiry into how our brains extract meaning from a confusing mix of object and field. The same preoccupation would resurface with even more passion when I tried to incorporate image recognition into robots 10 years later (Figs. 1 and 2).

Campbell

At the shipyard, I worked under the supervision of a charmingly sly and cocky Jamaica-born journeyman named Joe Campbell. By flaunting the technical jargon that permeates electronics, he had thoroughly convinced everyone that he was a master of his craft. However when it came time for Joe to explain to me the complex wiring blueprints of the telephone switchboard that I was about to wire up, I noticed major contradictions between what he and the blueprints were telling me.

I nodded appreciatively at his explanation and, after he'd left, started to connect wires according to the blueprint. When, weeks later, it came time to test the system, Joe threw the main power switch to ON, and lo, it functioned perfectly! Joe, probably more surprised than anyone, immediately started strutting around, shouting "Campbell, you're a fucking genius!"

Meanwhile, I was being mesmerized by what was happening within the guts of the switchboard. Whenever someone dialled a telephone number, electromechanical switches called "relays" would writhe and chatter like something alive, creating series of staccato clicks as they sought the desired connection (note, these were the days when telephone systems still used moving parts; it'd be another few years before relays would be replaced by silent, non-moving switches called transistors).

Though I had yet to make a connection between art and what the relays were doing, I recognized right away that what was going on, this crude simulacrum of life, was beautiful!

Reorientation

In the year and a half I worked at Hunter's point, I managed to save up about $2000. The money was targeted for extended travel abroad. I'd been reading a lot about the Middle East in books by Lawrence Durrell (Alexandria Quartet), Henry Miller (Colossus of Maroussi), and Nikos Kazantzakis (Zorba the Greek), and that unique Mediterranean light they spoke about pulled at me like a irresistible magnet. Cheap trans-Atlantic air fares were not yet available, so I forked out $108 for a New York-to-Tangiers sea crossing. In early 1964, with a fresh copy of "Europe on $5 a Day" in my backpack, I boarded a Jugolinea freighter that was to take 6 weeks to make frequent stops along the U.S.'s Eastern seaboard, and then diesel its way slowly across the Atlantic.

I spent the next 18 months hitch-hiking though Spain, France, Italy, Yugoslavia, Greece, Turkey, Syria, Lebanon, Iraq, Iran, West Pakistan, Nepal, and India. These were eye-opening months. The Islamic decoration and architecture that I encountered in Spain, Turkey, Iran, and the Arab countries resonated with me on many levels. At times exotically floral, at times geometrically stripped-to-the-bone, here were Mathematics and Biology wedded inextricably. Moreover, the passion of the artwork was expressed in terms of calculation and precision, a far cry from the Dionysian recklessness that the Abstract Expressionists had promoted as the only sane way to make art.

Wireways

Sitting in a cafe in Calcutta, I noticed that a rotating ceiling fan reflected in my spoon resembled a miniature turn-style. I took this as a sign that it was time to start heading back west. Three months later, after lingering one more month in

Fig. 3 Wireway Four (oils
on canvas)

Greece, I hitch-hiked to London. There I discovered that many English artists
too had turned their back on the recklessness of Abstract Expressionism, and that
masking tape had teamed up with paint as Op Art and related calculation-based art
became the new norm. After a couple of months of temp jobs, I got hired as a care-
taker for a block of Flats in Hampstead that allowed me the freedom to add my
own take to that art practice (Fig. 3).

One morning in a dream I received a clear vision spawned by memories of
Hunter's Point. Running along the ceilings of ships' passageways are structures
called "wireways". Masses of cables run along these wireways, crossing over each
other from time to time like roadways in a complex highway system. In my vision,
I saw cable-like structures doing much the same thing in a way that depended
upon quasi-Islamic calculation. Feeling I'd finally come up with imagery that
I could call my own, I embarked on a series of Wireway paintings, each one con-
sisting of a different logical enquiry. The cables pictured always had 45° or 90°
bends, and would always be the same diameter. These bends occurred at constant
intervals, and would sometimes be duplicated exactly by adjacent bends. But,
like the Lenny Tristano jazz tracks, the bends were often out-of-phase, giving the
impression of a random scramble. On careful analysis, however, a viewer could
discern that a rigorous logic was in force.

U.F.O.

At that time (mid 1960s) there used to be an basement dance venue on London's
Tottenham Court Road that could hold up to about two hundred people. I can't
remember what it was called, but I do remember, most of the week, it featured ball-
room dancing. On Saturday nights, however, it metamorphosed into a psychedelic

club called the "U.F.O." Lighting techies erected scaffolding, and on those scaffolds they mounted slide projectors. The "slides" themselves were thin sheets of glass between which were sandwiched mixtures of water and oil containing aniline dyes. Projected onto the wall behind the stage, the dyes created organic patterns so intense in colour as to be almost painful to look at. The techies then animated the projections by directing blowtorch flames onto the slides, causing the patterns to squirm, swell, and explode in an unpredictable manner. On the adjoining dance floor, strobe lights made from burnt-out car headlights created a now familiar fracturing of time. The stage itself was usually occupied by one of two newly-formed bands. One was The Soft Machine; the other, Pink Floyd. Burned into my mind's eye is the memory of musicians playing with their backs to the audience, using the projected patterns as sheet music.

Out in the lobby, little black boxes were for sale. These were approximately cubic, about 6 in. on a side. On the top of each box were nine miniature neon bulbs[2] that flashed in a seemingly random order. There was no switch, no way to turn the lights on or off, so the box was like a little creature that had a life of its own. You could stick it into a bottom drawer, but you knew that down there, covered in sweaters, it would still be flashing in its own secret way. These little boxes pushed me over the edge. They seemed to pull together all the elements that had fascinated me up till then: the artificial life of fishing lures, *Euglena*, Lenny Tristano's tapes, telephone relays, Islamic geometry... Suddenly I could hear electrons whispering urgently in my ear, "Follow!"

Radio London

Even with the encouragement of electrons, I still considered myself to be a painter. I would guiltily turn my back on whatever canvas I was working on in order to indulge my new obsession with electronics. My radio was often tuned to the pirate station called "Radio London", and one afternoon a calm, self-secure voice came on that caused me to put down my soldering iron. What it was saying made no sense at all, while at the same time making extreme sense. In some coded, poetic way it reinforced what the electrons were whispering, that my new obsession was not an indulgence at all, but something that desperately required the attention of artists. I waited excitedly for the speaker to finish so that I could find out his name. It was Marshall McLuhan.

[2]These were the only bulbs available at the time that had long life-expectancies. They required a hazardous 90 V to illuminate. Low voltage light-emitting diodes (LED's) would not appear on the market until about 5 years later.

Proops

A "U.F.O." Black Box cost more than I could afford on a caretaker salary,[3] so I set about building one. At the time I knew next to nothing about electronics, except for a few basic principles I had picked up from my high-school and college physics courses. This was mostly theory, with almost all my practical knowledge coming from the shipyard job. Theoretically, I understood the relationship between electronic "pressure" (volts), "flow" (amps), and "resistance" (ohms), and, practically speaking, I understood the importance of wire colour-coding so that one could more easily trace what was connected to what. But I had yet to learn how to read the stripes on resistors, or know what a capacitor or a diode did.

A few doors down from the "U.F.O." was an electronic surplus shop called "Proops". In the window of this shop were laid out an array of circuits and parts, like candy store sweets. Among them were neon bulbs exactly like the ones on the Black Boxes. One of these bulbs was made to flash by a small exposed circuit consisting of four or five parts, none of which I could identify for sure. Face pressed against the glass, I made a crude sketch of the circuit, which I brought inside hoping to get advice on how to build the circuit myself. Unfortunately the sales people were either too busy or didn't know themselves. Nevertheless, I purchased a few neon bulbs, and on succeeding paydays returned to Proops to buy more.

I then set about building a small table-top artwork called "The Blue-Green Machine".[4] It's purpose was to generate, on an 8×8 rectilinear grid, two simple overlapping light patterns, traversing the grid at slightly different speeds and opposing vectors, so as to create a confused result. I wanted to see whether the eye could disassemble this complexity into the two underlying patterns using Gestalt perception. This was exactly the same perception phenomenon I had pursued in my Wireway paintings, now brought into a kinetic dimension.

The technology I employed was inspired by wind-up music boxes. A single motor turned two cardboard drums at different speeds via different sizes of Mecanno gears. The drums were covered first in copper foil and then with adhesive plastic from which squares had been cut away. The resulting bare patterns allowed copper brushes to make electrical contact with the drums, thereby powering the neon bulbs in the desired sequences.

Resources

One of the perks of the caretaker job was access to the consumer electronics that the tenants were throwing out. I'd carefully disassemble and de-solder whatever transistor radios, tape-recorders, etc. I found in their rubbish bins, thereby

[3]Five Pounds Stirling, or about 14 U.S. Dollars a week.

[4]The title came from its shell of blue and green Plexiglas, scrounged by friends from Hornsey Art College bins.

accumulating an assortment of usable components. I found this tapping into a source of free parts tremendously satisfying. Like the burnt-out headlights that the Pink Floyd techies had turned into strobes, these materials were not only saved from land-fills, but resurrected for potentially creative uses, all at no cost! Trouble was, I had yet to learn how to substitute recycled parts for the ones specified by the D.I.Y. articles in hobby electronics magazines. While attempting to build a simple electronic organ, rather than dulcet tones I got shocks, sparks, and smoke! Nevertheless, there was no going back to painting; it was as though a huge bird has sunk its talons into my shoulders and carried me off into new giddy heights of wonder.

Around that time (1966), a Canadian friend sent me a newspaper clipping describing the work of Toronto-based artist, Michael Hayden. The article described a number of Hayden's large-scale electronic installations. What blew me away was that not only was there another artist working with electronics, but that he was getting his materials donated to him by various local electronics and plastics companies. While I was putting aside shillings to buy another motor or neon bulb, this Canadian guy was getting all his stuff free! A couple of months later, I was on a Holland-American liner bound for Canada.

Shift Register

The western Atlantic crossing took 5 days, way faster than the eastern crossing 2 years earlier. During those 5 days I spent most of my waking hours working on a circuit design problem. Using the only electric switching components I knew about, relays, I was trying to figure out how to pass binary (either on or off) signals along a chain of devices in an orderly manner… like a bucket brigade.[5]

I stopped off at my parents' home in Massachusetts still lacking a solution. When I told them what I was trying to do, they suggested I have a chat with an electronic engineer who lived down the street. And so it transpired that Charles Grandmaison, an electrical engineer who worked for a company called Sprague Electronics, sat down with me one evening over a pad of yellow paper. Right off the bat Charlie told me that I shouldn't be using relays at all; that it would be far easier to use integrated circuits (I.C.'s). I didn't have a clue what an integrated circuit was, but Charlie patiently sketched out the basics of what they were and how they worked. He told me moreover that a chip called a "shift register" did precisely what I wanted. A few weeks later, he sent over a box containing several hundred I.C.'s that looked like little metal octopuses, each with eight copper legs extending downward from a tiny inverted tin-can body.

[5]These days, you see this phenomenon in scrolling message signs.

On arriving in Canada, I landed a part-time job as a graphic artist for Erindale College, a satellite branch of the University of Toronto. On my days off, I returned to the shift register project, this time using the Sprague parts, and after a bit of frustration managed to get a chain of these working. Now it came time to put these to work in an art context.

E.A.T.

In the Fall if 1967, I heard about an exhibition[6] that was being organized by Billy Kluver, a friend of Marcel Duchamp, that was to take place in the Brooklyn Museum, New York City. It was sponsored by an organization called "Experiments in Art and Technology", or "E.A.T." for short. The idea behind the show, and indeed E.A.T. itself, was to bring together the creative minds of artists and engineers. The former would come up with concepts, and the latter, implementations. Since I could put down Charlie Grandmaison's name as my engineer, we indeed fit the paradigm, and here was a chance to show off my shift registers in action. As Charlie and I live hundreds of miles apart, both concept and implementation became my responsibility. Not that I regretted having to fill both shoes. I knew that if I gave an engineer a particular concept to implement, and if s/he were competent and the task do-able, I would get exactly what I asked for, nothing more, nothing less. But if I implemented the concept myself, I would probably make mistakes, and those mistakes might lead me to discoveries that would alter and enhance my original concept.

Still, I did need *some* kind of instruction, and during this period, my teachers were the people who wrote articles for the hobbyist electronics magazines of the day.[7] It was as though the physical junk available from surplus electronic stores was mirrored by informational junk sold at the corner variety shop! Instructions on building a windshield wiper control could be more broadly applied to the speed control of any direct-current motor, while a project involving maintaining an optimum water temperature in a fish tank could be useful as an insight into sensors generally.

The artwork into which I put the 300 shift register I.C.'s was called "First Tighten Up on the Drums", a tip of the hat to Archie Bell and the Drells, as well as to my belief that rhythm was humankind's first means of expressing the *logical* division of time. It used 109 neon bulbs arranged in a hexagonal matrix, on which I hoped to generate kinetic patterns similar to the dancing lights seen on the bottom of swimming pools. Instead I got patterns more like the sometimes stretching, sometimes compressing shapes of clouds, or rain water running down a window.

[6]"Some More Beginnings".

[7]E.g., Don Lancaster (*Radio Electronics Magazine*), and later Steve Ciarcia (*Byte Magazine*) and Forest Mims III (*Engineer's Notebook*).

Ménage

Over the next 8 years ('68 to '76) I designed and built a number of "machines" that manifested various nuances of logical interactions in light and sound. However, one of my artworks during that period took a small side step into more physical expression. It was inspired by an article in a 1950 *Scientific American* magazine documenting robotic projects by W. Gray Walter, an English neurologist. Dr. Walter had built wheeled artificial "tortoises" out of surplus parts, each incorporating the simplest possible control element: a single radio vacuum tube. In fact, his basic intention underlying the project was to demonstrate that complex and unpredictable behavior could derive from extremely simple control principles. Guided by emitted and sensed light, his robots would chase each other around and pull back from collisions, as well as autonomously find their way to recharging stations when their batteries were running low. If one singled out robots that approach *Euglena*'s economy of means, Walter's "tortoises" would undoubtedly be high on the list (Fig. 4).

Fig. 4 Ménage

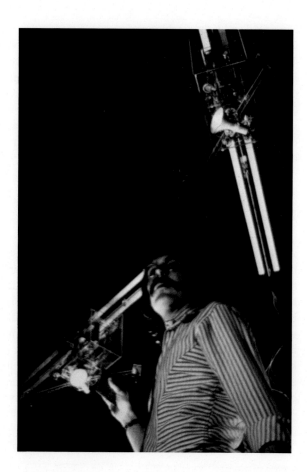

My 1974 response to Walter's work had no pretense of originality. "Ménage" consisted of five robots, four of which travelled slowly back and forth under separate ceiling-mounted tracks. A fifth robot sat on the floor, unable to move except to sense, track, and record the activity overhead. Each ceiling robot had a horizontally rotating antenna on the ends of which were attached light sensors, and a single incandescent light bulb mounted on the middle of the antenna. With this configuration, a robot could haphazardly locate the light emitted by one of its fellow robots. When this happened, its antenna would cease its searching behavior, and instead home in on the light source. This would increase the chances that it and the target robot would "lock into" each others' gaze. The drive motors that moved the robots along the tracks would ultimately break up any such semblance of machine rapport, a feature which prevented the installation from entering a steady state from which it could not extricate itself.

Meddle

My sound and light machine series culminated in two works called "Splish Splash One" and "Splish Splash Two", the first, a table-top prototype; the second, a 40 ft × 8 ft mural, built in 1976 for the Vancouver offices of the Canadian Broadcasting Corporation.[8] Again, the names were derived from a pop song, this one by Bobby Darin. The concept itself was triggered by a Pink Floyd album cover ("Meddle"), and was yet another expression of my old fascination with the way simple and similar, yet out-of-phase, events interact to create patterns of chaotic complexity. Hence, both of these machines portray raindrops falling on the otherwise still surface of a pond.

F.O.L.L.

After completing Splish Splash Two in 1976, I lost interest in building light machines. Momentous events happened to me that year that sent me off in another direction. The most life-changing was the birth of my daughter, Laura. The day following her birth, I celebrated by purchasing my first single-board microprocessor-based system, a "Motorola D-1 Evaluation Kit". By today's standards, the spec's of the D-1 are almost laughable. It required a dumb terminal for human interaction, and an audio cassette interface for downtime program storage. With less than 256 bytes of on-board memory, it had to be programmed in hand-assembled machine code. Though acutely aware of its limitations, I was enchanted with its potential to emulate the adaptive nature of living systems. Rather than hard-wired elements

[8]As of this writing, more than 38 years later, "Splish Splash Two" is still 100 % operational.

controlling an artificial organism's behavior, non-physical instructions could now take on that job. They could even be modified by the organism itself![9]

I immediately plunged into learning how to program the D-1. Its miniscule memory may have made it useless for screen graphics, but it was perfectly adequate for controlling devices that interacted with the physical world. With proper interfaces, I could use it to control the speed and turning direction of motors, create tone sequences, or read a variety of sensors. In other words, it was fine for simple robotics. When an invitation came from the National Gallery of Canada to participate in a four-person[10] show called "Another Dimension", I felt I had to submit something incorporating the D-1 Kit… something robotic.

The work I built for the National Gallery show I called "Facing Out Laying Low", or "F.O.L.L." for short. Onboard was the D-1 Kit, with its memory augmented to a staggering 8K. Conceptually it was an offshoot of Ménage's floor-situated robot. The bases of both machines were essentially stationary, and both had optical scanners that could rotate 360°. However, whereas the earlier robot simply recorded the kinetic light patterns of its environment by scribbling on a circular piece of paper, F.O.L.L. constantly scanned its surroundings looking for novel activity… most likely, the coming and going of humans. When it located such activity, its scanner would tend to linger in that quadrant, although from time to time it would glance "over its shoulder" to ensure it wasn't missing anything (Fig. 5).

I used a large portion of F.O.L.L.'s memory to create an internal map of where it was most likely to find activity. Conceptually peaking, it was like a square of stretched rubber sheeting that could be distorted by poking here and there. When a particular point was poked, adjacent points would also be distorted, proportional to their distance from the point of contact. With no further poking, the rubber sheeting would slowly return to its original flat state. In this way F.O.L.L. was able to "forget" about activity that ceased to be ongoing. The robot also used variable thresholds to decide whether a stimulus was strong enough, or unforeseen enough, to warrant a response. Therefore it would turn away from persistent stimulation coming from a certain sector.

Emotion

In 1978, I started teaching electronics and computer programming at the Ontario College of Art.[11] It's Chair was Richard Hill, a disciple of Marshal McLuhan. The story went that Hill had met Roy Ascot, then president of the College, at a 1970s

[9]Self-modifying code is very much frowned upon by professional programmers, as too easily it goes out of control.

[10]With Ian Carr-Harris, Murray Favro, and Michael Snow.

[11]As it was called at the time. In 1996 its name was changed to the "Ontario College of Art and Design", and in 2010, to "OCAD University" in moves that reveal an increasingly conservative, industry-minded mentality.

Fig. 5 Facing Out Laying
Low

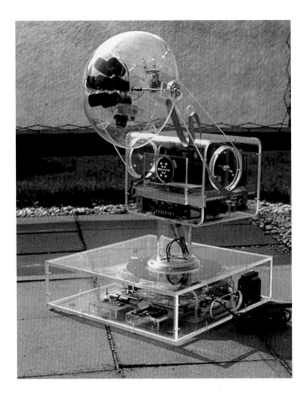

cocktail party, and had convinced him to create a new department called "Photo-
Electric Arts". The title derived from Hill's prophetic belief that the telephone, tel-
evision, and digital computer were about to fuse into a single technological
phenomenon, and that this would have huge consequences for human culture.
Although small, poorly funded, and often ridiculed by the rest of the College, the
Photo-Electric Arts Department attracted students with a wide range of talents.
Sensing the liberating truth of Richard Hill's prophesies, they bonded into a tight,
committed cadre.

Before my working at O.C.A., I described my art practice as a pursuit of the
aesthetics of logic, accompanied by an interest in the origins of chaos and the
mechanics of perception. Teaching, however, inspired me to pursue a different kind
of logic, one expressed in emotional terms. Turning away from computer science's
longstanding interest in Artificial *Intelligence*, I started focusing on the underval-
ued role that emotion plays in **directing** our intelligence. Could a machine which
is fundamentally a product of the intellect also model emotions? If so, how does
one even begin to build a conceptual emotional framework? Are there primary
emotions, like primary colours, from which all other emotions evolve?

With these questions in mind, I constructed a robotic installation that would
form a test bed for experimenting with Artificial *Emotion*. I called it "The Helpless
Robot" because it contained no motors, no way of moving any part of itself. This

Fig. 6 The Helpless Robot

was partly to get around the fact that motors are usually the first thing to go in a kinetic artwork. Mostly it was because the concept simply didn't require them. Inspired by an early Candid Camera TV skit involving a very perverse "Talking Mailbox", its only output device consisted of a speaker by which it could voice its thoughts to passers-by. Input-wise, it had sensors that informed it whether there are humans in the vicinity, and a rotation sensor that indicated whether and how it was being turned, as well as where it was pointed at any given instant (Fig. 6).

Superficially I designed the robot so that it looked nothing like a human. The disconnect between appearance and behavior was deliberate; it was important to me that its obvious mechanical nature contradict any life-like dimensions of its behavior.

The robot rotated on a large industrial "lazy susan", and did so only by enlisting the help of human beings. It had a verbal repertoire of 512 phrases, from which it selected one based upon the settings of sixteen 3-state[12] software "discriminators"

[12]The three possible states are "Yes", "No", and "Irrelevant".

that were constantly being recalculated by the main program. The discriminators answered such questions as "Is there a human present?" and if so, "Have they arrived recently", or "Am I being turned?" and if so, "In the right direction?" Also influencing the the next utterance was a 4-state "politeness" variable, which decremented with human cooperation and incremented when the robot was ignored. The only random aspect of the Helpless Robot's program was the selection of its next target position. What made the work unpredictable derived entirely from the jostling between its internal program and the uncertain behavior of humans.

It is this uncertain response of humans which is often the experiment's downfall. Most people take perverse pleasure in simply spinning the robot this way and that, ignoring its pleading for cooperation. As a result, most tormentors hear only a tiny fraction of its verbal repertoire: "Stop, please", "SLOW DOWN!", "Go the other way", etc. A notable exception occurred when it was installed for a month in the cavernous lobby of the Municipal Offices of the City of Ottawa.[13] The security guards there, grateful for an outlet from boredom, went to great lengths to listen to and alternatively fulfil and thwart its requests, thereby navigating its full interactive labyrinth.

Enough

Looking back on the evolution of ideas that brought me to the building of robots, I detect several evolving threads. Among these are:

(1) a love of organic form and process. There is no wiser muse than Nature.
(2) a deep respect for an Economy of Means. Achieving goals with a minimal expenditure of resources is an aesthetic act in itself.
(3) a celebration of emergent phenomena, whereby one sets up the starting conditions of an open-ended situation, hoping to be surprised at what ensues.
(4) "bottom-up" practice, first becoming intimate with materials and processes, and then letting their properties lead to concepts.
(5) "knowing enough"… in both its meanings: knowing enough to get a job done, and knowing what *is* enough.

[13]The installation, curated by Dr. Caroline Langill, occurred in 1994 under the broader exhibition cycle titled *Invading the Imagination*, which was generated out of the SAW Gallery, Ottawa, Ontario.

Still and Useless: The Ultimate Automaton

Nicolas Reeves and David St-Onge

Abstract Robots descend from the long genealogy of automata, machines with no practical purposes essentially meant to simulate objects embedded with an anima. Our hypothesis is that the thrust for the creation of every robot is rooted in the primordial myth of infusing inanimate matter with the breath of life: the aim of any automaton is to become a living thing. The ultimate automaton does not need to move or to do anything: the essence of any robot lies in the desire to simulate life to the point where it actually becomes alive. This chapter presents the Aerostabile research-creation program, which progressively evolved from an architectural origin to a research platform for exploring the nature of the elements that maximizes this deliberately created illusion. It goes through the origins and main methodologies of the program, then describes several artworks that were created along its evolution, focusing on the notion of behaviour and observed interactivity.

Automata and the Art of Life-Simulation

The proliferation of robots in all spheres of current life tends to obliviate the fact that they were, up to the beginning of the 60s, a tiny subset of the huge family of automata, so called because they are animated by an internal source of energy, from which they descend through a long and complex genealogy. It is all the most interesting to realize that the English word "automaton", dated from the beginning of the XVIIth century, and the French word "automate", dated one century earlier, do not only refer to movement: they have been coined from the same latin word *automatus*, itself derived from the Greek word *automatos*; auto refers to self, and *matos* has the

N. Reeves (✉) · D. St-Onge
NXI GESTATIO Design Lab (Arts Design Architecture Informatique)
École de Design, Université du Québec à Montréal, 1440,
Sanguinet, Suite DE6250, CP8888, Succ.Centre-Ville, Montreal, QC, Canada
e-mail: reeves.nicolas@gmail.com

© Springer Science+Business Media Singapore 2016
D. Herath et al. (eds.), *Robots and Art*, Cognitive Science and Technology,
DOI 10.1007/978-981-10-0321-9_12

Fig. 1 Two Tryphons aerostabiles in a state called "Paradoxical Sleep", Chalet du Mont Royal (Montreal 2014). The aerostabiles are flying cubic automata with no anthropomorphic or biomorphic features. In this state, they stand almost completely still in the air. To reach that result however, information and signal transfers in their electronic circuitry is frantic (Photo by Nicolas Reeves)

triple meaning of moving, thinking and willing. Diving a little deeper in the past, it appears that *matos* itself comes from the much older Proto-Indo-European root **mn-to*, from **men*, "to think"—the same word that gave "mind" and "mental".

Etymologically speaking, "automaton" thus describes a machine that can not only move or work, but also think and will, three notions that are usually associated with beings infused with a mind: conscious living beings. The oldest known automata were made for purposes that were often quite far from what we expect from contemporary robots: during Egyptian, Roman and Greek Antiquity, as well as in the Japanese Edo era, they were created in order to simulate animated or living beings, in order to infuse a sense of awe or mysticism, or simply for amusement. In most of the cases, their designers, or the people presenting them, declared that they were moved by some kind of spirit of deity.

Robots appeared in the XXth century as automata of a specific kind. As it is well known, the word "robot" appeared for the first time in the 1920 R.U.R theatre play by Czech writer Karel Čapek (though the word itself was coined by his brother Josef). It comes from the Czech word "robota", or "worker", itself derived from a Slavic root that means "slave". It conveys the status of robots as machines specifically designed to compensate for humans' limited abilities in the execution of tedious, precise, dangerous, costly or heavy tasks. Such working

automata began to develop at a large scale very late in history, at the beginning of the 60s. Before that, from the Renaissance on and all along the XVIIth century, automata were created mainly to simulate complex human or animal behaviours: playing music, writing letters, playing chess, eating, and even digesting and defecating, which resulted in some of the finest mechanical pieces of all times. The idea behind such attempts was to simulate life through its most complex manifestations: the precision of the simulation would reinforce the interpretation of the machine as a living organism. Smaller automata created for pleasure or amusement became very popular during the XIXth century.

If we except water clocks, whose origin is lost in the depth of times, the first automata specifically designed for practical purposes were most likely the 13th century early timepieces. All along their history, mechanical clocks remained intimately connected with the world of automata. Some of them, like elaborated Swiss cuckoos or James Cox's extraordinary Peacock Clock (now at the Ermitage museum in Saint-Petersburg), were associated with animated characters whose sophistication reveal their belonging to the realm of automata. Even today, complex clockworks, such as the Supercomplication watch by Henry Graves, reach tag prices of several million dollars, an amount completely disproportionate for a device whose sole function is to indicate time, but begins to make (some) sense for an automaton artwork—a device that seems to be animated by a living process.

The first mentions of robots specifically made for the execution of tasks date from the 20s. Jacquard's looms in the XVIIIth century had several characteristics of automata, but they were powered by human beings. This was also the case for the first computing devices such as Pascal's Pascaline or Babbage's machines, whose mechanism was directly inspired by Jacquard's looms. Apart from the first computing machines such as the Zuse (1941), the ENIAC or the Colossus, the first practical device that fully deserves the name "robot" seems to be General Motor's "Unimate", put to work in 1961. Computing machines also belong to the category of automata, but they are unable to implement any physical task; moreover, they have a unique feature that distinguishes them from all others automata: their ability to simulate themselves, and to simulate automata that replicate themselves. They can contain all the information required to produce a copy of themselves, as well as the information to produce the devices required to implement these copies. This property of self-representation/self-replication is unique and important enough to provide a precise definition for a computer; here again, it is usually associated with living organisms.

The long history of automata, joined to our fascination for self-animated machines, gives to all of them a powerful mythical stance, which can be seen as the essential cause for their very existence and proliferation. Trying to communicate with objects made from inert materials can be seen as one of the manifestations of human's primordial will to relate with every element of the world, even the non-living ones; and to convince themselves that they are not strangers in this universe that surrounds them. The obsession for the imitation of living beings does not only appear through robots, but was for long the object of many forms of art, from sculpture and painting to architecture. Automata is the realm where our impulse for *animation*, which fundamentally means

the process by which a soul (*anima*) can appear spontaneously in an artefact, expands to include movement and behaviour. It is directly related to a wealth of ancient legends in which *animated beings* are created from inert materials, from Prometheus to Adam, from Frankenstein to Pinocchio.

Some of these attempts may seem utterly naïve to us, but their role in the development of science and technology cannot be neglected.[1] Most of our contemporary technologies are related to mythological obsessions that can be traced to the oldest Antiquity: skyscrapers (a building like a mountain—the Babel tower), planes (flying—Daedalus and Icarus), rapid prototyping machines (fairy magic wands), internet (ubiquity)... The myth of a machine that simulates a living being to a point where it can be infused with life, thus transforming its creator into a demiurge, is at the root of the genealogy of about all robots and automata. It is thus not surprising that humanoids robots remain so popular and remain the object of so much research and experiments, despite the non-adequation of the human morphology and abilities for most of the tasks we try to delegate to robots: rationally speaking, the design of a robot should be optimized in order to implement tasks that they can do better, or more efficiently, than us. Humanoids shape are seldom optimal in that respect. This might be the best demonstration of the non-rationality of all attempts at creating artificial humanoids: such experiments reveal to which extent the field of automata, despite its new techno-scientific clothes, escapes rational logics by several aspects, and remains deeply rooted in the fields of mythology, poetics, and arts.

"Robotic arts" is the most common expression to designate artistic practices in which robots are designed implemented, or even hacked for the sole purpose of producing emotions, impressions and feelings, and for creating sense and signification through events that are originally senseless. In the vast majority of the cases, such practices should be more appropriately named "arts of automata", since very few pieces of robotic arts are actually made to implement any kind of practical task. Arts of automata can be conceptually described as the process of eliminating all pragmatic or practical functionalities from a robot, in order to create a machine whose sole purpose is to trigger empathy, fear, amusement, compassion—the whole range of human feelings and emotions, including awe, just like the first religious automata. More than any robotic technology, robotic arts are rooted in the most distant past through their similarities with such very early attempts.

Emerging Emotions, Induced Feelings

The question to know what are the features of a robot that actually triggers these feelings is mandatory for our research programs. It is a vast and important topic which is the object of an increasing number of studies.[2] Obviously, robots with

[1]See Bedini [1] for an historical account of the intersection between automata, life simulation and technology.

[2]See for instance Bruce et al. [2], or Imai et al. [3].

humanoid features have an advantage: the interpretation of their movements and facial expressions is facilitated by our own acquired knowledge and culture. Even very approximate simulations provide enough clues for an observer to find out the meaning or message they try to convey. In the medical field, several experiments use human-face robots for therapeutic purposes, e.g. for helping people with mental disorders such as autism or Asperger[3]: the exact repetition and predictability of their reactions creates a safety perimeter within which these patients will take the risk of attempting a relation with them. It may however be easily observed that such features are not necessary for generating emotions. For instance, most of Bill Vorn's machines have no face,[4] and adopt a heavily industrial aspect. Every element of their morphology is inspired by working robots; their appearance is often more hostile than welcoming. Their expressive power is nonetheless undeniable.

In every respect, the expressive power of an automaton depends not only on its morphology, but also on the number of configurations it can take. Each configuration ("state"), as well as every transition between these states, has the potential to trigger specific emotions in the observer. At first glance, this seemingly reductive statement can be seen as limiting their expressivity: being mechanical devices, automata cannot compete with biological organisms at the level of the number, variety, precision or subtlety of their movements. Strangely enough though, several robots with a very limited number of states reach an astonishingly high level of expressivity, despite the fact that the observer is fully aware of their artificial nature.

Such observations naturally raise the question to know which features or reactions of an artificial device are at the origin of the emotions and feelings felt by the people that interact with them. This topic has been the object of an exponentially growing number of studies in the last years, especially in the HRI community[5]; most of them point out to the vast number of disciplines that are involved. One of the most famous and most quoted attempt at understanding the link between human emotions and robotic morphology is already old: Mori's model called the "Uncanny Valley" links the nature of the feelings we experiment while looking at a robot to the level of resemblance between that robot and a human being.[6] Mori's hypothesis is unfortunately plagued by blurred definitions and a strong level of empiricism, which prevents it to be really useful even for planning an experimental protocol. The feelings that are listed ("negative feelings", "revulsion") are too vaguely defined to even allow the possibility of a metrics, mainly because the level and nature of feelings in front of any stimuli are not observer-independent: they are inextricably linked to the cultural origin of people, and to their personal history. Numerous observations and examples show frequent

[3]See for instance Pioggia et al. [4].

[4]See for instance the Mega Hysterical Machine at http://billvorn.concordia.ca/menuall.html.

[5]Destephe et al. [5].

[6]Mori, M.—The Uncanny Valley, Energy 7(4), pp. 33–35, 1970.

cases where automata with no biological or anthropomorphic features whatsoever do trigger feelings of empathy that can be stronger than the ones triggered by human-shaped or animal-inspired artefacts. Our own observations confirmed that the behaviour and reactions of an artificial system, especially during interactive processes, are much more important than any particular morphological feature. It is from our own researches that we came to this conclusion, along the development of a research-creation program called *Aerostabiles*, derived from a former research program on Self-Assembling Intelligent Lighter-than-Air Structures (SAILS). Before elaborating on this point though, some information should be given on the nature, history and evolution of one of our first robotic art projects, called Paradoxical Sleep.

An Architectural Origin

The purpose of the Aerostabile program is to design and implement automata that hover in mid-air and that are able to generate flying architectures by self-assembling themselves in flight. It was born from the desire to materialize another age-old myth, this time originating from the field of architecture: the myth of a heavy mass freed from the law of gravity.[7] This idea can be found in several countries all along the history of architecture. Even today, to make a building like a castle or a palace fly in mid-air with its thousands of tons of stone or concrete is everywhere seen as the manifestation of a supernatural power. Some of the oldest mythological examples are the flying vimanas (Chariots or Palaces) mentioned in Ancient India; though their mention in literature is not rigorously attested, they are still the object of a lasting fascination, and some representations show them as seven-storey high flying buildings.

Besides such imaginary structures, immense efforts were made across history to give stone, concrete or steel the appearance of weightless materials. Seen from inside, at certain times of the day, the dome of Hagia Sofia in Istanbul seems to hover on a layer of light. The contrast between this phenomenon and the bulky, massive appearance of the church is striking. It reveals the amount of energy and efforts that was deployed to create this effect at a specific, privileged place of the building. Six to seven centuries later, the architects of the Gothic period, especially those of the late Gothic, have developed an expertise in the use of stone that allowed them to use it to its very limits. Solid walls almost disappeared in order to maximize the penetration of sunlight, so as to best elevate the soul towards the weightless Heavenly City. The most striking example is the upper nave of the Holy Chapel in Paris (XIIIth century), in which the walls almost dissolve into huge glassworks separated by incredibly thin columns. Boullée's XVIIth century imaginary monuments, like his cenotaph for Newton, were so tall and huge that they could not be realized with the materials and techniques of the time. They

[7]Reeves et al. [6].

implicitly supposed the use of materials with an unseen relation to gravity. Right after the invention of flight, numerous projects or experiments were made on the theme of weightlessness by artists such as Malevich or El Lissitsky, or architects such as Krutikov,[8] whose project for constructivist flying cities used flocks of helium blimps to suspend whole communities between the clouds:

> Malevich believed that weightlessness constituted the highest aim of technology, and hoped that scientific advances would make free unpowered flight feasible, allowing cities to be placed as satellites floating in the cosmos.[9]

Without reaching such extremes, more familiar structures such as cantilever bridges or skyscrapers represent challenges to the limitations imposed by the physics of gravity and materials. Recent examples include buildings inspired from aeronautics, such as Jean Nouvel's Guthrie Theater with its cantilever awning, or Calatrava's opera in Valencia, where a huge, leaf-like structure seems to defy all laws of gravity and resistance of materials by seemingly hovering over an egg-shaped structure.

At its own scale, the Paradoxical Sleep project, derived from the Aerostabiles research program, inscribes itself in these mythological attempts to simulate weightless masses. At the origin of it is a very simple vision: to make a cube hover in the air as if it was levitating. The paradox between the cubic shape, whose all characteristics and features contradict the very idea of flying, and its ability to fly, was by itself an architectural manifesto (Fig. 1). This vision proved powerful enough to encourage several teams of scientists and engineers to contribute to the project: in the following years, the program has involved up to four science and/or technology labs (France, Switzerland, UK and Canada),[10] several individual researchers, and two major art centres. Developments in applied physics were undertaken specifically for it. The structure of the first cubes were made with basswood, which was easy to work, but proved too fragile on the long run. Current trusses are made with carbon fibre. After several iterations and studies, we were able to produce a 225 cm-edge rigid structure whose bare weight is just under one kilogram (Fig. 2). Each element of the cube (structure, mechatronics, software) was the object of successive design steps and kept evolving during the years, following the availability on the market of components, materials of increased performance, as well as the arrival on our team of engineers and students of greater expertise.

As a robot, the flying cube had originally no expected or intended practical use: it takes some efforts to even imagine a possible application for it. It was just

[8]Cooke [7].

[9]Bunge [8].

[10]Science/Technology: Laboratoire d'éthologie animale (G. Théraulaz, U. Paul Sabatier, Toulouse, France); Intelligent Autonomous System Lab (A. Winfield, U. of the West of England, UK); Collective Robotics Lab (now DISAL, A. Martinoli, EPFL, Lausanne, Switzerland; 3DVision (S. Roy, U. of Montreal, Canada). Arts: Society for Arts and Technology (SAT, L. Courchesne, Montreal, Canada); Hexagram (N. Reeves, Montreal, Canada). Researchers: P. Giguere, Laval University, Quebec, Canada; I. Sharf, G. Dudek, I. Rekleitis, U. McGill, Montreal, Canada.

Fig. 2 A Tryphon aerostabile being assembled, showing details of the carbon fibre trusses and the polycarbonate tubes that lead the flux of air coming from the ducted fans (at the centre of the trusses) towards the corners of the cube. From 2007 on, all mechanical connectors and components were realized by 3D prototyping (Photo by Nicolas Reeves).

meant to float still, like in a deep artificial meditation. This first suspended shape was christened "Aerostabile", in reference to Calder's "mobiles", which gave the name to the whole research program. In such a work, technology becomes its own poetics. The flying automaton is only there as a *being*: no doing or making is involved, no action or role justifies its existence, like it would be the case for a conventional robot. No arm, clamp, leg or protrusion is even there to suggest possible uses. The planned immobility further increases this impression of uselessness: building an automata (etymologically: he who moves, will and think autonomously) that does not even move contradicts the very idea of a robot in the same way as a cubic shape contradicts the very idea of flying.

From Architecture to Artificial Beings

Conceptually speaking, the flying cubes of the Aerostabile program are automatic machines from which everything that could contribute to identify them as robots has been removed, to focus on what constitutes the symbolical essence of the automaton. No one builds a robot for the sole reason of leaving it still: stillness is a trivial

and uninteresting task for a ground robot. It is not considered as its most desirable behaviour, and it is very easy to achieve: when unplugged and discharged, most robots will end up still and remain still forever. It is however quite a challenge for a hovering automata.[11, 12] Even when it reaches aerostatic equilibrium, several forces and influences, such as micro-atmospheric movements, convection streams, ventilation, pressure variations, concur to make it drift from its original position, to which it may never come back. To make it still requires a complex combination of physics, mechatronics and software. In order to better manage and coordinate it, we had to develop a workflow made from several parallel threads corresponding to the different expertises required, which, considering the scope of disciplines that were involved, became by itself a specificity of the project,[13] and led to the development of an international cooperation. Each aerostabile is equipped with up to fourteen distance sensors, as many light sensors, a compass, an inclinometer, eight or twelve ducted fans, a series of controllers and an onboard computer. In the simplest version, the distance to the nearest walls is measured at very short time intervals. Each departure from the prescribed position is immediately rectified by a thrust from the ducted fans, the strength, duration and acceleration curve of which being precisely determined by the computer. Such repositioning processes may occur up to one hundred times a second: for a hovering object, stillness is not a state, but a dynamic process.

The counterpart of the immobility of the automaton is thus a frantic agitation of electrons in all of its circuitry, making it extremely active in an invisible way. It is from this state that the name of the installation was decided: for humans, "paradoxical sleep" is the last sleeping phase of the night, during which the brain dreams. Though the body is totally relaxed, the brain is more active than during wake time, in a direct analogy with the state of a hovering aerostabile.

Like the vast majority of technological art projects, ours did not completely work quite as expected or planned. After one year of tests and experiments, we managed to reach a quasi-still state, but the constant repositioning of the cube created small, smooth oscillations that could easily be interpreted as a form of hesitations, translating the mood of an uncertain or undecided mind rather than the appearance of pure levitation. The intermittent noise of the motors began to be interpreted as a kind of breathing. Despite all our intentions, and despite a morphology that is all but biomorphic, the flying cube was explicitly seen by many visitors as a big, clumsy animal, immersed in a deep dream or meditation. It revealed in a rather radical way that no automata can escape its interpretation as a living organism, and that any animated objects can readily trigger such interpretations and meanings. It crystallized the essential symbolical ambition of any automata, the mythological impulse without which no robot would ever have existed: to be assimilated to a living being.

The flying cubes, as well as people's reaction to them, refute the basic claim of the Uncanny Valley hypothesis: though their morphology presents no similarity

[11]Van der Zwaan et al. [9].

[12]Lozano [10].

[13]St-Onge et al. [11, 12].

with humans or animals, even remotely, they usually elicit very positive feelings—
more than several animal-like or human-like artefacts.[14] The range of feelings
mentioned by the visitors includes empathy, tenderness, sympathy, amusement…
but fear, uneasiness or weirdness are seldom heard. Curiously enough, toddlers are
strongly attracted by the cubes, and demonstrate by their movements or facial
expressions a strong desire to interact with them. After their first performances,
the flying cubes project evolved from their architectural origin to give birth to a
complex and dense art piece about relations and artificial emotions.

Towards Hybrid Choreographies

From these observations, the idea to explore the potential of planned interactions
with people quickly emerged. Several projects and works in that direction were
developed during the last years, including performances in which dancers or actors
developed hybrid, interactive choreographies with the cubes. Among them, some
were specifically conceived to maximize the expressive ability of the automata.
They encouraged our team to undertake a detailed study in order to identify the
elements of their behaviour that could best convey expressions or emotions.

We first thought that these elements would be very limited in number. The
cubes have no limbs or moving protrusions that can generate emotions or feelings
through movement: they can only communicate through displacements of their
whole body, or through the sounds they produce. In terms of movements, they
have, in their first version, only four degrees of freedom: three translations (back
and forth, up and down, left and right), and one rotation (around the vertical axis).
This seems very few at a first glance: a human head whose expressivity would be
limited to its three degrees of freedom relatively to the body would only be able to
say "yes" (rotation around the left-right axis), "no" (rotation around the top-bot-
tom axis) or "maybe" (rotation around the back-front axis). But every movement
needs more than three parameters to be fully defined, and it appears more fruitful
to characterize it through an analytic description which physically corresponds to
the position and to its two time derivatives, speed and acceleration. To this, we add
for our purposes another feature that corresponds to the acceleration curve: the
oscillating rotation of a human head around a vertical axis will convey very
different meanings if the oscillation rhythm is fast, slow, or if its stops after one
half-rotation.[15]

Each of the four initial degrees of freedom is thus replaced by four new
parameters, each of which requiring three sub-parameters for position (three
scalars), three for orientation (three scalars), six for displacement (three vectors

[14]We could compare the reaction of the audience to several kinds of automata with various
morphologies, including ours, in specific robotic arts events, such as the Moscow "Science as
Suspense" event [13].

[15]St-Onge et al. [11, 12].

for speed and three for acceleration) and six for rotation (three vectors for speed and three for acceleration). This gives a total of eighteen parameters to find out where the cube is and where it is heading to. If we consider that each vector needs three components to be fully defined, and if we add that the acceleration curves for each of the acceleration vectors can itself be controlled by an arbitrary number of parameters, it is easy to see that the number of expressions that can be conveyed by a single floating cube becomes much greater than what the minimalism of its shape seems to imply.

Several research-creations experiments, as well as experimental protocols, were designed in order to identify more precisely some of the mechanisms and displacements through which the cube's expressive potential could be expanded. They were mainly implemented on our largest cubes, 225 cm-edge aerostabiles christened the "Tryphons".[16] They all call for sequences of movements whose dynamics (amplitude, speed and acceleration) brings a key role for the visitor's interpretation of their inner mood. For instance, a soft 2-m X translation (back-front axis, towards the visitor) does not carry the same meaning than a brisk 4-m one: the first may look like a manifestation of interest or curiosity, whereas the second can translate a threatening behaviour. A single, slow 45° oscillation around the left-right axis (horizontal and perpendicular to the visitor) may look like a greeting movement, whereas a series of short 30° oscillations around the same axis may translate a clear approbation, like the movement of head saying "yes". A cube lying on the ground and slowly rising to about 1 m when a visitor approaches may look friendly, interested, and ready for interaction; if it rises quickly to 3 or 4 m, it may look feared. The slow movements of a cubes adjusting its position in the Paradoxical Sleep installation gives the image of a big, sleepy animal, lost in a contemplative dream; when shorter and faster, the same movements looks like a feverish tremor, translating a very nervous attitude.

The Geometry of Expressions

By carefully studying all the parameters of these movements and sequences, the development of a full vocabulary of intended feelings and expressions becomes possible. Each of them is associated with a sequence of displacements and rotations, and with the precise dynamics of this sequence. A fully equipped Tryphon is a 6-degrees of freedom robot. If we except the three coordinates associated with positioning, this gives a total of eighteen basic parameters that become the basic elements of a vocabulary of expressions (see Table 1): they can be associated in a huge number of ways to create expressive sequences. It is easy to see that

[16]"Tryphon" comes from the first name of the famous absent-minded scientist Tryphon Tournesol, in Herge's Adventures of Tintin. He is known as Cuthbert Calculus in the English translation.

Table 1 Basic elements of the expressive vocabulary of a flying cube

	X (long.; back-to-front)	Y (transv.; left-to-right)	Z (vertical)
Translation	X-translation (m)	Y-translation (m)	Z-translation (m)
	X-axis speed (m/s)	Y-axis speed (m/s)	Z-axis speed (m/s)
	X-axis acceleration (m/s^2)	Y-axis acceleration (m/s^2)	Z-axis acceleration (m/s^2)
Rotation	X-axis rotation (deg)	Y-axis rotation (deg)	Z-axis rotation (deg)
	X-axis rotational speed (deg/s)	Y-axis rotational speed (deg/s)	Z-axis rotational speed (deg/s)
	X-axis rotational acceleration (deg/s^2)	Y-axis rotational acceleration (deg/s^2)	Z-axis rotational acceleration (deg/s^2)

Each association of these elements becomes a sequence of instructions that can allow for the evocation of a specific feeling or emotion through an appropriate coding. Back-to-front and left-to-right are defined in relation to the observer's location.

the number of such sequences, which defines the expressive potential of a single automaton floating in the air, is theoretically almost unlimited.

Practical considerations however limit this potential. First, the geometrical precision of this vocabulary can only convey the desired meaning if the cube is able to precisely follow a prescribed sequences of instructions. But a large flying cube, with its inefficient aerodynamics and its large inertia, cannot be controlled as easily as a ground object, or as a flying object with a flight-adapted geometry; its ranges of acceleration and speed are limited. Certain sequences of opposite displacements or rotations are forbidden, because of their negative impact on the stabilization and equilibrium of the automaton. Full rotations around arbitrary axis are difficult to control, since all references to external objects vary continuously. Then, the expressional or emotional interpretation of displacements and rotations is everything but an exact science. First, it strongly depends on the cultural background of the visitor [17]: the rotation of the head around the back-to-front axis is interpreted as "not too sure" in the Western world, and as "yes" in the Indian subcontinent. Second, like for all interaction processes, the attitude of a visitor or performer interacting with the cube can deeply influence the interpretation of the cube's moods by other visitors or by an audience. One of the ways we choose to explore the impact of this "cultural dialogue effect" is the implementation a software module that allows the control of the cubes by human voice, through short 3-notes melodies sung by a performer, or by anyone with minimal singing skills. The expressive potential of the human voice, combined to the general mood of each of these melodies (major, minor, 7th…) installs an initial atmosphere in which the reactions of the cubes take different meanings than in full silence.

[17]See for instance Joose et al. [14].

Evolving Performances

Because of the number of relevant variables, the conditions of a given perfor-
mance are not repeatable. To reach valid and useful conclusions, the exploration
of the expressive potential of artificial beings requires a methodology that dif-
fers from what is commonly encountered in applied or fundamental sciences.
From the beginning of the project, we decided to develop our research around
intensive work periods called "research-creation residencies", lasting from a few
days to a few weeks, during which engineers, scientists and artists from several
disciplines would work together towards the elaboration and implementation of
public human-automata interactive performances. The results and conclusions of
such events oriented the technological and artistic developments for the following
months, up to the next residency where they could be evaluated and finalized.

After the first presentations of the Paradoxical Sleep installation, we worked on an
event called *"ROM<evo>—the Evolution of a Dead Memory"*, based on a script
jointly written with Quebec media artist Luc Courchesne, which took place in 2006
at the Quebec Museum of Civilization.[18] It was based on the results of a
collaboration with two European research groups, and with our recent collaboration
with a Montreal lab that specializes in the field of artificial vision. During this event,
three cubes were hovering in a wide space in which a short footbridge was installed,
so as to allow the visitors to get very close to them. At the arrival of a visitor, the clos-
est cubes would light up; a pair of eyes would appear on its faces, and the cube would
trigger a spoken conversation with the visitor. The voice belonged to an actress[19] that
was hidden on a mezzanine. She could hear and see the visitors through a monitor
and a pair of headphones; her eyes were filmed real-time by a pair of small cameras
(Fig. 3). She was instructed to speak as if she was a computer-being trying to relate
with human beings, which means that her way to communicate with people should
simulate that of a computer program: every word and sentence was taken at its face
value; the cube could not understand metaphors, analogies or second degree. It had
no other knowledge than what it could learn form the visitors: its global knowledge
was supposed to accumulate during the performance. This scenario resulted in the
emergence of a schizophrenic personality for which every element of human
vocabulary was considered as a mathematical variable with a unique significance.

The reactions of the audience were extremely diverse, ranging from amuse-
ment to anger. To our surprise however, several people tried for a rather long time
to interact and speak with the cubes. Among the most intriguing moments, we
saw a man who tried to teach a poem to a cube, like if he was hoping to coun-
teract—or maybe heal—its dry, algorithmic and monosemic language through
poetry; as opposed to computer code, poetry is the form of language that is opened
to the largest number of potential interpretations. An old woman came several

[18]A more detailed description of this work appears in Reeves [13].

[19]Quebec city actresses Véronique Daudelin, Maryse Lapierre and Klervi Thienpont were alter-
natively the cube's eyes and voice.

Fig. 3 A Mascarillon aerostabile (170 cm edge) during the ROM<evo> Performance at the Québec Museum of Civilization in Québec City. Actress Maryse Lapierre's eyes, filmed through a pair of small cameras, are projected real-time on the faces of the cube through an adaptive projection system developed by Sebastien Roy and the Vision3D lab at University of Montreal. The Mascarillons were wade with basswood; the material was aesthetically compelling, but the trusses were way too fragile. The following models were made with carbon fiber (Photo by Nicolas Reeves).

times during the three weeks of the exhibition and began to confide in the cubes, complaining for instance that she felt very alone because her children never visited her. It is hard to explain why the Rom<evo>installation, with is high-tech aesthetics, triggered behaviours usually associated with confidence or intimacy. We made the hypothesis that the artificial nature of the automata, associated with the almost complete predictability of its answers and its obvious inability to interpret, judge or criticize, created an atmosphere where some people could feel secure enough to enter into a more intimate mode of discussion.

On the technological point of view, this performance, along with a few other ones, made us realize that the most critical problem associated with flying cubes was the question of precise positioning and displacement. We addressed this problem directly during a major installation at the Grand Palais in Paris (Fig. 4), during which the cubes were supposed to fly in a gigantic space—more than 200 m long by 45 m high—during an important Paris art event (The 2008 Summer of Dance). Due to the size of the space, the cubes could not rely anymore on the distance to the walls and floors to locate themselves. Positioning was more critical than ever, since adaptive video projections were planned on their faces for several

Fig. 4 A Tryphon aerostabile (225 cm edge) hovering mid-air in the huge nave of the Grand Palais (Paris, France) during the Summers of Dance 2008 event. Three cubes were flying for this event. During night performances, adaptive video projections real time by a team of Montreal DJ's (from Elektra), as well as text messages from the audience, were projected on their faces, transforming them in flying video lanterns (Photo by Nicolas Reeves).

hours. The problem was solved by using robotic video projectors equipped with cameras which detected the orientation and distance of the cubes as revealed by their 2D projections on the vision plane. This in turn allowed the computers to precisely track their position and orientation, which theoretically allowed the control of their displacements as well as the proper adjustments for the adaptive video projections. For reasons principally linked with the very turbulent and agitated atmosphere of the Grand Palais, in which sudden drafts created very unstable conditions, we had to back up the automatic control procedures with remote control systems, thus transforming the cubes performance in a kind of high-tech puppetry.

The adaptive video projections nonetheless worked fairly well. They showed sequences from the previous evening dance shows as transformed live by Montreal VJs during after-hour performances. We however realized that the expressive potential of the cubes themselves was strongly diminished by these projections: the content of the projected sequences overwhelmed the artistic impact of the cubes, which almost disappeared as automata to become mere floating screens. Instead of being artwork by themselves, they became supports for a non-related artwork.

We then decided to orient our development axis towards human-to-automata interaction. A few months before the Grand Palais event, we had presented our first

Fig. 5 Actress Véronique Daudelin taming the Nestor flying cube (160 cm edge) in the first aerostabile hybrid performance during the Robofolies festival, Montreal 2007. The actress was controlling the cube through her displacements and movements, and with small LED lamps hidden in the palms of her hands (Photo by Nicolas Reeves).

hybrid performance in Montreal. Called *Nestor & Veronique*, it involved our smallest floating cube (the "Nestor", 160 cm-edge) and an actress in a 10-min narrative performance. The actress was instructed to try to interact with the cube as if it was a real, living organism—like a wild animal she was trying to tame. She piloted it by her movements and displacements and through small LEDs attached to the palms of her hands (Fig. 5). Though implemented in a very controlled environment, this simple event revealed that while performing, the actress actually adapted the rhythm and speed of her movements to those of the automaton, resulting in a very fluid and smooth kind of dance: she reacted to behaviours of the cube that were triggered by her own behaviours. For the first time in our research, we could attend the emergence of a full, complex 2-ways interaction between an actress and our artificial beings.

Another installation that we presented later, during the FILE 2012 festival in Sao Paulo, was precisely based on this observation. It was a variation of the Paradoxical Sleep installation in which a performer tried to interact with the cube through her own movements and different vocal sequences, thus modifying the general ambiance in which both evolve, enlarging the cube's expressive potential and generating new possibilities for human-automata relationships. The scenario was written in collaboration with the performer, who was actually a dancer and choreographer from the Montreal dance scene.[20] The different states of the cube were changing

[20]Ghislaine Doté from Montreal Sinha Dance company.

Fig. 6 Dancer and choreographer Ghislaine Doté performing with a Tryphon flying cube during the Sao Paulo FILE festival (2012). The dancer was controlling the cube with her movements and displacements, as well as with very short sung melodies. The voice and frequency analysis software was developed specifically for the project by Belgian engineer François Séverin (Photo by Nicolas Reeves).

according to short vocal melodies (three notes only); in order to facilitate the learning for the performer, the cube was programmed to detect the intervals between the notes, instead of the notes themselves. One melody triggered the taking off of the cube, another one a particular rotation, and so on. Other melodies were mapped on a variety of states such as "oscillate", "get nervous", "fall asleep". The combination of the melodies and of the combined movements of the cube and of the performer generated a very fluid, semi-improvised "pas-de-deux" between the dancer and the automaton, in a hybrid choreography which involved no pre-programming whatsoever at the level of the cubes movements and dance (Fig. 6).

Geometric Butterflies

Several experiments and performances occurred between *Nestor & Veronique* and the Sao Paulo festival. Each one was triggered by a new development on the software or hardware, or by the emergence of new technological components or

Fig. 7 Three Tryphons cubes in the Winzavod Centre for Contemporary Arts in Moscow, during the Science as Suspense festival (2009). The cubes were flying in an area surrounded by intense blue spotlights. They were instructed to fly away from light and to avoid obstacles. These two simple instructions led to complex, never-repeated and unpredictable orbits for more than three weeks (Photo by Asya Ablogina).

devices. The Geometric Butterflies performance took place in Moscow in 2009. For this event, three cubes were instructed to fly freely in a large indoor space. Their flight area was surrounded with dark blue robotized spotlight that were slowly oscillating from left to right. Their behaviour did not consist in state transitions, like for the previous example, but was based on two very simple rules, in the manner of boids: they were instructed to avoid light ("be afraid of light") and obstacles. At some point during their flight, they were coming close to the blue spotlights, which sent them back towards the center of the flying space. By doing so, they unavoidably got close to the other cubes, which sent them back towards the spotlights, and so on. Through these elementary reactions, they flew autonomously during more than three weeks, following never-ending and never-repeating orbits (Fig. 7).

Like for any technological arts installation, unpredictable events occurred during these weeks. At some point, the three cubes found themselves in the same corner of the flight area. They tried desperately to avoid each other, but they were so close from the lights that no one could manage to do so: each of their displacements was sending them towards the other cubes, or towards the spotlights. The collisions that resulted, joined with the roaring and the grunting of the motors that were frantically reversing their rotation direction every few seconds, gave the impression of a fight. The cubes managed to solve the situation by themselves when one of them, through a particular interaction, was abruptly

ejected from the group. It went so fast that it managed to overcome the spotlight virtual barrier and to fly over the audience towards the exit of the exhibition hall, like if he was fed up with the situation and wanted to go out.

Here again, obviously, the interpretation of the cubes'physical behaviour as resulting from intentions or emotions results from our interpretation of strictly physical, meaningless events. What deserves to be noted is the wide difference between the simplicity of the programmed behaviour and the complexity of the interpreted one: getting involved into a fight, being fed up, running away because of exasperation, are by no way simple behaviours. The experiment revealed to which extent our brain tries to make sense with everything that surrounds us and to project onto inanimate objects sets of interpretations that actually correspond to a part of ourselves.[21] It shows how promptly we believe in the self-autonomy of animated artefacts, and how enthusiastically we surrender ourselves to this voluntary deception. Another anecdote is revealing in that respect: a psychiatry student came twice to see the Geometric Butterfly installation, and shared with us at length her "analysis" of the personality of the cubes: one was more extroverted, and acted as a leader; the second one had a more reserved and quiet personality, and tended to remain in the backstage; the third one was acting as a mediator who tried in its own way to reconcile the two others. What makes this analysis all the most interesting is that the three cubes were perfectly identical and identically programmed: they behaved essentially the same way.

The Floating Head Experiment

As mentioned above, from their artistic origin, the flying cubes were quickly seen by engineers and scientists as a rich research and development platform, opened to a wide variety of experiments in robotics, swarm intelligence, mechatronics, emerging behaviours, and so on. Several artists and art labs also collaborated to the project. In 2010, we had the pleasure of working with Stelarc and his team in the design of a performance that was presented in the Montreal Elektra festival.[22] This event gave us the opportunity to merge the flying cube project with an art installation from this team, namely the Prosthetic Head, a virtual model of Stelarc's head that is able to talk, to answer questions and to show facial expressions through the simulated musculature of his face (Fig. 8). Such apparatus have a long history: written accounts of mechanical devices meant to simulate the human speech have been found as soon as the XIIIth century (they have apparently been destroyed, since the church considered them as heretic devices). In the middle of the XIXth century, German astronomer Joseph Faber's Talking Euphonia managed to produce a mechanic talking machine by animating an artificial face through levers and the breath of a

[21]This concept of self-extension on inanimate things is explored through an interesting experiment by Kiesler et al. [15].

[22]St-Onge et al. [11, 12].

Fig. 8 The real Stelarc and David St-Onge, from the NXI Gestatio Design Lab, in front of Stelarc's Floating Head at the Elektra festival (Montreal 2010). Thanks to the "attention model" developed by Stelarc's team (Christian Kroos and Damith Herath), Stelarc's Prosthetic Head and a Tryphon aerostabile from NXI Gestatio could merge to create a hovering oracle who was able to maintain a cyberdialogue with members of the audience (Photo by Elektra).

bellow. Though the voice was described as ghostly and sepulchral, and though the machine itself was eerie to look at, the speech itself was perfectly understandable, and the machine is seen as the first "disembodied head" of the history of automata.

Stelarc's talking head was not only disembodied: it was also dematerialized, and the idea to project it onto a flying cube was partially triggered by the idea of reconnecting it to a physical body.[23] As a matter of fact, after decades of progressive dematerialization, the current state of automata evolution seems to imply that any machine meant to learn and evolve in the real world should be aware of the state of his environment at any moment, and to learn not only from its internal processes, but also from this environment. In order to do this, it cannot limit itself to a virtual being, communicating only with the material world through fluxes of information. Physical information coming from a perceptive body appears a primordial component of learning processes, and of the adaptation to a changing physical world.

By projecting the Talking Head onto an aerostabile, it became possible to increase its expressivity through the movements of the cube itself. An "attention model", a clever piece of software developed by scientist Christian Kroos and engineer Damith Herath, allowed the cube to rotate towards a specific visitor while Stelarc's face was orienting its eyes towards him, so as to increase its interaction

[23]Kroos et al. [16].

Fig. 9 The team of reseachers and graduate students working on software and technological development at the Chalet du Mont-Royal during the May 2014 research-creation residency. Twenty-five people, including a scenographer, a light designer, a choreographer, four performers, two musicians, worked together during this residency to develop and implement a hybrid performance for a contemporary art event called "Chromatic". On the forefront is professor Philippe Giguère, from the department of robotics at University Laval in Québec City (Photo by Nicolas Reeves)

level with him. Though rather elementary, this synergy between the two projects resulted in a haunting, strange installation, where the cube and its projected face, hovering in a dark space, looked like a levitating oracle, pronouncing prophetic sentences and answering questions about the future of intelligence, awareness and consciousness in a world were the distinction between artefacts and biological organisms is becoming more and more blurred.

Balades: A Major Art-Science-Technology Event

The spring of 2014 saw the most ambitious event ever realized with the flying cubes. A team of twenty-five people, including artists, scientists, engineers, students, scenographs, choreographs, musicians, dancers and capoeirists gathered around two flying cubes in a beautiful 19th-century hall located at the top of Mount Royal, a tall hill located in the heart of Montreal, in the middle of a forest. During three weeks, the team developed from scratch a performance in which two dancers and two capoeirists interacted with the cube in a twenty minutes choreography (Figs. 9, 10 and 11),

Fig. 10 Dancer Aychele Szot discusses with choreographer Eli Toussaint during the development of the Chromatic hybrid performance (Photo by Nicolas Reeves).

on a musical sequence that was composed specifically for the event. The music was composed from sounds recorded on the hill and on the Mount-Royal park—birds, insects, frogs, rains. Set designers also worked at bringing the mountain forest inside the building, by using animal-inspired make-ups, a fence-wall of trees and a dancing carpet of water-like material. All elements of the performance had to take in account the specific sensibility of the aerostabiles to their surroundings. One of the engineer teams worked at developing new control devices, using ground-based infrared laser beams; another one worked at improving a docking system so as to allow the cubes to autonomously bond to each other like giant atoms, and to fly together like huge molecules. A third one worked on a program that allowed a flying cube to detect, through an on-board camera, elements on a scene that were considered "interesting"—elements which differs from the rest of the captured image through

Fig. 11 The four performers rehearsing for the final performance of the 2014 Chromatic event. Development and rehearsals of the performance were open to the audience. Lighting and set design were developed by Montreal designers Josée Bergeron-Proulx and Audrey-Anne Bouchard (Photo by Nicolas Reeves).

their contrast, texture, density, movement, or other distinct parameters. At the end of this residency, other artists came in the same space to present their work; the cubes were regularly asked to participate in other performances. For instance, during the days that preceded the final event, the images captured by the on-board cameras were projected real time on a large screen behind a scene where musical shows were going on. The result was presented in front of a large crowd at the opening night of the 5th edition of the Chromatic digital arts festival (Fig. 12); it was the first large-scale public event using the flying cubes in their full potential as real actors of a hybrid human-automata performance.

Conclusion

From the simple architectural image of a heavy mass freed from the law of gravity, the aerostabiles haves developed into a full research program that generated a series of art and technological projects, some of them being now on the verge of producing transferable applications for theatrical scene, museology, education,

Fig. 12 Dancers Ghislaine Doté and Aychele Szot with caopeirists Eric Prido and Michel Zambrano dancing with two Tryphon aerostabiles during the opening night of the Chromatic contemporary arts festival (Montreal 2014) (Photo by MtlBlog)

space studies, robotics.[24] But none of them may be more surprising that his passage from an art piece, an automata that does not move and whose only skill is immobility, to a mechatronic being able and willing to interact with humans through the definition of a series of artificial emotions. The first Paradoxical Sleep installation puts technology to work; but technology here does not do anything practical, and does not create anything material. It tries to eliminate everything it is expected to do for the sake of generating a representation of itself—or rather, of

[24]Some applications are described in St-Onge et al. [17].

its own mythical or symbolical load. From a deep, lonely meditation to an active relation with humans in which the development of hybrid choreographies becomes possible, the flying cubes exemplify these situations where technology not only enriches the potential poetics of a project, but becomes itself a poetics and an imaginary, not through what it is or what it can do, but through what it represents. Combining a rigorously calculated morphology and a radically technological geometry with the hesitations and errances of a wandering being, the aerostabiles translate the implicit fact that any automaton wishes, more than anything else, to become a living being. Indeed, a lucid attitude would make us tell that no automaton ever wished anything, and that the wish actually comes out of our own minds—we project it on inanimate artefacts. But this wish transfer is precisely at the core of every attempt at creating automata, as well as an example where lucidity may not be the most fertile attitude. For artists as well as engineers and scientists, the deliberately accepted illusion of the automaton as a living being opens exploration territories that are infinitely wider than a too strict, objective interpretation of the machine as a sheer assemblage of inanimate components.

The authors want to thank:

The School of Design at University of Quebec in Montreal
The Hexagram Institute for Research and Creation in Media Arts and Technology
The Canadian Council for the Arts
The Quebec Council for Arts and Letters
The Quebec Research Fund for Nature and Technologies
The Quebec Research Fund for Society and Culture
The Natural Science and Engineering Research Council of Canada

References

1. Bedini SA (1964) The role of automata in the history of technology in technology and culture, vol 5, no 1, pp 24–42
2. Bruce A, Nourbakhsh I, Simmons R (2002) The role of expressiveness and attention in human-robot interaction. In: Proceedings from the ieee international conference on robotics and automation, pp 4138–4142
3. Imai M, Ono T, Ishiguro H (2003) Physical relation and expression: joint attention for human-robot interaction. IEEE Trans Industr Electron 50(4):636–643
4. Pioggia G, Igliozzi R, Ferro M, Ahluwalia A, Muratori F, De Rossi D (2005) An android for enhancing social skills and emotion recognition in people with autism, in neural systems and rehabilitation engineering, vol 13, 4, pp 507–515
5. Destephe M, Maruyama T, Zecca M, Hashimoto K, Takanishi A (2013) Improving the human-robot interaction through emotive movements, a special case: walking. HRI 2013:115–116
6. Reeves N, Nembrini J, Poncet E et al (2005) Mascarillons—flying swarm intelligence for architectural research. IEEE Swarm Intell Symp 2005:225–232
7. Cooke C et al (1990) Architectural drawings of the russian avant-garde (see in particular Krutikov's flying cities). Editions of The Museum of Modern Art, New York
8. Bunge E (2003) Jealousy: modern architecture and flight, in cabinet, Issue 11, Flight Summer 2003, New York

9. Van der Zwaan S, Bernardino A, José Santos-Victor J (2000) Vision based station keeping and docking for an aerial blimp. IROS 2000:614–619

10. Lozano R (2007) Objets volants miniatures: modélisation et commande embarquée (ch. 2), Lavoisier, Cachan (France)

11. St-Onge D, Gosselin C, Reeves N (Voiles|Sails) (2011) A modular architecture for a fast parallel development in an international multidisciplinary project. In: Proceedings of IEEE ICAR 2011, Tallin, Estonia, pp 482–488

12. St-Onge D, Reeves N, Herald D, Kroos C, Hanafi M, Stelarc S (2011) The floating head experiment. Proceedings of HRI 2011. Lausanne, Switzerland, pp 395–396

13. Reeves N (2009) Rom<evo>: Evolution of a dead memory. New realities: being syncretic, Angewandte edn. Springer, Vienna, pp 236–239

14. Joosse M, Lohse M, Evers V (2014) Lost in proxemics: spatial behavior for cross-cultural HRI. HRI 2014:184–185

15. Kiesler T, Kiesler S (2004) My pet rock and me: an experimental exploration of the self-extension concept. Adv Consum Res 32:365–370

16. Kroos C, Herath D, Stelarc S (2012) Evoking agency: attention model and behavior control in a robotic art installation. Leonardo 45(5):401–407

17. St-Onge D, Reeves N, Persson M, Sharf I (2014) Development of aerobots for satellite emulation, architecture and art. In: Proceedings of 13th international symposium on experimental robotics. Quebec Canada, pp 167–181

Machines That Make Art

Leonel Moura

Abstract Robots can make art. Based on simple rules and stigmergy it is possible to produce unique artworks that are at least partially independent from the human that triggers the process. I have coined it a "New kind of Art".

For more than a decade I have been working with machines able to create their own art works. Such a statement raises several questions from which the definition of art, as an exclusive human skill, is the most evident. Is it really art what these machines do? Or, as common sense claims, machines can only make something that looks like art because a human builds them, programs them and hits the on button. Hence the art made in such a fashion is still essentially human or, at best, the product of a man/machine symbiotic relation.

If we are less **anthropocentric** we may however recognize a certain degree of autonomy in creative machines. They can do things that are not programmed and/or result from an internal information gathering device. On the other hand if we accept the existence of such a thing as 'artificial intelligence', i.e. the intelligence of machines, why not recognize the possibility of 'artificial creativity', i.e. the art of machines?

As an artist I have state that robots can produce a kind of creativity that although triggered by a human and rooted in a symbiotic partnership may along the process generate novelty.

Robots are machines able to interact in the real world with humans, other machines and the environment. Their degree of autonomy varies considerable and can be measure in many ways such as intelligence, behavior, mobility or/and energy sustainability. Robots also diverge in the type of interaction that they can perform. Some depend entirely on some kind of human control, fitness or predetermined behavior, while others are able to evaluate situations on their own and determine possible reactions. The late are the ones I am interested.

I will demonstrate that based on simple rules and emergent behavior robots can create pictorial compositions that are not predetermined.

L. Moura (✉)
Rua Rodrigues Faria, 103, 1300-501 Lisbon, Portugal
e-mail: arte@leonelmoura.com

© Springer Science+Business Media Singapore 2016
D. Herath et al. (eds.), *Robots and Art*, Cognitive Science and Technology,
DOI 10.1007/978-981-10-0321-9_13

Intro

Mankind has been intrigued by the possibility of building artificial creatures. For the ancient Greeks this possibility was provided by *techné*, the procedure that Aristotle conceived to create what nature finds impossible to achieve. Hence, under this view, *techné* sets itself up between nature and humanity as a creative mediation.

This was the path taken by Norbert Wiener as he opened up the cybernetic perspective, viewed as the unified study of organisms and machines [1]. One line of development linked to this approach gave rise to the familiar humanoid robot, inspired by the von Neumannian self-replicating automata and based on the top-down attitude of the earliest Artificial Intelligence [2]. A much more interesting trend, also stemming from the seminal work of Wiener but intended to 'take the human factor out of the loop', emerged in the mid-1940s with William Grey Walter, who proposed turtle-like robots that exhibit complex social behavior. This was the starting point for a new behavior-based robotics, abolishing the need for cognition as mediation between perception and plans for action.

This line of research was pursued in the 1980s by Rodney Brooks [3], who began building six legged insect-like robots at MIT. This new generation of robots was based on Brooks' 'Subsumption Architecture', which describes the agent as composed of functionality distinct control levels under a layered approach. The addition of new layers doesn't imply changes in the already existing layers. The aforementioned control levels then act in the environment without supervision by a centralized control or action planning centre. Also, no shared representation or any low bandwidth communication system is needed.

The most important concept in Brooks' reactive robots is 'situatedness', which means that the robot's behavior refers directly to the parameters sensed in the world, rather than using inner representations. Linked to this concept is the 'embodiment' feature, which corresponds to the fact that each 'robot as a physical body and experiences the world directly through the influence of the world in that body'.

The idea of collective robotics appeared in the 1990s from the convergence of the above described Brooks' architecture with a variety of bio-inspired algorithms, focused on new programming tools for solving distributed problems. These bio-inspired algorithms stemmed from the work of Christopher Langton, who launched a new avenue of research in AI denoted Artificial Life that allows us to break our accidental limitations to carbon-based life to explore non-biological forms of life [4].

The well known collective behavior of ants, bees and other eusocial insects provided the paradigm for the swarm intelligence approach of a Life. This bottom-up course is based on the assumption that systems composed of a group of simple agents can give rise to complex behavior, which depends only on the interaction between those agents and the environment. Such an interaction may occur when the environment itself is the communication medium and some form of decentralized self-organized pattern emerges without being planned by any exterior agency.

Stigmergy

Based on ants and other social insect's studies [5], I have tried to reproduce artificially a similar emergent behavior in a robot swarm. These insects communicate among themselves through chemical messages, the pheromones, with which they produce certain patterns of collective behavior, like follow a trail, clean up, repair and build nests, defense and attack or territory conquest. Despite pheromone not being the exclusive way of communication among these insects—the touch of antennas in ants or the dance in bees are equally important, pheromone language produces complex cognition via bottom-up procedures. Pheromone expression is dynamic, making use of increments and decrements, positive and negative feedbacks. Messages are amplified when pheromone is reinforced, and lose 'meaning' when breeze disperses it. It is also an indirect form of communication, coined stigmergy by Grassé [6], from the Greek stigma/sign and ergon/action. Between the individual who places the message and the one who is stimulated by it, there is no proximity or direct relation (Fig. 1).

Following these principles and with the aid of an algorithm, coined Ant System, developed by Marco Dorigo in 1992 in his Ph.D. thesis [7], I have replaced pheromone by color in my first ant-robots (2001). The marks left by

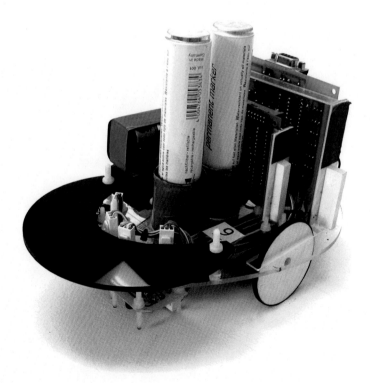

Fig. 1 Artsbot robot, 2003

one robot triggers a pictorial action on other robots. Through this apparent random mechanism abstract paintings are generated, which reveal well defined shapes and patterns. These robots create abstract paintings that seem at first sight just random doodles, but after some observation color clusters and patterns become patent. Through the recognition of the color marks left by a robot, the others react to it reinforcing certain color spots. The process is thus everything but arbitrary. As far as I know, ArtSBot (Art Swarm Robots) [8] was the first art project to use emergent organization for developing robot creativity. Every previous experiment focused exclusively on randomness or sometimes on target strategies leading the machines to fulfill a predetermined program created by the human artist. On the contrary, ArtSBot was meant to put into practice the utmost possible machine autonomy, aimed at producing original paintings. In operational terms, ArtSBot consists of a series of small 'turtle' type robots, equipped with felt pens and sensors. With these 'eyes' the robots seeks color, determine if it is hot or cold, choose the corresponding pen and strengthen it by a constant or variable trace. To begin the process, when the canvas is still blank, the robots leave here and there a small spot of color driven by chance. Based on these simple rules, unique paintings are produced: from a random background stands out a well defined composition with intense shapes of color. In other words, initial randomness generates 'order'. The process is emergent and based on the properties of stigmergy (Fig. 2).

Fig. 2 Artsbot painting, 100304, 2004, ink on canvas, 190 x 160 cm

Machine Creativity

The artistic product of these robots is unique. In the same way that somebody who writes a book cannot be considered as a mere instrument of his primary school teacher, robots cannot be seen as simple instruments of the artist that conceived and programmed them. There is an effective incorporation of new and non predetermined information in the process, which cannot be called anything but creativity. It is true that consciousness is lacking to this creativity. But if we look at the history of modern art, it is obvious that, for example, surrealism tried to produce art works exactly in these same terms. The 'pure psychic automatism', the quintessential definition of the movement itself, appeared as a spontaneous, non-conscious and without any aesthetic or moral intention technique. In the first Surrealist Manifesto André Breton (1924) defined the concept in this way: 'Pure psychic automatism by which it is intended to express, either verbally or in writing, the true function of thought. Thought dictated in the absence of all control exerted by reason, and outside all aesthetic or moral preoccupations.' [9]. In the field of the visual arts, Jackson Pollock was the artist that better fulfills this intention by splashing ink onto the canvas with the purpose of representing nothing but the action itself. This was coined Action Painting, as it is well-known. Perhaps, because of that, the first paintings from my robots are, aesthetically, so similar to the ones of Pollock or André Masson, another important automatism based painter. In his surrealist period, this artist tried frequently to prompt a low conscious state by going hungry, not sleeping or taking drugs, so that he could release himself from any rational control and therefore letting emerge what at the time, in the path of Freud, was called the subconscious. The absence of conscience, external control or pre-determination, allow these painting robots to engender creativity in its pure state, without any representational, aesthetic or moral intention.

Artsbot

Artsbot (Art Swarm Robots), created in 2003, can be described as a set of robots able to interact with which other through the environment (Fig. 3).

The basic architecture of each robot contains three components: the sensors, the controller and the actuators. The sensors receive signals from the environment, which are processed by the microcontroller in order to command the actuators.

The sensors are of two kinds: those that receive the signal from the key environmental variable chosen, which is color, and those that perceive the proximity of obstacles.

Each color sensor is composed by one LED (Light Emitting Diode) for each RGB color plus a fourth LED directed to White. The function of each LED is to measure the intensity of reflected light.

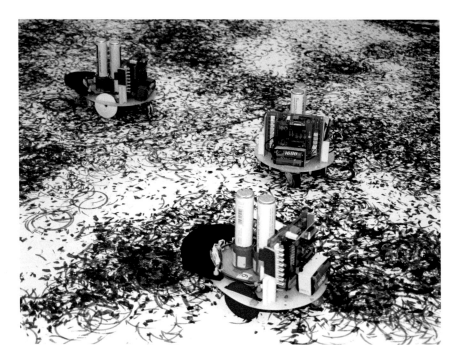

Fig. 3 Swarm of Artsbot robots, 2003

Proximity sensors are in a number of four located in the robot's front. They consist of an IR emitter/receptor that produces a signal which is proportional to the distance from a white surface. Hence, the bounding barriers of the *terrarium* where robots evolve must be white. Since solar light may interfere with the sensors, robots should function in an artificial light setting. The range of distances perceived by this type of sensors is 1–15 cm.

The controller is an on-board PIC 16F876 from Microchip, which reads signals from sensors, processes them according to a program and transmits the result to the actuators. The program is uploaded into the robot's chip, prior to each run, through the serial interface of a PC. This program is developed based on the PC graphic interface, consisting of a flowchart where test blocks for sensors and actuators are combined according to a certain sequence that can obviously be changed whenever wanted. Each test block compares a given variable with a previously defined control parameter and executes an 'IF…THEN' rule.

The actuators consist of two servomotors producing movement by differential traction based on velocity control and one servomotor for manipulating the two pens that execute the action of painting. The latter is commanded by a signal analogous to the one sent to traction motors but, in this case, an angular position control is used.

The 'warm' colors corresponds to an intensity <128, encompassing yellow, red and green, whilst 'cold' covers blue, violet and rose.

The chassis consists of an oval 20 × 15 cm platform, moved by 3 wheels and carrying two pens. Each robot is 12.5 cm tall and weights 750 g. Their life-time endowed with the 8 AA type batteries is 4–5 h.

Prior to launching any collective experiment, the following procedure is done:

- Parameterization of the control program in the graphic interface with the same values, compilation and transmission for each robot.
- Calibration of all sensors of each robot in the programming interface.
- Provision of fresh batteries for each robot.

This procedure guarantees that all robots have the same individual behavior, in order to meet the non-hierarchy requirement. Autonomy and self-organization are other preconditions assured by this procedure. In regard to how stigmergy is achieved in the experiment, it is worth noting that robots interact only via the environment. In fact, they avoid each other through the effect of the proximity sensors and 'communicate' only through the trail left in the canvas by a previous passage. Given that this signal is amplified through the positive feedback mechanism and that no 'fitness' function is included in the process, the problem arises of how to stop the experiment. If the battery power was infinite, the canvas would be completely full after a certain time. Hence, in the Artsbot project an exterior stopping criterion must be applied. The more 'natural' criterion is the familiar attitude of the human painter, when he stands back from the canvas and realizes that the painting 'works'. The other, less discretionary is when batteries run out of power.

The experiment performed in the same conditions is driven by the following rules (introduced by a trial-and-error parameterization of the programming interface):

- If any of the proximity sensors detect an obstacle nearer than 10 cm, the robot turns to opposite side of that sensor.

If no obstacle is detected:

- If both RGB sensors read a color, then the pen whose color corresponds to the same range as the average intensities is activated and the robot goes ahead.
- If the left RGB sensor reads a color and the right reads white, then the pen whose color corresponds to the same range as the average intensities is activated and the robot turns left.
- If the right RGB sensor reads a color and the left reads white, then the pen whose color corresponds to the same range as the average intensities is activated and the robot turns right.
- If both RGB sensors read white, then the random module is fired and a pen is activated with the probability of 2/256 and the robot, painting or not, goes ahead.

The results of the experiment are prone to pass the Turing Test for intelligent machines. In fact, it is not possible to discriminate the paintings from human hand made art (Fig. 4).

The case to be made by the proposed approach is that creativity emerges in the set of robots as a consequence of self-organization, driven by their interaction with the environment. Actually, the random walk of each robot is only interrupted by the 'appeal' of a certain color spot, trace or patch that was previously left in the canvas by another robot. Given that the robot only 'sees' a limited region of the canvas, if no color is detected in that region, it follows its way, putting down a mark of its passage only in the case that its random number generator produces a value that exceeds a given threshold. In statistics language, each one of the outcomes of the experiment is regarded as the realization of a Random Function (RF), i.e., as a Regionalized Variable (RV). The RF is defined as the infinite set of dependent random variables $Z(u)$, one for each location u in a certain area A. In this case, the area A is canvas, and the random variable is discrete, taking only three nominal color values—'Warm', 'Cold' and 'White'. The underlying feedback process leads to the spatial dependency of the random variables and explains why clusters are usually formed in most of the RF instances. These instances are the mapping of the RV onto the canvas, depicting its hybrid structural/random constitutive fundamental nature.

The collective behavior of the set of robots evolving in a canvas (the *terrarium* that limits the space of the experience), is governed by the gradual increase of the deviation-amplifying feedback mechanism, and the progressive decrease of the random action, until the latter is practically completely eliminated. During the process the robots show an evident behavior change as the result of the 'appeal' of

color, triggering a kind of 'excitement' not observed during the initial phase characterized by the random walk.

This is due to the stigmergy interaction between the robots, where one robot in fact reacts to what other robots have done. As referred before according to Grassé [6], stigmergy is the production of certain behaviors in agents as a consequence of the effects produced in the local environment by a previous action of other agents.

Thus, the collective behavior of the robots is based on randomness and stigmergy.

Man/Machine

From the results of this experiment, one can draw the concept of the thing that feels, the thing that plays, and, a fortiori, the thing—the group of robots—that interacts with the environment in an arty way. This line of thought can be derived from the original idea of Asger Jorn [10] that individual creativity cannot be explained purely in terms of psychic phenomena. In his critique of Breton's surrealism, Jorn made the point that explication is itself a physical act which materializes thought, and so psychic automatism is closely joined to physical automatism. What is overwhelming is that this attitude corresponds to the approach developed by Rodney Brooks [11] in the field of robotics. Conversely, it is worth noting how Brooks's approach influenced computer-based art in its 'materialization' aspect. In fact, the MIT researcher considers that human nature can be seen to possess the essential characteristics of a machine, even though this idea is usually rejected instinctively by our putative uniqueness, stemming from some kind of 'specialness'.

In spite of its specific character, the proposed art-making mechanism shares obviously some characteristics with a large range of creative activities.

In first place, when the urban science context is called upon, the way robots evolve evokes irresistibly *situationists's dérive* [12], a haphazard drift in a city performed since the 1950s by any group of individuals in compliance with their *psychogeographic* emotional penchants. Indeed, the positive feedback mechanism may be seen as the drive for revisiting certain spots of the city, which were considered particularly appealing in former passages. In addition, both in the *dérive* and in the robots' pseudo random walk, there is always place for the surprise that is the core of art (and of the aforementioned collective art form developed by situationists by viewing their strolls as an aesthetic experience). Also, the 'emogram', a map of emotive impressions produced by the participants in the *dérive*, is the analogue, in urban *psychogeographic* terms, of the final artwork produced by the robots.

Another way of looking at this experiment is inspired by the surrealists' *cadavre exquis*. This 'game' involved a group of persons that contributed to the eventual collective artwork of which they only knew, until the final outcome, their individual part. When one of the players finishes his contribution, the sheet

of paper upon which he had drawn is folded, in order to prevent the next player from seeing the previous composition, except in a small part, which is the starting point for his input to the collective artwork. Similarly, in our experiment, each robot does not have the 'general picture'; it 'must' rely on the clue left by a previous passage of another robot.

The positive feedback, coupled with a hint of randomness, produces novelty by unexpected change in the spatial arrangement of traces in the canvas. Since no predefined plan commands the global behavior of the group of robots, this experiment can be interpreted at the light of Lefebvre's [13] idea that 'Topos is prior to logos'.

Aesthetic creation is defined in this context as set of transformative rules that claims for a vital examination of all stages of the aesthetical production/consumption process, instead of overrating the output (as used to come about when art was considered as a 'matter of taste').

In the scope of the experiment presented here, it can be stated that if an idea becomes a machine that makes the art [14], then there is no point in imitating Nature, but to perceive the 'beauty of the idea'. If a self-referential conceptual art that does not care for objects is to be made, then the point is to simulate those artificial features of life (as it could be) that are driven by creativity. And creativity is not the capacity of arranging objects and forms, it is the invention of new laws on that arrangement.

Modern and contemporary art distinctive features are 'magnificence and unusefulness' as stressed by Fernando Pessoa referring to his own masterpiece 'The book of disquiet', and confirmed by the main artistic tendencies of the 20th century. In the art of our time the conceptual prevails over the formal, the context over the object manufacture and the process over the outcome.

In consequence, if art is to be produced by robots no teleology of any kind may be allowed. Accordingly, all the goal-directed characteristics present in the industrial-military and entertainment domains of robotics must be carefully avoided. Also bio-inspired algorithms that have any flavor of 'fitness' in neo-Darwinian terms or any kind of pre-determined aesthetical output must be regarded as of limited and contradictory significance.

Art produced by autonomous robots cannot be seen as a mere tool or device for human pre-determined aesthetical purpose, although it may constitute a singular aesthetical experience. The unmanned characteristic of such a kind of art must be translated in the definitive overcoming of the anthropocentric prejudice that still dominates Western thought. In short, a true robotic art must be the matter of robots themselves.

As opposed to 'traditional' artworks, the constructing of the painting by the collective set of robots can be followed step-by-step by the viewer. Hence, successive phases of the art-making process can be differentiated.

Instead of trying to 'tell a story' by assigning 'movement' or 'sequence' to a preset spatial image, the proposed approach shows in real time the picture construction, relating each stage of the process with the conditions under which the set of robots is evolving.

Even though the same parameters are given to the program commanding the behavior of the set of robots, the instances produced are always different from each other, leading to features like novelty and surprise, which are at the core of contemporary art.

From the viewer's perspective, the main difference from the usual artistic practice is that he/she witnesses the process of making it, following the shift from one chaotic attractor to another. Though finalized paintings are kept as the memory of an exhilarating event, the true aesthetical experience lies in the dynamics of picture construction as shared, distributed and collaborative man/machine creativity. At any given moment, the configuration presented in the canvas fires a certain gestalt in the viewer, in accordance with his/her past experience, background and penchant (a correspondence may be established between the exterior color pattern and its inner image, as interpreted by the viewer's brain).

The propensity for pattern recognition, embedded in the human perception apparatus, produces in such a dynamic construction a kind of hypnotic effect that drives the viewer to stay focusing on the picture's progress. A similar kind of effect is observed when one looks at sea waves or fireplaces. However, a moment comes when the viewer feels that the painting is 'just right' and stops the process. Such a gesture can be defined as a moment of aesthetical awareness.

Autonomous robots able to produce their own art based on simple rules, randomness and stigmergy represent for the human viewer the opportunity to understand life and aesthetics beyond the anthropocentric paradigm and the mystifying separations it generates.

If robots can make art, humans can envision a global consciousness based on co-operative and distributed creativity, with no distinction between human beings, life forms and machines.

RAP

RAP (Robotic Action Painter), created in 2006 for the Museum of Natural History in New York, is an individual robot artist and not a swarm, but makes use of the same composition methods based on stigmergy and emergence. Additionally it is able to determine, by its own means, the moment in which the painting is finished. Previous versions didn't have this capacity being conditioned by battery discharge or my will to stop the process. The wrapping up decision is taken based on the information that the robot gathers directly from the painting, what produces a considerable variation of time and form. RAP can decide that the work is complete after a relatively short while (entailing accordingly a low pictorial expression) or can extend the picture construction for a quite long period, making it much more dense and complex. The 'secret' of this behavior is in the significant change of the sensors, which passed from two to nine 'eyes', allowing now the reading of local patterns, in addition to color spots. RAP is also my first robot to sign its works (Fig. 5).

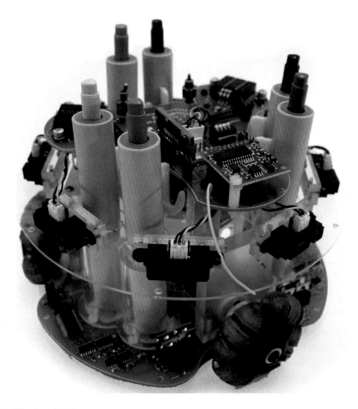

Fig. 5 RAP robot, 2006

RAP is equipped with a grid of 3 × 3 color detection sensors, eight obstacle avoidance sensors, a compass, a microcontroller and a set of actuators for locomotion and pen manipulation. The microcontroller is an onboard chip, to which the program that contains the basic rules is uploaded through a PC serial interface.

The algorithm that underlies the program uploaded into RAP's microcontroller induces basically two kinds of behavior: the random behavior that initializes the process by activating a pen, based on a small probability, whenever the color sensors read white; and the positive feedback behavior that reinforces the color detected by the sensors, activating the matching color pen. These two distinct behaviors are described as modes, the Random Mode and the Color Mode. In the random mode RAP searches for color. If a sufficient amount is not found RAP activates here and there, randomly, a pen stroke choosing also randomly the color and the line configuration. The shape, orientation and extent of these initial lines are determined by the robot based on a random seed acquire from its relative position in the space. This is done with the data retrieved by the onboard compass. In this way RAP's random generator can be described as real random and not pseudorandom.

When a certain amount of color is detected the robot stops the random behavior and changes to color mode. In this phase RAP only reacts to the spots where a certain amount of color is found, reinforcing it with the same tone.

Fig. 6 RAP painting, 200906, 2006, ink on canvas, 90 x 120 cm

After a while a discrete pattern emerges, where from a general random background a well defined composition can be recognized.

In order to determine when the painting is finished RAP makes use of a grid of 3×3 RGB sensors. If a certain (generative) pattern is found the robot 'considers' the work to be done, moves to the down right corner and signs (Fig. 6).

RAP creates artworks based on its own assessment of the world. At any given moment the robot 'knows' its situation and acts accordingly. It scans constantly the canvas for data retrieving. It uses its relative position in the space as a real random generator. It builds gradually a composition based on emergent properties. It decides what to do and when to do it. It finishes the process using its particular 'sense of rightness'.

Although the human contribution in building the machine and feeding it with some basic rules is still significant, the essential aspects of RAP's creativity stems from the information that the robot gathers by its own means from the environment. In this sense RAP's art must be seen as a unique creation independent of the human artist that was at the origin of the process.

A New Kind of Art

My painting robots were created to paint. Not my paintings but their own paintings. The essential of their creations stems from the machine own interpretation of the world and not from its human description. No previous plan, fitness, aesthetic taste or artistic model is induced. These robots are machines dedicated to their art.

Such an endeavour addresses some of the most critical ideas on art, robotics and artificial intelligence. Today we understand intelligence as a basic feedback mechanism. If a system, any system, is able to respond to a certain stimulus in a

Fig. 7 RAP painting, 230807, 2007, ink on canvas, 130 x 180 cm

way that it changes itself or its environment we can say that some sort of intelligence is present. 'Sheer' intelligence is therefore something that doesn't need to refer to any kind of purpose, target or quantification. It may plainly be an interactive mechanism of any kind, with no other objective than to process information and to react in accordance to available output capabilities.

Hence and although my starting point was bioinspiration, in particular modeling social insect's emergent behavior, the idea was to construct machines able to generate a new kind of art with a minimum of fitness constraints, optimization parameters or real life simulation. It is the simple mechanism of feedback and stigmergy that is at work here.

These artistic robots are singular beings, with a particular form of intelligence and a kind of creativity of their own. They do art as other species build nests, change habitats or create social affiliations. But since we, humans, are for the time being the only pensive observers, the relation between machine art and human aesthetics principles is here the central issue. Many people like the robot paintings, probably because we seem to gladly embrace fractal and chaotic structures. But, more than shapes and colors, what some of us really appreciate in this idea and its associated process, is the fact that it questions some of our most strong cultural convictions as it was supposed art to be an exclusive matter of mankind. In this sense, my robot paintings are a provocative conceptual art that problematizes the boundaries of art as we know it (Fig. 7).

References

1. Wiener N (1948) Cybernetics; or the control and communication in the animal and the machine. MIT Press
2. von Neumann (1966) Theory of self-reproducing automata. In: Burks AW (ed) University of Illinois
3. Brooks R (1991) Intelligence without reason. In: Kauffmann M, Mateo S, Brooks R (eds) Proceedings of the 12th IJCAI, (2002) Flesh and machines: how robots will change US. Pantheon Books
4. Langton C (1987) Proceedings of artificial life. Adison-Wesley
5. Wilson Edward O (2006) Nature revealed, selected writings 1949–2006. The Johns Hopkins University Press, Baltimore
6. Grassé PP (1959) La réconstruction du nid et les coordinations inter-individuelles chez bellicositermes natalienses et cubitermes sp. La théorie de la stigmergie: Essai d'interpretation des termites constructeurs, Insectes Sociaux 6:41–48
7. Dorigo M, Stützle T (2004) Ant colony optimization. MIT press, Cambridge (For a description of this algorithm)
8. Moura L, Pereira HG (2004) Man and robots: symbiotic art. Institut d'Art Contemporain, Villeurbanne
9. Breton A (1969) Manifestoes of surrealism. University of Michigan Press
10. Jorn A (2001) Discours aux pingouins et autres écrits. Ed ENS des Beaux-Arts de Paris
11. Brooks RA (2002) Flesh and machines: how robots will change us. Pantheon Books
12. Sadler S (1999) The situationist city. MIT Press
13. Lefebvre H (1968) La vie quotidienne dans le monde moderne. Gallimard, Paris
14. Lewitt S (1967) Paragraphs on conceptual art. Artforum

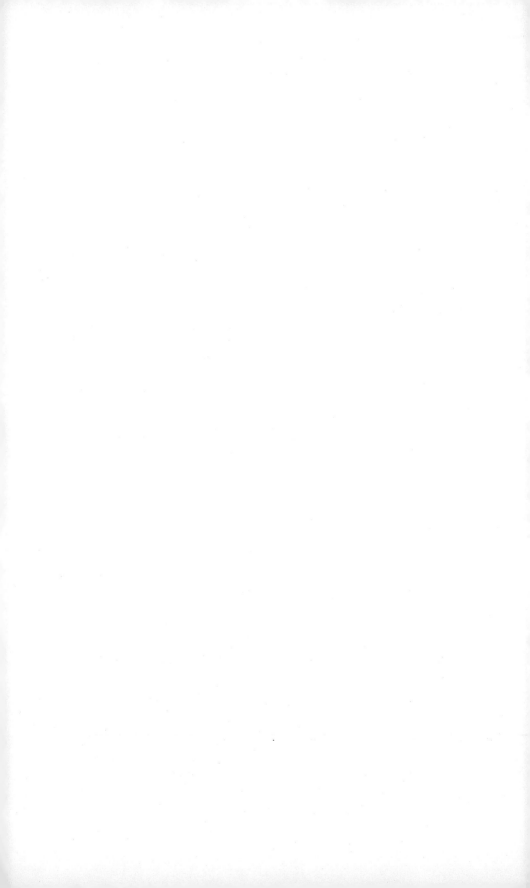

The Multiple Bodies of a Machine Performer

Louis-Philippe Demers

Abstract This chapter examines the potentials arising from the embodiment of Machine Performers. Thru an analysis of a robotic reappropriation of the early 20th century dance ensemble named The Tiller Girls, I argue that alternate views of the body further the concept of embodiment as currently seen by artificial intelligence. The chapter first compares embodiment from the biological to the social and cultural. Second, it analyses the passage of a walking robot, nicknamed Stumpy, from the AI lab to the stage. It describes how the historical body of the Tiller Girls shifts the perception of audiences and how such inherited competence contributes to the interpretive skills of a machine. I discuss on intrinsic characteristics that make them perform as opposed to solely function. Finally, by shifting this scientific investigation on gaits towards the perception and reception of robot movements, I am exploring audience mechanisms of empathy and identification towards those non-human performers.

Introduction

When I bring machine and performance together into the title of this chapter, I refer to the theatricality (or dramatization) of the spatio-temporal experience between the audience and the *machine performer*. These encounters include theatre, dance, human-robot interactions as well as interactive robotic artworks. This spatio-temporal encounter implies the intrinsic characteristic of co-presence between the audience (in the broad sense) and the machine (on stage and in other contexts). I have coined the term '*machine performers*' to express the aspect of my own robotic artwork as being based not directly on a dramatic text but rather on

L.-P. Demers (✉)
School of Art, Design and Media, Nanyang Technological University,
81 Nanyang Dr., 4-31, Singapore 637458, Singapore
e-mail: lpdemers@ntu.edu.sg

© Springer Science+Business Media Singapore 2016
D. Herath et al. (eds.), *Robots and Art*, Cognitive Science and Technology,
DOI 10.1007/978-981-10-0321-9_14

Fig. 1 The Tiller Girls (by Demers, 2010) (*Photo credits* Conception photo)

the behaviour of fictional characters, using sound rather than voice. This expression deliberately enlarges the notion of acting (theatre) to include dancing and movement, performance art, kinetic art and the robotic sense of "performing" a task or a goal. I do not seek to compare machine performers with actors rendering a dramatic text on stage, though I aim to transpose some of those human centric theories towards application to machine performers [1–4].

I employ the word machine as opposed to robot to include a broader definition of the machine as a performing agent. I define the machine performer as embodied and intentional (whether or not this is apparent, whether or not real) and set to perform in a specific spatio-temporal situation (e.g. a play, a social or cultural context). The term robot has many connotations in its visual representations: android, industrial arm, automaton, to name only a few. The vagueness of the word machine helps me to present non-anthropomorphic embodiments as "equal" to anthropomorphic ones and to look at machine functions (behaviours) in a broader context (from the mechanical to the human, from the useful tool to the misbehaving).

Threading through this chapter is the quest to pinpoint, and subsequently illustrate the qualities of the machine performer. This illustration is mainly operated with one of my own performance works, *The Tiller Girls*, as the main case study. *The Tiller Girls* takes a robot developed to study morphological computing and locomotion and brings it onto the dance floor (see Fig. 1). The Tiller Girls[1] is also a direct allusion to a famous ensemble known for its precision kick line dance motion.

[1]In the text, the italicised *The Tiller Girls* refers to my own performance while the Tiller Girls points to the original ensemble.

The Tiller Girls casts an ensemble of up to 32 identical autonomous robots as a mechanical reappropriation of this early 20th century dance company. The piece is improvised and the robots' choreography, sound and visuals are performed live.

Hence, I discriminate between a functional machine seen from an Artificial Intelligence (AI) context and a performing machine seen from a theatrical perspective. I am not interested in criticising the whole discipline of AI, but in illustrating the current spirit of this field and its meanings of the body and the environment. In this context, this performance expands the levels of embodiment found in nouvelle (embodied) AI principles, e.g., the ecological and the morphological body, with alternative views from fields such as phenomenology and anthropology, e.g., the constructed, the historical, the cultural and the perceived body [5–8].

I am looking at the body of the machine performer from within, as imagined by the recent trends found in Nouvelle AI [9–12] and from the outside, as explored by concepts of animacy, causality and attribution found in moving objects. Embodiment and phenomenology offer me an interdisciplinary framework to conduct my analysis of the *machine performer*. The socially and morphologically constructed bodies of *machine performers* can offer dramaturgy as a way to understand how cultural convention is embodied and enacted. One aim here is to differentiate between the ecological body of the "robot in the lab" and an historical enactment of that body.

I will then dissect some elements of human perception to bootstrap the process of understanding the act of perceiving the machine performer. In turn, I will look into the repercussion of such acts in the reception of the machine performer, would they lead to identification, empathy or anthropomorphism; the many acts found in the construction of a human-machine relation.

As a starting distinction, there are two opposite qualities of machine performers: the animate and the animated body. An animate body has a flavour of aliveness while the animated one has a sensation of mechanical automatism. Analysed by historian Jessica Riskin, the famous *Kempelen Chess Player Automaton* operated under the identification of two separate powers, the hidden "vis directrix" and the visible "vis motrix". Riskin reports historical writing by Windsich: "[he] celebrated Kempelen's accomplishment, not of an identity between intelligence and machine, but of a connection between intelligence on one side of the boundary and machine on the other" [13]. In other words, from the embodiment and the enactments emerged a sensation of body and intention congruence, an alignment of the "vis motrix" and the "vis directrix".

For the contemporary world, theatre theorists, through the concept of presence, have been investigating this body and intention congruence. The plethora of synonyms of presence in theatre are: immediacy, spontaneity, intimacy, liveness, energy, "the presence of the actor", etc. In performance theory, embodiment also has become central to the analysis of audience perception and the reception of the human performer. This embodiment has to be experienced and empathized with by other bodies, those of the audience: "The synergy of the actor's embodiment and the spectator's willing imagination creates possibility, the potential for new

understanding and insight charged by the necessity of intersubjectivity" [3]. My task is to seek common ground between the perceived embodiment of human and machine performers. In doing so, I acknowledge that the phenomenological analysis of the machine performer also covers its interaction with the environment: it does not exist or act in isolation. From both the academic and artistic point of view the machine performer needs the co-presence of the audience to be fully realized.

The body and intention incongruence is manifested in the pseudo-scientific thesis of the Uncanny Valley. Rather than embarking into a discussion on the acceptance of the robot in regards of its anthropomorphic qualities, lets look on how expectations arising from a specific embodiment encompass its competence in the physical and social environment. By investigating potential ways to realign those dissonances, embodied AI provides not only new ways of considering embodiment but also techniques and principles to achieve alternative morphologies that could have an impact on how artists can design machine performers.

The field of mirror neuron systems (MNS) is a flourishing one and, among the many hypotheses offered by MNS experts, neuroeasthetics and embodied simulation can help with the examination of audience perceptions of art and human performers [14]. The framework of embodied simulation provides some background on how a phenomenological reaction arises in an observer of human movement [15] and specifically, in dance [16–18]. MNS proposes that embodied mechanisms can simulate actions, emotions and corporeal sensations. If, inspired by this scheme, I can relate mechanisms involved in the perception of human movements to the perception of *machine performers'* movements, I will be able to offer grounds for understanding the empathic reactions of audiences to inanimate objects.

Comparing Embodiments

Embodied Artificial Intelligence

In the opening chapter of his seminal book *How the body shapes the way we think*, Pfeifer defines the term embodiment in the following way: "an intelligence always requires a body. Or, more precisely, we ascribe intelligence only to agents that are embodied, i.e., real physical systems whose behaviour can be observed as they interact with the environment" [9]. Pfeifer further suggests that the consequences of embodiment are related to our obvious obedience to the laws of physics, as well as to the more complex interactions between physical processes and information processing. In biological agents, embodiment lies between physical actions and neural processing. In a robot, embodiment lies between its actions and its control program, between "body" and "brain". Equally, the morphology and anatomy of the robots built in AI can help sensors to pre-process information. For instance sensors at the fingertips will always face the action of moving forward and hence provide useful, structured information to the brain. Equally, when a hand grabs a glass or an object, the anatomical and morphological capacity of the forearm and hand enable it to adapt to different shapes [9].

Thus the perpetual paradox of GOFAI (good old fashion AI) and nouvelle AI is the highly contested marriage between the brain and the body, between the Cartesian "top-down" and the phenomenological "bottom-up" and between modelling and simulation. The grasping hand demonstrates that this kind of intelligence resides outside of the brain, as GOFAI would memorized and model the different forms of drinking glass. Grasping intelligence of this kind is distributed and "outsourced" between the brain, the body and the environment. This example chimes with the title of an early book by Rodney Brooks: *Intelligence Without Representation: The World is its Best Model* [19].

However, it is far from clear what kind of body is actually required for embodied cognition [20]. Although Ziemke agrees with Pfeifer's view "that intelligence requires a physical body is not at all as accepted as one might think" (p. 1), others like Wilson consider it problematic that there is such an enormous variety of definitions of the term embodiment and of its relation to cognition [21]. Perhaps this is why artists are attracted to the term, but I would imagine that the real attraction for creative artists resides in embodiment's empirical formulation, its relation to phenomenology, and how it implies the process of learning by doing.

Sharkey and Ziemke argue that: "many of the new roboticists drift between poles of the mechanistic and the phenomenal", and continue: "In a mechanistic embodiment, cognition is embodied in the control architecture of a sensing an acting machine. [...] This is similar to the notion of physicalism in which the physical states of a machine are considered to be its mental state, i.e., there is no subjectivity" [22]. Of course, even the nouvelle AI robot, despite its situatedness and embodiment, does not actually experience the world. Some authors compare this experience of the "real world" with robots whose navigation is electronically controlled by digital tape (i.e. by the designer). They judiciously contrast examples that simulate (or model) embodied cognition via mechanistic embodiment with phenomenal embodiment. In other words, these machines neither have their own sensation nor a body to experience the world directly. Sharkey and Ziemke rightfully state that the meanings of the robot's actions are in the observer's rather than in the robot's world.

In traditional robotics, scientists start with particular body morphology and then the robot is animated and controlled to perform certain tasks. In such cases, there are clear separations between the brain (software) and the body (hardware). When the morphology and the materials take over some of the functions normally attributed to the control (brain), Pfeifer calls the phenomenon "morphological computation" [9]. The main argument is that this computation cannot be understood simply by looking at brain mechanisms and their controls; it is the result of a physical interaction of the robot's body in and with the physical world.

The broader field of "natural computing" is also used in this context. It implies borrowing from nature, particularly nature's capacity to repair itself, to evolve and to adapt. In a more specific way, natural computing also means to leave the digital symbolic representations and models found in computer machinery behind. Instead of calculating an equation or a model, turning the digital computer into an analogue computer would then be able to measure the answer. For example,

a typical scheme might operate from a question that is later turned into a model, then the model is programmed and calculated, and this results in the answer to the question. A natural computing scheme, however, utilizes an analogy to the question by "building" it, and seeks its answer in terms of observing and measuring this object [23]. The fundamental issue here is that researchers build an object in the world that serves the purpose of measuring or modelling some part of it. For instance, modelling a natural phenomenon could require a differential equation, however, one that measures the phenomenon sees how the differential equation behaves without actually developing the equation.

Morphological computing resonates with Kleist's view of the puppet, where the dynamics rule the behaviour of the object [24]. When Steve Tellis discusses puppet manipulation, he considers that movements exclusive to their morphology can create the illusion of life. This more easily encourages the audience to accept the living existence of an otherwise inanimate object [25].

Another influence is that embodied artificial intelligence reaffirms the role of the body building the construction of complex behaviours. In other words, the design of the body and the process of "animation" have to be integrated [12]. Such a paradigm is similar to the psychophysical relation found in theatre acting methods, where behaviour and emotions are inherently physically grounded [26]. Actually, this "outsourcing" of behavioural and emotional models into physical constructions is similar to the creative process of making Kinetic Art.

In the framework of *Devolution (2006)* and the mutualism of species, dancers were altered with mechanical extensions (parasites). This variation is modulated on the perception of how harmful the parasite is to the host body, or how far it is in control of that body. By attaching a minimalistic articulated joint, the machine extension also becomes a variation of the object "human dancer" (see Fig. 2). The human performer in turn, expands the simplistic joint mechanistic behaviours into the realm of the organic. Being integrated and real, it becomes a factual variation of the body. However, when the dancer is on the floor, subdued by the violent articulations of the mechanical arm, the variation is mechanical.

Multiple Meanings of the Body

In 2008, philosopher Mark Johnson surprised many people by suggesting that only 30 years ago in mainstream Anglo-American philosophy "people did not have bodies" [6]. This attitude was reflected in the cybernetics view where the role of the body was marginalized. Here, signals and models were considered to be an abstract representation that existed in an abstract form independent of their biological carrier. Emily Martin notes that the current increased interest in the body might also be due to the contemporary historical moment in which "we are undergoing fundamental changes in how our bodies are organized and experienced" [27]. This transition suggests that attitudes towards phenomenology may also have changed since cybernetic days.

Fig. 2 A hybrid morphological computation between mechanics and human (*Photo credit* Chirs Herzfeld)

Andy Clark criticized the cybernetic model because it offered narrow views on our own carrier, the body: "Fortunately for us, human minds are not old-fashioned CPUs trapped in immutable and increasingly feeble corporeal shells. Instead they are surprisingly plastic minds of profoundly embodied agents: agents whose boundaries [...] are forever negotiable and from whom body, sensing, thinking and reasoning are all woven flexibly and repeatably from the accommodating weave of situated, intentional action" [28].

In other words, the body changed from a simple fact of nature, to one with a history, an experiencing agent, and finally to one that rethinks the distinction between sex and gender. Csordas concluded "The contemporary cultural transformation of the body can be conceived not only in terms of consumer culture and biological essentialism but also in discerning an ambiguity in the boundaries of corporeality itself" [5]. Csordas points out three approaches that are characteristic to the anthropology of the body: the analytical body, the topical body and the multiple body. The *analytical body* suggests a discrete focus on perception, technique, bodily processes and activities. The *topical body* is about the understanding of the body with regard to specific domains of cultural activity. Csordas suggests that the body is more than the sum of its topics, so in his third category, *multiple body*, the number of bodies depends on how many of its aspects one cares to recognize.

With respect to his classification Csordas boldly claims: "Yet of all the formal definitions of the [sic] culture that have been proposed by anthropologists, none have taken seriously the idea that culture is grounded in the human body" [5].

For Mark Johnson, the term spans a wide spectrum of definitions and interpretations of the body, from the functional to the cultural. Johnson posits five interwoven levels of embodiment.

(1) *The Body as Biological Organism.* The body is a functional biological organism with sensing and motoric systems. It can perceive, sense, move, respond and finally transform the environment [29].

(2) *The Ecological Body.* The body does not exist independent of the environment. The organism and the environment are not two separate, nor two fully integrated things [8, 29]. Both organism and environment bring their own structure and pre-established identity into the interaction that is experience.

(3) *The Phenomenological Body.* This is our body as we live and experience it. It involves at least three aspects: body percept, body concept and body affect [30]. The body awareness lies in proprioception (our feeling of our bodily posture and orientation), kinaesthetic sensations of bodily movement, and internal bodily states, the felt sense of ourselves [31].

(4) *The Social Body.* The human environment goes beyond the physical or the biological. It is also composed of relations and experiences of the social other. The body does not come fully formed, and it is shaped by social interactions.

(5) *The Cultural Body.* Cultural artefacts, practices, institutions, rituals, and modes of interaction that transcend and shape any particular body and any particular bodily action also constitute our bodies.

Cognitive Scientist Tom Ziemke also attempted to disentangle the many notions of embodiment [32]. While Ziemke aims at redefining the body from the perspective of cognition, many of his examples stem from nouvelle AI, where embodiment is more concrete and immediate. In the following list, I extract from Ziemke the following characteristics of embodiment.

(1) *Structural coupling* between agent and environment. This is the broadest notion to qualify a "system" as embodied through its mutual interaction with the environment.

(2) *Historical embodiment* as the result of a history of structural coupling. This historical embodiment reflects the course of the construction of the body structurally coupled in the environment: "A system is embodied if it has gained competence within the environment in which it has developed" [33].

(3) *Physical embodiment.* Physical embodiment restricts the notions of embodied systems to the concept of a physical body. Joining the above notions, *living systems* are a particular instance of physically embodied systems: they are also historically embodied, as many physical systems are not.

(4) *Organismoid embodiment*, i.e. organism-like bodily form: both living organisms and their artificial counterparts. However, an artificial organismoid—as opposed to the living organismoid—is the product of human design and not usually of an historical embodiment.

Because of its simplicity, I will mainly utilize Johnson's five levels of embodiment where I will loosely cluster the first three levels, the biological, the ecological and the phenomenal body under the roof of either physical (for the stage discussion) or ecological (for the nouvelle AI discussion) embodiment. Furthermore, I will refer to the upper levels of social and cultural embodiment mainly as "social embodiment". To collate Johnson's levels with the embodiment levels and techniques found in nouvelle AI, I can freely equate the following points:

(1) *The Body as Biological Organism*. This is similar to the sensorimotor principle: the mechanical body with its mechatronic systems. There is body schema to enable sensorimotor coupling. I consider that the body of a machine performer functions at this level.

(2) *The Ecological Body*. Morphological computing is due here to the close interaction of the robot body with the environment. Machine performers may need a strong ecological niche, possibly emphasized by the turning of a failure into normal machine behaviour.

(3) *The Phenomenological Body*. Not many "true" phenomenal bodies are found in nouvelle AI. What might be perceived as a phenomenal body could be due to bias in the observer's perception.

(4) *The Social Body*. A social robotics researcher will often create scenarios for his or her agent such as a caretaker, a toy for an infant, a coffee waiter or a receptionist. While social robotics at lower levels of embodiment is often based on bodily gestures, superimposing higher levels of intelligence tend to create disconnect between their bodies and their brains.

(5) *The Cultural Body*. Though some consider social robotics to be part of the cultural body, I would consider that robots by artists are the main representatives of this level, since artists are trained in poetic metaphors and abstraction.

The Tiller Girls

The Tiller Girls is a dance piece comprising an ensemble of 32 small autonomous robots with a prior history in artificial intelligence. My main goal is to differentiate between a functional machine seen within the AI context and a performing machine seen on the theatrical stage.

Originally, the *Tiller Girls* robots were developed by scientist Fumiya Iida and refined by Raja David and Max Lungarella of the Artificial Intelligence Lab, Zurich. Nicknamed *Stumpy*, the resultant robot was constructed to study locomotion and gaits derived from simplified morphologies. These morphologies, in turn, generated a fairly rich set of movements.

While I was searching about machines on stage from the perspective of performance theory, I encounter theatre theorist Phillip Auslander's essay on the performative values of robots [34]. Auslander nuanced the performative skills of humans in a range from the technical to the interpretive. He then based his analysis on the Tiller Girls, which he considered mechanistic and solely technical.

Table 1 The *Tiller Girls* and their embodiment

Work	Embodiment Csordas	Embodiment Johnson	Embodiment Ziemke
Tiller Girls	Analytical in dancing	Ecological in the morphological computing of balance	Historical embodiment
	Topical in performing	Phenomenological. The live operator feigns the sense of self-perception	Social embodiment with the *Tiller Girls* analogy
	Multiple if we collate performance theory with machine performers	Cultural in the icon of the *Tiller Girls*	Historical in the competence of the operator

For me the Stumpies possessed a singular flare for interpretation, and I found myself proceeding in the opposite direction to Auslander: on the basis of a mechanical ensemble, typically considered by humans as purely technical performers, I wanted to demonstrate the interpretive potentials emerging from morphological computing.

Furthermore, by appropriating the performance of the 1930s Tiller Girls, I would not only have a title with multiple bodily associations, but also—by framing the live performance as a dance performance—a background canvas for a theoretical and theatrical analysis of the movement of *machine performers*. The Table 1 presents *The Tiller Girls* in relation to the three different theorists on the theme of embodiment.

Stumpy: A Morphological Computing AI Experiment

How *Stumpy* was described and envisioned by its researcher-developers? What were *Stumpy*'s intended behaviours? In early AI publications by its researchers, *Stumpy*'s morphology is written in plain description of its anatomy. Moreover, its behaviours are also neutrally described in terms of gaits: "During walking, it is experimentally shown that the robot can move in a straight line, reverse direction and control its turning radius" [35]. Pfeifer finally included "dancing" in his description of *Stumpy*'s gaits [35]. Before this, Iida, Dravid and Paul had not mentioned dance in any paper or thesis concerned with *Stumpy*'s locomotion [9].

Stumpy actually achieves locomotion by using the inverted pendulum to induce rhythmic hopping and by using the traverse rotational movements to generate directional control (see Fig. 3). *Stumpy*'s abstract, simplistic shape enables it to achieve a surprising range of gaits with unique characteristics. In *Stumpy*, the behavioural model was turned into a physical construct where the apparent jumping actions emerge from the machine's interaction with the physical world. This is cleverly realized with minimal computational effort and representational models. For example, *Stumpy* can also balance sideways, regaining equilibrium due to its low centre of gravity and soft feet. It is also noteworthy that failure is coterminous

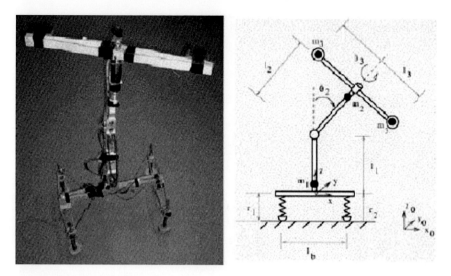

Fig. 3 *Stumpy* photograph and schematic [35] (*Photo credit* Iida)

here with instability or falling. However, Iida does not consider how the variation within each gait bears on *Stumpy*'s rationale and related argumentation. There is, I would argue, considerable potential in the robot's different walking qualities: higher frequency in a joint, for example, would increase walking energy.

From Stumpy to the Tiller Girls

So what might the Tiller Girls dance group represent in the view of humanities scholarship and performance theory? They were famous for their precision kick line dance motion. These precise synchronized steps include rows of dancers with their arms around each other waists to maintain balance, while they kick their legs up high in the air. The Tiller Girls represented uniformed bodies in perfect synchronicity and this would erase the audience perception of the individual; so they could be perceived as a mass-performing object (see Figs. 4, 5 and 6).

Most academic writing about the Tiller Girls refers to this object as a "The Mass Ornament" [37]. Many artistic movements tended to depict the human as machine, an attitude that was influenced by the Industrial Revolution and body culture. Sigfried Kracaeur also saw an analogy between the patterns of a stage performance and the conditions of assembly-line production: "The hands in the factory correspond to the legs of the Tiller Girls" [Ibid 37]. He read the geometry of human limbs as an allegory, a staging of disenchantment in which mass ornament presents itself as a cult of the physical, mythological but devoid of meaning—an emotion that appealed to me for my own work.

Fig. 4 The Tiller Girls chorus line up [36] (*Photo credit* Tiller Family)

Comparing Embodiment in Stumpy and the Tiller Girls

1. *Body Morphology and Historical Embodiment.* In theatre, the performer is constructed historically by the given cultural as well as social connotations of the character and by the live audience that perceives and interprets the movements and apparent behaviours. Likewise, with the mechanical performance of *The Tiller Girls,* the audience has a phenomenological response to the performance because of the bodily associations they make with their human counterparts. As Judith Butler argues, gender is often an historical situation rather than a natural fact [38], so the audience assumes the machines are women (more literally girls from the ensemble name). This situation intersects with the physiological and ecological levels of embodiment found in nouvelle AI in such a way as to give the social/cultural embodiment of the machine performer a gender.

 Butler writes, "gender is instituted through the stylization of the body and, hence, must be understood as the mundane way in which bodily gestures, movements, and enactments of various kinds constitute the illusion of an abiding gendered self" [38]. With *The Tiller Girls* this illusion takes a double-vision turn: their gender is obviously not physiological, nor directly linked to actual movements (however stylized). The interpretation of their enactments, read as female gestures, is tainted by the connotative social values carried by the ensemble's name. There is a mechanical facticity in the Stumpies in that there is no physiological

Fig. 5 The robotic *Tiller Girls* chorus line up (by Demers, 2010) (*Photo credit* Jan Sprij/V2)

sex and gender is a signification not of that facticity (it can't be) but a significa-
tion of a cultural interpretation. Under the conditioning of the label "Tiller Girls",
the audience perception of the historical body supersedes the functional body.

2. *Constructed bodies*. I attempt to create a phenomenological body for the audience
by expanding simple gaits into dance and by introducing improvised elements
(dynamism of the live event). The constructed body of the Stumpy matches the
biological and ecological body of Johnson's classification while *The Tiller Girls*
also constitutes a feigned phenomenological body (audience perception, human
operator to orchestrate the gaits) and as well a constructed cultural body.

Fig. 6 The robotic *Tiller Girls* chorus line up (by Demers, 2010) (*Photo credit* Conception photo)

3. *Gaits.* In nouvelle AI, gaits are intrinsically related to the shape of the object and the main focus is to understand the potentialities of cheap design and of an ecological niche for locomotion. On the stage, gaits are orchestrated to resemble dance movements that also include failures of locomotion (or behaviours). Apparent intentions surface when machine performer movements do not follow Newtonian causality (or folk physics). For instance, after falling down, a *Tiller Girls* is able to stand up even if its body scheme does not suggest this ability.

4. *Stage and Lab: co-presence.* In nouvelle AI, robots are not often staged because the goal is to test the functionalities of the embodiment. Experimental scientific protocol usually targets controlling variables, aiming at reproducibility of the experimental conditions. The notion of environment is limited to the physiological level and so it tends to exclude theatricality as a variable. In theatre, the body of the *machine performer* augments or transforms behaviours that are derived from similar morphologies (cast of actors). The liminal situation of the physical body and its representation borders on quite unpredictable situations [38]. In a lab environment, the audience (observers) deconstruct and analyse the behaviours more than on a stage. In theatre, the audience shares the same time and space as the machine performers. As explained by Fischer-Lichte: "By transforming its participants, performance achieves the re-enchantment of the world. The nature of performance as event—articulated and brought forth in the bodily co-presence of actors and spectators, the performative generation of materiality, and the emergence of meaning—enables such transformation" [39].

5. *Presence and representation.* In nouvelle AI, the presence of an observer aims to be seen as a value for authenticity, while in theatre, value belongs to how the authoritative controlling mechanisms are represented. While nouvelle AI researchers strive to define how functional robots are grounded in the physical reality connected to the robotic agent, theatre brings together the real and the unreal: fact and fiction. This is what Jean Cocteau called "the realism of the unreal", a way of blending magical motifs with everyday realism he suggests is something "not to be admired, but to be believed".

6. *Psychophysical movements.* The combination of morphological computing and the associative characteristics of choreography stimulate psycho-physiological interpretations in the audience. As a phenomenological reaction, audiences both identify with the body-schema of the robot and with how they interact (or in this case dance) together.

7. *Cultural and Social.* In the lab, audiences are observers. In the cultural domain, they are the curious witnesses of the construction of fiction. Cultural functions make social relations broader. In AI, researchers strive to make social robots learn to be social over time through exposure to the manmade environment around them. In theatre, learning is already embedded, not only in the experience of the past, but also because illusion is a priority that can be used to create social metaphors. Therefore, while both social robots and *machine performers* are designed to socially engage with people or other robots, nouvelle AI scientists see social interactions as a specific functional attribute. However, theatre designers see these interactions with robots as having potential for bodily metaphors and interesting associations.

In conclusion, by taking the same machine, *Stumpy*, and by reappropriating it in a different context, broader definitions of embodiment emerge. This is because in theatre, mimicry is based on social, historical and cultural factors and these factors become an integral part of *Stumpy*.

Comparing Human Performers and the Tiller Girls

In *Humanoid Boogie*, Auslander tackles the human and mechanical opposition of performing. Yuji Sone sees this as exposing the indeterminacies in the binary thinking found in the traditional performing arts [3]. Auslander states: "I want to make clear that although I clearly do wish to make a case for seeing machines as performers, I am not proposing that machines can perform in all of the ways that a human being can" [40]. His main stance is that definitions of performance typically put an emphasis on the agency of an artist who expresses something through interpretation. Hence, Auslander's main argument is that "Although I insist that robots can possess technical performance skills, I will not claim that robots possess interpretive skills" [34]. Though I agree that machine performers do not perform in all the ways of human beings, I will try to demonstrate that unrecorded and unmodelled machine performers based on morphological computing have some starting ingredients that could lead to interpretive skills in the machine performer.

Auslander develops his argument by confronting performance scenarios whose execution is based on either technical or interpretive skills, and where the latter are regarded as specifically human. Auslander highlights the 'grey' area between these skills with the practised routines of orchestral musicians, and the Tiller Girls' synchronized chorus-line dance, in which human performers are "called upon to exercise their technical skills but not their interpretive skills" [34]. In such a context it should be a small step to conclude that a Stumpy-as-Tiller-Girl is solely based on technical skill. After all, its operative element is a simple pendulum. In this context I can regard the interpretive skills of *the Tiller Girls* in two ways: first through the agency of the chorus and second, through a discussion of apparent agency.

Theatre historian and theorist Tobin Nellhaus disputes Auslander's views on the blurring distinction between human beings and machines in conventional genres that involve repetitive routines. According to Nellhaus, Auslander considers that the performers cede a substantial part of their agency to someone else such as a conductor or choreographer [41]. Nellhaus' reading of Auslander is that one either possesses individual agency or cedes agency and becomes machine-like. Introducing the notion of organized group agency,[2] Nellhaus disagrees with the view that the demand on a performer's technical skills leads to a loss of agency. He even goes further by stating that the chief alternative to individual agency is to participate in larger forms of agency where the artistry lies in ensemble performance. The concluding tableau of my *Tiller Girls* performance exemplifies this situation. It operates as a deconstruction of the chorus line, constantly showing the minute (and imperfect) differences in the ensemble that not only act as a counter-intuitive representation of the stereotypical repetitive capabilities of a machine but lead to structured chaotic "improvisation" of the ensemble. The programmed motions of this section of *The Tiller Girls* are based on a set of individually fixed movement phrases that can be modulated live (via speed and amplitude for

[2]Nellhaus calls this "corporate agency".

instance). Delivered as an ensemble, night after night, the patterns, clusters, and falls are always different and always tainted by various apparent individual machine performer interpretations (for similar movements, some machines end up on their flanks, some standing in a duet, some in the audience). This situation could not be claimed as the result of pure randomness; it is the result of an organized improvisation.

At the beginning of his paper Auslander outlines when a machine can perform or not. Based on Tellis [25], he discards the automaton as a simple animated kinetic sculpture, nuancing this notion on the basis of playback devices[3] such as a programmed automaton, and he sees some mechanical works as technologies of production not reproduction. Auslander would consider machines as part of performance when they go beyond the re-creation of a prior performance. Auslander then brings examples of robots and activities that potentially demonstrate a certain sense of agency but not interpretation. Starting from performance theorist Michael Kirby's concept of nonmatrixed[4] performing, he demonstrates that some stage actions are based solely on execution [42]. Auslander then brings a solid example with *The Table* by Max Dean (1984–2001). *The Table* is a machine shaped like a table that chooses to follow certain persons of the audience in the room within which it is set. Auslander rightly claims that this machine goes beyond the playback device to the level of performance, but he still situates the decision making of *The Table* as a technical performance, like the nonmatrixed performing of Kirby. He uses this example to contrast apparent agency with real agency, while showing that in such cases there is no difference in overall artistic intention whether a human or robot performs the task.

Here I would simply follow up on the discussion about the mechanistic and phenomenal embodiments found in robotics. Walter's *Tortoises* were not hungry; they simply executed a nonmatrixed set of rules. However, machines that begin to make incursions into the phenomenal body, such as those guided by morphological computing depart from nonmatrixed performance. It is difficult to root interpretive skills in the physiological/ecological embodiment unless we consider machine interpretation solely as the unpredictable movements issued from the coupling of the robot and its environment. The interpretive capacities of *The Tiller Girls* are based on two elements: their enactments through morphological computing and my operations and modulations of their movement phrases. Even though *Stumpy*'s body does not sense itself, its construction does: this is morphological computing. It has a tendency to stay upright and self-stabilize. Even if such construction sounds like a pure mechanical production of movement, the object-in-the-world really departs from the level of simple "closed" automaton. This specific *machine performer* does not fully claim equivalence to human interpretation. However, the staging brings intentionality just as the live operator injects

[3]Auslander's body of work deconstructs the concept of "live performance".

[4]These, like happenings, are task-based, non-representational events, where a performer does not feign or present any role, but is simply being himself or herself, carrying out tasks.

interpretive skills into *The Tiller Girls*. As seen from the audience—and as with puppets—the manipulator is part of the image, but the puppet is the location of the interpretation.

Fischer-Lichte attributes an aura to objects on stage but denies them the quality of presence. She proposes a range of presence: weak, strong and radical. The weak refers to the mere presence of the body onstage, the strong refers to the performative value of the body and the radical intertwines the semiotic and phenomenal body [43]. When she applies her scale to objects, she argues: "While aura is frequently applied to objects, only the first two concepts of presence allow for such an application. Objects can command space and attention and qualify for the strong concept of presence as long as these qualities are detached from the embodiment processes. The radical concept, however, cannot be attributed to objects. Objects are frequently perceived as present, especially in theatre performances and performance events. The radical concept of presence requires the idea of an embodied mind at its centre and therefore has to be limited to human beings" [Ibid 43]. And she continues that "presence brings forth humans as that which they always already are: embodied minds. Ecstasy, in turn, makes things appear as what they already are but which usually remains unnoticed in everyday life because of their instrumentalisation."

Giving an historical body to the machine performer can also alleviate this very instrumentalisation. Such action makes the machine performer depart from the simple object status of a prop. I would, then, attribute radical presence to machine performers, seeing them equally as an embodied mind, the result of a staged construction given to the machine performer (see Fig. 7). Fischer-Lichte's presence scale also tries to nuance the grey area between *having* a body and *being* a body. Here I would return to the animate and animated qualities of machine performers. The animated body is simply an articulated structure, while the animate body has some perceptible essence of inner motivation. I would claim that morphological computing helps the machine performer to "*be* a body" since enactments are not issued by a model (*having* a body) but emerge from the on going actualisation of the body in the environment (*being* a body) (Table 2).

Perception

In this section, I investigate how alternative and non-human morphologies can engender a phenomenal (visceral) reaction in the audience, and how the biological mechanisms of the perception of human motion can provide grounds of empathy towards inert mechanical bodies.

Fig. 7 Aliveness and liveness of *The Tiller Girls* (by Demers, 2010) (*Photo credit* A. Jan Sprij/V2, B. Jan Sprij/V2, C. Demers)

Table 2 Comparison of machine performers and human performers

Machine performers: stumpies as tiller girls	Human performers: dancers and instrumentalists
Movements are the result of an effector articulating a given body schema, potentially sensing its environment	Movements are both the results of body schema, body image and cultural and historical bodies
Inanimate object becoming animate. Machine performers can become more than just "things" by borrowing techniques of presencing	Performers have the tacit capacity of presencing
Randomness from natural computing, incorporating failures and other "unaccounted for" parameters	Performers' historical bodies can contribute to randomness of movements via improvisation and interpretation
Machine performing—aliveness	Live Performance—liveness
Technical Skills from mechanical construction and design	Technical skills from training
Performing from its own construction, its own body. Potentially enhanced by an operator (similar to a puppeteer). Stumpy is similar to a puppet, they are linked by virtual strings to the computer/operator/puppeteer that makes them move	Interpretive skills
Even with carbon copies, a machine performer body becomes unique through minute variations in its construction that impact on its movement. Individualities are also created by contrasting one robot to a mass of robots	Biological individualities Historical individualities
Initially mechanomorphic but becomes anthropomorphic through staging	Initially anthropomorphic but becomes mechanomorphic by repetitive movements
Constructed, synthetized, and historical embodiment vested by mise-en-scène	Biological body grows and is constantly shaping and reshaping itself. Historical body is developed only through time and experience
Limited to a "niche" but yet its impact can be optimized. For instance, *Stumpy* as a dancer of "Mass Ornament"; the singular body movements of water puppets	Multi-tasking
Multi-stability in the order of presence and representation. Fischer-Lichte	Multi-stability in the order of presence and representation. Fischer-Lichte
Stumpies as Tiller Girls humanize the mechanical performers	Tiller Girls turns human performers into mechanical performers
Transfer from functioning to performing opens audience interpretation of stage acts	Expression and development of vocabularies of movements. Cultural codes of dance

Animancy, Causality and Attribution

When an audience perceives an object in motion, principles of animacy, causality and attribution offer a body of theory and corresponding experimental verification concerned with the attribution of intention to this object. As Albert Michotte suggested, scientific evidence was being accumulated about very simple displays (visual cues) and how they give rise to surprisingly high-level percepts [44]. The simplest way to describe perceptual causality and perceptual animacy is to use Michotte's description of the "launching effect" [45] when an object A is moving towards an object B. When A hits B, B gets pushed away. This seems like an objective description based on simple physics and kinematic movement. However, if B moves before A gets in contact, we have two salient situations. An analysis of subjective perception indicates that it distinguishes causality and animacy while a certain intention attributed to their motions, such as B trying to flee from A. In Michotte's concept of "functional relations", in which properties are perceived from visual cues (objective environment), he posits that these interpretations cannot be located in either the actual events or their retinal reception.

Heider and Simmel expanded the awareness of those fields through the method of testing and collecting animated perceptual responses with different audiences [46, 47]. They showed that functional relations are primarily perceptual but that their interpretation is highly personalized and individual. Heider and Simmel built three sets of experiments where test groups watch animated pictures (see Fig. 8). The moving pictures are animations of geometric figures that could be described as: "The large triangle is referred to by T, the small triangle by t, the disc by c (circle) and the rectangle by 'house.' 1. T moves toward the house, opens door, moves into the house and closes door. 2. t and c appear and move around near the door 3. …12. T hits the walls of the house several times: the walls break [46].

The first group was simply asked to "write down what happened in the picture." The second group was asked to interpret the movements of the figures as actions of people, for instance, "What kind of a person is the big triangle? What did the circle do when it was in the house with the big triangle? Why? The last group was shown the picture in reverse with a subset of questions from the second group. Results show that all but a few (less than 5 %) interpreted the picture in terms of actions of animated beings, chiefly human.

Fig. 8 Frames from Heider and Simmel's experiment (*image credit* Heider and Simmel)

I devised a small experiment reproducing similar conditions and goals as Heider and Simmel's 1944 apparent behaviour tests with *The Tiller Girls*. The aim of this experiment was to verify whether an audience would indeed, as for abstract figures, build narrative structures and endow the *Tiller Girls* with intentions and attitudes. I was particularly interested to see if gaits would be perceived as dance, i.e. if the machine performer would shift, in audience perceptions, from a functional behaviour (walking) to an intentional behaviour (dancing a specific choreography).

The experiment included some variations on the original procedure. The candidates were first presented with a series of 15 short (10 s) clips. Each segment was presented only once and each showed one *Tiller Girl* robot performing one gait (e.g. turn left, walk forward, crawl, see Fig. 9). For each clip, the participants were asked to briefly describe the action they saw and attribute an internal state to the robot. The audience was instructed to answer nil if they did not discern any state. Two longer sequences (35 s and 1.45 min respectively) followed these short gaits (see Fig. 10). These sequences showed a series of gaits successively linked together with two robots. The machines performed the exact same moves with their respective position constantly altered as a result of their respective movements. After the presentation of the first sequence, people were asked to state "What they saw". After the presentation of the second sequence, people were again invited to state their perception but they were also asked to describe the two different characters they had just seen in the sequence. I administered the test on three small groups for a total of N = 19 subjects, where the gaits and sequences were projected in a single frontal screen before the whole group. All the videos were played silently.

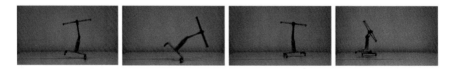

Fig. 9 Gaits—stumping, falling, turn left, dervish (*image credit* Demers)

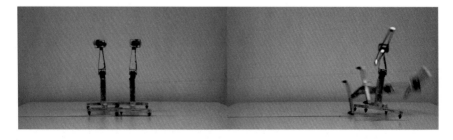

Fig. 10 Duets. Embracing (*left*). Throwing partner on the floor (*right*) (*image credit* Demers)

Among all the observed gaits (15 gaits shown × 19 respondents = 285), only six were described using the word dance (or variation of), which appeared three times for one specific sequence (walking forward and away from the camera). The most striking result was with the narrative sequences, where the word dance appeared 13 times for the first sequence (approx. 68 %) and 6 times for the second sequence (32 %).

Not only did the presence of a second character induce the perception of animacy and causality in the subjects, but it also transformed a series of successive gaits into dance gestures. Unfortunately the tests did not include a sequence where successive gaits of a single robot were linked back to back, in order to isolate the experimental variables: solo versus duet and single gait versus a series of gaits. Regardless of either variable as responsible for the actual contributing factor in perceiving *The Tiller Girls* as dancing, both cases would be the result of an act of mise-en-scène (this act being similar to the animation of Heider and Simmel). The only case that represents a neutral viewing condition of *Tiller Girls* "function" (lab scenario) is the one of single gait where subjects read a negligible amount of movement as dance.

In the two sequences, both *Tiller Girls'* motors were simultaneously controlled by the same commands. Obviously, the lack of variation in each robot structure, as well as in the floor and in their original starting positions, were among contributing factors that made the robots' behaviour in principle comparable and in fact perceptibly different. This mirroring state was respectively noticed for sequence one and two by 42 and 21 % of the subjects. Therefore, in both sequences, the staging makes the characters appear to behave differently (under the same actuation), especially after the breaking points: one protagonist falls off the stage while in the second sequence one protagonist throws the other on the floor. These observations corroborate that the environment cannot be solely ecological but must also include the cultural or social staging of tensions in order to attribute intentionality.

Perception: Human Movement

There has been rising interest recently in the perception of dance—human movement—and its potential relations with the mirror neuron systems (MNS) of the brain [48–50]. Dance analysis is focused not so much on the imitative powers of MNS as on the potentials of empathy bound to what Vittorio Gallese has called the shared manifold hypothesis [14]. Lying at the root of phenomenal identification with the dancing body on stage, this hypothesis resides in the human ability to perform an embodied simulation [15]. As studies in motion perception have mixed results about the systems' activation when watching a non-human (or non-biological) agent, I investigated possible correspondences between machine and human performers with *The Tiller Girls*. Regardless of whether the shared manifold hypothesis can be solidly proven or not, the establishment of pathways between

the perception of the human and the mechanical body might provide a rationale for our visceral reactions to machine performers.

For Gallese, the same neural structures are involved in our conscious modelling of our body acting in space as in our awareness of living bodies and objects in the world. Basically this is the neural route of empathy based on a mutual understanding of social and cultural codes found in human gestures. This hypothesis proposes, therefore, that we understand actions by a process of simulation, against a personal background of emotions, within our own bodies.

To create this awareness, neuroscientists refer to the concept of "body schema" and "body image" [15]. The body schema is an unconscious body map that is used to move and monitor the actions of our body parts. In contrast, the body image is a conscious perception of our own body. The body schema operates at the physiological level while the body image corresponds to a phenomenological level. Robots of nouvelle AI have a body schema, and in my works I suggest that *machine performers* have (i.e. create) a body image.

Meaningful conceptual structures also arise from our innate capacity to imaginatively project from certain well-structured aspects of bodily and interactional experience to abstract conceptual structures [51]. Given the observations made in this section, we may conclude that a robot with wheels, as opposed to legs, would lead to very different bodily reactions in the audience. Hence the role of the designer is to endow both structures and movements of the machine performer with some level of shared mutual bodily understanding with the audience.

The correspondence problem is an important issue in imitation by agents. Dautenhahn and Nehaniv posit this problem as: "given an animator (a biological or artificial system) trying to imitate a model (the biological or artificial system to be imitated)", and ask: "how can the imitator identify, generate, and evaluate appropriate mappings (perceptual, behavioural, cognitive) between its own behaviour and the behaviour of the model?" [52]. For instance, structural homologies among tetrapod animals and artefacts could link the head, the feet and the hands. In a similar fashion to the body-map, the imitator has to identify structural correspondences. However, even systems with very dissimilar bodies (and body-maps) can achieve the same behaviour such as in the case of the Stumpy.

We rarely have to rely on animate motion alone to generate shared bodily understanding or correspondence, as multiple cues are usually present at the same time. In order to isolate the visual perception of biological motion, Gunnar Johansson introduced point light displays (PLDs) into experimental psychology some 40 years ago [53]. Replacing the normal visual cues of a human body by a small number of dots matching the major structural points of the body, these create a vivid percept of the human body [54]. See typical PLDs in Fig. 11.

The PLD technique has been mainly used for human gait and it is far from clear how this can be generalized to nonhuman movements. Pyles and Grossman's experiments are based on synthetic creatures derived from evolutionary algorithms [56, 57]. They suggest that there is evidence for neural mechanisms of perception that processes novel dynamic objects such as non-human creatures.

Fig. 11 Point light displays for human movement [55] (*image credit* Shiffrar)

Chouchourelou and Shiffrar compared stimuli from biological (human and animal) and non-biological sources in order to expand on previous observations that percepts of biological and non-biological objects are neurologically dissociable. Among their conclusions: "[t]he results [of their experiment] are consistent with the existence of a perceptual category that might be called "biological motion" that includes at least people and animals but not human made objects" [58]. Chouchourelou and Shiffrar report that: "The visual percepts of human motion and object motion typically differ from one another dichotomously while the percepts of human motion and non-human, animal motion vary smoothly along some continuum. That continuum appears to be graded in a manner that reflects the degree of similarity between an observed event and the observer's ability to produce that event with his or her own body" [58]. It is suggested that this gradient may be defined by the degree of bodily similarity between the observer's own body and observed bodies: "Indeed, observers in the simple studies described here consistently demonstrated greater visual

sensitivity to some non-biological entities, such as cars, than to some biological entities, such as the apedal bodies of fish and snakes. Interestingly, when non-biological objects, such as wooden blocks, are positioned so as to mimic the structure of the human body, observers tend to interpret the movements of those non-biological objects as if they were actually human movement" [58].

In order to investigate if there are phenomenological levels where a human audience could identify with *The Tiller Girls*, I sought to establish whether or not there was any form of correspondence between the *Tiller Girls'* body schema and that of humans. In this experiment, I tried to see if the "shared manifold" hypothesis could be verified by the audience's biological perception of the movement of the machine performers on stage. I also tested the possibility of modulating the perception of mechanical motion and shifting it into the realm of animal motion.

The generation of the PLDs of the Tiller Girls was done in a dance studio using motion capture recording systems (see Fig. 12). Only one robot was recorded at a time. I made three sets of recordings with a different number and location of light points on the robots (see Fig. 13). The recordings with nine points are the fullest and most literal representation of the Tiller Girls' morphology, virtually mapping the points where the four feet touch the ground. Two other in-between scenarios utilize six points, the first with the shoulders and feet points aligned (two opposed T's), and the second with only the extremities aligned (two opposed V's).

In the spirit of the previous Shiffrar experiment, the test consisted of 15 different PLD sequences with each lasting around 3–4 s. The clips were played three times in a row. There was one clip for training the subjects. The clip was a human walking normally. The subjects were asked to determine if the movements they saw were mechanical, animal or human in nature. Subjects were instructed to assign "other" if they could not categorize what they perceived and, if they wanted to be more specific (e.g. insect as opposed to animal), to write their alternative perception. The subjects were also asked to label the action and give the direction of

Fig. 12 Motion capture of Tiller Girls (*image credit* Demers)

Fig. 13 Tiller Girls' PLDs. Four legged versus two legged bodies (*image credit* Demers)

the perceived movement. I administered the test to three small groups for a total of $N = 19$ subjects where the PLDs were projected in a single frontal screen before the whole group. All videos were played silently.

The 15 clips comprised five human, four animal and six mechanical movements. The human actions ranged from the simple (jogging, cartwheel and side-kick) to the complex (performing push-ups and crawling on four legs). Among the five animals, none were bipedal (dog walking and seal crawling) and two were apedal (owl and bat flying). All the clips except the mechanical ones were taken from an existing database made by Tomas Shipley's Spatial Cognition, Action, and Perception Lab at Temple University.[5] All the mechanical PLDs were extracted from the Tiller Girls' motion capture. Two out of the six sequences utilized the "four legged" Tiller Girls and the others, the double V configuration.

For a sub-group, prior to the training video, I presented the image of Fig. 14. This image suggests a potential mapping that is transferable from the human figure to the Tiller Girls: it aims at establishing a correspondence between human shoulders and arms and the upper T structure of the Tiller Girls and also between human waist and legs and the waist and feet of the robot. I selected the double V point light displays as opposed to the nine points, so the suggestion does not refer to an obvious mechanical artefact.

Tables 3 and 4 report the success rate of identification of the object in motions. These results are comparable with the results from Shiffrar depicted in Table 5. Complex human movements are confused with mechanical ones in the Shiffrar study and with animal movements in my case. There is a remarkable difference for apedal animals. In my experiment, the wing flapping of flying animals was rather easy to detect, while Shiffrar's tests included swimming motions, which are more intricate and difficult. Mechanical objects seemed to be identified by the majority of participants in both studies.

[5]http://astro.temple.edu/%7Etshipley/mocap.html.

Fig. 14 Suggestion for mapping—experimental variable

Table 3 Success rate by category and stimulus type

Observer categorization response	Human (simple)	Human (complex)	Animal (walking)	Animal (flying)	Tiller Girls (four legs)	Tiller Girls (two legs)
Human	*0.96*	*0.24*	0.26	0.03	0.03	0.11
Animal		0.39	*0.61*	*0.61*	0.08	0.20
Mechanical	0.04	0.08	0.03	0.03	*0.82*	*0.54*
Other		0.29	0.11	0.34	0.08	0.16

Table 4 Success rate for each clip, by category of stimulus

Table 5 Success rate by stimulus [59]

Observer categorization responses	Experiment 1: stimulus category				
	Easy human actions	Difficult human actions	Bipedal animal	Apedal animal	Mechanical object
Human	*80.5*	*37.7*	38	14	10.3
Animal	21.5	16.3	*41.5*	*10.3*	25
Mechanical	6.8	37	10	18.7	*47.5*
Other	1.2	9	10.5	57	17.2

Table 6 Correspondence impact on two-legged Tiller PLDs

Tiller Girls two-legged observed as G1—non-exposed G2—exposed	Walking	Crawling	Dervish	Walking
Human G1		0.11		0.11
Human G2	0.40			0.30
Animal G1	0.11	0.44		
Animal G2	0.2	0.70	0.56	
Mechanical G1	0.67	0.33	0.80	0.78
Mechanical G2	0.30	0.10	0.44	0.70
Other G1	0.22	0.11	0.20	0.11
Other G2		0.20		

The main results are that the two-legged *Tiller Girls* are perceived as less mechanical than the four-legged ones, and that the suggestion for equivalences between the human body and the two-legged *Tiller Girls* had some influence on their categorization as non-mechanical (see Table 6). Among the four sequences including the two-legged robot, three had their most frequent responses miscategorised. In the upright walking position, the robot perceived as walking is more frequent in the group exposed to the transfer suggestion indicated above. In its crawling position, the exposed group perceives the motion more as animal than the non-exposed group. In its rotating dervish motion, most members of the exposed group see the robot as an animal, while the non-exposed group clearly stick to a perceived mechanical gesture.

This experiment still needs to investigate the scrambling and noise factors that are a norm in the PLD studies of human motion. The tests presented here were made in the spirit of verifying whether the correspondence problem can be in part analysed with the help of point light displays. The outcome is modest though promising, whereas to fully investigate this avenue would require further analysis of the repercussions of the number of points on a moving body. The motion capture of both human and machine bodies should be made in concert with equivalences already established prior to the recordings. Finally, the distribution of the points on the body must be carefully assessed—for instance, in the example of *The Tiller Girls* a nine point cloud screams mechanical construction, while a six point structure brings some freedom in the interpretation of the moving dots.

The experimental results indicate that participants recognize alternative loco-motion patterns in some special cases of a *Tiller Girls'* PLDs, and also that any structural correspondence suggested between humans and *Tiller Girls* disturbs the classification of some *Tiller Girls'* gaits.

Conclusion

By looking at various aspects of the perception and reception of machine performers, from innate (biological) to constructed (intentional and anthropomorphic) motion, the loop can be closed on the definition of embodiment of the machine performer.

In embodied AI, the notion of environment is limited to the physiological level. It excludes theatricality as a variable because fiction is not considered a scientific method. By taking an AI robot away from its lab and using it in a different context, I illustrated that a broader definition of embodiment enables a richer palette of perceived behaviours. I demonstrated that methodologies from morphological computing could be transported and applied to *machine performers*. This creates a tighter coupling of the animation process to the given morphology of the robot. These techniques can enhance the stage presence of the *machine performers*, causing more fully embodied behaviours to occur with apparent energy and inner motivation. This presence makes the audience see the machine performers' actions as agentic as opposed to strictly func-tional. Thus, on a performative level, I claim that the audience identifies more with an agentic object than a functional object. Morphological computing also helps a machine performer to have both performative and interpretive skills. Moreover, morphological computing enables the machine performer to reach the radical concept of presence put forward by Fischer-Lichte. With *The Tiller Girls*, I challenged her claim that the radical concept of "presence" can only be applied to human performers and not to objects.

As opposed to science, failures and mistakes can be fully exploited by design-ers of machine performers. From the AI standpoint, a Stumpy with an ill-formed gait is seen as a negative result, but in *The Tiller Girls* such a gait can create a sense of suspense (like falling) or a sense of spontaneity (like jumping for no rea-son). In nouvelle AI, mimicry in the physical embodiment is one the main focuses for researchers. By adding new variables, such as the vocabulary of the mise-en-scène, *The Tiller Girls* is designed to shift locomotion gaits into dance vocabulary. While the physical embodiment of the machine performer is essential, the social embodiment of the robot is the main focus to create perceptible and empathic behaviours for *machine performers*.

Behaviours that are attributed to agents do not necessarily embody subjectivity in the final perceived intention. Walter's tortoises are even regarded as hungry and the largest geometric figure of Heider and Simmel's animation is regarded as an aggressive character.

The designer of a *machine performer* aims to create a competent body that will radiate with intention. Whether simulated, modelled or computed naturally,

the fact of its being given a set of perceived behaviours means that the machine performer has to first align its animation with its body in order to become a credible agent. Its animation (behaviours) has then also to be aligned with its given social embodiment. These behaviours will make the fictitious historical embodiment credible. The charisma of the machine performer, the presence of the machine body on stage is supported by this alignment. When the body feels animated, mechanical, or arbitrarily assembled, this presence vanishes and is gradually replaced by its sole representation, the object. Therefore, if a lack of presence leads to a perception of behaviours that are solely based on automation, the machine performer will feel animated rather than embodied.

Via *The Tiller Girls*, I have suggested that any morphology can lead to different perceptions of causality and intention, but that movement is the most highly prioritized factor in the perception of an agent's behaviour. It seems that while anthropomorphism is often an inevitable reflex for the viewer, it is very important to reconsider the pre-objectified and objectified relationship with the external agent. This is why in *The Tiller Girls* I adapted a live performance from the Heider-Simmel psychological experiment on animacy, causality and attribution. However, I tried to design the *Tiller Girls'* movements with morphological computing methods, and attribution theory was applied afterwards. Consequently, a wider variety of audience reactions then occurred and they invented narratives, became empathetic and shared their associations. In sum what seemed an obvious situation of replaceable and substitutable behaviours among a cast of identical objects is not so direct. This emergence of perceived intentions signifies the potential of ensembles of identical robots, patterns that would encompass the mechanical nature of their common group movements.

But when agents have dissimilar bodies on stage it is more challenging to trigger identification. Furthermore, when the correspondence problem is combined with the "shared manifold" hypothesis, the embodied simulation suggests our visceral reaction to the machine performers. My experimental results not only illustrated that we can recognize locomotion patterns, like the *Tiller Girls'* point light displays, but also that we can correspond or match some of our human body schema with the original *Tiller Girls'* body schema. It seems that different visceral reactions have been underexplored in the performance milieu, and machine performers certainly can be used to trigger strong anthropocentric and identification reflexes. Therefore, when the co-presence of audience and human performers is bonded, the machine performers also become more embodied.

The designer of a *machine performer* should seek for morphologies and cultural embodiment that help robots to recall, re-experience and re-enact human experiences, invented or not, simulated or not and certainly not, with a complete computational model.

References

1. Garner SB (1994) Bodied spaces: phenomenology and performance in contemporary drama. Cornell University Press Ithaca, NY
2. Demers LP, Horakova J (2008) Anthropocentrism and the staging of robots. Transdisciplinary digital art. Sound, vision and the new screen, pp 434–450
3. Fischer-Lichte E (2008) The transformative power of performance: a new aesthetics. Routledge
4. Power C (2008) Presence in play: a critique of theories of presence in the theatre, vol 12. Rodopi Bv Editions
5. Csordas T (ed) (1994) Introduction: the body as representation and being in the world, in embodiment and experience: the existential ground of culture and self. Cambridge University Press, Cambridge, pp 1–24
6. Johnson M (2008) What makes a body? J Speculative Philos 22(3):159–169
7. Gallagher S (2012) Taking stock of phenomenology futures. Southern J Philos 50(2):304–318
8. Merleau-Ponty M (1962) Phenomenology of perception. Routledge & Kegan Paul, London
9. Pfeifer R et al. (2007) How the body shapes the way we think: a new view of intelligence. MIT Press
10. Brooks RA (1999) Cambrian intelligence: the early history of the new Ai. MIT Press
11. Brooks RA (2002) Flesh and machines: how robots will change us. Pantheon Books
12. Kaplan F, Oudeyer P (2008) Le corps comme variable expérimentale. Revue philosophique de la France et de l'étranger 3:287–298
13. Riskin J (2003) The defecating duck, or, the ambiguous origins of artificial life. Critical Inquiry 29(4):599–633
14. Gallese V (2001) The shared manifold hypothesis. From mirror neurons to empathy. J Conscious Stud 8(5–7):33–50
15. Gallese V (2005) Embodied simulation: from neurons to phenomenal experience. Phenomenol Cogn Sci 4(1):23–48
16. Hagendoorn I (2004) Some speculative hypotheses about the nature and perception of dance and choreography. J Conscious Stud 11(3–4):3–4
17. Cross ES, Hamilton AFC, Grafton ST (2006) Building a motor simulation de novo: observation of dance by dancers. Neuroimage 31(3):1257–1267
18. Rubidge S (2010) Understanding in our bodies: nonrepresentational imagery and dance. Degrés: Revue de synthèse à orientation sémiologique: Dance Research and Transmedia Practices. 38(141)
19. Brooks RA (1998) Intelligence without representation. In: Cognitive architectures in artificial intelligence: the evolution of research programs
20. Ziemke T (2001) Are robots embodied. Citeseer
21. Wilson M (2002) Six views of embodied cognition. Psychon Bull Rev 9(4):625–636
22. Sharkey NE, Ziemke T (2001) Mechanistic versus phenomenal embodiment: can robot embodiment lead to strong AI? Cogn Syst Res 2(4):251–262
23. Lazere C, Shasha DE (2010) Natural computing: DNA, quantum bits, and the future of smart machines. WW Norton
24. De Man P (1984) Aesthetic formalization: Kleist's Über das Marionettentheater. The rhetoric of romanticism, pp 263–288
25. Tellis S (1992) Toward an aesthetics of the puppet: puppetry as a theatrical act. Greenwood Press, New York, p 181
26. Hoffman G (2005) HRI: four lessons from acting method. M.I.T. Media Laboratory
27. Martin E (1992) The end of the body? Am Ethnologist 19(1):121–140
28. Clark A (2008) Supersizing the mind: embodiment, action, and cognitive extension. Oxford University Press, USA
29. Dewey J (1988) Experience and nature, vol 1. In: Jo Ann Boydston (ed) The later works, 1925–1953. Southern Illinois University Press, Carbondale

30. Gallagher S (1995) Body schema and intentionality. The body and the self, pp 225–244
31. Damasio A (1999) The feeling of what happens: body and emotion in the making of consciousness
32. Ziemke T (2003) What's that thing called embodiment? In: Proceedings of the 25th annual meeting of the cognitive science society. Lawrence Erlbaum, Mahwah, NJ
33. Riegler A (2002) When is a cognitive system embodied? Cogn Syst Res 3(3):339–348
34. Auslander P (2006) Humanoid boogie: reflections on robotic performance. In: David Krasner DZS (ed) Staging philopshy: intersections of theatre, performance, and philosophy. University of Michigan Press, pp 87–103
35. Iida F, Dravid R, Chandana P (2002) Design and control of a pendulum driven hopping robot. In: International conference on intelligent robots and systems (IROS 02). pp 2141–2146
36. TheTillerGirls (1967) Sunday night at the London palladium. http://tillergirls.com/forums/topic/sunday-night-at-the-london-palladium/
37. Kracauer S (1995) The mass ornament: weimar essays. Harvard University Press, Cambridge, Ma
38. Butler J (1988) Performative acts and gender constitution: an essay in phenomenology and feminist theory. Theatre J 40(4):519–531
39. Fischer-Lichte E (2008) Reality and fiction in contemporary theatre. Theatre Res Int 33(01):1–13
40. Sone Y (2008) Realism of the unreal: the Japanese robot and the performance of representation. Visual Commun 7(3):345–362
41. Nellhaus T (2010) Theatre, communication, critical realism. Palgrave Macmillan
42. Kirby M (2011) A formalist theatre. University of Pennsylvania Press
43. Fischer-Lichte E (2012) Appearing as embodied mind—defining a weak, a strong and a radical concept of presence. Archaeologies of presence, pp 103
44. Michotte A (1963) The Perception of causality. Methuen, London, UK
45. Scholl BJ, Tremoulet PD (2000) Perceptual causality and animacy. Trends Cogn Sci 4(8):299–309
46. Heider F (1944) Social perception and phenomenal causality. Psychol Rev 51(6):358
47. Heider F, Simmel M (1944) An experimental study of apparent behaviour. Am J Psychol 57:243–259
48. Jola C, Ehrenberg S, Reynolds D (2011) The experience of watching dance: phenomenological, Äineuroscience duets. Phenomenol Cogn Sci 1–21
49. Reason M, Reynolds D (2010) Kinesthesia, empathy, and related pleasures: an inquiry into audience experiences of watching dance. Dance Res J 42(2):49–75
50. Hagendoorn I (2005) Dance perception and the brain. In: Grove R et al. (ed) Thinking in four dimensions: creativity and cognition in contemporary dance. Melbourne University Press, pp 137–148
51. Lakoff G, Johnson M (1999) Philosophy in the flesh: the embodied mind and its challenge to western thought. Basic Books (AZ)
52. Dautenhahn K, Nehaniv CL (2002) Imitation in animals and artifacts. MIT Press Cambridge, Mass
53. Johansson G (1973) Visual perception of biological motion and a model for its analysis. Atten Percept Psychophys 14(2):201–211
54. Johansson G (1976) Spatio-temporal differentiation and integration in visual motion perception. Psychol Res 38(4):379–393
55. Shiffrar M (2011) People watching: visual, motor, and social processes in the perception of human movement. Wiley Interdisc Rev: Cogn Sci 2(1):68–78
56. Pyles JA, Grossman ED (2009) Neural adaptation for novel objects during dynamic articulation. Neuropsychologia 47(5):1261–1268
57. Pyles JA et al (2007) Visual perception and neural correlates of novel'biological motion'. Vision Res 47(21):2786–2797

58. Chouchourelou A, Golden A, Shiffrar M (2013) What does biological motion really mean? differentiating visual percepts of human, animal, and nonbiological motions. In: People watching: social, perceptual, and neurophysiological studies of body perception, pp 63
59. Chouchourelou A, Golden A, Shiffrar M (2011) What does biological motion really mean? Differentiating visual percepts of human, animal, and non-biological motions. In: Visual perception of the human body. Oxford University Press

Bio-engineered Brains and Robotic Bodies: From Embodiment to Self-portraiture

Guy Ben-Ary and Gemma Ben-Ary

> *The cyborg is a kind of disassembled and reassembled,*
> *postmodern collective and personal self.*
> Donna Haraway [1]

Abstract Guy Ben-Ary is an artist and researcher at SymbioticA: the Centre for Excellence in Biological Arts, at the University of Western Australia since 2001. The biological laboratory is his studio, and tissue engineering, electrophysiology, and other biological techniques are his artistic mediums. His work explores a number of fundamental themes that underpin the intersection between art and science; namely life and death, cybernetics, and artificial life. This paper examines the methodologies and theories that underpin his artistic practice by using four major projects as examples: MEART, Silent Barrage, In-Potentia, and cellF, with discussion of terminology, ethics and the idea of robotic embodiment as an artistic strategy.

Introduction

I believe art plays an important role in encouraging engagement with, and critical reflection on, a unique cultural moment where we are witnessing the unprecedented evolution of bio-technologies and various modes of liminal lives that hover in an ambiguous zone, defying our traditional understanding of life. Art has the

G. Ben-Ary (✉)
The School of Anatomy, Physiology and Human Biology,
The Centre for Excellence in Biological Arts, The University of Western Australia,
24 Dryandra Crs, 6070 Darlington, WA, Australia
e-mail: guy.benary@uwa.edu.au

G. Ben-Ary
24 Dryandra Crs, 6070 Darlington, WA, Australia

© Springer Science+Business Media Singapore 2016
D. Herath et al. (eds.), *Robots and Art*, Cognitive Science and Technology,
DOI 10.1007/978-981-10-0321-9_15

potential to initiate public debate on the challenges arising from the existence of liminal lives, and the shifting forces that govern and determine life and death.[1]

I am an artist at SymbioticA, the Centre of Excellence for Biological Arts at the University of Western Australia (UWA), and have been a core researcher there since 2001. The biological laboratory is my studio where the creative process takes place, and tissue culture, tissue engineering, electrophysiology, microscopy and other biological techniques are my artistic mediums. My research is inter-disciplinary and the production of the artwork usually involves the collaborative effort of artists, scientists and engineers.

My research explores a number of fundamental themes that underpin the inter-section between art and science; namely life and death, cybernetics, and artificial life. It investigates processes of transformation of bodies or living biological mate-rial from artistic, philosophical and ethical perspectives. This exploration makes use of new scientific and cybernetic technologies and processes to re-evaluate understanding of life and the human body. In my work, I use bio-technologies in a subversive way, attempting to problematize these technologies by putting forward absurd and futuristic scenarios. These strategies allow critical engagement with the technologies and help lure the viewers into exploring the artworks. It also draws viewers into a wider practical and ethical dialogue about the future of these tech-nologies and their use, and forces people to re-evaluate their own perceptions and beliefs. This paper examines some of the methodologies and theories that underpin my artistic practice by using as examples, four of my major projects completed over the last decade: *MEART*, *Silent Barrage*, *In-Potentia*, and *cellF*, with some preliminary discussion of terminology, ethics and the idea of robotic embodiment as an artistic strategy (Fig. 1).

In 1999 I collaborated with the Tissue Culture and Art Project[2] on the develop-ment of an artwork entitled *The Stone Age of Biology* in which muscle cells and neurons were grown over miniaturised replicas of pre-historic stone tools.[3] This led me to the realisation that I could grow biological neural networks in vitro, and monitor them via time-lapse photography in order to effectively visualise their growth over long periods of time.

Observing the activity of the neurons as they grew, interacted, transformed, formed new connections, and reorganised themselves spontaneously into neural networks, caused me to wonder about the internal nature of the cells, and whether I might be able to influence the cells, or interact with them in some way. This led to finding electrophysiological techniques which offered various interfaces to the neural networks. Electrophysiology makes it possible to record and monitor the behaviour of neurons. More importantly, the electrophysiological interface gave me a glimpse into the state of the neural network and the way that individual

[1]Throughout this paper, the word "I" denotes Guy Ben-Ary. However, this paper is a result of a collaborative writing effort between Guy Ben-Ary and Gemma Ben-Ary.

[2]The 'Tissue Culture and Art Project' are Oron Catts and Ionat Zurr, and during the years of 1999–2003 I collaborated with them (http://www.tca.uwa.edu.au).

[3]http://www.tca.uwa.edu.au/pastIndex.html.

Fig. 1 The lab as the studio. Inspecting and choosing stem cell colonies in the lab for pluripotency, Barcelona University

neurons were interacting with each other. It also gave an impression of the ways that the neural networks respond to external events via stimulations. This moment in my research marks a starting point that is crucial to the development of later bio-robotic artworks. My artistic practice, from this point forward, focussed on attempting to match bio-engineered neural networks to artistic, robotic bodies, in other words, matching a 'brain' to a 'body', although this terminology is problematic and will be explored further in the following paragraph. The cultural, as opposed to the scientific, articulation of these bio technologies is at the heart of my artistic practice.

Terminology

The use of the words 'brain' and 'body' are in context with my artwork. It is important, at this stage, to note the difference between neural networks grown in vitro consisting of approximately 50,000 neurons, and actual living brains, which consist of approximately 100 billion neurons, interconnected via trillions of synapses, not factoring in the complexity of thought, intent, memory and 'personality'. Thus the 'brains' of my projects are essentially symbolic. However, we use

real living neurons deliberately, as a way to force the viewer to consider future possibilities that neuro-engineering and stem-cell technologies present, and to begin to assess and critique technologies not commonly known outside of the scientific community. However simple or symbolic these brains may be, they do produce quantities of data, and they do respond to stimulation, and they are subject to a lifespan. The term 'brain' when used in this paper in relation to my work, refers only to biological neural networks grown and supported in vitro.

Ethics

Oron Catts, co-founder and director of SymbioticA, claims that he feels a sense of unease whilst working with dissociated neurons, or 'bits of brains', more than with any other type of tissue. This sense of unease draws him back to the lab to try to understand exactly why such research provokes an instinctively unsettling feeling. I sympathise with this sentiment, and agree that when working with neurons, ethical questions are raised in regard to consciousness, intelligence and sentience. Questioning their ability to feel pain is valid, whilst also understanding that the neural networks currently only exist in a symbolic realm. Other ethical questions posed are: which direction will these technologies take us in the future, and what are our responsibilities? What kind of ethical boundaries will need to be established around these living entities? Catts and Ionat Zurr state that "it is important to critique the use of neurons for computational devices and the possibility of the creation of a sentient computer [2]." Art should play an important role here; art is capable of bringing those scenarios to life and confronting the viewer, both instinctively as well as intellectually.

Robotic Embodiment as a Strategy

The aim in embodying the brain with robotics was to highlight the liveliness of these microscopic neural networks, and to manifest their erratic existence through movement and behaviour. I was compelled to provide a manifestation for the brain by giving it a robotic body. Moreover, the electrophysiological interface allowed me to establish a feedback loop between the robotics and the biological brain, and thus create an autonomous cybernetic entity. These entities represent the fears and hopes of humanity as we enter into an unknown future with soon-to-be obsolete bodies [3]. They illustrate, in a highly visceral manner, ideas around disembodied consciousness and intelligence. Ideas of disembodied brains are found across diverse philosophical discourse, from Plato's allegory of the cave, to René Descartes' evil demon, to cybernetic theory, and appear frequently in science-fiction. These entities might instil in the viewer a sense that science-fiction is a step closer to actualisation. In reality, the existence of these creatures is absurdly

Fig. 2 **a** Embryonic rat neurons growing over multi electrodes, and **b** a multi electrode array (MEA) dish

vicarious, and immediately becomes recognisable as remaining firmly within the realm of fiction.

The bio-engineering processes I use are in some ways similar to the process of developing robotics, and have the same three cornerstones; hardware, software and sensors. The bio-technologies that are used to bio-engineer the brains are:

Hardware: This could be better described in this practice as 'wetware'; neurons are grown and maintained in vitro using tissue culture and tissue engineering techniques.

Software: Stem cell technologies, mainly Induce Pluripotent Stem cells (iPSc) which assist in reprogramming and converting cells to become stem cells, allowing them to be differentiated into any other cell type, such as neurons.

Sensors and interface: an electrophysiology system consisting of amplifiers connected to a specialised Petri dish, the Multi Electrode Array (MEA) hosting the living neural network. These dishes consist of a grid of electrodes that can record the electric signals that the neurons produce and at the same time send stimulations to the neurons—essentially a read-and-write interface to the brain (Fig. 2).

MEART—The Semi-living Artist

In 2000, Phil Gamblen was an artist in residence at SymbioticA, and was at that time, developing artificial muscles as part of his research into bio-mechanical processes. Conversations with Gamblen led us to the idea of providing a robotic embodiment to a bio-engineered neural network and to exploring the possibilities of creating a brain-machine hybrid or a cyborg. Together, we became interested in the manifestation of neural data via movement or robotic behaviour and later invited Dr. Stuart Bunt, a neuro-scientist[4] at UWA to join the discussion, and it

[4]Dr. Bunt has a lab in the school of Anatomy & Human Biology, UWA and was back then the scientific Director of SymbioticA.

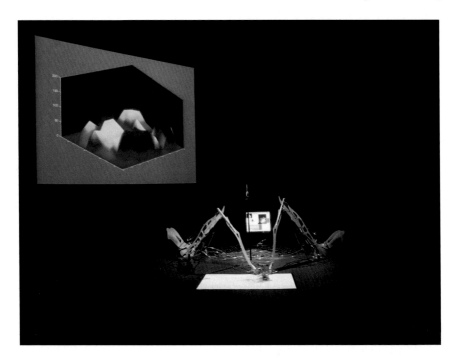

Fig. 3 MEART—The semi-living artist, 2001–2006, photograph by Philip Gamblen

was he who confirmed the biotechnological feasibility of these ideas. Later still, Oron Catts, Ionat Zurr and Iain Sweetman joined the three of us to develop a project titled *Fish and Chips* that later evolved to be *MEART—The Semi-Living Artist*[5] (Fig. 3).

MEART—The Semi-Living Artist is an installation distributed between two locations in the world. Its brain of dissociated rat neurons in culture was grown on an MEA dish in Dr. Steve Potter's laboratory[6] while the geographically detached robotic body resided wherever the work was exhibited, sometimes in different continents. The body consisted of pneumatically actuated, insect-like robotic arms capable of drawing on paper. These robotic arms were designed and constructed by Gamblen and inspired by natural and biological structures such as bone and muscle fibres. A camera located above the drawing captured the progress of drawings created by the neuron-controlled movement of the arms. The visual data was then sent back to the lab to instruct stimulation for the electrodes on the MEA that hosted the brain and the response to the stimulations was then sent back to the

[5]The collective who developed *Fish and Chips* and *MEART* was known as the SymbioticA Research Group.

[6]Dr. Steve Potter is an Associate Professor in the Laboratory for neuro-engineering at Georgia Tech, Atlanta, USA. Potter and his then-Ph.D. student, Douglas Bakkum, were our scientific collaborators and played a major part in the development of *MEART*.

robotic arm. The geographical remoteness of the brain and body was overcome by the Internet, acting as an extended nervous system. Thus the brain and robotic body communicated with each other in real time for the duration of the artistic activity, providing a closed loop communication for the neurally-controlled semi-living artist.

Neuro-engineers usually make robots that perform utilitarian tasks such as navigating, however, *MEART* was given the very non-utilitarian purpose of being an artist. It allowed us to engage viewers in discussion about the future use of neuro-engineering technologies, and to raise questions about the nature of semi-living entities, that may potentially be conscious, sentient, or creative in the future. Throughout its public exhibitions *MEART* had a specific task—to draw portraits of viewers. *MEART* explored the cognitive dimensions of 'seeing' and converged what it sees into representation. Thus the optical element, the digital camera, instructs the mechanical element, the robotic arm, how to draw via the interpretation of the wet element, or neurons. Unlike human artists, there is no knowledge in the arm itself [4].

After exhibiting *MEART* and the portrait series a few times the work was developed further. Douglas Bakkum, a Ph.D. student in Potter's lab at that time, who worked closely with the team on the development of *MEART*, suggested changing the task given to the neural networks. He observed that human portraits are of a complexity that the neurons may not be able to cope with, and that a simple geometric shape such as a square might be better. At the same time I was in conversation with Bulgarian artist, Boryana Rossa, who was writing a text juxtaposing *MEART* with Malevich's famous Suprematist artwork, *Black Square*. She wrote "*Black Square* is considered to be the beginning of a new and redefined art form. The Suprematist paintings are projects for, and instruments of, a new universe and a new system of the world. The Suprematist canvases were sign-projects, containing images of the technical organisms of the future Suprematist world. *MEART* is a real futuristic organism, an organism existing in reality, a realized project of the futurist's and Suprematist's dreams [5]."

Following conversations with Bakkum and Rossa, the team decided to engage *MEART* to reproduce the *Black Square*. The visual properties of the work were a factor in this decision, as well as the conceptual value of the artwork, as a continuation and contribution to this significant work and its place in art history. A video camera, the sensory input and the 'eye' of *MEART*, was set up to observe a video recording of the painting, captured in the Tretyakovsky Museum, Moscow. By reducing the input to the neurons to a simpler shape, *MEART*'s task was made simpler, and it was able to cope with the data more efficiently. This allowed for an examination of the relationship between input and output, and the possibility of detecting behavioural patterns. This outcome satisfied many criteria, both scientific and artistic. *MEART* was a proof of concept, showing that it was possible to create a coherent feedback loop between the bio-engineered brains and a robotic body, and to use the artistic processes as a metaphor to raise questions about the potential of semi-living entities to be emergent or creative (Fig. 4).

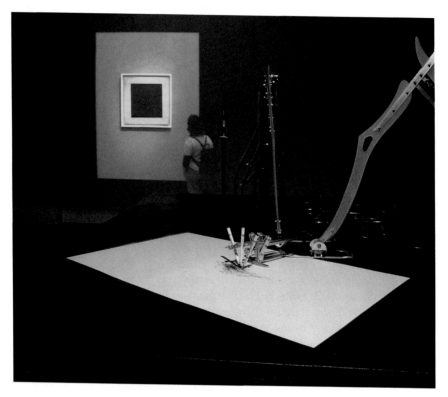

Fig. 4 MEART and *black square*, 2005, photograph by Philip Gamblen

Paul Vanouse describes *MEART* as presenting "a collage of contradictions that are designed to create cognitive dissonance in its viewers, and it forces them to re-evaluate their own perceptions and beliefs. Its authoritative complexity simultaneously convinces us of its technological re-engineering of cognitive processes, while also calling attention to just how far it has strayed from generally held conceptions of life, intelligence or creativity. *MEART* is the ultimate Cartesian dualism; a machine body completely removed from its brain and to complicate matters even further the brain has been reconstituted in vitro from its cellular components [6]." This accurately describes our aims for *MEART* and underlines the way in which the artwork serves to assist the viewer in engaging in a critical reflection on notions of life and sentience.

Art and Science Collaboration

The mode of collaboration which was set up with Steve Potter and Douglas Bakkum was unique in that both the artists and the scientists were fully engaged in the development of the project, and explored the same questions from different

perspectives. In an early e-mail, Potter writes "Your project is very exciting to me for a number of reasons. It is very similar to mine, in hardware and goals. It combines art and science, and I am very interested in both and their overlaps. It addresses an important aspect of my work that I have had a very hard time addressing: How should the lay public think about these things?"

Oron Catts, in an interview with Emma McCrae in 2006, described the collaboration between the artists and scientists in *MEART* as being a true collaboration; in other words, both parties engaged and explored possibilities, rather than exploiting the skills of the other for their own purposes [7]. Whenever *MEART* was exhibited, there were always two parallel experiments being conducted. One side of the experimentation was the artistic, cultural exploration by the artists, and the other was a scientific experiment recording data and drawing conclusions in alignment with Potter's own research. The scientists tried to increase their understanding of the fundamental mechanisms that underpin the behaviour of embodied neural networks in vitro.

One notable finding for the scientists was related to Potter's research into the way neurons behave when growing in vitro. Potter writes "We noticed that a culture that was being used to control *MEART*, after days of receiving stimulation fed back via the internet from its video camera eye, began to calm down, showing less and less epileptiform activity. We found we could quell the barrages of activity in all of our cultured networks by sprinkling low-frequency pulses of electricity across the network, delivering via the substrate electrodes [8]." Interestingly, this discovery, made by observing one of *MEART*'s cultures responding to specialised stimulations, was one of the focal points of a subsequent work—*Silent Barrage*.

Silent Barrage

In 2006, Gamblen and I were invited as research fellows to Dr. Steve Potter's lab, one of the eight laboratories for neuro-engineering in the Coulter Department for Bio-Medical Engineering at Georgia Tech. This proved to be a pivotal development which provided a significant advancement in both the creative and technical aspects of our work. The outcomes of the research, alongside Steve Potter, Douglas Bakkum, Riley Zeller-Townson and Peter Gee,[7] eventuated in the production of a major project and artwork entitled, *Silent Barrage*.

Up until 2006, communication between the artists and the scientists in the Potter laboratory was based purely on email exchange, so it was a remarkable experience for us to finally access the Potter lab, and become part of the scientific

[7]When Douglas Bakkum graduated and left the Potter Lab, Riley Zeller-Townson took his place in the *Silent Barrage* team. Peter Gee, an engineer, also joined the team. Both were instrumental in the development of *Silent Barrage*. Dr. Nathan Scott, an engineer, and Brett Murray, a programmer, also assisted in the production of the work.

environment of our collaborators. *Silent Barrage* is similar to *MEART* in its basic architecture; a cybernetic entity that is assembled from a bio-engineered brain that grows over an MEA interfaced to a robotic body. However it has a different narrative and set of aesthetics, and the development and creative process during *Silent Barrage* also differs from *MEART*. Being in Potter's lab allowed us, the artists, close proximity to the brain. We began to understand the brain better, and become acutely aware of its fragility and the complex process involved in growing and nurturing it. As well as this, we became familiar with the experiments being conducted by the scientists, and these interactions were creative triggers that led to the development of some of the essential narratives that underpin *Silent Barrage*.

During the residency in the Potter lab my aim was to focus on learning about the process of growing neural networks on to the Multi Electrode Array (MEA) interface. The phenomenological experience of making a brain in Potter's lab, coupled with experimentation with new ideas for robotic embodiment, being conducted at the time by Gamblen, led us to develop the aesthetics of *Silent Barrage*. We realised how important the MEA dishes are to the scientists; each scientist had their own dishes, and each had developed a unique relationship with them. An email from Potter in 2001 sums it up; "(we were) a bit reluctant to 'anthropomorphize' them, and that naming them was my idea [...] The name goes with each dish, which usually serves for several successive cultures, usually lasting several months, and in one case, for about 2 years. [...] It is difficult not to feel the cultures are 'alive' since we use many of the same terms we use for living animals, say, like 'feeding', 'growing', 'keeping warm', and that the behaviour of the cultures is complex and dynamic, as is the structure. We go through hours if not days of 'mourning' if a workhorse culture dies from getting infected or other mishap. And the excitement of seeing a new culture fire great signals for the first time must be like seeing your baby take its first steps."

During this residency we observed that the scientists spent days upon days looking down the microscope, observing the cultures and using many different visualisation techniques to illustrate the events that continuously occur in the MEA dish. It became apparent that the dish was a microscopic arena for a neuronal performance. It was at this point that we decided to create a 'parallel magnified immersive space' within which the robotic body could perform. We tried to create a space evocative of the MEA so that viewers could walk through *Silent Barrage's* brain and thus experience its complexity and chaos.

As the viewer approaches the space housing the robotic body of *Silent Barrage*, thirty two robotic components can be heard and seen, as they move vertically up and down the columns of PVC piping. At 2.4 m in height, these columns tower above the viewer and are arranged in a grid-pattern across the gallery floor. As the robotic parts navigate the columns, they leave traces around their circumference with a pen pressed against sheets of paper wrapped around each column. These drawings are the robotic body's translation and representation of information received from the bio-engineered brain hosted on one of the MEA dishes in the Potter Lab. But the origin of the mark-making has another layer of complexity because the audience plays a crucial role; there is feedback between the audience

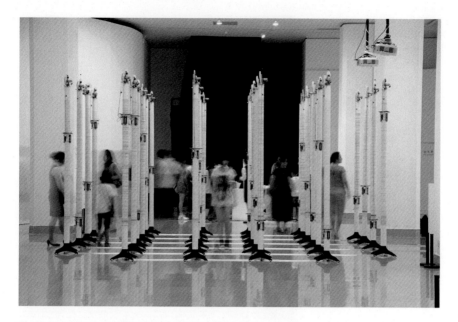

Fig. 5 Silent Barrage, 2009–2012, photograph by Philip Gamblen

and the neurons. The viewers are invited to step into this immersive space and move around the chaotic robotic objects, and through their presence in the space, the viewer communicates directly with the neurons. Cameras are located on the ceiling to capture the movement of the audience, and this information is fed back to the brain as stimulations. In response, the neurons produce their own electric signals that are then fed back to the robotic objects to enact their kinetic choreography and mark-making activities, and draws further attention from the viewers. This process occurs in real time. The drawings on the poles are unique to each individual neural network, and more importantly, they trace and record the interaction between the viewer and the brain (Fig. 5).

The scientific research conducted in Potter's lab during the residency in 2006 inspired us and became central to the development of *Silent Barrage*. The scientists were researching specialized stimulations in order to calm unwanted bursts, or barrages of activity, to try and enhance the functional plasticity in the cultured neural networks. In other words, they discovered that once the neurons formed a network over the MEA, they showed spontaneous epileptiform activity; a similar thing happens in the brain of a patient experiencing an epileptic seizure. These barrages of unwanted neural activity may originate due to lack of sensory input and disturb the neural network with the processing of data. Potter and his research team managed to overcome this problem by sending specialized stimulations to the networks to calm them, and enhance their functional plasticity, increasing the possibility for learning [9]. These experiments contributed to our vision of multiple robotic objects arranged in an immersive environment in which we ask the

Fig. 6 A detail of a drawing made by Silent Barrage, photograph by Philip Gamblen

viewers to generate stimulations to the neurons by moving through this environment. Thus the viewers, in a symbolic and poetic way, are helping cure the dysfunctional brain from its epileptic properties by walking through the space and being among the poles. The viewers help to 'silent' the 'barrage' (Fig. 6).

In-Potentia

In 2008 the media became saturated with news of the development of a new stem cell technology known as Induced Pluripotent Stem Cells (iPSc). The iPSc technology was pioneered by Professor Shinya Yamanaka who showed that the introduction of four specific genes could convert adult cells into pluripotent stem cells. Yamanaka was awarded the 2012 Nobel Prize, along with Sir John Gurdon, for the discovery that mature cells can be reprogrammed to become stem cells.

In layman's terms, the iPSc method transforms adult specialised cells into a form that is equivalent to stem cells, which are capable of becoming any other type of cell in the body (skin, liver, muscle, neuron, etc.). The process involves re-programming their 'software' (genome), and coaxing them back into their embryonic state.

Initially, iPSc was hailed as the technology that would help resolve some of the ethical dilemmas associated with embryonic stem cell harvesting, but it is now clear that it merely transformed the ethical landscape of this field of research. Not only are there increasing concerns regarding the relative ease with which iPSc cell samples could potentially be taken from us, without our knowledge or consent, but more specifically, there are increasing concerns regarding the ethically loaded potential for iPSc technology to be used in the derivation of gametes; human reproductive cells, i.e. sperm and oocytes.

The discovery of this biological alchemy intrigued me. I realized how malleable and fragile our bodies are; how we are able to deconstruct, manipulate and re-assemble the microscopic building blocks of life in completely new ways.

Around this time, I had a conversation with Boryana Rossa who criticised artists using the biological material of other species, and she questioned the ethical aspect of this practice and why human material could not be used. I had to concede that *MEART* and *Silent Barrage* both relied on mouse and rat neurons grown over the MEA interface, a standard scientific practice. Human brain cells were at this point out of the question, as there is no way to harvest brain cells from a living creature without causing it fatal harm. iPSc technology offers a way to safely use human cellular material. By hacking into the cell's software, it is possible to manipulate the genetic make-up of the cells and from there craft the building blocks necessary for the creative process. By re-programming human skin cells, it seemed that I would be able to create a brain from scratch, in a sense.

In collaboration with Dr. Kirsten Hudson, Mark Lawson and Dr. Stuart Hodgetts, I produced *In-Potentia*, a speculative, techno-scientific experiment using disembodied human skin cells and diagnostic biomedical equipment. This project allowed me to experiment, for the first time, with the new technology and to learn how to carry out the iPSc technique. In this project, the iPSc technique was redeployed to create a liminal boundary creature of animate and inanimate matter [10]. We deliberately set out to problematize the new iPSc technology and selected human foreskin cells, which can be easily purchased from on-line scientific catalogues. These were selected as a starting point to learn the iPSc technique, with the aim of reprogramming them into stem cells, and then into brain cells. We aimed to highlight the absurdity of the scenario; to reverse-engineer foreskin cells, and from this material, create a living 'brain'. In fact, the project was affectionately given the working title of 'Project Dickhead' (Fig. 7).

The brain of *In-Potentia* was encased within an incubator-like robotic body which served to keep it alive, as well as to present the exalted new technology on a pedestal. The Robotic body was designed using an 18th Century aesthetic, as a way to denounce the era of enlightenment and the associated pomp of new scientific discovery. The phallic, somewhat steampunk incubator was custom-made from hand-blown glass and polished timber panels, with aged brass fittings. This elaborate encasing concealed a bio-reactor that automated the process of feeding and clearing wastage from the living brain cells. There was also a DIY version of an MEA that converted the electrical activity from the brain into an unsettling sound-piece. In this work, unlike *MEART* and *Silent Barrage*, there was no

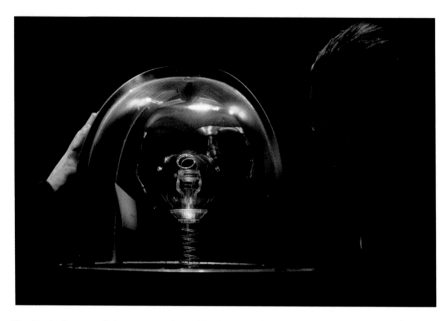

Fig. 7 A close-up of the upper section of In Potentia, showing the incubator with the bio-engineered brain inside the dish, photographed by Where Dogs Run, 2009

feedback loop or interaction with the brain. We placed the brain on a pedestal, presenting it with the indifference of a museum specimen, or a piece of jewellery; something to be viewed, behind glass, feted, admired, and perhaps even feared.

Since the era of enlightenment, philosophers have attributed the human brain with a great deal of importance as the organ that determines life or death. With Descarte's famous declaration "I think therefore I am", western philosophy established the anthropocentric belief that thinking is required before any living being can be granted human status. This distinctly modern philosophical paradigm placed the brain on a pedestal, and clearly marked the thinking brain as the primary signifier of individual existence or personhood within modern western culture. By literally placing a live, male 'brain' on a sculptural robotic pedestal that has been informed by the aesthetics of 18th century scientific paraphernalia, *In-Potentia* raises some interesting questions in regards to why we still seem to be ruled by an antiquated and distinctively modern historical form of personhood, and in turn, with *In-Potentia* we ask: what does it really mean to be alive and be human in the 21st century [11]?

In-Potentia has the ability to symbolize our worst nightmares as it threatens accepted and clear-cut categories of the human body. This work serves to challenge definitions surrounding embodied material wholeness, and provokes many more questions than answers in the viewer. What is the potential for artworks to activate responses about shifting perceptions surrounding understandings of 'life' and the materiality of the human body? And what does it mean artistically, philosophically and culturally to make a living biological brain from foreskin cells?

cellF

In 2012 I was awarded a Creative Australia Fellowship from Australia Council for the Arts to create a new project, a cybernetic self-portrait, entitled *cellF* (Fig. 8).

cellF is a progression of the past 14 years of research conducted through various projects involving robotic embodiment and bio-engineering. This project is a continuation of my interest in problematizing new bio-technologies and contextualising them within an artistic framework. The fellowship allowed me the time and space to develop this idea and at the current time of writing, *cellF* is still under development.

The project has been divided into two parts; the first, which posed enormous challenges with biological protocols, was to reprogram my own skin cells taken from a biopsy and to transform them into neurons to create a functional neural network, an external brain independent from my body. The second part has been to develop a robotic body to interface to this external brain so that they work in synergy, including a real time feedback loop and in many ways this biological self-portrait follows the same hardware, software and sensors formula as the other projects.

Fig. 8 The process of differentiation—my neural stem cells transforming into neurons, taken at day 8

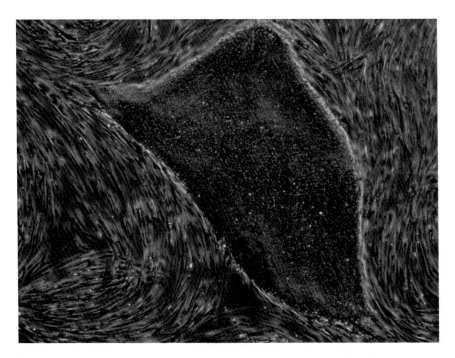

Fig. 9 A stem cell colony at week 4, after being reprogrammed from my skin cells

In 2012 I had a biopsy taken from my arm, and cultivated the skin cells in vitro in the labs of SymbioticA at UWA, then froze them cryogenically and shipped them to Barcelona, where I collaborated with Dr. Michael Edel.[8] In Barcelona, with the help of Edel, I reprogrammed the cells using iPSc and created stem cells, which began to differentiate and were pushed down the neuronal lineage until they became neural stem cells. These were frozen and shipped back to SymbioticA, where I, in collaboration with Dr. Stuart Hodgetts[9] began to develop a protocol to fully differentiate them in an MEA dish. Working with Edel and Hodgetts is another example of a close collaboration with scientists where both parties benefit from the research; the scientists are using the artistic cells for scientific purposes and this project has allowed them a unique opportunity to do so (Fig. 9).

In parallel to the biological work carried out in Barcelona and Perth, I also spent time considering the very important artistic aims of the project; namely, what sort of robotic body will I give to myself? My decision is based on a long-standing passion for music, a juvenile dream that is shared by many—to be a rock star.

I plan to embody my external 'brain' with a sound-producing 'body' comprised of an array of analogue modular synthesisers. The aesthetics of the synthesiser,

[8]Head of the Laboratory for Pluripotency, University of Barcelona.

[9]Director of the Spinal Cord Repair Lab, University of Western Australia.

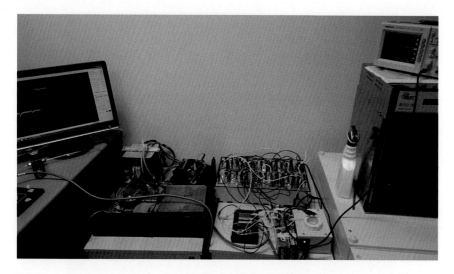

Fig. 10 Testing the interface between the neurons and the synthesisers

which are similar to that of an electrophysiological laboratory, fits my vision perfectly. Furthermore, there is a surprising similarity in the way neural networks and synthesisers work in that in both voltages are passed through the components to produce data or sound. There is also a practical consideration, the neural networks produce large and extremely complex data sets, and by its very nature, the analogue synthesiser is well suited to reflecting the complexity and quantity of information via sound. The finished artwork is still on the design table however my plan is to embed the synthesisers into a sculptural object that will also house a mini bio-lab that hosts my external brain.

Essentially this robotic-sound artwork can be seen as a cybernetic musician. The intention is that the artwork will be performative, and that human musicians will be invited to play with *cellF* in a series of special one-off shows. The human-made music will be fed to the neurons as stimulations, and the neurons will respond by controlling the analogue synthesisers, and together they will perform live, improvised sound pieces.

Dr. Douglas Bakkum[10] has returned to collaborate again with me and will be assisting in developing the interface software and other modules that are required to connect the MEA to the sound producing body. Andrew Fitch[11] will custom-design the synthesisers specifically for this project while Dr. Darren Moore[12] will work with me on the aesthetics of the sound (Fig. 10).

[10]Dr. Bakkum is currently a group leader at the Department of Biosystems Science and Engineering, the ETH Zurich.

[11]Electrical engineer from Perth, aka nonlinear circuits.

[12]Experimental musician and lecturer at Lasalle College of the Arts in Singapore.

Fig. 11 My neurons growing over a multi electrode array at day 10

Moore and I are interested in contextualising the work from a musical perspective and in conversation, Moore referred to several examples. The futurist, Russolo, in the early 1900s, wrote about the art of noise and was interested in expanding the sonic palette to include noise and noise-making machines; conceptually ahead of its time and not fully realised by others until the 1950s and 60s when synthesisers became more commonly used in music. John Cage's 4′33″, also known as 'the silent piece', was an important work in the conceptual development in the field of experimental sound-art; it emphasised the noise of the environment around the performance and the non-musical aspects around the music. David Tudor, in the 1990s, combined the engineering of electronics with the inspiration of biology and developed a synthesiser that was controlled by an artificial computer coded 'brain', not made from biological matter, but closely resembling one in its activity and intention and used it to composed and play a series of works titled *Neural Synthesis Nos. 6–9*. In other words, Tudor's artificial neural network simulated the way real biological neural networks operate using a computer code and wired this to a synthesiser to create sound. *cellF* builds on these precedents, and in particular it takes Tudor's vision a step further from using an artificial neural network and making use of a real biological neural network to play electronic music (Fig. 11).

Conclusion

The four artworks presented in this paper, *MEART*, *Silent Barrage*, *In-Potentia*, and *cellF*, highlight the way in which my experimentations have focussed on matching robotic bodies to bio-engineered brains. *MEART* was a cybernetic entity exploring notions of creativity and emergence. *Silent Barrage* allowed viewers proximity to the brain via a robotic interface. *In-Potentia* responded to break-throughs in iPSc technology to create a brain and place it on a robotic pedestal. *cellF* gathers all this work together, and will culminate in a robotically-enhanced performance of my own biological material; a self-portrait. My intention is to create strongly subversive projects that problematize emerging biological innovations and technologies, and critique them from a cultural perspective rather than a scientific one. In each, there has also been a desire and a deliberate attempt to set up absurd scenarios that suggest possible, contestable futures, in line with post-humanist theory and to contribute a cultural voice to a scientifically-biased discourse. My work is an exploration, posing more questions than answers, through which cybernetic technologies and processes and asks us to re-evaluate our understanding of life, the human body, sentience, and personhood.

References

1. Haraway D (1991) A cyborg manifesto: science, technology, and socialist-feminism in the late twentieth century. In: Simians, cyborgs and women: the reinvention of nature, pp 82–149
2. Zurr I, Catts O (2003) The ethical claims of bio-art: killing the other or self-cannibalism? Aust N Z J Art 5(1):167–188
3. Stelarc (2013) Fractal flesh/liminal desire: The cadaver, the comatose and the chimera. Evolution haute couture, art and science in the post-biological age. In: Bulatov D (ed) National Centre for Contemporary Arts (NCCA) Baltic Branch, Kaliningrad, p 271
4. Hughes R (2007) The semi-living author: post-human creative agency. In: Anstey T, Grillner K, Hughes R (eds) Architecture and authorship. Black Dog Publishing, London
5. Rossa B (2004) Art digital 2004, I click therefore I am. M'ARS Association, M'ARS Centre for Contemporary Arts, Moscow, p 23
6. Venouse P (2006) Contemplating MEART, strange attractions, charm between art and science. In: Ivanova A (ed)
7. McCrea E (2006) A report on the practices of SymbioticA Research Group in the creation of MEART, the semi-living entity
8. Potter S (2013) Better minds, cognitive enhancement in the 21st century. Evolution haute couture, art and science in the post-biological age. In: Bulatov D (ed) National Centre for Contemporary Arts (NCCA) Baltic Branch, Kaliningrad
9. Madhavan R, Chao ZC, Wagenaar DA, Bakkum DJ, Potter SM (2006) Multi-site stimulation quiets network-wide spontaneous bursts and enhances functional plasticity in cultured cortical networks. In: Paper presented at the 28th annual international conference of the IEEE engineering in medicine and biology society, New York
10. Hudson K, Ben-Ary G. In-Potentia. http://in-potentia.com.au/about
11. Hudson K, Ben-Ary G. In-Potentia. https://dl.dropboxusercontent.com/u/9468392/ARS_concept_notes_final.pdf

Android Robots as In-between Beings

Kohei Ogawa and Hiroshi Ishiguro

Abstract The Geminoid is an android robot based on an existing person and it can act as an avatar of the original person using a teleoperation system. The Telenoid is another android which is characterized by implementing a minimal design representation of a human. By this design, the Telenoid allows people to feel as if a spatially distant acquaintance is close-by. We created two artworks with the Geminoid through collaborations with artists. Firstly, we conceived the Android Theater. In Android Theatre human actors and androids shared the stage in a first play of its kind worldwide. The second work is an "Intelligent Mannequin". Here the Geminoid was interacting with the visitors in a department store as an interactive mannequin. In this chapter, we give an overview of the Geminoid and the Telenoid, describing its appearance, teleoperation system and the concept of Android Science. We then focus on the artworks.

Android Technology and Science

In this section, we describe the android technology of the Geminoid and the Telenoid including their control systems. We then outline the concept of Android Science.

K. Ogawa (✉) · H. Ishiguro
Graduate School of Engineering and Science, Osaka University,
1-3 Machikaneyama, Toyonaka, Osaka, Japan
e-mail: ogawa@irl.sys.es.osaka-u.ac.jp

© Springer Science+Business Media Singapore 2016
D. Herath et al. (eds.), *Robots and Art*, Cognitive Science and Technology,
DOI 10.1007/978-981-10-0321-9_16

Overview of a Geminoid

Why do we feel another person's presence? How can this presence be captured, revived, and transmitted? To tackle these mysteries, we have developed a new artificial being, Geminoid. The word "Geminoid" comes from the Latin geminus meaning "twin" or "double" and postfix "oids" which means "similarity". As the name suggests, the Geminoid is a robot that will work as a duplicate of an existing person. Because they are closely connected by network and sensor technology, the Geminoid not only appears but also behaves just like its source person.

Geminoid belongs to a new category of robots, which were originally planned to be test-beds for studying the individual nature of human beings. Whilst humanoid robots are good for studying the effectiveness of having a human-like body, and androids are used for seeking the general nature of humans, studies using Geminoid focus on investigating the nature of individuality. Geminoids allow us to examine personal aspects, such as presence or personality traits, tracing their origins and implementing them into robots. Differences among people enable us to distinguish individuals and they emerge from complex combinations of various elements, such as appearance, facial expression, or ways of speaking. We intuitively know this from our daily experience, but until now scientific ways to examine this complex interplay have been rather limited. By using Geminoid, we can systematically investigate the essentials of what makes a person an individual.

The first Geminoid prototype HI-1, created in 2006, was modeled on Dr. Hiroshi Ishiguro, Professor of Osaka University and ATR (Fig. 1). Since then numerous studies have been performed. Research with Geminoid takes two approaches: The first one follows the engineering approach that focus on aspect such as the development of an effective teleoperation interface and the generation of natural human-like motion. The second follows the cognitive modeling approach to study aspects of human nature, such as "human presence". These two approaches in combination will eventually lead to both advanced robots that closely resemble humans and new insights on human nature.

Appearance of Geminoid

The appearance of Geminoid is based on an existing person and does not depend on the imagination of designers. Currently, two factors are considered: how Geminoid looks and how Geminoid moves. Similarity to the original person can be measured by comparing these two factors with those of the original. Also the existence of a real person analogous to the robot enables us to easily perform comparison studies. As HI-1 presented here is modeled after a researcher, we even have access to the source person's most personal subjective impressions. These insights are especially important at the very first stage of a new field of study.

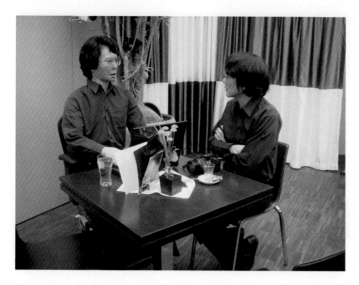

Fig. 1 Android robot, Geminoid HI-1 (*left* Geminoid HI-2, *right* Creator of Geminoid)

In creating the first Geminoid prototype HI-1, efforts were concentrated on making a robot that appears not just to resemble a living person, but also to be a copy of the original person. Silicone skin was molded using a cast taken from the original person; shape adjustments and skin textures were painted manually based on magnetic resonance imaging scans and photographs. Fifty pneumatic, i.e. air-pressure driven, actuators let the robot generate smooth and quiet movements, which are important attributes when interacting with humans. The allocation of actuators was used so that the resulting robot can effectively show the necessary movements for human interaction and also allow for the recreation of the original person's personality traits. Of the 50 actuators, 13 are embedded in the face, 15 in the torso, and the remaining 22 move the arms and legs. The softness of the silicone skin and the compliant nature of the pneumatic actuators also provide safely while interacting with humans.

Teleoperation

So far several androids have been developed. Although these androids enabled us to conduct a variety of cognitive experiments, their functionality was still quite limited. The bottleneck in interaction with humans is an android's inability to perform long-term conversation. Robots equipped with artificial intelligence cannot yet perform at a level comparable to that of adult humans and still respond in a simple manner. This heavily constrains research on human-robot interaction. Thus, our solution to this problem lies in combining androids with teleoperation technology. Using

Fig. 2 The tele-operation console of Geminoid HI-2

teleoperation we can immediately start researching and implementing high-level human interaction, shedding light on mysteries such as human presence (Fig. 2).

The teleoperation system with which every Geminoid is equipped also allows us to tackle a more philosophical question: whether a human's "mind" is separable from his or her "body". In Geminoids, the operator (mind) can easily be exchanged, while the robot (body) remains the same. In addition, the strength of connection—that is how much information of which kind is exchanged between Geminoid's body and an operator's mind—can easily be reconfigured. This is especially important when taking a top-down approach that adds or deletes elements from a person to discover the "critical" elements that constitute a human's character. Before the era of Geminoid, this research methodology was impossible.

Some operator movements are captured, converted and transmitted to drive Geminoid. Therese includes, for example, lip motions while speaking and head movements while looking around. The operator can also explicitly send commands for controlling android behavior using a simple graphical user interface. Several selected movements, such as nodding, opposing, or staring in a certain direction, can be triggered with a single mouse click. This relatively simple interface was used because the robot has 50 degrees of freedom, which make it one of the world's most complex robots. This huge amount of actuators cannot be manipulated manually in real time. Thus, a simple, intuitive interface was conceived so that the operator can concentrate on the interaction itself and does not have to think much about how to drive the androids' behavior. Despite its simplicity this interface enables the operator to generate natural humanlike motions for the robot, with the help of Geminoid management system.

The teleoperation system also maintains the state of interaction and generates autonomous movements for the robot, which are driven unconsciously in humans. With a robot's appearance nearly matching that of a human, its behavior should also become suitably sophisticated to retain a "natural" look. A human never stops

breathing or eye blinking, because these easily observable kinds of behavior are driven unconsciously by the autonomic nervous system. Most robots, however, lack these movements. Thus, to increase Geminoid's naturalness, Geminoid management system emulates a human's autonomic nervous system by automatically generating these micro-movements, depending on the state of interaction. When the android is "speaking" its micro-movements are different from those triggered when it is "listening" to others. These automatic robot motions, generated without an operator's explicit orders, are merged with explicit operation commands from the teleoperation interface.

Telenoid

Humans cannot recognize others based on only one picture. We change clothes everyday, make our face up in a morning, hair grows day by day, and the face changes during the day. One picture does not represent the person. We humans, therefore, create the images of others by imagination. Imagination is also an important ability in communication. Language is an incomplete way to understand each other. We cannot transfer everything that we think through language. However we can feel as if we understand each other because imagination fills the missing information.

We expected that room for interpretation might maximize human imagination and that this can be applied to android design.

The Telenoid was designed to appear and to behave as a minimalistic human; at very first glance, one can easily recognize the Telenoid as a human while on the other hand the Telenoid appears to be both male and female, both old and young (Fig. 3). The Telenoid has 9 degrees of freedom (3 for the eyeballs, 1 for the mouth, 3 for the neck and 2 for the arms for giving a hug) and it is controlled by teleoperator using the same system as in the Geminoid. By this design, Telenoid allows people to feel as if a spatially distant acquaintance is close-by. In other words, the Telenoid's minimal design maximizes the imagination of the person talking through the Telenoid. Moreover, the Telenoid's soft and pleasant skin texture and the small body size (approx. 50 cm) allow one to enjoy hugging and having intimate communications with it.

In fact, some elderlies start weeping when they talked with someone through the Telenoid. They said, "He was very kind to me like my true family" or "He must be a best friend of mine". This implies that, basically, the imagination works in a positive direction. In other words, the Telenoid's minimal design generates room for interpretation, and then the user's imagination fills in details and creates a good communication experience.

Android Science

If we could build an android that is very similar to a human, how can we distinguish a real human from an android? The answer is not trivial. While interacting

Fig. 3 Android robot, Telenoid

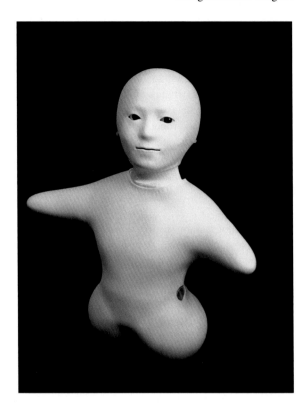

with androids, we cannot see their internal mechanisms and thus we may simply believe that they are human.

We propose to use androids that behave similarly to humans for studying what it essentially means to "be human", i.e. the mystery of human nature. Androids and Geminoids are artificial humans that allow us to investigate human nature by means of psychological and cognitive tests, which we conduct during interaction with people. This new approach for understanding humans is called Android Science.

Current robotics research builds upon the field of cognitive science, especially in the area of human-robot interaction. Robotics researchers try to adopt mechanisms underlying successful human-human interaction to create robots that people can easily communicate with. At the same time, cognitive scientists have begun to utilize robots. As the scientific understanding of complex, higher-level human functions steadily increases, expectations will rise for robots to function as easily controlled machines with communicative ability. However, the contribution from robotics to cognitive science has not been adequate because the appearance and behavior of current robots cannot be separately handled. Since traditional robots look quite mechanical and very different from human beings, their appearance strongly influences a human's expectations. As a result, researchers cannot clarify whether a specific finding reflects the robot's appearance, its movement, or a combination of both.

We expect to solve this problem using androids, which closely resemble humans in their appearance and behavior. To achieve this goal, an objective, quantitative means to measure the effect of appearance is required, which forms part of our research endeavor.

In summary, the motivation of Android Science is twofold: On the one hand, a major robotics issue in the construction of androids is the development of humanlike appearance, movements, and perception functions. On the other hand, cognitive scientists are aiming to gain insights into the processes leading to "conscious and unconscious recognition." The goal of android science is to realize a humanlike robot and to find the essential factors for representing human likeness. How can we define human likeness? Further, how do we perceive human likeness? It is commonly assumed that humans have conscious and unconscious recognition. When we observe others, various brain areas are activated. Each of them matches sensory input with human models, thereby modulating our response behaviors. These unconscious processes let us, for example, treat an android as if it were a human partner in conversation, although we consciously recognize it as what it is: a robotic system with very humanlike appearance. This is a fundamental issue for both engineering and scientific approaches. It will be an evaluation criterion in android development and helpful for understanding the mechanisms of human brains that make us social and emotional creatures.

Android Theatre, "Good-Bye"

Can androids become more human than humans, if only for a split second, if they look, move and talk like real people? What does it mean to be human, if human beings feel that androids are as human as themselves? These questions are what we have on the "robot theater project".

As we described above, since artificial intelligence technology has still not reached the level of human behavior, robots can only respond in quite a simple manner. This was a major obstacle in conducting research on human-robot interaction. With Geminoid's teleoperation system, it is possible to avoid this problem, and conduct various kinds of research on the implementation of high-level human interaction, including the study of human presence.

Research using Geminoids follows two approaches. One is the engineering approach, such as the development of effective tele-operation interfaces or the generation of natural, human-like motion. The other approach focuses on cognitive aspects, investigating the sense of human presence. Through these two approaches we aim to create an advanced robot that is very similar to humans, and, at the same time, to discover the essence of human nature.

The collaborator, Oriza Hirata, and we have been co-developing a robot-human theater project, which combines theater with our research on the cohabitation of humans and robots. The creation process and presentation of the research data fuse to make the performance a groundbreaking collaboration of engineering, science and theater.

As an aspect of engineering, for example, this collaboration has the potential to make robots more natural and human-like. Androids can induce familiar feelings in humans because of their human-like appearance. However, android's appearances may induce a negative feeling [1]. The unnatural sensation of interacting with humanoid robots is caused by tiny differences between androids and humans. In fact, 76 % of subjects cannot distinguish an android from a human after watching for less than two seconds [2]. Therefore, the negative feeling is induced after long-term exposure to an android robot and remains a central barrier to comfortable human-android interactions. According to several studies, harmony between a robot's appearance and behavior alleviates the negative feeling in observers [3]. This consideration has led to some successfully implemented android behaviors that do not evoke the negative feeling [4, 5]. However, a methodology for building an android robot that is perceived as a human-like entity after long-term exposure has yet to be established. To tackle this issue, the robot theatre project, in which robot and humans act in a long-lasting stage production it is important to know how we can achieve the android which doesn't cause uncanny feelings.

The history of stage art is replete with implicit knowledge for directing actors on the stage. Therefore, by collaborating with stage directors, we can acquire useful knowledge for humanizing a robot. Moreover, creating a stage play and presenting public performances enables large-scale evaluation of audiences' impressions toward acting robots.

Stage plays are universal culture in all over the world from ancient ages. A large number of art works have been produced based on professional technique of stage directors and actors. A director focuses on a representing human behavior for improving his stage plays. Therefore stage directors may have important knowledge for developing robots representing human behavior.

Oriza Hirata, is a widely esteemed as a playwright and stage director, and has advocated what he calls the "Contemporary Colloquial Theatre Theory (CCTT)" [6]. Since CCTT replicates on stage the reality of everyday human activities, it is potentially applicable to designing robots with human behaviors. CCTT advocates precise, rather than ambiguous, instructions for actors. Actors are instructed when to alter their physical actions, such as utterances and body orientations. Such precise instructions are expected to be directly applicable to android robots. Therefore, creating the stage play with android based on the CCTT, it might be helpful for developing more human-like android.

Premiered in 2010, the android theater play "Good-bye" shows an android and a person communicating with each other at an unprecedented level (Fig. 4). This short piece is the latest achievement of our collaboration, which started in 2008. We, researcher, and the Oriza Hirata, an artist, have been working together on this project to present a rendition of human-robot interaction in the near future: robot and humans acting, talking and communicating with one another naturally.

In "Good-bye", Geminoid F (Fig. 5), a female version of Geminoid, is cast as an android calmly reading poems to a dying girl, played by a human actress. Their quiet conversation casts profound questions such as "What is life/death for a robot/human?" and "What does it mean to be a human/robot?"

PHOTO BY TATSUO NAMBU

Fig. 4 Android Theater, "Good-bye" (*left* Geminoid F, *right* human actor)

Fig. 5 Android robot, Geminoid F (*left* Geminoid F, *right* original person)

The robot theater project does not seek to amaze people with advanced robots as shown at expositions. The aim is to show the presence of robots and how they interact with humans on stage, to provoke the audience to reflect about what it means to be human.

It is also a social experiment for robotics to know the cultural differences of how people perceive long-term exposure to an android. In fact, this performance

Fig. 6 Geminoid F inside the show window

was held in many countries such as Japan, China, Thailand, Austria, Germany, France, Australia, US, and so on. We asked the audience about their impression toward the android. The results are very important to capture different stereotypes of androids across the world.

Intelligent Mannequin

By creating the android theater, the teleoperated android could be perceived as a natural existence on the stage. As a next trial, we tried to create an autonomous android in a real world scenario that is "Intelligent Mannequin" (Fig. 6).

A mannequin is an ordinary and familiar thing for us. We can easily find it everywhere in town. On the other hand, a mannequin is sometimes an uncanny. There is a dissonance between its human-like appearance and non-human-like communication ability. We, humans are forced to read the communication ability of an object from its appearance. A mannequin cannot move its body even though it has human-like appearance. Humans sometimes feel uncanniness toward an object, if its appearance does not meet our expectation of its communication ability. This is well known as the effect of the "uncanny valley". The effect of the uncanny valley implies that if an object's appearance becomes similar to humans beyond a certain point, humans suddenly experience a feeling of uncanniness. The uncanny valley is named so because the line representing how natural an object is draws a valley on the graph with the ordinate axis for naturalness and the abscissas axis for human-likeness.

A mannequin is used for advertising human's outfits or accessories. It makes sense to use a mannequin for this purpose because these goods are designed for humans and the mannequin's human-like appearance induces customers to imagine themselves with these goods. Why then not use actual humans instead of mannequins? Why is a mannequin used, despite being sometimes associated with uncannyness? One of the reasons is that there is an ethical resistance against using humans. We feel disgusted when a human is treated as if it were just an object. By contrast, androids that we have developed for this project, can talk and behave like humans by using several sensors, and yet androids are not recognized as humans—they are on a boundary between humans and objects. That's why androids can play the role of an intelligent and human-like mannequin that does not stir up ethical resistance. This means that an android can play a special role in being an alternative entity to human and mannequin, because of its intermediate presence.

This experiment was a preliminary trial. Therefore we did not measure or survey visitor responses. However, we are sure that the visitors enjoyed the interaction with the android and they considered its existence natural. This suggests that the android could autonomously play the role of an intelligent mannequin.

Conclusion

Humans have envisioned autonomous machines for a long time. Numerous scientists and engineers have dreamt of building a machine that behaves and thinks autonomously. It is still a big challenge to pass the "Total Turing Test". However, we believe that the development of android technology, even if slow, gives us a chance to meet this challenge.

References

1. Mori M (1970) The uncanny valley. Energy 7(4):33–35
2. Noma M, Saiwaki N, Itakura S, Ishiguro H (2006) Composition and evaluation of the human-like motions of an android. In: Proceedings of the IEEE-RAS international conference on humanoid robots, pp 163–168
3. MacDorman KF, Ishiguro H (2006) Opening pandora's uncanny box: reply to commentaries on "the uncanny advantage of using androids in social and cognitive science research". Interact Stud 7:361–368
4. Chikaraishi T, Minato T, Ishiguro H (2008) Development of an android system integrated with sensor networks. In: Proceedings of the IEEE international conference on intelligent robots and systems (IROS 2008), pp 326–333
5. Ogawa K, Taura K, Ishiguro H (2012) Possibilities of androids as poetry-reciting agent. In: IEEE Ro-Man 2012, pp 565–570
6. Hirata O (1995) Gendai kogo engeki no tameni (for contemporary colloquial theater). Banseisha (in Japanese)

Into the Soft Machine

Chico MacMurtrie

Abstract This chapter traces the evolution of "soft machines" and inflatable robotics in the work of artist Chico MacMurtrie/Amorphic Robot Works (ARW). These kinetic machines, which take various forms and scales, explore the underlying essence of movement and transformation in organic and non-organic bodies. The artist recounts his creative journey as well as the technological and material aspects that enable the soft machines to change shape in relation to internal air pressure acting on multiple inflatable tubes, behaving like both muscles and bones. Early performances involving latex skins led to inflatable sculptures powered by inflatable "muscles." More recent sculptures are conceived as a modular or "molecular" system, comprising webs of interconnected, inflatable members with hundreds of operable joints. The process of constant reinvention and refinement is reflected in the increasing sophistication of the couplings of the inflatable members and of light-weight, minimal-control systems. Interaction between machines and humans has been an ongoing pursuit of the soft machines, which are increasingly designed to interact with each other on the basis of air exchange. Ultimately the goal is to imbue the machines with a capacity for supple gesture and expression.

Introduction: Body and Movement

The essence of the body, for me, lies in movement. Rather than static form, I am interested in changing positions, expressions, and gestures. Making kinetic sculpture allows me to explore these dynamics of the body. My work is based on a long-running fascination with living organisms and the technological entities with which we surround ourselves.

C. MacMurtrie (✉)
Artistic Director/Founder of Amorphic Robot Works, 111 Pioneer Street, 11231 Brooklyn, NY, USA
e-mail: amorphic@earthlink.net

© Springer Science+Business Media Singapore 2016
D. Herath et al. (eds.), *Robots and Art*, Cognitive Science and Technology,
DOI 10.1007/978-981-10-0321-9_17

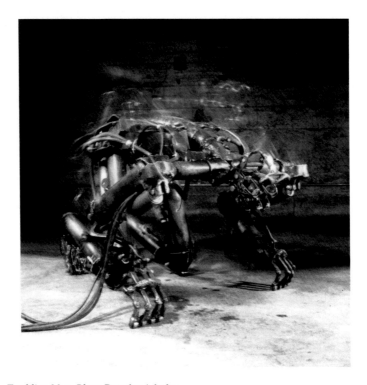

Fig. 1 *Tumbling Man. Photo* Douglas Adesko

Inspired by my 1987–89 residency at the Exploratorium, a museum of science and art in San Francisco, I founded Amorphic Robot Works (ARW) in 1991. It grew into an ever-changing collective of artists, engineers and scientists, devoted to exploring the potentials of machine movement, intelligence and responsiveness. What we shared was a desire to make robotic and interactive sculpture as a reflection on the human condition (Fig. 1).

While ARW's output over our first decade comprised largely metal machines and robotic sculptures defined by structure, more recently I have focused on developing "soft machines" based on inflatable components. I will trace my creative and technical journey from an early interest in supple forms, toward rigid machines, and back into more sophisticated soft robotics. I will devote the most space to this most recent and current phase, where I continue to concentrate my efforts today.

An Echo of the Living Body

I have long been fascinated with finding an echo of the living body in soft forms and inflatable machines. While in art school in the mid-1980s, I went into intense improvisational movement studies as well as the study of martial arts, healing

Fig. 2 *Black* Air. *Photo* Gil
Lutz

and anatomy. I began to suspect that I could learn more from my own body than from traditional techniques of painting and composition and sculpture. One night I used my whole body to make a direct impression on the impasto surface, ending up covered in thick paint. The real discovery was in how the paint encased my body, forming a second skin as it hardened. The act of shedding this skin became a cathartic moment in my performances: I would entrap my body in a layer of paint and later on latex, only to break out of that skin in an act of primordial release and transformation (Fig. 2).

This in turn led to another tantalizing discovery: the empty latex skin, buffeted by ambient air currents, suggested the possibility of an autonomous form. I envisioned artificially reanimating that form and imbuing it with life of its own. To animate these skins, I began putting mechanical structure inside them, and experimenting with cast rubber air muscles to animate them. Although the rubber components imbued the forms with a softer presence, I focused on hard mechanisms, leading to a decade's worth of kinetic machines in which structure became increasingly prominent.

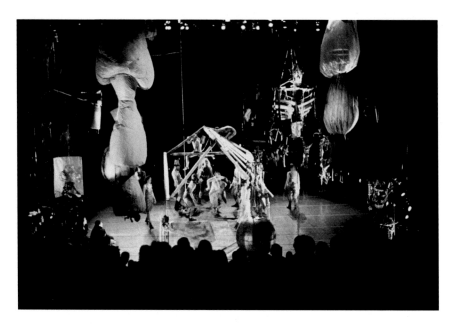

Fig. 3 *Trigram: A Robotic Opera. Photo* Kurt Prasse

ARW's technology has evolved over the years from repurposed circuit boards and early machine languages to complex servo control systems, vision systems, and dual redundant ladder logic systems. Frequently we have invented tools and techniques simultaneously with the development of the sculpture itself. By 1992, collaborator Geo Homsy had introduced the first multi-channeled, MIDI-controllable computer. By 1994, MIDI hardware designer "Stock" Bart Plum, Engineer Frank Hausman and Artists Brian Kane and Marc9 were programming full performances of movement and sounds with midi software.

In 1992–94, I experimented with inflatable media to help animate the large elements of *Trigram: A Robotic Opera*, a performance involving 16 musical robots and 16 human performers set to a score composed by Bruce Darby (Fig. 3). This work represented a high point of machine to human interaction in a performance format. Several performers performed with machines via radio telemetry suits (Fig. 4). Inflatable robotic set pieces such as the "Charnel Grounds mountain range" and the "triple-dripping fetus" foreshadowed later experiments in inflatable machines.

Experiments in Locomotion and Interaction

Throughout the 1990s, soft machines took a back seat to a series of hard-bodied skeletal machines. These bipedal and quadrupedal machines, typically composed of metal frames with pneumatic muscular systems, were inspired by the mechanics

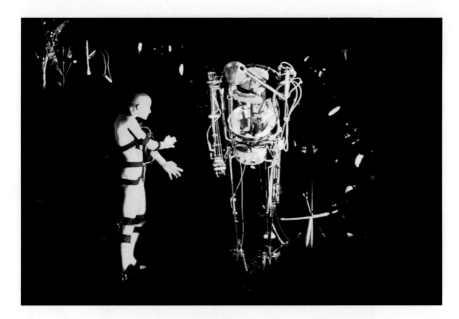

Fig. 4 *Telemetry Suit* performing *String Body* in the *Robotic Opera*. *Photo* Kurt Prasse

of animal and human locomotion (Fig. 5). The ever-growing corps of kinetic machines, reaching into the hundreds by the mid-1990s, constituted a Machine Society in parallel with our own. It was both alluring and frightening to me to participate in the technological medium of robotics. I saw exciting and poetic possibilities, but with the advance of technology I also saw a potentially more sinister side. (The same tension still holds true for my soft machines today.) Military research and large corporations seemed to be leading the field of robotics. The technologies that controlled my machines were simplified versions of the ones which, in my somewhat dystopian view, I thought might one day control human society.

We combined inflatable and metal machines on a large scale in *The Amorphic Landscape* (2000), a 20-m-long installation shown and commissioned by the NOW2000 arts festival in Nottingham, England and the Muffathalle in Munich, Germany (Fig. 6). This was an all-encompassing, animated hydroelectric environment involving more than 250 machines. It elaborated upon *The Ancestral Path*, a large ensemble performance and kinetic installation that ARW toured during the 1990s. Visually and acoustically immersive, *Amorphic Landscape* provided a physical and narrative backdrop to the individual machines.

The inflatable mountain ranges from the *Trigram* opera reappeared, this time larger and imbued with percussive function. These soft sculptural elements had an ability to transform the performance area as the audience moved around it. The internal hydroelectric mechanisms were birthing the machine performers and elevating them at heights where the audience, no matter how large, could always view them. Comprising giant inflatable bladders of air driven by large valves that

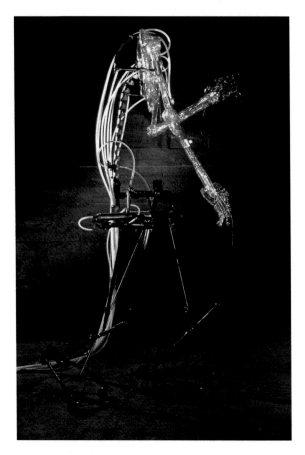

Fig. 5 *Walking Legs. Photo* Douglas Adesko

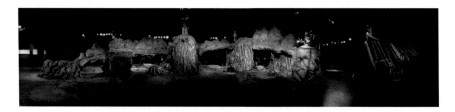

Fig. 6 *The Amorphic Landscape. Photo* Brian Kane

exhausted percussively, the mountain ranges sounded deep rhythms, evoking a mysterious life force within, while the other percussive machines would attempt to synchronize their rhythms in a primal gesture of connection (Several dozen percussive robots from this period have been refurbished and reunited to form *The Robotic Church*, a site-specific installation and performance series that debuted in 2013 in our Brooklyn studio.).

Fig. 7 *Skeletal Reflections.*
Photo Douglas Adesko

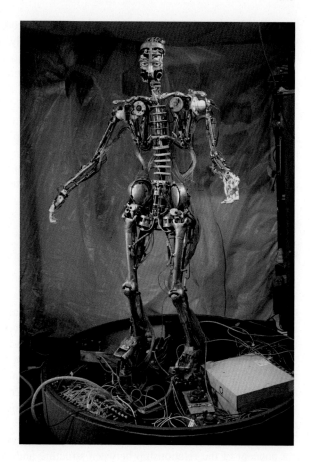

Simultaneous with this sprawling ensemble of *Amorphic Landscape*, I created my first servo-controlled humanoid robot, *Skeletal Reflections* (2000), which effectively combined the capabilities of the other machines into one (Fig. 7). It was the most complex machine ARW had ever designed and built. It had 30-plus degrees of movement, closed-loop servo control, and an anatomy inspired by the way nerves, muscles and bones work together in the human body. Its performance was interactive: A vision system would study the body language or posture of the viewer and retrieve from its library and perform the most similar pose based on a repertoire of classical poses found in the history of art. Interpolation software would allow the machine to elegantly move from one gesture to the next.

In 2004, Richard Castelli curated ARW's retrospective exhibition in Lille, France, set within a massive exhibition on Robotics. An elaborate vision system tracked the audience, allowing them to move in front of the machines to bring out one of their pre-memorized qualities. Keeping 250 machines and mechanisms alive and working for over 3 months was an epic finale to our work with

hard machines, but it spurred me toward another approach. My metallic machines were not well suited to interact physically and safely with humans, which was an increasingly important goal. I dreamed of doing yoga with robots, or embracing them, rather than only directing and observing them. This desire for physical, expressive interaction suggested an entirely different kind of machine body, one more supple and forgiving.

I began a conceptual and technical shift toward lightweight materials and inflatable technology. In some ways I was building upon previous inflatable machines or components, like the inflatable muscles of *Inverting Woman* or the inflatable mountains of *Amorphic Landscape*. But instead of using inflatable machines as accessories to a larger machine or installation, I wanted to make stand-alone soft machines.

Supple Gesture and Soft Media

Gesture and surface expression, for me, is one of the most fascinating capacities of the body, and one of the most exciting potential areas of synthesis of art and robotics. There is a vast amount of expressive power and topological change contained in routine human motions. To rest one's face in one's hand, for example, is to let the face muscles relax and let the skin slide gently over them. The malleable, forgiving nature of flesh inspired my next generation of machines. In terms of materials, the path forward lay in high-tensile fabrics. We needed a fabric strong enough to hold forced air at high pressures in complex and organic shapes and to support the mass of the inflated sculpture.

Conceptually, this shift also required a different anatomical model, a different concept of the relationship between structure and movement. We had to look beyond the vertebrate musculoskeletal system, in which hard bones are pulled by soft muscle and ligament tissues. Could we build dynamic bodies without recourse to a hard skeletal structure? Could we build machines relying exclusively on lightweight inflatable technology? A host of new questions and challenges arose from this fundamental shift, many of which still propel the work of the studio today. These challenges revolve around the manipulation of air supply to trigger form, gesture, and movement (Fig. 8).

The current work of ARW focuses on soft machines composed of high-tensile fabric tubular forms, air valves, and a variety of articulated or integrated joints. They are operated remotely by computer and fed from a concealed air compressor or blower or an on-board air storage vessel. Designed and built at increasingly large scales, these ephemeral bodies, either freestanding or suspended in mid-air, use air pressure/vacuum to inflate and deflate through various states of articulation. They exhibit the phenomena of gradual metamorphosis, growth, decay, and interaction. As works of sculpture they present a spectrum of form. Their in-between states are just as important to their poetic expression as the two end points of their metamorphosis.

Fig. 8 Study for *Inflatable Bodies*

These soft machines return the focus of sculptural expression to the surface, rather than the structure. The outer skin not only functions simultaneously as muscle and bone, but also as the zone where breathing and gesture are made visible (Fig. 9). In what initially came as a surprise, soft machines have proven themselves more versatile than traditional hard robots, in my art as well as in scientific and technical robotics research. Their pliable physiologies offer new possibilities of form and performance.

The quiet metabolism of the machine—the increase and decrease of air in different modules—is usually performed at a slow pace, creating an alternate sense of time in the immediate vicinity. The gentle cycle of air exchange becomes a meditation on the flows of energy and constant movement that defines living organisms dependent on their environment. Sounds emanate from the machine as it changes shape, continuing ARW's long fascination with rhythmic percussion in the robotic body. The machines slow down, pause, and accelerate only to pass out, exhausted. The search for expression involves the modulation of tempo, duration, pauses, and repetition. The rate of air intake and release becomes part of the character of each machine within the frame of a given performance.

The evolution of our soft machines corresponds to increasing technical and material sophistication. Two of the most important areas of ongoing refinement are the joint details and the high-tensile flexible material, itself. ARW's relationship with Dyneema®, the manufacturer has been a mutually beneficial learning

Fig. 9 Detail of *Organic Arches*

collaboration, over 10 years in the making. At each step along the way, as I visualize new ideas, the manufacturer, typically respond with new possibilities for more optimal, high-performance coatings and structural integrity suited to the needs of the project.

The chemistry of the finish helps the fabric endure the high levels of heat and pressure to which we subject it during the course of fabrication and exhibition. By modulating the degree of surface transparency and reflectivity, it also affects the visual performance of the sculpture. The woven fibers of the material are permanently altered by tensile forces, so that they reproduce the given form of the sculpture in response to pressure and vacuum. The material thus possesses a kind of memory.

As the number of fabric modules has multiplied and their couplings have grown more complex, we have developed the capacity to supply or remove air directly to and from specific members of the sculpture (Fig. 10). This has required, on the one hand, more elaborate networks of air distribution to deliver air exactly where needed. It also requires us to monitor the air pressure of each tube at a given moment in order to close the loop of control. By continuing to enhance the machines' capacity for movement, my goal is to draw out their qualities of gesture and expression.

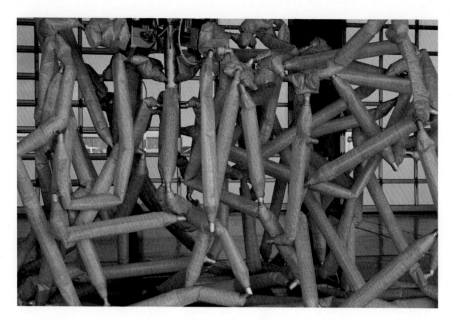

Fig. 10 Detail of *Chrysalis*

Inflatable Muscle and Bone

In 2004 I began to design and build the Inflatable Bodies. I envisioned an inflatable machine that could perform live with a human performer on the basis of physical interaction. The two performers would be able to fully lift each other, hold each other in the air, and respond to each other's gestures. The anatomy of the machine was composed purely of inflatable vessels. While the "bones" or limbs were shaped like tubes, the muscles took the form of more spherical bladders. Pairs of these inflatable muscles, glued into the inflatable bones, worked in opposite directions to push and pull the inflatable limbs into the desired position.

After some months of experimentation in the Inflatable Bodies, I had an opportunity to exhibit my first purely inflatable sculpture at the 2005 *Elektrische Stadt* Festival in Dresden, Germany. I arrived with my collaborator, Marc 9, with only a suitcase containing a roll of high-tensile fabric, a series of inflatable muscle devices, and a control system to animate an inflatable humanoid. The vast scale of the space—the hall of a former factory—called for a correspondingly large-scale installation. I responded by creating a suspended sculpture consisting of two long, conical, inflatable wings spanning over 30 feet. The inflatable muscles animated the movement of a series of humanoid limbs that merged into the center of the massive wing. I saw the "wings" as abstractions pushing my work toward dual-state metamorphic forms.

Fig. 11 *Inflatable Quadruped*

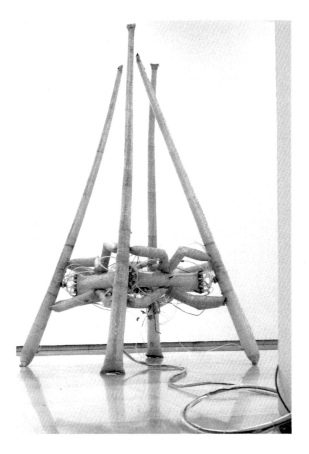

An important lesson was buried in this project, although I did not at first realize its significance: in a very provisional way, the vessel combined the functions of muscle and bone in one. It thus promised new potentials for metamorphosis and kinetic action. With the *Inflatable Quadruped Spider*, I applied this system of inflatable muscle-driven limbs to make freestanding, mobile machines on the ground working on the problem of mobility (Fig. 11).

I decided to continue using the simple yet elegant metaphor of birds' wings to further develop the soft machines, but to shift from individual forms to aggregated systems. This metaphor allowed for both abstraction and organic figuration, most importantly in the central kinetic device of inflating and deflating. The point was not to simulate the anatomical action of actual bird flight, but to probe deeper into the potentials of high-tensile fabric combined with inflatable muscles. ARW's first multi-inflatable-sculpture installation was *Sixteen Birds* (2006), curated by Melentie Pandilovski, commissioned by and exhibited at Adelaide, at the Australian Experimental Art Foundation (AEAF). A central muscle controlled the movement of the wings of each simplified, V-shaped form. The utter simplicity of the concept took on a surprising lyrical power when aggregated across the flock.

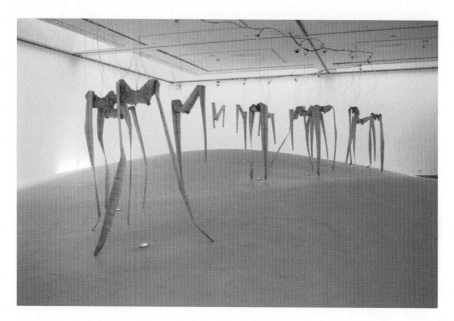

Fig. 12 *Interactive Birds*

Soon we removed the distinction between muscle and bone to create built-in structural muscles. The medium of pressurized air itself, entering or exiting the fabric body, would activate or elevate that body. We also introduced sensors to respond to the presence or movement of visitors. This approach came to fruition with the VIDA Art and Artificial Life awards in Madrid, Spain and the installation of *Interactive Birds* (2008), curated by Zhang Ga at the National Art Museum of China (Figs. 12 and 13). Initially inert fabric strips would gradually extend into pairs of long, gracefully tapering cones in response to visitors entering the gallery and approaching the sculpture. However, if viewers approached too close to a sculpture, it would exhibit nervous behavior—a metaphor for humans' overzealous interventions in our natural environments. The sensors alternated with random signals to regulate the slow rising and falling of the abstracted wings.

The cycle of the wings not only reminded me of patterns in nature but also of the way man-made structures decay and collapse and return to nature. The image of the array of birds losing their volume appeared to me as a long collapsing vertebra. This aspect of the piece inspired the notion of Inflatable Architecture.

A major work in this period, and a significant step in the evolution of the soft machines, was the *Totemobile* (2007). *Totemobile* is a robotic sculpture that initially appears in the form of a life-sized representation of the culturally iconic Citroën DS automobile. In performance, this familiar figure is visually exploded, subverted and elaborated through various levels of abstraction until it reaches its final form: an organic 20-m-tall totem pole (Fig. 14). Upon reaching its full height, the work blooms with light, in the form of multiple organically-inspired inflatable sculptures suggesting the final maturation of an enormous biological organism (Fig. 15).

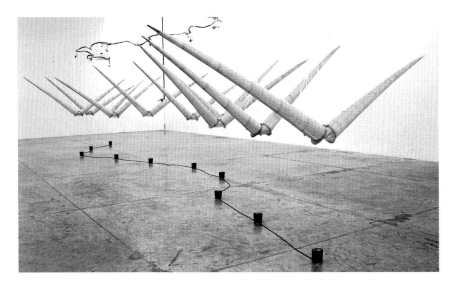

Fig. 13 *Interactive Birds*

The initial form of the robotic sculpture is surprisingly simple. The car body shell conceals the existence of nearly 50 interdependent machines of varying aesthetic and functional purpose. As the sculpture opens and rises, these metal and inflatable machines give voice to varying modes of mobile abstraction, which develop throughout the growth and final "blooming" of the full, 20-m-tall work. The collision and negotiation between the organic and the inorganic aspects suggest narratives of entropy, domination, transformation, mortality, and strength.

Modular and Architectural Bodies

The simplification of muscle and bone, combined into a single module, suggested new possibilities for the soft machines. To aggregate these modules into more complex forms and geometries, I conceived of a flexible system (Fig. 16). Back in the studio we created a series of interlocking inflatable parts, connected by cast and CNC-milled plastic joints, and embedded with custom-made, electro-pneumatic valves. Instead of the tapering cones used in the bird sculptures, we built cylindrical or cigar-shaped tubes which, in turn, would couple to the spheres that determined their angles. The conical valves would transmit pressurized air throughout the machine.

The first incarnation of the *Inflatable Architectural Body (IAB)* was commissioned by the *Machine And Souls* exhibition at the Reina Sofia in Madrid. Installed

Fig. 14 *Totemobile*

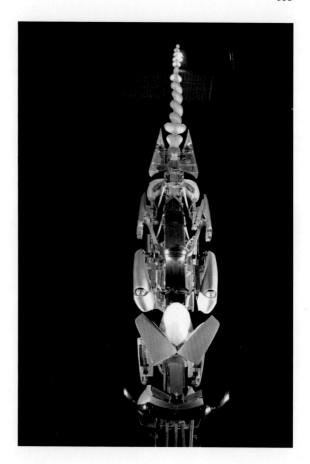

in a passageway through the exhibition, *IAB* would lay dormant, then reveal its inflated form as a web with large interconnecting orbs, gathering in a mass (Fig. 17).

The *IAB* concept developed in two directions: one, abstract modular structures that evoke of the "inner body" of cells and molecules, where one finds a deeper geometry. And two, architectural-scaled constructions deployed in the urban realm. The sculptural form-finding process still unfolded through hand-made models and drawings. But the extreme technical precision required of the coupling and the angles required digital modeling and CNC fabrication techniques coordinated by the long-time collaborators Geo Homsy and Bill Washabaugh.

Inflatable Architectural Growth (2009) was our first major robotic outdoor sculpture to use the inflatable technology in public space, and the first to utilize the closed-loop hardware/software system developed with Tymm Twillman and Chris Cerrito. It was commissioned by eArts Beyond, Shanghai International Exhibition of Media Art, and curated by Zhang Ga. Sited in the public plaza at the base of

Fig. 15 Detail of Organic
Stamen of *Totemobile*

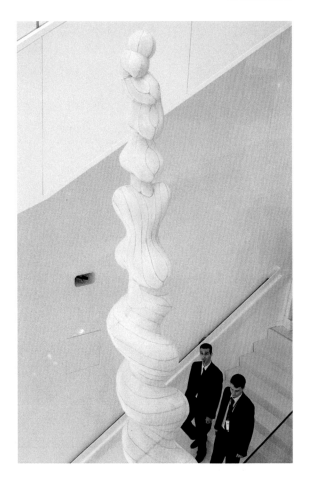

the giant Oriental TV Tower, the work consists of multiple 5-m-long segments growing out of curved bases (Fig. 18). These organic truncations, resembling elephant trunks, are released and drawn in by servo-control capstained tendons. Custom-made mandrels allow multiple nested sections to come out of each tube as it inflates and extends. The piece has a built-in feedback system that compensated for air leakage based on pressure sensors. A random chemo-acoustic breathing sound would accompany each move of the machine. Moving towards a lighter approach, improving upon the *Inflatable Architectural Bodies*, this project required us to develop new tooling and fabrication methods. We built large ovens, and pressure-clamped and laminated multiple pieces of fabric to form each truncated unit.

Inner Space (2010) was the third installation of the Inflatable Architectural Bodies (Fig. 19). Curated by Melentie Pandilovski, funded by CEC Artslink and shown at the National Gallery of Macedonia—an ancient hammam converted to a museum in Skopje, Macedonia—this work attempts to fully involve the audience

Fig. 16 Molecular Inflatable Structure study

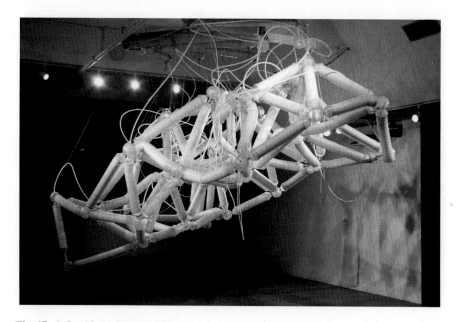

Fig. 17 *Inflatable Architectural Body*

Fig. 18 *Inflatable Architectural Growth*

Fig. 19 *Inner Space. Photo* David Familian, UC Regents

in the inner workings of the inflatable machine environment. As part of an exploration of living systems, machines, and architecture, *Inner Space* intended to shift the boundaries between internal and external spaces, and between artwork and audience. The kinetic sculpture evokes the magnification of a microscopic living system as it appears in the human bodies and gives the viewers the opportunity to witness their direct influence upon such forms. I used compression, much the way our ribs are held closed by our musculature. The entire assembly was done using just the fabric, without joints, relying on the flexibility of the flesh as structure, muscle, and bone all at once.

By building on the visual commonalities between what we build and what we are comprised of, the *Inflatable Architectures* make us aware of our actions and the symbioses in which we are embedded. The inflatable robotic structure of *Inner Space* is meant to be installed in a physically accessible location. When the work is at rest and deflated, it remains folded back on itself. As it inflates and extends (and it is capable of compressing in a taught state) in response to audience interaction, the articulated form takes various shapes, much like a living organism. The percussive sounds of the clicking valves, the air flow and crinkling sound of the extreme tightening of the skin of the tubes surrounding the audience, contribute to a sensory experience that draws the viewers in as spectators.

I expanded significantly upon these concepts to create *Chrysalis* (2013), a live interactive environment created for my solo show at the Museum of Contemporary Art in Tucson, Arizona and later fully realized installed at Pioneer Works Center for Art and Innovation in Brooklyn, New York. *Chrysalis* is composed of 100 interconnecting high tensile fabric tubes that form, when fully inflated, a 12-m-long, 8-m-wide and 5-m-high architectural space, evocative of crystal formations (Fig. 20). The tubes are networked into 16 live sections and animated by compressed air via a servo-controlled computer system. *Chrysalis* was designed and assembled with a more advanced version of the modular plug-and-play technology. This time, the tubes were glued to lightweight cast urethane cone and saddle couplings. They were joined by machined aluminum connectors equipped with retaining clips, allowing each of the joints to rotate without losing its connection. As the air is released out of the fabric, servo-controlled capstans enable *Chrysalis* to gently collapse into an organic shape.

Inspired by the architecture of the human body on a molecular level, *Chrysalis* provides a direct, visceral experience of the minute geometric constructions that underlie all life forms. Programmed by Bill Bowen, *Chrysalis* responds to a visitor's approach by opening one or a combination of several sections or by creating a portal that invites him or her inside. It also performs independently from the audience by drawing upon previously recorded software sequences. These sequences regulate the amount of air flowing in and out of the fabric tubes, creating a muscle-and-bone dynamic capable of expanding and retracting, lifting and lowering, and collapsing movements. In its transition from an organic to a geometric state, *Chrysalis* is best appreciated from inside of the sculpture. Here the audience faces their own biology on an inverted scale. *Chrysalis*, with

Fig. 20 *Chrysalis. Photo* Douglas Adesko

its ever-changing geometry, manifests the hidden organic life that inspires and informs certain human-built systems.

By redefining space, the sculpture begins to enter the domain of architecture. *Organic Arches* (2014), co-produced with SESC Santana, SP, Automatica and Molior and shown at the SESC in São Paolo, Brazil; and *Organic Arches II*, shown at the National Art Museum of China for the 2014 New Media Triennial curated by Zhang Ga, are site-specific installations consisting of a progression of inflatable arches in different sizes that undergo cycles of metamorphosis (Fig. 21).

Suspended from the ceiling so that they barely touch the floor, these hand-formed, levitating arches define an occupiable space with a fleeting architectural form. These soft machines signify a connection with the animate world of living matter and form. Their lightweight translucent skin catches the daylight, offering a view into their inner mechanisms. When inflated, the arches invite linear movement along their axis. This clear orientation gives way to an entirely different set of geometries as the air is allowed to escape the rigid fabric tubes. The crisp architectural forms yield gradually to a seemingly chaotic configuration that actually speaks of another, more organic order. The former arches coil inward to form spiraling strands reminiscent of DNA or complex molecules. These newly revealed, individual organic forms suggest a latent awakening or suspended chrysalis phase of life.

While not necessarily anthropomorphic, these various soft machines signify a connection with the animate world of living matter and form.

Fig. 21 *Organic Arches. Photo* Douglas Adesko

Future Soft Machines

The trajectory of the soft machines points toward increasingly close connections between the inflatable sculptural body, the human body, and the environment. The machines' dependence on a constant energy supply reflects our own constant appetite for food and other resources. I am still motivated by the possibilities of physical machine-human interaction, reflecting both old and new modes of bodily connection, even in an age of increasing virtual interaction.

I am currently building soft machines that can physically interact with humans and their own inflatable environment. These newest machines are able to store their energy internally and use sensing technology to autonomously seek out air-refill machines that have been set up in the exhibition space, like refueling or nourishment stations. These larger architectural machines allow the mobile machines to temporarily dock and refuel while sensing the movement around them.

One current project in development, expanding upon the *Inflatable Architectural Bodies*, is *Inflatable Architecture Intervention (IAI)*. It consists of a giant molecular sculpture or expanding exoskeleton capable of carrying a human performer (myself) while filling and conforming to the architectural space (Fig. 22). It blurs the boundaries between organic and inorganic life by performing a joining between my body and that of the robot. It represents the next step toward my vision of a mobile, humanoid soft machine that can interact on a physical level with humans. The human begins the performance of *IAI* positioned amidst a web

Fig. 22 Study for *Inflatable Architectural Intervention*

of deflated tubes. Compressed air would flow through valves integrated into my bodysuit, and into the tubes, activating them as extensions of my bodily movements. As the mass of tubes swells into a large sculptural form, accompanied by the percussive respiration of the air valves, a tensile structure of crystalline geometry would takes shape around me, slowly lifting me into the air. By progressively changing its form, it would take me through a series of bodily attitudes and positions—lying, standing, sitting, even turning upside-down.

IAI is conceived as part of an ensemble of soft machines that subsist on air, the *Inflatable Architectural Bodies* of the Air Society. It becomes the infrastructure or architectural extension or atmosphere of the bodies of the soft humanoid robots that ply the space, searching for their next infusion of air. The various inflatable machines nourish and replenish each other's air supply, with ensuing consequences for their physical form and movement.

In this scenario, a semi-autonomous tribe of humanoid robots wanders the space in search of sustenance. Their movements and behavior are driven by the need for survival, but also expressive of intention and the capacity for change. The Air Society is partly a metaphor for humans' precarious relationship with our environment, and partly an experiment in human-machine relations.

Another project in the works is the *Border Crossers*, designed to challenge spatial boundaries. I have created the first of a flock of six machines. These soft machines initially grow upwards as if to gain a view of their surroundings, then cantilever over the boundary. Current planning of the project is to deploy them in a series of performances along different borders around the world. For example, along the U.S.-Mexico border, three of the machines would be placed on the Mexico side, and the other three on the U.S. side. Activated simultaneously, the six towers would cross the border from two sides, forming a white, semi-translucent archway. *Border Crossers* in turn could explore all manner of borders, from the political to the architectural and social.

From a technical point of view, these new prototypes are pushing the fabrication and assembly process to the next step. The increasingly elaborate networks of tubes will be assembled and joined in the lightest possible configuration, while reflecting the best structural combinations for fastening them to each other.

How does the soft machine fit into the future of robotics? And how does the artist contribute to a wider conversation about how advances in robotics and artificial intelligence will change our world, and who guides those changes? These are questions that drive my practice every day, and ones that will not be quickly resolved.

What is clear to me is that soft machines can go where other harder machines cannot because of their light weight and ability to change size and shape. They are becoming increasingly capable of expression and gesture as we learn to work with their air-driven physiology. Most of all, soft machines promise closer and more physical interaction between humans and machines. This proximity and even intimacy suggests a possible underlying compatibility or reciprocity, in which both machine and human retain a kind of agency.

Chico MacMurtrie

Acknowledgments Contributing writers: Gideon Fink Shapiro, Luise Kaunert

Part VI
Interactions

I Want to Believe—Empathy and Catharsis in Robotic Art

Bill Vorn

Abstract Since the early 90s, we have been creating interactive installation and performance projects using robotics, audiovisuals, and processes inspired by Artificial Life. The goal of these projects is to induce empathy from the viewers towards characters that are nothing else than simple articulated metal structures. Our objective is to conceive and realize large-scale robotic environments that aim to question, reformulate and subvert the notions of behavior, projection and empathy that generally characterize interactions between humans and machines.

Robotics as Artistic Medium

Robotic Art is an emerging discipline where scientific research, artistic creation and philosophical investigation are intimately interrelated. Of the few artists actively involved in this field, each one of them has in some way or another developed new technologies, techniques and methodologies of production that enable the creation of innovative works of art integrating robots, machines and automatons. Moreover, these works are raising fundamental philosophical and sociological questions about the relationships between human beings and machines, between the real and the artificial, and between the living and the non-living.

From Karel Capek to Nam June Paik to Survival Research Labs, artists have been exploring the concepts of robots and robotics for a few decades now, sometimes on their own, but often in collaboration with engineers and scientists. In 1997, Eduardo Kac coined the term "Robotic Art" to describe artistic projects based on or developed around robotic technologies. In *Foundation and Development of Robotic Art* [1], he stated "As artists continue to push the very

B. Vorn (✉)
Concordia University, 1455 de Maisonneuve West, Room EV-6-783,
Montreal, QC, Canada
e-mail: bill.vorn@concordia.ca

© Springer Science+Business Media Singapore 2016
D. Herath et al. (eds.), *Robots and Art*, Cognitive Science and Technology,
DOI 10.1007/978-981-10-0321-9_18

limits of art, traditionally defined by discrete and inert handmade objects, they introduce robotics as a new medium at the same time as they challenge our understanding of robots". In the last 20 years, artists like Mark Pauline, Christian Ristow, Eric Paulos, Chico MacMurtrie, Ken Rinaldo, Simon Penny, Stelarc, Guy Ben-Ary, Robotlab and Jim Whiting, just to name a few, distinguished themselves by their impressive artistic application of robotics. Well-known Canadian artists like Max Dean, Norman White, Reva Stone, Istvan Kantor, Louis-Philippe Demers, Rafael Lozano-Hemmer, Janet Cardiff and David Rokeby also used robotics and behavioral systems in many of their works.

Since its early stages, our artistic work has been strongly influenced by scientific advances in the fields of Artificial Life and Robotics. We are particularly interested in creating original artistic projects by appropriating various engineering and scientific concepts and techniques such as cellular automatons, genetic algorithms, adaptive behaviors and reinforcement learning processes in order to subvert them from their intended purpose.

Robotic Art is not a single homogeneous discipline; rather it is a mixture of multiple technological areas involving mechanics, electronics, programming, as well as multimedia. In the same manner, our research program does not focus on one single problem or one field of study, it encompasses a wide variety of research projects that all have one thing in common: producing a work of art as a final outcome. This is why we simultaneously conduct research and develop projects that address machine perception and motion on the one hand, and machine aesthetics in both robots' visual aspect and behaviors on the other.

An Aesthetics of Artificial Behaviors

Our aim is to artistically investigate how a machine can eventually turn into a sentient creature. We believe that behavior is a keyword in bio-inspired automaton design and actualization. A certain level of realism may be achieved by the illusions induced by actions and reactions of the machines and animats: the success of this dynamic form of computer-mediated communication may be measured by the effectiveness of the simulacrum. An effective simulation of the living is the result of different parameters acting to trigger impressions and empathy (visual appearance, sound emission or physical movement, for example), but behavior may be seen as the most convincing one as it generates a strong impression of autonomy and self-consciousness.

As we have been able to experience throughout the years, uncertainty and variability also play an important role in the behavioral relation with the viewer. Animated metal parts in a robot or dots on a computer screen can be seen as being alive if they move and react in a non-repetitive and unforeseeable way, giving a strong impression of self-decision and autonomy. One may wonder if Artificial Life creatures have to be figurative representations (anthropomorphic, zoomorphic or bio-inspired) to be convincing. From what has been observed in the various

encounters with the public, as long as they manifest autonomous behaviors in the interaction process, effective agents could bear any abstract visual form.

The success of our work depends on two main interrelated factors: the make-believe imbedded in the robot artifact and the viewer's desire to believe (evoking Eco's *intentio auctoris* and *intentio lectoris* [2]). It functions through cathartic projection by triggering sensations, feelings and emotions in the viewer's eyes. What happens next is a matter of pure subjective interpretation from the viewer's part. Machines are a perfect reflection of our mind and we can certainly learn more about ourselves by interacting with them.

Robot Ontology and Perception

Recent advancements in Artificial Life and robotic technology encourage a new kind of art form that combines artificial morphogenesis, immersive environments, interactivity and reactivity with cognitive machines (robotics, automation and animatronics) to achieve aesthetic results. We often use the expression "theatrical machines" to describe physical and autonomous robotic agents integrating some kind of multimedia objects in their ontology (sound, light, video, etc.) as mean of expression. Application examples of this new practice include emulation of realistic creatures and lifelike systems, conceptual exploration in the aesthetics of artificial perceptions, behaviors and interactions, embodiment of machine mechanisms, etc.

Our research projects are principally based on the notion of perception: the viewer's perception of the robot and the robot's perception of the environment, as well as itself. Perception guides the effect created on the viewer, as our work is steered by the fundamental assertion that it is possible to create an impression of life simply through human-machine reactive behaviors of abstract robotic structures.

We can integrate both notions of sentience and embodiment in the larger concept of ontology. An ontology describes how the world in which the agent lives is constructed, how the agent perceives this world and how the agent may act upon its world. Our work is based on the merging of aesthetic, philosophic and scientific questions related to machine ontology, its awareness, perception and potential sentience. Our research projects also investigate the notion of the artificial construction of the "self" as one of the leading themes of our creative work.

Early Artistic Work

We started to develop Robotic Art projects in 1992, with the initial intent to animate sound and light in space in response to the viewers' presence. *Espace Vectoriel*, a collaboration with Louis-Philippe Demers, was an interactive mechatronic piece where eight robotic tubes project sound and light beams in a

dual choreographed and behavioral manner (see Fig. 1). Each tube contained a speaker and a light source and was mounted on a pan-tilt mechanism. Viewers were detected using an array of ultrasound devices. This installation was then presented in many international events dedicated to New Media and Electronic Arts and eventually followed by other projects of the same kind. For example, *The Frenchman Lake* (1995) also used the same concept of replicating a basic robotic audiovisual unit multiple times, in order to create a more complex overall environment.

Among these earlier works, *La Cour des Miracles* (1997) has certainly been a milestone in our trajectory. With this project, we moved away from simple duplication and produced multiple different types (or "species") of robotic creatures, each one exhibiting specific behaviors in response to the visitors. Based on the conceptual framework of a "misery of the machines" and somehow strongly inspired by Victor Hugo's *Les Misérables* [3], these machines were designed to express such notions as "pain" and "affliction", as if they had their own difficulties in life. For example, the *Crawling Machine* was creeping laboriously on the floor. Slow and vulnerable, it tried to run desperately away from the viewers approaching. The *Harassing Machine* called upon the viewers passing by while moving its articulated arms towards them. At the extremity of these limbs, small tentacles agitated by compressed air tried to tease the intruders with importunate touches. The *Convulsive Machine* was a thin metal structure shaking with frequent but irregular spasms, especially when viewers come too close. The *Heretic Machine* was locked

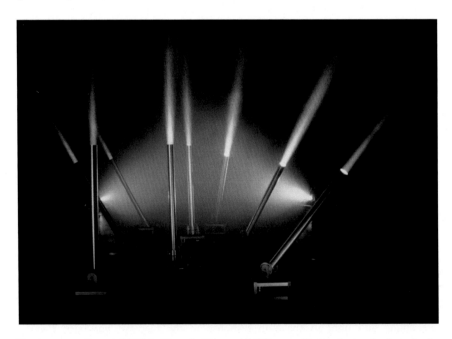

Fig. 1 *Espace Vectoriel* (1993) *Photo* B. Vorn and LP Demers. Each robotic tube is projecting sound and light

up in a cage, and when curious viewers came close by, it rushed violently towards them, grabbing the metal grid with its claws and shaking furiously its cage [4].

Le Procès (1999) was a live multimedia performance staging a world populated exclusively by robotic actors (see Fig. 2). It was presented for the first time as part of *Zulu Time*, a theatre play by Robert Lepage. Because it was our first robotic performance, this project was a logical following to our perceptually subversive démarche of creating machinic automata and cybernetic organisms showing metaphoric behaviors, as well as inventing surrealistic immersive environments where viewers are both visitors and intruders. Le Procès showed in a symbolic way the trial of machines by men, as well as the trial of men by machines. It acted like a reflexive tribunal where identities intermixed, where judges, jurors, victims and accused, took flesh in metal creatures born from our own conception of the world, of what is good and what is bad, of what is alive and what is not. As in Kafka's famous novel [5], of which crime are we accused? Who's judging? What will be the verdict?

During the same period, we developed a series of Max software functions [6] called *LifeTools* and explored cellular logic by building monumental audiovisual cellular automatons. In projects like the *Evil/Live* (1997, 2002, 2004) series, Conway's *Game of Life* [7] was used to generate patterns of light and sound in a large-scale aluminum matrix of halogen light bulbs. In the different versions, viewers were either consciously (by using video game-style controllers) or involuntarily (by using discrete sensors hidden in the environment) modifying the evolution of the light patterns on the grid. This series of audiovisual installations aimed to create a paradoxical context confronting the single-plane world

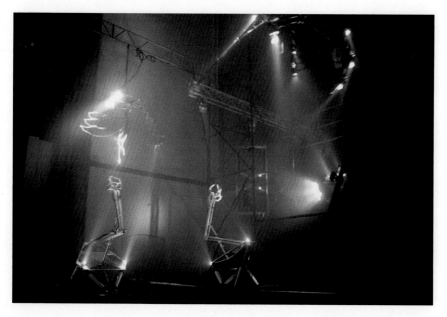

Fig. 2 *Le Procès* (1999) *Photo* B. Vorn and LP Demers. Le Procès at EMAF 2002 (Osnabrück)

of a cellular automaton to the 3-dimensional immersive environment surrounding the viewer. By using fast stroboscopic changes in light and quadraphonic sound effects, it produced a clear illusion of physical volume.

In a similar way, in the *Stèle 01* (2002) installation, a cellular automaton was used to control an array of 128 small pivoting mirrors on top of which an anthropomorphic robot was standing, vaguely mimicking a statue towering above a mortuary stele (see Fig. 3). Inspired by monuments and tombstones from the Père Lachaise cemetery in Paris, this piece was designed to evoke the intimate dichotomy between the real and the virtual, life and death, movement and inertia.

Recent Work

The *Hysterical Machines* robotic installation (2006) was very much inspired by similar ideas as *La Cour des Miracles*. It was conceived on a principle of deconstruction, suggesting dysfunctional, absurd and deviant behaviors through a functional machine. It operated on a dual-level process expressing the paradoxical nature of Artificial Life. The first prototype of the Hysterical Machine (it was then renamed *Prehysterical Machine*) appeared in 2002, but later on we built ten more machines inspired by this prototype that became part of a larger environment. More recently, we have also created the *Mega Hysterical Machine* (2010), a super-sized version of the original robot (eight times the size of the Hysterical Machine

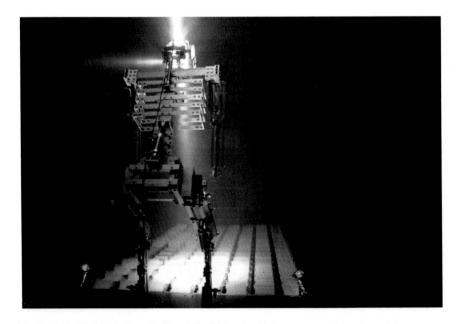

Fig. 3 *Stèle 01* (2002) *Photo* B. Vorn. The Stèle robot facing an array of rotating mirrors

in volume and weight). Until now, this huge robot has only been exhibited on wide theater stages in places such as the Théâtre National de Toulouse, the Théâtre des Salins (Martigues) and the Théâtre de l'Avant-Seine (Colombes).

Each Hysterical Machine has a spherical body and eight arms made of aluminum tubing (see Fig. 4). It has a sensing system, a motor system and a control system that functions as an autonomous nervous system (entirely reactive). These machines are suspended from the ceiling and their arms are actuated by pneumatic valves and cylinders. Ultrasound sensors allow the robots to detect the presence of viewers in the nearby environment. They react to the viewers according to the amount of stimuli they receive (how close are the viewers, how many viewers walk by). Programmed with sets of very simple internal rules, the perceived emergent behaviors of these machines engender a multiplicity of interpretations based on single dynamic pattern of events.

Built in continuity with our investigations in the aesthetics of artificial behaviors, *Red Light* (2005) was another interactive robotic environment conceptually similar to Hysterical Machines and La Cour des Miracles. In this case, the project evoked a certain "deviance of the machines" as it would exist in the hottest areas of a fictive world populated exclusively by these specific cybernetic creatures. This installation also explored techniques and technologies related to parallel mechanics and pneumatics with the construction of homemade pneumatic muscles. A parallel mechanism is a mechanical system that is connected to its base by two or more independent kinematic chains (assemblage of links and joints). A pneumatic muscle (also called McKibben actuator) is a flexible air piston made of inflatable material such as silicone or latex that contracts when activated. In *Red Light*, six suspended machines

Fig. 4 *Hysterical Machines* (2006) *Photo* B. Vorn. One of the hysterical robots equipped with small lasers

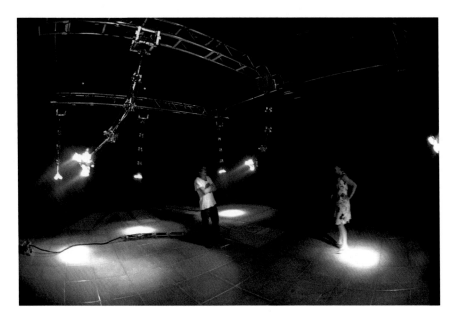

Fig. 5 *Red Light* (2005) *Photo* B. Vorn. *Red Light* being tested in the Hexagram black box

reacted to the presence of viewers by generating sound and light and by moving their body in a very organic and unusual way (see Fig. 5). Each robot unit was an assembly of four freely moving segments joined together by twelve McKibben actuators. Each one possessed a small network of pyroelectric sensors that allowed detection of moving visitors and triggered the various effectors part of the robot.

At that time, we had been working with different types of parallel mechanisms (for example, the two center-stage robots mounted on Stewart platforms in *Le Procès*) and pneumatic muscles (like the suspended robot tentacles in *Red Light*) and it appeared that they were able to provide unusual types of physical motion that could produce a more organic feel to our machines. Since then, we have explored various designs and build several experimental prototypes of machines that make use of these technologies to create lifelike artificial creatures.

In 2007, pursuing our experiments with parallel mechanical systems, but with a totally different approach, we started to work on the *Grace State Machines* project. The name of this project was inspired by a virtual "state of grace" that could be expressed by automatons and other finite state machines. This piece was a stage performance involving solely a human performer and a group of machines (see Fig. 6). Both were linked via a custom-made wireless motion capture system (based on fiber optics) and a set of specialized interfaces. By monitoring the human body movements and internal states and transposing this information to the robots' body, we aimed to establish a dynamic and symbiotic relationship between the actors. They all eventually blended into a single organism, where flesh, bones, wires and tubes became a whole individual body.

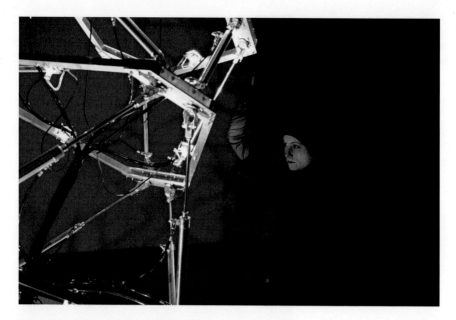

Fig. 6 *Grace State Machines* (2007) *Photo* B. Vorn. Emma Howes interacting with one of the GSM robots

In this performance project, four robotic machines were built as abstract shapes and composed of stacked Stewart platforms (actuated sections similar to flight simulator platforms) and capable of producing very complex movements. These machines sometimes reacted to the performer's body movements, sometimes moving on their own, inducing a response from the performer. With this project, we wanted to question the notions of physical perception, body expression and personal identity, and address kinesthesis not only as an internal proprioceptive mechanism but also as a potential exterior phenomenon actualized through the robotic extension of the body.

Also very different from our previous works, *Partie de chasse* (2010) was an interactive installation project that aimed to turn an industrial robot arm into a reactive organism. For this project, we used a Fanuc M16iB industrial robot. An aluminum moose head was installed at the tip of the robot arm and moved towards the viewers nearby (see Fig. 7). In order to detect the presence and location of the viewers in the surrounding space, we used the *ManyEars* microphone array system [8] and an elaborate set of sensors. (For obvious security reasons, viewers were kept at some distance from the robot.) When a viewer talked, the microphone array detected the position of the sound source in the room and the robot moose head moved in its direction. The robot moose was also able to react to certain vocal commands, but it was up to the visitors to find out what these were.

The particularity of this project resided in bypassing the normal programming paradigm of this type of robot in order to have it execute real-time commands instead of a predefined sequence of actions. Many artists have used industrial

Fig. 7 *Partie de chasse*
(2010) *Photo* B. Vorn. The
aluminum moose head on the
Fanuc robotic manipulator

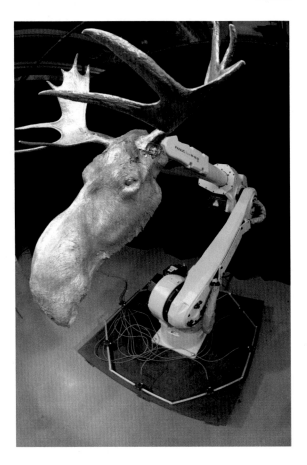

robots in the past but they have always used them as simple automatons, in a similar way they are normally used in car factories. Few have ever tried to turn them into autonomous reactive creatures. With this project, we wanted to build a sensitive and responsive machine, which was conceptually based on adaptive and evolutive behaviors.

In our latest piece, *DSM-VI* (2012), the installation staged creatures expressing symptoms of "abnormal" psychological behaviors and stuck with some serious "mental health" problems, such as neurosis, psychosis, personality disorders, paranoia, schizophrenia, depression, delirium, and other forms of behavior and mental disorders. The project title was inspired by the famous reference manual published by the American Psychiatric Association, the DSM-IV [9].

The robotic creatures are the sole characters and actors of this singular interactive allegory. They were built in order to evoke dysfunctional behaviors that make believe in the disease that they internally bear. These machines are abstract structures made of aluminum, plastic and silicone, with no deliberate intent of visually representing anything (see Fig. 8). Above all, they are just machines and it is mainly their behaviors that give them an organic and living aspect.

Fig. 8 *DSM-VI* (2012) *Photo* B. Vorn. Early prototypes of DSM-VI robots

In the center of the DSM-VI installation, eight *Psychotic Machines* stand on their legs, lie down on their side or on their back (see Fig. 9). These machines have a pneumatics-actuated pair of aluminum legs, speakers, lights, sensors, and DMX pan-tilt LED spotlights. They react to the approaching viewers, but they also react to each other. They look like they are going to jump or run away, but they are helplessly fixed there, sometimes very calm, sometimes completely agitated, like a herd of untamed but chained animals.

In the surrounding space of the installation, three independent robots revolve on their base. They seem like they live in their own world, not so much connected to the environment. We call them the *Autistic Machines*. They are free-spinning turrets, on which a pneumatic robotic arm actuates something that looks vaguely like a human face. This facial impression is caused by the visual combination of a speaker and two pan-tilt robotic cameras. Using these cameras, the robots can look around in the environment using a face-tracking software. But instead of following the viewers like we would expect, they tend to avoid them. Also, due to the face-tracking software limitations, the robots sometimes see faces in the environment where there are not and suddenly fall in trance looking at the wall or the ceiling.

Fig. 9 *DSM-VI* (2012) *Photo* B. Vorn. Opening of the BIAN 2012 exhibition in Montreal

Current and Future Work

In collaboration with Louis-Philippe Demers (Nanyang Technological University, Singapore), we are currently developing the *Inferno* project. Inferno is a robotic performance inspired by the representation of the different levels of hell as they are described in Dante's Inferno [10] or Haw Par Villa's Ten Courts of Hell (which is based on a Chinese Buddhist representation) [11]. In this piece, the "circles of hell" concept is mainly a scenographic framework, a general working theme under which the different parts of the performance are regrouped.

The specificity of this performance project resides in the fact that the different machines involved in the show are installed on the viewers' own body. The public then becomes an active part of the performance. Depending of the kind of mechanism that they are wearing, the viewers are free to move or in a partial or entire submission position, forced by the machines to act/react in certain ways. Like if they were inverted exoskeletons, some mechanical structures coerce the viewers in performing certain movements; others induce a physical reaction from them. With this work, our aim is to question the "cyborgification" of the modern man, as well as how technology imposes its rules upon us.

At the same time as Inferno is being completed, we are also developing the *Copacabana Machine Sex* performance project. It can be described as a mini Music Hall show where kitsch and machine aesthetics blend together in a single theatrical delirium. More conventional in its form, it involves a succession of different musical numbers where machines perform on stage as actors, musicians and

dancers. The performance will be created in a way that it can either be configured for a traditional *à l'italienne* stage or with viewers standing all around a central ground-level presentation.

Loosely inspired by Chico MacMurtrie's *Robotic Opera* (1992), where a small group of humanoid robots performed various percussive musical pieces [12], the Copacabana project wants to present music-making machines as well as acting and dancing robots. Our goal is not to replicate a real nightclub, but to conceive a metaphorical extravaganza in response to the very deep question: "What would happen if machines would be on the stage of a cabaret?"

Acknowledgments Special thanks to Concordia University (Montréal, Canada) for its support; the Canada Council for the Arts; the Conseil des arts et des lettres du Québec; the Fonds de Recherche du Québec Société et Culture (FRQSC); Martin Peach, who has been a dedicated technician for many years; as well as the numerous graduate and undergraduate students who have been working as research assistants on many of these projects.

References

1. Kac E (1997) Foundation and development of robotic art. Art J 56(3):60–67
2. Eco U (1991) The limits of interpretation. Indiana U Press, Bloomington
3. Hugo V (1862) Les Misérables. A Lacroix, Verboeckhoven & Cie, Paris
4. Ismert L (1998) La Cour des Miracles. Musée d'art contemporain de Montréal
5. Kafka F (1925) Der process. Verlag die Schmiede, Berlin
6. Max (or MaxMSP) is a graphic object-oriented programming environment dedicated to multimedia control. http://www.cycling74.com/products/max. Accessed 3 Aug 2014
7. Adamatzky A (ed) (2010) Game of life cellular automata. Springer, New York
8. ManyEars is a sound localization software developed by IntRoLab at University of Sherbrooke. It implements real-time microphone array processing to perform sound source localization, tracking and separation. It was designed for mobile robot audition in dynamic environments
9. The DSM (2013) (Diagnostic and Statistical Manual of Mental Disorders) is now in its 5th edition
10. Alighieri D (circa 1308–1321) Divina Commedia. English edition: Alighieri D (2013) The divine comedy. Arcturus Publishing Limited, London
11. Turbeville T, Brandel J (1998) Tiger balm gardens: a Chinese Billionaire's fantasy environments. Aw Boon Haw Foundation, Hong Kong
12. MacMurtrie C (2014) http://www.amorphicrobotworks.org/works/early/. Accessed 3 Aug 2014

Designing Robots Creatively

Mari Velonaki and David Rye

Abstract Designing robots creatively involves not only the conceptualisation and realisation of robots that can interact with humans, but demands a focus on the experience of people as they encounter and interact with the robot. This focus on interactant experience requires an understanding of the context of the interaction and the culture within which it will take place, underscoring the importance of the social sciences and creative arts to social robotics; disciplines that have a long history of studying people and their relationships to the spaces that they inhabit. Four case studies of collaborative art-robotics projects are presented to illustrate the process of designing robots creatively, with strong emphasis on creating an engaging experience for people as they interact with the robot.

Over the last decade there has been a dramatic increase in human-robot interaction (HRI) research [4]. The progress that has been made in technological aspects of robotics has served only to emphasise the gap in knowledge of human perception and behaviour as people begin to encounter and interact with robots. It is inevitable that the next generation of robots will need to interact with humans to a much greater extent than ever before [5]. According to the International Federation of Robotics, approximately three million robots were sold for personal and domestic use in 2012 [8]. Sales exceeding 22 million units are projected by 2016, an increase of 630 % over 4 years. Japan has responded to its coming demographic challenge by directing substantial research funding towards robotic assistance for the aging. It is now widely accepted that robots will play an important role in domestic environments, hospitals and aged care facilities of the future. Even the field of industrial robotics will require collaborative operations between humans and robots [5]. For social robotics to make a positive contribution, however, we need to better understand how people respond to robots, and what factors influence their responses.

M. Velonaki (✉) · D. Rye
NSW Art & Design, The University of New South Wales, PO Box 259,
Paddington, NSW 2021, Australia
e-mail: mari.velonaki@unsw.edu.au

© Springer Science+Business Media Singapore 2016 379
D. Herath et al. (eds.), *Robots and Art*, Cognitive Science and Technology,
DOI 10.1007/978-981-10-0321-9_19

Twenty-first century research in interactive technology is driven by the need to understand the way technological systems are—and will be—embedded in the everyday physical and social world. The coming generation of interactive systems will be pervasive, certainly including intelligent machines and robots in our homes and workplaces. Interactivity has arrived at a new cultural frontier, where innovation depends on our capacity to understand the complex and often unpredictable interrelations between human users, technologies and social settings.

The greatest challenge in human-robot interaction research is to understand the human component, since people are far more complex and variable than any technological system, being influenced by cultural and social factors in addition to variations in personal preferences. It is essential that this existing knowledge gap is addressed through principled multidisciplinary research. Human-robot interaction research must therefore be approached from a variety of disciplinary perspectives—including Interactive Media Arts, Engineering, Artificial Intelligence and Cognitive Psychology—that are united in aiming to better understand how people perceive and respond to robots so that the conceptual, perceptual, computational and behavioural design of future robots that interact with untrained members of the general public can be improved, and so that interaction with these future robots can be more effective, intuitive and rewarding to the interactant.

Within this multidisciplinary continuum, media artists create unique environments that act as triggers for new behaviours to manifest; behaviours that subsequently lead to new knowledge of how people can interact with machines in cultural environments. Embodiment and agency are concepts that have been extensively researched by creative practitioners in a variety of interactive works that link the digital with the physical, the kinetic and the responsive.

The title of this chapter "designing robots creatively" signifies to us the process of conceptualising and realising a robotic system that is able to create a unique and engaging experience for the interactant. In this chapter, the conception and design of an interactive robot will therefore include the design of the robot's appearance and behaviour, and the overall interaction design that includes the environment and situational awareness. In designing these aspects it is important to understand and account for the context of the interaction and the culture within which it will take place. In order to create an experience in human-robot interaction, the realisation of the conceptual, behavioural, aesthetic and interactive elements of the design must be technologically executed in an equally innovative, efficient and effective manner that facilitates an experimental interaction between a person and a technological 'other'.

[Mari] I have worked as an artist and researcher in the field of interactive installations and responsive environments since 1996. The year 2003 found me with a Ph.D. in experimental interface design and the need to expand and shift my research and practice towards autonomous kinetic objects—robots. My first postdoctoral position was at the Australian Centre for Field Robotics (ACFR) at the University of Sydney where I endeavoured to materialise the Fish-Bird project, a concept that had haunted my thoughts for quite some time.

[Mari] At ACFR I formed a team with David Rye, Steve Scheding and Stefan Williams, bringing expertise in systems and software design, machine vision and robotics. What brought us together was our shared goal to better understand the complex space of human-robot interaction, and what elements could assist in triggering an engaging exchange between a human and a robot. That was the beginning of my collaboration with David Rye, a close collaboration that continues until today and has produced several robotic works, alongside with academic papers, Ph.D. graduates, interviews, travels, arguments, celebrations and unparalleled joy.

[David] I was introduced to Mari by the then Director of ACFR, Hugh Durrant-Whyte, after Mari came to discuss Fish-Bird with Hugh. I was immediately struck by Mari's innovative ideas and the strong and coherent conceptual foundation for the project that she was proposing. I thought that it would be quite interesting to build robots that interacted with people. Furthermore, as an engineer I thought that I knew a lot about art. I had no idea how much I was to learn over the years…

In the following sections we discuss four of our collaborative projects as examples that demonstrate some aspects of designing robots creatively: *Fish-Bird: Circle B—Movement C* (2004–2006), *Circle D: Fragile Balances* (2008), *Circle E: Fragile Balances* (2009) and *Diamandini* (2009–2013).

Project 1: Fish-Bird: Circle B—Movement C (2004–2006)

We have written about Fish-Bird since 2004, continually refining our views of the work. The description most satisfying to us can be found in the excerpts below [17].

Fish-Bird is an interactive autokinetic artwork that investigates the dialogical possibilities between two robots, in the form of wheelchairs, that can communicate with each other and with their audience through the modalities of movement and written text. The chairs write intimate letters on slips of paper that they then drop to the floor, impersonating two characters (Fish and Bird) who fall in love but cannot be together due to 'technical difficulties' (Fig. 1).

Spectators entering the installation space disturb the intimacy of the two objects, yet create the strong potential for other dialogues to exist. The spectator can see the traces of their previous written exchanges on the floor, and may become aware of the disturbance that they have caused. Dialogue occurs kinetically through the wheelchair's perception of the body language of the audience, and on the audiences reaction to the unexpected disturbance would be to converse about trivial subjects, like the weather… Through emerging dialogue, the wheelchairs may become more "comfortable" with their observers, and start to reveal intimacies on the floor again.

Each wheelchair writes in a distinctive cursive font that reflects its 'personality'. The written messages are subdivided into two categories: personal messages communicated between the two robots, and messages written by a robot to a human participant. The messages are an amalgamation of words, verses and

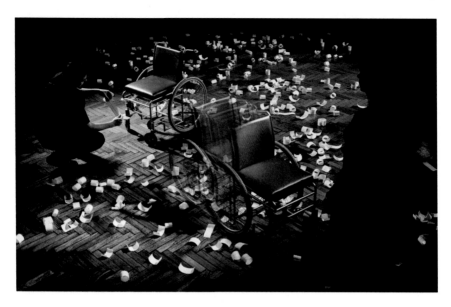

Fig. 1 Mari Velonaki, *Fish-Bird: Circle B—Movement C* (2004–2006). Interactive installation with two autonomous robots and distributed data fusion system. *Image* Paul Gosney

sentences selected from a large database containing excerpts of the poetry of Anna Akhmatova [1], fragments of love-letters donated to the project by people over the period of 3 years, and text composed by me.

At the time, by choosing the wheelchair as the form for the robots, I aimed to introduce a new aesthetic proposition in robotics: one that was far removed from humanoid, android or pet-like robots. A wheelchair is the ultimate kinetic object, since it self-subverts its role as a static object by having wheels. At the same time, a wheelchair is an object that suggests interaction—movement of the wheelchair needs either the effort of the person who sits in it, or of the one who assists by pushing it. A wheelchair inevitably suggests the presence or the absence of a person. Furthermore, the wheelchair was chosen because of its relationship to the human—it is designed to almost perfectly frame and support the human body, to assist its user to achieve physical tasks that they may otherwise be unable to perform. In a similar manner, the Fish-Bird project utilises the wheelchairs as vehicles for communication between the two characters (Fish and Bird) and their visitors. One of my aims was to test the hypothesis that robot behaviour can be more important that appearance in determining levels of engagement in human-robot interaction.

"The dialogical approach taken in this project both requires and fosters notions of trust and shared intimacy. It is intended that the technology used in the project will be largely transparent to the audience. Going further than a willing suspension of disbelief, a lack of audience perception of the underlying technological apparatus will focus attention on the poetics and aesthetics of the artwork, and will

promote a deeper psychological and/or experimental involvement of the partici-pant/viewer. Robots in the context of popular culture have historically been asso-ciated with anthropomorphic representations. Although they represent characters, the robots in Fish-Bird are not anthropomorphic, nor are they pet-like or 'cute'. The audience internalises the characters through observation of the words and movements that flow between the characters, and between the characters and the audience, in response to audience behaviour. Through movement and text the art-work creates the sense of a person, and allows an audience to experience that per-son through the perception of what is not present."

[Mari] When designing the behaviour of Fish-Bird, I included the possibil-ity that if the 'emotional state' of the robots is positive and the participant spends more than 20 min interacting with a robot in close proximity, a 'bond of trust' is formed and the robots give instructions to the participant on how to set them free. In 2004, during Ars Electronica in Linz one visitor attempted to liberate Fish fol-lowing Fish's plea to take it to the nearby river and set it free. Security personnel had to intervene.

[Mari] Something that I would like to reveal is that in my original concept of Fish-Bird, the wheelchairs were to have extended writing arms instead of print-ers (Fig. 2). I imagined the Fish and Bird characters, assisted by the arms, writing messages on the floor. I initially incorporated the printers for the first exhibition at Ars Electronica and was extremely pleased to see people taking their printed messages with them when leaving the gallery; in a way the little paper slips became mementos of their interaction with the Fish and Bird characters. I also liked how Fish and Bird continuously 'littered' the space with messages as they

Fig. 2 CAD drawing of a Fish-Bird robot showing the writing arm

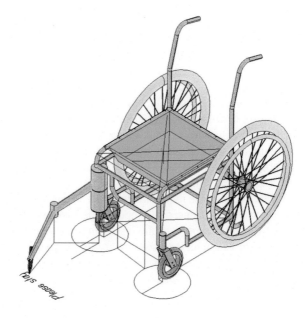

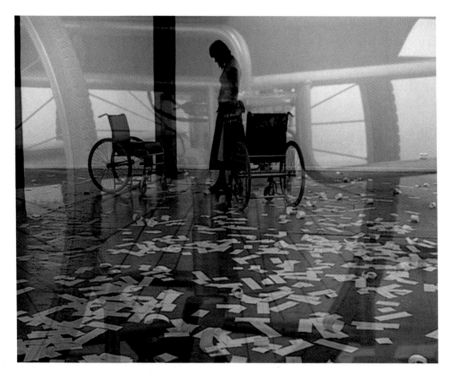

Fig. 3 Mari Velonaki, *Fish-Bird: Circle B—Movement C* (2004–2006) Interactive installation with two autonomous robots and distributed data fusion system (composite image of installation at Artspace, 2005)

communicated with each other (Fig. 3). Timing was another factor that influenced my decision to use the mini thermal printers—the immediacy of the printing contributed to the flow of the interaction between the visitors and Fish-Bird.

The realisation of a robot will always require the design of elements for power supply, supporting structures, sensing of the operating environment and the people in it, means of actuation, software architecture and algorithms, all verified by supporting calculations. Any collaborative project necessarily involves input from all collaborating parties, and any complex system design will inevitably involve accommodation between conflicting requirements, requiring dialogue between the collaborators. One important aspect of the Fish-Bird project was to determine the key requirements that would allow the project to move from a concept to its practical realisation. These requirements relate to the quality, performance and reliability of the system, to the need to support experimental modification of robot behaviour, and also involve aspects of the installation and operation of the robot in a museum setting. For example, it was necessary to design a separate user interface to allow gallery attendants to easily start up, shut down and recharge the robot daily.

[David] Although the design of robotic hardware tends to be decided relatively early in a project, we make the hardware modular whenever possible to facilitate future changes, should they be needed. We also go to considerable lengths to make the software very general, and to ensure that all significant aspects of a system's operation can be configured without rebuilding the software. Typically, all software configuration is done through simple text files that are read on start up.

Many aspects of the Fish-Bird system design were strongly influenced by the desire to create a fluent kinetic artwork, whilst concealing the underlying technological apparatus. It should not be obvious to a spectator/participant how a wheelchair moves, promoting rapid engagement with the work and focussing attention on the form of interactive movement. As a consequence of this conceptual and ideological consideration, standard electrical wheelchairs could not form the basis of the autokinetic objects in the artwork. Consequently, two custom wheelchairs were designed and constructed for the project. Apart from the rear rims and tyres, and the front wheels, each wheelchair is custom built. The tubing that forms the chassis was carefully shaped to give the impression of a hospital wheelchair. Dimensions of the structural elements were freely adapted to suit the requirements of other components, whilst maintaining a strong visual impression of a stereotypical wheelchair.

The frame of the wheelchair is skeletal, so that all power storage, electronics and computing for both the wheelchair and the 'handwriting' thermal printer must be concealed within the seat of the wheelchair. Since a wheelchair seat has typical plan dimensions of 400 mm^2, and is at most 150 mm thick, care must be taken with component size.

The electrical power required to move the wheelchairs and to operate the embedded computers needed to be stored in rechargeable batteries within the wheelchairs. These batteries must allow for at least 10 h of continuous operation, and must recharge overnight. Such a requirement indicates that the design should utilise the highest volume-density battery technology available, together with efficient components that have low power consumption. The largest unknown factor in the power system design was the 'duty cycle' of motor operation—the percentage of time that the motors were operating—as this depended almost entirely on interactant behaviour. Unfortunately, lithium-ion batteries could not be used because of a need to transport the robots by air freight, and sizable batteries would exceed the maximum energy storage capacity that is permitted on board aircraft by regulations. The next-best battery technology—nickel metal hydride—was therefore selected. The increased battery volume led to a bulkier seat than desired, with the batteries occupying two thirds of the under-seat volume. To disguise the bulk of the seat, the under-seat battery tray was cut away along participant sight lines and the visible sides of the tray were covered with the upholstery fabric. Cables for motor current and encoder phase signals between the motor controllers and the motors were routed inside the frame tubes. The motors and reduction gearboxes were concealed by a snap-on trim tube that runs the full width of the wheelchair rear frame.

The steel tubing, fabricated parts and aluminium components were satin chromed to unify them visually. Seat cushions were upholstered in a synthetic fabric, in red for Bird and blue for Fish, that has a discrete geometric self-pattern and a pronounced metallic sheen. These finishes were chosen to distinguish the chairs as designed objects that exist in a space outside of the hospital or nursing-home environment where one might expect to encounter them.

It is clear that power and size considerations dominate the design of on-board electronics and computing. The combined requirements of concealment, extended operating duration and moderate performance discourage physically large and/or high-powered sensing and computing hardware. These considerations led to the use of two custom-designed microcontroller-based motion control boards rather than an embedded PC as the on-board control element, and the selection of Bluetooth rather than wireless Ethernet for radio communications to the wheelchair robots. Each motion control board has a dedicated Bluetooth transceiver, allowing computationally-intensive tasks such as wheelchair and 'handwriting' trajectory generation to be placed off-board the wheelchairs in the installation control computer.

Forward- and rearward-facing analogue infrared sensors were mounted underneath the wheelchair seats, and measure the distance to nearby obstacles. These allow some imminent collisions to be detected using only on-board sensors. Additional on-board sensing is limited to wheel encoders, plus battery voltage and load current monitoring. To promote the illusion that the wheelchairs are not under direct control, most of the environment sensing for the system was mounted off-board. This choice also minimises the requirement for power storage on the wheelchairs, and allows a much wider variety of sensors to be used for tracking the robots and human participants.

In the current implementation, two scanning laser sensors are concealed on the perimeter of the space and provide range and bearing observations to the wheelchairs and participants as they move within the space. Cameras mounted on the ceiling are used to provide observations of the wheelchairs and participants moving within their fields of view using a background difference method. Laser and camera observations are sent to the installation controller where a series of Kalman filters are used to estimate the current state of the system. Communication between the various modules in the system is based on the active sensor networks architecture reported in Makarenko et al. [10].

Many robotic systems are commanded and controlled using a combination of scripting and reasoning systems. The behaviour of each robot in the Fish-Bird system is controlled through a finite state machine containing a number of discrete states. Each state corresponds to a behavioural primitive, or action, such as 'sleep', 'talk', 'gaze', 'follow' etc. Transitions between the various states are handled by a behavioural engine, and both the conditions that cause state transitions and the transition target states are specified by a scripting language that was written for the project.

[Mari] It was important for me to be able to directly script the behaviours of the robots. A scripting language resembling a primitive form of the C language was devised to give me the compositional freedom that was essential in developing the behaviours of the two robots.

One of the goals of the Fish-Bird project was to provide an engaging interface between the robots and the participants through movement and text. The way that each wheelchair robot moves serves to communicate the robot's 'personality' and current 'mood'. Generally, the behaviour of Bird was designed to be more 'outgoing'. It is the wheelchair that first approaches an audience member, and its motion tends to be more pronounced. Fish is more 'reserved', as it appears to be more inhibited.

Project 2: Circle D: Fragile Balances (2008)

The next projects that we worked on were *Circle D: Fragile Balances* and *Circle E: Fragile Balances*. Although not robotic by definition, both projects act as devices that allow additional communications modalities between the Fish-Bird robots and their interactants. We view, thematically, the two Fragile Balances works as companions to the Fish-Bird project. In the case of Circle D, my aim was to create two physical avatars of the Fish-Bird robots to enable the activation of their dialogues in locations remote from the robots. The following text describing the work is from Velonaki [17].

Circle D: Fragile Balances comprises two luminous cube-like wooden objects that appear to be floating above the surface of a lacquered structure that perches on impossibly slender legs (Fig. 4). Each object is comprised of four crystal screens where 'handwritten' text appears, wrapping around it conveying a playful sense of rhythm. The text represents personal messages that flow between the virtual characters of Fish and Bird, and in that sense each object is a physical embodiment of a character. The objects can be lifted from their wooden stand and handled freely by participants. Handling provides an interface that facilitates bidirectional communication between the participants and the artwork in a playful way.

[Mari] *Circle D: Fragile Balances* was created as a companion work to *Fish-Bird*. I wanted to create new embodiments of Fish and Bird that would act as avatars to enable the activation of their dialogues in locations remote from the robots. She also wanted to test agency in relation to physical appearance and, in particular, how people would respond to hand-held interactive objects. In *Circle D: Fragile Balances* she chose to design another object with a non-technological appearance, although it had to house highly-technological electronic modules. The choice was to work with wood, an organic traditional material.

If a gallery visitor picks up one of the cubes from its floating base (Fig. 5) the text becomes disturbed and barely readable, influenced directly by the movement of the visitor's hands. The sensitive structure of the flow of messages between the two fictional characters remains disrupted as long as the visitor moves or turns the object quickly or abruptly. The only way that the participant can allow the messages to again flow around the object is to handle it with care—gently and softly cradling the object in his/her hands in concert with the rhythm of the 'handwritten' messages. If visitors do not handle the luminous cubes, the work stands on its own

Fig. 4 Mari Velonaki, *Circle
D: Fragile Balances* (2008–
2010) Interactive installation
with two autonomous objects.
Image Paul Gosney

as a complete sculptural piece containing an internal kinetic element—the moving
text. *Circle D: Fragile Balances* was never intended to be game-like in the sense
that it gives rapid gratification; instead, the intention was to use the cube as an
interface to slow people down, by creating an almost meditative space where paus-
ing becomes rewarding.

In this installation, the objects provide an interface that facilitates bidirectional
communication between the participants and the autonomous objects. *Circle D:
Fragile Balances* deals with concepts of fragility, trust, and communication by
playfully challenging the participants to pause and enter the rhythm of the floating
words and the dialogues that they lead to.

Interaction occurs between artwork and audience through the reactive objects
as information passes from the object to the participant and from the participant
to object. Another linkage involves the latent relationship between the two partici-
pants: the objects become the medium for a participant to become aware of the
existence of a virtual character—in this case, Fish or Bird. The moment that a par-
ticipant chooses to pick up and hold one of the objects, s/he becomes an avatar for
this character in the actual physical space of the installation. Should *both* partici-
pants then choose to vocalise their individually-received fragmented messages as
they appear around the surface of their objects, or to move close to each other in

Fig. 5 Mari Velonaki, *Circle D: Fragile Balances* (2008–2010) Interactive installation with two autonomous objects (detail). *Image* Paul Gosney

Fig. 5 Mari Velonaki, *Circle D: Fragile Balances* (2008–2010) Interactive installation with two autonomous objects (detail). *Image* Paul Gosney

order to read each other's messages, then the dialogue between the virtual characters is manifested and completed in the physical space. To reach into this fragile stream of text, the participant must attain a moment of stillness.

"As in *Fish-Bird*, in *Circle D: Fragile Balances* it was important that the technological apparatus was concealed, and therefore invisible to participants. This need inspired innovations in engineering and design to meet a set of aesthetic criteria on the physical manifestation of the two avatars. Each small cube conceals custom-built miniaturised microcomputers, accelerometers, batteries, and circuitry for battery charging and power management. No external wires are visible—the design was purposely manipulated to eliminate the visibility of screws and other such traces of the assembly process, and the stand also functions as a concealed battery charger."

[David] *Circle D* was very challenging to realise, in part because of its small size. It was the most intricate object that we had made at ACFR at the time. Because it was important to maximise the operating time of the object off the charge point, approximately 2/3 of the internal volume was filled with batteries, leaving little room for everything else. The solution was to design a printed

circuit board that contained all electronics, and allowed the two Linux computers to be plugged in. The displays that were selected had to be modified to replace the high-voltage tube backlights with LED light strips. It was the connections to the four display panels that caused the most difficulty. A connection through a flexible printed circuit (FPC) with conductors of 0.3 mm pitch was required, and we rejected four prototypes before we found a manufacturer able to make FPCs to the required specification.

[David] Working with wood for the *Circle D* objects also presented challenges. We first approached woodworkers, but were told that it was not possible to make the wooden structure that we envisaged to hold the display panels. One of our colleagues, Iain Brown, experimented with cutting wood on a metal-working milling machine and found ways to hold the wood securely so that fine sections could be cut accurately. Thanks to Iain we were able to design, assemble and manufacture an 'impossible' wooden structure.

Project 3: Circle E: Fragile Balances (2009)

The third work in the *Fish-Bird* series, *Circle E: Fragile Balances*, was created to provide an interface where participants could handwrite and 'post' their own messages to the Fish and Bird avatars of *Circle D*. *Circle E* is a wooden table-like object with a rotating brass drum partially sunk into it. A notepad and pencil are placed on its top and a 'postal bag' hangs under the object (Fig. 6). Members of the audience are encouraged to write to Fish and Bird, or to their loved ones, and donate their letters to the project by feeding them through the slot in the drum when it pauses momentarily (Fig. 7). All the letters are scanned and, at a later stage, added as text to the dialogues between the Fish-Bird robots and the interactive cubes of *Circle D: Fragile Balances*.

[Mari] Every time we exhibit *Circle E*, regardless of the country—Australia, Hong Kong and mainland China, Korea, New Zealand to date—I am always overwhelmed, not only by the thousands of letters that people contribute to the project, written to the Fish-Bird characters or to their loved ones, but by the intimate nature of the messages which often reveal very personal information. There seems to be a pattern in younger interactants, of offering drawings and tender letters to their mothers.

Project 4: Diamandini (2009–2013)

[Mari] Diamandini wasn't initially conceived as a humanoid robot. I wanted to create a single new organic form that experimented with elements of distance and tactility. For about a year I experimented with more abstract sculptural forms and, although an interesting exercise I found it extremely difficult to develop an

Fig. 6 Mari Velonaki, *Circle E: Fragile Balances* (2009) Installation with kinetic object. Image courtesy of the Art Gallery of NSW

Fig. 6 Mari Velonaki, *Circle E: Fragile Balances* (2009) Installation with kinetic object. Image courtesy of the Art Gallery of NSW

emotional activation towards something so abstract. Since I wanted to introduce response to touch in this new robot I felt that I needed to add some reference points.

These considerations influenced my decision to create a humanoid robot. This was a challenging decision, especially when deciding how the robot should look. After a long period of reflection, I began to think of *Diamandini* as a female sculpture. In my mind *Diamandini* had a diachronic face that spans between centuries, a style that could be reminiscent of post-World War II fashion influences and, at the same time, with futuristic undertones. Most importantly, I didn't want *Diamandini* to look like a stereotypical humanoid robot. *Diamandini's* exterior was treated with a porcelain-like material that makes her look more like a floating statue than a robot (Fig. 8).

Diamandini is small—only 155 cm high. I wanted her figure to be small and slender so that people did not feel threatened by her when she 'floats' in the installation space. I wanted *Diamandini* to look youthful, but not like a child, and for her age not to be easily identifiable. In my mind *Diamandini* is between 20 to 35 years old.

Fig. 7 Mari Velonaki, *Circle E: Fragile Balances* (2009) Installation with kinetic object. Image courtesy of the Art Gallery of NSW

Fig. 8 Mari Velonaki, *Diamandini* (2009–2013) Interactive humanoid robot. *Image* Paul Gosney

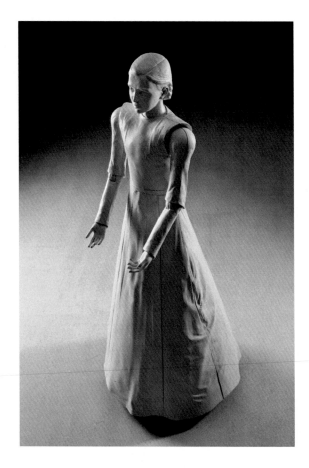

The construction of *Diamandini* was a multi-stage process, involving a sculptured prototype terracotta head, a custom-tailored fabric dress made over a wooden armature, and high precision three-dimensional laser scanning and manipulation of the scanned data, followed by computer-aided design modelling. The external shell was made using stereolithography—an additive manufacturing process that uses computer-controlled UV lasers to polymerise a resin in very thin layers.

"As it was conceptually important for *Diamandini* to appear to 'float' across the floor of an installation space a commercial motion base could not be used. An omnidirectional motion platform containing three computer-coordinated driven and steered wheels was designed and constructed. The omnidirectional motion base (Fig. 9) decouples *Diamandini's* facing direction and rotational motion from the direction and speed of her movement so that she can glide backwards, forwards or sideways, and transition smoothly between these movements" [17].

Overhead cameras that are sensitive to near-infrared wavelengths are used to localise the robot and track people who are present in the robot's operating space. Four infrared diodes concealed within the robot's head form a fiducial marking that allows easy differentiation of the robot from people. This marking was designed to provide information about the robot's position and 'gaze' direction. Although invisible to the human eye, the infrared diodes are easily visible to the cameras. Twenty four infrared distance sensors are hidden underneath *Diamandini's* skirt, mounted near to the floor. These sensors allow imminent collisions near floor level to be detected without recourse to information derived from the off-board environment sensors. Data communication between the robot and a central control computer is via wireless Ethernet. All associated electronics and software were custom-designed and all power and embedded computers are

Fig. 9 Mari Velonaki, *Diamandini* (2009–2013) Interactive humanoid robot (motion base detail). *Image* Mark Calleija

located on-board the robot. Nickel metal hydride batteries were selected for the same reasons as in the Fish-Bird project.

The project has involved considerable research into touch sensing and the transmission and interpretation of social messages and emotions via touch. Techniques based on electrical impedance tomography (EIT) were developed that can be used to implement flexible and stretchable artificial 'sensitive skin' using conductive fabrics to facilitate the interpretation of touch by robots during human-robot interaction. A classifier based on the 'LogitBoost' algorithm was developed and used to identify six specific social messages, such as 'acceptance' and 'rejection', and the six so-called basic emotions proposed by Ekman and Friesen [3], when transmitted by touch to an arm covered by the EIT-based skin. Experiments demonstrated, for the first time, that emotions and social messages present in human touch could be identified with accuracies comparable to those of human-to-human touch [15, 16]. Current work in the project aims to transfer these techniques to *Diamandini*.

To date *Diamandini* has been presented in only three contexts: as a prototype during ISEA 2011 in Istanbul, as an interactive sculpture in the Medieval and Renaissance Gallery at the Victoria and Albert Museum (Fig. 10), and as a performative automaton at as part of *Time and Motion: Redefining Working Life* at the Foundation for Art and Creative Technology (FACT) in Liverpool in 2013–14. At the V&A Museum, more than 34,000 people interacted with Diamandini during the London Design Festival (Figs. 11 and 12).

At the V&A Museum, the interaction system was programmed to select the most distant person present in the working area, turn Diamandini to 'face' them, and then attempt to move the robot to the target person within a time of 30 s. A damped potential field algorithm was used to generate the robot's trajectory, with the selected person serving as the attractor and both fixed and moving obstacles—typically people—serving as repulsors. If the robot was not able to reach the selected person within the allowed time, a new person was selected by the system. At FACT, Diamandini was programmed to perform along a path around the exhibition, pausing in front of other artworks and then continuing her spatial exploration of the gallery in a choreographed manner, stopping only when her desired path was blocked by people.

The exhibition of Diamandini at the V&A Museum provided an opportunity for us to observe how situational context affects human-robot interaction. We were able to install Diamandini in two very different spaces in the Museum, the Medieval and Renaissance Gallery and the Sackler Centre. The Medieval and Renaissance Gallery is a very formal exhibition space, imposing and prestigious due to the wealth of the collection of sculptures and architectural artefacts that it hosts, there is always a museum attendant present to remind the visitors that they should refrain from touching the exhibits. The Sackler Centre, on the other hand, is the most contemporary recent addition to the Museum that has been conceived and designed as a 'hands on' experiential learning and experimental space that

Fig. 10 Mari Velonaki,
Diamandini (2009–2013)
Interactive humanoid robot.
Image courtesy of the
Victoria and Albert Museum

invites the visitors to participate in various activities in the form of workshops. Diamandini's behavioural patterns were programmed to be the same in both exhibition spaces, yet the ways that the visitors interacted with 'her' were diametrically opposite. In the Medieval and Renaissance Gallery most of the visitors initially perceived Diamandini as one of the sculptures and were surprised by the fact that she was kinetic and responsive, but when it came to interacting with her, although standing close to her and taking photos with her, they appeared hesitant to touch her. In the Sackler Centre, on the other hand, the nature of the interaction was far more experimental. Visitors of all ages from school children to the elderly interacted in a far more playful way by holding her hands, tapping her shoulders, trying to dance with her, and even hugging her.

Fig. 11 Mari Velonaki,
Diamandini (2009–2013)
Interactive humanoid robot.
Image courtesy of the
Victoria and Albert Museum

Methodologies

Designing robots creatively incorporates design for subsequent evaluation and testing of the effectiveness and engagement of human-robot interaction. The authors use a two stage evaluation process in moving interactive robots from the laboratory to social/cultural environments. The first stage of testing is conducted in the laboratory using methodologies from psychology, and working in collaboration with cognitive scientists. The second stage involves placing the robot in social or cultural spaces such as museums. Cultural institutions such as museums and galleries provide fertile environments for experimentation and data collection, as they attract a broad variety of people of all ages, and from diverse socioeconomic and cultural backgrounds. Human-robot interaction data gathered in such

Fig. 12 Mari Velonaki, *Diamandini* (2009–2013) Interactive humanoid robot. Image courtesy of the Victoria and Albert Museum

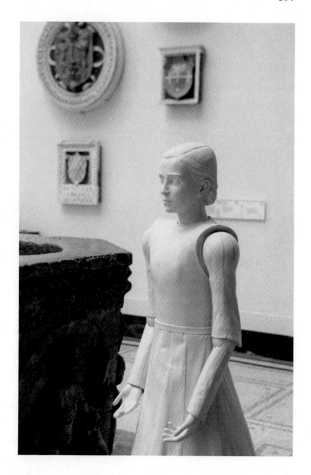

environments can lead to an understanding of human behaviour patterns and human preferences, contributing in turn to the design of better interactive systems.

We define a new research methodology called "open experimentation" in which public spaces are substituted for laboratories to acquire large sets of relatively unbiased HRI data from diverse social groups. In such public environments, humans are notionally free to interact with robots in intuitive and explorative ways while information about the interaction is obtained unobtrusively via observation and concealed sensors. The open experimentation technique can be used in environments as diverse as schools or universities [14], shopping centres [9], museums [13, 18, 19] and public exhibition spaces [11]. Open experimentation can be used to evaluate how large numbers of participants interact with a robot in public spaces, allowing the effects of the robot on the interactants to be inferred. Observational ethnographic and behavioural research techniques, as well as machine learning algorithms can be used to make these inferences from the observations.

Fig. 13 Composite overhead view of *Diamandini* in the Victoria and Albert Museum, London. 'Hot' *coloured areas* in the superimposed normalised density map show locations where participants spent most of their time

As one example of the open experimentation technique, 4,310 instances of people encountering *Diamandini* during one day of exhibition in the Medieval and Renaissance Gallery at the Victoria and Albert Museum were analysed. The robot's position and 'gaze' direction (head orientation) were obtained automatically through the overhead vision system. Figure 13 shows one composite frame from this exhibition, with a superimposed normalised density map that indicates locations where participants spent most of their time. Participant information, including position, gaze direction (assumed to be coincident with head pointing direction), gender and approximate age were labelled manually by a research assistant naïve to the purpose of the experiments. Children were distinguished from adults principally on the basis of their size. People of a size up to that of a typical 9 year old were labelled as children. Male and female adults were distinguished from each other principally on the basis of the style of their clothing and hair. There were relatively few children in the population analysed: just 264, in comparison with 3,538 adults.

The labelled data were clustered using the unsupervised expectation maximisation machine-learning algorithm [2]. Three clusters of participants were identified: (a) Non-interactants; (b) Observers; and (c) Interactants. Non-interactants were people who—to choose one typical example—walked through the installation space on their way to another location in the Museum. Observers were people who observed the robot from a 'safe' distance, but did not approach it for close

Table 1 List of features used during data clustering, in descending order of information gain

Feature
1. Minimum distance to robot
2. Mean distance to robot
3. Time spent within the robot's Social zone
4. Time spent within the robot's Public zone
5. Time spent within the robot's Personal zone
6. Minimum angular direction of person's gaze relative to the robot
7. Time spent in the installation space
8. Mean walking speed of person
9. Time spent within the robot's Intimate zone

interaction. Interactants were people who observed and approached the robot to interact at closer distances. Nine features were used in this clustering, selected from an initial list of over 40 candidate features using information gain [12] to measure the relative contributions of the candidate features and thereby rank them in order of importance in an information sense. Table 1 lists the nine features that were used. Features 3–5 and 9 were assessed according to Hall's theory of proxemics [6].

Further analysis was performed on the "Observer" and "Interactant" groups, a total of 2,919 encounters. A one-way analysis of variance (ANOVA) followed by post hoc comparisons using Tukey's honestly significant difference (HSD) [7] test was conducted to assess potential differences in the interactive behaviour of groups of participants. Different groups of participants were chosen as independent variables and the time of interaction at different proxemic distances [6] as the dependent variable. The results show that Observers and Interactants spent significantly more time interacting with the robot at a social distance than at any other proxemic distance category, and that children spent significantly more time than adults interacting at both social and personal distances from the robot. Differences in time spent at different proxemics distances were not statistically significant between male and female adults.

Clustering by age showed that more than three times as many children as adults interacted with the robot at an Intimate distance, and almost double the number at a Personal distance. Interactants preferred to be located at Intimate or Personal distances from the robot, Observers preferred to be in the Personal or Social proxemic zones, while Non-Interactants remained (as expected by definition) within the Social and Public zones.

Using a one-way ANOVA and subsequent Tukey HSD tests showed that children looked more directly at the robot than adults did. Again, differences in relative gaze between adult males and females were not statistically significant. Other statistically significant differences between adults and children were found; interestingly, children show greater maximum speeds of both approach and retreat from the robot than adults, despite their smaller size. Both adults and children show higher maximum approach speeds than maximum speeds of retreat relative to the robot.

Closing

The collaboration described here began 13 years ago as cross-disciplinary research between art and robotics, with the principal aim of exploring interactions where a person and a kinetic agent occupy and share a space. Naturally, robotics provides a means of implementing the interactive systems that allow such exploration and provide for the automatic computer-based acquisition of quantitative interaction data. It was also thought that interactive media art installations based on such technology would provide an ideal opportunity to gather these data unobtrusively.

These aspects of collaboration between art and robotics are undoubtedly true. As our collaboration developed over time, we were able to confirm our belief that the emerging field of social robotics was inherently multidisciplinary. What began as a binary art-robotics collaboration has now grown to include computer science, artificial intelligence, machine learning, psychology, cognitive science, interaction design and medical research.

Our experience of collaboration has reinforced the crucial importance of a multidisciplinary approach to social robotics research, where collaborators are able to receive ideas from outside of their own thinking spaces, finding creative inspiration from many directions. On a practical level, our initial art-robotics collaboration has led to the founding of a dedicated research lab and forthcoming National Facility for Experimental Human-Robot Interaction Research that involves five university departments across the University of New South Wales, the University of Sydney and University of Technology, Sydney, together with St Vincent's Hospital in Sydney.

References

1. Akhmatova A (1998) The complete poems of Anna Akhmatova. In: Reeder R (ed) Hemschemeyer J (trans). Zephyr Press, Chicago
2. Celeux G, Govaert G (1992) A classification EM algorithm for clustering and two stochastic versions. Comp Stat Data Anal 14:315–332
3. Ekman P, Friesen W (1971) Constants across cultures in the face and emotion. J Pers Soc Psychol 17(2):124–129
4. Goodrich MA, Schultz AC (2007) Human-robot interaction: a survey. Found Trends in Human-Comput Interact 1(3):203–275
5. Harper C, Virk G (2010) Towards the development of international safety standards for human-robot interaction. Int J Soc Robot 2(3):229–234
6. Hall E (1966) The hidden dimension. Anchor Books, New York
7. Hochberg Y, Tamhane A (1987) Multiple comparison procedures. Wiley, New York
8. International Federation of Robotics (2014) World robotics: service robots, 2013. http://www.ifr.org/service-robots/. Accessed 16 September 2013
9. Kanda T, Shiomi M, Miyashita Z, Ishiguro H, Hagita N (2009) An affective guide robot in a shopping mall. In: Proceedings of the ACM/IEEE international conference on HRI, pp 173–180, San Diego, USA, 11–13 March 2009

10. Makarenko A, Kaupp T, Grocholsky B, Durrant-Whyte F (2003) Human-robot interactions in active sensor networks. In: Proceedings of the 2003 IEEE international symposium on computational intelligence in robotics and automation, vol 1, pp 247–252, Kobe, Japan, 16–20 July 2003
11. Moshkina L, Trickett S, Trafton JG (2014) Social engagement in public places. In: Proceedings of the ACM/IEEE international conferences human-robot interaction, pp 382–389, Bielefeld University, Germany, 3–6 March 2014
12. Russell S, Norvig P (eds) (2010) Artificial intelligence: a modern approach. Prentice Hall
13. Rye D, Velonaki M, Williams S, Scheding S (2005) Fish-Bird: human-robot interaction in a contemporary arts setting. In: Proceedings of the Australasian conference on robotics and automation, 9 pp, Sydney, Australia, 5–7 Dec 2005
14. Šabanović S, Michalowski MP, Simmons R (2006) Robots in the wild: observing human-robot social interaction outside the lab. In: Proceedings of the 2006 IEEE international workshop on advanced motion control, Istanbul, Turkey, 27–29 March 2006. IEEE, pp 576–581
15. Silvera Tawil D, Rye D, Velonaki M (2012) Interpretation of the modality of touch on an artificial arm covered with an EIT-based sensitive skin. Int J Robot Res 31(1):1627–1642
16. Silvera-Tawil D, Rye D, Velonaki M (2014) Interpretation of social touch on an artificial arm covered with an EIT-based sensitive skin. Int J Soc Robot 6(4):489–505
17. Velonaki M (2014) Human-robot interaction in prepared environments: introducing an element of surprise by reassigning identities in familiar object. In: Lee N (ed) Digital Da Vinci: computers in the arts and sciences. Springer, pp 21–64
18. Velonaki M, Rye D, Scheding S, Williams S (2008a) Fish-Bird: a perspective on cross-disciplinary collaboration. IEEE Multimedia 15(1):10–12
19. Velonaki M, Scheding S, Rye D, Durrant-Whyte F (2008b) Shared spaces: media art, computing and robotics. ACM Comput Entertain 6(4):51:1–51:12

Robot Partner—Are Friends Electric?

Stefan Doepner and Urška Jurman

Abstract This text examines Doepner's individually realized works as well as his works within different art collectives from the early 1990s up until today, work that spans the broad field of technology-based art: Van Gogh TV/Piazza Virtuale; Ikit; Playground Robotics: When Robots Play; When Robots Draw: At The Borderline Between Human and Machine; Robot Partner; Living Rooms—Happy End of the 21st Century; Automated Table Modification; DrillBot; NoiseBot, and others. The text focuses on Doepner's artistic explorations of today's prevalent reception, use and impact of technology as a materialization of certain systems and techniques that critically influence our daily lives.

This text examines my individually realized work as well as my work in different art collectives from the early 90s until today, work that spans the broad field of technology-based art, including robotics. The text focuses on my artistic explorations of today's prevalent reception, use and impact of technology.

To discuss my art practice, which stretches over various media and disciplines (art, music, technology, science, urbanism, etc.) within a certain frame—art and robotics—demands a *detour* before starting to write about concrete projects and the concepts behind them.

The idea of organizing the field of art and its discourse according to a specific medium (sculpture, video, robotics, Internet, etc.) is basically an art historical endeavour, which is still impregnated with the modernist tradition. This tradition is grounded around the idea of medium specificity, which is based on the distinct "materiality" of artistic media and the ability of an artist to manipulate those

Are "Friends" Electric? is a song by English band Tubeway Army from their 1979 album Replicas. The song was written and produced by Gary Numan, the band's frontman and lead vocalist.

S. Doepner · U. Jurman (✉)
f18institut, Cirkulacija 2, Ljubljana, Slovenia

S. Doepner
e-mail: info@f18institut.org

© Springer Science+Business Media Singapore 2016 403
D. Herath et al. (eds.), *Robots and Art*, Cognitive Science and Technology,
DOI 10.1007/978-981-10-0321-9_20

features that are "unique to the nature" of a particular medium [1]. I studied paint-
ing and experimental film, I've worked with video, performance, experimental TV,
sound, graphics, machines, robots, programs, (kinetic) sculpture, (interactive) instal-
lations, urban interventions, etc. I could claim that I couldn't care less about inter-
pretations of my work, which are medium specificity-based. But, is this really true?

Art historians and theoreticians would probably interpret my reservation to the
medium-based approach to art in relation to the so-called post-media/post-medium
condition, which undermines the modernist "medium specificity" tradition [2]. But
within my daily professional reality (calls and invitations for festivals, exhibitions,
catalogues, applications, grants, etc.). I am most often interpellated [3] as so-called
new media-, computer-, robotic- or inter-media artist—basically, just with some
more prefixes than was usual some 50 years ago [4].

If I had to label (the majority of) my art, I would prefer the broader term *technol-
ogy-based art*. First, I am convinced that the technology employed—be it a hammer
and chisel or an electronic circuit—shapes artistic expression in an important way.
And second, more important, as an artist exploring today's prevalent reception, use
and impact of technology in our daily routine I need to understand the technical aspect
of technology as well as different conditions behind it. To be able to explore and better
understand complex systems—technical, ideological, economic, social, etc.—which
are inscribed within technology and also reproduced by technology, I work with tech-
nology not just on the level of content and iconography, but also on the level of its
"materiality" and in my working methods. This, for me, is politically crucial, and in
this sense I have always been keenly interested in de-constructing and re-building
technology. In order to interrupt the automated, mechanical, non-reflexive, consumer-
ist relation to technology, I reinvent technology covering the entire creative process—
from developing (often in close collaboration with other artists) electronic hardware,
circuits, devices, machines, autonomous systems, and even tools/production means to
creating artistic interpretations of technological visions. So, yes, even with some of
the reservations I mentioned previously, in the end, the medium does matter in my
artistic practice. But more than any single medium by itself, the driving force in my
art is the exploration of systems, with a particular interest in technology as a materiali-
zation of certain systems and techniques that critically influence our daily lives.

It was already in my youth, my formative years being active in the punk and
industrial scene, that ruling systems—economy, politics, religion, media, educa-
tion, etc.—had their first stronger impact on me and I understood them as some-
thing that binds us, that is imposed on us, and as something that needs to be
challenged. Today, as an artist, I am interested, on the one hand, in penetrating into
already existing systems in order to explore and question their aims, procedures
and limits, and on the other hand, in creating my own systems—be they electro-
mechanical structures, robots or artist-run co-working spaces.

My technology-related art practice and artistic exploration of systems started with
the *Van Gogh TV/Piazza Virtuale*, "an interactive television project that could be
received all over Europe via four satellites for 100 days during *documenta* IX in 1992.
Visitors of the *documenta* could beam themselves in via videophones and cameras that
had been permanently installed in Kassel and other European cities to the live broadcast

called 'Piazza Virtuale'. It was possible to use telephone, fax or modem to dial into the broadcast from home. The aim of the project was to transform the mass medium of television into an interactive medium that reverses the relationship of one broadcaster and many receivers" [5]. The project consisted of several broadcasting units—so-called Piazzettas—in cities all over Europe, as well as in North Africa, the U.S. and Japan. I was part of the Piazzetta Telematica in Bremen, where I was then a student at the art academy (Hochschule für Künste Bremen). Using the latest communication technology available at that time, we were co-creating content and communication with and for the TV users. The 3Sat public television station was the main host of this interactive TV platform, which intended to interrupt the prevalent, one-way use of TV and to experiment with social relations established through mass media. But, what struck me is how strongly the meta level of the project—mass media system—determined the perception and possible use of our interactive TV platform by the TV audience. Today, active media participation and co-creation are inherent to the Internet and also already well economized, but within the traditional TV channel, the possibilities of this project were very limited; the more we tried, the more I felt constricted (Fig. 1).

Kicked by this experience, I co-founded the *Media Access Bureau* in Bremen in 1993 (with Ronald Gonko, Tobias Küch, Tobias Lange, Ole Wulfers, Malcom Dow and others), where we could establish our own conditions. The place grew instantly into a public media atelier equipped with a fax, Internet, picture phone, Amiga and Mac workstations, and a restaurant/bar. It functioned as a social and a co-working place, but not that long, because our idealism soon led us into financial problems and we had to close about half a year later.

Fig. 1 *Piazzetta Telematica Bremen, Van Gogh TV*, 1992, photos by Piazzetta Telematica Bremen

At the same time, new collaborative relations that developed through the *Van Gogh TV* project enabled us, a group of students, to invite artists like Mike Hentz and Nicolas Anatol Baginsky to the independent inter-media program that we were organizing at the Bremen art academy. The collaboration with N.A. Baginsky, who became my mentor for the artistic use of electro-mechanical technology, was crucial for me. Nick soon invited me to participate in some of his projects and I had the pleasure to *learn by doing* under his mentorship. Through working with him, I acquired an understanding of working with machines, robots and electronic systems from the perspective of a sculptor—how to develop, construct and use this machinery in order to *sculpt* a situation or a space.

By working with Nick, I also got the opportunity to work with some acknowledged artists from the so-called machine art scene [6], and that prompted me to define my own position in the world of art and technology. Furthermore, it became even more clear to me that the complexity of working with/in technology would require me to either learn programming and designing electronics on a professional level (or at least a self-sufficient level) or to find partners with necessary technical skills and expertise. I guess because of my affinity for teamwork as well as due to my life course, I found that team in Hamburg, a city that played an important part in my artistic formation.

In 1995, I joined the *Trojan Ship* [*Das Treujanische Schiff*] in Hamburg, a 6-month long project initiated by Mike Hentz, who was at that time professor at the Hamburg Academy of Fine Arts [Hochschule für bildende Künste]. The project was conceived as a kind of a Trojan horse into the academic education system, which often lacks active connection with life outside academic ateliers and classrooms. It took place on a ship, which was docked in the city centre at the famous Fischmarkt and used as a meeting and collaboration venue for students of the Hamburg fine art academy and also for other interested parties to intertwine education, art and life. Concepts that fuelled the *Trojan Ship*—the idea of art as a research into/for culture, the importance of establishing artist-run spaces, of carrying a full circle of artistic production, of self-organization and taking individual responsibility while working in cooperation, and the importance of making processes public and an important part of the art work—manifested in numerous exhibitions, concerts, lectures, symposiums, performances, parties, etc., and overlapped with my own artistic credo. I was literally living all of that within the *medialab@sea*, a small shack on the ship filled with ISDN Internet connection, computers and a handful of enthusiasts.

The *Trojan Ship* brought together Gwendoline Taube, Lars Vaupel and me, and in 1996 we founded the f18institut for Art, Information and Technology as a collaborative platform for artistic exploration of contemporary technology. The core unit of the f18institut soon expanded, integrating additional artists and programmers, with the composition of the group changing over the years, depending on the needs and interests of specific projects (Ole Wulfers, Jan Cummerow, Tom Diekmann, Joachim Schütz, Stora). Teamwork was, from the beginning, our *modus operandi*, since it creates the most dynamic processes, increases exchange and know-how and fosters individuals towards self-positioning. Already in our first projects we learned how to work collaboratively while at the same time leaving space for individual expression.

The first productions of the f18institut, which took place outside of our Blue House [7], where we were living, working and organizing public events, were connected with the Kampnagel cultural factory, Hamburg. From the late 80s till the late 90s, this former crane factory was an important producer and promoter of technology-related art, not just on a local or national, but also on an international scale. For a young art group such as f18institut at that time, it offered a priceless environment for our early artistic explorations. Besides supporting our work [8], Kampnagel was important for us also as a hub for the international scene of technology-based art. Through Kampnagel, f18 was able to establish connections and in some cases also collaborations with other artists whose projects we supported with our artistic and technical knowledge. No doubt our most important collaboration was in 1998 when f18institut developed and constructed in collaboration with Stelarc his *Exoskeleton*, a 3-m in diameter, insect-like six-legged robot that supports the artist who navigates the robot. *Exoskeleton* initiated a string of further collaborations with Stelarc: in 2000, f18 developed the *Motion Prosthesis*, a pneumatic robot unit for controlling the upper body; and in 2006, the *Walking Head*, a 2-m in diameter, six-legged autonomous and interactive platform with an avatar head by Steve Middleton displayed on a monitor. Then, in 2014, I started to work with Stelarc on *Microbot,* a six-legged autonomous robot and performative intervention into Stelarc's mouth that thematizes the growing intimacy of machines and the human body, and depicts a possible future in which the body will be colonized by micro- and nano-sensors, devices and robots augmenting our bacterial and viral populations (Figs. 2, 3 and 4).

f18's own artistic work has explored systems and techniques characterizing contemporary society (e.g. work, leisure time, science, art, etc.) with a special interest in technology, the promises it carries and the belief it serves. The procedure we have followed was to dive into the world of technology, to explore it through hands-on experience and to achieve our own decoding within it. One

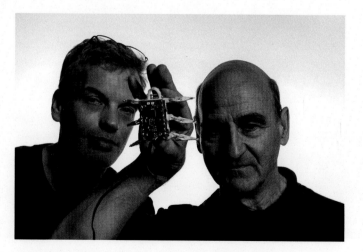

Fig. 2 Stelarc and S. Doepner, *Microbot*, 2014, photo by Miha Koron

of our approaches has been the development of our own tools (computer controls, programs, devices, etc.), which enabled us to enter the world of technology through the "back door" and to create our own positions and possibilities in that context. We have strived to overcome technological glorification and mystification. For this, we believe, it is necessary to work from within—to examine and grasp technology through reinventing it. We have also been interested in giving a twist

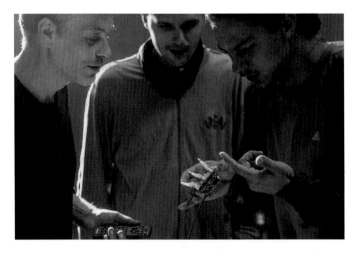

Fig. 3 Stelarc and S. Doepner, *Microbot*, 2014, photo by Miha Koron

Fig. 4 Stelarc and S. Doepner, *Microbot*, 2014, photo by Miha Koron

on the application of technology taken for granted in our daily lives, while at the same time also showing a daily routine as a kind of machinery. In our collaborative projects and also in my own work, familiar situations are interrupted and objects are ripped out of their actual contexts and entrusted with new tasks and meanings.

Works that I realized within the f18 projects create a poetics of everyday routines, which may at first seem absurd: *Buddha Machine* and *Jesus Walking Over the Water*—two motorized installations dealing with religion as a kind of automatization (within the *Drop Outs* exhibition, 1998); *Midi Shelf*, version 1—household appliances turned into a sound orchestra played by a sequencer (within the *generalpark.de* project, 1999); moving forest—autonomous platforms with trees (within the *generalpark.de* project, 1999); *Exploding Wardrobe*—computer-controlled performative object, 1999 (Figs. 5, 6, 7, 8 and 9).

Our interest in technology and its implementation in everyday life, in the phenomena of automatization, and in the notion of a system, directed us more and more toward robotics. f18institut's first own bigger robotics project was *Ikit*, which we performed in a public park in Zürich in the year 2000. The project was part of an educational exhibition *Playground 03*, which was presenting computer games (under the leitmotif of playing and learning) and was organized by the Migros Culture Percentage. *Ikit* was one of the artistic "interventions" in this exhibition and was a kind of jump and run computer game translated into the real world. It consisted of three robot platforms that could move autonomously across the lawn and establish contact with the public; a huge server-station, which served also as seating

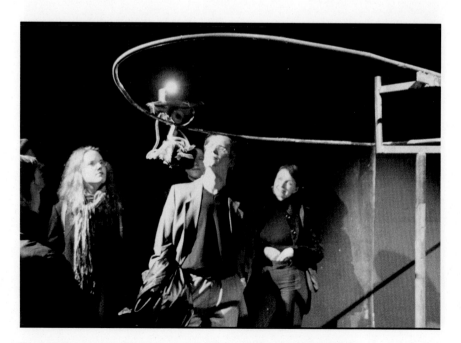

Fig. 5 S. Doepner, *Buddha Machine (Drop Outs)*, 1998, photo by f18institut

Fig. 6 S. Doepner, *Midi Shelf (generalpark.de)*, 1999, photo by f18institut

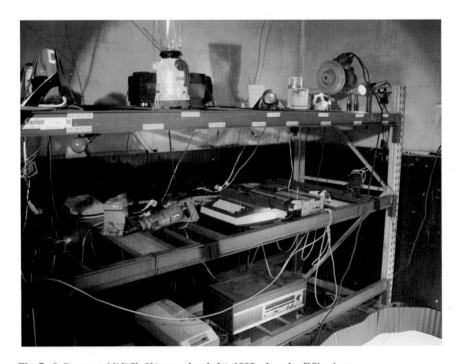

Fig. 7 S. Doepner, *Midi Shelf (generalpark.de)*, 1999, photo by f18institut

accommodation, referring to the famous supercomputer Cray-1 from 1976; and a large display consisting of 512 bulbs showing coarse video images transmitted by the robots as well as texts and graphics. The robots looked for "obstacles" (people), went towards them and, if people moved, robots followed them. The basic idea was to translate typical chase and escape computer-game activity into a bodily and playful experience. In addition to this, we were interested in observing what kind of relations and communication the public would establish with our robots. The interaction

Fig. 8 S. Doepner, moving forest *(generalpark.de)*, 1999, photo by f18institut

Fig. 9 S. Doepner, *Exploding Wardrobe*, 1999, photo by Tinka Scharfe

ranged from teenagers ignoring the robots after they did not immediately fulfill their expectations to a very playful discovering and intuitive use of functions by younger children to a more technically interested approach and "appropriation" (using the "following mode" for a walk with a robot through the park) by pensioners. Through these observations, we obtained direct feedback regarding our artistic and technical concepts, and this feedback proved invaluable for it gave us a clearer picture of our own understanding of autonomous robots and of the relations people are establishing towards them—a kind of a second-order cybernetics situation according to which an observer is always a part of the observed system (Figs. 10, 11 and 12).

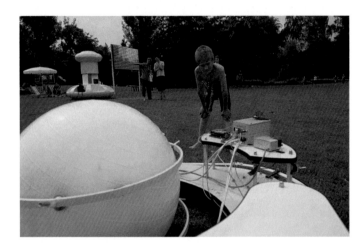

Fig. 10 f18institut, *Ikit*, 2000, photo by Dominik Landwehr

Fig. 11 f18institut, *Ikit*, 2000, photo by Dominik Landwehr

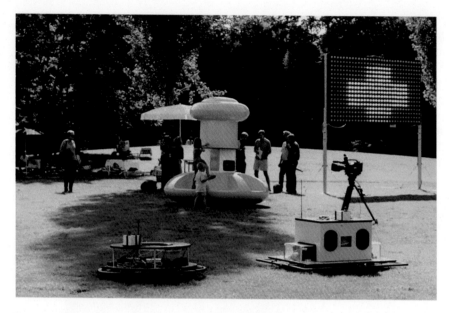

Fig. 12 f18institut, *Ikit*, 2000, photo by Dominik Landwehr

In the year 2004, f18institut realized an exhibition series under the title *Playground Robotics: When Robots Play*, an overview of our latest robotic works. Three exhibitions in three different Swiss cities [9] were presenting our works, robotic works by Swiss artist Jürg Lehni (*Hektor*) and researcher Raja Dravid (*Stumpi*) as well as artistic services which f18 realized for other artists (Stelarc's *Exsoskeleton* and Andres Bosshard's rotating loudspeakers *Rotobossophone*, 2003).

Within the *Playground Robotics: When Robots Play* exhibition project, I would like to point out the exhibition *When Robots Draw: At The Borderline Between Human and Machine* [*Wenn Roboter Zeichnen: Im Grenzbereich von Mensch und Maschine*] displayed at the Kunstmuseum Solothurn. The exhibition examined the unclear boundary between artistic process and mechanical design and included works by Dieter Roth, Jean Tinguely, Roman Signer, Jürg Lehni, f18institut and others. f18 was involved in the selection of exhibited works and participated with *Drawing Spiders* by Lars Vaupel and *PaintBot* by me. *PaintBot* is an autonomous mobile platform (40 cm in diameter) equipped with a brush and an exchangeable container filled with oil paint, with the color to be chosen each day anew by the museum technicians. The robot moves within a given area that is covered with canvas, simultaneously dipping a brush into the paint and then leaving traces behind and thus slowly covering the canvas day by day. So, there was a space, dominated by the robot that was painting and then painting-over every moment a new image, a canvas and the intense smell of oil paint. Probably the first scent of oil paint in this museum, filled with Ferdinand Hodler's oil paintings since long ago. The question arises as to which part of the process was under my artistic authorship, what was my decision and what was the result of the continuously

running automated procedure? From my perspective, the painting was never a piece of art, rather more a byproduct of the artistic process *sculpting* the situation and the space. Or as the authors of the accompanying text for the *When Robots Draw* exhibition put it: "With this collection of drawings, sketches and design processes [e.g. codes for computer programs], not only the visual thinking of the participating artists are made visible, but also those transitions where the artistic process takes shape within the borderline between man and machine. The works shown here present not only their poetic content, but also a critical and ironic conflict with the possibilities and limitations of technology as well as with the definition of the concept of art" [10] (Figs. 13, 14 and 15).

Fig. 13 S. Doepner, *PaintBot*, 2004, photo by Jörg Mollet

Fig. 14 S. Doepner, *PaintBot*, 2004, photo by Jörg Mollet

Fig. 15 S. Doepner, *PaintBot*, 2004, photo by Jörg Mollet

With the *Playground Robotics* tour, the collaboration of the initial f18institut group ended. We continue to support older projects and work in individual teams on new developments, sometimes still under the f18 label.

In my experience, designing and building robots is a good way to learn about technology and cognition on the basis of trial and error. I have always embraced mistakes and failing as an important part of creative and cognitive processes as well as a conceptual tool with which to address the ideals, promises and beliefs closely attached to technology. What makes it so inspiring to work with robotics for me is that it provides a chance for self-reflection, for understanding your own concepts of behavior, perception, intelligence and corresponding processes like mistakes, routine, prejudices, misinterpretations and the like. When it comes to a situation where a certain circuit, program, etc., does not work according to your aims, you have to look at your own patterns of understanding. Developing robotics involves dealing with a whole bunch of system modules like sensors, behavior, control and mechanics as well as with the factors of human-robot interaction and of the desired or expected environment. In a way, it leads to a kind of artistic bio-digital exploration, a striving to understand the relationship between human beings and digital-electronic associates throughout the whole process, from development to application.

An important project that questions ideals, promises and beliefs that are closely attached to technology as well as exploring the relationship between human beings and digital-electronic associates is *Robot Partner.* It is a long-term project, or better: a conceptual frame within which I have realized several works that relate to the promise of robots to facilitate our daily living, to make it more efficient and thus better. The project focuses on the concept of partnership between humans and machines and also on the contemporary ideas and images of *fortschritt* (progress).

Hegel once wrote that the progress of the mind is not yet the progress of happiness. At the present time, it seems obvious to me that promised progress is also

only promised happiness. *The Living Rooms—Happy End of the 21st Century* (2006, with Jan Cummerow) [11] addresses this ambivalence, since any kind of progress also produces new contradictions and conflicts, and any kind of promise produces new expectations and desires.

The installation takes the form of the interior of an apartment in which home appliances and furniture take on a life of their own. *The Living Rooms* consists of a kitchen, bedroom, bath and a living room. Each area is equipped with ubiquitous items—furniture, home devices, accessories and tools. Items function "correctly" to a certain degree; however, their function is not determined by their usability, but they are programmed as if they were subject of their "own" dynamics. The apartment seems to generate a potential inhabitant in a virtual state. A course of action involving furniture and devices arises, which then increasingly runs into an escalating independence—kitchen devices, tools, chairs and tables, etc., jump into a rhythmic state and absurd dance. Part by part, the objects slowly calm down, the mobile furniture moves back to its original location and the virtual inhabitant goes back to bed, the light fades. This performative installation creates an image that we can relate to our past, present and future. It offers the visitor the possibility to explore his/her own everyday world as a type of machinery, as well as to reflect on the ideas and dreams of the improvement of our daily lives and environments through the help of technology (Figs. 16, 17 and 18).

The Living Rooms works with absurd, travesty, humor, and also with the sense of the uncanny [*das Unheimliche*], which is achieved especially with the sound element of the installation. This sense of the uncanny includes a peculiar mixture of the familiar

Fig. 16 S. Doepner, J. Cummerow, *Living Rooms*, 2006, photo by Kathrin Doepner

and the unfamiliar. According to Freud, who elaborated on this concept, the uncanny derives from the known, the familiar, which has at one time gotten suppressed. The uncanny is nothing foreign, or strange per se. It is something that is familiar to our psychological life but has been alienated through the process of suppression. The uncanny is something that should have remained hidden but came to light.

Fig. 17 S. Doepner, J. Cummerow, *Living Rooms*, 2006, photo by Kathrin Doepner

Fig. 18 S. Doepner, J. Cummerow, *Living Rooms*, 2006, photo by Kathrin Doepner

Similar to *The Living Rooms*, *Automated Table Modification* (2008) [12] refers to the idea of an augmented environment. It is a kind of *tableau vivant* where objects displayed on the table perform their own motion and sound choreography. It consists of 400 electromagnets underneath the table's glass top, which is covered with several everyday items usually found on a work desk at home. The items start, one by one, to make one or more steps towards a possible goal. Eventually they create a chaotic, and thereafter a seemingly orderly, structure. Like *The Living Rooms*, this work was often perceived as an interactive or even intelligent installation; nevertheless, it is based on a loop of programmed steps, such as, for example, a car-welding robot. Any interference is disturbing the system and endangering the efficient workflow (Fig. 19).

In the context of the *Robot Partner* project, *DrillBot* (2009, with Lars Vaupel) deals particularly with the ideal of service robots facilitating and simplifying human labour and the everyday routine as well as serving people as partners in an alienated, mechanized and systemized society. The robot consists of a grid to which four drill machines are connected, driven by computer-controlled pneumatic actuators. It moves autonomously on the wall holding itself there by drilling holes in it. With the accompanying text, the project aims its critique at economically conditioned propaganda-like advertisements, like the kind we see everyday everywhere, ads that promote tentative technological innovations as effective and promised perfection, despite whatever elusive benefit or possible unforeseen problem might be associated with them. Opposite to the notion of efficiency, *DrillBot* performs partly slow, almost meditative motions, and partly abrupt violent disturbances. And opposite to the hyper-designed, contemporary technological items, *DrillBot's* aesthetics is pure function-based and appears anachronistic, whereas it does still perform its "awesome" service of "drill-climbing" the walls (if I may borrow from the usual advertisement vocabulary) (Figs. 20 and 21).

In my aesthetics, form usually follows function, and the artworks often have a kind of a shabby appeal. While examining everyday routine and everyday application

Fig. 19 S. Doepner, *Automated Table Modification*, 2008, photo by Miha Fras

Fig. 20 S. Doepner, L. Vaupel, *DrillBot*, 2009, photo by Miha Fras

Fig. 21 S. Doepner, L. Vaupel, *DrillBot*, 2009, photo by Miha Fras

of technology, I like to use ordinary items in my works. *Living Rooms*, for example, does not look like a high-tech, upscale, designed apartment that would rather refer to a near future or a very expensive apartment, but looks ordinary, even cheap or *démodé*. Objects used in the *Automated Table Modification* or in the *Midi Shelf* are also very ordinary, the kind of items one can buy in a corner store and not in a design shop. The aesthetics of my works is also connected to my working methods—I often re-use

material and work with whatever might be at hand, which is also a matter of urgency and of finances when one prototypes a lot—as well as to my rather critical position towards the superficial role aesthetics and specifically design can play in our consumerist and commodified culture. In the case of technology, design often predominantly serves the purpose of branding, beautifying and polishing the object of desire—the object that should meet our desires for a better, up-to-date, easier, happier, more efficient life. Design importantly supports constructing these desires that cover a void in a consumerist society. And if design constructs a phantasmatic "surface" to cover this void, then perhaps I am trying to reach through and work with this very void itself.

Even if the *Robot Partner* project has a certain dystopian view towards technology, especially when it comes to the human-machine relation in the context of consumerist society, I have always found that it is also important to work with a positive attitude towards the utopian aspect of technology—to explore the potentials of technology in its ability to seek for the "different" ways possible. A new degree of value, one that is not in the service of accelerated production, but is a tool for social action. This social function would not be implemented in the tool itself (e.g. as in Facebook, Twitter, you name it!); the tool would just cause the moment or situation wherein these social functions would actually have to be a matter of discussion.

In recent years, I have focused on creating robotic tools for acoustic interventions and performances. These artistic endeavors take the shape of robotized sound instruments and of moving sound and speaker systems (different rotating sound speakers and rotating instruments) that I use on different occasions—concerts, installations, theatrical and other performances.

Part of my ongoing research on different possibilities of dynamic sound performing is also *NoiseBot* (2011–14, with Lars Vaupel), an autonomous robotic sound object on wheels that navigates with the help of ultrasonic sensors. In contrast to prevalent sound systems, which, by "aiming" sound, patronize the listener towards a static perception and "imprison" us into a homogeneous way of experiencing sound, *NoiseBot* does not "throw" sound from one single static point to another, but is a tool for shaping sound in space and space through sound in motion. By moving in the space, executing its own programmed behaviour, *NoiseBot* is a sound actor that creates a dynamic sound space. Rather than just virtually moving sound to desired places, like in case of multi-channel sound systems, the idea is to play with the acoustic effects of the given architecture using the physical movement of the powerful sound source. *NoiseBot* can be used as an instrument for different occasions—music and sound, dance and theatre performances. Most of *NoiseBot's* applications in these areas required an extended navigation system. That is why the robot was equipped with a kind of indoor GPS, an infrared positioning system that was developed by Lars Vaupel. The system makes it is possible to mark-out a space using several infrared beacons with individual tags that can be used to trigger different behavior patterns as well as to remote control directly the motion of the robot (Figs. 22 and 23).

Moving sound and speaker systems were also the main focus of the *Noise Is Us* festival, which took place in 2014 at Cirkulacija [2], an artists initiative based in Ljubljana that I co-founded in 2007. For the festival we developed, in the final step together with the invited artists, an 8-channel sound system composed

Fig. 22 S. Doepner, L. Vaupel, *NoiseBot*, 20011–14, photo by Miha Koron

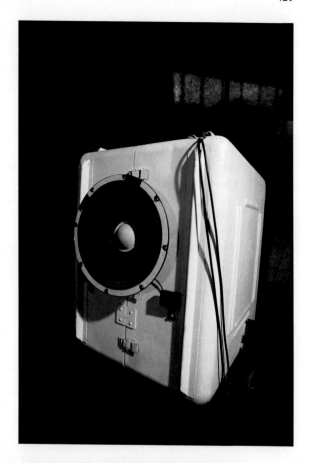

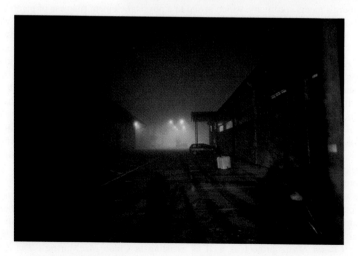

Fig. 23 S. Doepner, L. Vaupel, *NoiseBot*, 20011–14, photo by S. Doepner

of different sound-moving and moving sound systems—like turning, swiveling, driving or switching speakers. The user interface has been developed as a kind of technical organism that is conceptually tuned to the social protocol that we've been establishing over the years—an interrelated horizontal platform for a free improvisation. It's based on a very simple bi-directional protocol, MIDI, developed at the end of the 70s as a standard for electronic musical instruments; it is a cross-platform protocol being used by a wide spectrum of applications. Via this protocol, every participating author can connect into the platform with his individual applications and thereby feed and control the motion-sound system, so it is also possible to share control in a group of artists, each of them using their own system but the same protocol. Everyone can connect to this platform, but as it is as unrestricted as possible, any activity could potentially cause problems if it is not "tuned" and integrated regarding the ongoing or planned activities of any other participant, So far, it seems to be an attempt at a wider kind of communication, a step beyond the protocol and a step towards the other, me and the machine.

References

1. The concept of medium specificity was, in the mid-20th century, most notoriously propagated by the American art critic Clement Greenberg
2. I am referring to three oft-cited conceptualizations of the post-media/post-medium condition. According to Lev Manovich, various cultural and technological developments rendered meaningless one of the key concepts of modern art—that of a medium; still, the old media-based typology of art persists (Manovich L (2001) Post-media Aesthetics. http://manovich.net/index.php/projects/post-media-aesthetics. Accessed 9 March 2015). Peter Weibel's post-media condition brings about not only the equalization of individual media (as compared to the historic primacy of painting), but also new combinations and mixtures of artistic media (Weibel P (2012) The Post-media Condition. http://www.metamute.org/editorial/lab/post-media-condition. Accessed 9 March 2015). Rosalind Krauss derives from a critique of Greenberg's media specificity, which is tied to a physical element (flatness of painting, three-dimensional sculpture, etc.), and elaborates on the "knights of the medium" whose works reinvent what art can achieve through a particular medium (Krauss R (2000) A Voyage on the North Sea: Art in the Age of the Post-Medium Condition. Thames & Hudson, London)
3. Louis Althusser's concept of ideological "interpellation" describes the moment and process by which ideology constitutes individuals as subjects. According to Althusser, the ideological social and political institutions and the discourses they propagate "hail" the individual in social interactions, giving him/her his/her identity. By recognizing him/herself in that "hail", the concrete individual is "always already interpellated" as a subject
4. Parallel to these art historical and cultural policy operations that split the art field into different (media-based) branches, I understand the splintering of the art (field) into specific niches and novelties as being determined as well by market operations, through which differences can be easier economized
5. See: http://www.medienkunstnetz.de/works/piazza-virtuale. Accessed 20 Feb 2015
6. In the year 1994, Nicolas Anatol Baginsky invited me to work with him in Hamburg for a production with NVA (NVA was founded in 1992 by Angus Farquhar, a former member of the industrial music group Test Dept) at Kampnagel, and on that occasion I also built my first publicly performing machine *Butter-Fliege*. In 1995, I worked with Nick and Barry Schwartz on the *I-Beam Music* project as well as assisting at Chico MacMurtrie's *The Amorphic Evolution* project, both at "cultural factory" Kampnagel in Hamburg

7. Blue House [Blaues Haus] functioned as the f18 living, working and public space, where we were organizing exhibitions and public events presenting our work and the work of other Hamburg-based artists (*Testsequel Present T1*, 1997; *Testsequel Present T2*, 1998)

8. At Kampnagel, Hamburg, f18 realized the motorized and computer-controlled installation *Drop Outs* within the framework of the *Junge Hunde* program, 1998; and *generalpark.de: A Soap-Opera Between Machines, Computer, Video and Sound*, 1999

9. *Playground Robotics: When Robots Play* was displayed at the Kornhausforum in Bern; Kunstmuseum and Altes Spital in Solothurn; and Plug. In in Basel. The exhibition series was produced by the Migros Culture Percentage. Later that year, an excerpt of this exhibition project was presented at the Kapelica Gallery in Ljubljana, Slovenia

10. Ammann K, Mollet J (2004) Wenn Roboter zeichnen. http://www.kunstmuseum-so.ch/wenn-roboter-zeichnen. Accessed 28 Feb 2015

11. *The Living Rooms—Happy End of the 21st Century* was produced by the SMARt 2006

12. *Automated Table Modification* was produced by the Kapelica Gallery, Ljubljana

Part VII
Epilogue

Encounters, Anecdotes and Insights— Prosthetics, Robotics and Art

Stelarc

Abstract Performing with prosthetic attachments and robotic extensions, the artist's body becomes an operational system that combines improvised actions with involuntary and automated motions. The body interfaced and interacting with machines, experiences its own movements as machinic. Using anecdotes, insights and references to my own practice, as well as to recent developments in robotics for medical, industrial and military uses, there is a discussion of the issues and ethics of human-robot interaction. Notions of aliveness, embodiment and agency become problematic. The hybridization of robotics and art generates contestable futures of form, function and aesthetics. Possibilities that can be actualized, interrogated, evaluated and possibly appropriated. Alternate anatomical architectures are engineered, experienced and interrogated.

After a lecture I gave in Aix En Provence, where I also demonstrated the operation of my Third Hand, a person came up to me and excitedly asked if she could try actuating the mechanism with the EMG electrodes I used. It was only after a few minutes of speaking to her that I realized one of her arms was a cosmetic arm. It was convincingly real in appearance and on first sight I just assumed she was fully enabled. Anyway, I attached some electrodes on the flexor and extender muscles of her other arm and gave her some simple instructions on what to do. She was delighted in being able to control the mechanical hand functions with her own muscle signals and she asked me what I thought of her prosthesis. I said that I did like her artificial arm. Although it had no functions it was beautiful in appearance. Without further ado she wrenched it off and handed it over to me and started to walk away. It was most disconcerting that her body was no longer a visually complete body. She had detached her arm. It was an embarrassing moment, she with one hand and me with four. I stopped her leaving and convinced her that she should have her arm back.

Stelarc (✉)
Distinguished Research Fellow, School of Design and Art,
Curtin University, Perth, WA, Australia
e-mail: stelarc@curtin.edu.au

© Springer Science+Business Media Singapore 2016
D. Herath et al. (eds.), *Robots and Art*, Cognitive Science and Technology,
DOI 10.1007/978-981-10-0321-9_21

427

Preface

Initially, my interest in machine systems was related to their capacity to be intimately interfaced to and actuated by the body. A prosthesis is not considered as a sign of lack, but rather is a symptom of technological excess. A prosthesis is seen not as replacement but as an addition. The THIRD HAND is capable of independent movements when the electrodes are attached to the abdominal and leg muscles, allowing independent movement of the 3 hands. It has a pinch-release, a grasp-release, a 290° wrist rotation (CW and CCW) and a tactile feedback system for a rudimentary sense of touch. It was state-of-the-art at the time of its completion in 1980 to be invited to demonstrate it to the Jet Propulsion Lab in Pasadena and the Johnson Space Centre in Houston to the Extra-Vehicular Activity Group. Yet, it was never really completed due to a lack of funding and an impatience to begin performing with it after spending four years on the project. The THIRD HAND was not intended to be in a fixed position on my arm but rather, in addition to its other functions, was also intended to rotate around my right arm. The THIRD HAND is not merely a visual addition to the body but rather an attachment that generates additional operational and performance possibilities (Fig. 1).

For Stelarc, the body has always been prosthetic - a site of radical experimentation that in his art has been objectified, penetrated, virtualized, roboticized, emptied out, alienated and suspended with such ferocity that the purely prosthetic quality of the body has been forced to surface.

ARTHUR AND MARILOUISE KROKER - Stelarc: The Monograph Edited by Marquard Smith, MIT Press, 2005.

Introduction

Robots are not only a mistaken metaphor for the dehumanization of the body but also for the future sentience of machines. Already the invasion is on, with robots appearing in the human imaginary through literature, film and art. We are increasingly populated by artificial body parts, robots, and are being invaded by algorithms. The definition of a robot is generally of a machine able to perform programmable tasks automatically. But with such classes of machines as wearable robots and medical robots, intimate and haptic interfaces have been developed to incorporate the human as a component of the machine system. And with web Crawlers[1] and Chatbots[2] one can think of these as virtual robots. Robots prolifer-

[1]A Webcrawler is a program, a type of search engine, that automatically searches and indexes internet information using keywords, links and other data.

[2]A Chatbot is a rudimentary AI that can converse with people or with itself either in text or in spoken language.

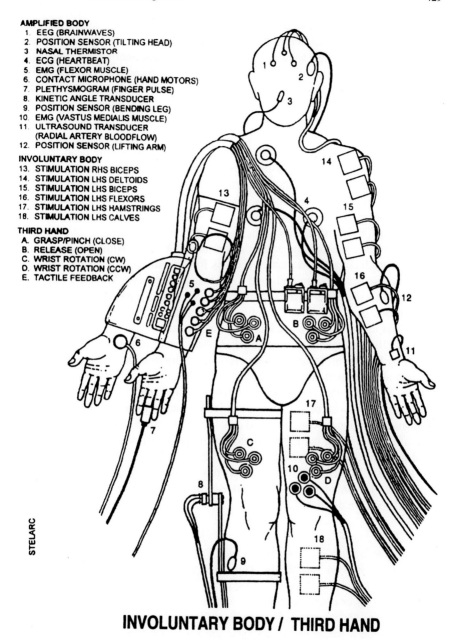

AMPLIFIED BODY
1. EEG (BRAINWAVES)
2. POSITION SENSOR (TILTING HEAD)
3 NASAL THERMISTOR
4. ECG (HEARTBEAT)
5. EMG (FLEXOR MUSCLE)
6. CONTACT MICROPHONE (HAND MOTORS)
7. PLETHYSMOGRAM (FINGER PULSE)
8. KINETIC ANGLE TRANSDUCER
9. POSITION SENSOR (BENDING LEG)
10. EMG (VASTUS MEDIALIS MUSCLE)
11. ULTRASOUND TRANSDUCER
 (RADIAL ARTERY BLOODFLOW)
12. POSITION SENSOR (LIFTING ARM)

INVOLUNTARY BODY
13. STIMULATION RHS BICEPS
14. STIMULATION LHS DELTOIDS
15. STIMULATION LHS BICEPS
16. STIMULATION LHS FLEXORS
17. STIMULATION LHS HAMSTRINGS
18. STIMULATION LHS CALVES

THIRD HAND
A. GRASP/PINCH (CLOSE)
B. RELEASE (OPEN)
C. WRIST ROTATION (CW)
D. WRIST ROTATION (CCW)
E. TACTILE FEEDBACK

STELARC

INVOLUNTARY BODY / THIRD HAND

Fig. 1 Involuntary body/Third Hand, Melbourne, Yokohama 1990. *Diagram* Stelarc, Stelarc

ate in the human landscape in a multiplicity of forms and with increasing number of functions. They range from massive and intimidating machines to nano-scale structures not visible to the human eye. They perform with a reliability,

repetitiveness and robustness not possible with our human bodies, and furthermore they can be accessed and actuated remotely. Robots are becoming more athletic with springy legs, varied sensors and speedier computational capabilities. They range from being fully automated to fully autonomous, responsive and interactive. They can incorporate insect and animal-like locomotion and human-like grasping and manipulation. They can be cute (caricature approximations) and uncanny (uncomfortably realistic). They can be increasingly human-like in appearance with facial expressions and lip movements that can generate affect that augments spoken communication. And embedded cameras in their eyes enable head tracking and face recognition. Soft, snake-like robots can deform and transform in shape to negotiate restrictive spaces and to perform particular tasks. There are factory robots, rescue robots, medical robots, military robots, flying robots and now nanorobots that can inhabit the human body. They are beginning to invade roads, buildings, hospitals, in our skies and in the theatre of war. Tele-operated robots can be seen as surrogate sensors and end effectors of our bodies. With increasing high fidelity visual feedback and haptics such as force-feedback, the spatial and psychological distance between body and robot collapses. Marvin Minsky's "telepresence" becomes Sasumu Tachi's "tele-existence" where you are effectively the remote robot. And artists are creating unexpected outcomes with prosthetics, robotics and interactive systems, incorporating the automated, the autonomous and the artificially intelligent into their work. Chimeras are now possible with robots actuated by bio-brains, located in labs elsewhere. Through the engineering of non-utilitarian and aesthetic alternate anatomical architectures, artists generate hybrid machine systems that obliquely interrogate aliveness, affect and agency. Engineering robots can be seen as both an interrogating of and a going beyond the human and evolutionary condition and capability. Biomimcry is not simply a replicating of the biological but rather an incorporation of their forms and functions in hybrid and unexpected ways. This text will be a collection of encounters, anecdotes and insights from research in prosthetics, robotics and my own performance art projects. The theoretical, social and ethical issues of this meshing of meat, metal and code are discussed.

On arrival in Moscow, I was questioned by one of the Custom's officers. In those days I had my THIRD HAND packed in a small aluminum case, which at the time I was able to carry on the plane as literally as my hand luggage. The officer, after a few general questions insisted on opening the case and was surprised at the sophisticated object I was carrying. He asked me what it was. I said it was a prosthetic hand. He asked me whose it was. I said it was mine. He observed I was fully enabled. He asked if I was in Moscow to do business. I said I wasn't. He persisted by asking if some company was going to produce this hand in Moscow. I said no. The customs official was becoming increasingly irritated, not being satisfied with my answers. Well, then what was the commercial value? I said there was no commercial value.

I then reluctantly admitted it was my artwork, thinking that this would clarify all my previous answers. His response was completely unexpected. He got even angrier, took off his glasses, glared at me and waving his finger insisted that this was not art! (Fig. 2).

Extended Arm and Ambidextrous Arm and SRL's

The EXTENDED ARM was completed and first performed with in 2000. This was realised with the assistance of Jason Patterson in Melbourne and f18 in Hamburg. It is an eleven degree-of-freedom manipulator that is worn on my right arm. It extends my arm to primate proportions. It has 300° wrist rotation, thumb rotation, individual finger flexion and each finger splits open. Potentially each finger is a gripper in-itself. It is pneumatically actuated and the finger, thumb and wrist movements are registered with sounds generated by the solenoid clicks, the percussion of the fingers, the compressed air sounds and synthesized sounds generated by the control signals. Whilst the artist actuates the Extended Arm manipulator, his left arm is moving involuntarily using two muscle stimulators, matching the eleven degrees-of-freedom. The event duration was 4 h, continuously performed. The AMBIDEXTROUS ARM is a work in progress that I originally initiated, with Dr. Tatiana Kalganova, as a collaboration between the School of Art and the School of Engineering and Design at Brunel University. Because of its

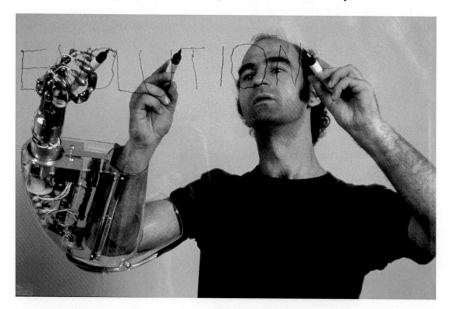

Fig. 2 Handswriting: writing one word simultaneously with Three Hands Maki Gallery, Tokyo 1982. *Photographer* Keisuke Oki, Stelarc

double-jointedness, the fingers can bend one way and the thumb can rotate for a left hand, or they can bend completely the other way and the thumb can rotate back to enable the mechanism to be a right hand as well. The components of the hand are 3D-printed with tendons that are actuated by bundles of pneumatic air-flow muscles positioned in the forearm. If an amputee, needs an arm, why not have an ambidextrous arm rather than one of a particular handedness? And if a mobile robot platform or a wheelchair has a robot manipulator attached, it would be much more versatile as an ambidextrous arm. But as an artist, what I am inter-ested in are the choreographic possibilities of performing with an ambidextrous arm attached. I've always imagined the extra arm being attached from the shoul-der. But that's not necessarily the best position as it could interfere with your nor-mal arm's movements. In recent years, extra limbs engineered as human attachments have been developed at the MIT d'Arbeloff Laboratory for Information Systems and Technology—two arms attached not only from the shoulders but also alternatively two arms attached at the hips. The arms from the waist can also act as a pair of extra legs, bracing the user in performing certain tasks. A full-body exoskeleton, aside from its additional weight would be cumber-some and constraining. Electronic limbs that can be both arms and legs are a bet-ter, more versatile solution. increasing the task envelope of these robot extensions. Known as Supernumerary Robotic Limbs (SRLs), these extensions are actuated by the acceleration and motion of the users arms.[3] Simpler wearable robot limbs have also been developed. Even two 3 degree-of-freedom extended fingers attached to the wrist can be very useful, enabling two handed functions performed with the one hand. These extra fingers can exert the force of your real fingers. So prosthet-ics initially imagined for the paralyzed can have applications for augmenting fully enabled humans for carrying out more complex multitasking (Fig. 3).

Indicators of Aliveness, Affect and Agency

> **Nobody complains that Bernini's sculptures are too darn real, right? Or that Norman Rockwell's paintings are too creepy. Well, robots can seem real and be loved, too. We're trying to make a new art medium out of robotics.**
>
> **DAVID HANSON, Robotics Engineer, Hanson Robotics.**

Increasingly intelligent and autonomous robots and virtual agents are populat-ing our human social architectural and electronic and internet spaces. Strategies for interaction and collaboration need to be considered and contested. As well as humanoid anatomies, robots will proliferate in a multiplicity of bio-mimicked forms and operate with varying functions. These chimeras will be not only on

[3]http://newsoffice.mit.edu/2014/getting-grip-robotic-grasp-0718; http://spectrum.ieee.org/robot-ics/industrial-robots, 2 June 2014).

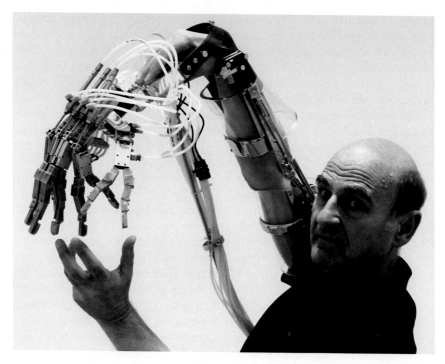

Fig. 3 Extended Arm, Melbourne, Hamburg 2000. *Photographer* Dean Winter, Stelarc

wheels but also will walk, run, leap, hover, float and fly-with human, insect-like, animal-like and bird-like maneuverability. Raffaello D'Andrea from the ETH Zurich calls his flying robots "athletic machines", performing remarkable airborne feats.[4] Another micro radio controlled flying robot called *"KULibrie"* flies by flapping its wings.[5] Boston Dynamics is known for its DARPA funded research for engineering robust robots for rough terrain (primarily for military use) and keeping their balance even if bumped, pushed or kicked. See *"Big Dog"*,[6] with dynamic manipulation[7] and the novel locomotion of "RHex",[8] with its springy, single jointed legs (a combination of wheels and legs, or "whegs") that enable fast movement and the ability to leap over obstacles. But especially with their *"Little Dog"* robot,[9] the Uncanny Valley becomes an issue not only with humanoid robots

[4]http://www.youtube.com/watch?v=C4IJXAVXgIo.

[5]http://www.youtube.com/watch?v=33z0xEBtwgI.

[6]http://www.youtube.com/watch?v=J6cekvxatu4.

[7]http://www.youtube.com/watch?v=2jvLalY6ubc.

[8]http://www.youtube.com/watch?v=ISznqY3kESI.

[9]http://www.youtube.com/watch?v=nUQsRPJ1dYw.

and avatars, but also with all bio-mimicked robots. And in 2013 more artificial agents than humans browsed the internet, with malicious bots such as *Scrapers* (content theft and duplication), *Spammers* (posting malware), *Hackers* (data theft) and *Impersonators* (bandwidth consumption) continuing to proliferate. Biological life is now increasingly contaminated by machine systems and viral codes. Arthur Kroker points out that as code is executable it is essentially performative.[10]

What becomes apparent is that only a simple vocabulary of behaviours generates a sense of aliveness and affect and this might suffice for our initial interactions, whatever form and function they might have. An intelligent agent is one that can respond appropriately, in a timely manner, in unpredictable social situations. To generate contestable futures requires an interdisciplinary approach and one that incorporates strategies in mixed realities.

Being alive is a biological condition beginning with birth and ending in death. Of developing, maturing and gradually deteriorating—unless a body dies unexpectedly from some pathology or catastrophic accident. This general observation can be applied to all living things including insects and animals. Aliveness, on the other hand is attributable here to machine systems and other artificial life forms that become animated and perform by being switched on and switched off either mechanically or by programmed code. This condition can be characterized as digital, rather than analogue. A kind of "operational aliveness". But as biological bodies are increasingly augmented and automated by prosthetic additions and artificial organs and kept alive by technological life support systems, the distinctions between the biological and the machinic blur as do the distinctions between "being alive" and "exhibiting aliveness". At the same time machines are becoming increasingly actuated by shape-memory alloys, rubber muscles and electro-active polymers. And with bio-brains grown with neurons kept alive in remote lab incubators, not only do robots have silicon chip circuitry but also are now engineered with soft and flexible components and can have wet, living media as generating agency.

Our responsiveness is determined not only by our intelligence and awareness but also by our hard-wired behaviour, our personal and social habitual and cultural conditioning. We do not always have to be attentive and we generally behave involuntarily and automatically. Much of what we do, we do not have to be aware of, as in the case of the basic functioning of our bodies. In fact it has been argued that awareness occurs when we malfunction, for example when we fall over or become sick, which interrupts our perceived seamless operation in the world. If a robot system can behave appropriately in social institutions, respond adequately in unpredictable situations and skillfully operate human technologies then a robot would appear to be a useful companion and assistant. Humanoid robots have become increasingly important in aiding humans, collaborating in complex tasks, augmenting human capabilities and even taking over certain roles that humans no longer wish to perform.

[10]Kroker, Arthur. 2012 *Body Drift: Butler Hayles Harraway* Minneapolis University of Minnesota.

What facilitates the proliferation of prosthetics and robotics and the development of more integrated and interfaced bodies and machines is the present engineering of the Internet of Thinks (IoT) and the notion of Object Oriented Ontology (OOO).

THE INTERNET OF THINGS

As physical objects are embedded with sensors, miniaturized circuitry and Cloud-based software they become increasingly connected and able to communicate with other objects as well as people—allowing monitoring, sensing and remote controlling. An integration of the physical world with computational systems. Objects generate data streams, becoming visible and relevant to other objects as well as people in an immense and expanding envelope of information. Objects become smarter and networked, including prosthetic attachments and implants in people.

OBJECT ORIENTED ONTOLOGY

Is a philosophy that rejects the primacy of human existence over the existence of non-human objects and entities. It's a kind of flattened ontology. A mode of co-existence, of individuated entities-in-themselves, of bodies, surfaces, viruses, algorithms that not merely inhabit the world but construct the world that we co-exist in. Rather than negating meaning it generates new kinds of relationships and sensibilities in a world we come into that is already populated by diverse, distributed and connected objects, entities and events.

To interact with humans and operate in our social spaces it is advantageous for robots to somewhat emulate human form and human function or at least engage in behavior that humans can be cognizant of and empathize with, as with bio-mimicked insect-like and animal-like robots. For a robot to approximate human actions it requires a robot anatomy of sensors to monitor the world, computational capabilities to process and comprehend its context and also to provide appropriate control signals for its musculature/actuators to generate the physical responses. Manipulation and mobility allow for an appropriate task envelope of operation that will increasingly overlap and become inextricably interwoven with the human. In the case of humanoid robots, having approximations of the anatomical architecture of biological bodies will allow robots to more adequately and seductively engage with us whilst simultaneously being capable of operating our machines and instruments that have been designed for use by a human body. As biological bodies we examine and are alerted by not only sight, but also hearing, smell and touch. Engineering a robot that can hear a human voice, respond to sounds that indicate a hazardous or even dangerous situation, feel if something is soft or hard, cold or hot, rough or smooth and distinguish smells that might be pleasurable or noxious to humans becomes a necessity. And of course robots would need adequate cognition to process and contextualize that information. What would it mean for a robot

to experience affect itself? Could it develop in addition to an artificial intelligence and artificial emotion as well? How would it approximate to the human? Would it be a somewhat extended and therefore an alien intelligence, an alien experience and an alien affect? Would a machine physiology generate a machine phenomenology? A reflective loop developing an awareness and consciousness? Until complex cognitive systems learn to incorporate new experiences and make appropriate associations machines will not achieve the intelligence for subtle interactions with humans. For now, hard-wired systems that can generally approximate and anticipate pre-programmed situations might be adequate enough to allow for useful interaction. And embodied conversational agents (AI chatbots) already carry on a charming conversational exchange with humans and other agents, although with somewhat limited logic and continuity.[11]

There is also the possibility of growing wet bio-brains kept alive in incubators, that can remotely control a silicon chip and metal robot. This hybrid is already occurring, albeit with rat neurons conditioning small robots, that learn to better navigate obstacles more effectively in their environment.[12] There may be good reasons for a humanoid robot to have an additional arm and that arm ambidextrous in operation. It might also be advantageous for the humanoid to have vision that allows it to zoom-in, to examine in macroscopic and microscopic detail and to see frequencies beyond the mere optical range of the human. And an eye-in-hand might enable better handling of small objects obstructed by our normal line of sight. An eye-in-hand would also become a mobile eye and disembodied eye that could more closely inspect and look around corners. (An ear on arm becomes an eye in hand.) Engineering such capabilities is trivial. We engage with others through facial expressions, hand and arm gestures and body postures. A Humanoid robot or virtual avatar with similar behavioral gestures can be a more effective interactive and seductive agent.

There are technical and perhaps fundamental philosophical reasons why robots will never act convincingly in adequately human-like ways to be accepted and incorporated into a society of humans. The Uncanny Valley[13] is a hypothesis that asserts that as a robot becomes more and more human in appearance and operation it can become more creepy to people interacting with it. It's convincing but not enough so. It makes us feel uneasy. But we know that people can be creepy too if they malfunction in subtle ways, stammer, at times appearing irrational, even pathological or not sensitive enough to social expectations and situations. So perhaps the Uncanny Valley is a problem more about technical inadequacies rather than a fundamental philosophical barrier.

Robot anatomy and avatar code appear increasingly advantageous for better integration with the Internet, instantly accessing its data and connected devices. Biological bodies are not designed to be intimately interfaced to the Internet. Bots can be engineered to be always on-line, massively amplified with immense data

[11]http://www.youtube.com/watch?v=WnzlbyTZsQY.

[12]See the work of Kevin Warwick on robots with bio-brains, Reading University, UK.

[13]First proposed by Japanese roboticist Masahiro Mori in the 1970s that indicated a significant dip in the graph he plotted at the point where the robot most resembled a human.

streams and become remote end-effectors for machine intelligence. For a human body to participate effectively it needs to be interfaced. These human-robot-information chimeras would increasingly function as extended operational systems. Separate domains of operation appear increasingly less likely. Task envelopes are overlapping. As robots become safer to interact with they are likely to be confronted with problems and situations that are uniquely human and they need to react appropriately. Should robots be susceptible to human emotions? Can robots interact with humans if they cannot recognize and respond appropriately by expressing emotions themselves? What do you entrust to robots that you wouldn't entrust to humans, given their potentially more lethal capabilities? Will it be mandatory for robots to have black boxes to record and replay their actions if serious malfunctions occur as now happens with some of our other technologies? And semi-autonomous robots would have to have the capability of "intelligent disobedience"[14] if the remote operator is unaware of the local consequence of a remote command. David Woods asserts that people who develop and deploy robots should be held responsible for them.

Want responsible robotics? Start with responsible humans.

DAVID WOODS, Cognitive Systems Engineering Laboratory, Ohio State University.

Can robots be armed, autonomous, intelligent—and ethical? Joanne Mariner who was the Director of Terrorism and Counterterrorism Program at the Human Rights Watch hopes that because robots are simply programmed and do not possess human emotions, not being driven by fear or hatred that they can be engineered to discriminate and to follow the laws of war. Can robots autonomously effectively operate in the theatre of war? If robots cannot be self-optimizing, then they become non-phenomenological, non-persons where empathy and ethics become problematic.

Robofair is the annual event that features the engineering and robotics work done at Curtin University in Perth and is for the general public, students and children. I've performed twice, both occasions continuously for the 4 h of the event with some unexpected comments and feedback from the audience. Whilst performing with my Extended Arm, a small boy, neatly combed hair and very well dressed kept walking past me and glancing at what I was doing. Finally he stopped, looked up and rather accusingly said, "You can't fool me. You're not a real robot!" In another 4 h event, I was performing with the Rethink Robotics Baxter robot,[15] a collaboration with Raymond Sheh from the Intelligent Robots Group, at the Department of Computing,

[14]A capability displayed by guide dogs and incorporated into Japanese roboticist Sasumu Tachi's "Tele-Existence" system.

[15]http://www.alternate-anatomies.org/projects-2/musclesmotors; http://www.alternate-anatomies. org/videos.

Curtin University. My right arm was moving involuntarily to the pre-programmed movements of its arm, whilst my left arm was generating the robot's movements. The improvised and involuntary movements of the body and robot generated a cacophony of sounds from streaming data and attached sensors. A girl, about three years old had stopped with her parents to watch. At a pause in the sequence she looked up and quizzically asked "What are you doing?" Actually, that was a question asked by much older people who saw the performance. The little girl was genuinely confused about what this was all about. Others were more bemused, not willing to accept that it was a performance, not a demonstration of some utilitarian function. For most who saw the performance the human-robot coupling was not adequate as an aesthetic performance but had to have some physio-therapeutic function.

Networked Robots

As alluded previously, robots need not function individually. In fact it would be advantageous that they are networked. Multiple robots coordinated and collaborating to perform a particular task spatially separated that would not require mobility, nor perform in proximity. They would perform sometimes in sync, sometime complementing each other. The system of wired robots would be able to access information and images beyond the sensory range of any individual robot. For example, it would be possible for a humanoid physically located in Perth Australia, to see with the eyes of a robot in London, to hear with the ears of a robot in New York, whilst another robot in Tokyo is accessing its limbs to perform a collaborative action. It's sensory experience of the world will not be determined by its local sensing system and its actions will not solely be the outcome of its machine musculature. In fact a networked robot potentially will have access to any internet embedded cameras and other sensors, sequentially or simultaneously. As Vijay Kumar, from the GRASP Lab, Engineering and Applied Science, University of Pennsylvania also asserts, such robots will have access to streaming data and will be able to function online in real-time in multiple and complex ways. In this extended operational system of sensors, cameras, robots and humans components can be swapped in and out to facilitate or dynamically reconfigure whatever task, in whatever complexity it is to be achieved.

With the FRACTAL FLESH (1995), PING BODY (1996) and PARASITE (1997) performances the body experiences itself as an accessible, programmable, remotely actuated and networked, that performs sometimes involuntarily, sometimes automated and sometimes in improvised ways. It is both a possessed and performing body. It is acoustically extended in the local

gallery space and electronically extended via the internet. A touch-screen interface to a muscle stimulation system in Fractal Flesh allowed people in the Pompidou Centre in Paris, the Media Lab in Helsinki and the Doors of Perception Conference in Amsterdam to remotely access and choreograph the body's movements in Luxembourg. In Ping Body, pinging 40 global sites during the performance resulted in the body actuated not by people in other places but by the ping signals themselves, measured in milliseconds and mapped to the body's musculature with the body becoming a kind of barometer of internet activity. With Parasite there is both optical and electrical input into the body. A customized search engine scans the internet, displays images of the body and the system analyses the images. The images you see are the images that move you. In these performances the controlled actuation of the Third Hand with the EMG signals of the muscles counterpoint the involuntary limb movements triggered by the muscle stimulation system. The body becomes a split body (voltage-in, voltage-out), partly here in this place and partly elsewhere, everywhere (Fig. 4).

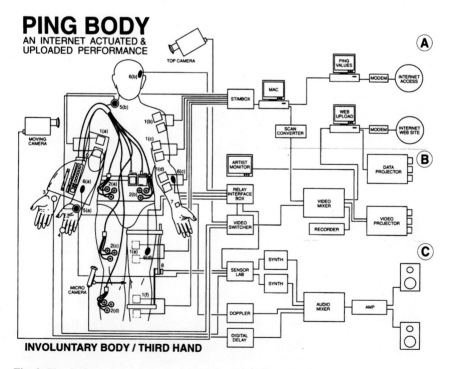

Fig. 4 Ping body: an internet actuated and uploaded performance. *Diagram* Stelarc, Stelarc

Six-Legged Walking Machines and Robots

EXOSKELETON is a six-legged walking machine, a locomotion prosthesis, robust enough to support the artist's body. This was engineered with the assistance of Tom Diekman, Stefan Doepner and Gwendolin Taube and Jan Cummerow, with electronics and programming by Lars Vaupel of f18. It is 3 m in diameter, and is pneumatically actuated, which means it is tethered to air and power hoses directed above it to allow unrestricted motion with its performance space. The robot moves forwards and backwards with a ripple gait, sideways with a tripod gait and also turns on the spot. The robot can squat and lift by splaying or contracting its legs. The artist is positioned on a turn-table, enabling him to rotate on his axis, facing forwards or backwards when necessary. The upper body exoskeleton sensors and controller allow the artist to navigate the robot. The left arm is an extended arm with a manipulator having 11 degrees-of-freedom. It is human-like in form but with additional functions. As well as thumb rotation, wrist rotation and finger flexion, each finger splits open—each finger becoming a potential gripper in-itself. The body actuates the walking machine by moving its arms, using magnetic sensors on the articulated exoskeleton to select the mode of locomotion and its direction. Different gestures make different motions—a translation of the artist's arm movements to the robot's leg motions. The result is a cacophony of pneumatic, mechanical and sensor modulated sounds. Composing the sounds means choreographing the movements of the machine. The robot is a hybrid insect-human-machine system to experience alternate gait and acoustical sensations (Fig. 5).

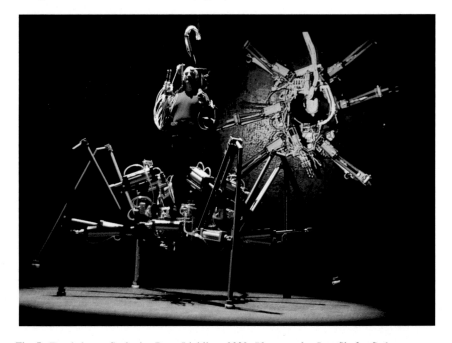

Fig. 5 Exoskeleton, Cankarjev Dom, Ljubljana 2003. *Photographer* Igor Skafar, Stelarc

When I was artist-in-residence for Hamburg City, I was obliged to have a performance at Kampnagel, a performance art space. For some years I had wanted to to engineer and perform with a 6-legged robot and when I discovered I had a 50,000 DM production budget I convinced the curator to allow me to spend the money on realizing that idea. Exoskeleton is a crude, jerky and powerful walking machine, it's legs hitting the concrete floor, sometimes with great impact. I had expected to perform naked on the robot, but the shock waves through the legs and chassis of the robot and up my spine were so strong that I realized the only way I could stand on the robot was wearing shock-proof boots. I thought it prudent then to also wear the rest of my clothing, much to the disgust of friends who thought I should be on the robot wearing only my boots. As the Amplified Body and Third Hand performances were about more delicate electrodes, sensors and wiring attached and stuck onto skin, becoming a kind of external nervous system for the body, exposing the skin and technology was visually important. Being fully clothed made more sense with the more industrial and mechanical nature of the walking robot. In fact, Exoskeleton was the first performance I did with my clothes on.

MUSCLE MACHINE[16] is a 5 m diameter walking machine that is more physically coupled to the body. It is pneumatically actuated, not by steel cylinders as with Exoskeleton but with air flow rubber muscles. Inflated with four bar of air pressure, the muscles act as springs holding the structure together. Seven bar of air pressure and the muscles expand in girth, contracting twenty percent of their length, producing a strong pulling force. These muscles are antagonistically bundled, a combination of inflating/contracting and deflating/extending to pull, lift and swing the legs. So by stepping up and down with encoders at the hip joints, the artist animates the machine. Sensors in the chassis detect the direction that the artist is facing and the robot moves in that direction. Human bipedal gait is translated into a six legged, insect like locomotion (Fig. 6).

[16]The Hexapod prototype and the MUSCLE MACHINE project was jointly funded by the Wellcome Trust and the Arts and Humanities Research Board in collaboration with The Nottingham Trent University and The Evolutionary and Adaptive Systems Group, COGS, The University of Sussex. The project was coordinated by Prof. Barry Smith (DRU, TNTU). Engineering of the robot by Dr. Philip Breedon (FaCCT, TNTU). The first demonstration and presentation of the project was at Byron House, The Nottingham Trent University, 26 June 2003. The first performances were done at Gallery 291, London, 1 July, 2003.

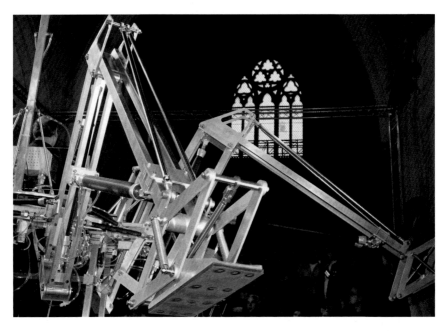

Fig. 6 Muscle machine, Gallery 291, London 2003. *Photographer* Mark Bennett, Stelarc

An impressive hexapod walking machine developed outside of university or military funded research is the MANTIS robot,[17] by Micromagic Systems in the UK. It has a 5 m in diameter working envelope, it is two ton in weight, hydraulically powered and it walks at an impressive pace. The operator sits in an enclosed cabin, so it has an industrial feel about it. MANTIS can also be controlled remotely.

A 2 m diameter autonomous and interactive robot, WALKING HEAD[18] performs on a 5 m diameter plinth. It has a LCD mounted on its chassis, displaying an animated human head. Its scanning ultrasound sensor detects if someone is in front of it in the gallery space. It then stands, selects from its library of possible movements and performs a choreography for the viewer. When it is finished, it sits and goes to sleep until it detects the next visitor. The intent was to engineer an actual/virtual system where the mechanical movements of the robot's legs modulate the avatar head movements and its facial expressions. The walking machines and the robot are also sound machines. The mechanics, the solenoid clicks, the pneumatic sounds and signals from their controllers augment the cacophony with synthesized sounds. The composition of the sounds is determined by the choreography of the machine movements (Fig. 7).

[17]http://www.mantisrobot.com.

[18]Engineering and software programming by f18, Hamburg.

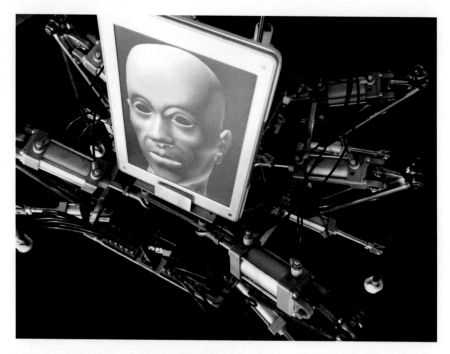

Fig. 7 Walking head, Heide Museum of Modern Art, Melbourne 2006. *Photographer* Stelarc, Stelarc

Exoskeletons and Assistive Technologies

Can a robot be brave? Can it selflessly sacrifice? Can a robot, trained to identify and engage targets, have some sense of ethics or restraint?

ERIC SCHMIDT, The New Digital Age: Reshaping the Future of People, Nations and Business.

Prosthetics and Exoskeletons are effectively wearable robots that can provide support and rehab for traumatized bodies, animate paralyzed bodies, augment human power for industrial use or amplify the capabilities of the military user. Even standing upright is advantageous for normally wheel-chair bound patients. And if the control of the exoskeleton is a brain-computer interface, then the exoskeleton becomes a more intimate and agency driven mechanism. The MINDWALKER is being developed and refined by the The Biomechanical Engineering group (BME), University of Twente. The ReWalk Robotic Exoskeleton is powered at the hips and knees enabling spinal cord injury patients to stand and walk. Ekso Bionics, Berkeley CA, pioneered and was the first to commercialize a robotic exoskeleton for rehab and paraplegic use in cases of stroke, spinal cord injury or disease, and traumatic brain injury. It typically facilitates walking for people with a broad range of motor abilities.[19] Daewoo Shipbuilding

[19]http://intl.eksobionics.com/ekso.

and Marine Engineering (DSME) has developed a hydraulically and electrically actuated EXOSKELETON PROTOTYPE for industrial use. Although it weighs 28 kgms it is self-supporting thus has no load on the human wearer. At present it only lifts 30 kg but the aim is to lift 100 kg. Attachments can also be fitted to turn the wearer into a human crane. The mobility and intelligence of the operator is augmented by the power of the machine that is being worn.[20] The Japanese exoskeleton, HAL 5 can be used for both medical and military use. It is a powered exoskeleton and controlled by skin bio-signals, with the exoskeleton mirroring the user's movements. The Human Universal Load Carrier (HULC), originally developed by Ekso, was licensed to Lockheed Martin to develop military applications. It was designed to be used in multi-terrain conditions, with front and back load support and upper body lifting. Its flexibility allows for squatting and crawling. Powered by an 8 h battery, it is a versatile and robust exoskeleton. DARPA's WARRIOR WEB program is engineering less cumbersome robotics designed to be worn under clothing, generally increasing endurance and lessening muscle and skeletal strain. The US military's TALOS (Tactical Assault Light Operator Suit) aims for greater protection as well as enhanced mobility and power. An alternative use of an exoskeleton with the X1 Mina being developed by NASA is to provide resistance in Zero G to exercise muscles.[21]

Robots not only traverse our natural and city terrains but can now also fly. From large surveillance drones to micro-miniature drones to ones propelled with flapping wings. Flying machines have gone from auto-pilot, to adaptive flight control, to learning systems. Whereas drones have been deployed to do surveillance of places, especially in the theatre of war, micro drones will now do surveillance of particular people. Mosquito-like, it is plausible that these micro-drones might even take blood or dna samples whilst the person is sleeping. Lighter and stronger materials, 3D printing, laser cutting, smaller, lighter and innovative actuators and more efficient means of powering small robots makes increasingly smaller, more robust and reliable insect-like flying drones possible.

In addition to the Predator and Reaper, a veritable menagerie of drones now circle in the skies over war zones. Small UAVs such as the Raven or the Wasp fly just above the rooftops, transmitting video images. Medium-sized drones such as the Shadow circle at heights above 1,500 feet. Predators and Reapers roam at 5,000 to 15,000 feet. Global Hawks fly at 60,000 feet, monitoring electronic signals and capturing detailed imagery. Each Global Hawk can stay in the air as long as 35 h.

Robots at War - P.W. Singer, The Wilson Quarterly.

[20]http://spectrum.ieee.org/automaton/robotics/industrial-robots/korean-shipbuilder-testing-industrial-exoskeletons-for-future-cybernetic-workforce 5 August, 2014.

[21]http://www.businessinsider.com.au/military-exoskeletons-2014-8?op=1#early-1960s-the-man-amplifier-1.

Fig. 8 Motion prosthesis,
Melbourne, Hamburg 2000.
Diagram Stelarc, Stelarc

The MOVATAR, an upper body motion prosthesis, was first performed for
Cyber Cultures at The Casula Powerhouse on the 19 August, 2000. It is an
inverse motion capture system that allows an avatar to partially access a
human body and perform with it in the real world as a virtual-actual interface.
A pneumatically actuated upper body exoskeleton allows the avatar to ani-
mate the performer's arms with a total of 6 degrees of freedom. The avatar's
evolutionary algorithms alter its behavior during the performance. The lower
body can interrupt and influence the interface through an array of switches on
the floor, creating an extended and interactive operational system. The body
becomes a split body whose upper torso is constrained and prompted whilst its
legs are free to move and modulate the choreography. The Movatar is a ges-
tural dialogue between a virtual entity and a physical body that evolves and
is modulated through interactivity during the performance. The body is again
simultaneously a possessed and performing body prompted—not by other peo-
ple as in FRACTAL FLESH, not by internet activity as in PING BODY, not by
internet images as in PARASITE—but by a virtual entity (Fig. 8).

Medical Robots

The Da Vinci Surgery System was the first robotic system to be approved by the FDA in the USA for general laparoscopic surgery.[22] It is not simply a natural extension of the surgeon's eyes and hands. Medical robots translate the surgeon's hand movements into more precise and reliable micro-actions,[23] minimizing error in performing minimally invasive surgery. With small attachable tools, enhanced vision for the surgeon and able to dampen the surgeon's hand tremors, this becomes especially advantageous for micro-surgery. The overhead boom allows all the 4 arms to rotate as a group as well as to have extended reach into the body. This provides easy and safer reach into the body than with the bulky hands of a human surgeon. The Da Vinci robot provides enhanced surgical control, with the system constantly computing the safety of the surgical procedures. And its instruments provide seven degrees-of-freedom, better than the human wrist. It combines a magnified, 3D HD augmented vision that is immersive and it has motion control to go beyond conventional surgical techniques and skills. It is an ergonomically designed system that maximizes performance with its use of multiple, interactive arms. The fact that the system scales, filters and translates the surgeons hand movements and suppresses any autonomous movements results in safer surgery. The assisting nurses can visually monitor the internal surgical procedure and patient critical information on the available monitors. The two telescopic cameras allow for 3D stereoscopic views. The result is more skilled surgery and less patient trauma. The Da Vinci robot can be used proximally or remotely, given its audio-visual and haptic capabilities. In 2014 almost 500,000 surgeries were done using robots. A fully automated robot surgeon can apply the history of previous surgeries and improve on all its past procedures.

[22]http://www.davincisurgery.com/da-vinci-surgery/da-vinci-surgical-system/; https://www.youtu be.com/watch?v=VJ_3GJNz4fg

[23]Demonstrations to show the dexterity possible have included miniature paintings and folding miniature origami and paper planes.

Inside the Body

Having endoscopically filmed 3 m of internal body space into the lungs, stomach and colon between 1973–1975 and with the realization that the body is not only a structure of tissue, muscles and bones but also of empty spaces, cavities and circulatory systems there was always a desire to insert technology into the body. In 1993 I designed a sculpture for the inside of my stomach, for the Fifth Australian Sculpture Triennale in Melbourne whose theme was site-specific works. The STOMACH SCULPTURE[24] was realised with the assistance of a jeweller, a micro-surgery instrument maker, a musician and a lighting designer! This simple machine was a tethered worm screw and link mechanism that once inside the stomach could open and close, extend and retract, with a flashing light and a beeping sound. The stomach had to be inflated with air to make it safe to insert the object. It took six insertions over several days to document 15 min of video. You have to imagine this as a machine choreography inside a normally wet and dark environment of the stomach cavity. Instead of a sculpture for a public space, this was a sculpture for a private, physiological space (Figs. 9, 10 and 11).

Fig. 9 Inside of my stomach, Yaesu Cancer Research Centre, Tokyo 1973. *Photographer* Mutsu Kitagawa, Stelarc

[24]The Stomach Sculpture was realized with the assistance of Jason Patterson, Rainer Linz and Nathan Thompson.

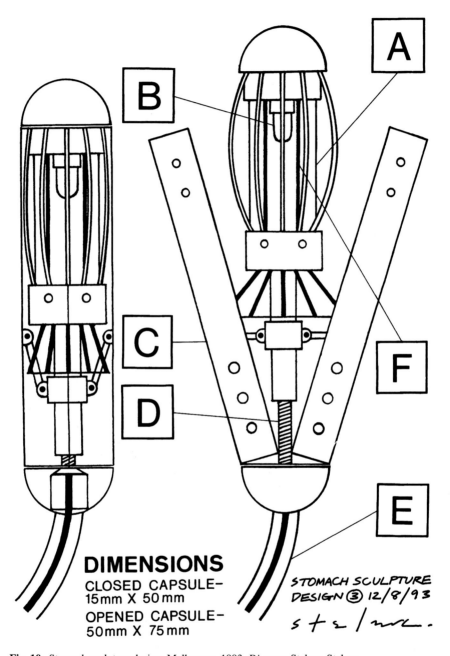

DIMENSIONS
CLOSED CAPSULE-
15mm X 50mm
OPENED CAPSULE-
50mm X 75mm

STOMACH SCULPTURE
DESIGN ③ 12/8/93
s t s / mc.

Fig. 10 Stomach sculpture design, Melbourne, 1993. *Diagram* Stelarc, Stelarc

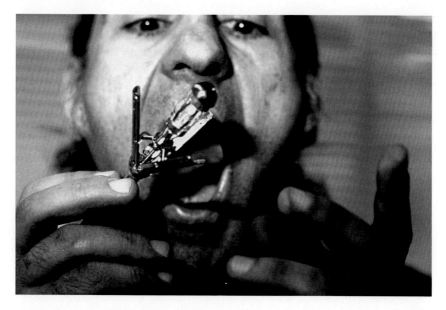

Fig. 11 Stomach sculpture, Fifth Australian Sculpture Triennale, NGV, Melbourne, 1993. *Photographer* Anthony Figallo, Stelarc

Another art project, MICROBOT[25] is a work in progress, initially funded by the Australia Council, and now a collaboration with Stefan Doepner. The plan is to engineer a six legged walking robot small enough and robust enough to climb up my tongue and into my mouth. I will however, have to be careful not to swallow it. The micro robot took its first slow steps in Ljubljana in October 2014. The legs were 3D printed, folded and pinned each with 3 degrees of freedom. Nitinol shape-memory muscles were used. The micro robot needs to be further scaled down one third of its present scale and requires more speed and flexibility in its movements. Micro and nano fabrication techniques has led to the development of MEDICAL MICRO-ROBOTS. These pill-sized capsule medical devices are designed to be swallowed with the purpose of screening, diagnostic analysis, to perform biopsies, and even to perform basic surgery. The robot- like capsules have both locomotion and manipulation capabilities in gastro-intestinal and intravascular environments. In other words they can propel through the liquid environment in the stomach and circulatory system but also crawl along intestinal tracts. Effectively they are surgical tools that can be magnetically guided by an external robot to exact locations for precise drug therapy and to perform basic surgical procedures including plaque busting. With camera and wireless telemetry these procedures can be adequately monitored. These guided capsules will in the future become more autonomous with added sensing, motion control, intelligent programming and further sizing down. At a nano scale functioning in inter and intra cellular spaces becomes possible. Augmenting our bacterial population with micro

[25]The Microbot animation was done by Steve Middleton.

and nano robots would contribute to maintaining the healthy functioning of the body and provide an early alert warning system that indicates and acts on problems automatically.[26] Imagine repairing or even redesigning the body with nano robots, atoms up, inside out. They would not be seen, not be sensed, not be felt until the surface landscape of the body visibly transforms.

> **Replicating assemblers and thinking machines pose basic threats to people and to life on Earth. Among the cognoscenti of nanotechnology, this threat has become known as the gray goo problem.**
>
> **ERIC DREXLER**

The title for the Robots and Art Workshop organized for the International Conference of Social Robotics 2014, Sydney was "Misbehaving Machines". I was complicit with both Christian Kroos and Damith Herath in coming up with the title. But as the workshop approached and I began thinking of my presentation I became uneasy about the title. Being interested in embodiment and agency, I felt it was important to make the distinction between malfunctioning and misbehaving. It is not a trivial observation. The word malfunction indicates an operational failure, whilst the word misbehaving indicates a behavioral problem. That is malfunction indicates an error, whilst misbehavior indicates an agency. In other words, an intelligent agent that makes a certain choice. An error can be said to occur when the functions that the machine or robot have been designed to carry out fail. A malfunction can occur in the absence of someone. On the other hand misbehaving can only occur in the presence of someone as there is always a subjective or social framing of what is considered misbehavior. So we need to more carefully describe what kinds of motions and actions are happening in our relationships with technology. Machines and robots are increasingly doing the "dull, dirty and dangerous" tasks. We can engineer or allow to evolve smart, robust and reliable machines but we have to make sure they are not making dumb or downright dangerous decisions in terms of the social consequences of their actions.

Avatar and Robot Heads

The PROSTHETIC HEAD is an embodied conversational agent that speaks to the person who interrogates it, with its real-time lip syncing and speech synthesis. It was developed with the assistance of Karen Marcelo, Sam Trychin and Barrett

[26]See the work of Sukho Park, Kyoungrae and Jongho Park, School of Mechanical Systems Engineering, Chonnam National University, Korea http://robotics.tch.harvard.edu/workshops/iros2012/resources/park2010development.pdf.

Fox. It has a data-base, a conversational strategy and a vocabulary of facial expressions that generate affect. The head is modeled and skinned to somewhat resemble the artist. It is a screen-based installation, typically projected as a five meter high head. Notions of intelligence, awareness, identity, agency and embodiment become problematic. As part of the THINKING HEAD project, iterations and alternate embodiments are realized. The ARTICULATED HEAD (2006–2011)[27] has a six degrees-of-freedom robot body that with it's vision and sound location sensors and its THAMBS attention model[28] the system is able to track and apportion its attention with the people it interacts with. As a sculptural and physical presence it is able to better interact with its interlocutors in 3D space. The FLOATING HEAD (a collaboration with NXI Gestatio, Montreal and MARCS, UWS) enabled the Prosthetic Head to be embodied as a floating, flying robot. Sensors on the robot indicated its exact position in 3D space, enabling the direction of the projector to be continuously adjusted, thus keeping the head embodied. A vocabulary of interactive behaviors was especially developed for the floating robot's slower responses expressing such emotions as indifference, curiosity and nervousness (Fig. 12).

Fig. 12 Floating head Montreal, 2010. *Photographer* Conception Levy, Stelarc and NXI Gestatio

[27]Project team at the MARCS Lab, University of Western Sydney, included Damith Herath, Christian Kroos and Zhengzhi Zhang.

[28]The attention model was developed by Christian Kroos.

SWARMING HEADS (2011)[29] is an installation of a cluster of 7 small, wheeled robots with mounted LCD screens displaying the Prosthetic Head. These robots interact with themselves and with other people. This is the beginning of a project that will explore social behavior and verbal interaction between agents and audience. The installation can also be a platform of multiple robots for interactive video conferencing between people in other places, not only seeing each other but also interacting physically in real-time with each other and the person conducting the group conferencing.

Alternate Anatomical Architectures

Evolving robot anatomies through accelerated selection of more appropriate designs is not only a strategy of engineering better robots but this approach is also producing research platforms for understanding the architectures and operation of living and extinct insects and animals, as these engineered robots are observed and evaluated performing in the physical world.[30]

It's important to emphasize again that engineering robots is about engineering contestable futures, creating possibilities to be explored, possibly appropriated or more likely to be discarded for improved iterations in form and function. Machine systems have in the past been confined and constrained to specific task environments, but with potentially more robust anatomies that allow them to operate in diverse terrains and in both hazardous and remote locations the possibility of proliferation of robots becomes real, especially if some kind of self-organization and self-replication is devised. Not only can robots proliferate in both alien and human landscapes but also, nano-scaled, inside the human body. This profound penetration of technology adds to the accelerated proliferation of robots, which become an extremophile, an exobiological operational system. The first signs of an alien life-form may well come from this planet.

Biomimicry is not simply replicating insect and animal architectures. Unexpected outcomes occur in this process. Shigeo Hirose's robot snake engineered at Tokyo Institute of Technology becomes a more flexible endoscope or a modular rough terrain lunar vehicle. The Whegs robots at Case Western Reserve University in Cleveland hybridize wheels and legs for faster locomotion on both flat and off-the-road terrain. Alternate embodiments allow for modulated behaviors and thus unexpected intelligent outcomes. New robot bodies enable interesting behavior

[29]Developed at the MARCS Lab, University of Western Sydney, by Damith Herath, Christian Kroos and Zhengzhi Zhang.

[30]See "Darwin's Devices: What Evolving Robots Can Teach Us about the History of Life and the Future of Technology". John Long, New York: Basic Books, 2012.

through new physical interactions with the environment. Although initially replicating biological bodies can assist in designing efficient robots, what is also created is the possibility of alternate interactions and operations in the world. Robots with multiple vision, extended sensors, more precise manipulation, faster and more robust architectures and extended, online cognitive systems quickly transition from service machines to smart systems that can become autonomous and interactive.

They become operational systems that have never existed before. If robots have complex anatomies, sensors and cognitive systems would it be advantageous to be imbued with expressions of emotion and also to generate empathy? Affect allows for more subtle and modulated interaction with others and the world, especially in human societies. But do we want moody machines? Robots have been seen as reliable and robust mechanical and electronic systems with specific task envelopes. To adequately interact with humans there should be at least a recognition and comprehension of human facial and gestural expression. And importantly, a consensually shared symbolic and phenomenological model of the world. But will an artificial life form (AL) with an artificial intelligence (AI) reproduce a human or an alien experience? Is it meaningful to speak about an alien phenomenology if the feedback loops reverberate into a kind of self-reflection. Having a sense of self, or should I say a sense of system, would be equally as important as having a sense of the world. Whilst we animate our machines we increasingly automate our bodies and with the proliferation of biomimicked robots we are blurring the distinction between bodies, insects, animals and machines. There is the possibility of creating chimeras of meat, metal and code. Constructing hybrid human-machine systems that might incorporate evolutionary outcomes of adaptation with imaginative engineering.

The examples of industrial exoskeletons and robots mentioned in this chapter will rapidly be replaced by improved models. Just as the body has become profoundly obsolete in the technological terrain it now inhabits, robots have an accelerated and shorter operational life-span before updates and redesigns take over. Robots and artificial limbs and manipulators are becoming more sophisticated with greater dexterity and degrees-of-freedom. This is not merely an urge to augment, amplify and extend the human. What is being creatively constructed are artificial organs and machine designs that bypass body architectures and body functions. Artificial components and operational systems that radically interrogate the human condition. Several years ago the first turbine heart was inserted into the chest of a terminally ill patient.[31] This small and robust artificial heart circulates blood continuously without pulsing. So in the near future, you might rest your head on your loved ones chest. He is warm to the touch, he is breathing, he is speaking, he is certainly alive—but he has no heartbeat....

[31]William Cohn and Bud Frazier from the Texas Heart Institute in Houston.

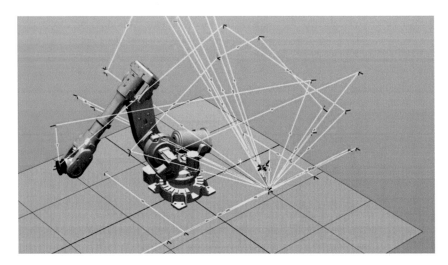

Fig. 13 Offline propel programming, Wintech Engineering, Yangebup 2015. *Image* Video Still Stelarc

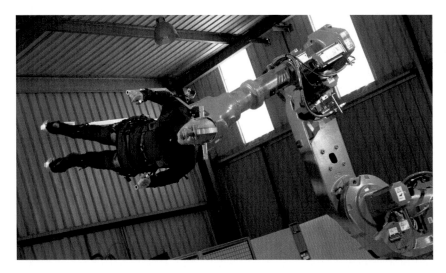

Fig. 14 Propel: body on robot arm, Autronics, Yangebup 2015. *Photographer* Jeremy Tweddle, Stelarc

Fig. 15 Propel: ear on robot arm, Autronics, Yangebup 2015. *Image* Video Still Stelarc

The PROPEL performance with the body and animated installation with the sculpture was planned for "DeMonstrable" an exhibition at the Lawrence Wilson Gallery, UWA, Perth. The exhibition was curated by Oron Catts, Jennifer Johung and Elizabeth Stephens. The performance was realised with the assistance of Paul Caporn. The idea was to choreograph the trajectory of the body using a 6 degree-of-freedom ABB IRB 6640 industrial robot arm, varying the trajectory, velocity and position/orientation of the body in space.[32] I was to perform coupled to the robot for an afternoon and then have my body replaced by a body-sized replica of my ear for the remaining months of the exhibition. The choreography of the ear sculpture on the robot matched the choreography of the body.[33] Interestingly, the robot that choreographed the ear was also the same robot that carved the ear. Due to a structural analysis of the floor it was not possible to install the robot in the gallery. The weight of the robot plus the forklift to position it in place far exceeded what the concrete floor of the gallery could support. The performance and installation had to be realized and documented at Autronics, the company where the robot was located. What was finally shown in the exhibition were large projections of both the body and the ear on the robot as well as the physical objects of the support structure and the large ear sculpture. Because of the perceived danger of being coupled to the robot arm the choreography could not be performed without a programmer holding the

[32]https://www.youtube.com/watch?v=2bRpTn0KKd8.

[33]https://youtu.be/1vzJJjjF0vs.

controller with his thumb on the "kill switch". The performance would not have been possible without the support of Jim Tweddle, Wintech and Peter Bradbury, ABB Australia. The programming of the robot was done offline with Hayden Brown and James Boyle. The sculpture was carved at Foam Shapers (Figs. 13, 14 and 15).

While Kant could entertain the fantasy of chimeras, he could not foresee that they would one day exist as objects of experience. Stelarc's work underlines and extends the prosthetic character of the human body, throwing into question the philosophical distinctions in which it has traditionally been thought. By emphasizing the view of the body as technologically organized matter, Stelarc performs an alignment of matter and form that would avoid any metaphysical opposition. In some ways the logic of his work can be seen to have been anticipated in Kant's text, even if Kant was eventually unable to sustain the thought of the technological chimera.

HOWARD CAYGILL "Stelarc and the Chimera: Kant's critique of prosthetic judgement (Aesthetics and the Body Politic)". Art Journal, Spring, 1999.

Printed in the United States
By Bookmasters